Washington-Centerville Public Library
Centerville, Ohio

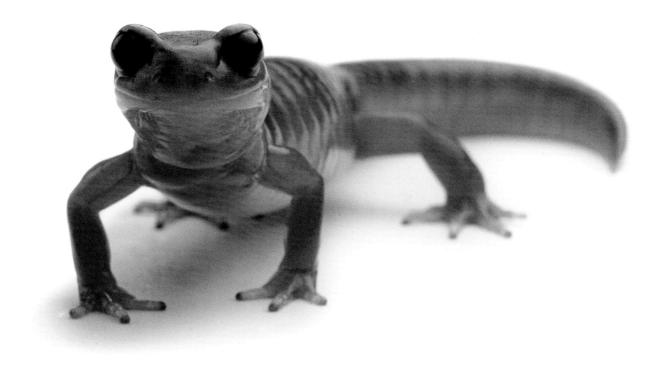

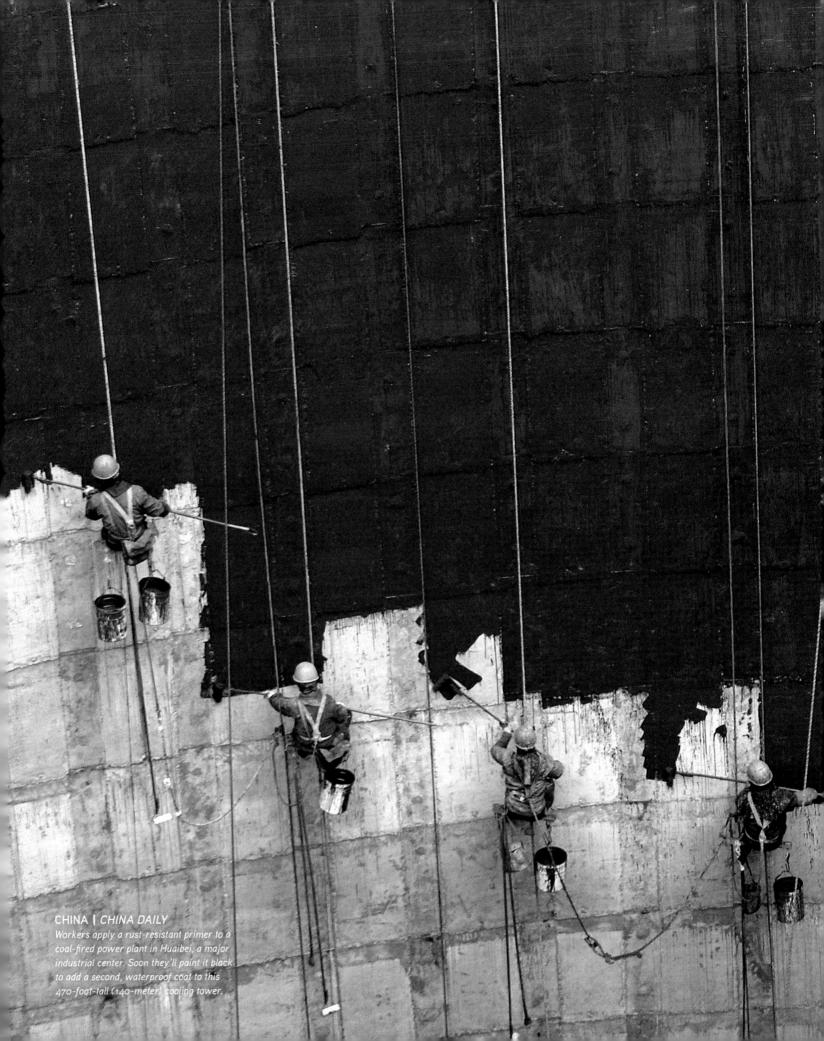

VISIONS OF EARTH

BEAUTY • MAJESTY • WONDER
SUSAN TYLER HITCHCOCK

NATIONAL GEOGRAPHIC

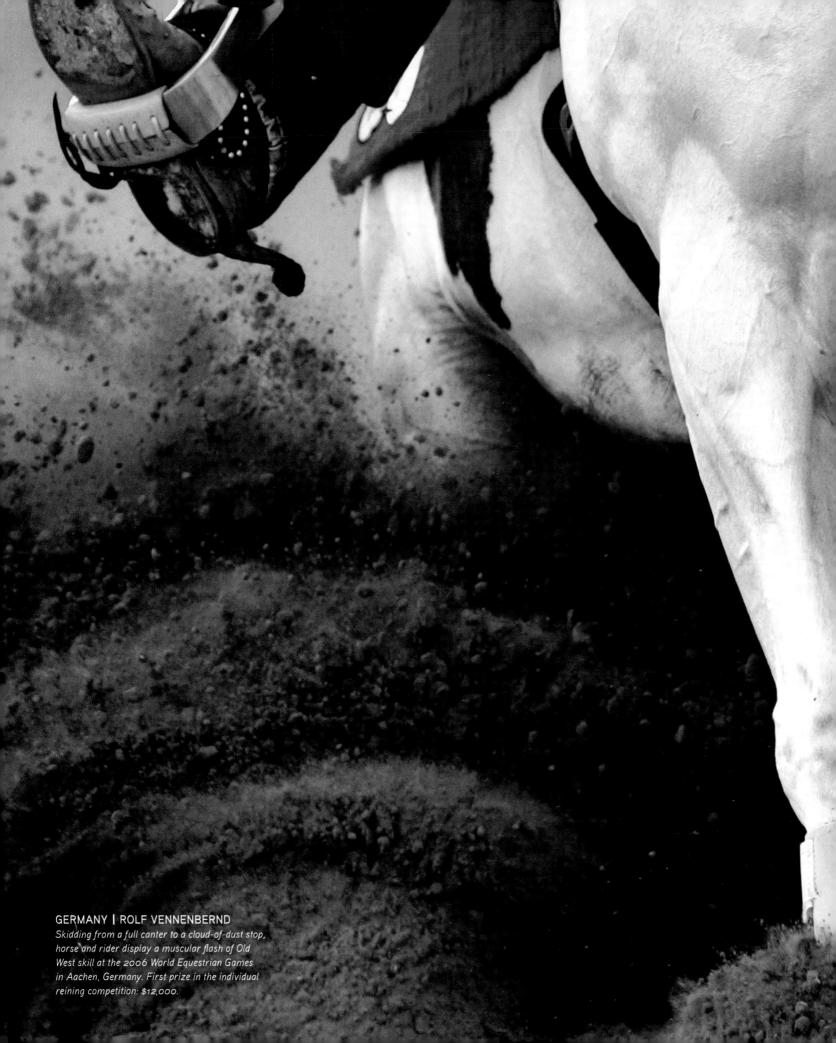

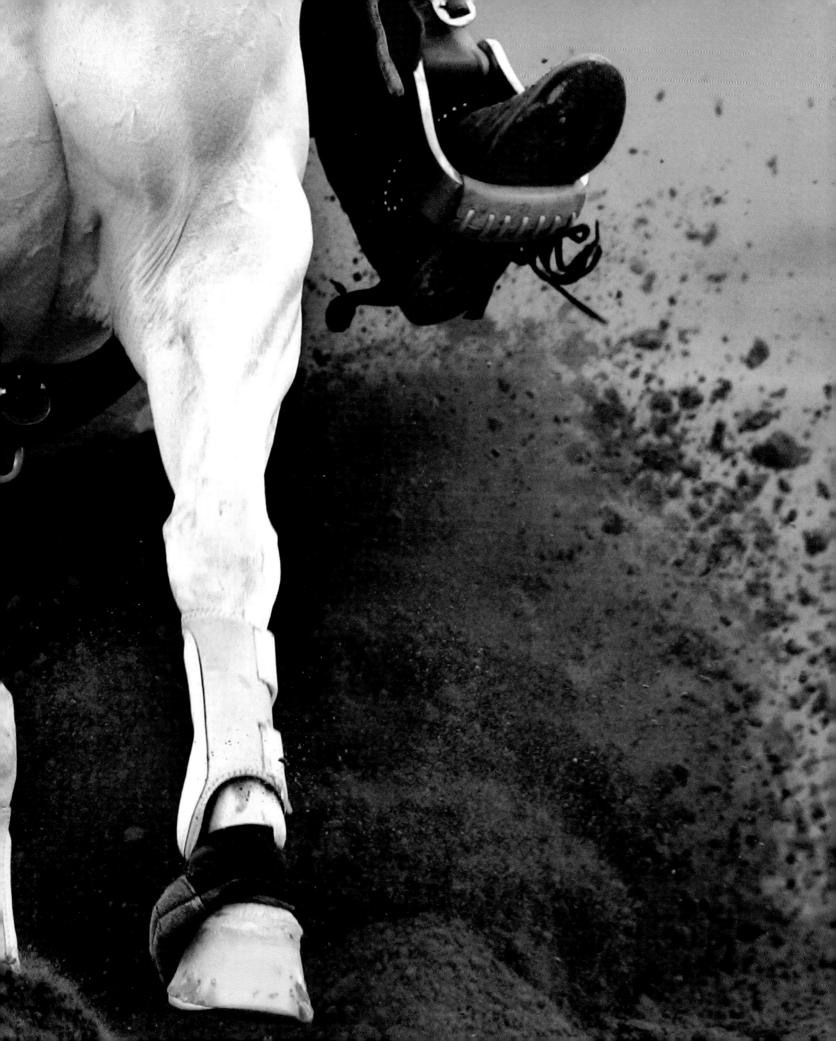

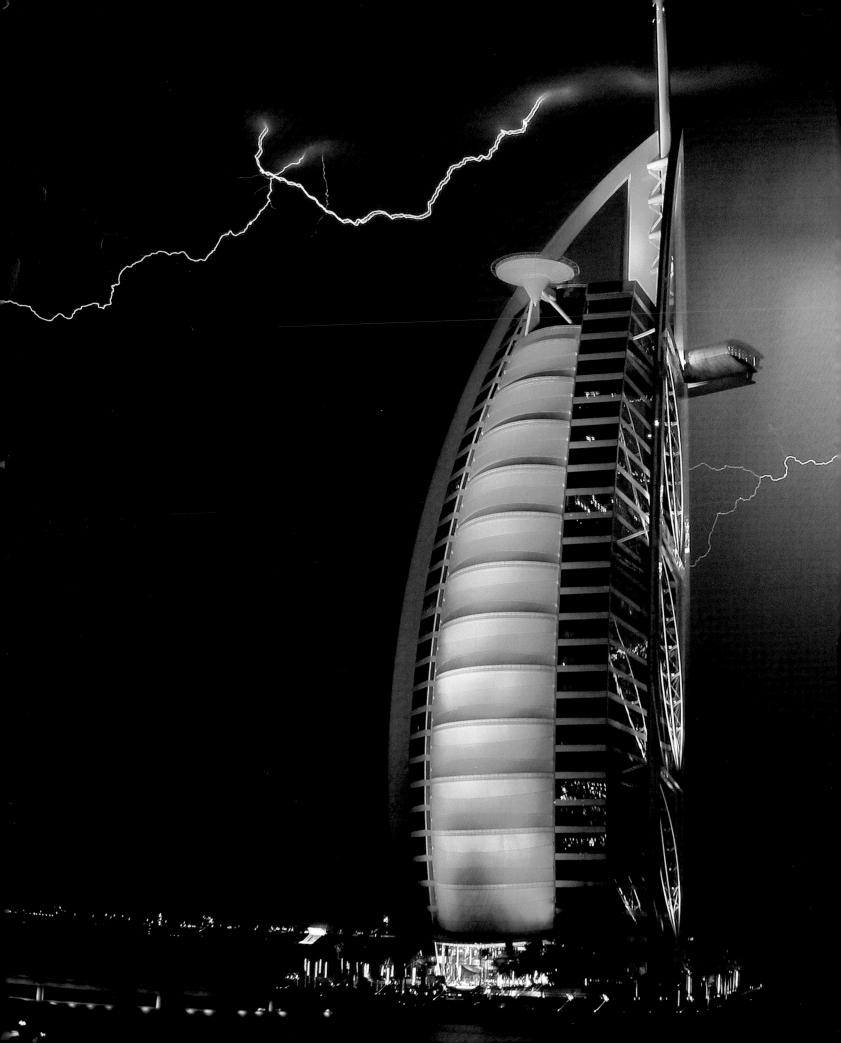

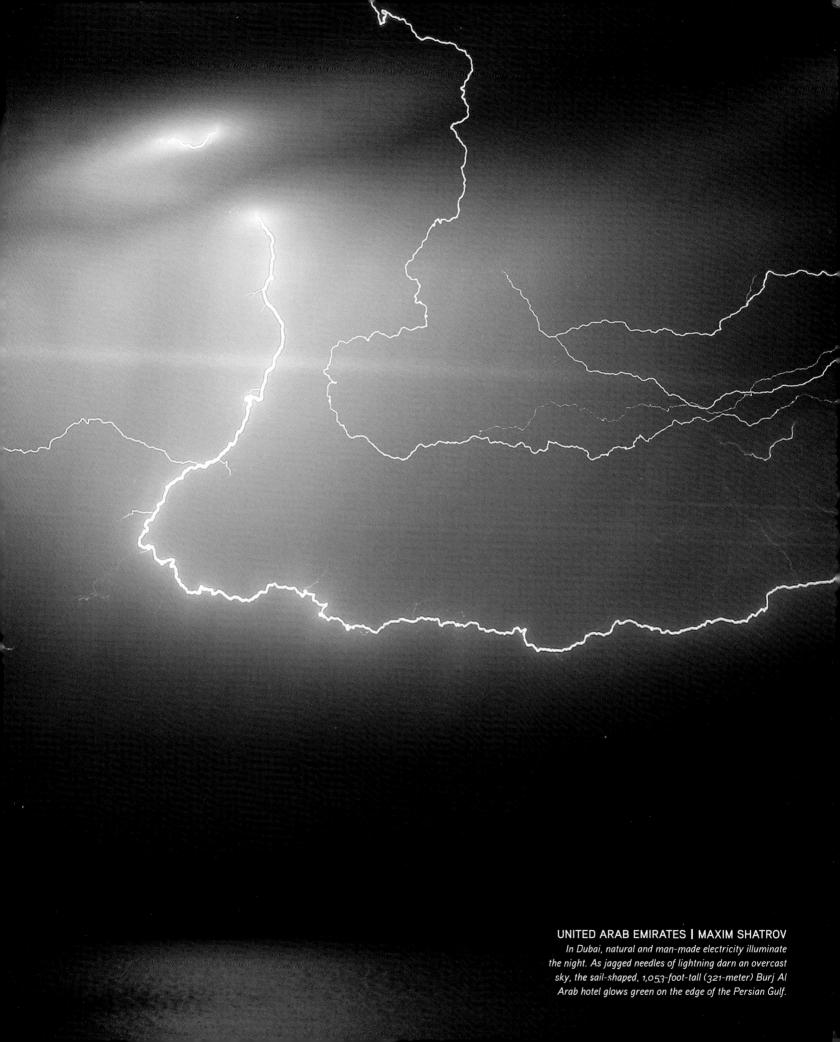

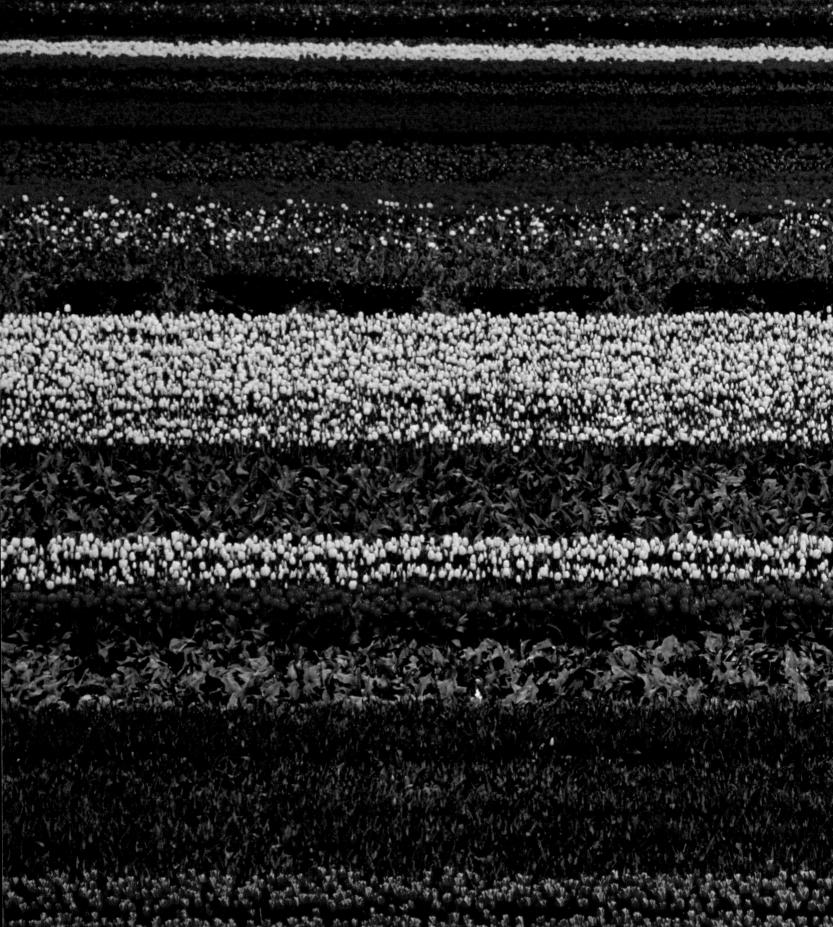

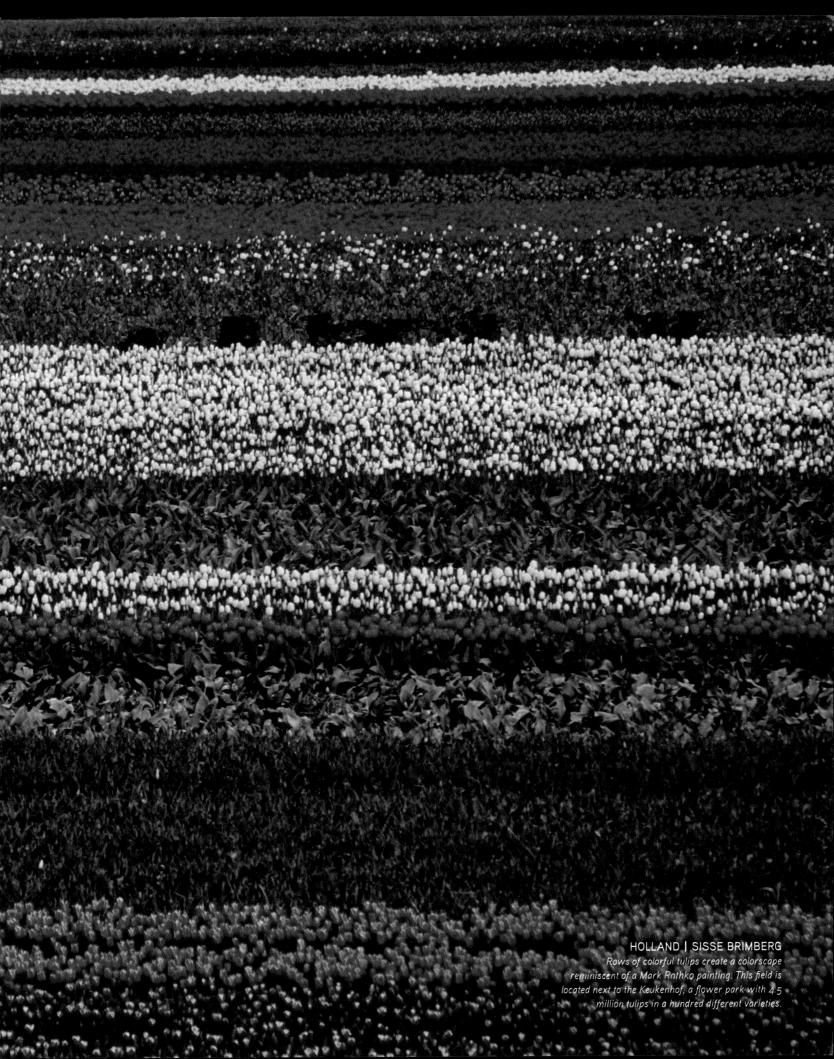

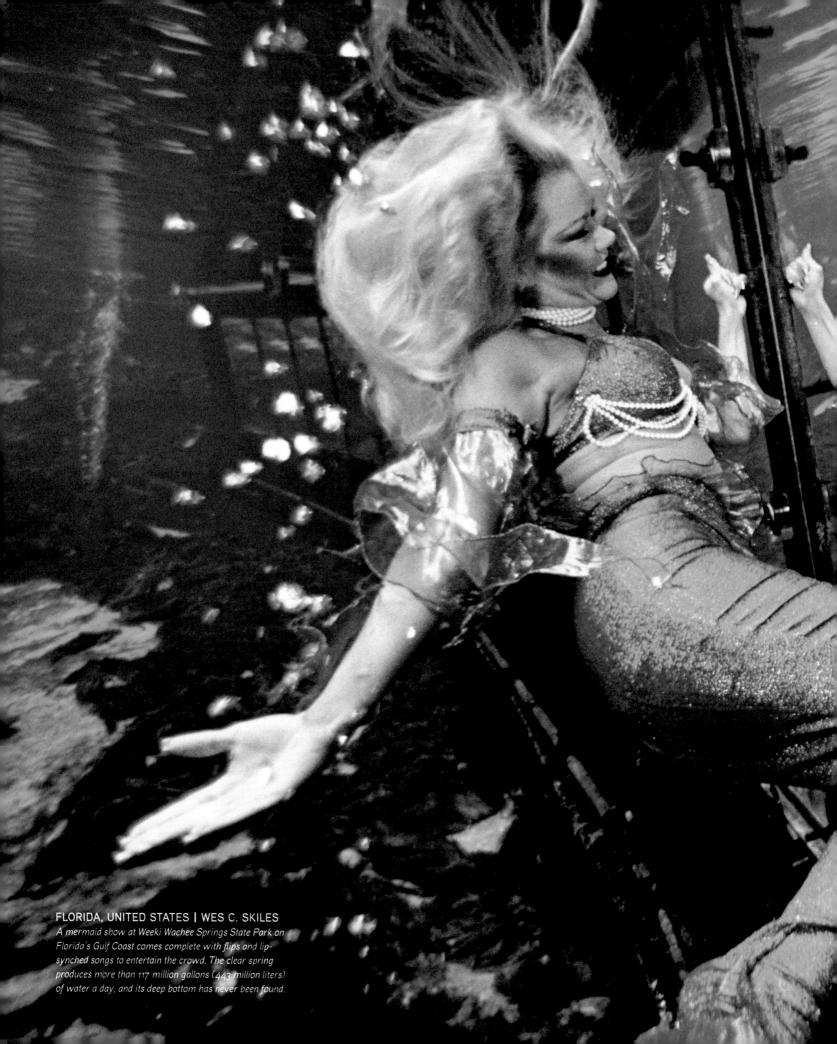

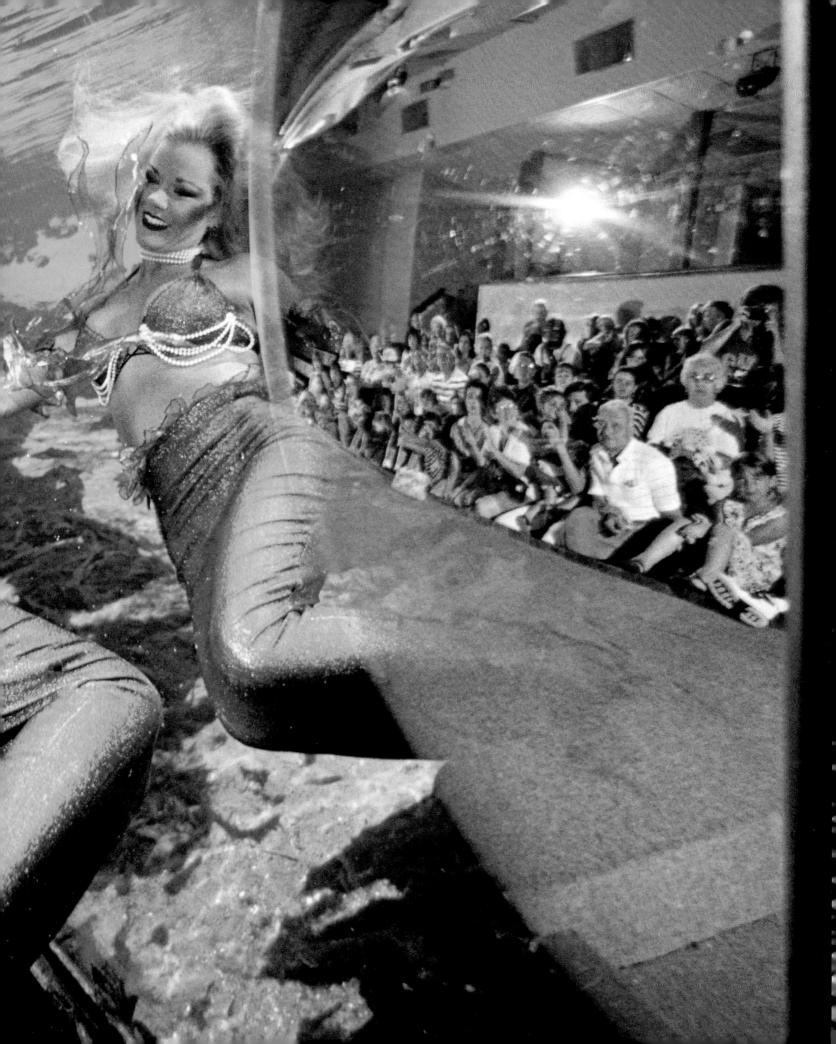

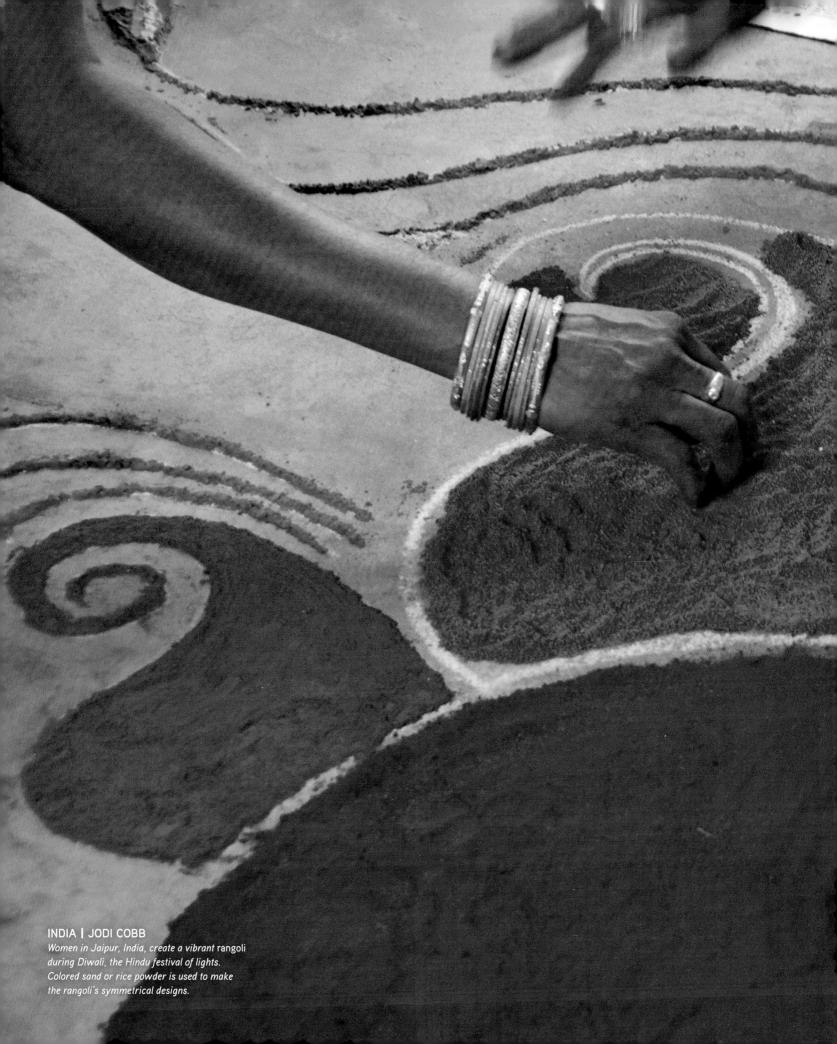

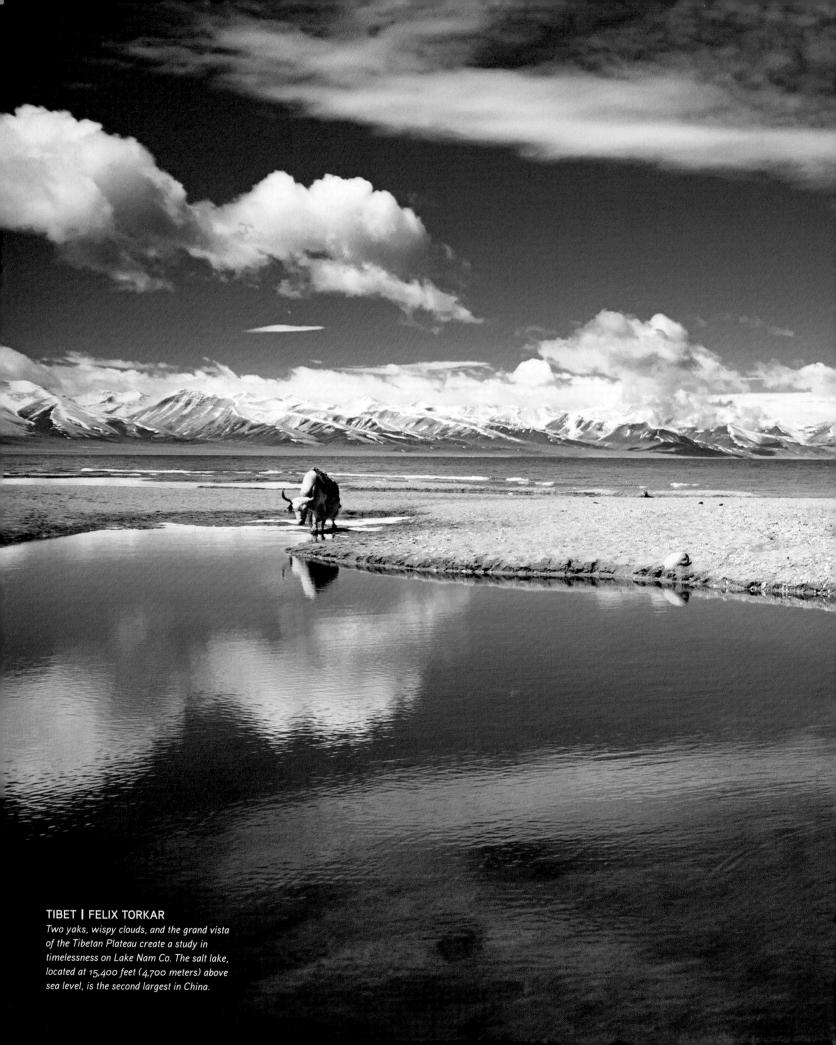

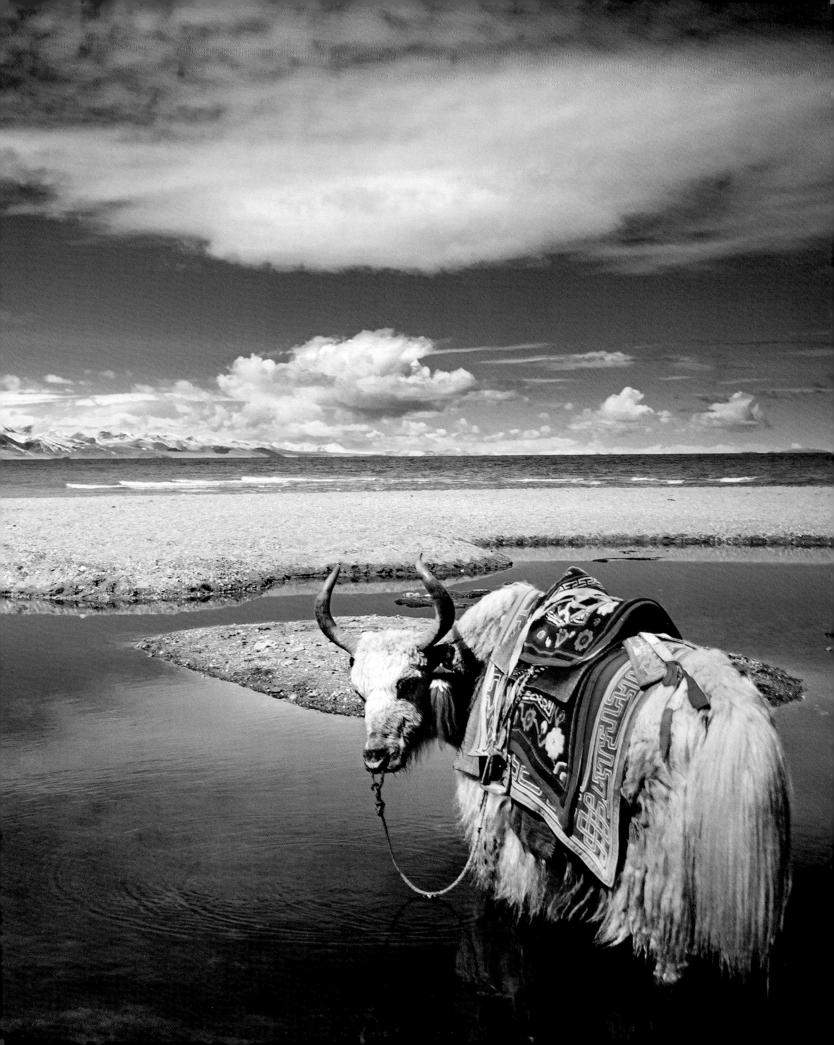

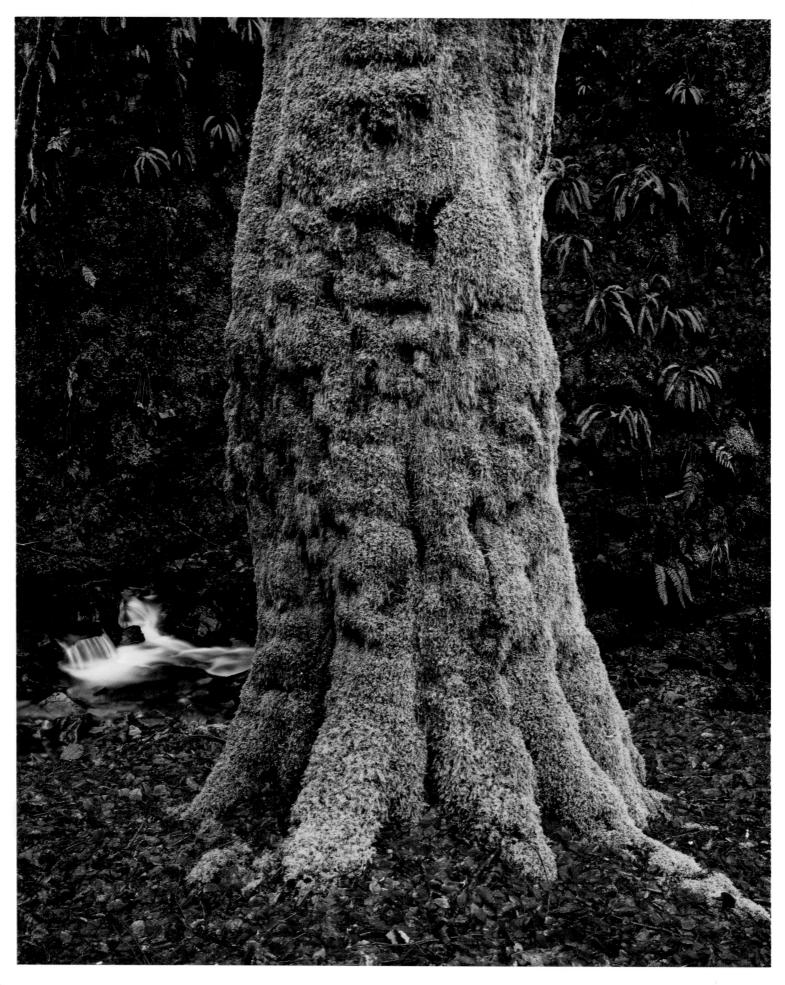

FÖREWURD BY CHRIS JOLINS . . . 18
INTRODUCTION BY SUSAN TYLER HITCHCOCK . . . 20

BEGINNINGS...24

CURVES...56

SURFACES...86

PATTERN ... 118

EMANATION...150

AGGREGATION...182

PARALLELS...216

UNEXPECTED ... 250

PERSPECTIVE...282

SPECTRUM...314

INTERLOPERS...348

BREAKING...380

ENDINGS...412

FLOW ... 446

RADIANCE ... 478

ILLUSTRATIONS . . . 510

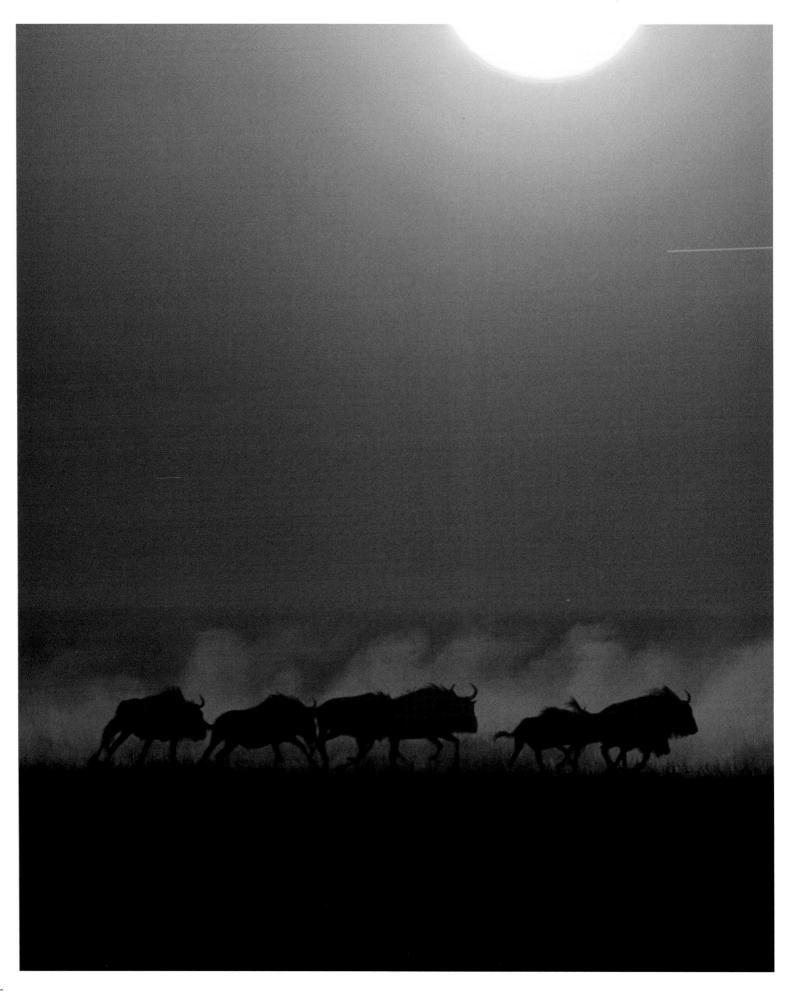

FOREWORD BY CHRIS JOHNS

ideas come from? How do they take shape? I'm convinced an idea has little to do with the clichéd bolt of lightning or switched-on lightbulb. Rather, an idea percolates. Annie Dillard, who wrote Pilgrim at Tinker Creek, once said that you might work and work on a paragraph and then throw it away, but you never really lose it. It comes back in different form, and so it can be with an idea.

Some years ago I had a conversation with a colleague about how to celebrate photography in *National Geographic*. We started with the thought of casting a wide net to find a singular spectacular image. It could serve, I suggested, as a kind of preface to the magazine, hinting at the excitement and wonder to follow. That was the inception of Visions of Earth—or at least the concept that was kicked around sometime in 2003.

Gradually, the idea took shape. It would not be an intellectual thing, but more gut based and emotional. The single image would be . . . arresting, I guess, is the best word—the kind of picture you'd want to, even need to, look at twice or more. The photograph would have to be unique, surprising, and upbeat. But *National Geographic* doesn't go for syrupy images with no substance. It had to be thoughtful. And because it would run in the front of the magazine, it had to set the tone of what followed.

It was a tall order, but we finally launched the feature in August 2004 with a picture I had taken while still working as a photographer. The image showed a stampede of wildebeests, silhouetted against a dusty sky the color of a blood orange. To make it, I journeyed across the flood-prone Zambezi Plain, one of the wildest places in Africa. At the time there were no roads and few people. It was impossibly remote, and that brings up another trademark of a Visions photograph: It has to be an image that people have never seen, perhaps never even imagined they would see.

In March 2006, overwhelmingly positive reader response convinced us we ought to expand Visions, so we went from one photograph to three. The pictures had to have some sort of connective tissue—whether it was a similar color palette, a pattern, even a quality, so subtle you might not be able to pinpoint what it was; you just sensed something that linked the three. And, I insisted, there ought to be in the mix a photograph that somehow celebrated humanity. Something deep, with soul, that spoke to who we are.

Today, Visions of Earth is consistently our top-rated department in the magazine. "Month after month you capture the wonders that the earth has to offer," wrote one reader. And that, come to think of it, is a pretty good description of the vision behind Visions.

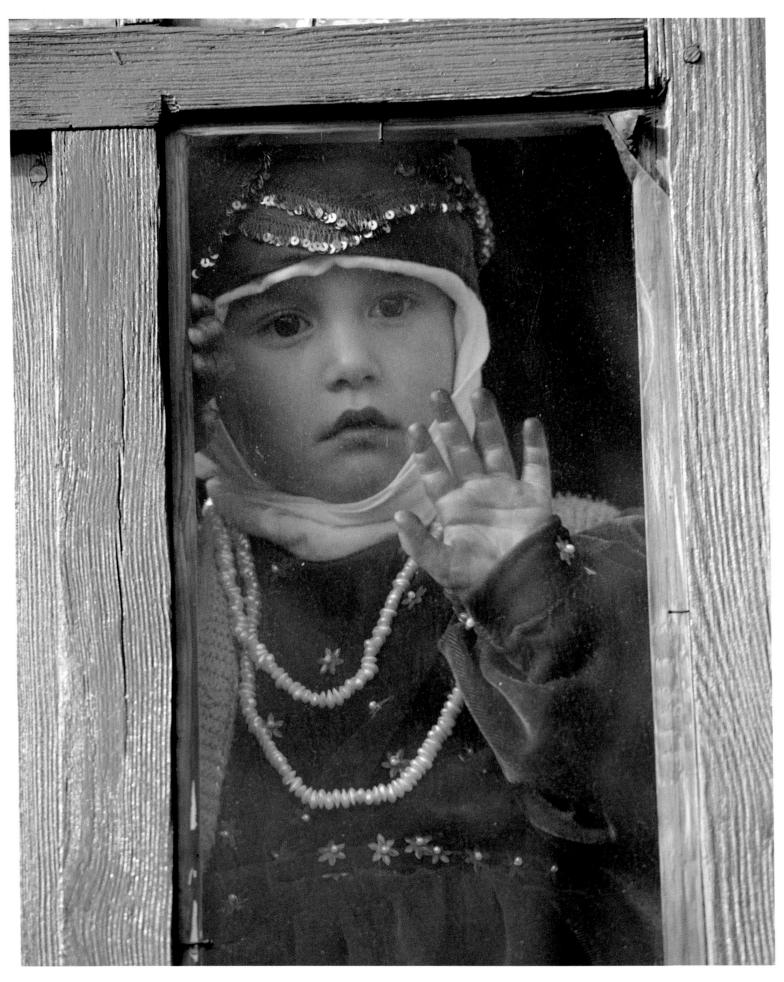

INTRODUCTION BY SUSAN TYLER HITCHCOCK

IN THE BEGINNING is the world. A world full

of shapes and patterns, colors and contrasts, rhythms and rules. We are born into it with wonder and awe, eyes wide open. We drink in the sensations without category, without censorship, without understanding. Innocent onlookers in a world full of life-forms that grow in shapes and sizes other than our own and populate landscapes where the forces of time and physics have molded water, soil, and stone into one-of-a-kind fractal shapes, some ever present and some ever changing, at least when viewed through the lens of a human lifetime.

In the beginning is the world, and there are so many good things about it. Nature takes on a multitude of identities, and even crafty disguise becomes beautiful and intrinsic to self.

Psychologist Carl Jung wrote of archetypes of the mind—universally recognized images, patterns, and relationships, oft-seen emblems of meaning through which all human beings connect, find meaning, and understand one another. For Jung those archetypes generally arose from the primeval human family: the father, the mother, the wise elder, the trickster, the maiden, the child. But what about the world in which we live and grow and learn? Might not the universe of things present to our eager minds the concrete corollaries that build and accrete into archetypes of meaning? Patterns and parallels, similarities and differences: We learn time and space, cause and effect, light and dark, joy and pain through our interactions with the world outside us. Learning, understanding, making sense of things—not to mention poetry, metaphor, and revelation—all happen at that balance point where the human mind meets visions of Earth in all its multitude and finds a way to bridge outward objects and inward sensations.

Early learning starts with the game of naming. To name is to know, the human mind convinces itself. On the one hand, naming confers intellectual possession: I can name it; therefore, it is a thing whose being I understand. Yet naming may carry our senses away from authentically seeing, because a named object gathers associations that may clutter the mind and blind the eye to oddities and exceptions.

To name is also to segregate and to confer a unified thingness to something we see. Edges and boundaries become lines that divide, and objects take on separate identities. An entity takes on a wholeness, but as soon as we know one thing to be a whole then we can see how that thing might be split into pieces, each belonging to the whole yet distinguishable from all the others in the company. To know a whole is to know its breaking.

Soon thereafter, we learn the space-time relationship of cause and effect. Sequence becomes influence; relationship involves dominance and power. We watch and wait and wonder as the multitude of phenomena we have learned to name and know interact. An animal hunts its prey; a forest shades the plants down under; a stream carves out a canyon. We see the relationships among all phenomena, between living beings and landscapes, and the complex human mind learns to combine memories of what was, observations of what is, and expectations of what will be.

Part of the return to true knowledge of the external world—a key component of science—is recognizing and verifying the difference between what in fact will be and what the human imagination can conjure up, the "might be's" that never will happen. Just as important in building our true knowledge of the external world is realizing the breadth of phenomena that exist beyond the limits of human experience, the "can't be's" that are.

Here is where photography, through exquisite visions of Earth, steps in to assist us. Photographers take their cameras where few of us can follow. They see, and show, the world with wonder. They return us to that open-eyed amazement based not on our presumptions but on the true observation of all that is in the world, nature and culture and all meeting points in between—visions of Earth that promise moments of enlightenment, marvel, amusement, sorrow, and joy.

We cannot all be scientists or photographers, but in some way, every one of us, as a thinking human being in this physical world, performs both functions intellectually. We seek to distinguish truth from our fantasies, to know things as they really are and not as we imagine them to be, and we do so by testing the world and seeing it as it really is. We make meaning by connecting the sensations coming into us with the feelings and passions that dwell within—the work of an artist, using the raw materials presented by the universe of things outside of our bodies and creating meaningful combinations with the thoughts and feelings within. To make sense of it all is to find the echoes and harmonies between the kaleidoscopic world outside and the interior world within.

Photographers re-create those primeval moments, before our eyes and minds have become so accustomed to what we drink in that we no longer see. They provide us with reminders of the shapes and patterns, colors and contrasts, rhythms and rules that exist in the world we see—so that, refreshed in our vision, we may make sense of the world of thought and feeling, intention and plans. Nature photographers are the unacknowledged scientists of the world today: the objective eye, the unbiased observer, holding before us clear visions of the world around us, so very different from the human mind and yet so much what has made us who and what we are.

PORTFOLIO ONE

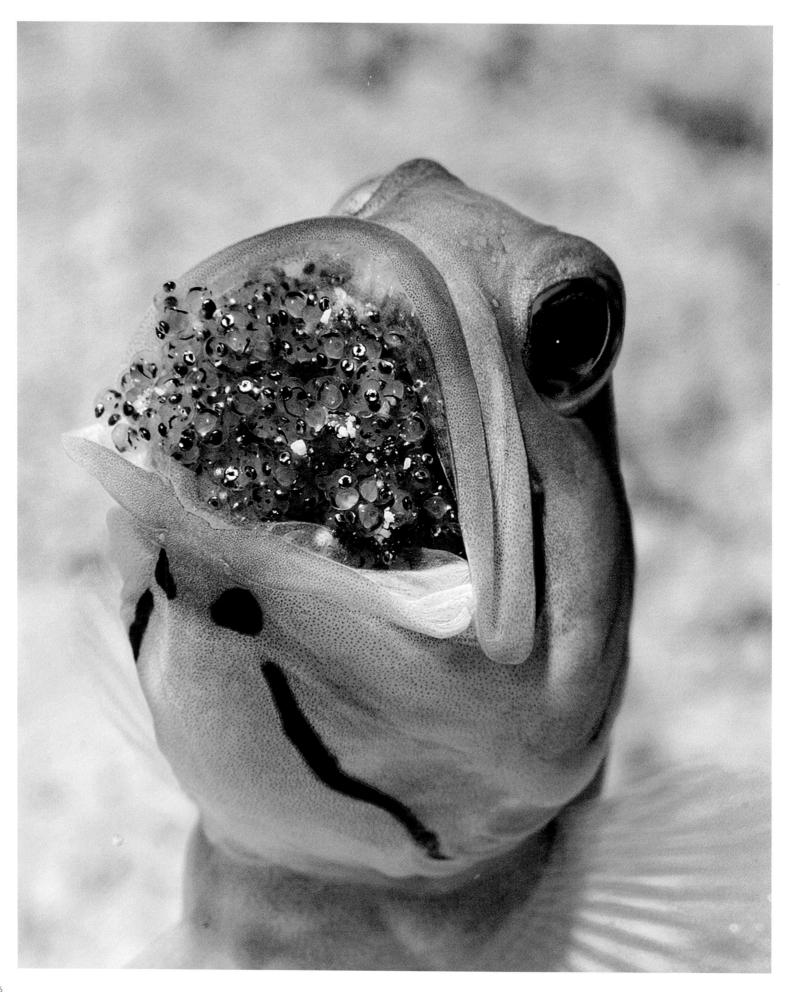

Then sixteen.

Beginnings multiply into beings in the blink of an eye. We pause and want to stay here at the start, so pleasant it is to dwell in the moment in which little is certain, everything is possible, and all is unhindered growth and enthusiasm.

A fuzzy bud bulges, balancing precariously atop a slender stalk. One more morning's sunshine, and a bright orange poppy brightens the world—a new beginning. A shiny pupa dangles, shades of black and brown as if old wood with layers of varnish. Spring winds caress it, and something starts to move within. Threadlike legs push out; head and body emerge; wings unfold and pulse in the sun—a new beginning.

A human infant, a newborn mammal, a hatching egg, a sprouting seed: In each of nature's new beginnings, we recognize that genetic destiny already has an upper hand, but it is so enticing to imagine, in those early tender times, that anything could happen. Or, rather, that only the best will happen, and all the potential enfolded in that tiny shape will open up, take shape, and blossom into reality.

We cherish new life, at once so tender and unprotected yet so quintessentially endowed with spirit. The mass of life has not yet taken over. An excess of matter does not yet burden the impulse to grow and thrive; the weight of the world has not landed.

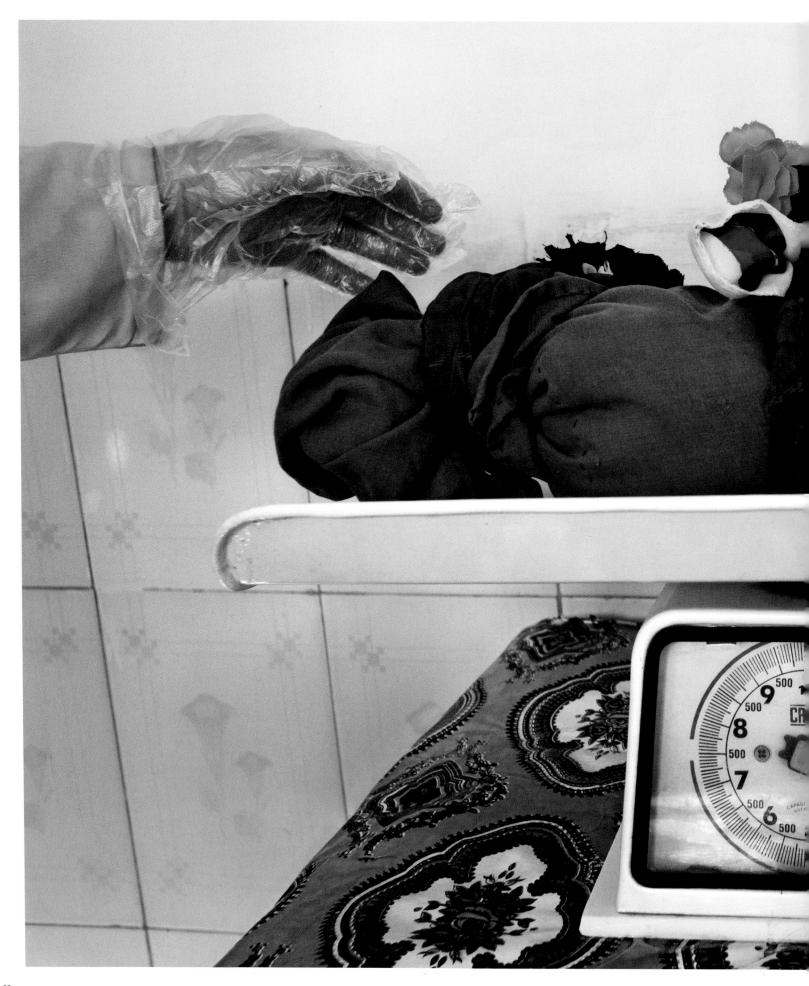

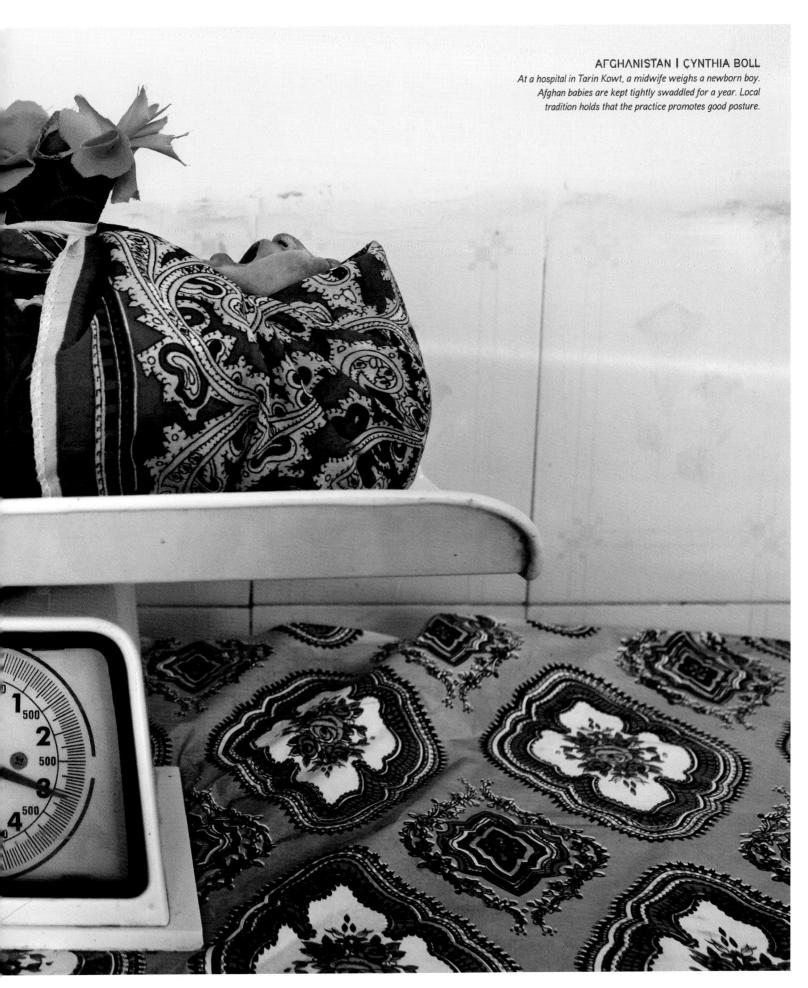

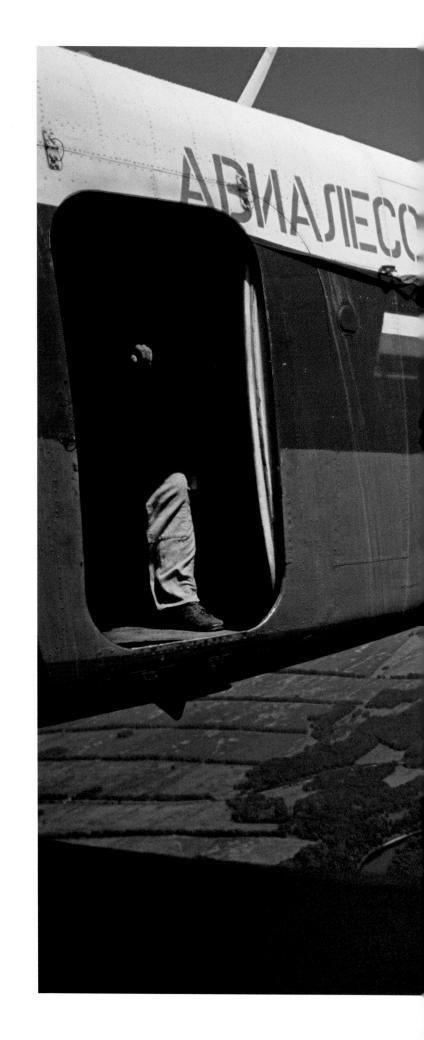

RUSSIA | MARK THIESSEN

The jump is just the beginning for this Russian smoke jumper. Once on the ground in Siberia, he'll work to contain wildfires in the world's largest coniferous forest.

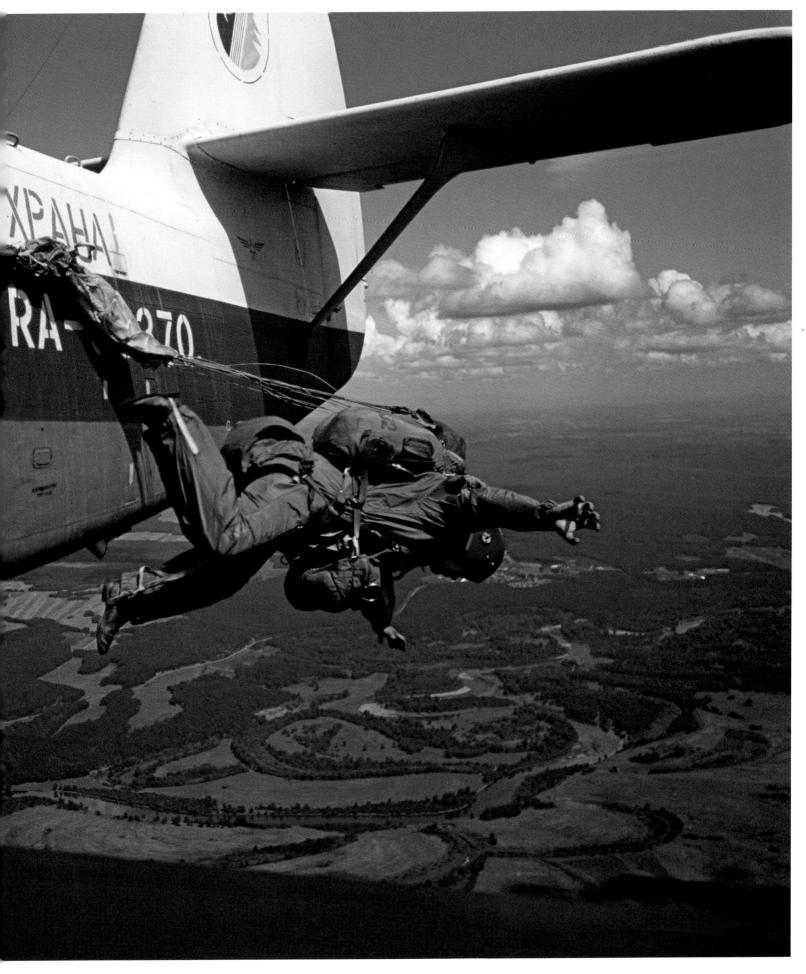

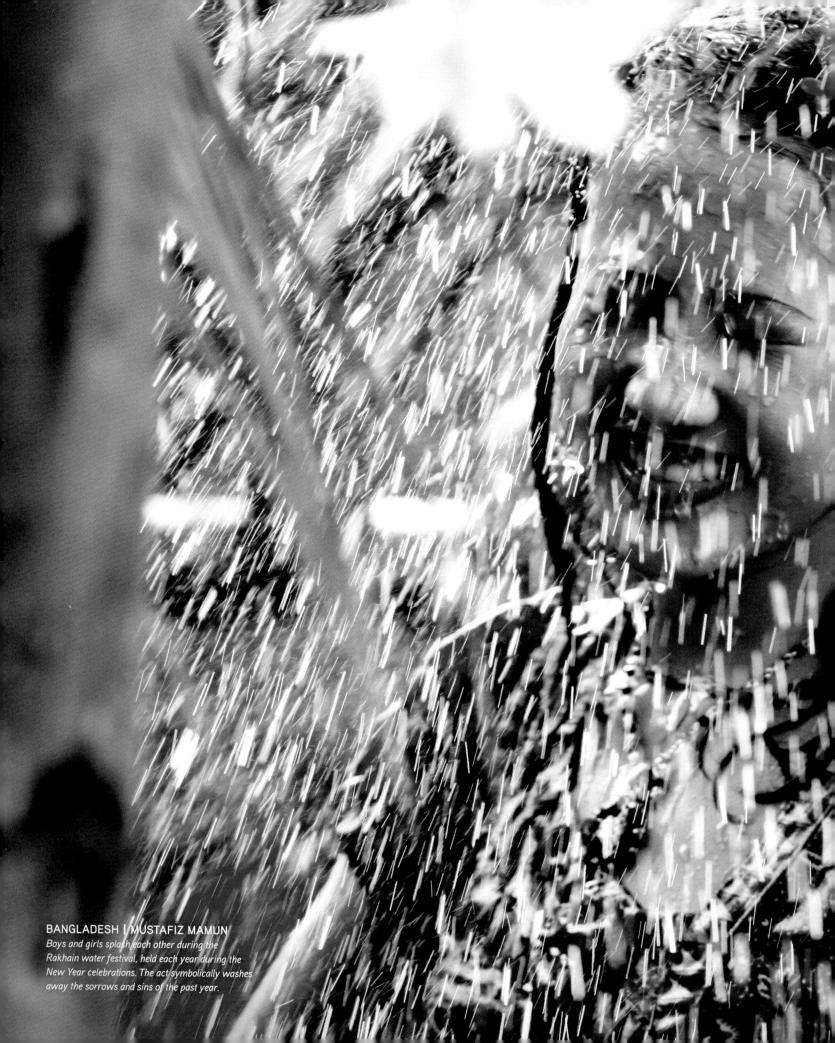

Because their eyes can detect ULTRA-VIOLET LIGHT, butterflies can see more colors than humans can. But in the human world they would be considered visually impaired, because they cannot see fine details.

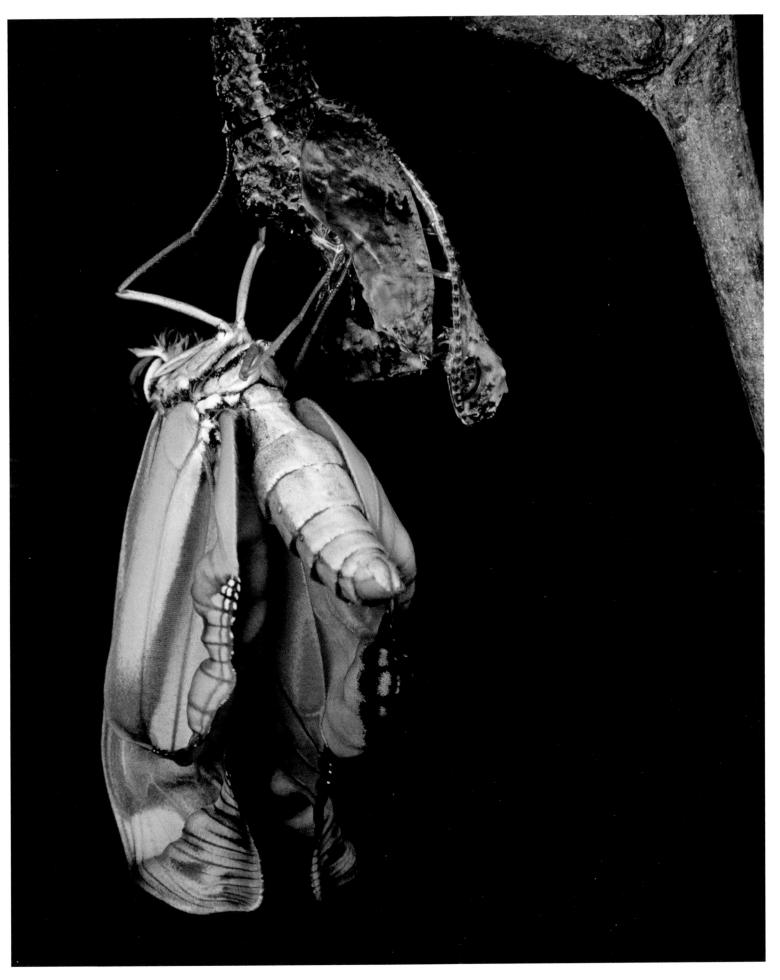

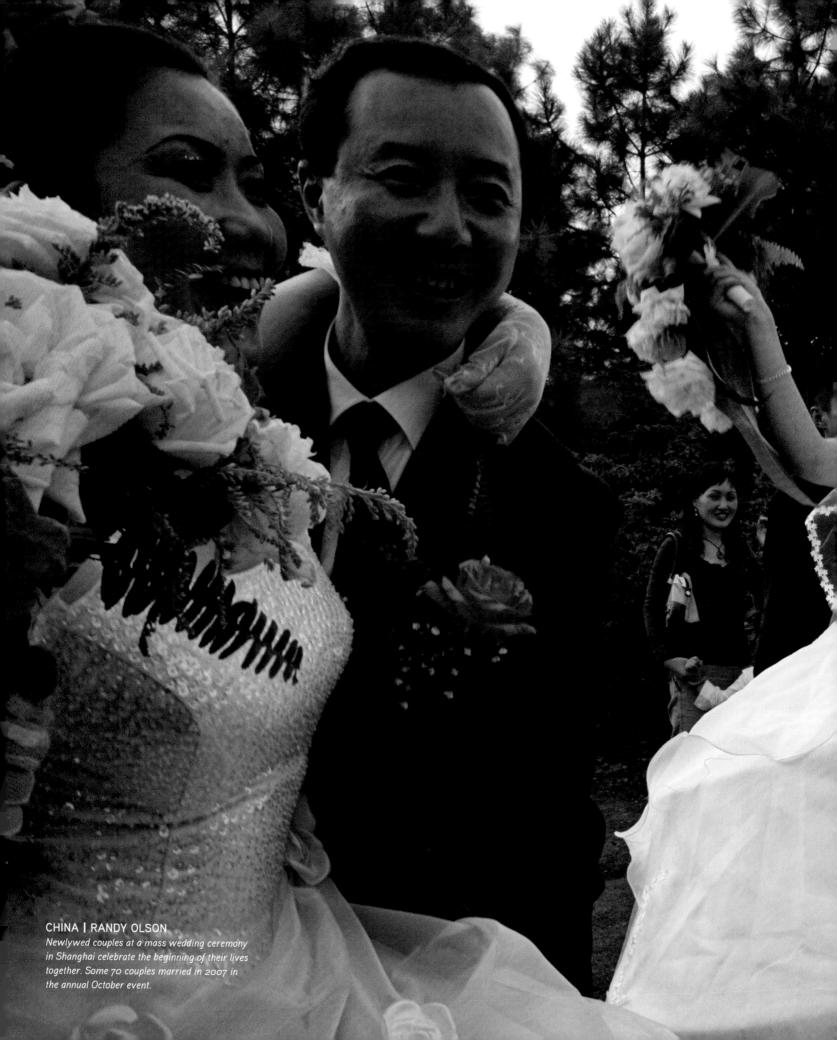

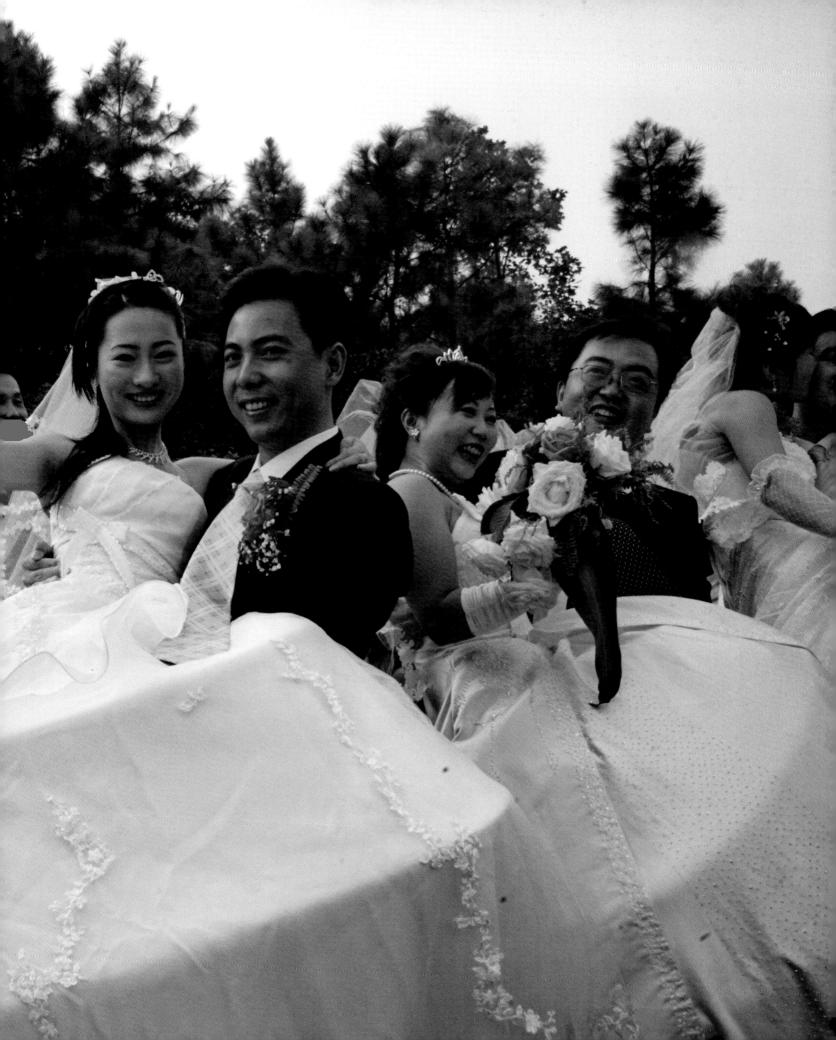

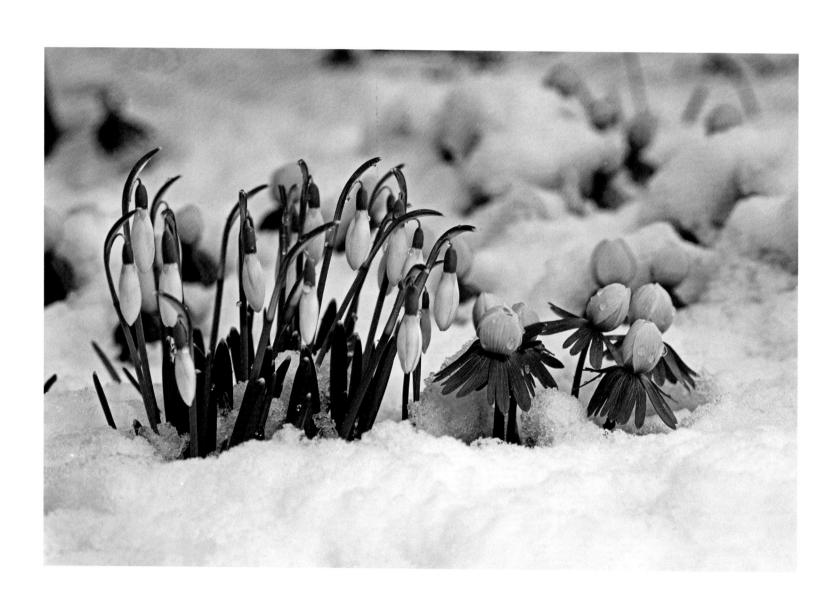

GERMANY | KONRAD WOTHE

The arrival of these white snowdrops and yellow winter aconite helps to signify the coming spring. Although these hardy plants look beautiful in the snow, winter aconite is poisonous, and the snowdrop bulb is mildly toxic.

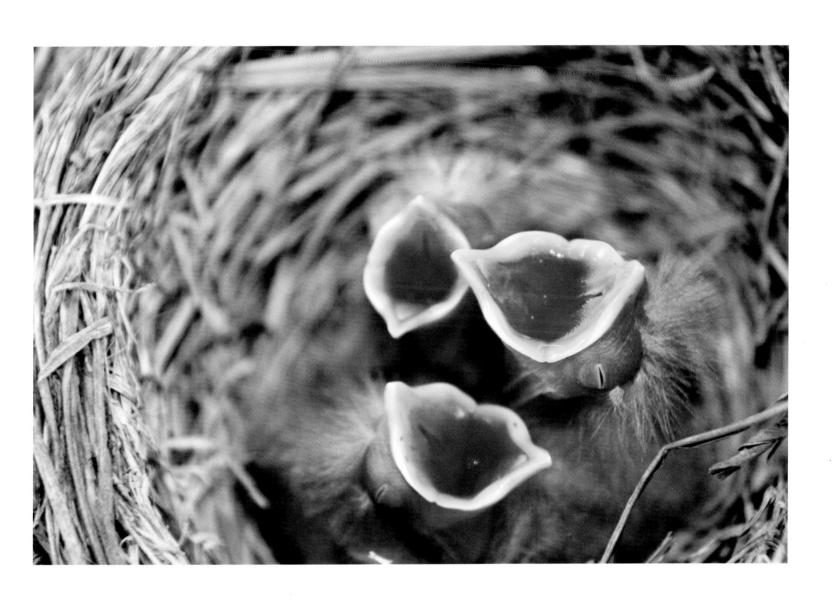

IOWA, UNITED STATES | DARCI DUEY

With mouths opening like hungry flowers, these day-old robins eagerly wait for food. The baby robins, whose nest was located in a backyard fort, fledged in a few weeks.

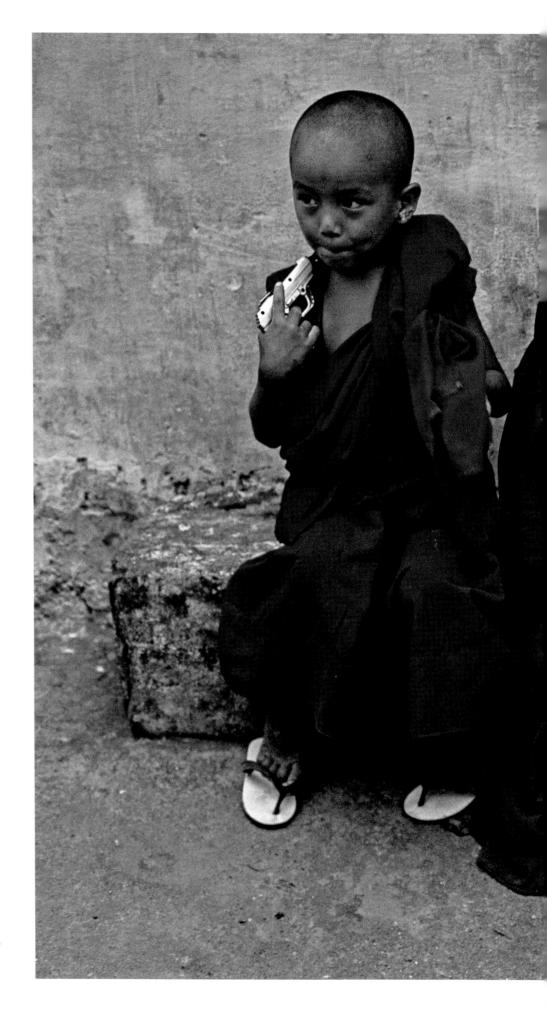

INDIA | STEVE MCCURRY

The red robes of these young Buddhist monks evoke meditation, but the handheld games show off their playful side. Some 100,000 Buddhists fled Tibet in 1959, and yet the faith continues to flourish.

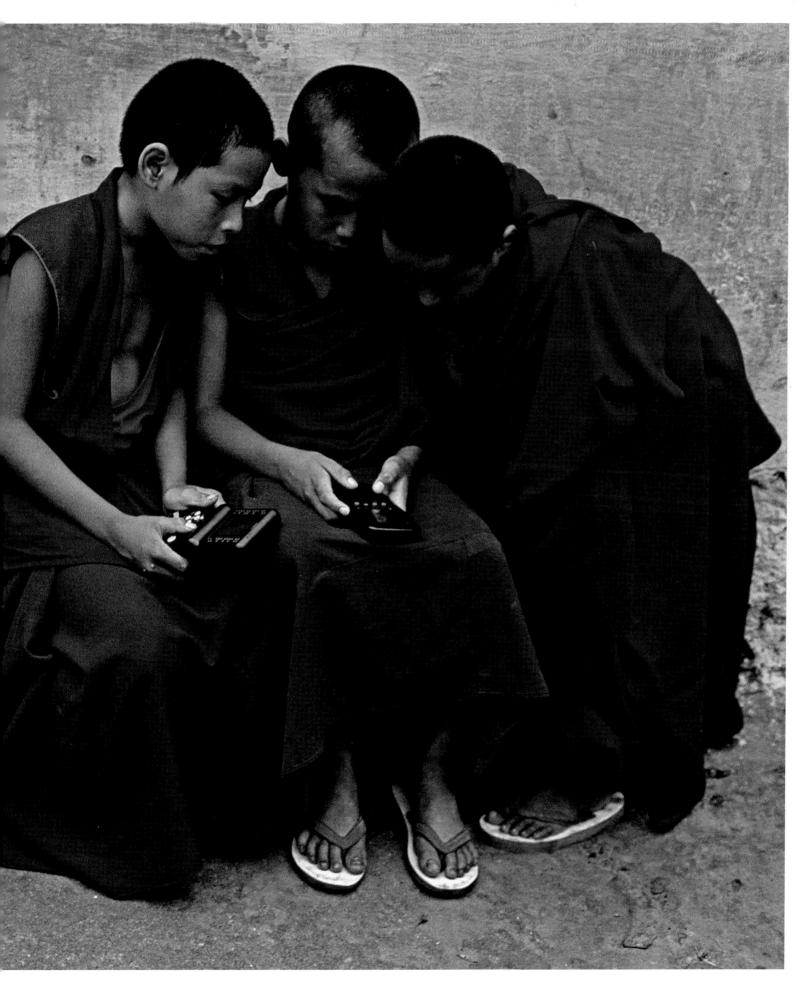

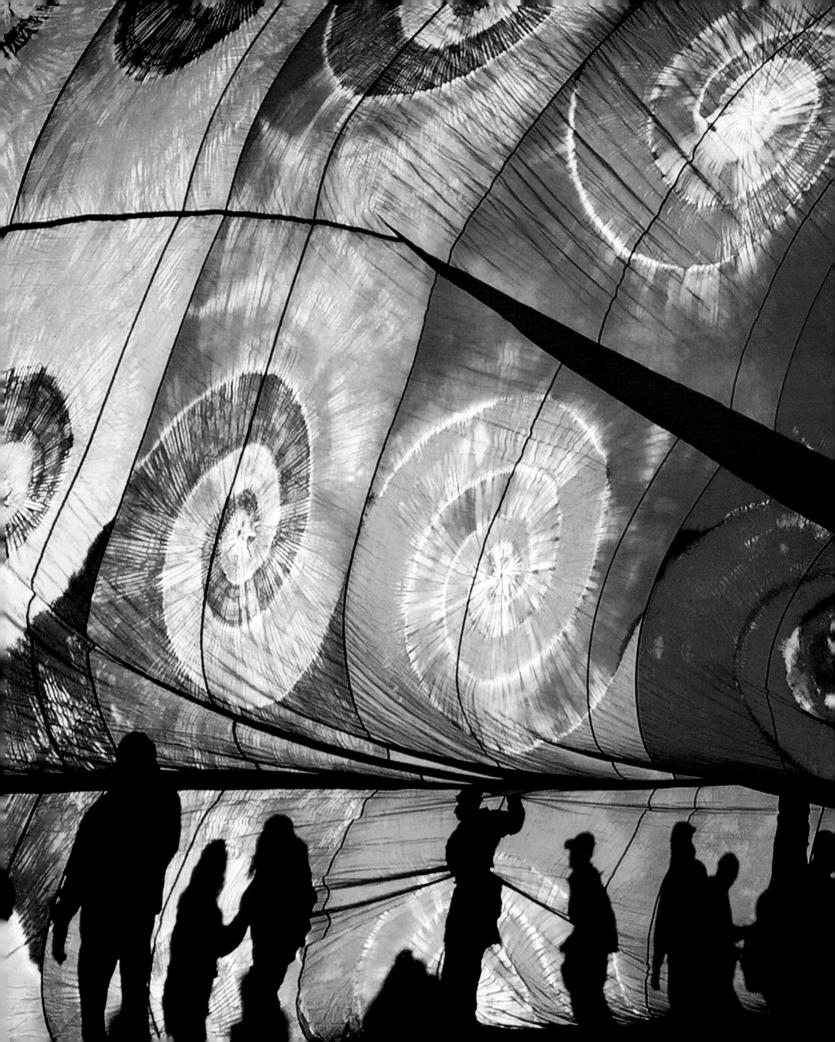

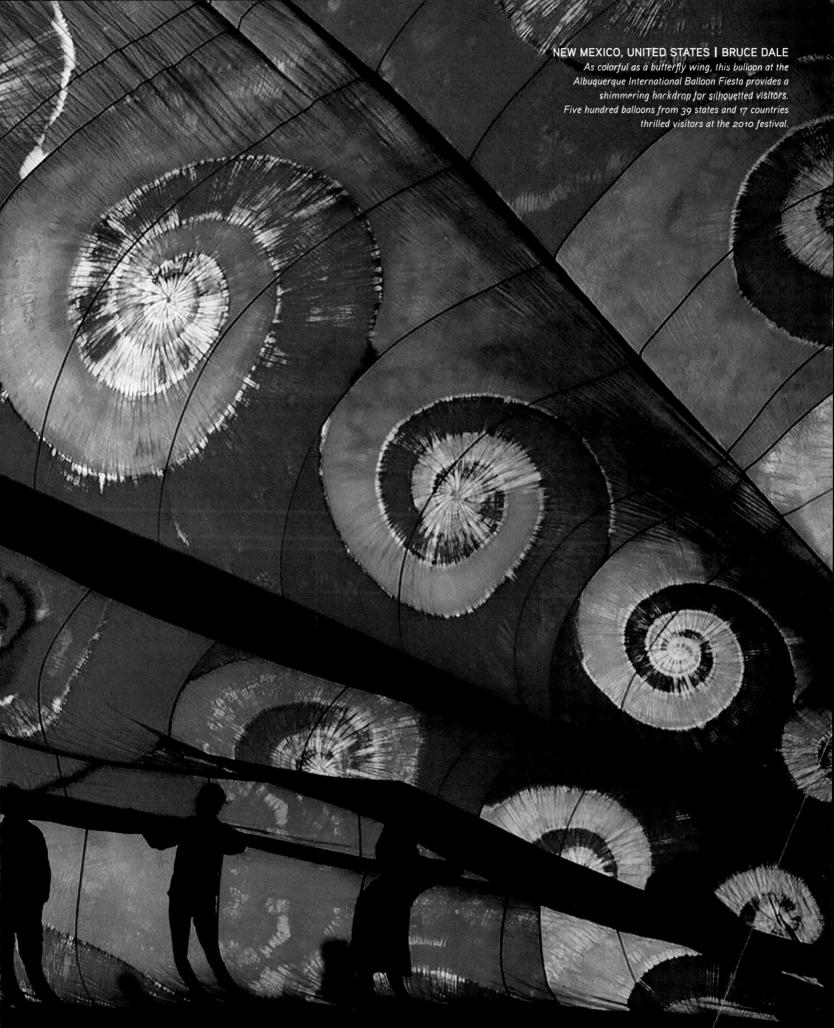

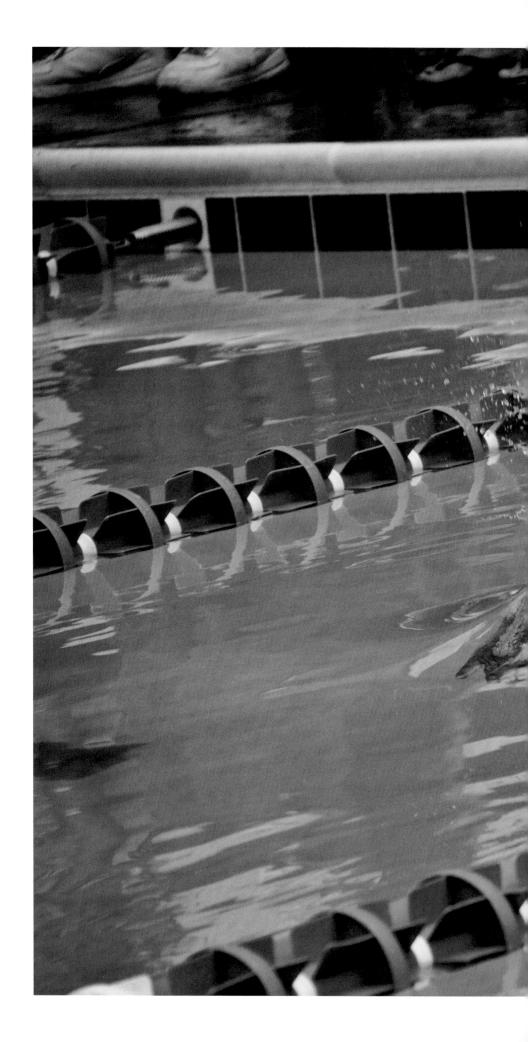

MARYLAND, UNITED STATES | STACY GOLD With focused determination, a high school athlete dives into a pool to begin his race. He'll leave more than a splash in his wake, as student athletes are more likely to attend college and have lower dropout rates.

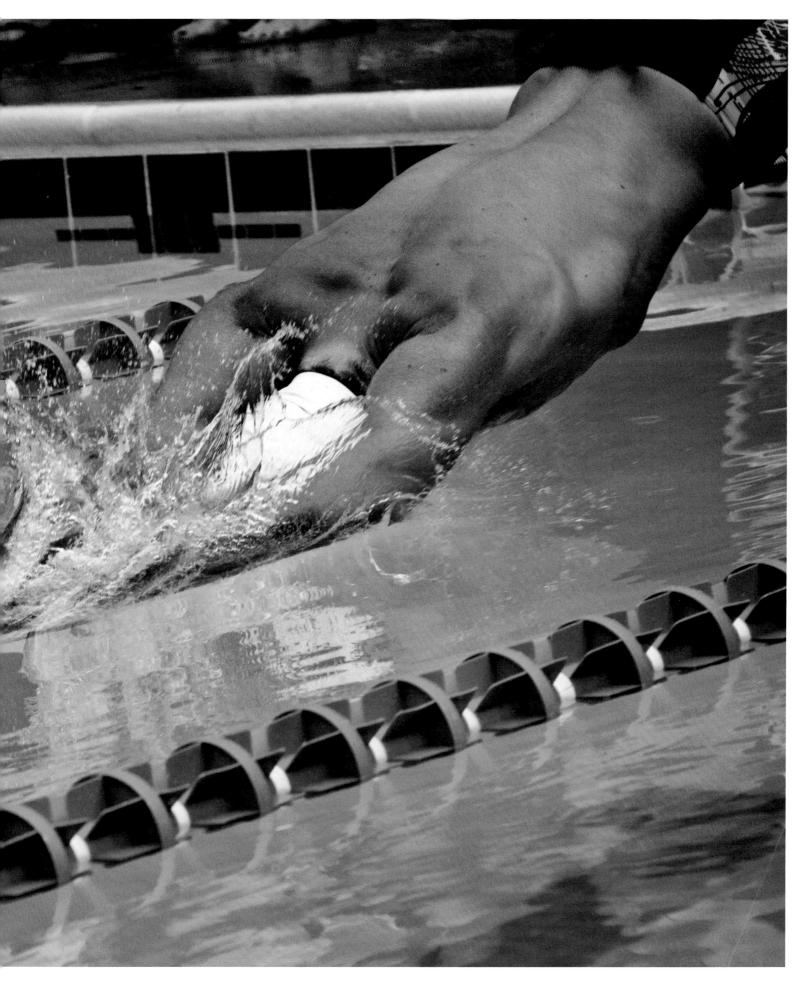

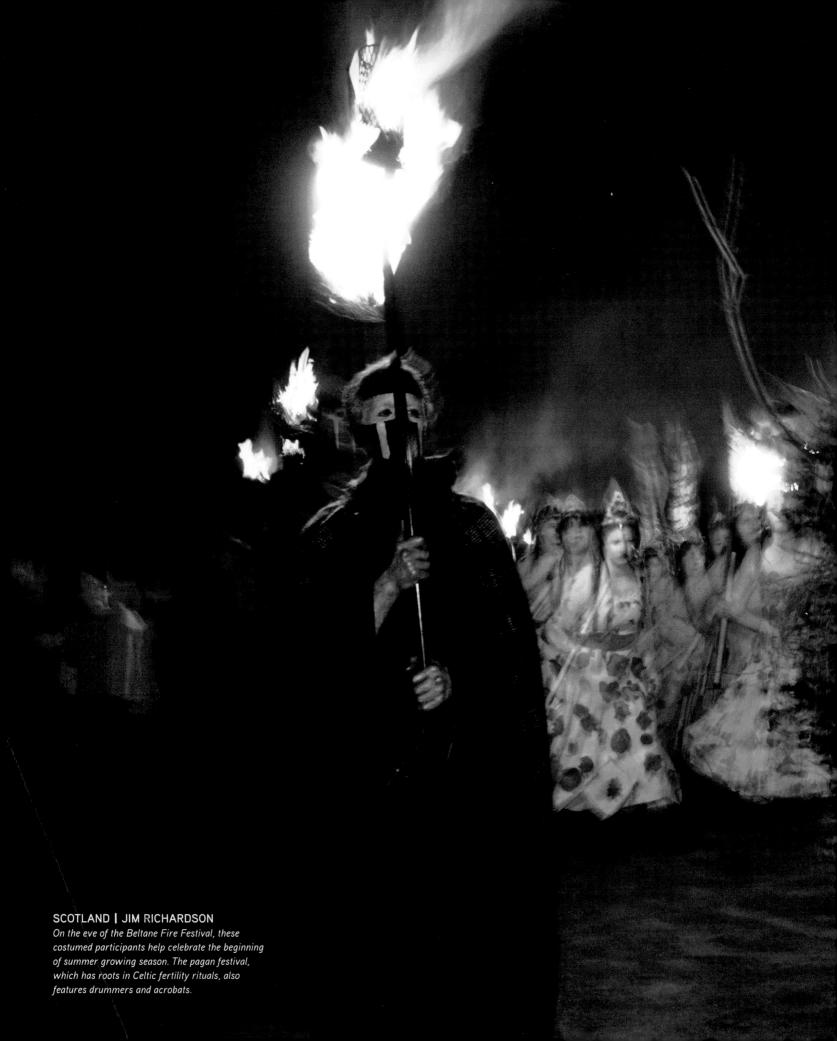

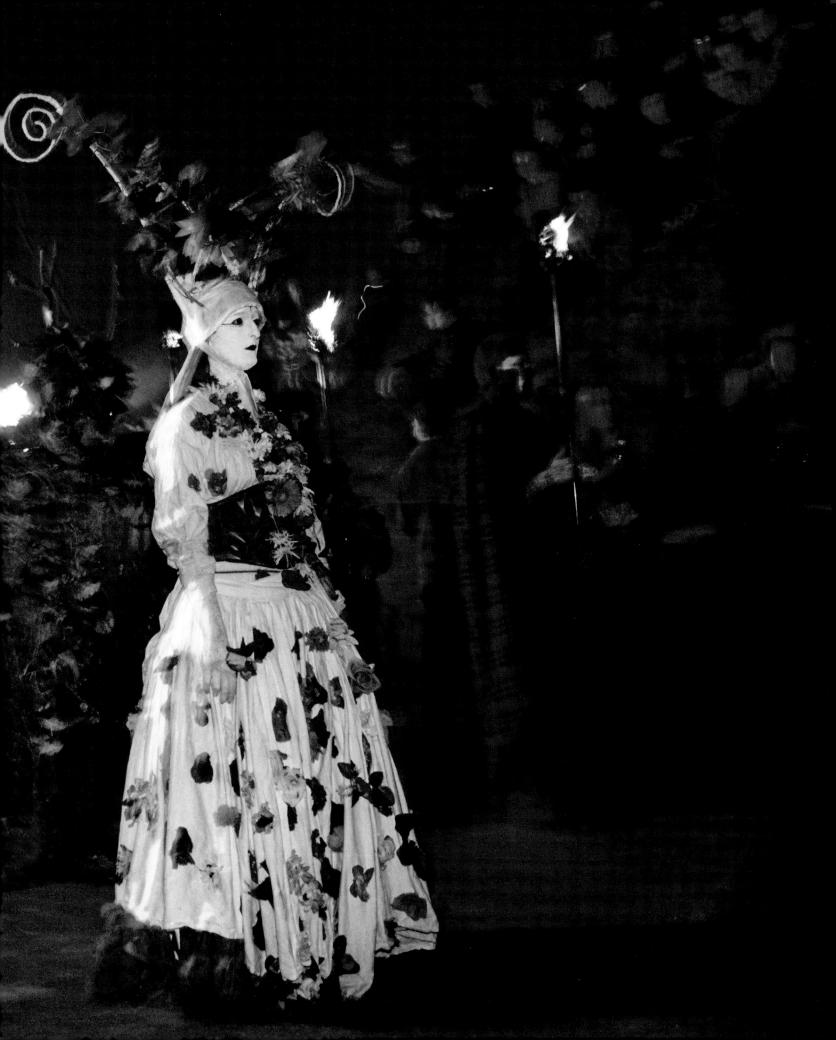

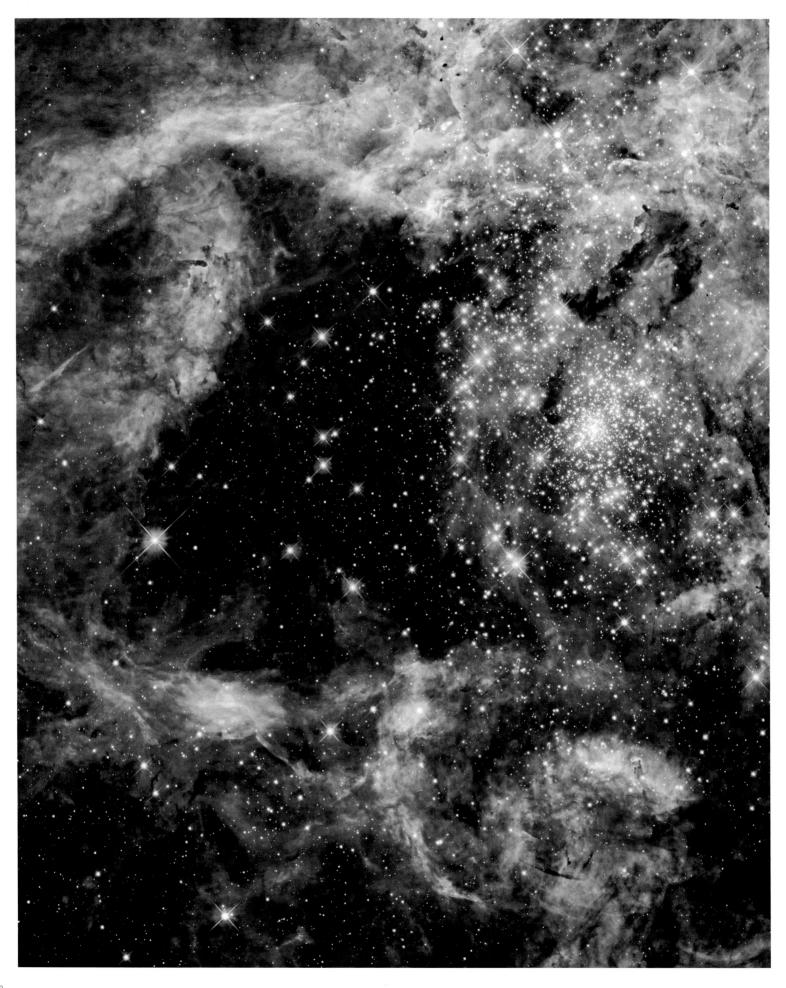

THE MILKY WAY is made up of some 100,000,000,000 stars. So it should come as no surprise that there are more stars in the universe than there are grains of sand on the entire planet Earth.

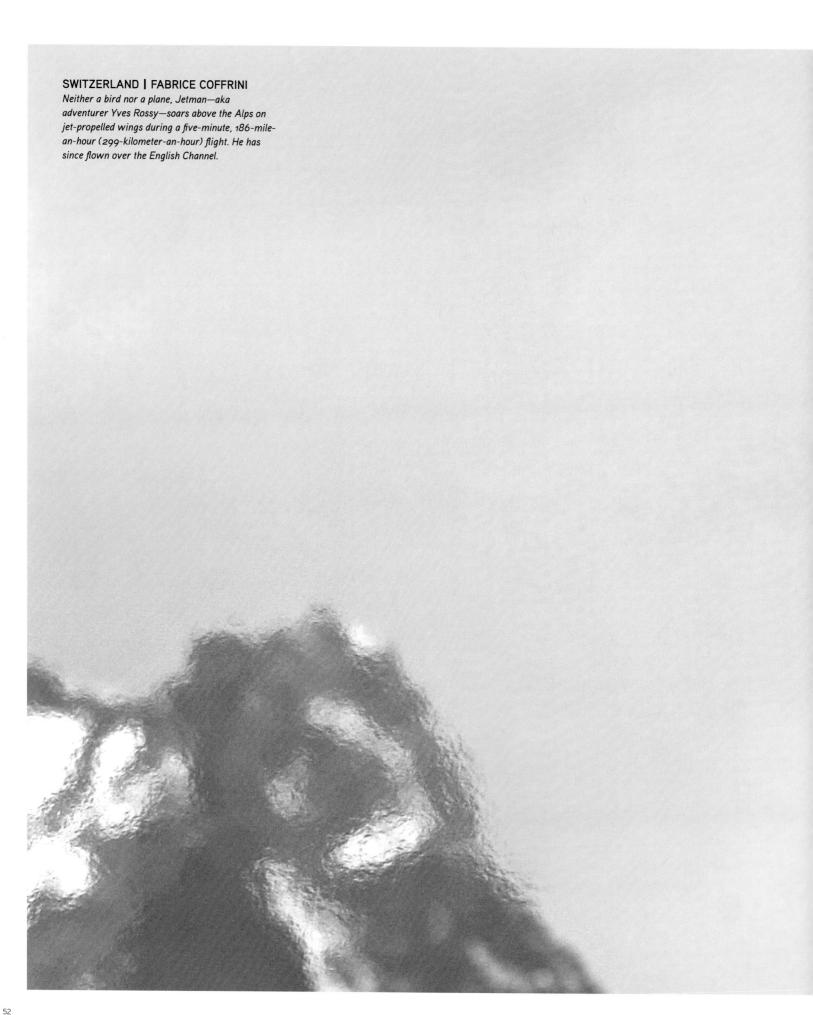

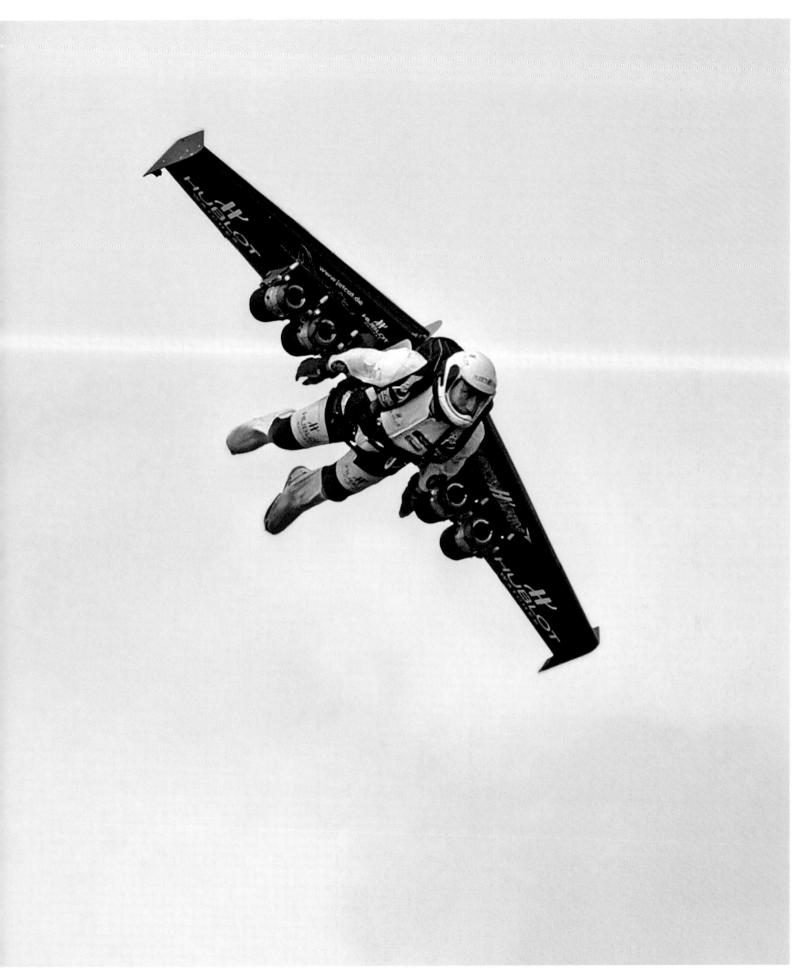

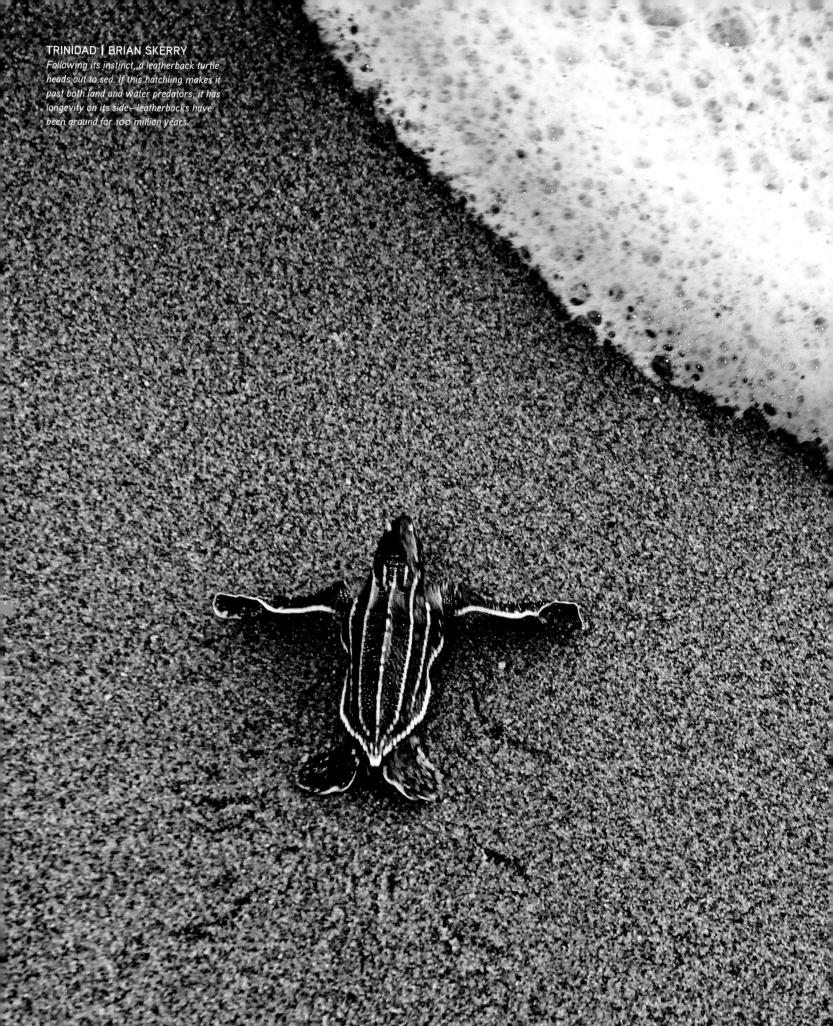

PORTFOLIO TWO

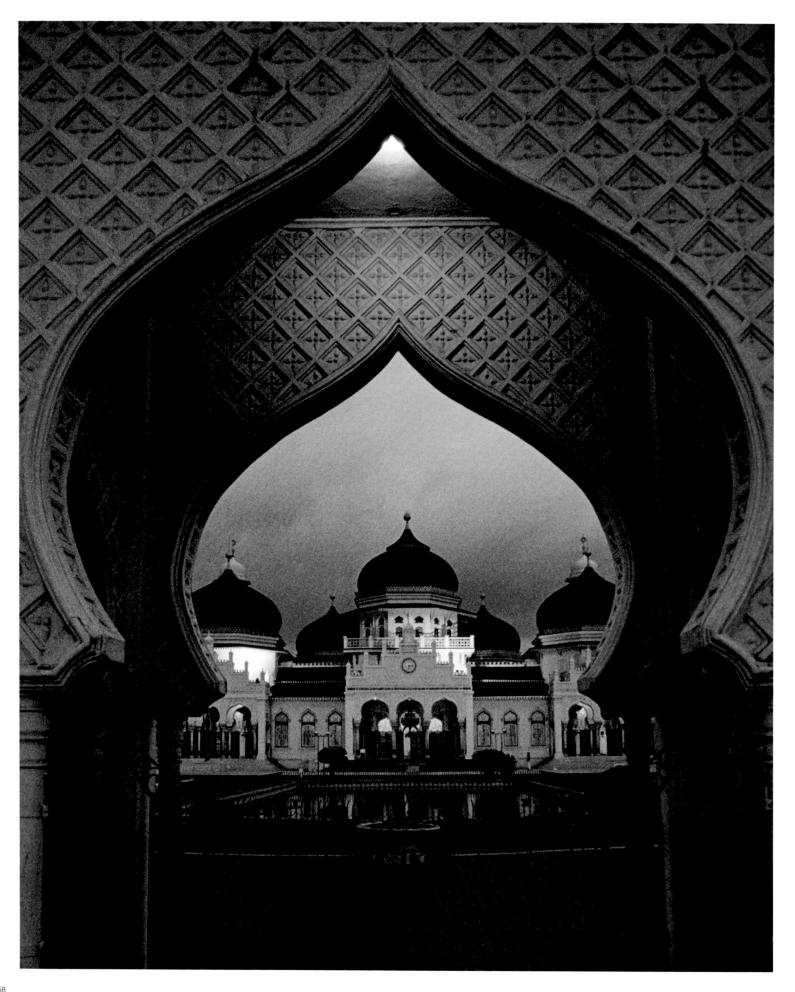

abhors a straight line. Instead, it curves. The reach of a tree branch, the soft slopes of its

leaves. An anthill path, in and out and over and under the mounds of leaf mold. The delicate outline of a butterfly's wings, its sensitive antennae. The shared swoop of a flock of blackbirds, dipping in unison, winging as one in an autumn sky. The graceful S-curve of a snake, sashaying to move forward. The loving sweep of a mother lion's paws, pulling in cubs toward her, claws relaxing into soft leather pads. Every embrace is a curve, arms enfolding. Every curve is an embrace.

Time turns straight lines into curves. Fractured rocks, worn by running water, lose their angles and assume curves. The stone steps of an ancient cathedral, pathway to serenity for centuries, likewise lose sharp edges, soften and curve with time.

Every curve is a piece of a circle, bending around, its ends destined to meet. The circle of life, the circle of story, a circle of friends around a campfire. Even the horizon—that feature of our landscape that seems so straight its name denotes a mathematical axis—is, in fact, a curve. To test this observation, which has provoked high-court battles and lost men their lives, one need only sail a boat into open water or, better yet, pilot a craft into outer space, where the known horizon becomes the curving circumference of our spherical blue planet.

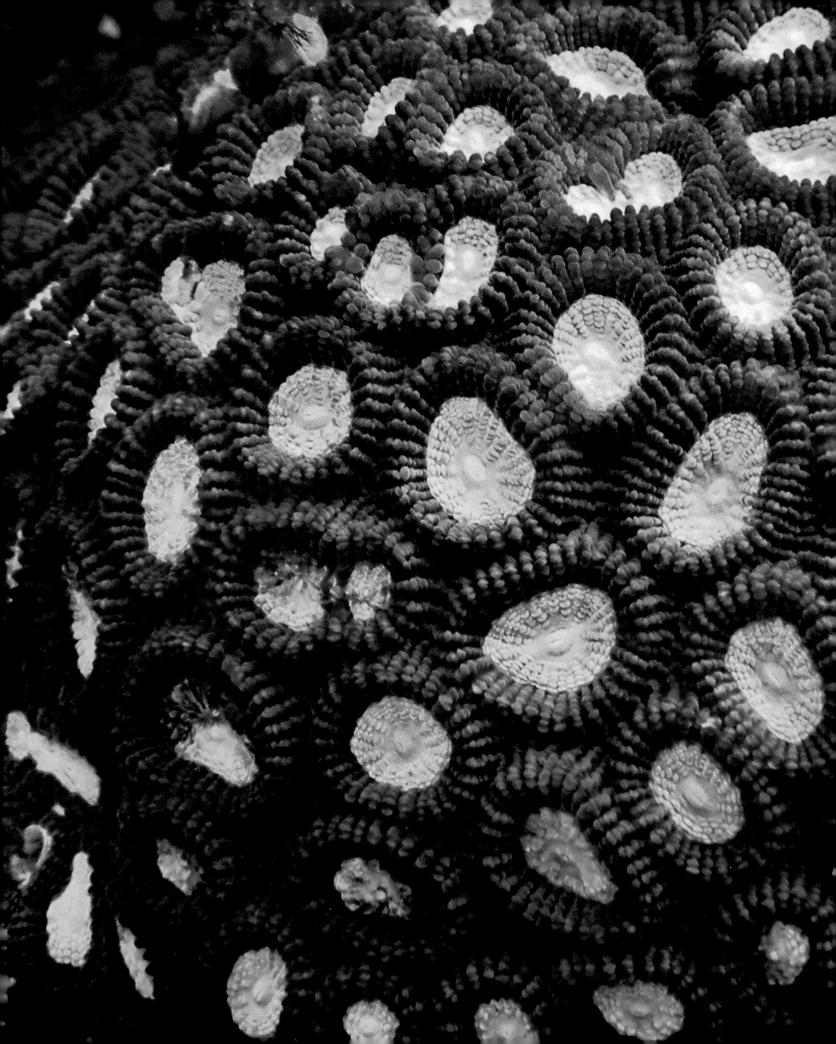

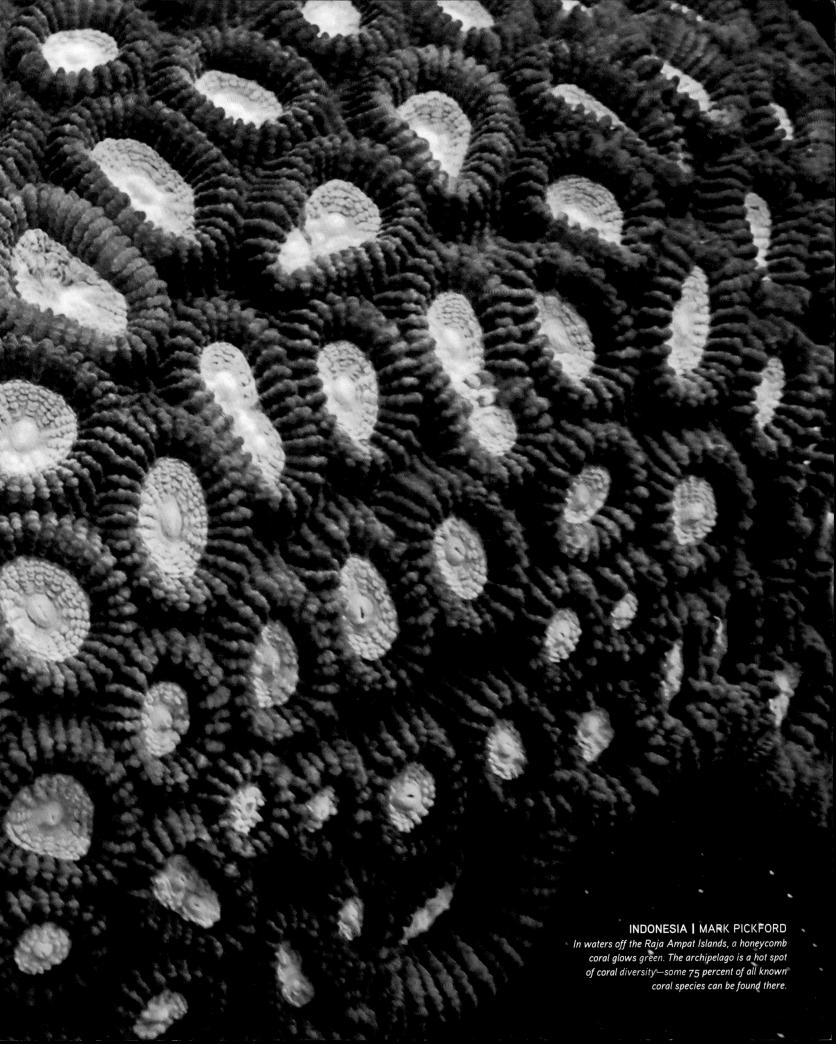

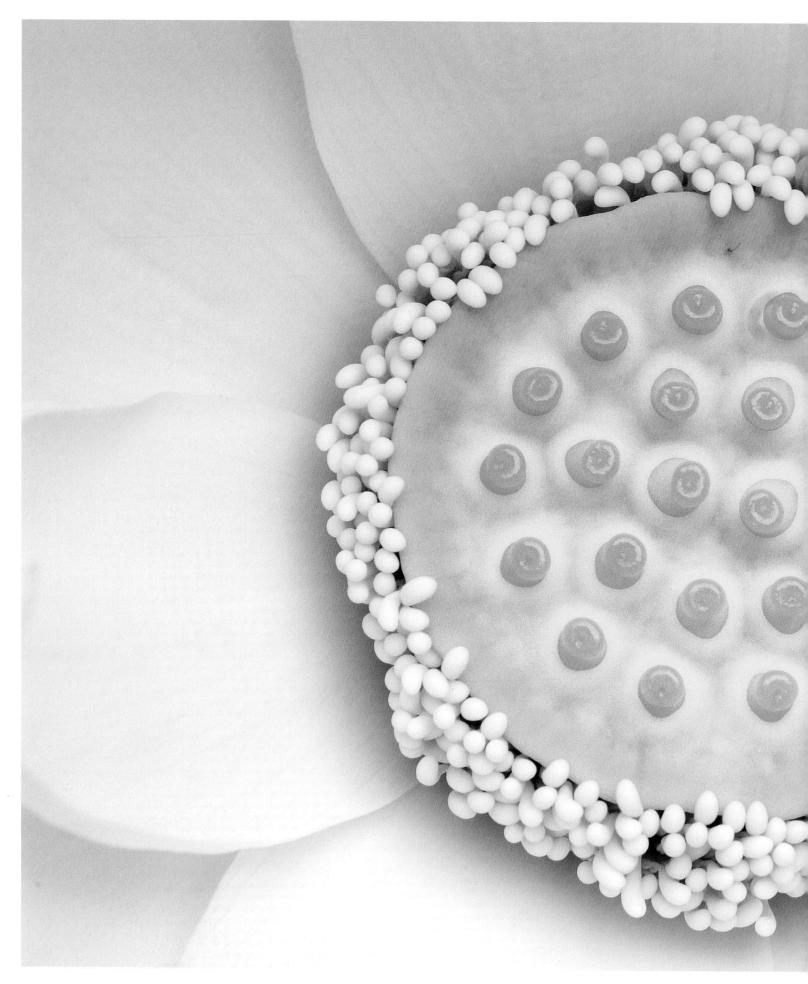

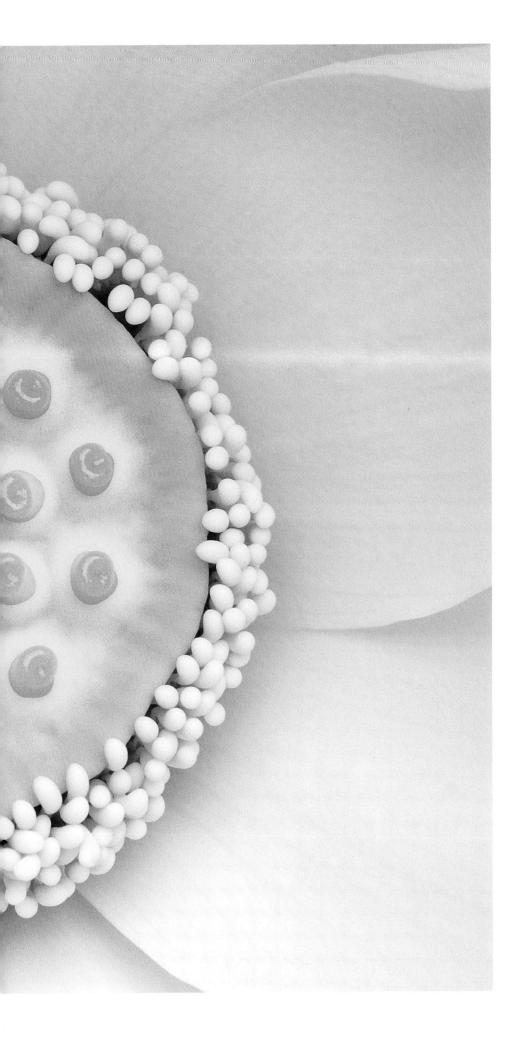

MARYLAND, UNITED STATES | STEPHANIE LANE Looking like a lemon torte on a plate of petals, a lotus blooms

in a Maryland garden pool. The churtreuse circle, three inches (eight centimeters) in diameter, is dotted with 23 seed holders and ringed by immature pollen sacs.

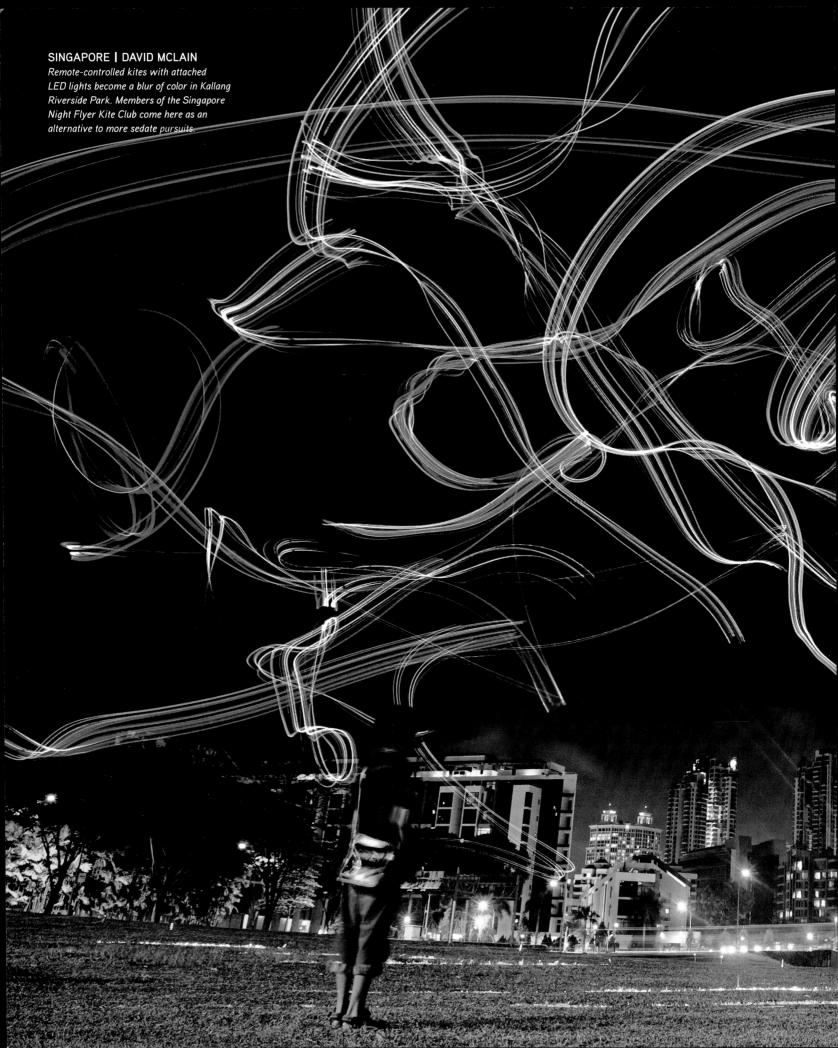

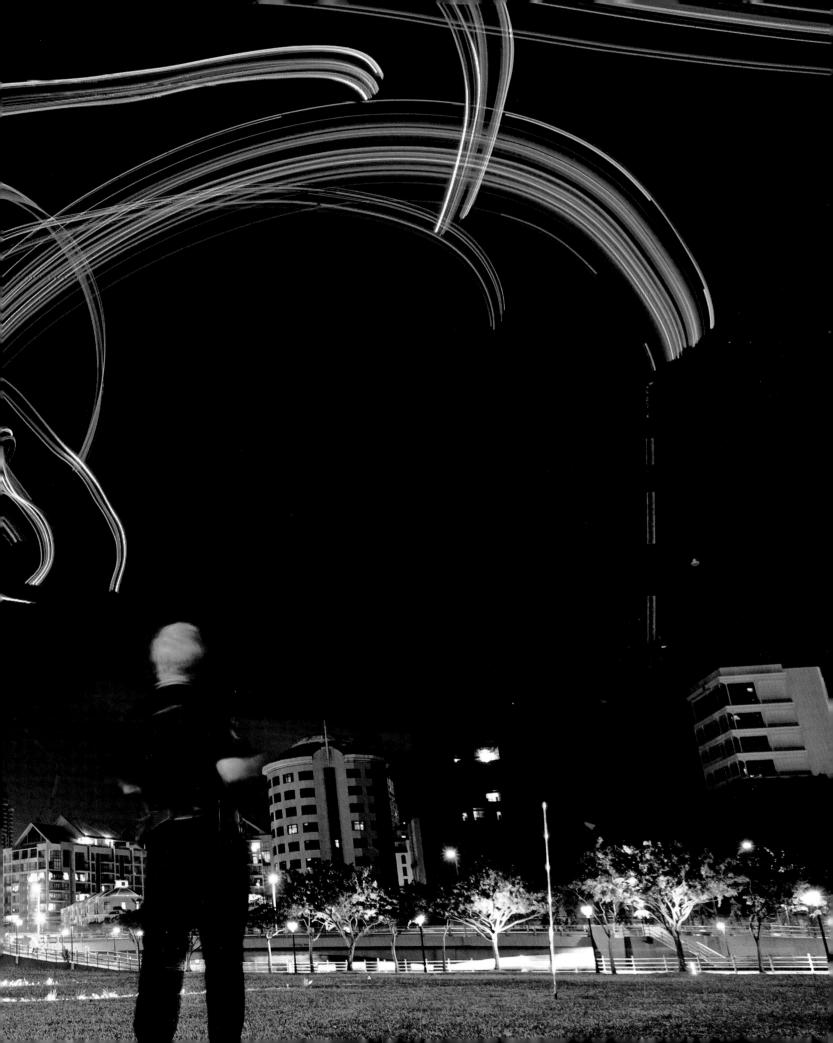

LIGHT as a feather:
In many birds, the cumulative
weight of their feathers exceeds the
weight of their bones. Feathers provide
birds both insulation and protection from
ultraviolet light.

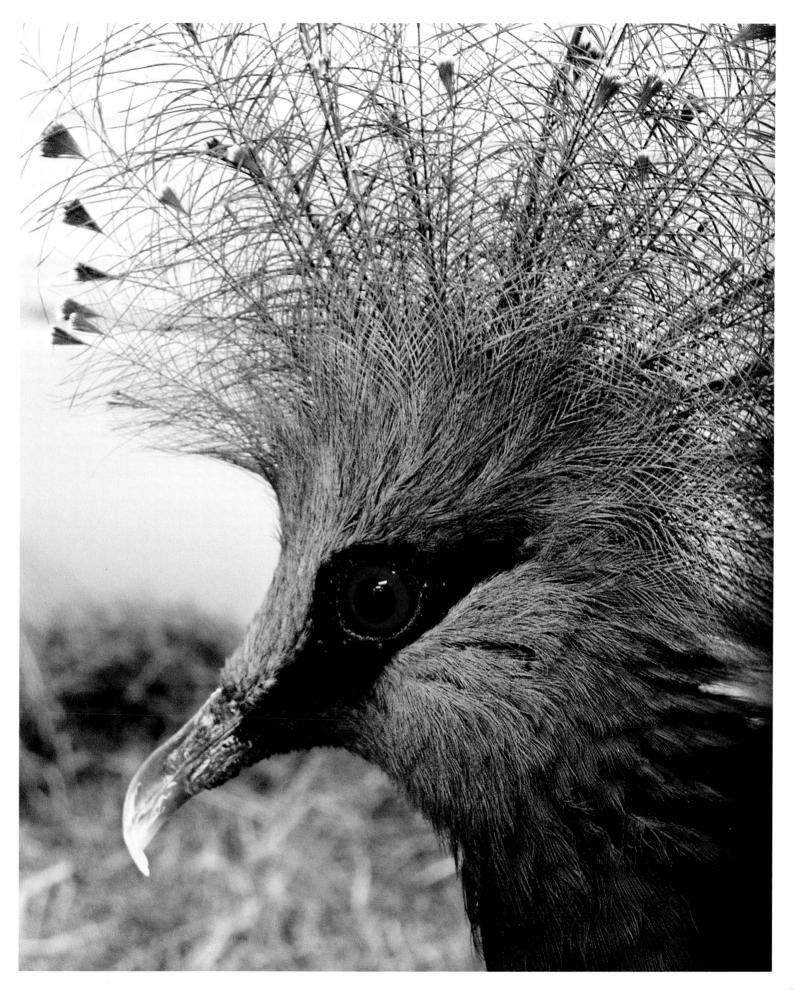

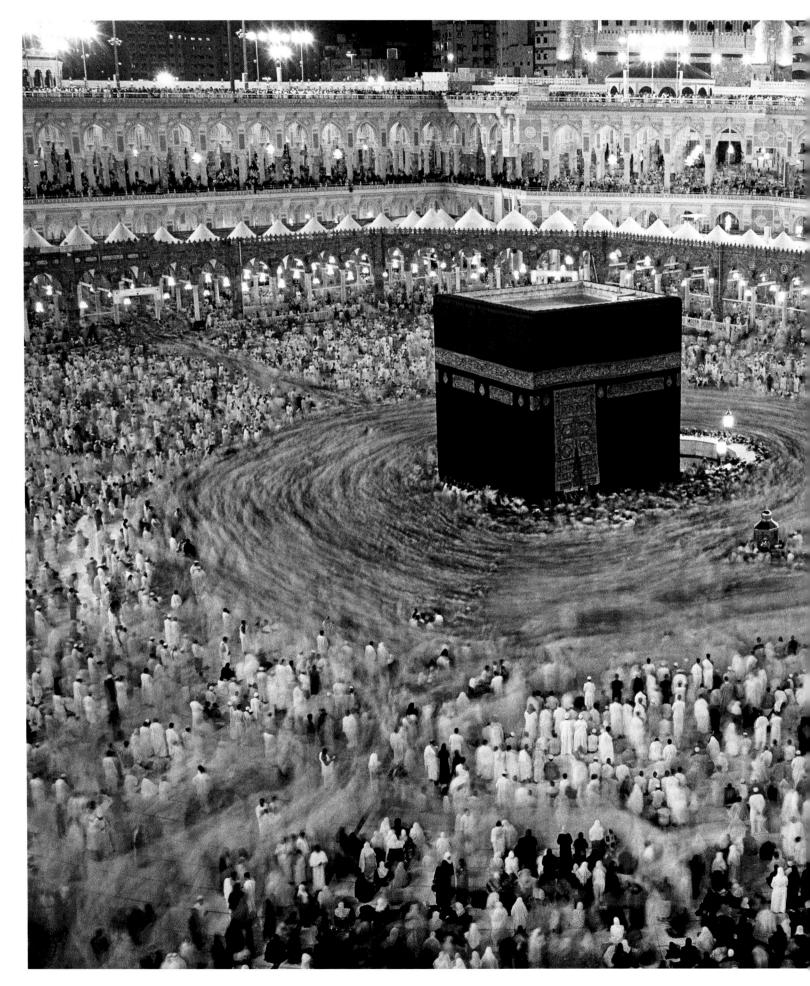

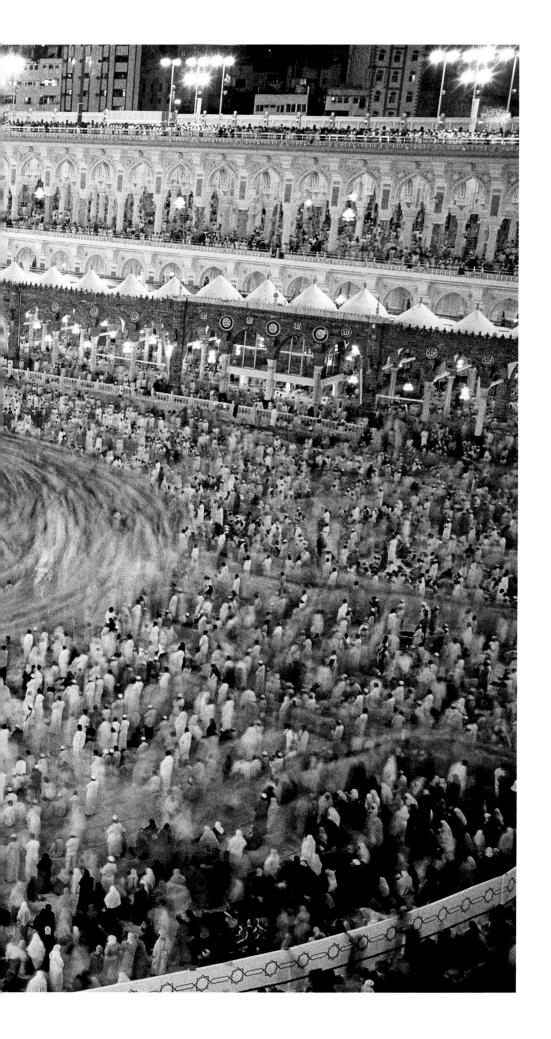

SAUDI ARABIA | REZA

Muslims in Mecca become a blur of faith in this long exposure. During the annual hajj, pilgrims walk seven times around the Kaaba in the Grand Mosque—a ritual performed at least twice.

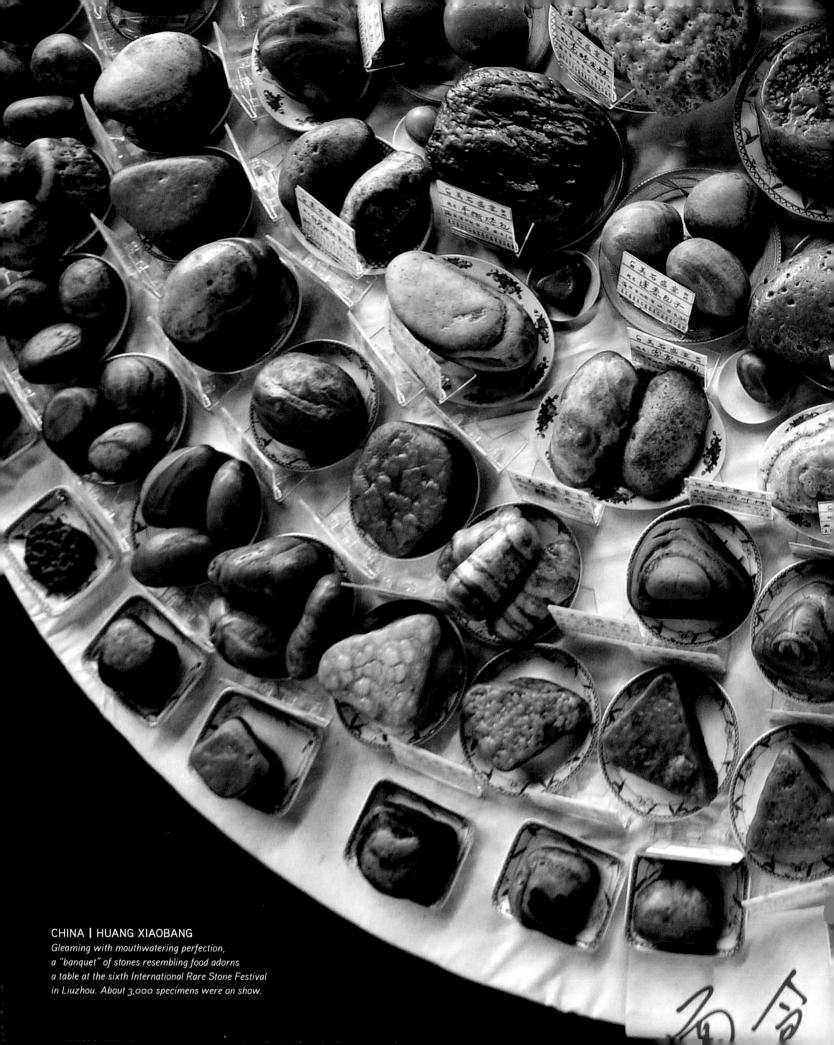

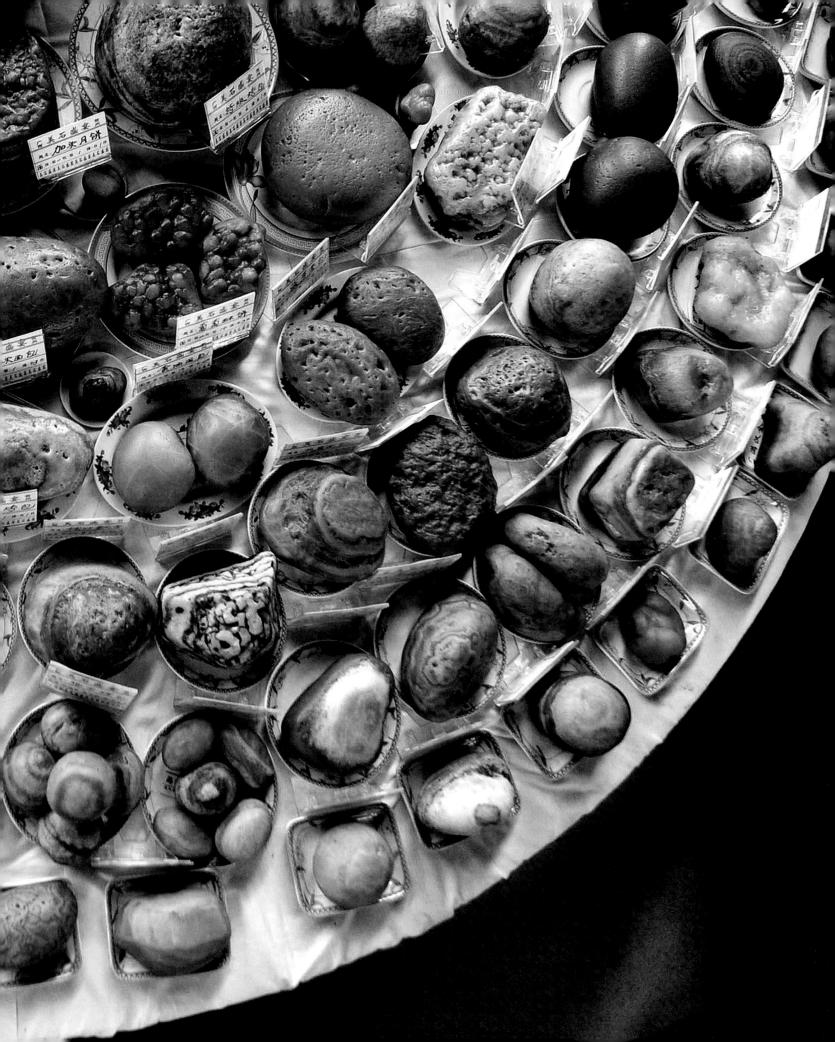

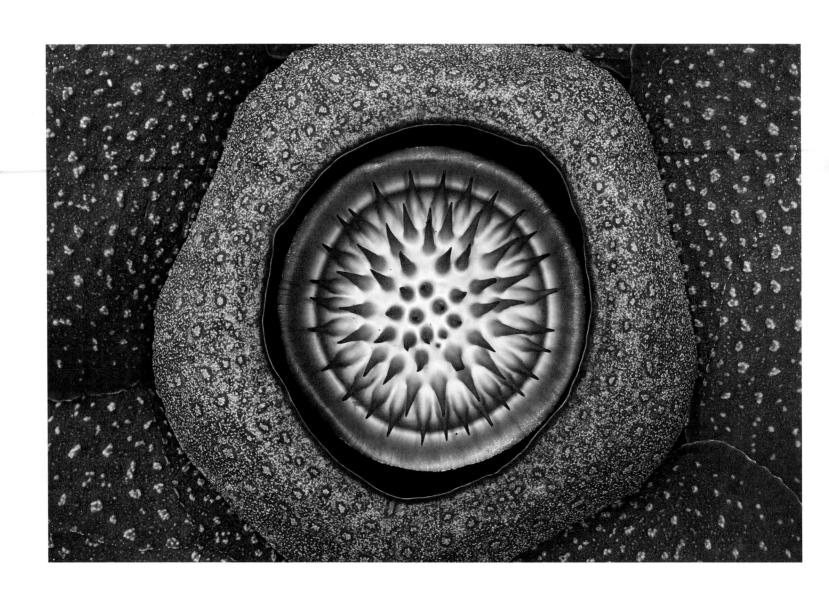

MALAYSIA | INGO ARNDT

Spikes at the center of the Rafflesia kerrii flower may help disperse its odor—the stench of rotting meat—throughout its jungle habitat, thus attracting the carrion flies that pollinate the platter-size bloom.

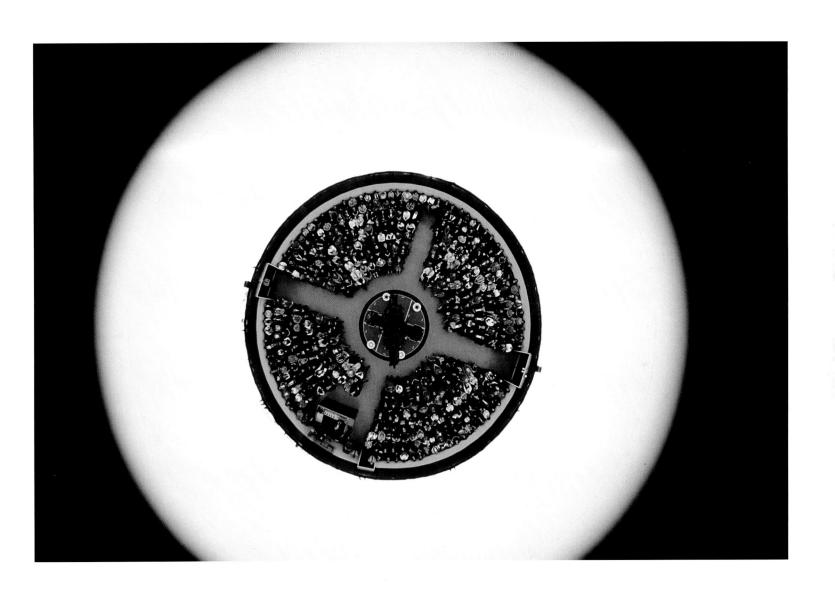

MISSOURI, UNITED STATES | BRUCE DALE

Stargazers seated around a projector appear as specks in a giant eye at the McDonnell Planetarium in St. Louis, Missouri.

The projector can be programmed to show the celestial sky as seen from any place on Earth.

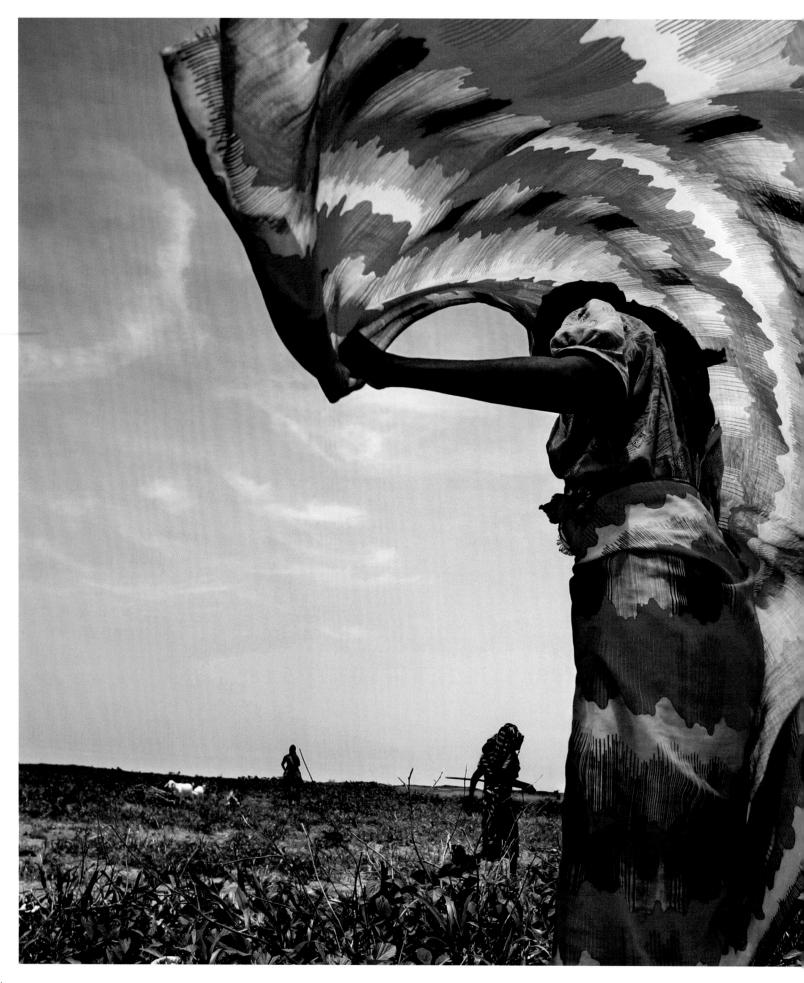

SUDAN | J CARRIER

Women walk miles from their West Darfur refugee camp—and risk assault by roving militiamen—to gather wood and grass for fuel. A full sack earns some 50 cents in their camp, home to about 15,000 people.

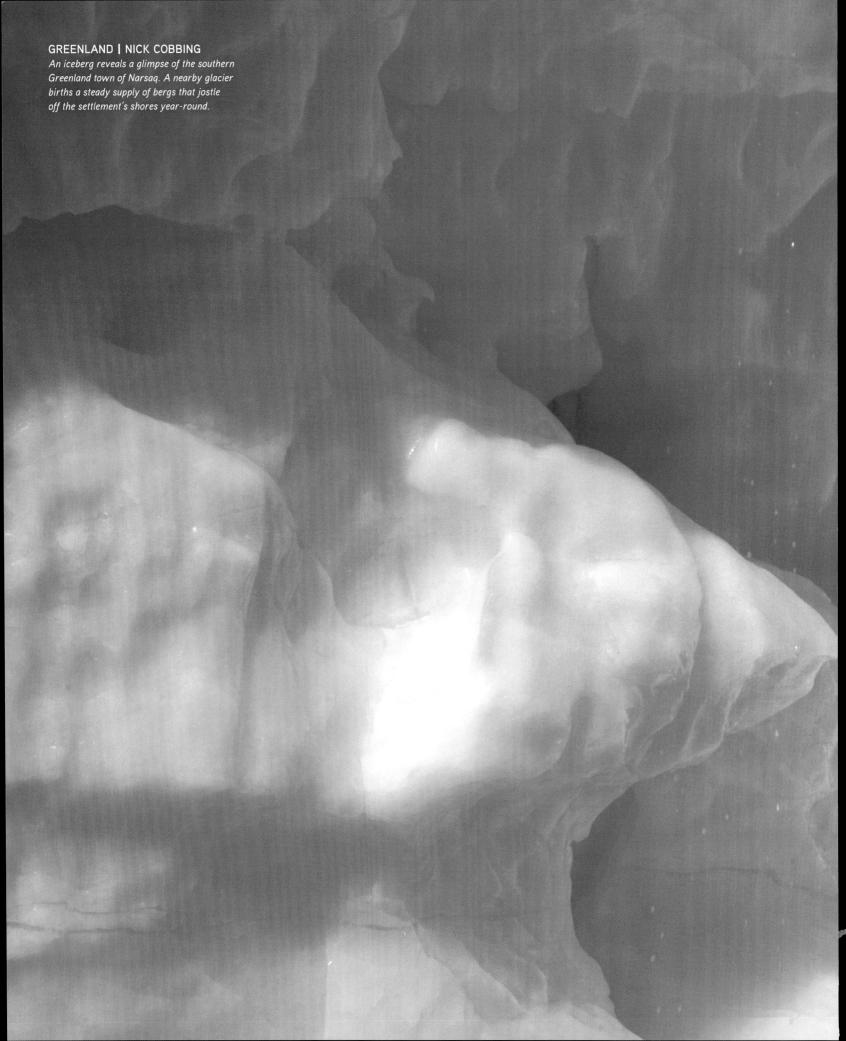

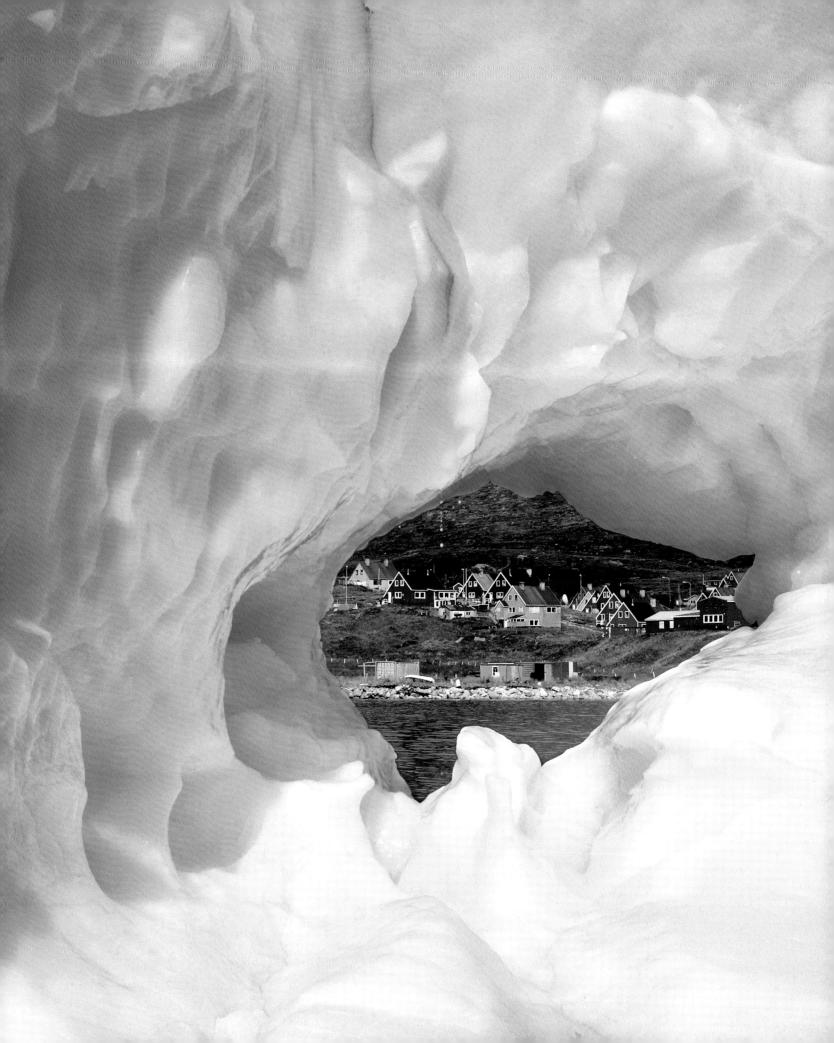

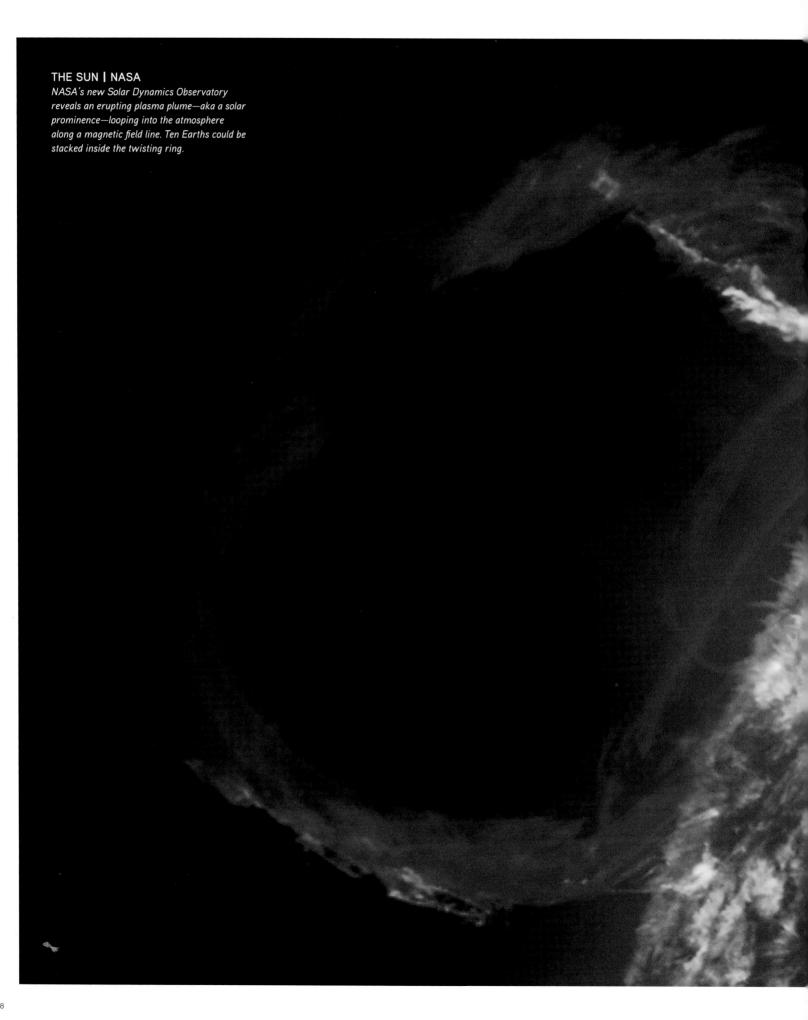

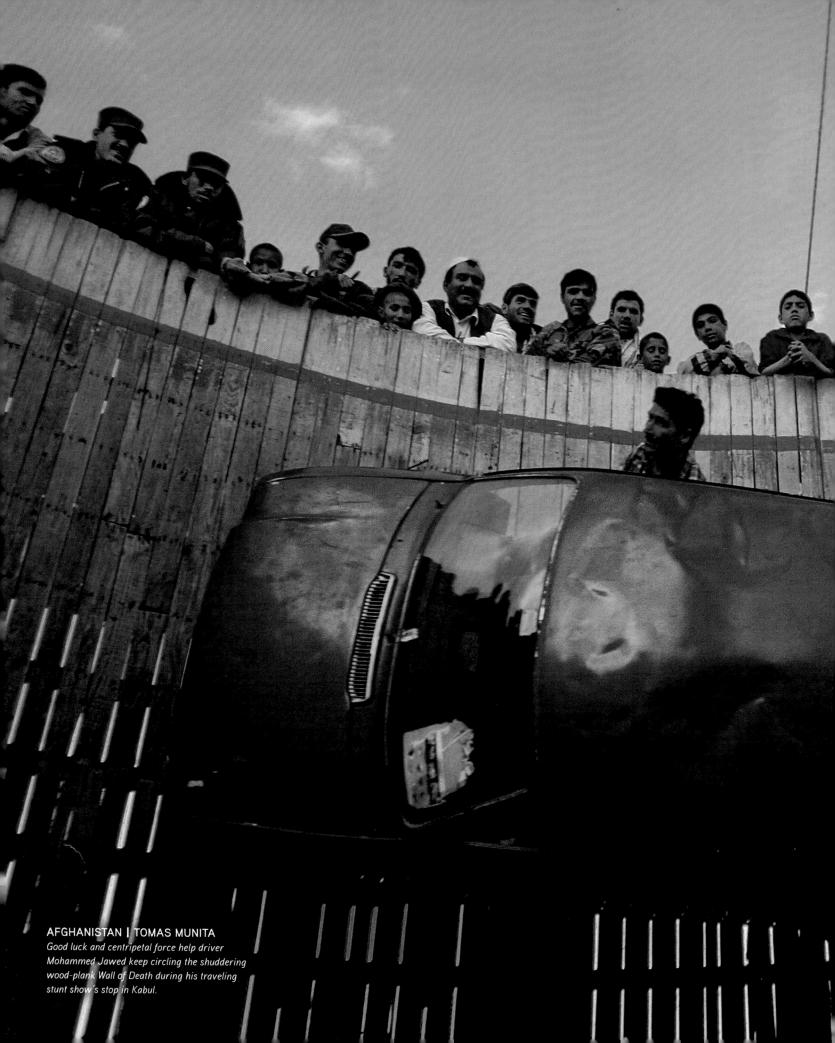

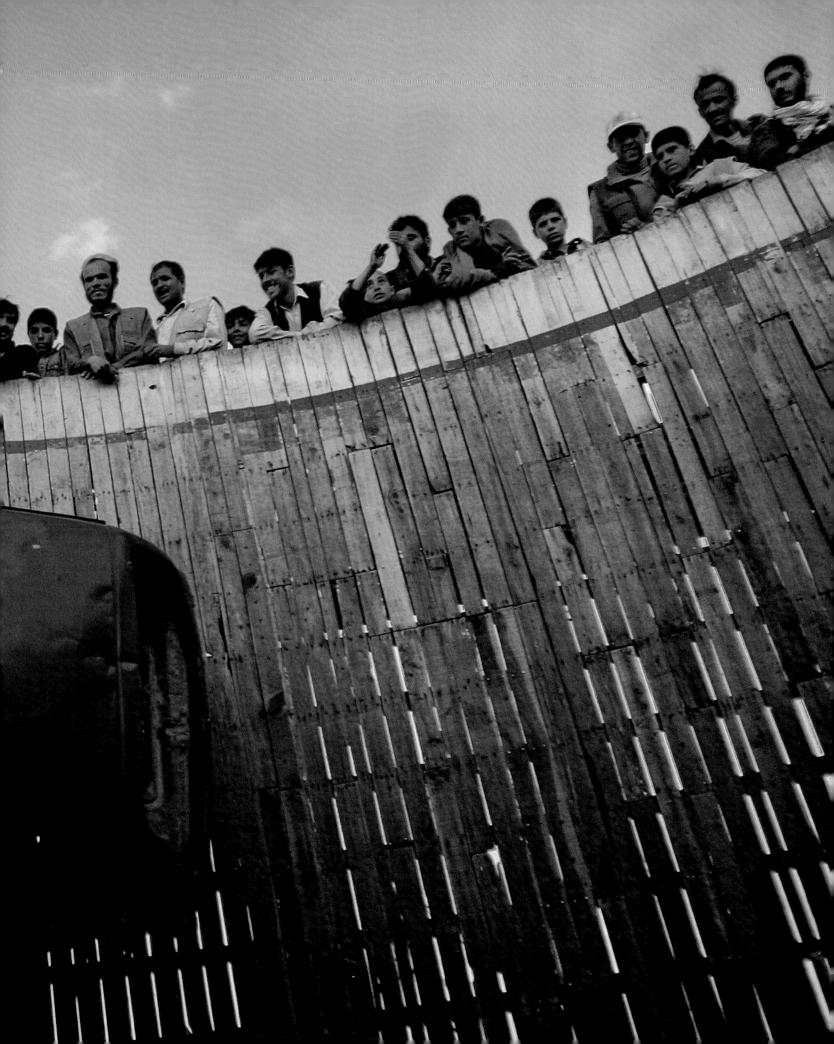

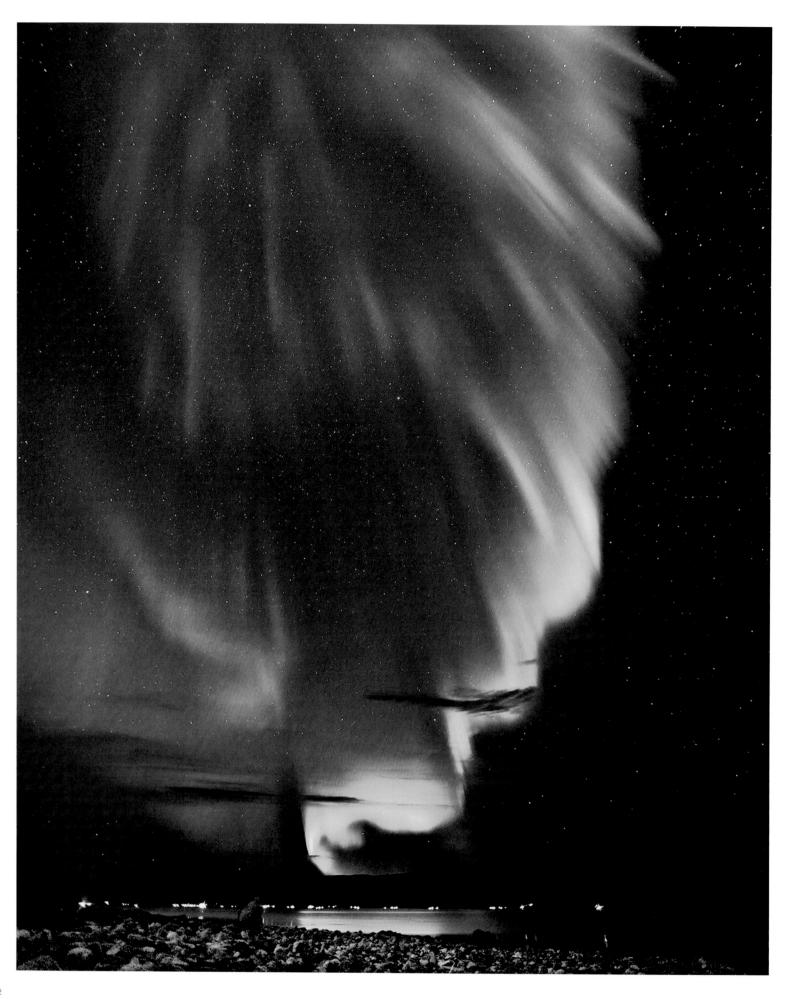

MAGNETIC STORMS

in 1989 caused a flurry of problems in

Canada: The power grid in the
province of Quebec collapsed, compass
readings became unreliable,
radio transmissions were disrupted,
and there were even reports of
automatic garage doors opening and closing

On their own.

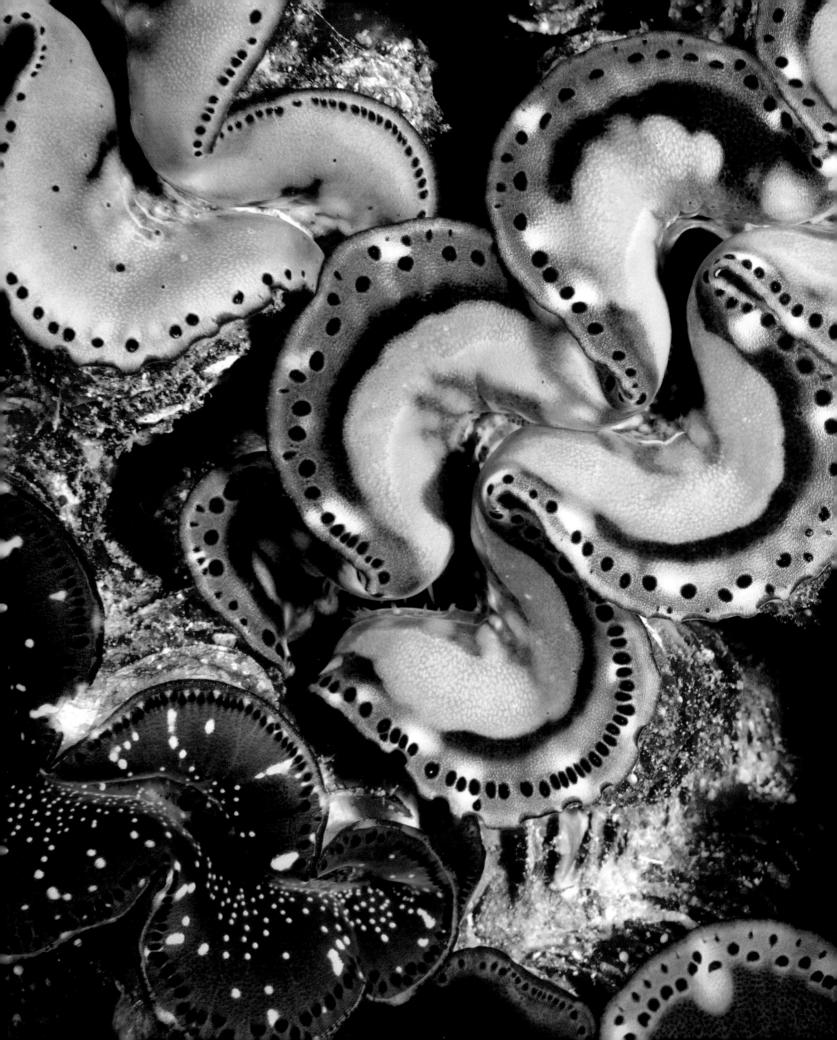

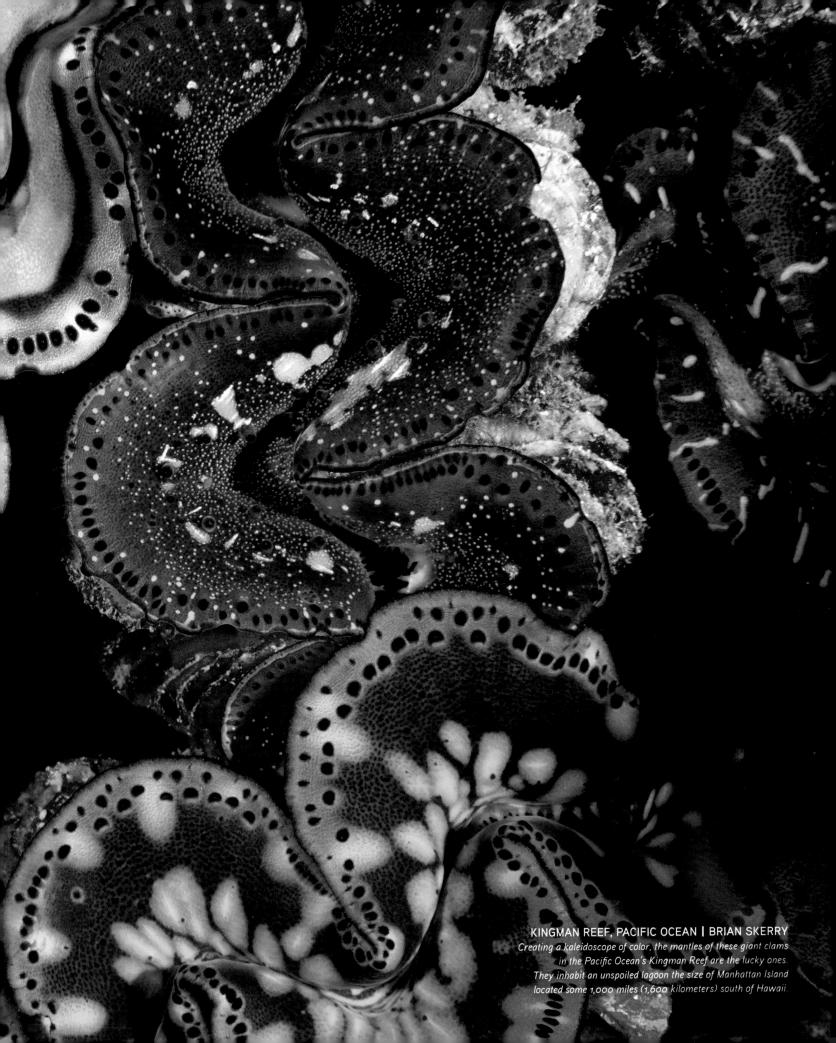

PORTFOLIO THREE

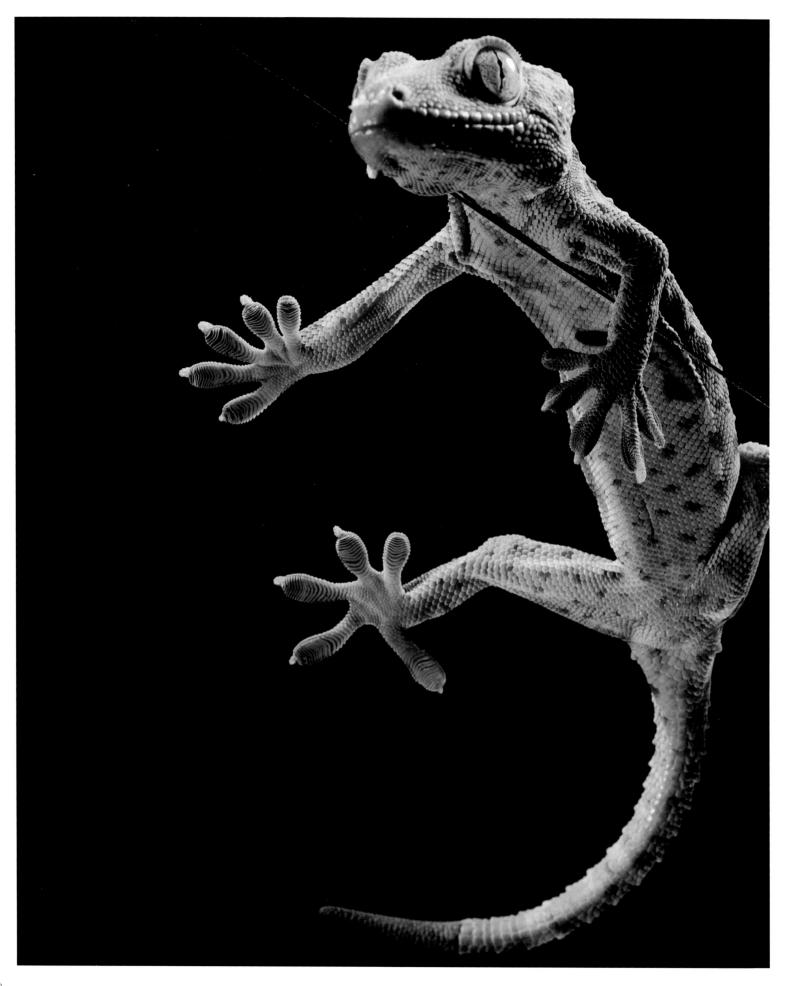

real in the world of nature. At the surface, inner being meets outer surround. Smooth or mottled, waxy or velveteen, surfaces delight our senses, not only because of the intricacy of pattern, a feast for the eyes, but also because we imag-

ine how they might feel if we touched them. Any array of surfaces evokes the sense of touch, the one all-body sensation. A surface can feel soft, gentle, and pleasing, or it can feel jagged, dangerous, and cruel. A photograph that brings our attention to a surface is likely to create a body-feel experience of the mind.

See a downy nestling, a day-old Canada goose all yellow-green fuzz, and fancy caressing it with your fingertips. Behold a sheet of cold stream water shimmering over a smooth rock, and imagine entering that cool, eternal flow with the flat of your hand. Enjoy a picture-postcard portrayal of a sunbaked beach of white, white sand with nobody on it, and you're bound to imagine the soles of your feet sinking into the surface. Peer into the feathery details of a fern frond unfolding; feel it tickle the soft skin of your upper lip and cheek.

In the world of humans, we are given the warning that appearances can be deceiving. But in the world of nature, surfaces do not lie. Yes, there may be dark ocean depths under the surface of the water, but those dimples, ripples, and waves are every bit as authentic as the dark fathoms below.

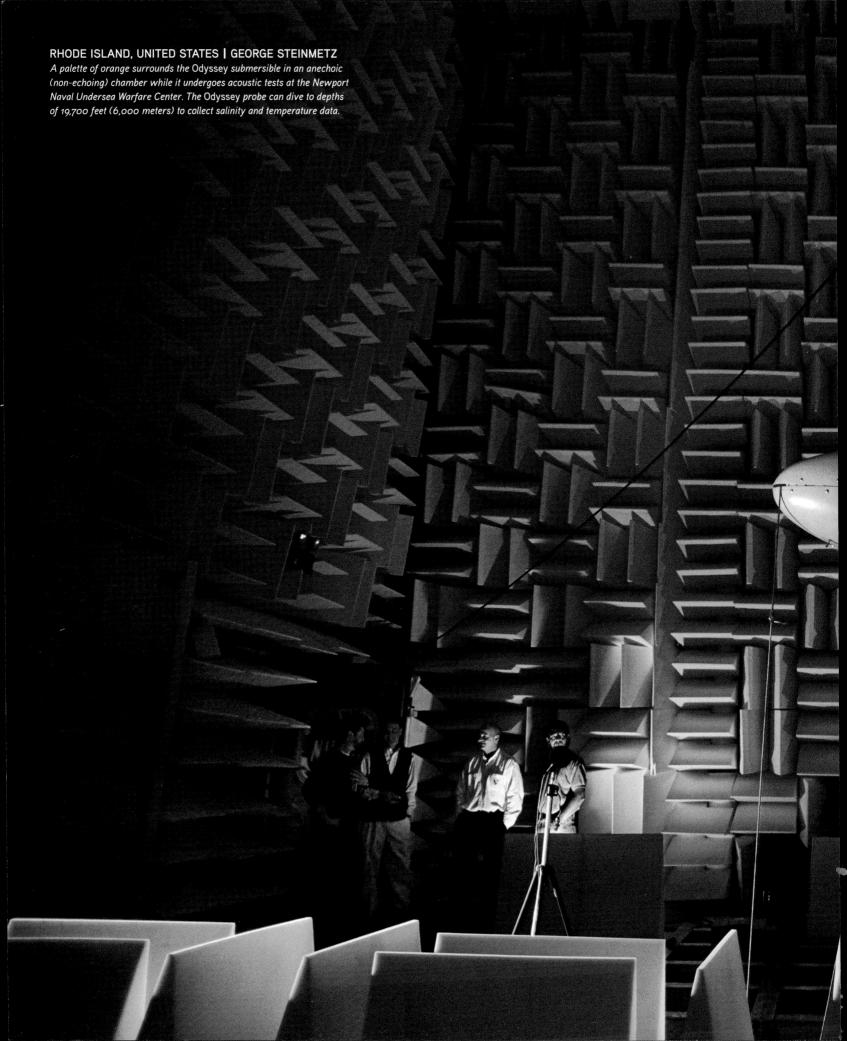

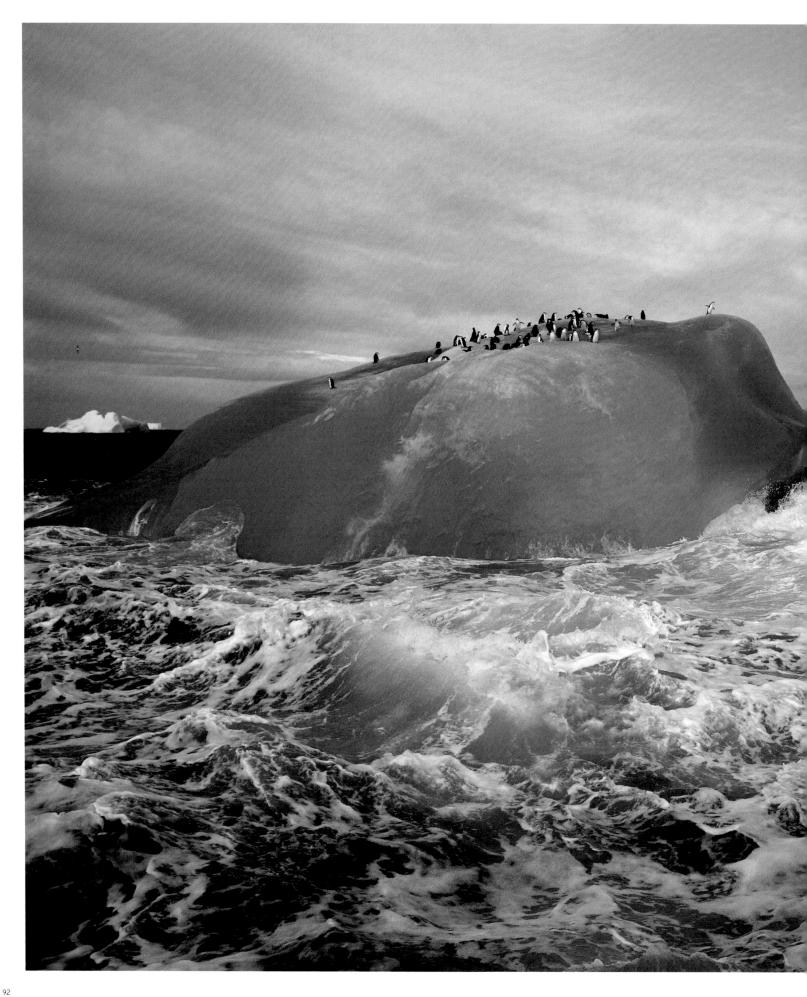

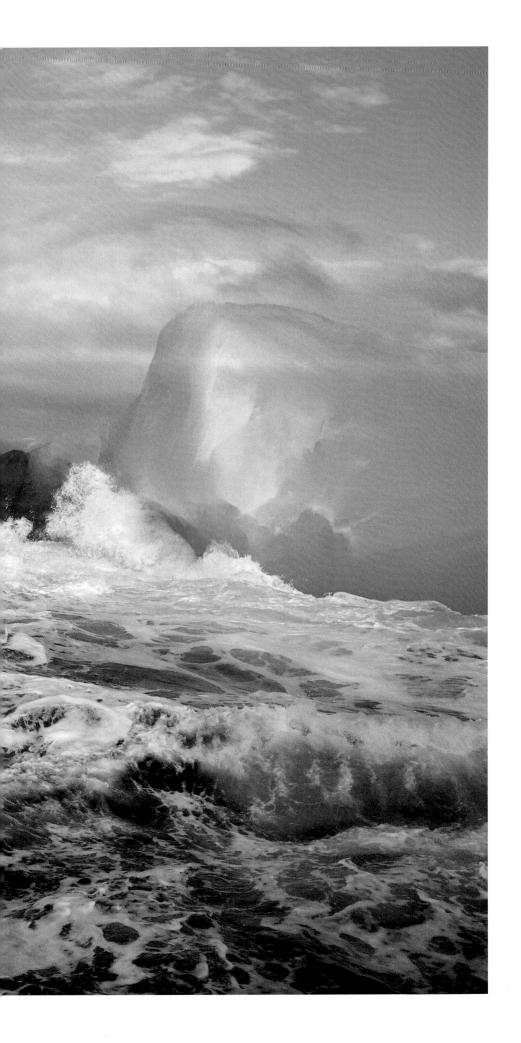

ANTARCTICA | MARIA STENZEL

Riding on top of a blue iceberg, chinstrap penguins near Candlemas Island in Antarctica use this eroded iceberg as a temporary resting spot. For most of the year pack ice keeps the South Sandwich Islands in place, but for about four months during the austral summer a brief thaw occurs.

PHILIPPINES | ALFONSO LIZARES

An earth-colored participant at the Mambukal Mudpack Festival appears as if coming from another time. The festival is held at the height of the monsoon season and celebrates our connection to the natural world.

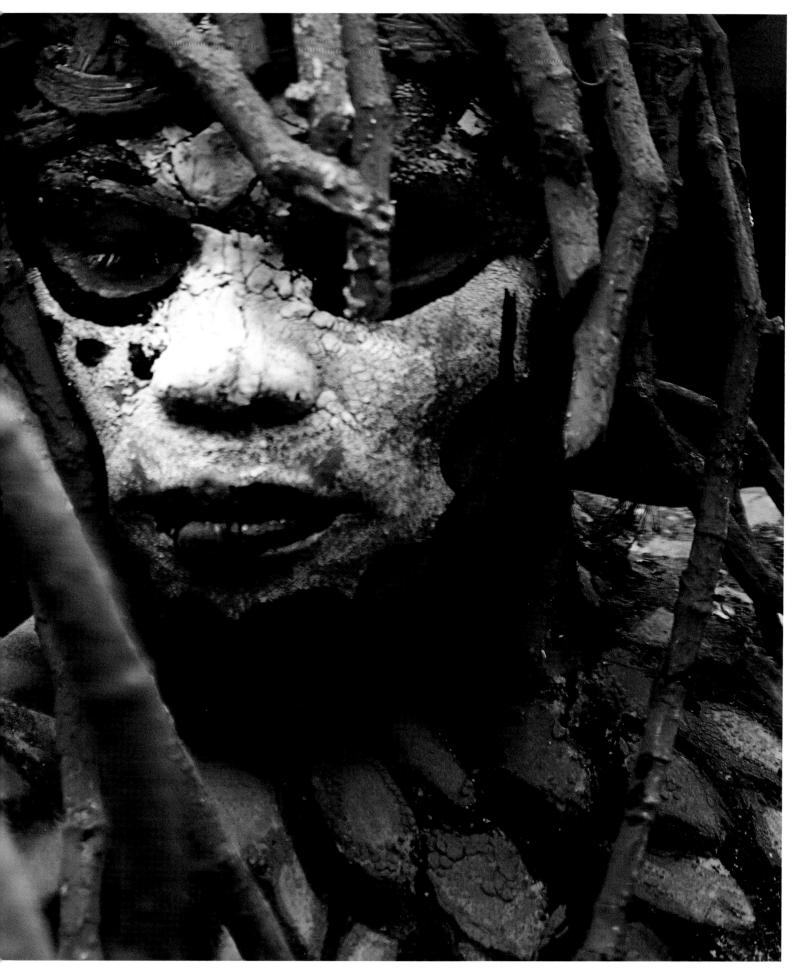

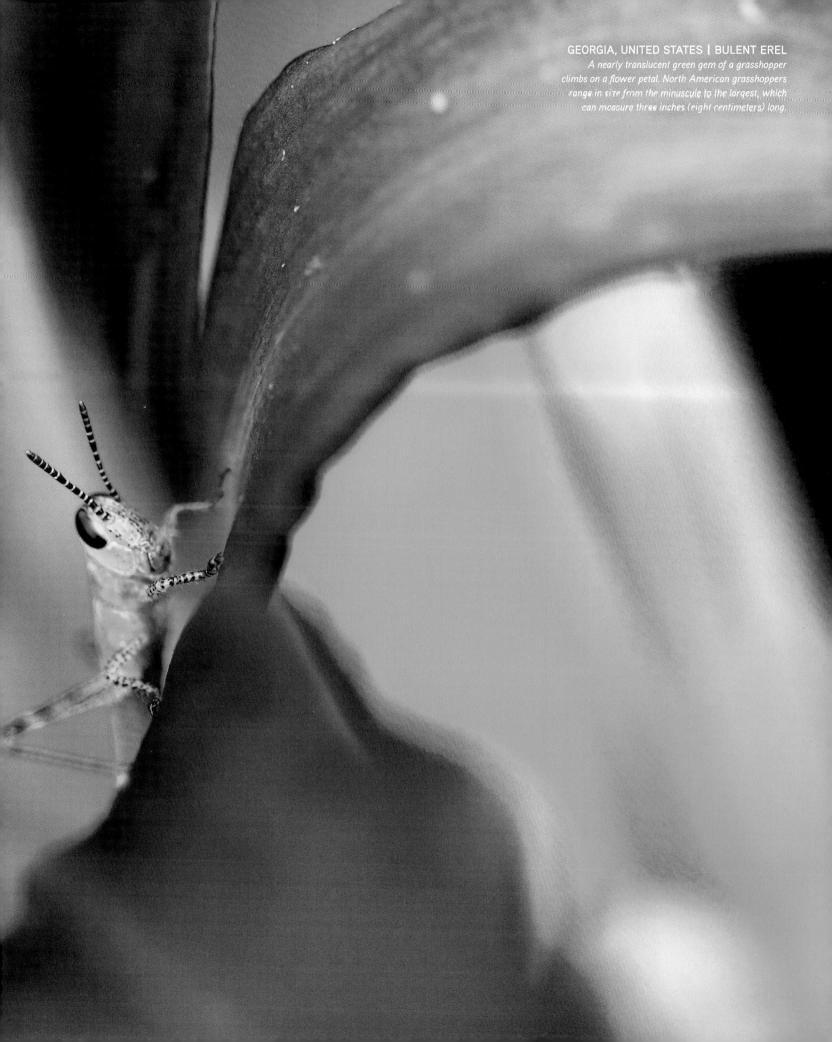

DISTANCES between objects in space are vast, and light from stars and galaxies takes a long time to reach Earth. So when we see these things through our telescopes, we are actually seeing them as they appeared long ago, when their light first started its journey.

In essence, we are looking back in time

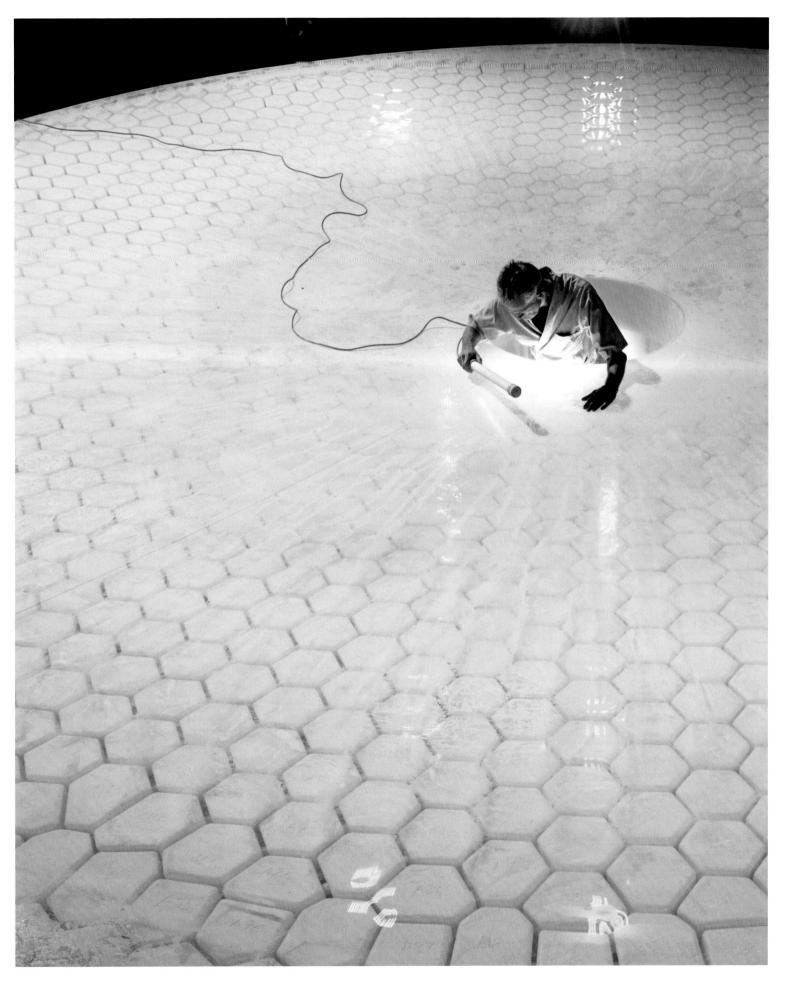

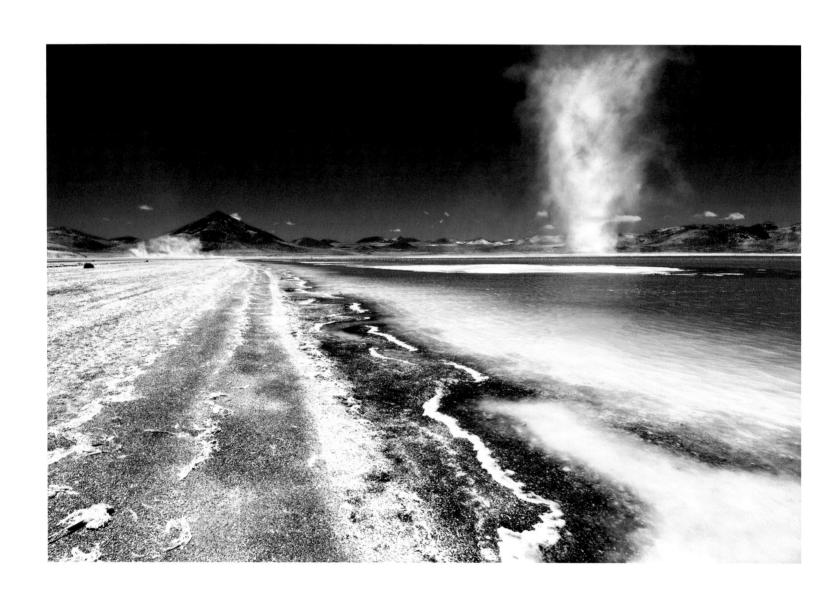

BOLIVIA | DORDO BRNOBIC

The Altiplano shows its otherworldly appeal in South America's high Andes. The red waters of Laguna Colorada, tinted by algae, take their place among jagged mountains, mud volcanoes, and salt flats.

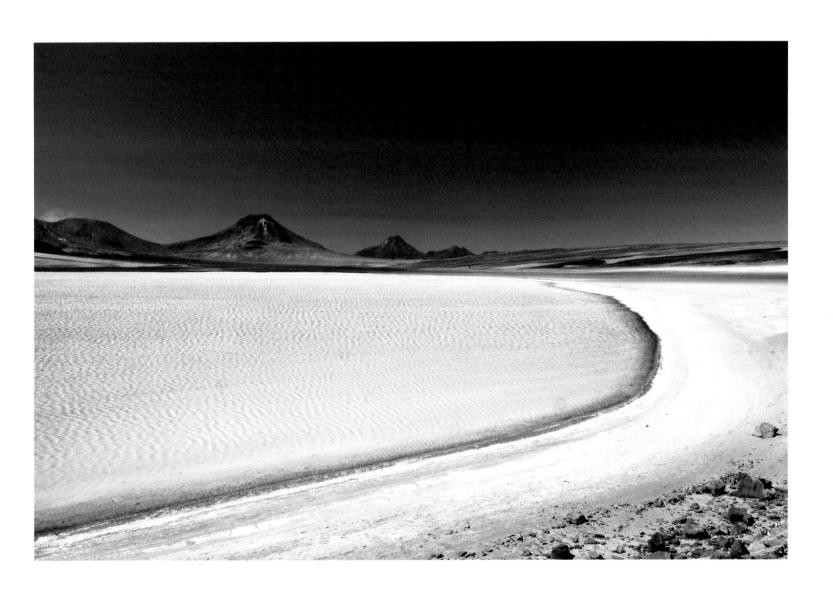

CHILE | DORDO BRNOBIC

The yellow-tinted waters of Laguna Lejía wash up against not white sand but salt flats in the Chilean Altiplano. Extinct volcanoes surrounding the lake lend a stunning backdrop for the vista.

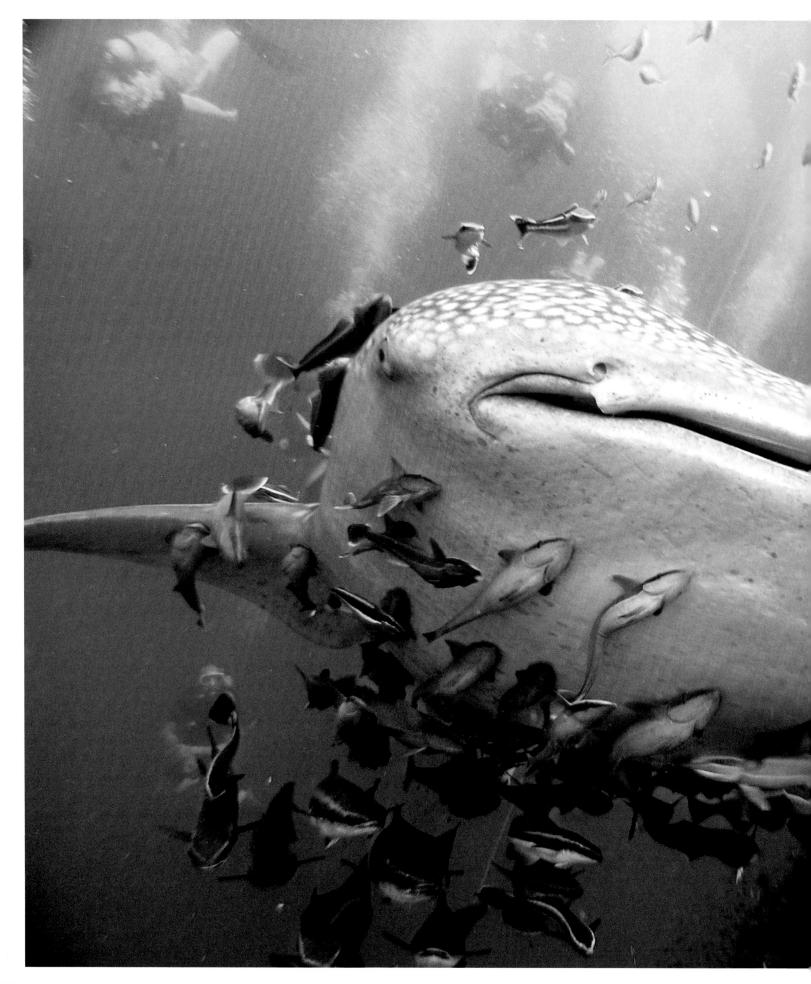

GALÁPAGOS ISLANDS | COLIN PARKER

Hitchhikers come along for the ride on a whale shark.

They don't have much to fear since this fish,
the largest one in the ocean, feeds nonaggressively
by filtering water through its formidable mouth.

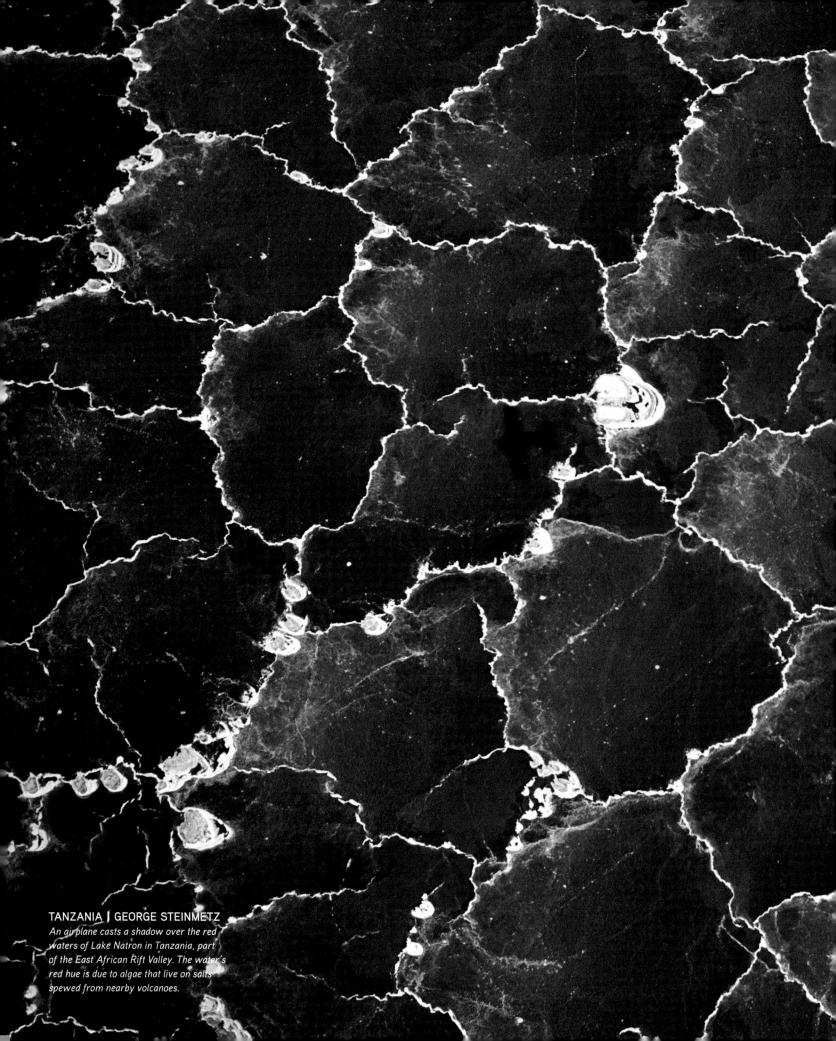

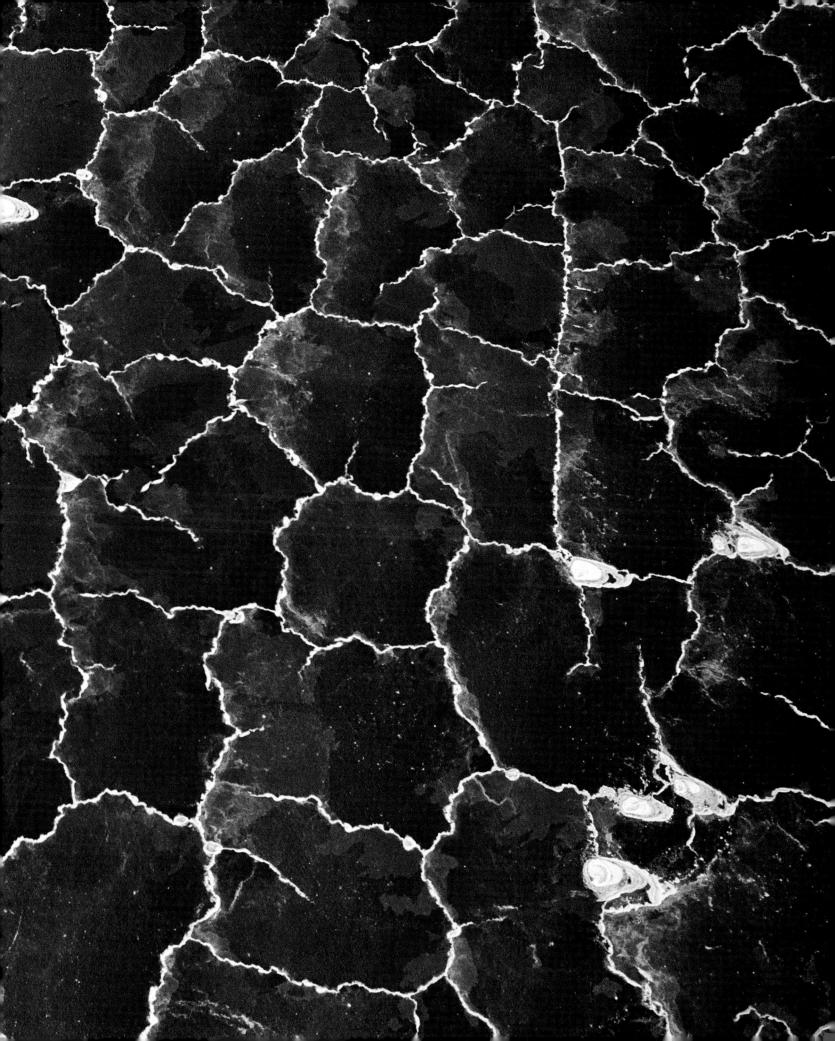

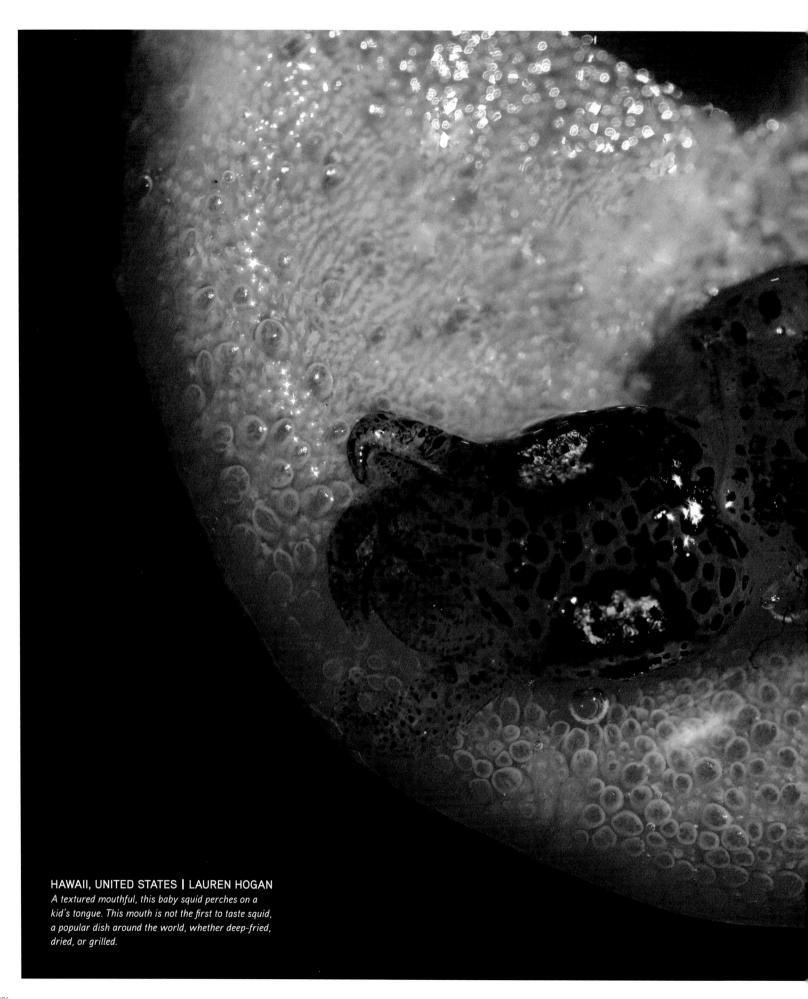

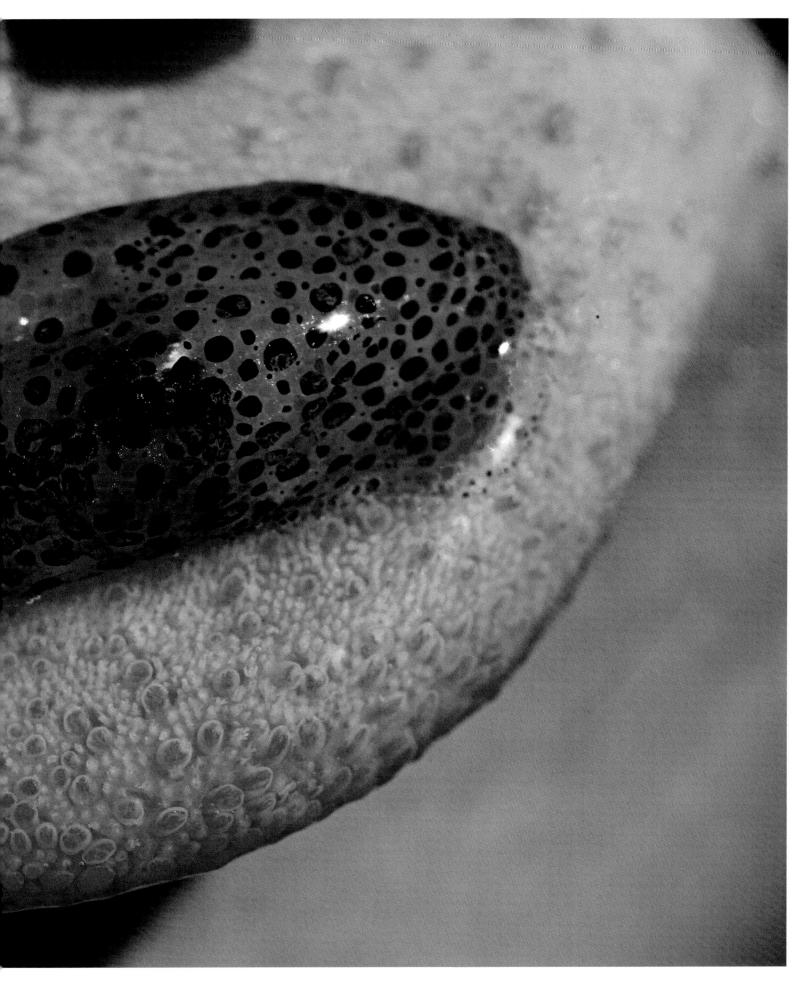

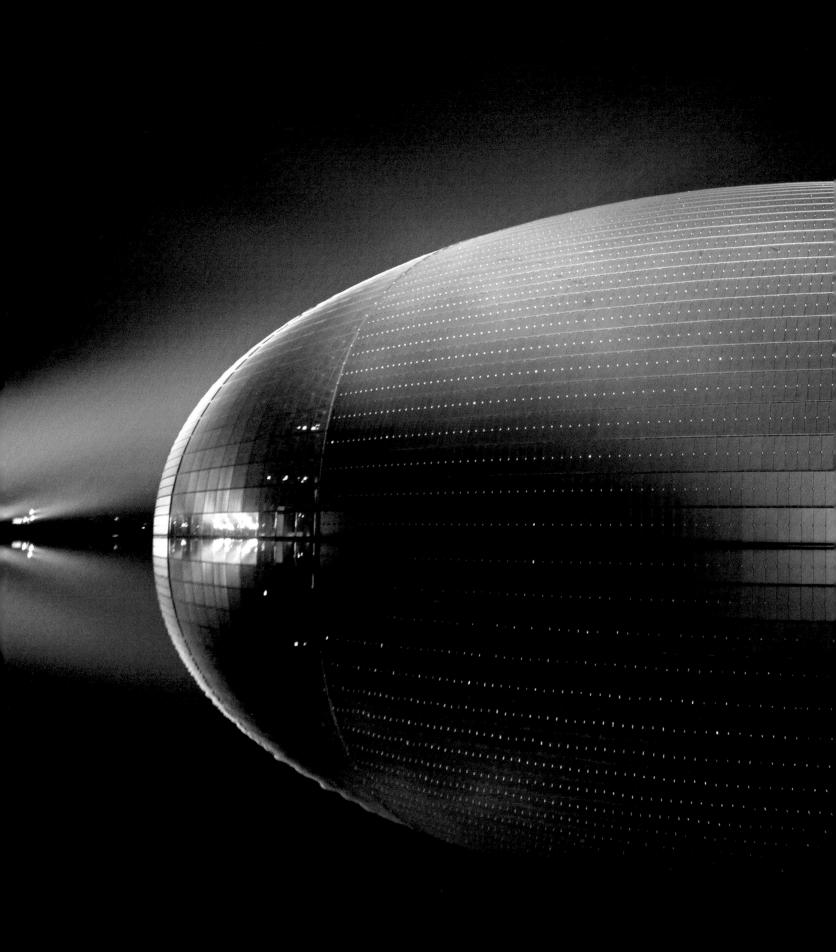

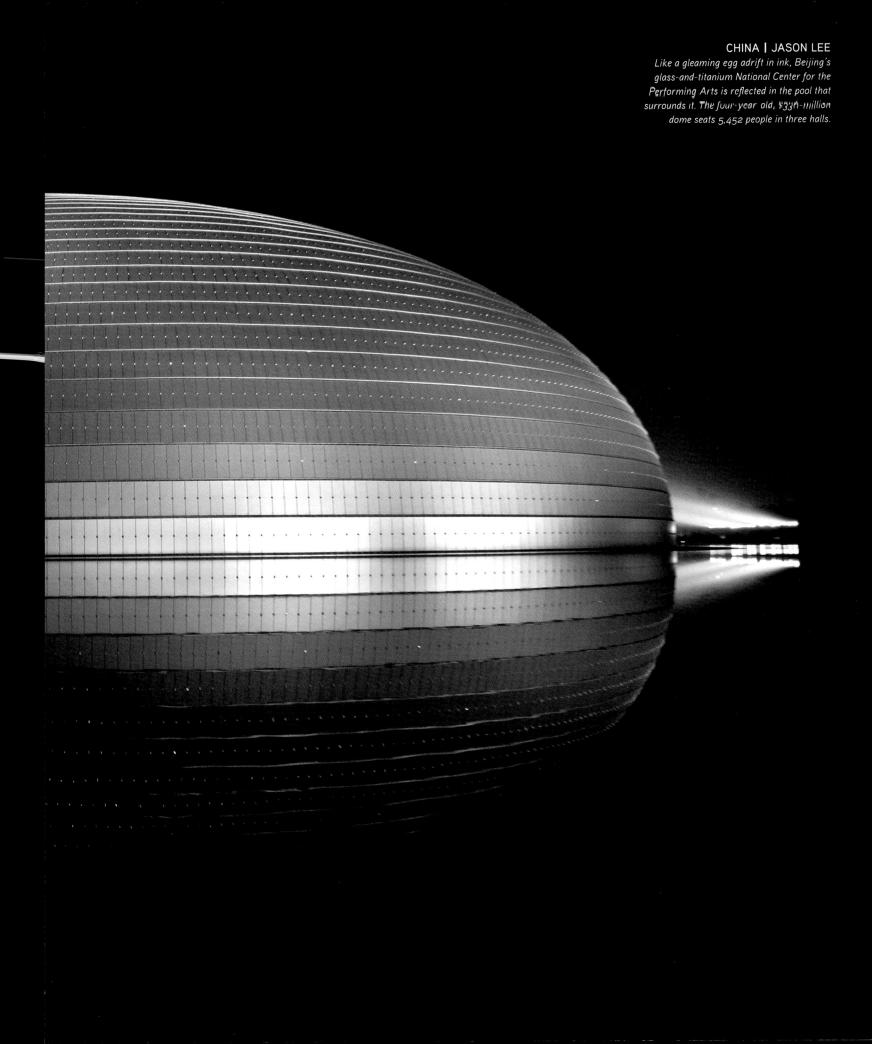

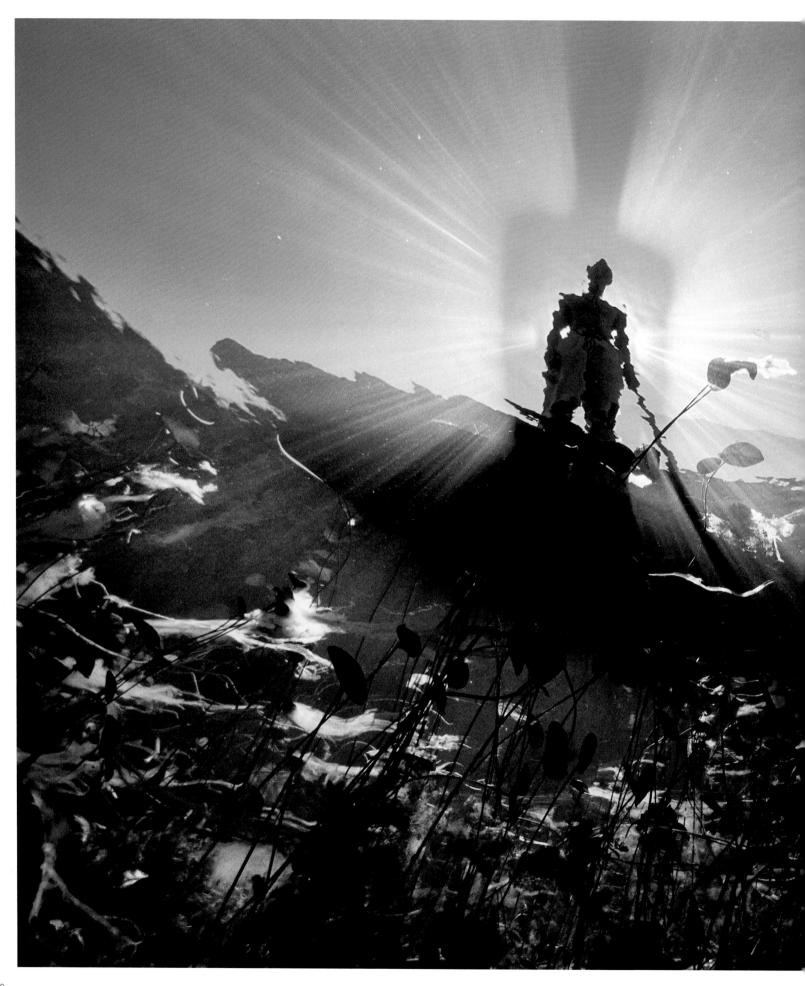

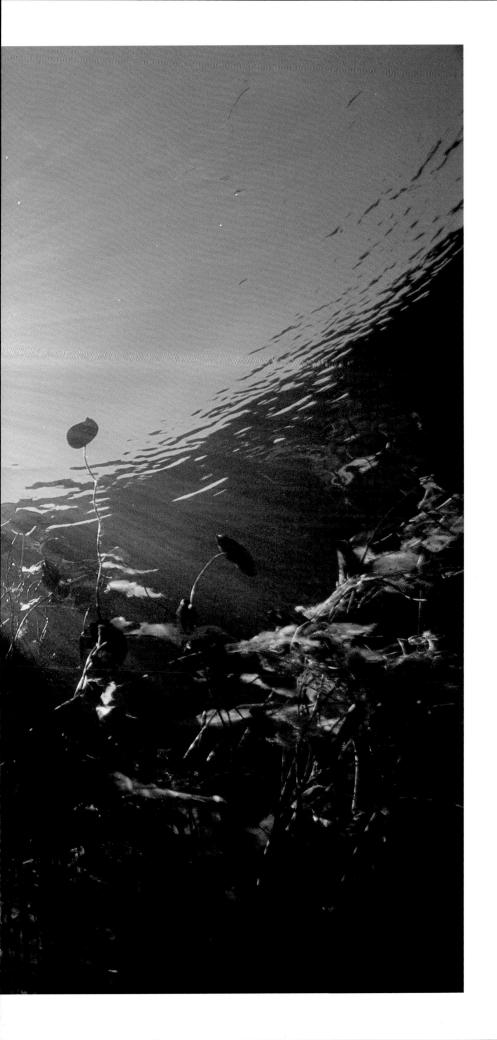

BOTSWANA | DAVID DOUBILET

Sunlight and shadows highlight a river Bushman in a canoe in the Okavango River. When the river swells and floods, it creates an alluvial fan of more than 10,000 square miles (26,000 square kilometers).

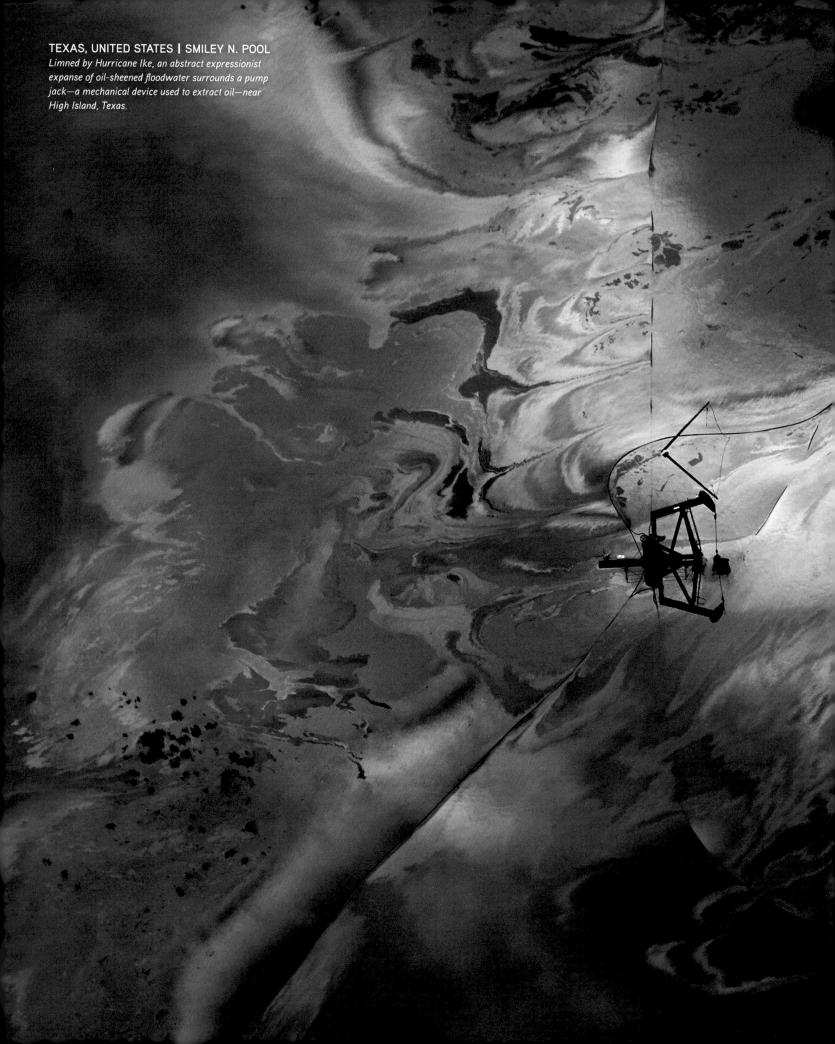

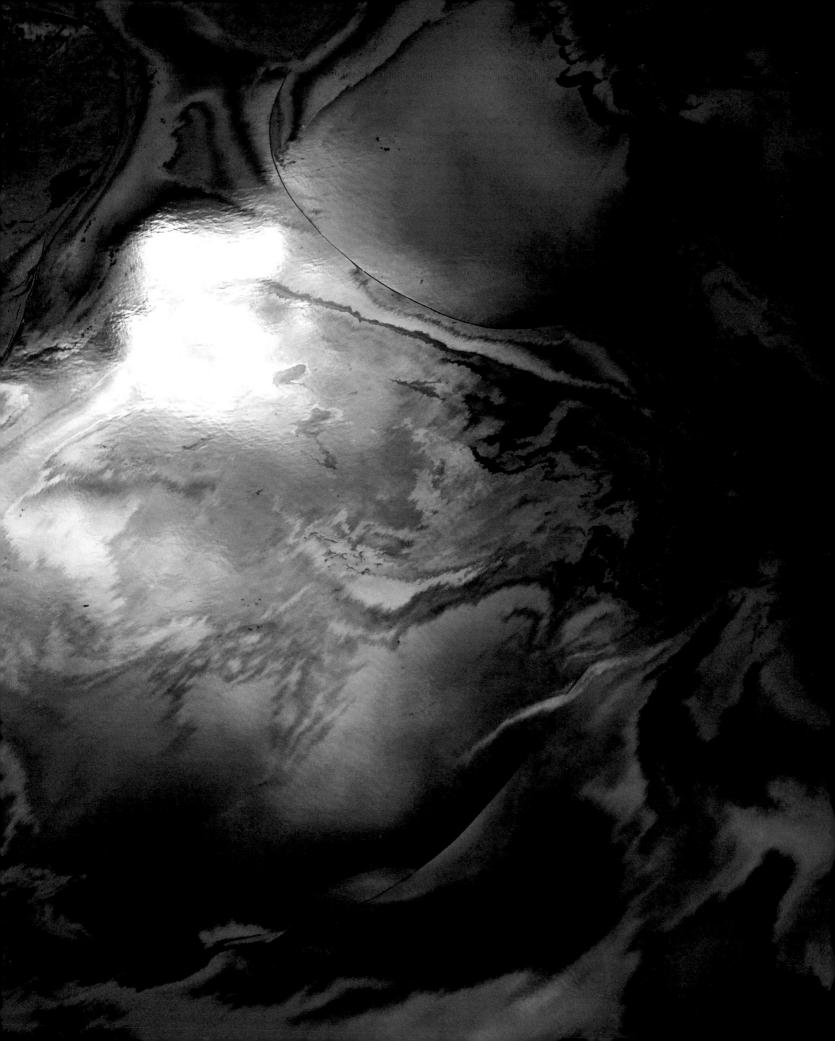

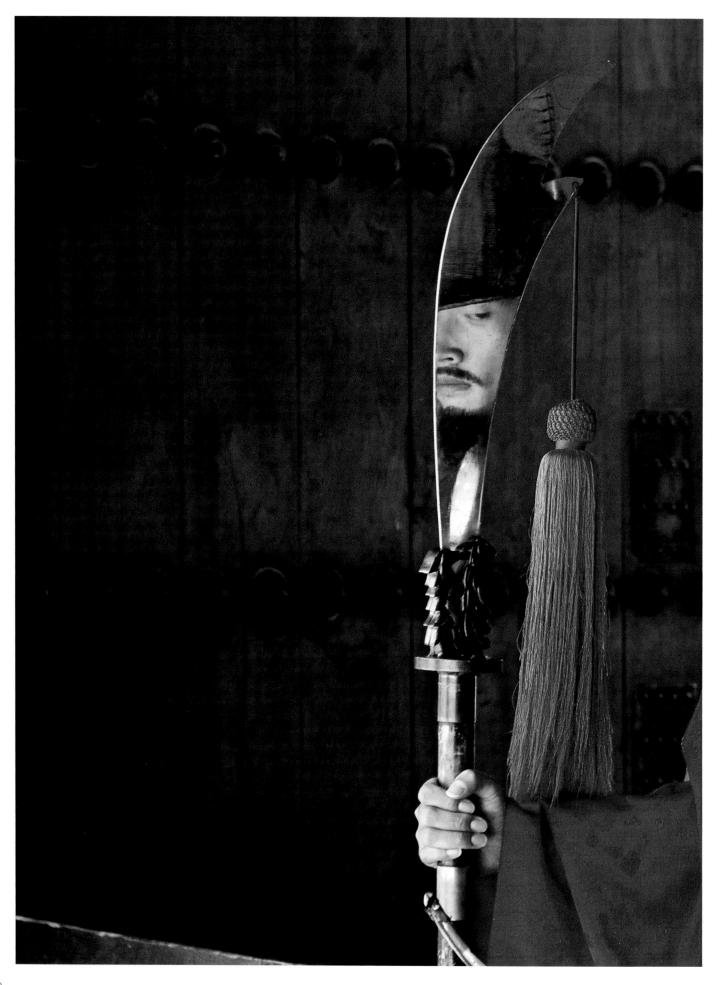

In Turkey,

6,000-YEAR-OLD MIRRORS

made of obsidian have been discovered;

the ancient Egyptians made theirs

from polished copper.

Modern mirrors, made of metal-backed

glass, were first produced

during Roman times.

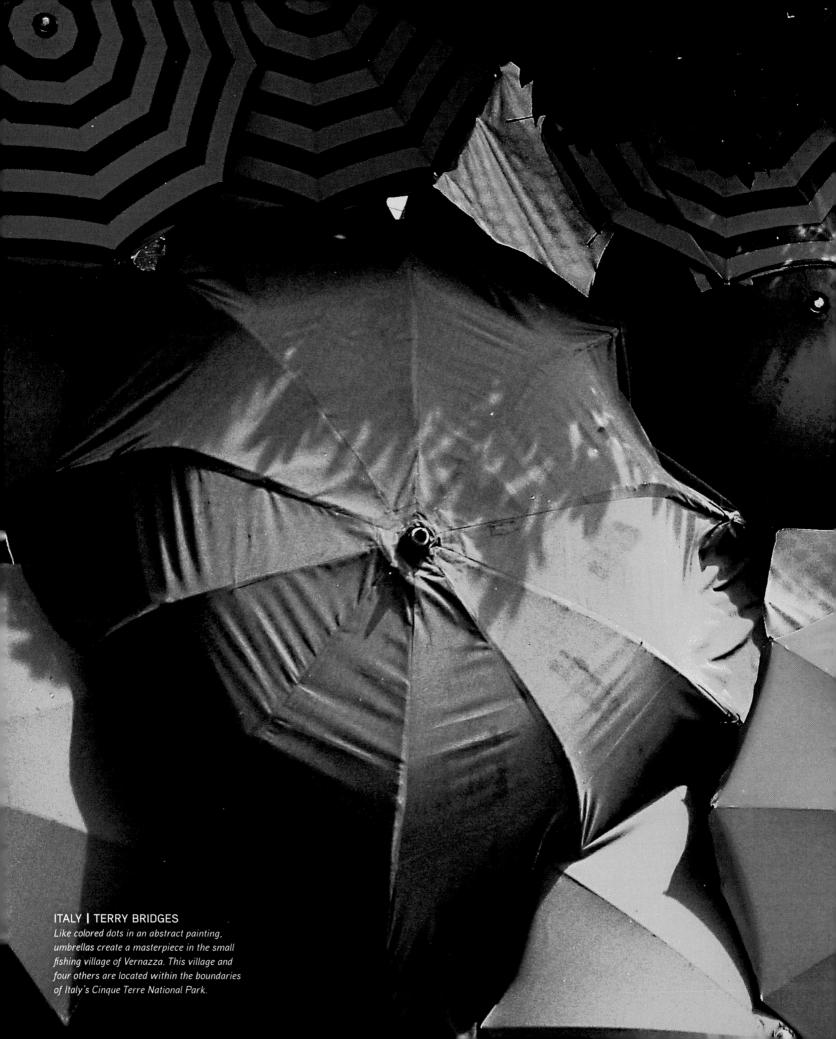

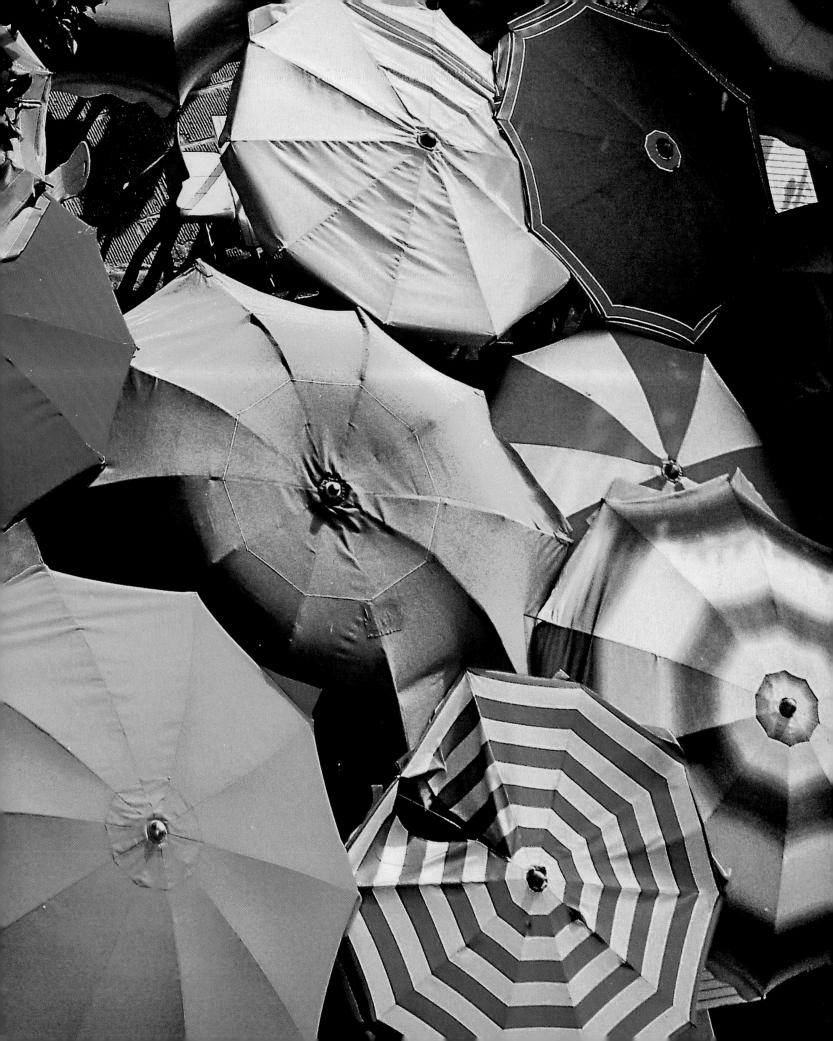

PORTFOLIO FOUR

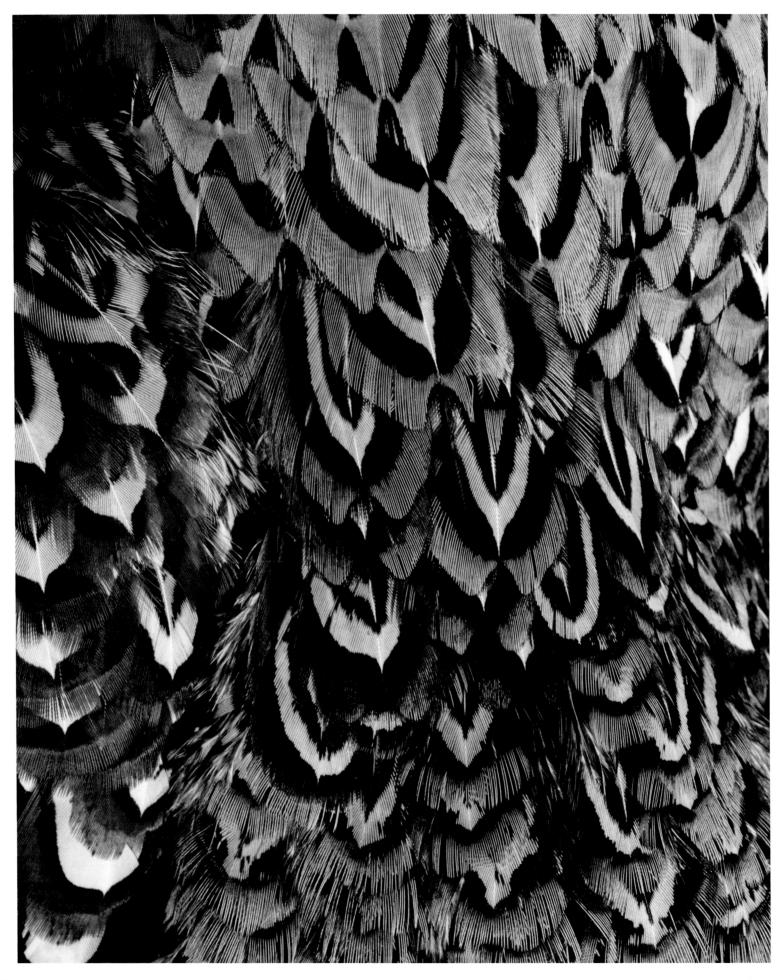

Seek pattern just as the mind seeks

meaning in the chaos of things. It's a human impulse, driven by the comfort that expectability brings and satisfied by the relationships that repetition and meeting points confer. Perfectly concentric circles pulsing out from where a pebble dropped into a pond. A fringe of icicles dripping motionlessly off a fence line. A snowflake's hexagon. Diamonds and stripes in earth tones, the natural geometry of snakeskin. Black veins outlining brilliant orange panels in the monarch butterfly wing, nature's stained-glass window, ornamental grace notes to the already pleasing symmetry of two antennae, head, thorax, abdomen, six legs, four wings.

Pattern makes the unknown feel familiar. Half a world away, rain forest orchids blossom in the dappled light of tropical undergrowth. We have seen this pattern before petals, sepals, lip, lobes; blooms alternating up a stalk stretching up out of the crown of moist green leaves. Leaves, stalk, flowers, buds: a familiar pattern, and yet the photographer trekked hours, far from any known road or shelter, to capture this particular iteration of it.

In the human world, we revel in pattern as well. We find or we impose it. Buildings, neighborhoods, landscapes, farmlands: each repeating square as if part of a patchwork quilt, oddities within each piece but a regularizing pattern overall. Notes in a scale, beads on a string, flowers in a circle, chairs in a row. There is safety, there is beauty in pattern.

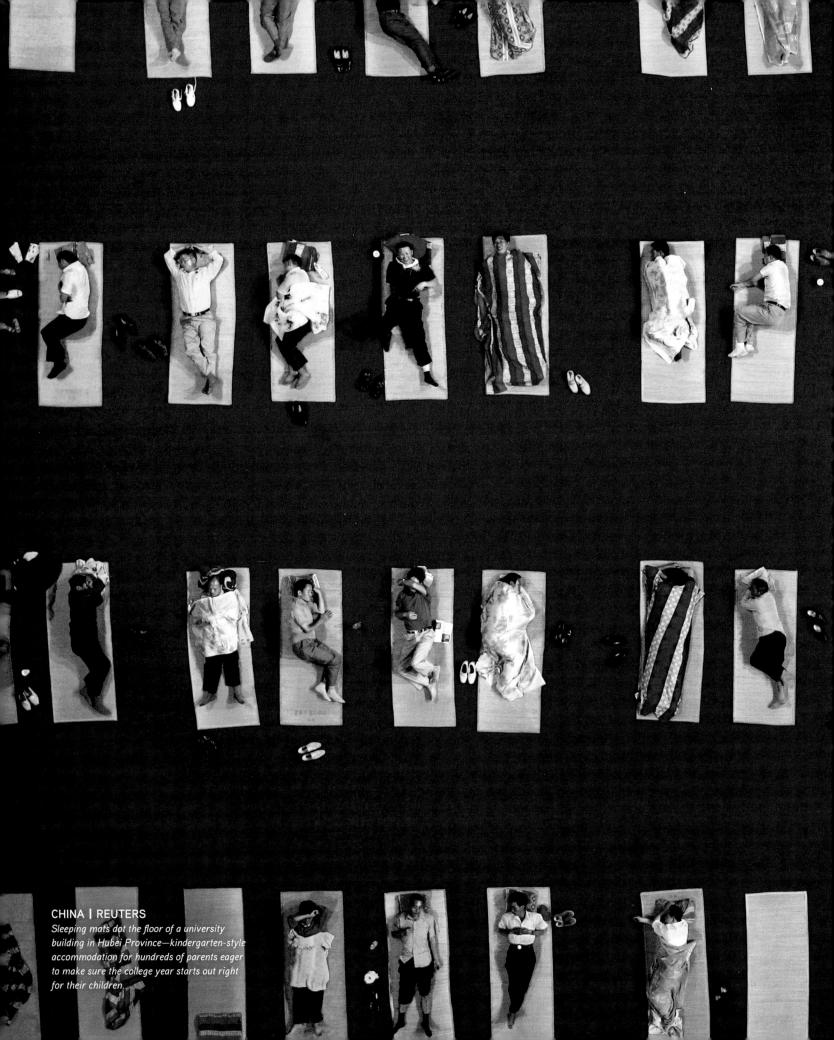

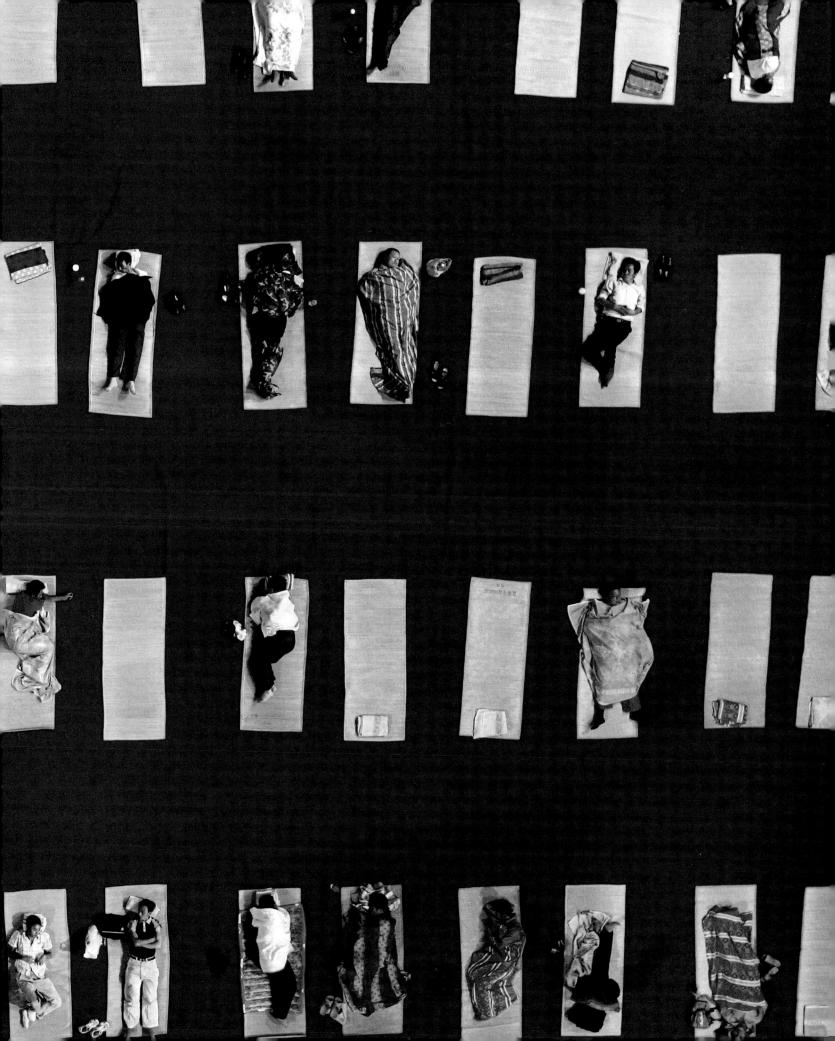

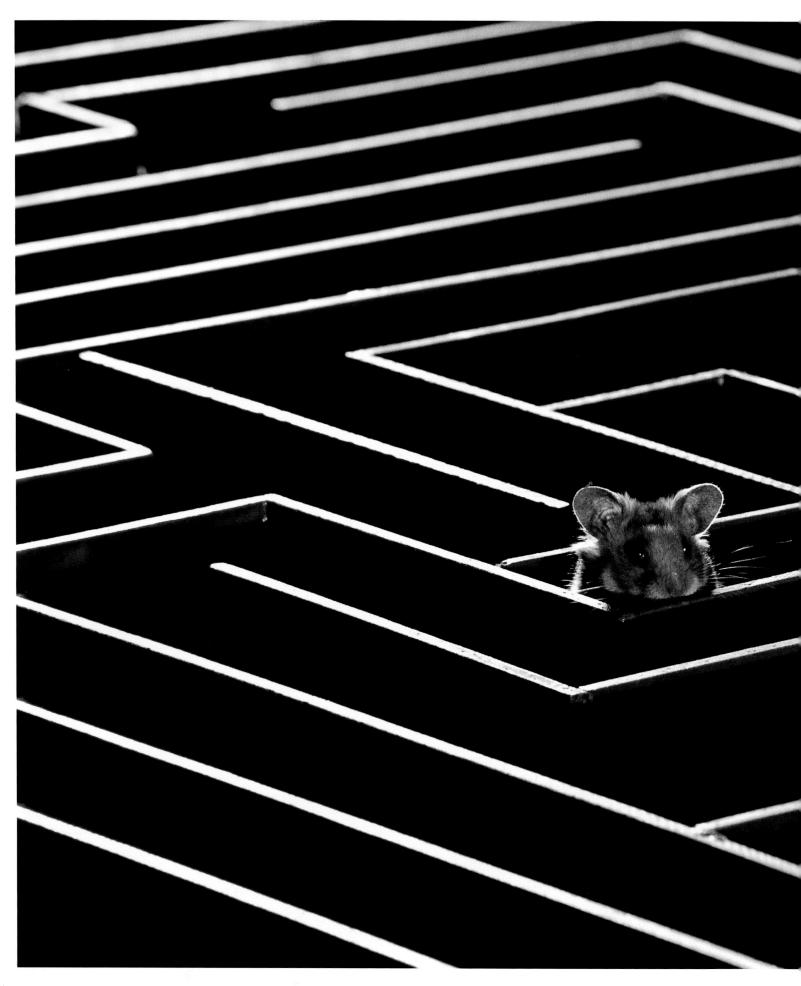

GERMANY | HEIDI AND HANS-JÜRGEN KOCH Seemingly stuck inside a labyrinth, this golden hamster appears to be considering another way out. Golden hamsters at Martin Luther University, Halle-Wittenberg, take about a week to learn how to navigate out of this 4-foot-by-5-foot (1.2-meter-by-1.5-meter) maze.

IRAQ | JULIE ADNAN

Some 160 miles (257 kilometers) northeast of Baghdad, in a Sulaymaniyah music hall ravaged by war, looting, and neglect, a violin-playing boy sounds a note of hope. His teacher, Azad Maaruf, lives there and instructs scores of students.

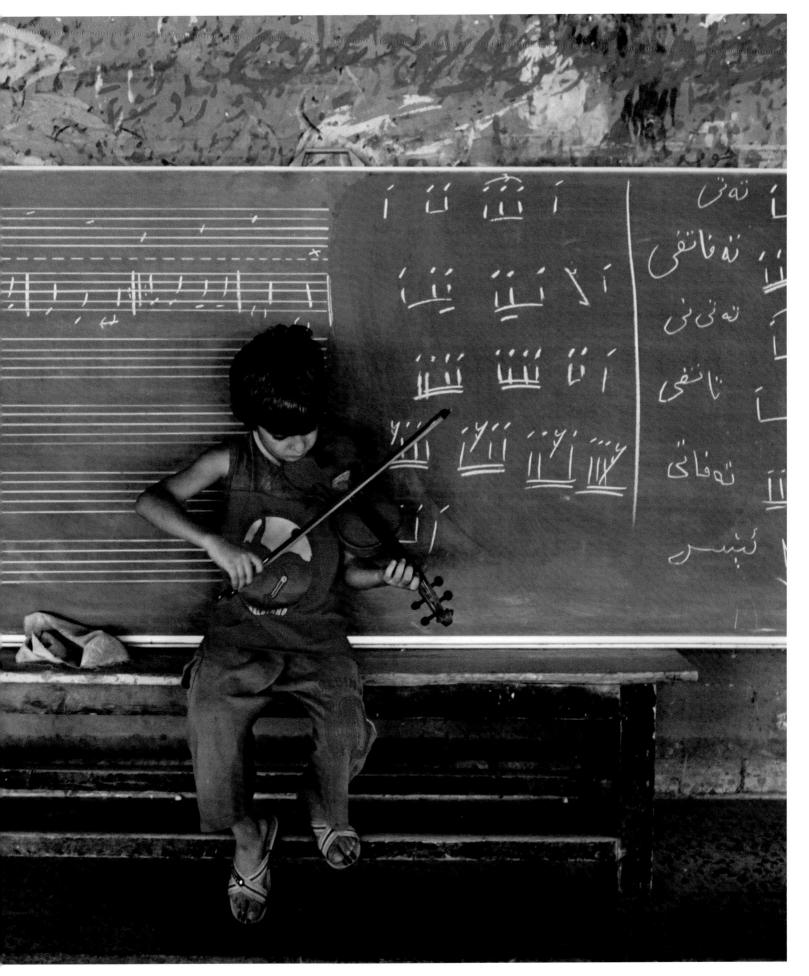

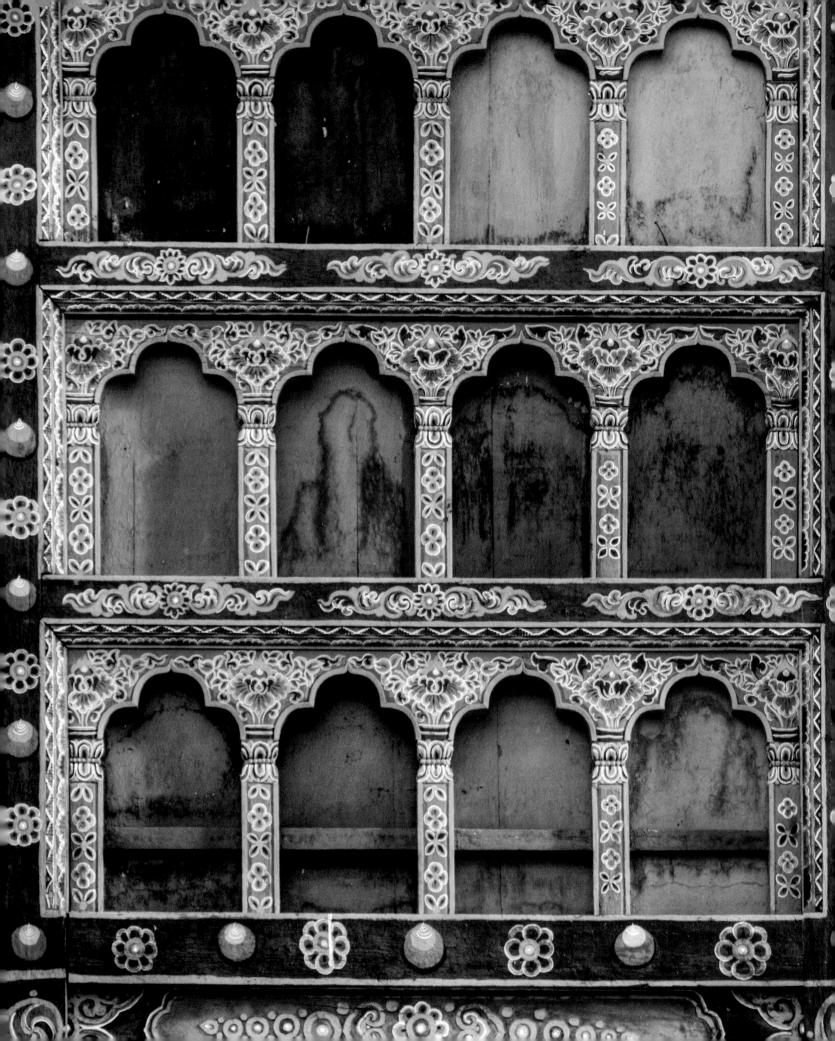

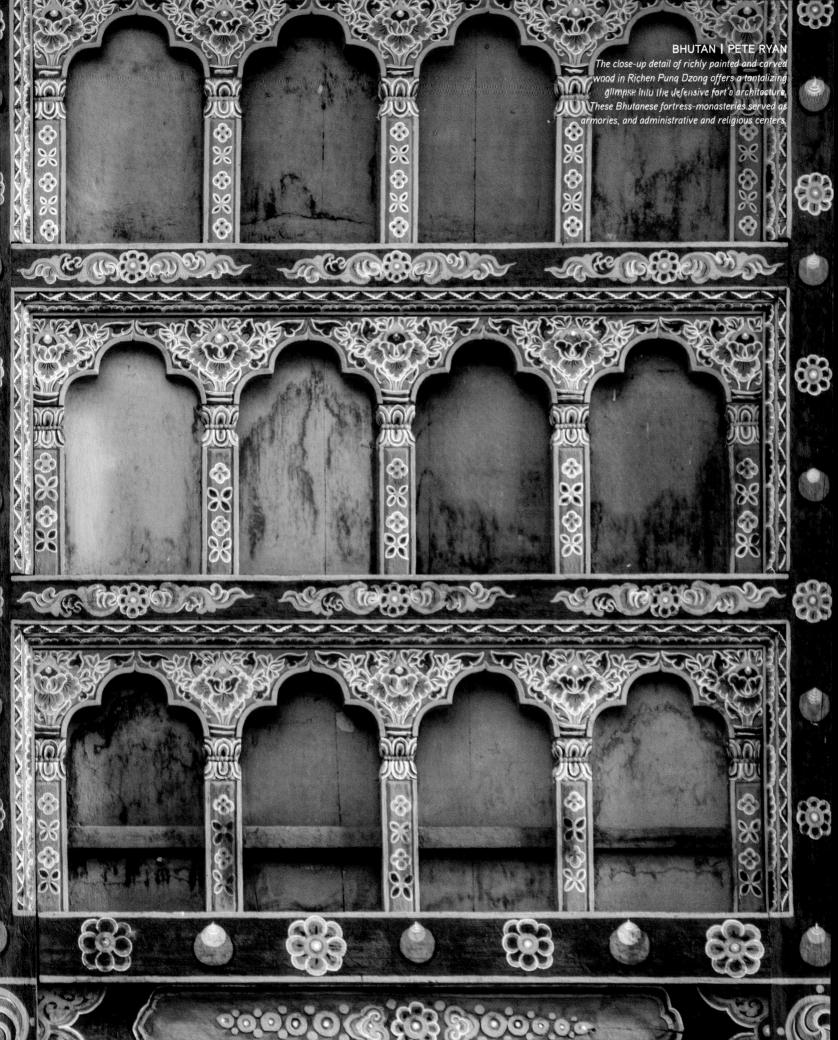

PRAIRIE DOGS

are not dogs at all; they are rodents.

Their name comes from the sound of their warning call, which sounds somewhat like a dog's bark.

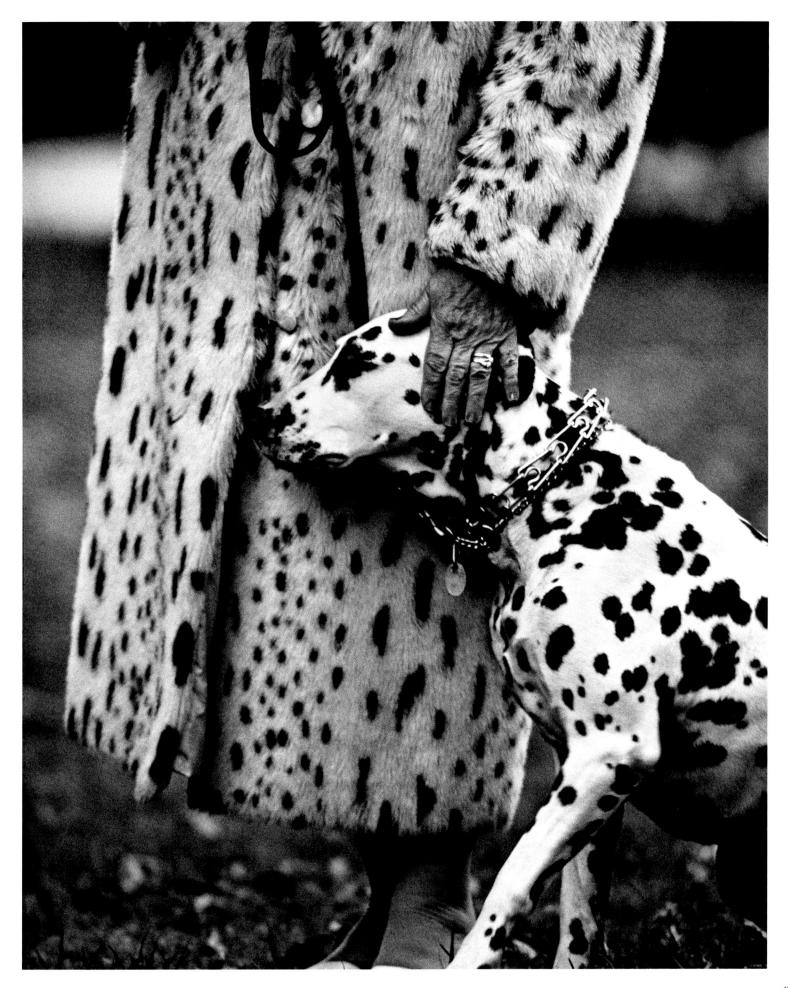

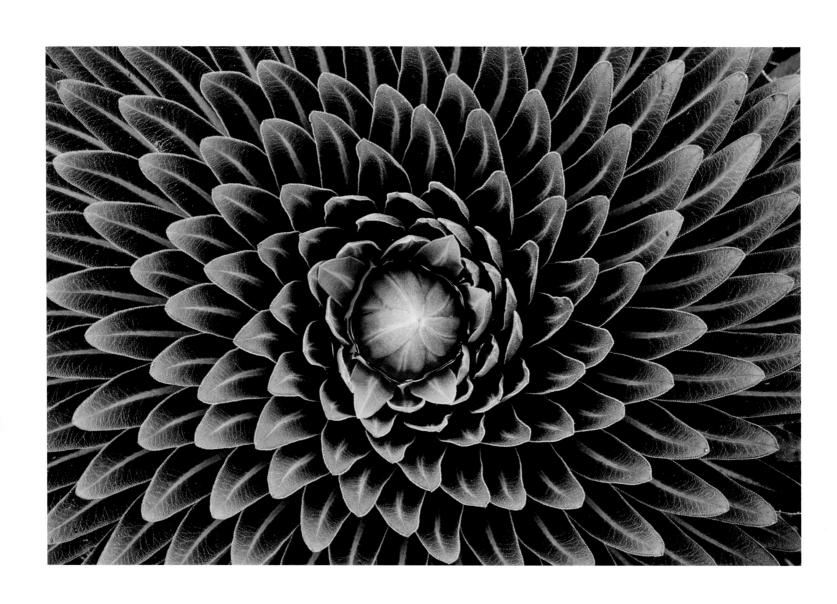

TANZANIA | GEORGE F. MOBLEY

The deep green whorls of the giant lobelia, Lobelia telekii, grace rocky alpine slopes with good drainage in East Africa. The plant, which can grow to ten feet tall (three meters), can take as long as 50 years to reproduce.

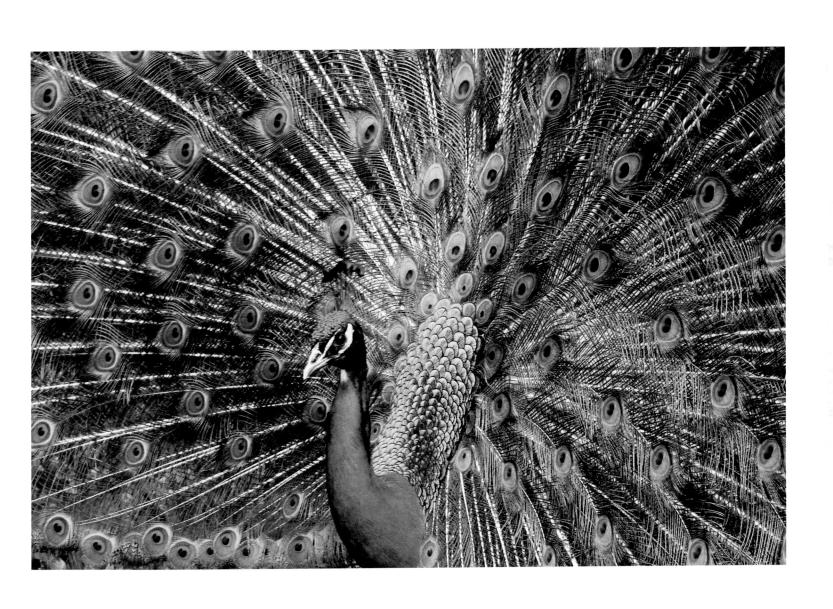

PENNSYLVANIA, UNITED STATES | LYNN LUCK

Showing off its iridescent eyespots, this Indian peafowl, Pavo cristatus, will molt and lose its elaborate plumage each year. It's the tail, though, that encouraged Charles Darwin to formulate his theory of sexual selection.

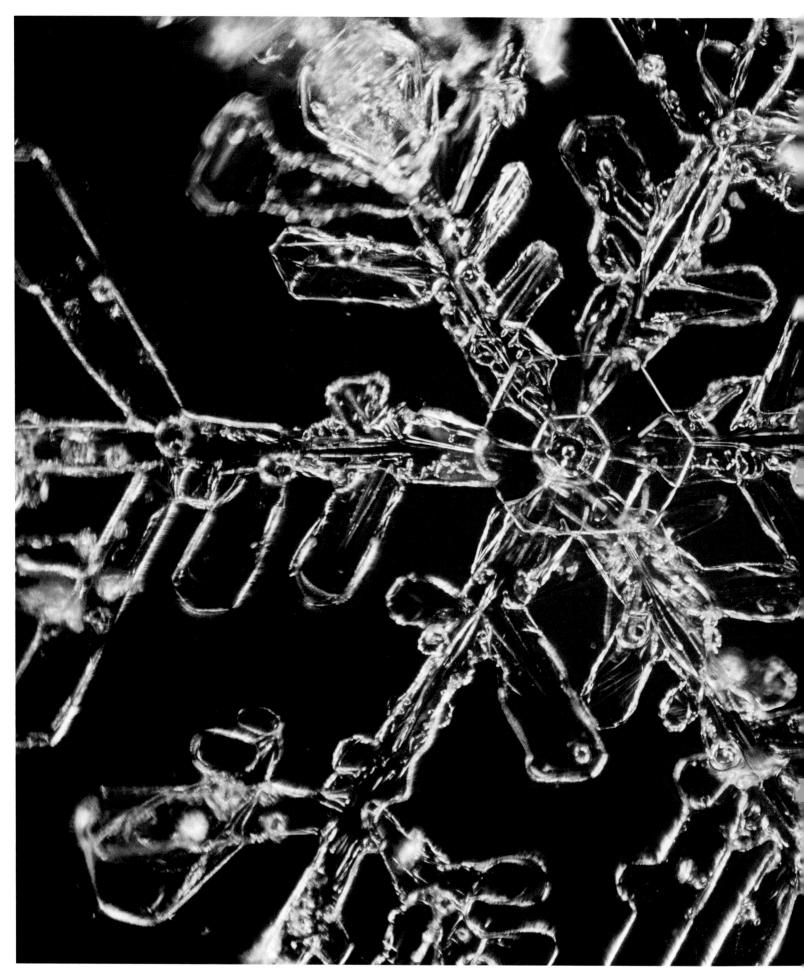

VIRGINIA, UNITED STATES | ROBERT SISSON

Polyvinyl resin preserves the unique shape of this snowflake. The levels of moisture and air temperature help determine a snowflake's pattern, and snowflakewatchers describe the shapes as columns, needles, plates, and dendrites.

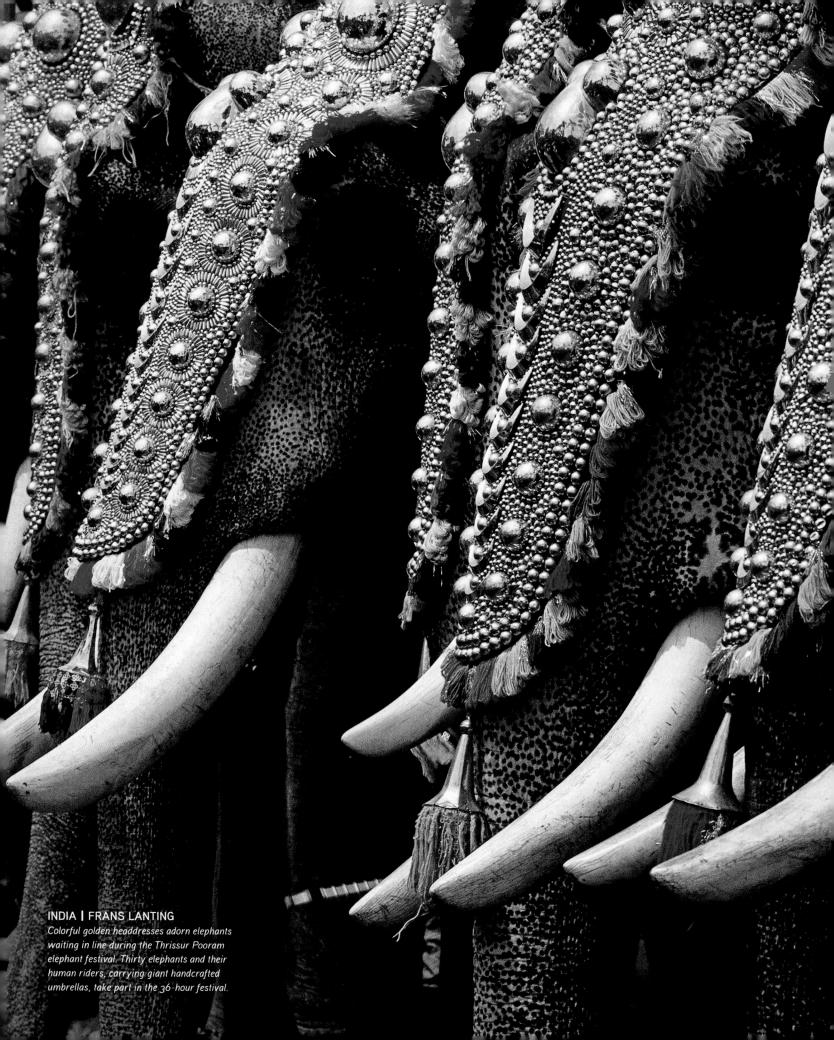

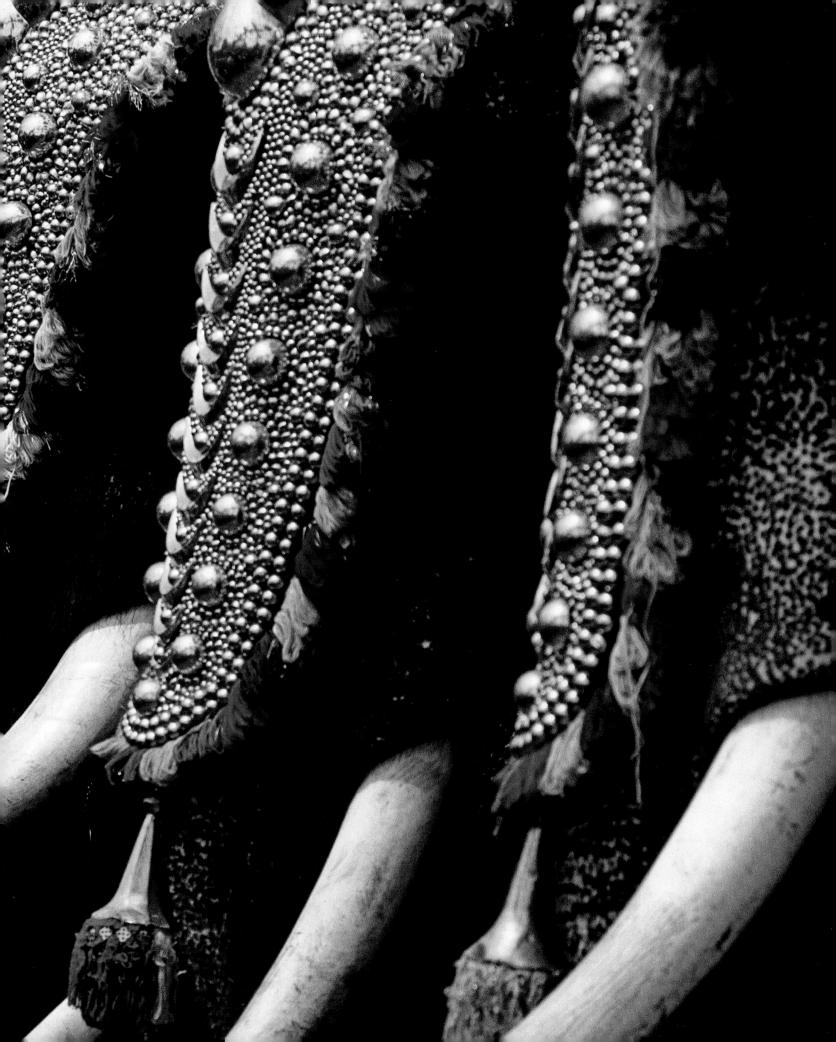

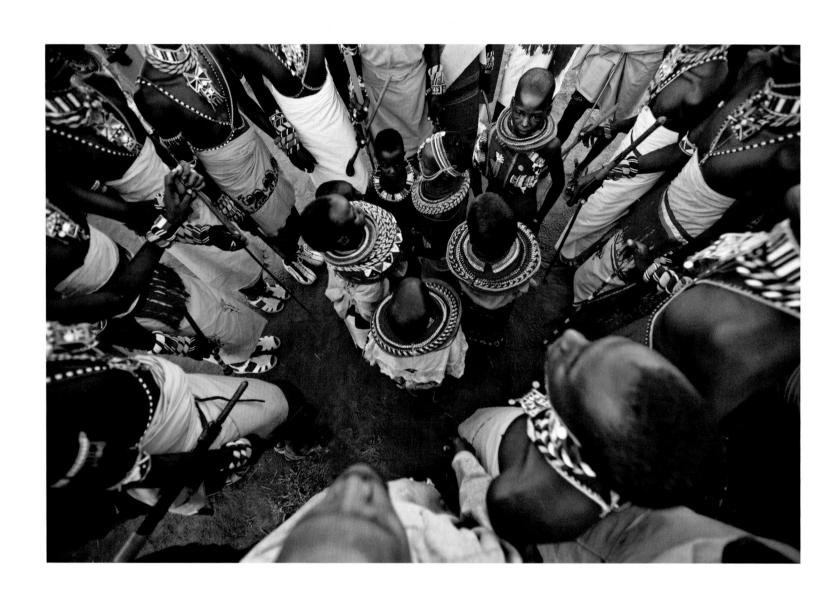

KENYA | MICHAEL NICHOLS

The Samburu people express their pastoral traditions during a three-day wedding ceremony. Samburu women make the elaborate beaded bracelets and necklaces worn by both men and women.

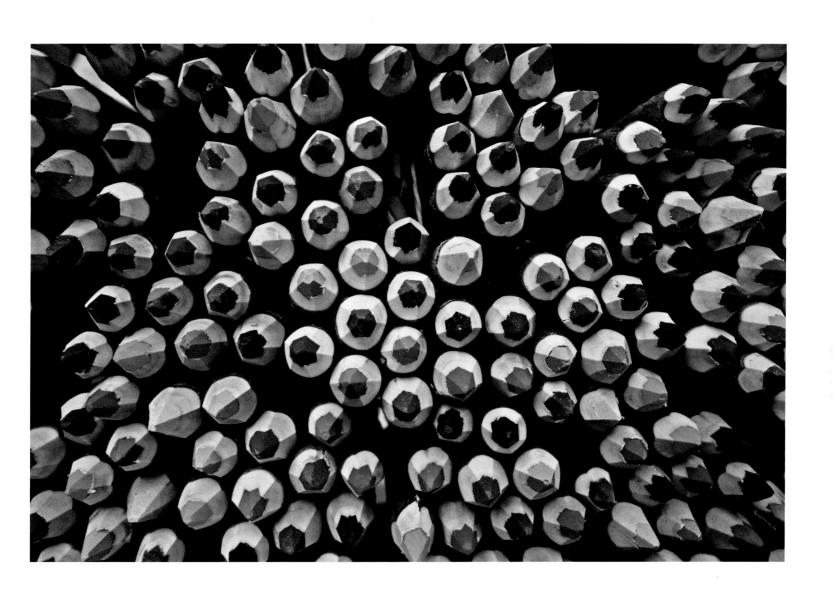

ARGENTINA | JASON EDWARDS

Shoppers can choose any color of pencil in this street market in Buenos Aires. The city thrives on its streets, where you can buy just about anything, watch an impromptu tango, or breathe in the local art.

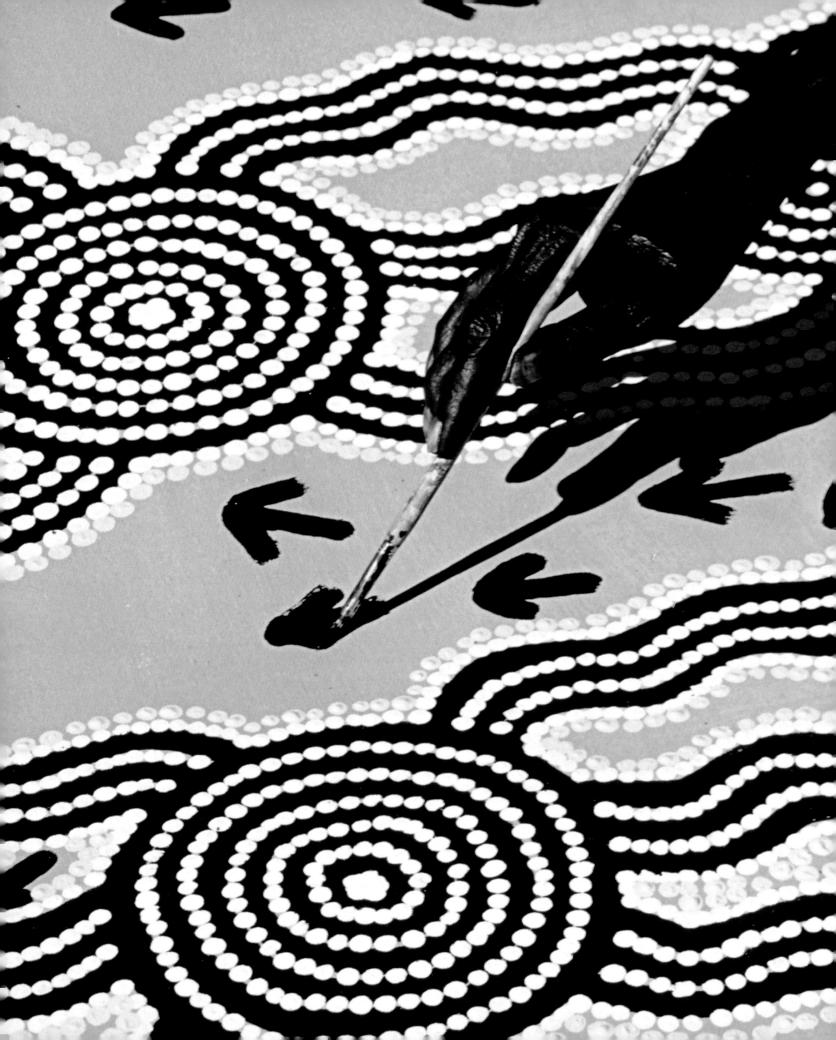

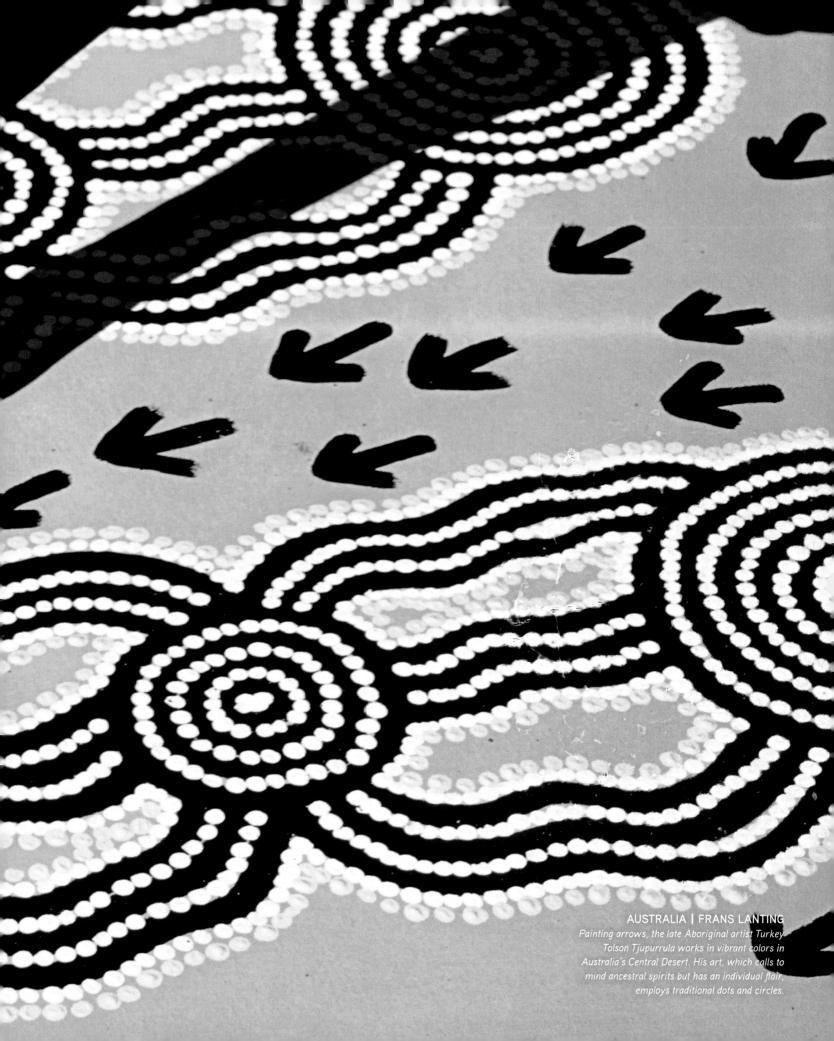

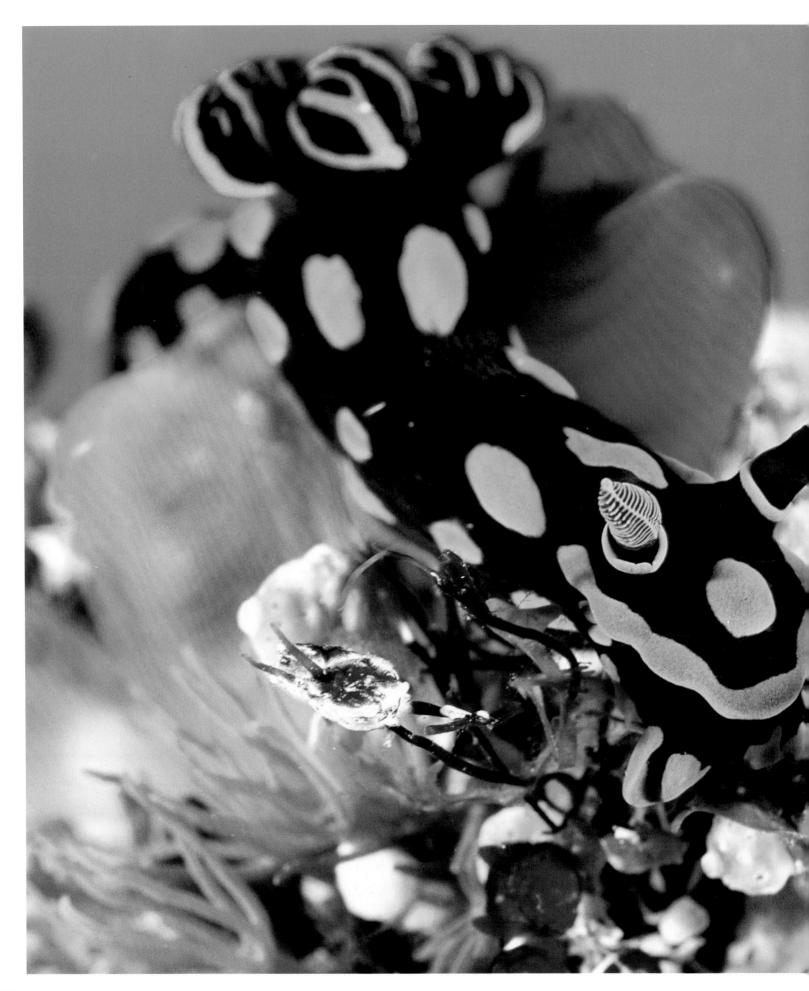

WESTERN PACIFIC OCEAN | DAVID DOUBILET

With its bright colors warning predators to stay away, this green-spot nudibranch, Nembrotha kubaryana, glides over strawberry ascidians. Nudibranchs can secrete the poisons of their prey as a defense.

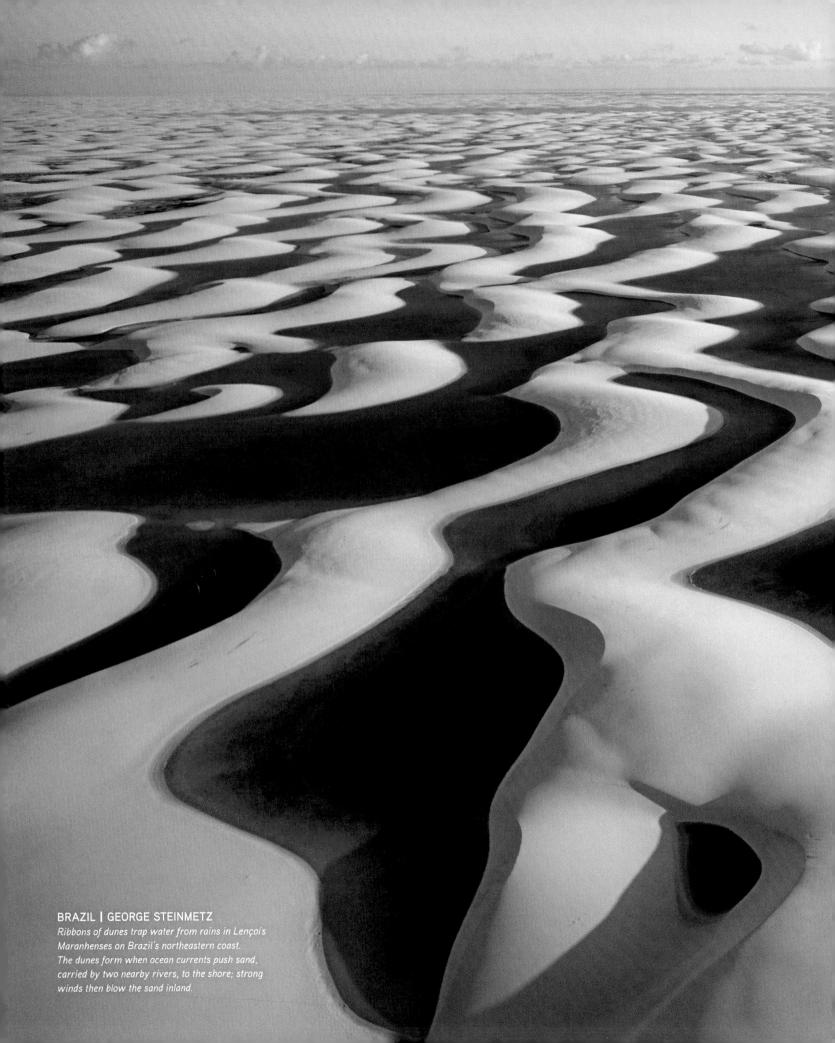

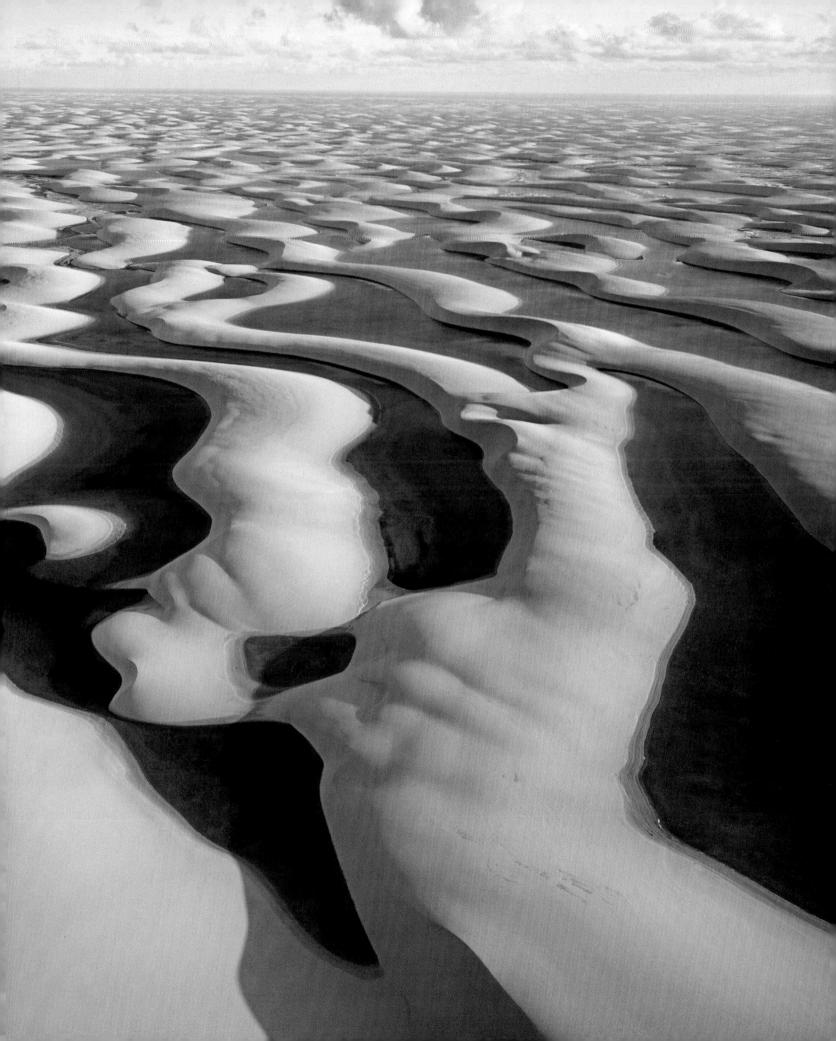

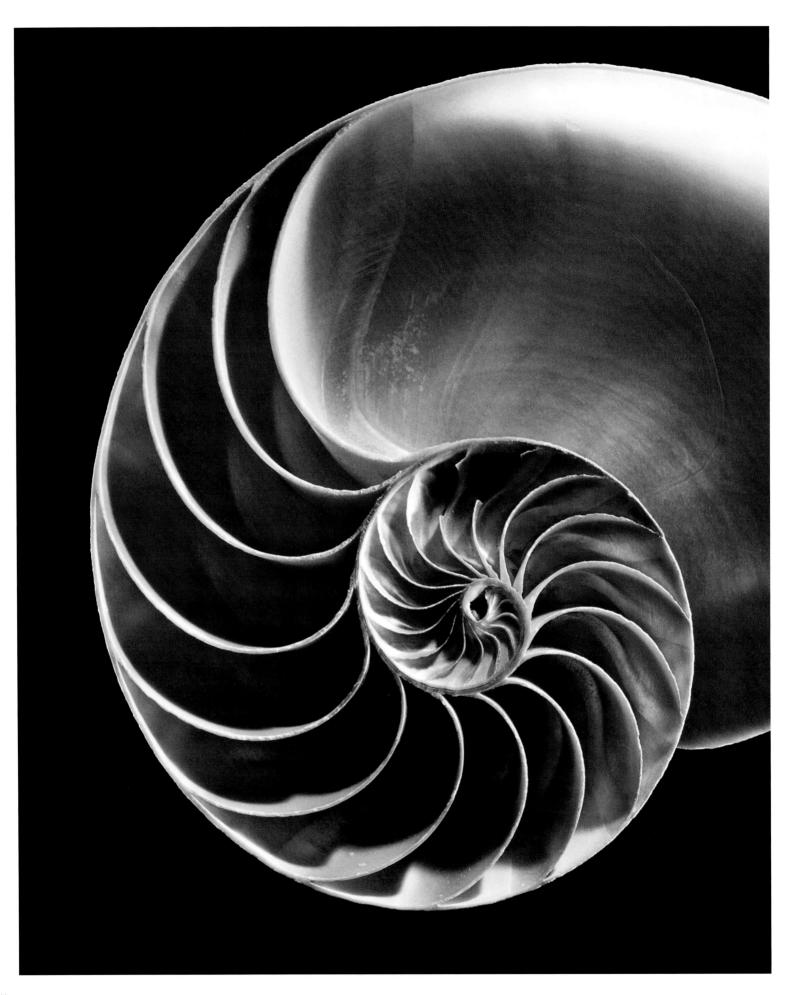

CEPHALOPODA,

the class of marine creatures including nautiluses, squid, octopuses, and cuttlefish, share several traits. They usually have three hearts and blue blood and are able to expel an inky substance to cloud the water when threatened.

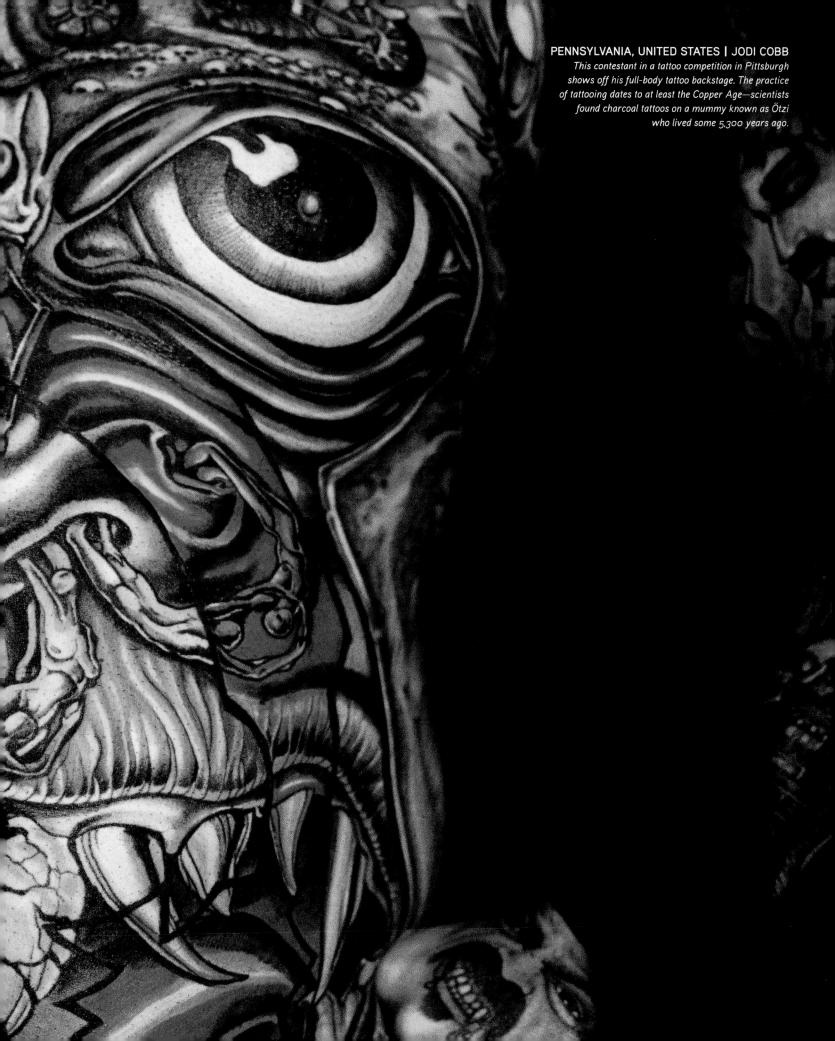

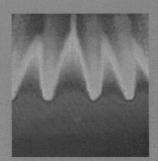

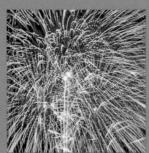

PORTFOLIO FIVE

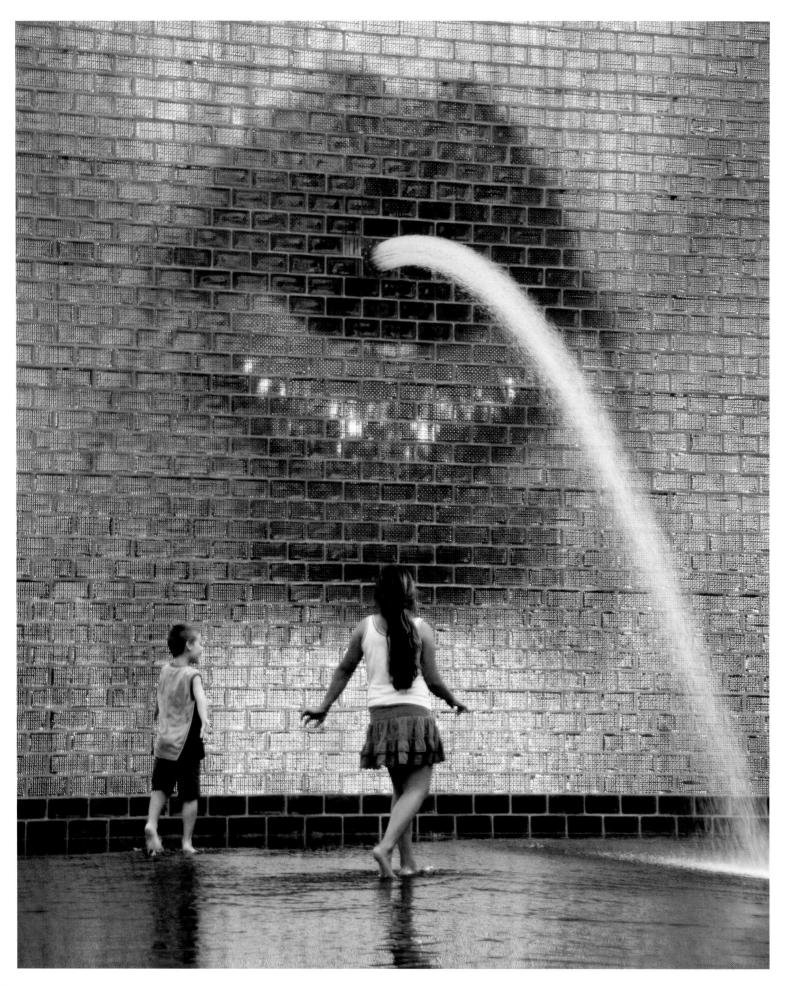

explain to us that all this stuff, everything we see around us,

started off with one big bang. From a tight and secret center of void and silence broke forth light, life, and energy—all the particles and particulars of our universe. No one saw that first big bang, but we can all imagine. We have seen it before, we see it every day, in the nature that surrounds us, in our visions of Earth.

The perfect pouf of a dandelion going to seed: a firm center surrounded by a sphere of feather-winged seeds, delicately congregating, a wispy aura where just yesterday there was a thick yellow bloom. Touched by the slightest wind, the emanation disperses and sends tiny slivers of dandelion being out into the world to propagate their kind.

The burst of life that took centuries to build, revealed in an old tree trunk's cross section. At its center, material memories of the sapling that this tree once was. Year after year it grew by accretion, adding successive layers of the interplay of xylem and phloem, water in and water out, sap traveling up and down, transporting complexities under the corky protection of callous bark. If we could read the code of this great being, we would hear tales of drought summers or deep winter snows melting into spring overflow. The history of a life much longer than any human's tells its tale in concentric rings.

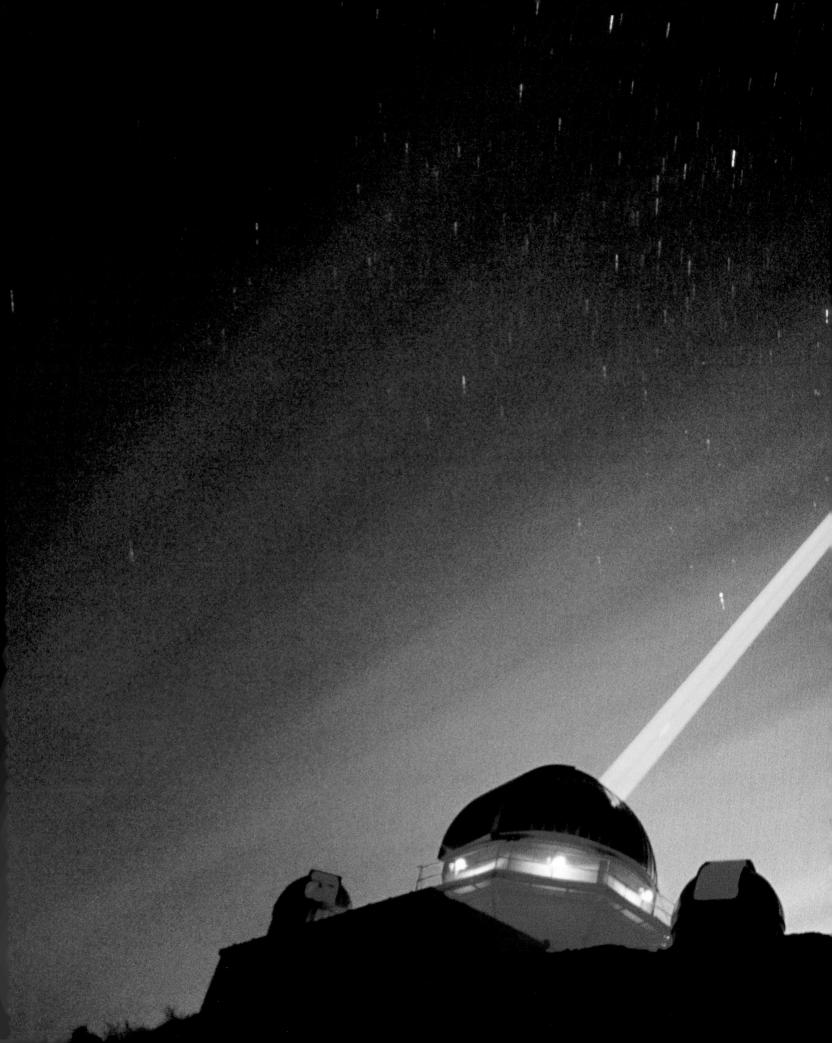

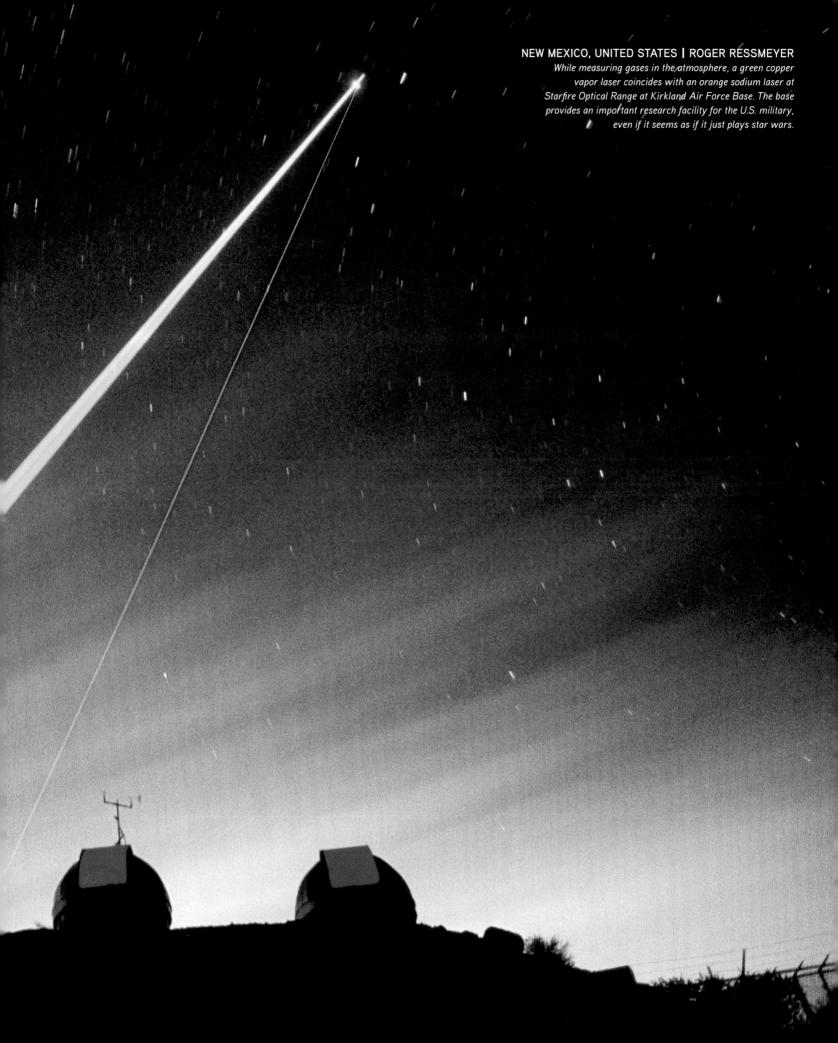

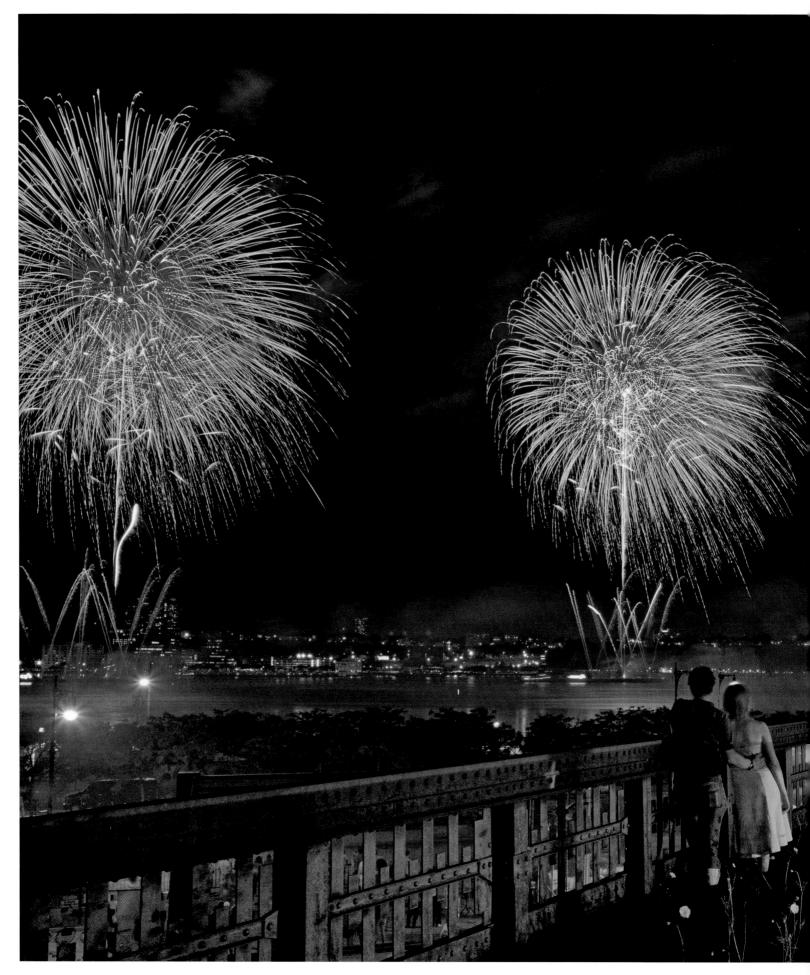

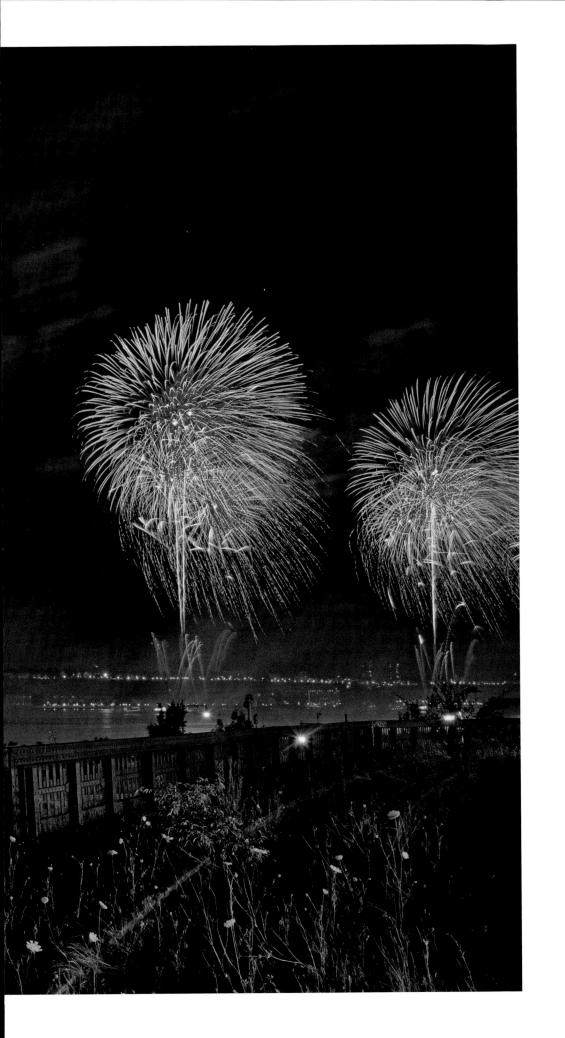

NEW YORK, UNITED STATES I DIANE COOK AND LEN JENSHEL

A couple watches Fourth of July fireworks bloom over the Hudson River in the Chelsea section of New York City. The different bursts of color require careful control of the chemistry and temperature.

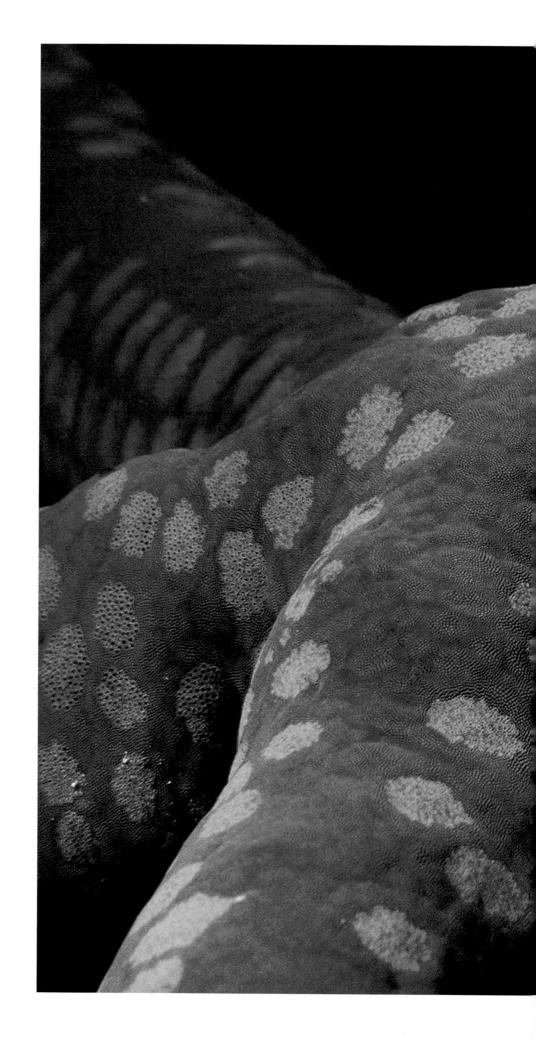

SOLOMON ISLANDS | BIRGITTE WILMS

Like a pale brooch atop royal velvet, a brittle star—barely as big as a nickel—crawls across the arm of an 18-inch-wide (46-centimeter) blue sea star. The smaller creature took just seconds to traverse the larger.

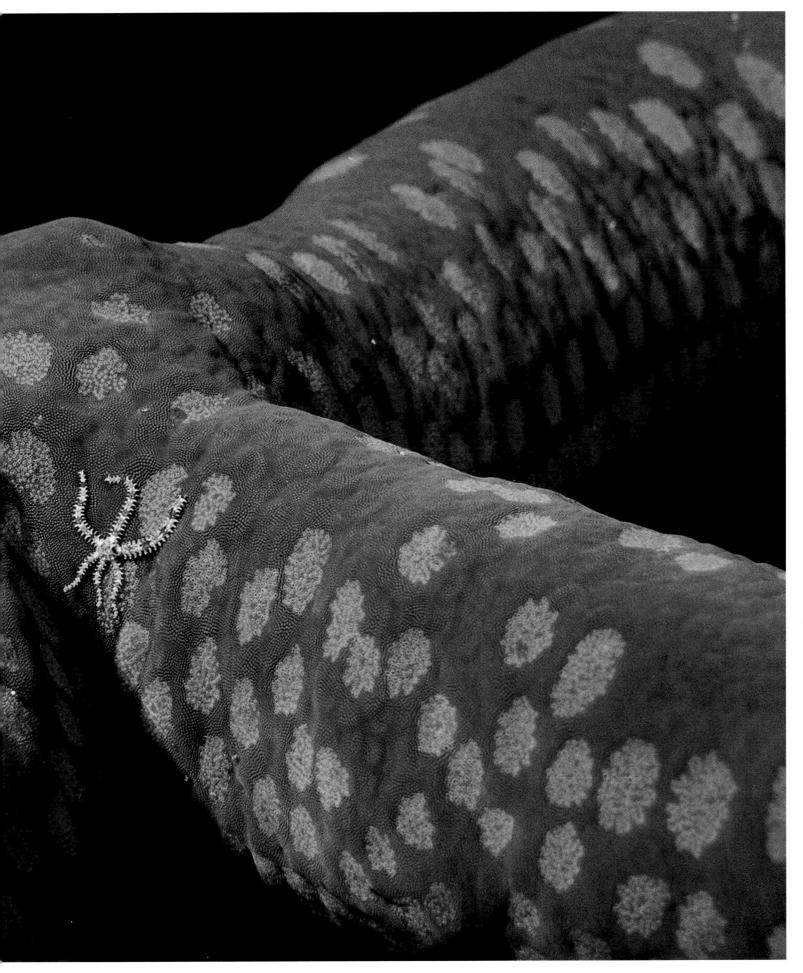

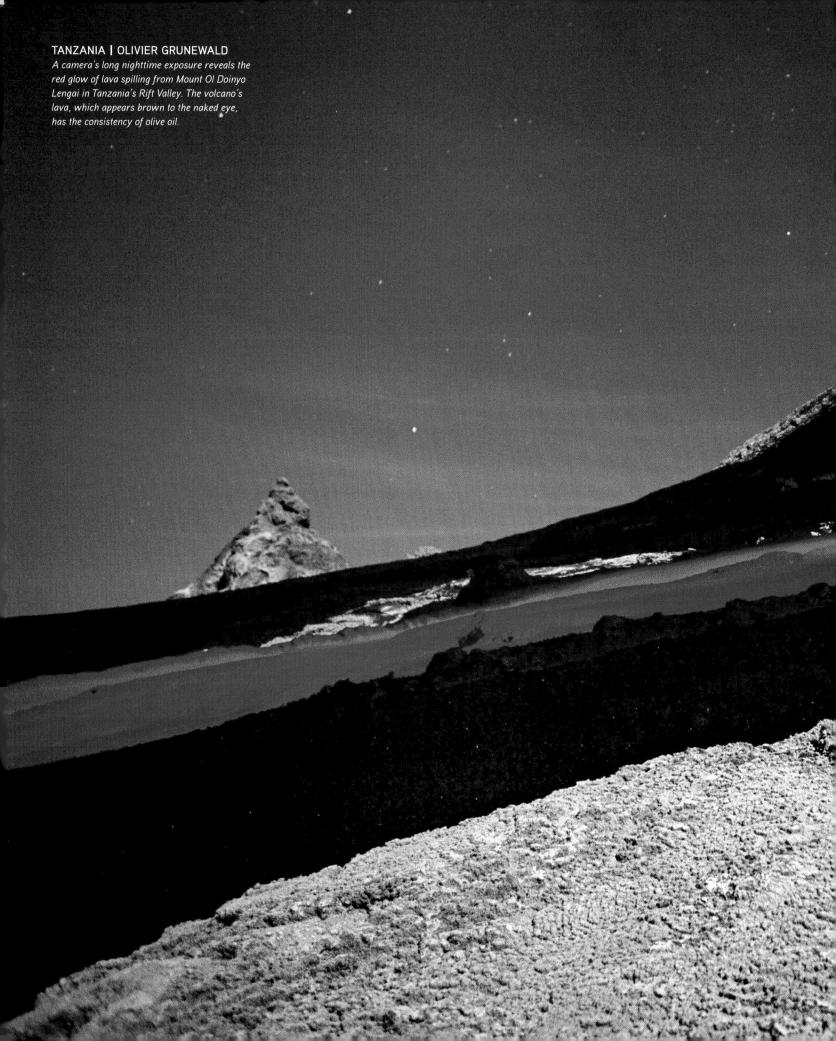

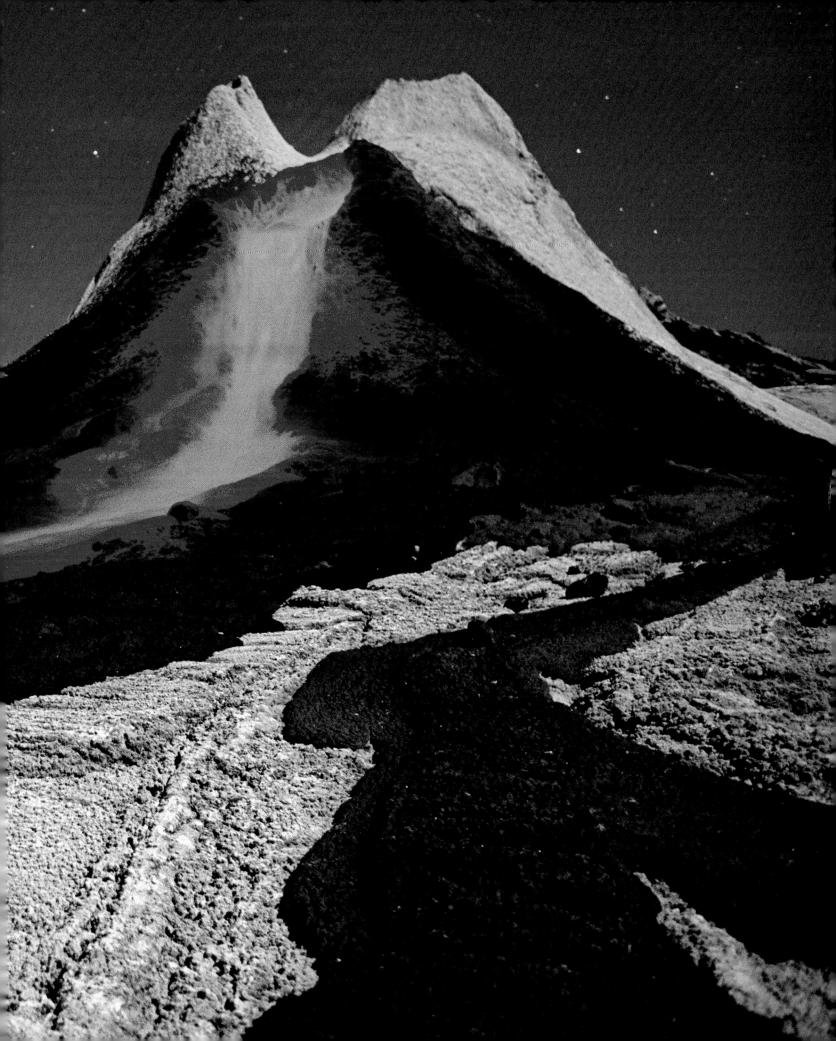

ELECTRIC EELS

can produce strong electric shocks of around 500 volts.

They use this ability both for hunting and self-defense.

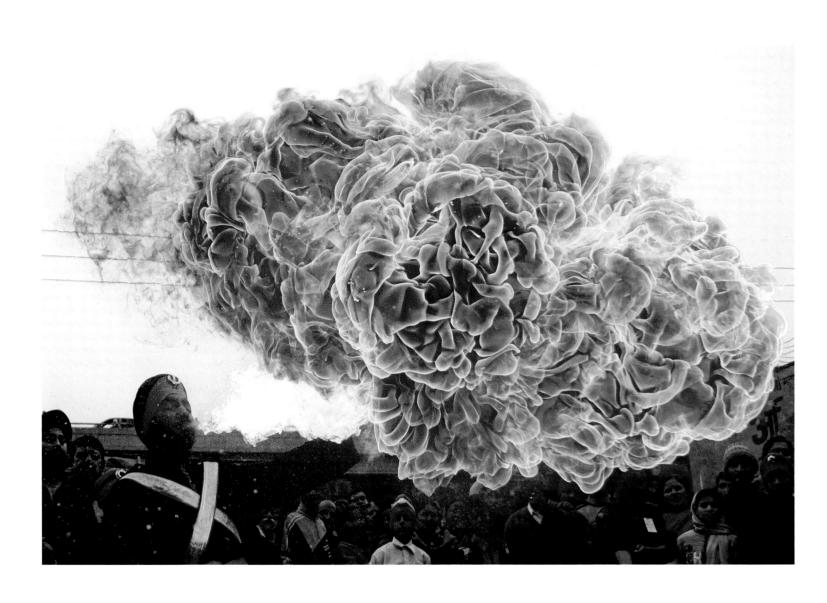

INDIA | JAIPAL SINGH

In Jammu, a flower of flame blooms from a man's kerosene-filled mouth. Devotees of Sikhism, the world's fifth largest organized religion, were marking the 342nd birthday of Guru Gobind Singh, a founder of the faith.

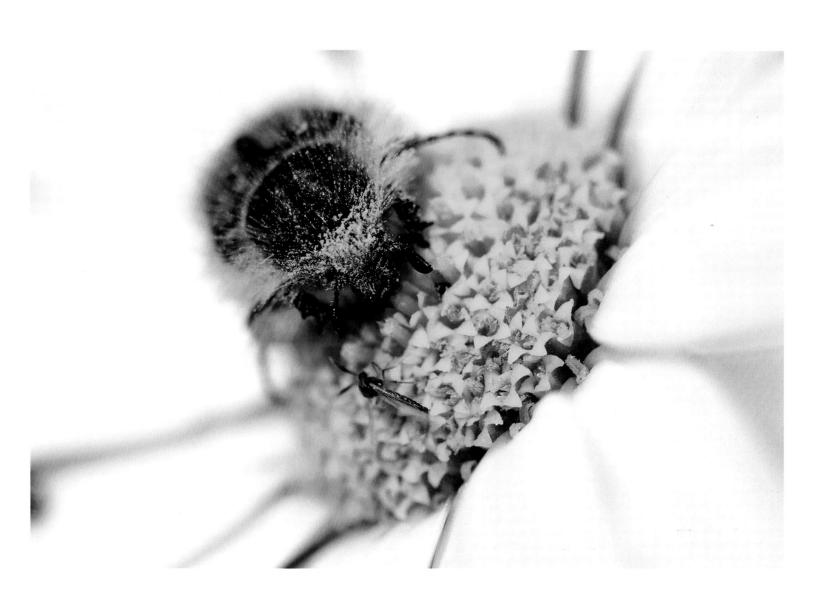

CANARY ISLANDS | MANUEL M. ALMEIDA

Bright yellow pollen adds a golden, beelike tinge to this weevil's body. These small beetles might be considered pests in the home, but they are intrinsically important for plant fertilization.

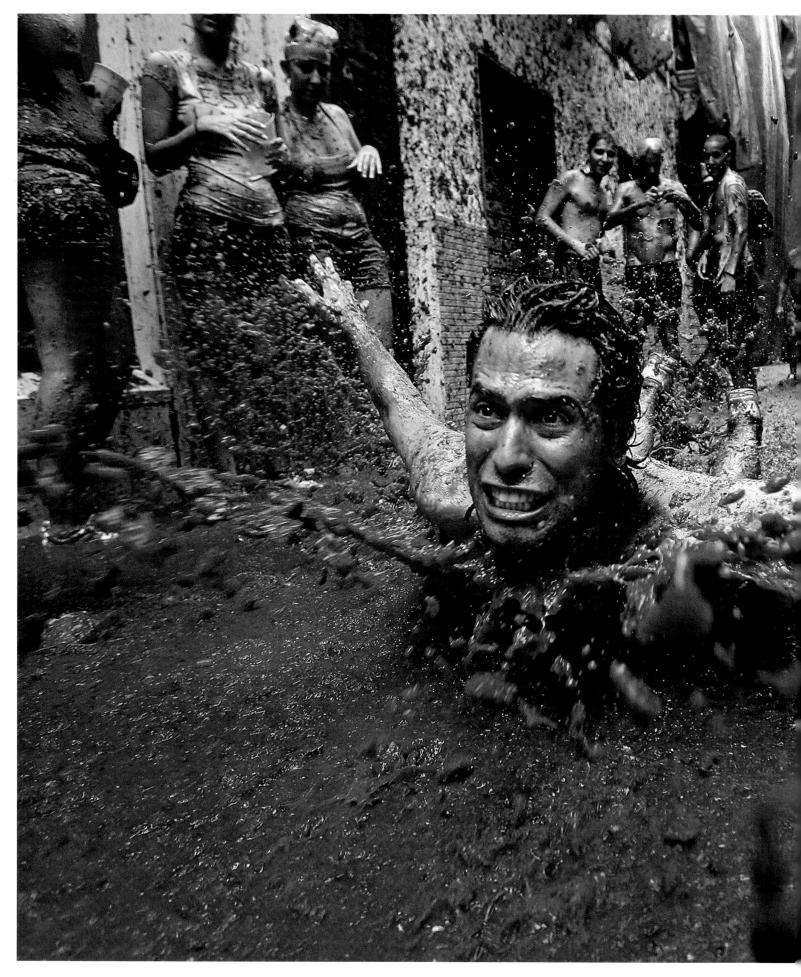

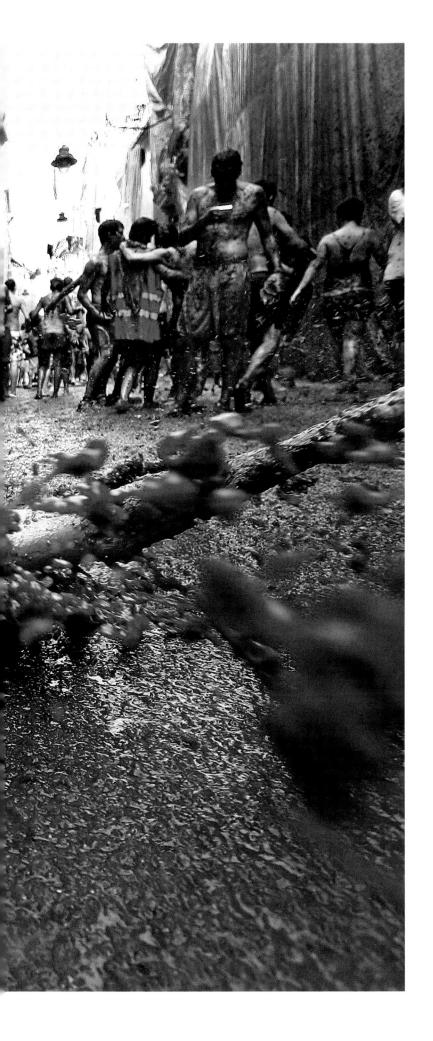

SPAIN | BIEL ALINO

Sliding headlong through a tomato-juice torrent, a young man celebrates La Tomatina in Buñol on August 26, 2009. The event is a one-hour food fight that can use up to 275,000 pounds (125,000 kilograms) of tomatoes.

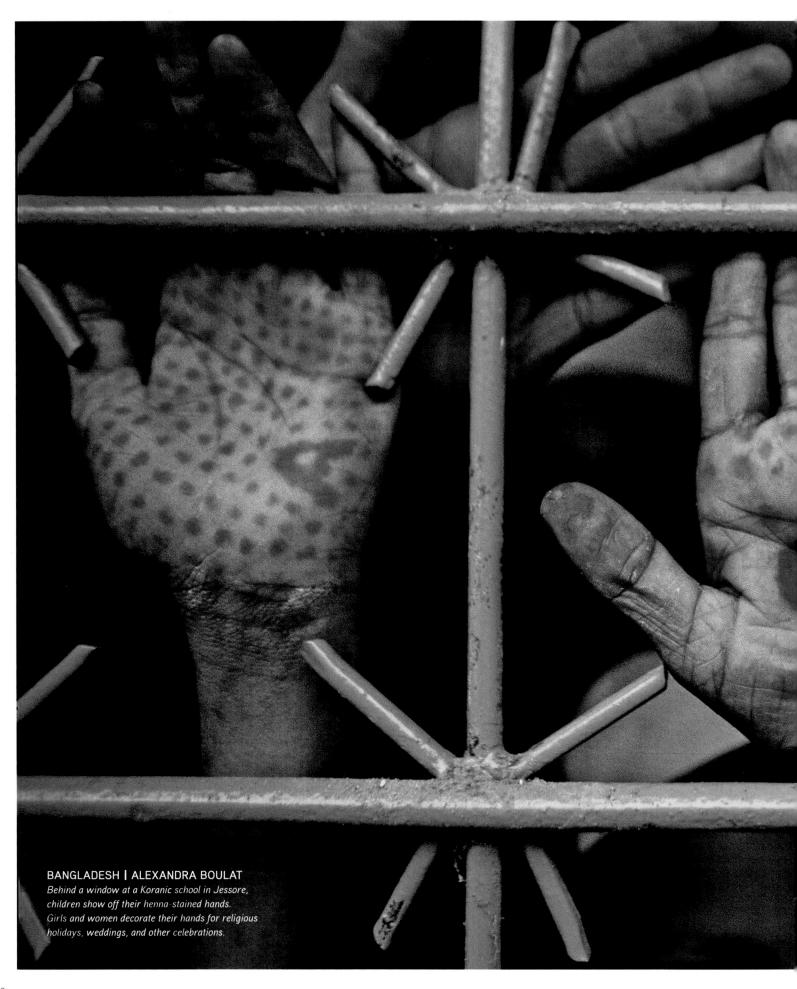

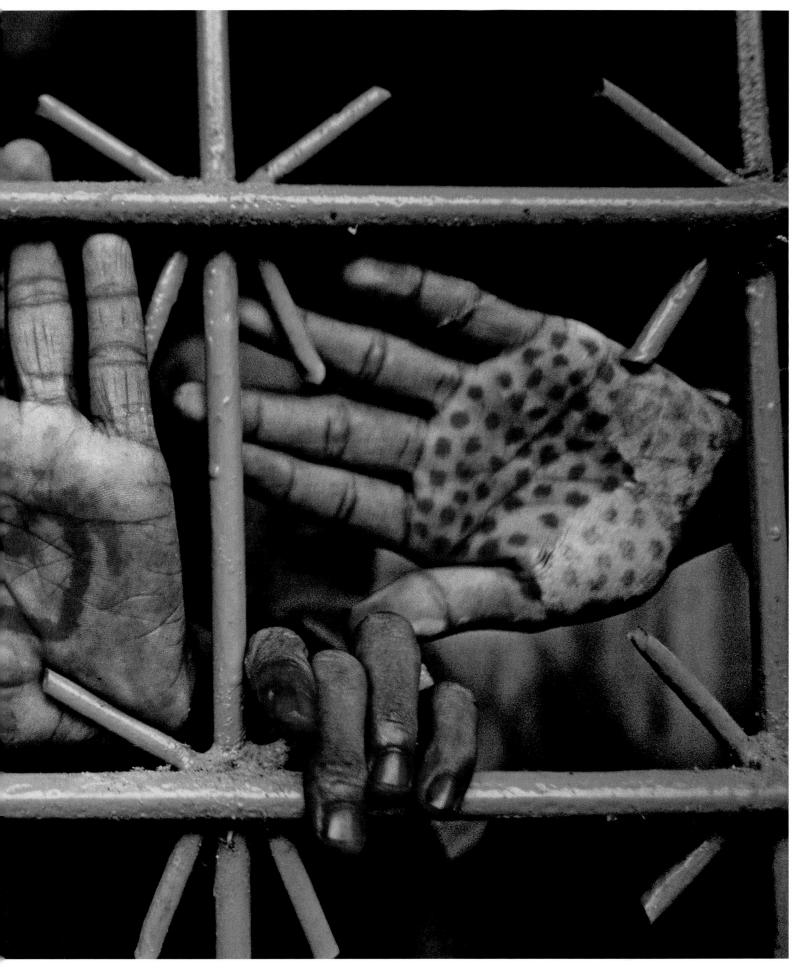

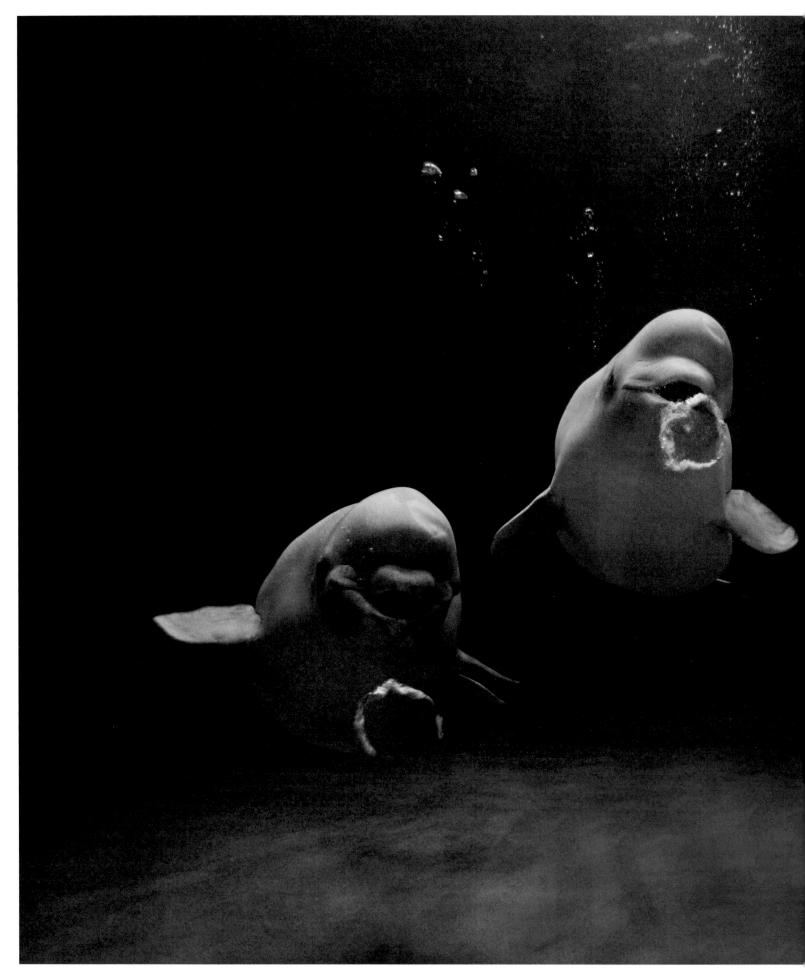

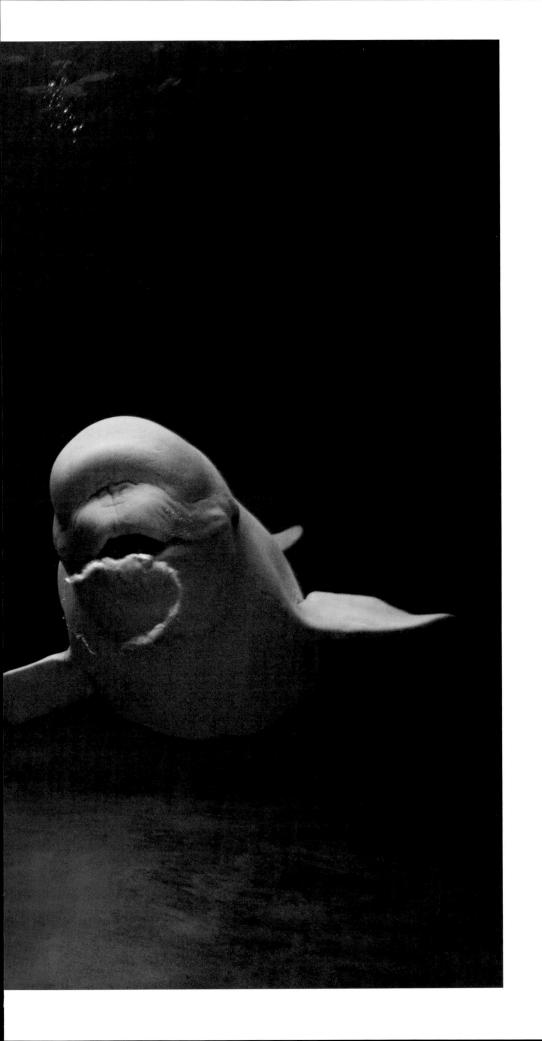

JAPAN | HIROYA MINAKUCHI

Bubble-blowing beluga whales in Iwami Seaside Park's Shimane Aquarium appear to be choreographed. Beluga (which means "the white one" in Russian) whales not only play but also make and mimic a wide variety of sounds.

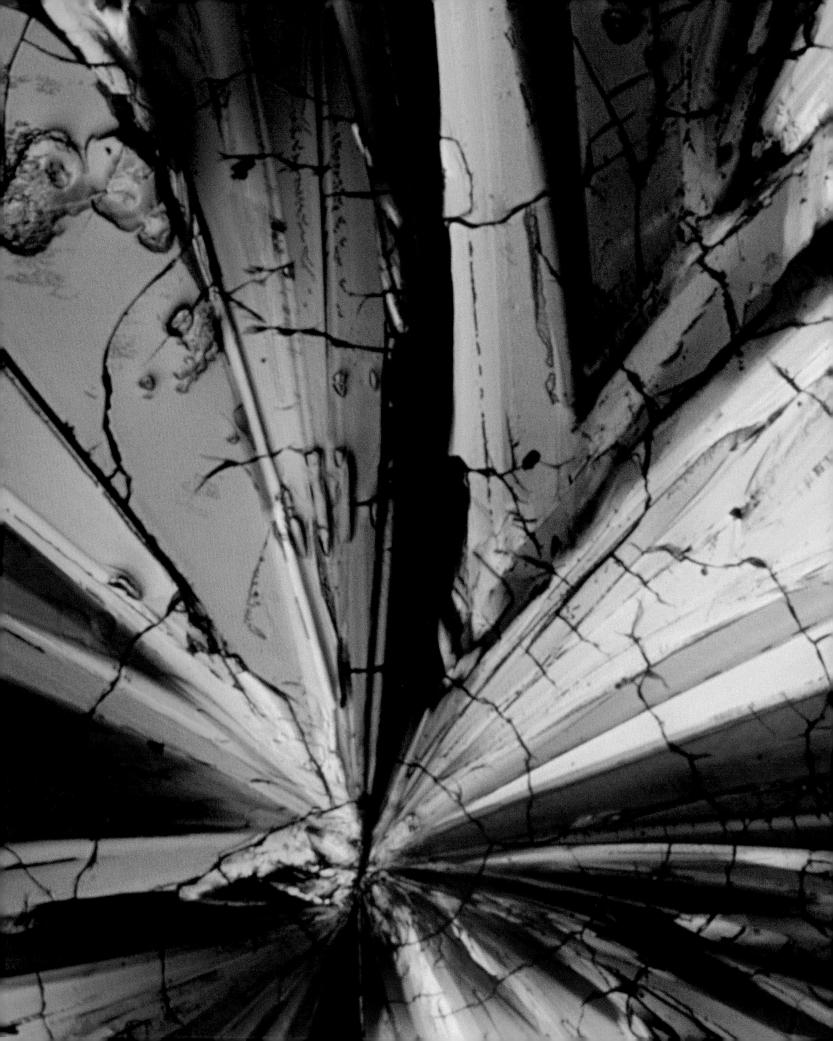

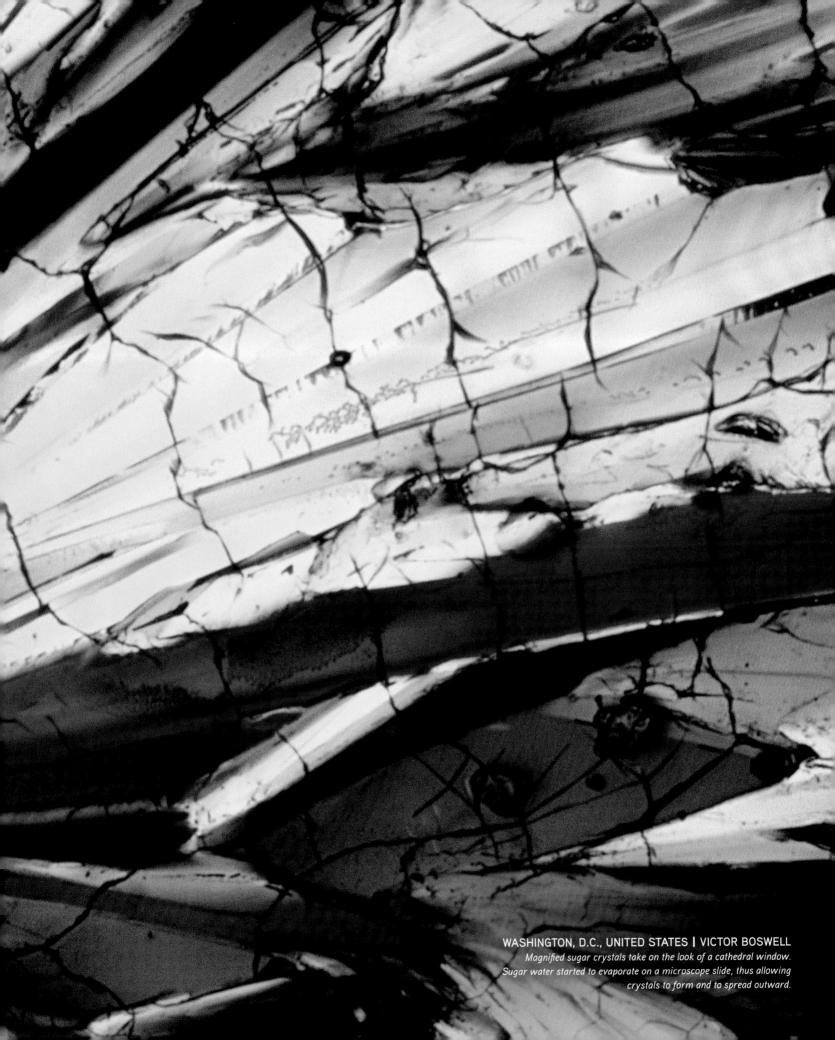

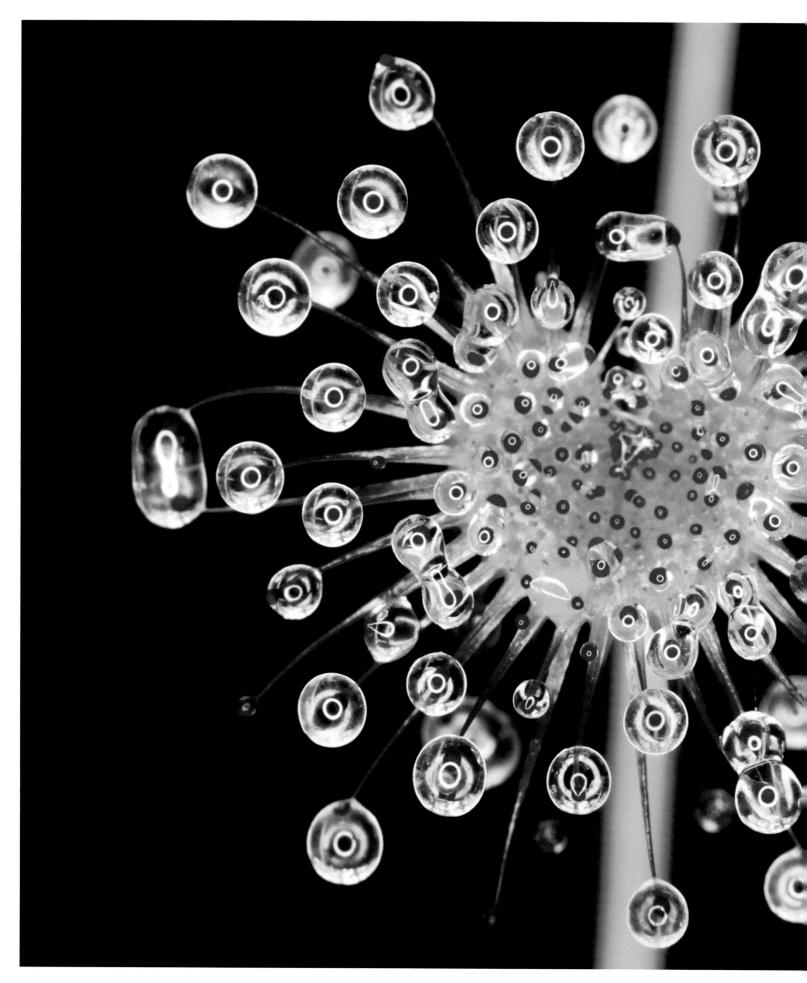

GERMANY | HELENE SCHMITZ

What look like dewdrops on an Australian sundew (Drosera stolonifera) act as lures for thirsty insects. Drawn to the carnivorous plant, they find themselves entangled in its sticky tentacles.

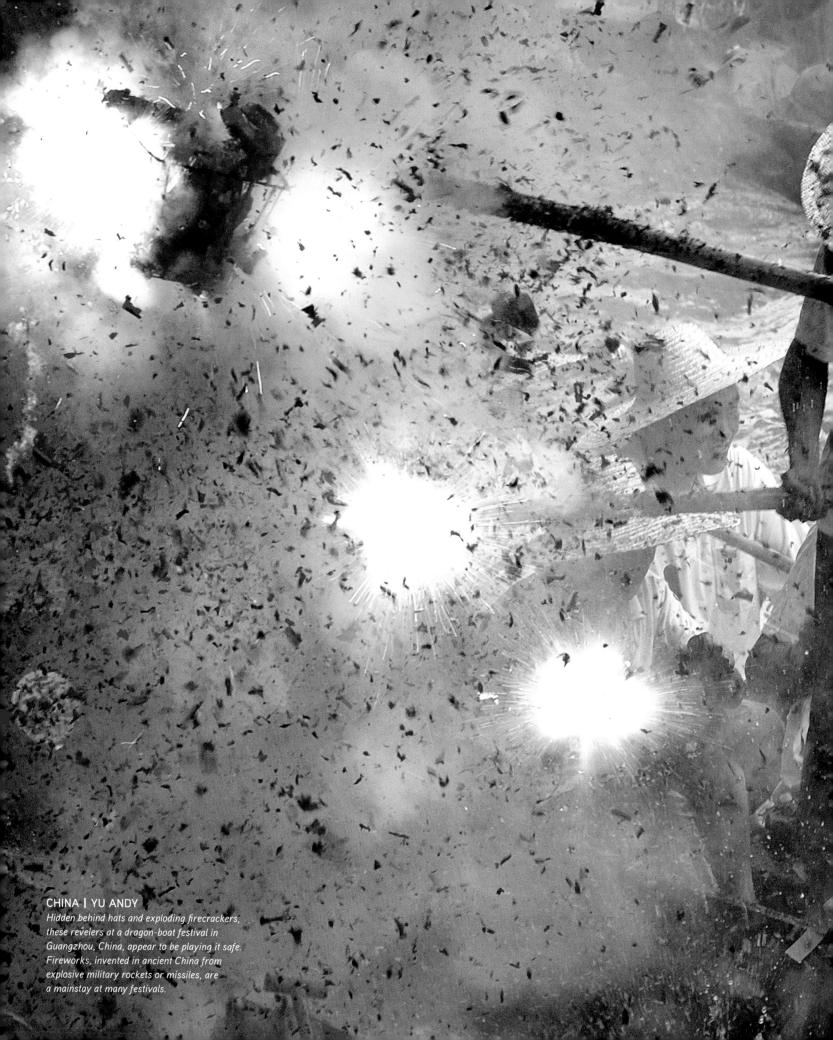

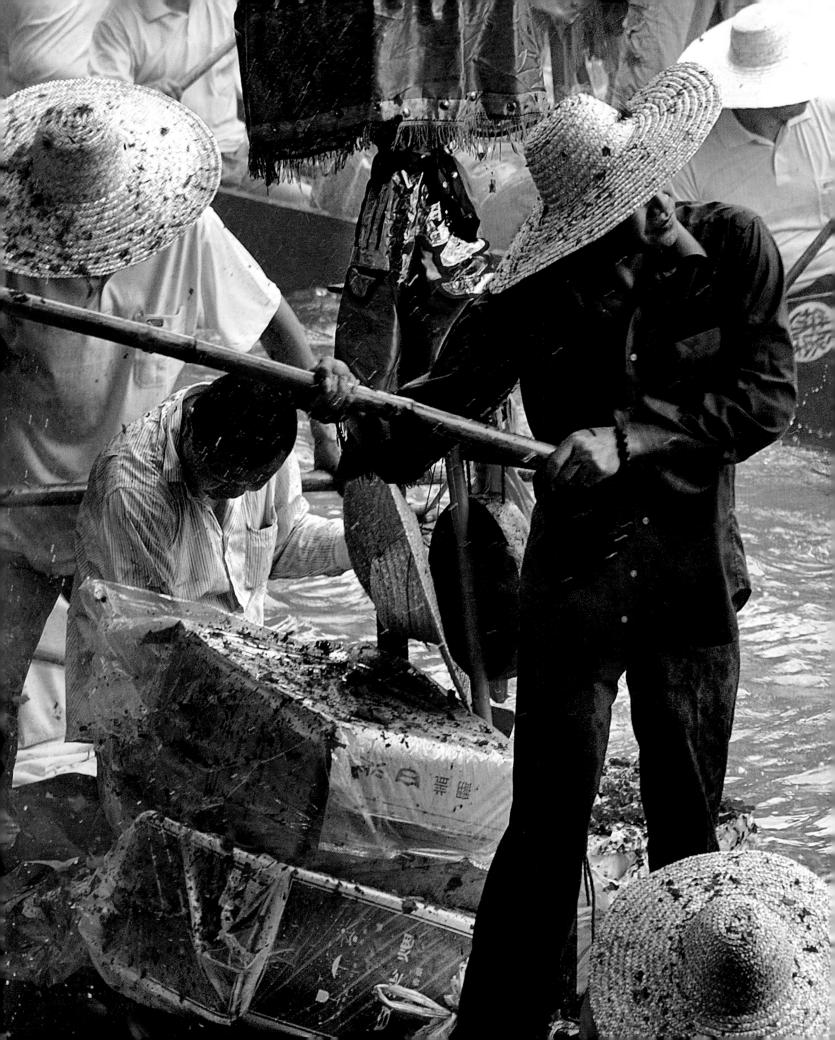

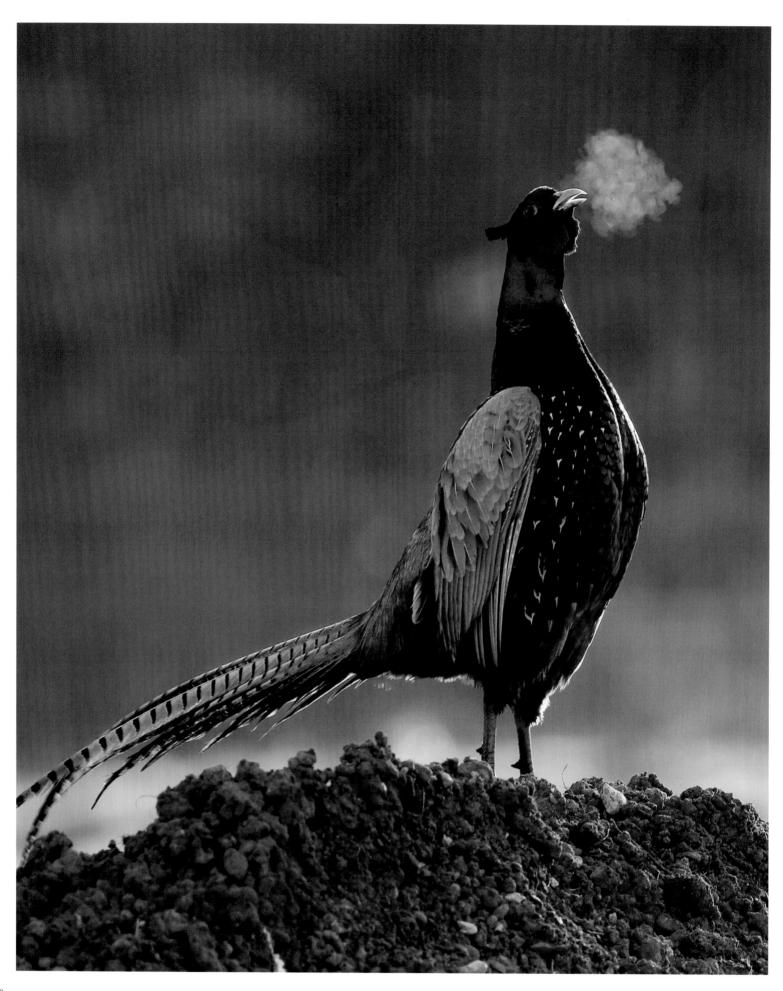

The average person takes about 25,000 breaths every day. That's about 2,000 gallons (8,000 L) of air.

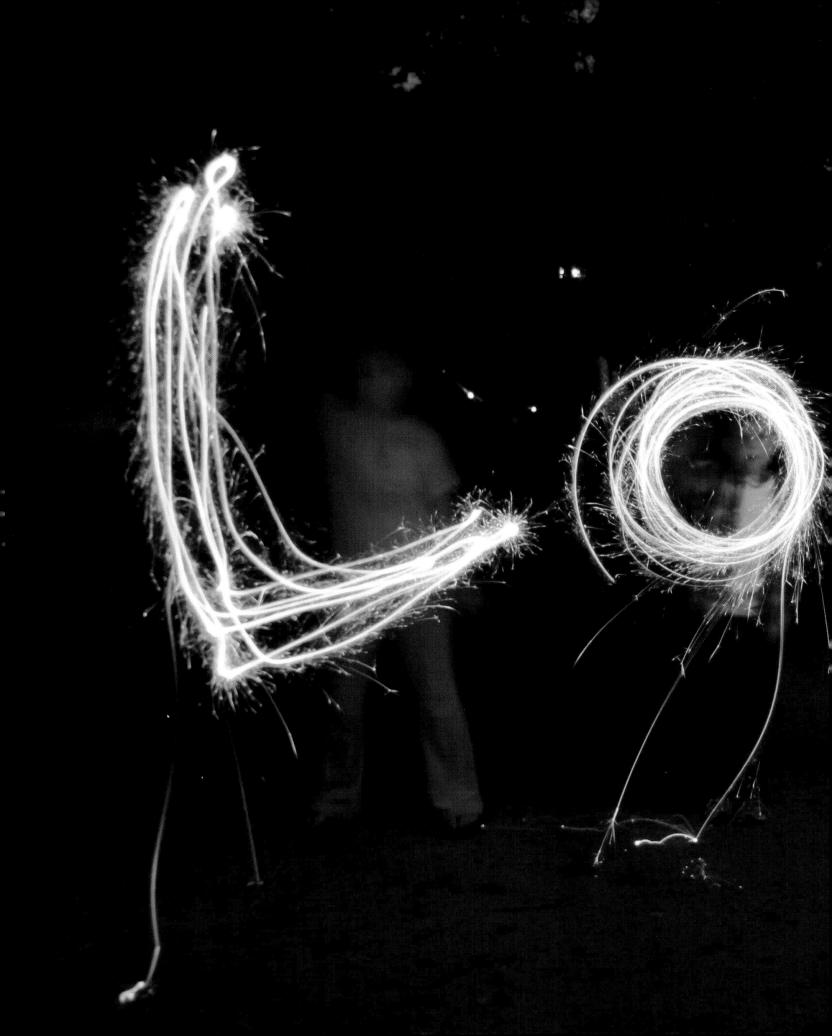

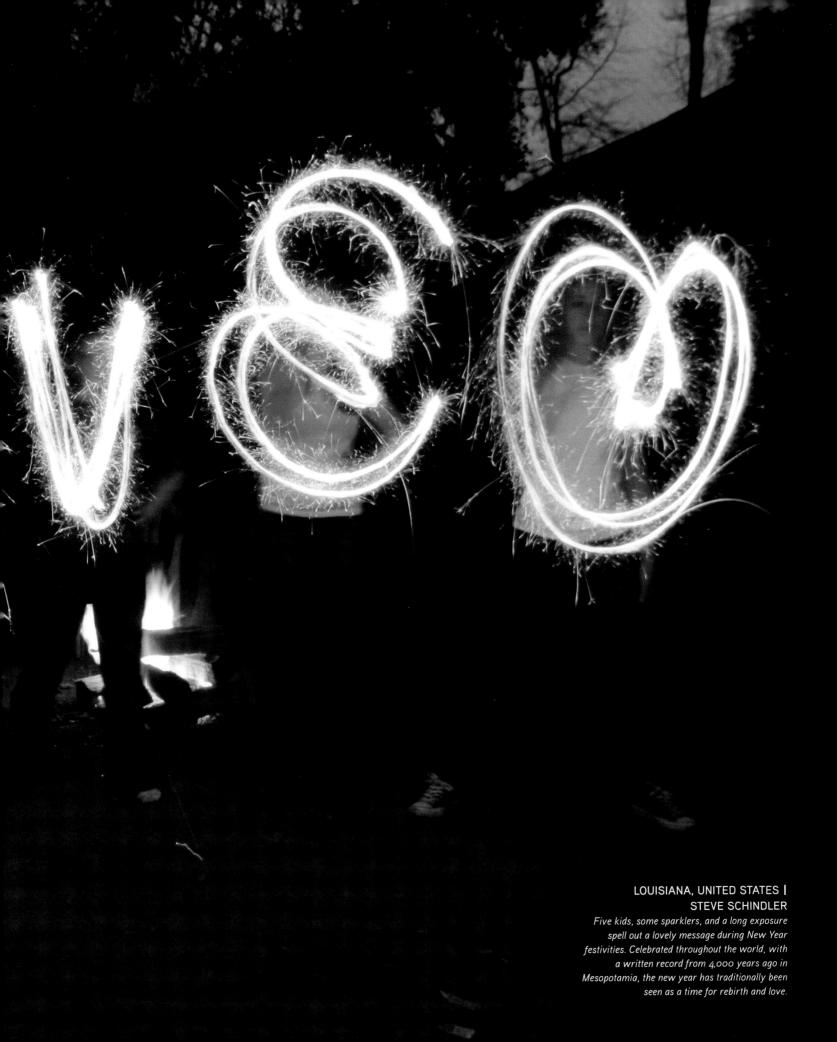

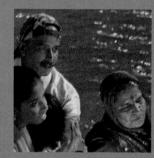

PORTFOLIO SIX

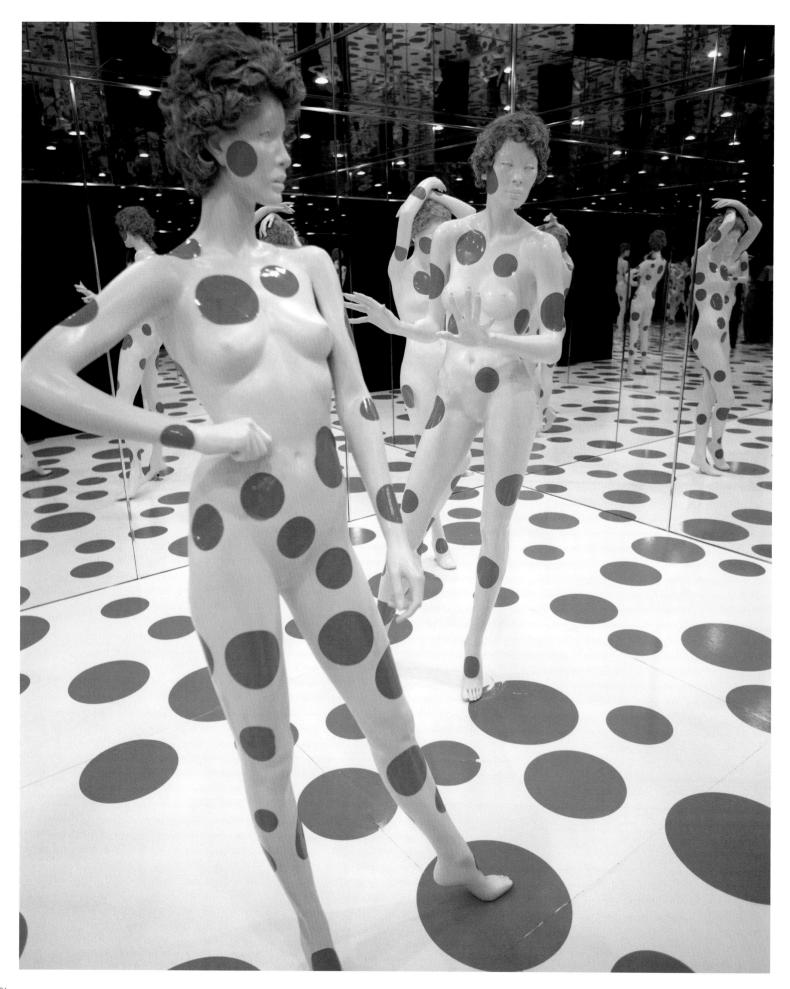

safety in numbers, a sense of plenitude approaching delight. To

know that there are many confirms our sense of permanence and the persistence of life.

Some things naturally come in aggregations. A viscous mass of frog eggs, nearly liquid in itself and yet solid enough to resist dissolving, hundreds of tiny orbs, each holding a living and growing amphibian life. The spring hatch of a praying mantis egg case, wintering over as a bit of dried-out foam but becoming the birthplace of as many as hundreds of miniature mantids, perfectly engineered, emerge and enter the weedy world. Snowy egrets by the dozens, gathering in the mangroves as the sun goes down, clucking quietly as they jostle each other to find just the right perch for a nighttime roost.

We humans so enjoy natural aggregations that we have amassed an entire vocabulary of words to name them: swarm, pack, smack, pride, brace, flock, warren, bevy, brood, exaltation. Each multitude of creatures seems to assume a different personality; each aggregation becomes a new kind of one. And indeed that is the fascination of these natural gatherings. Blackbirds swirl through autumn skies, and it seems so likely that centrifugal force will fling them out in all directions. But no: They fly as one. Minnows pulse through ocean shallows, but do they dart hither and yon? No: They swim as one.

The one made of many, a symbol of synchronicity and wordless coordination.

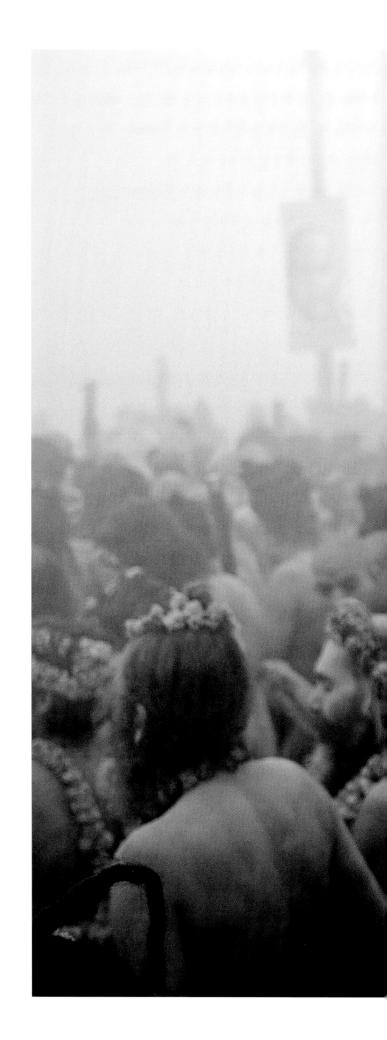

INDIA | GREG VORE

A Hindu boy bedecked in flowers looks out from a sea of people during the Kumbh Mela festival in Allahabad, India. Millions of Hindus travel to the confluence of the Yamuna and Ganges Rivers to take part in the most auspicious of sacred baths.

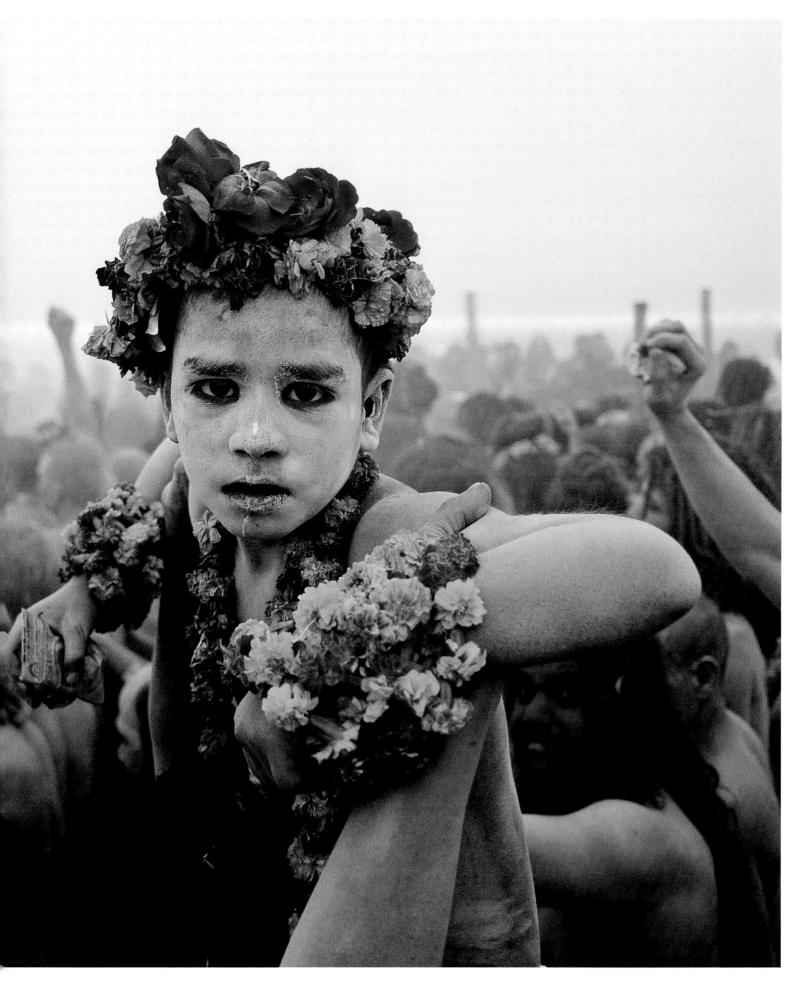

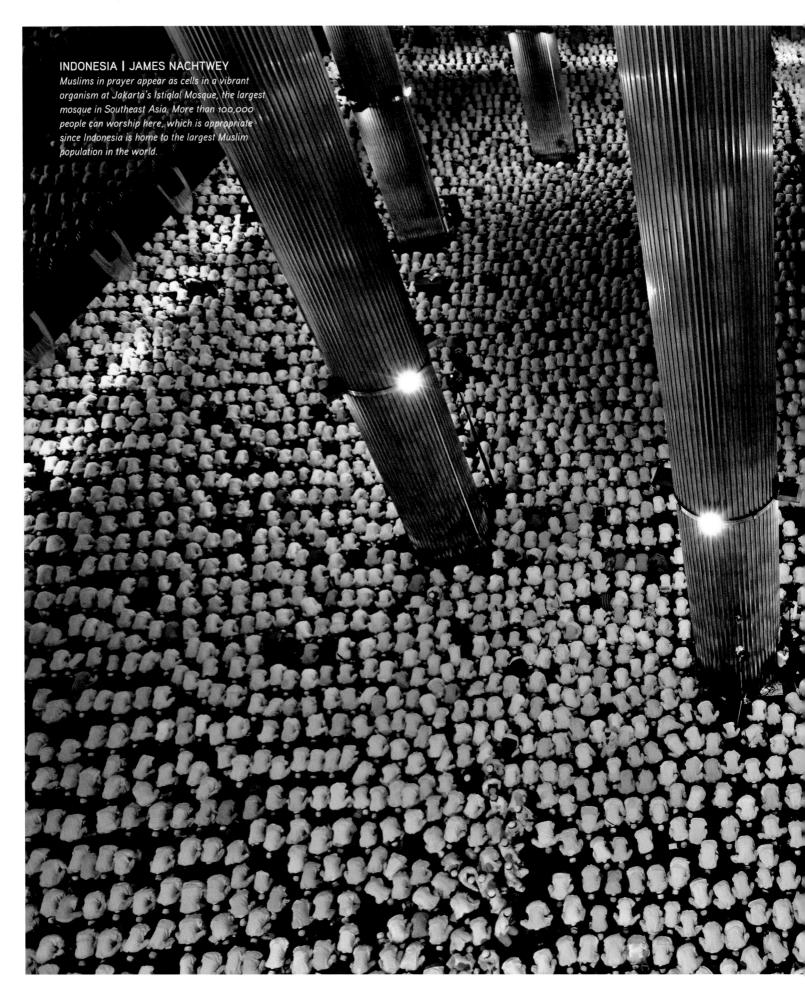

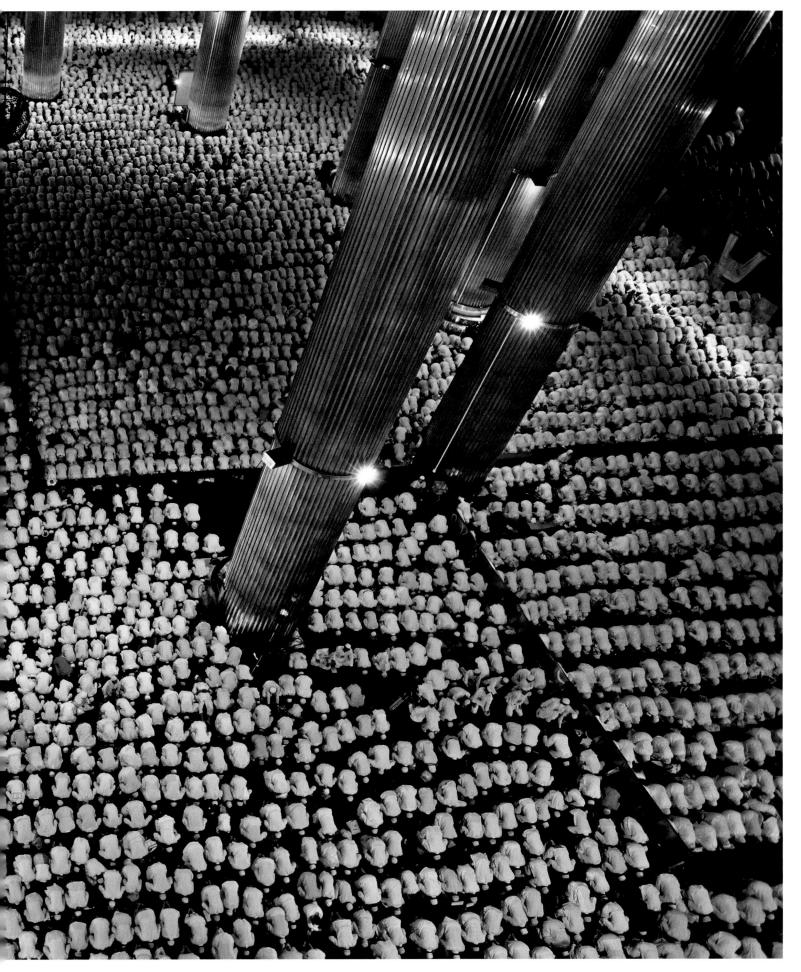

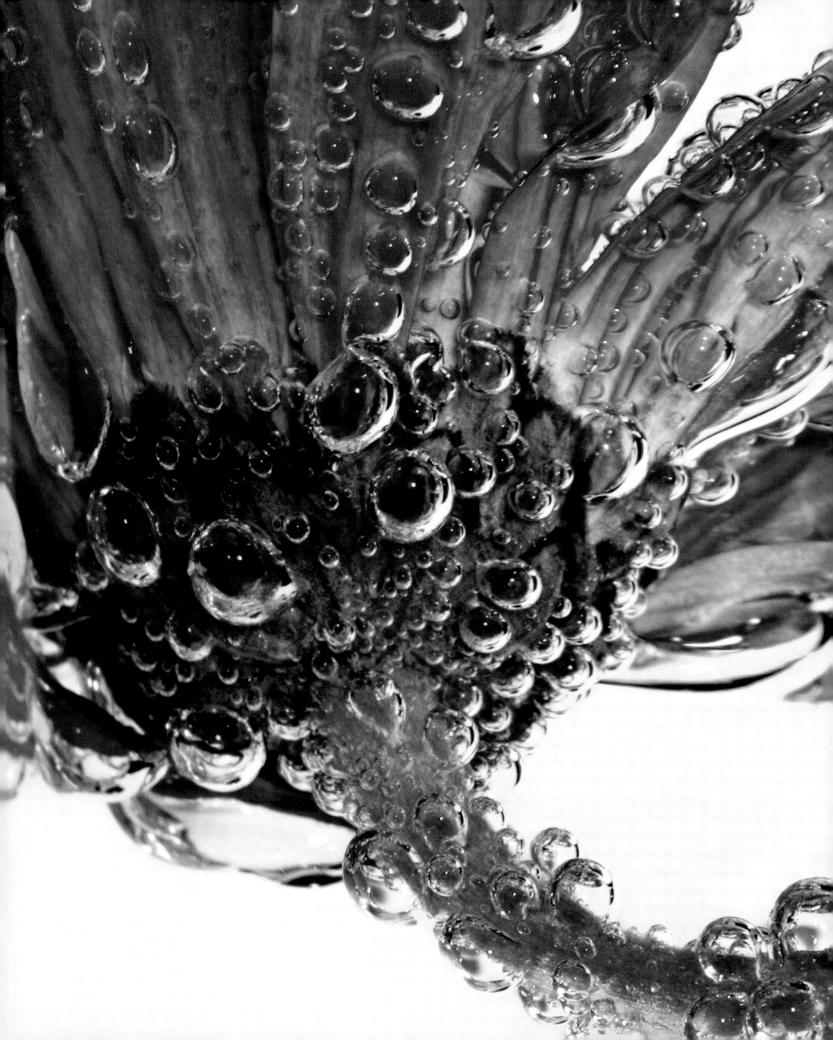

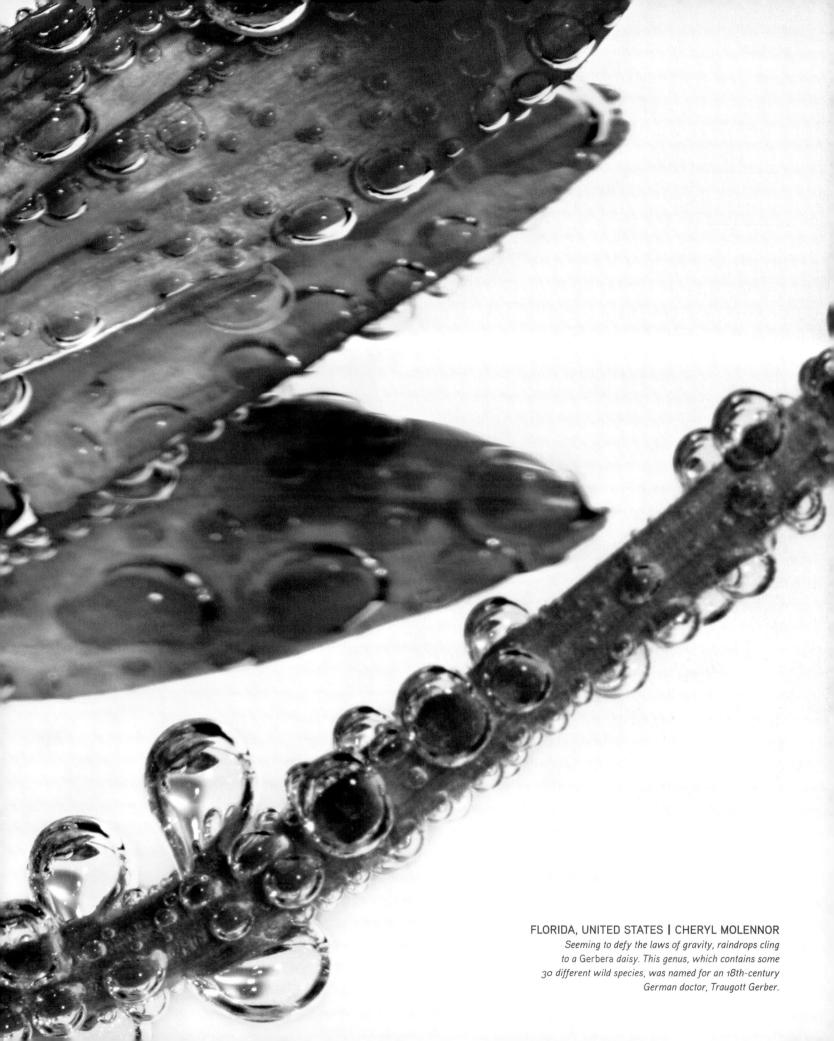

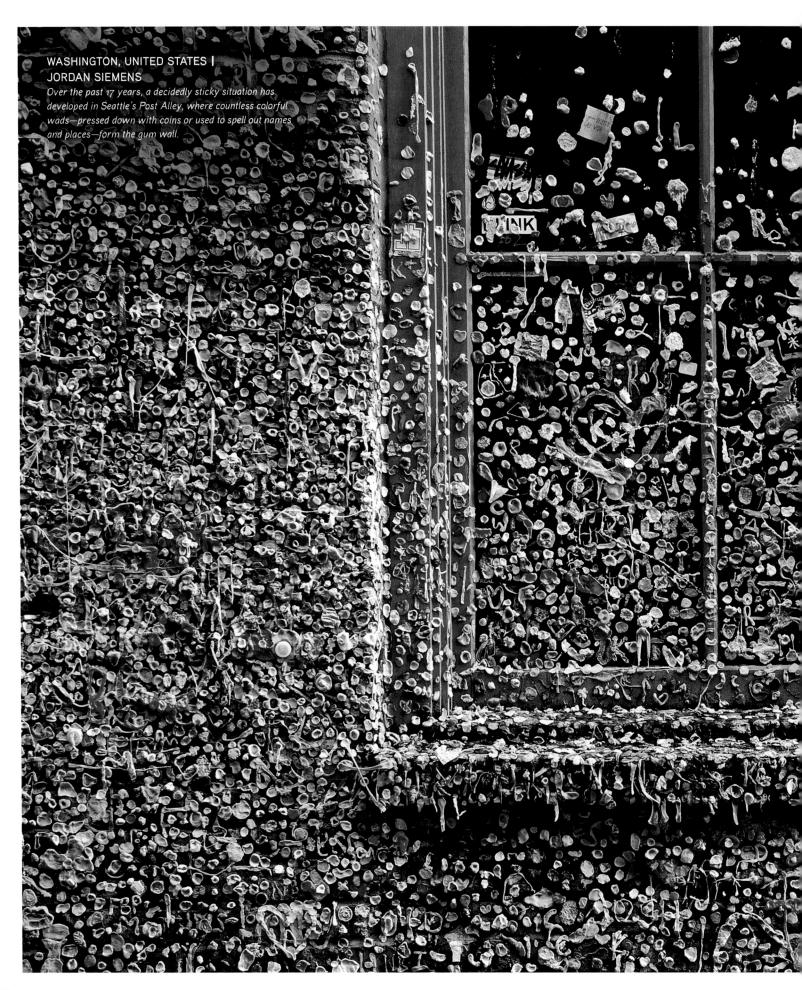

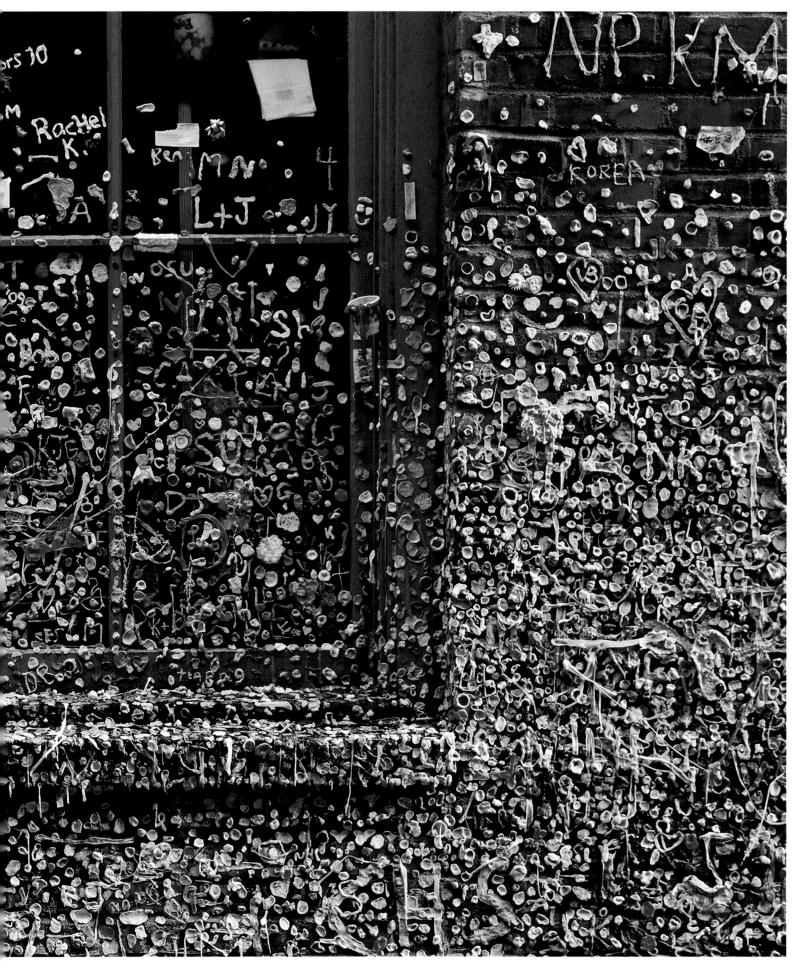

The number of people on

PLANET EARTH is projected to

reach seven billion by the end of 2011.

With more than 1.3 billion people,

China is the most populous country,

followed by India and

then the United States.

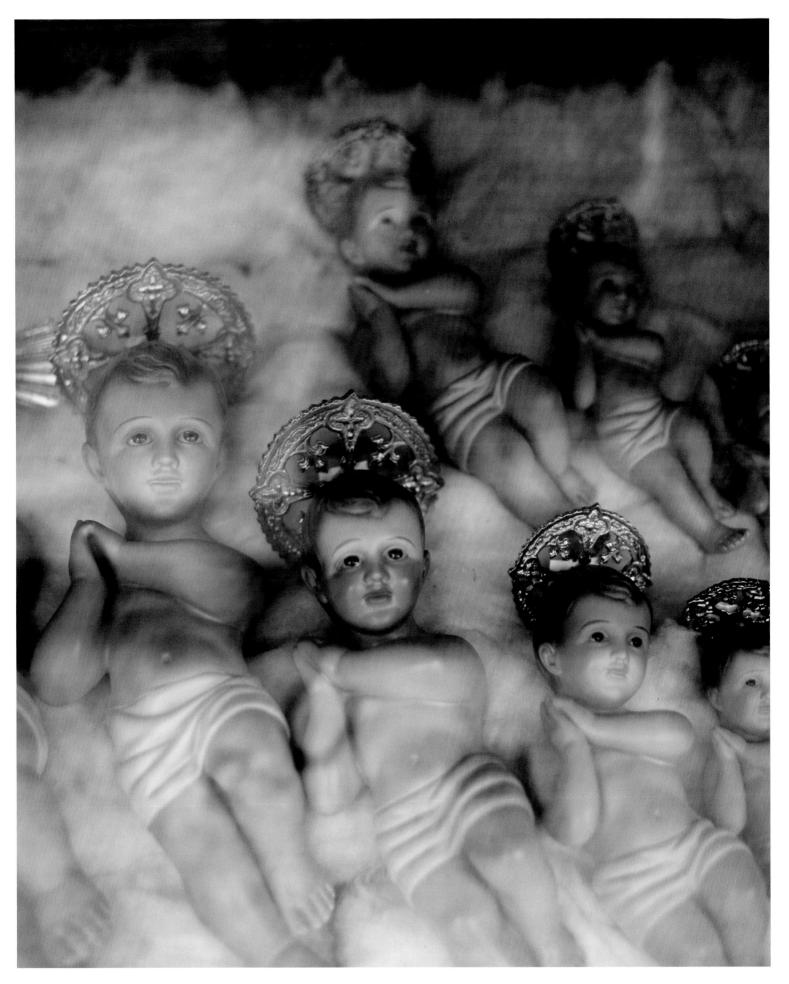

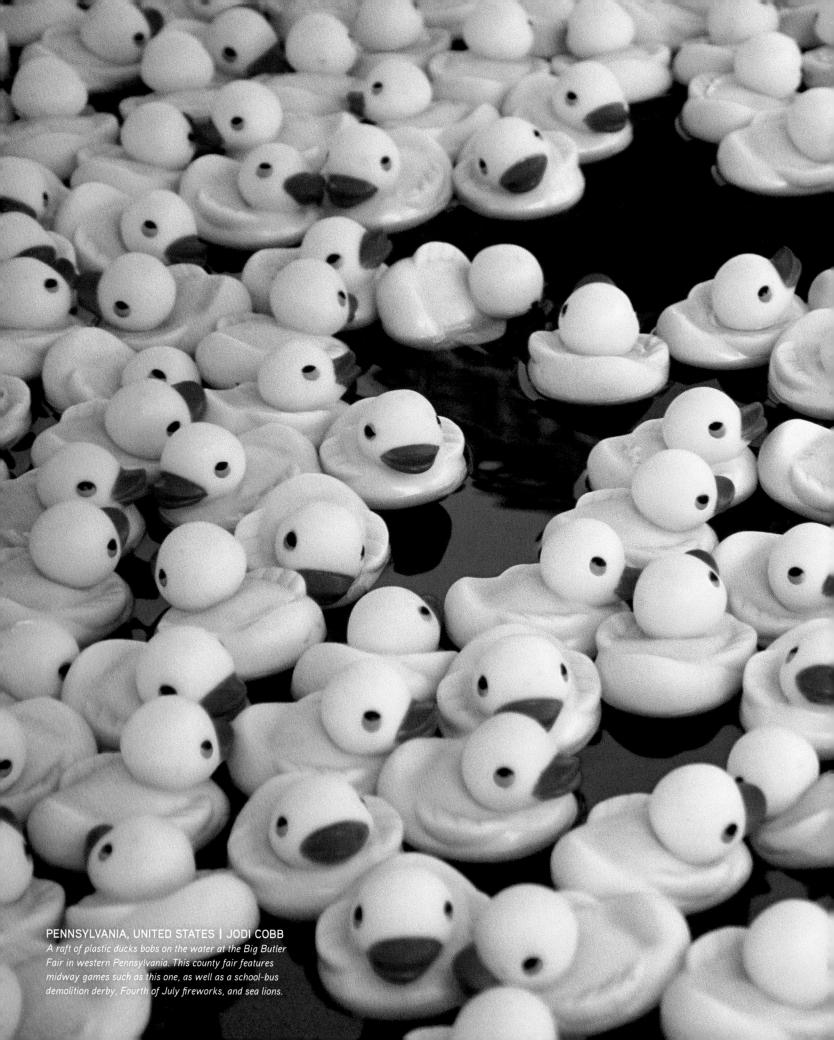

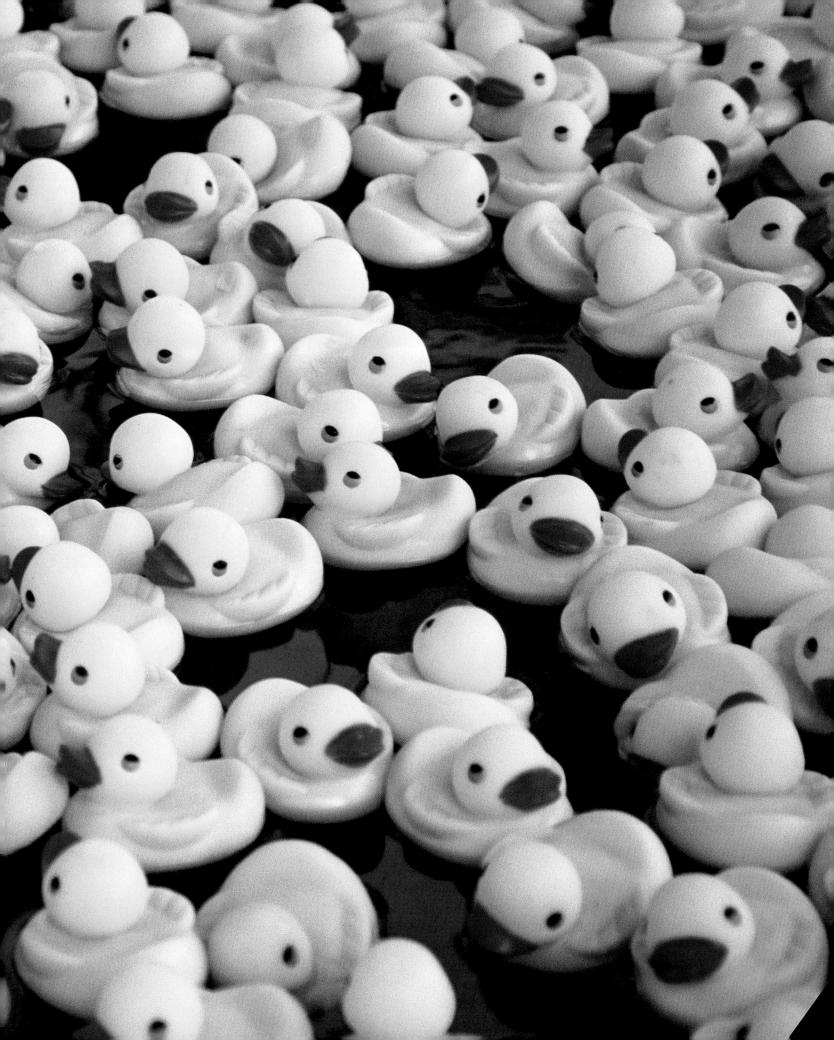

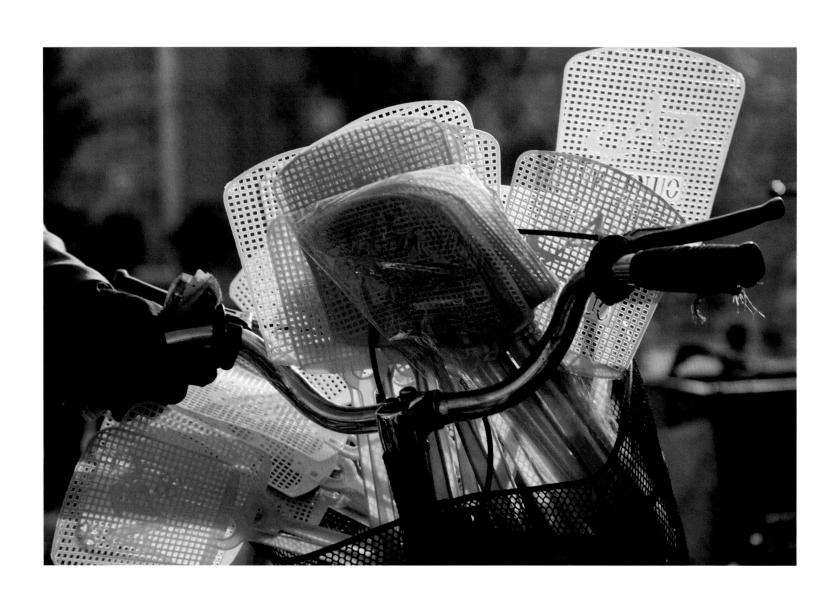

CHINA | DAVID EVANS

The pastel hues of fly swatters create a plastic bouquet in this bike basket in Xining, China. In the markets here you may be able to find anything you'd like, including caterpillar fungus used in traditional medicine.

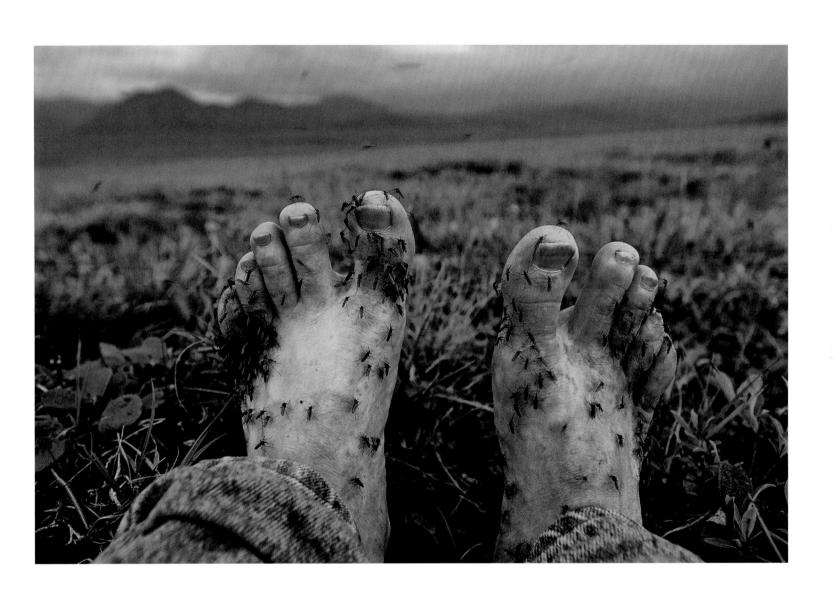

ALASKA, UNITED STATES | JOEL SARTORE

This photographer sacrifices his feet to tenacious mosquitoes on Alaska's North Slope. But there was a price to pay for his art: "I scratched the bites for hours afterward."

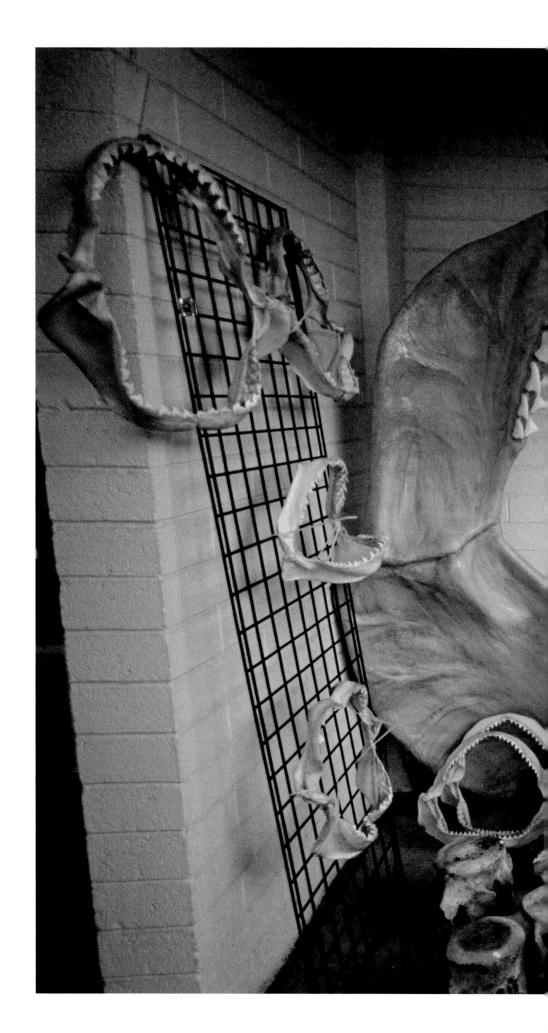

ARIZONA, UNITED STATES | LYNN JOHNSON

This jaw and teeth beckon fossil collectors instead of guarding against thieves at a hotel room in Tucson, Arizona, home to a popular gem and mineral show. The lucrative fossil trade forces museum curators, paleontologists, and private collectors to jockey for the best specimens.

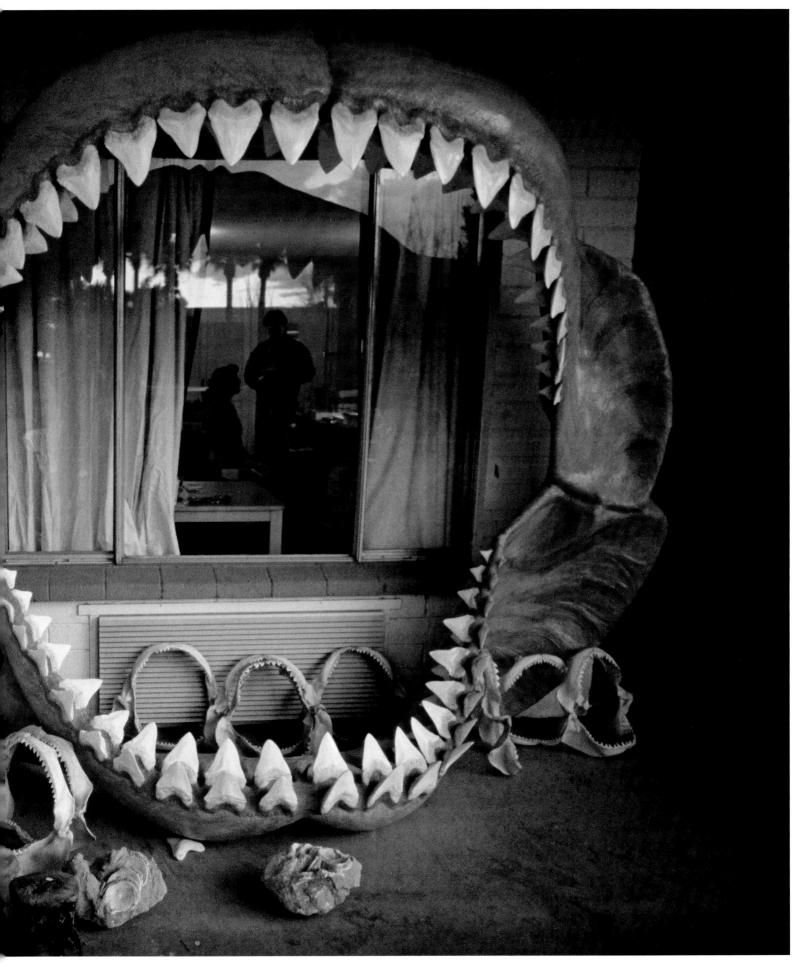

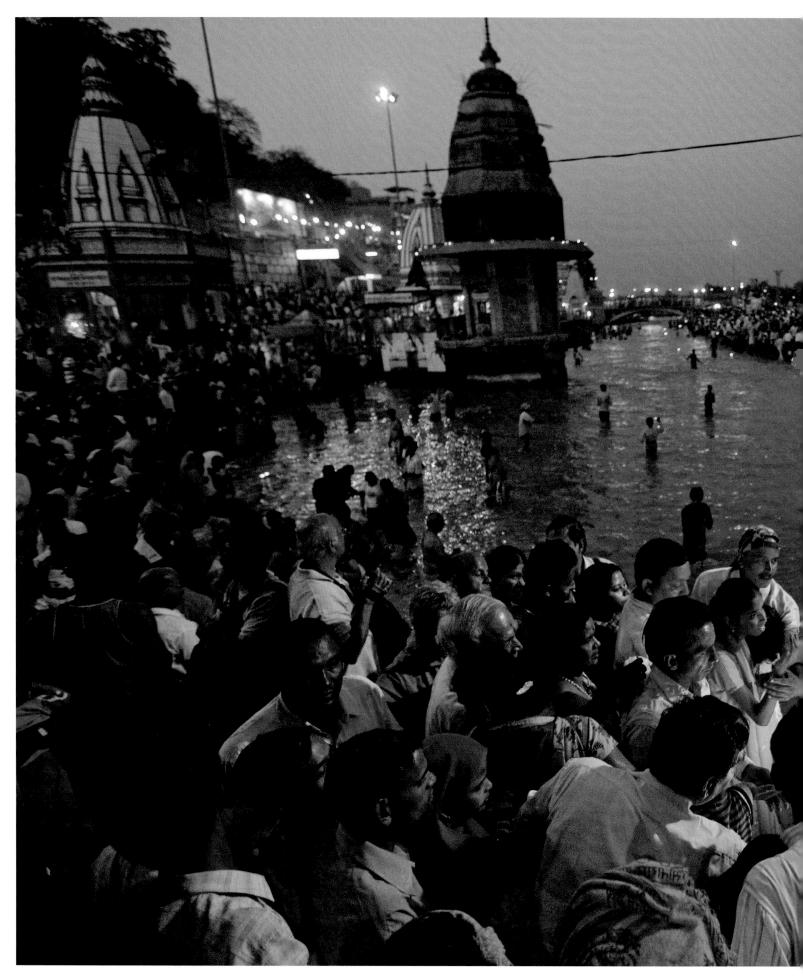

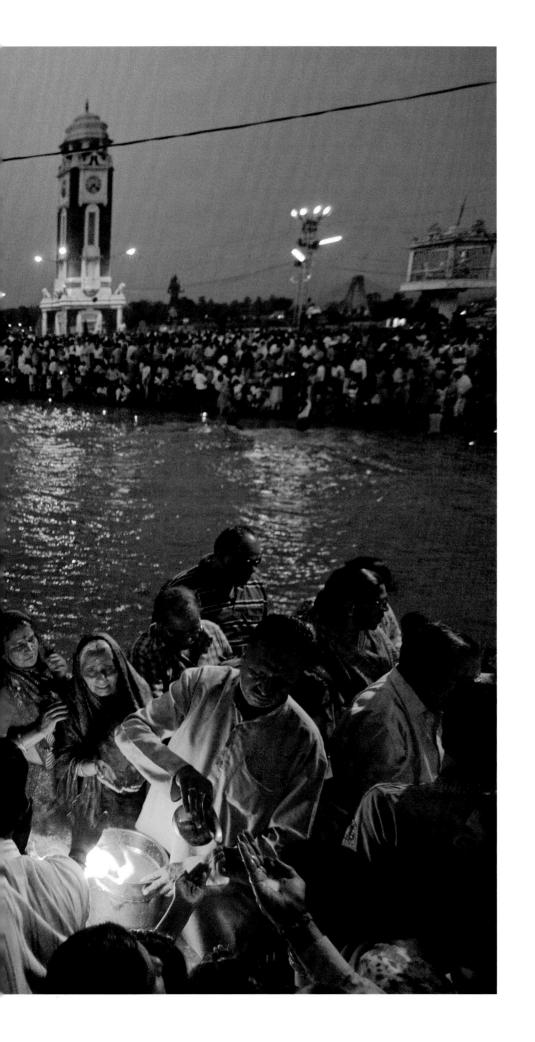

INDIA | JOHN STANMEYER

Hindus perform aarti, an offering of lamps to the sacred Ganges in Haridwar, India. Here, they believe, the power of Mother Ganga to wash away sins is strong.

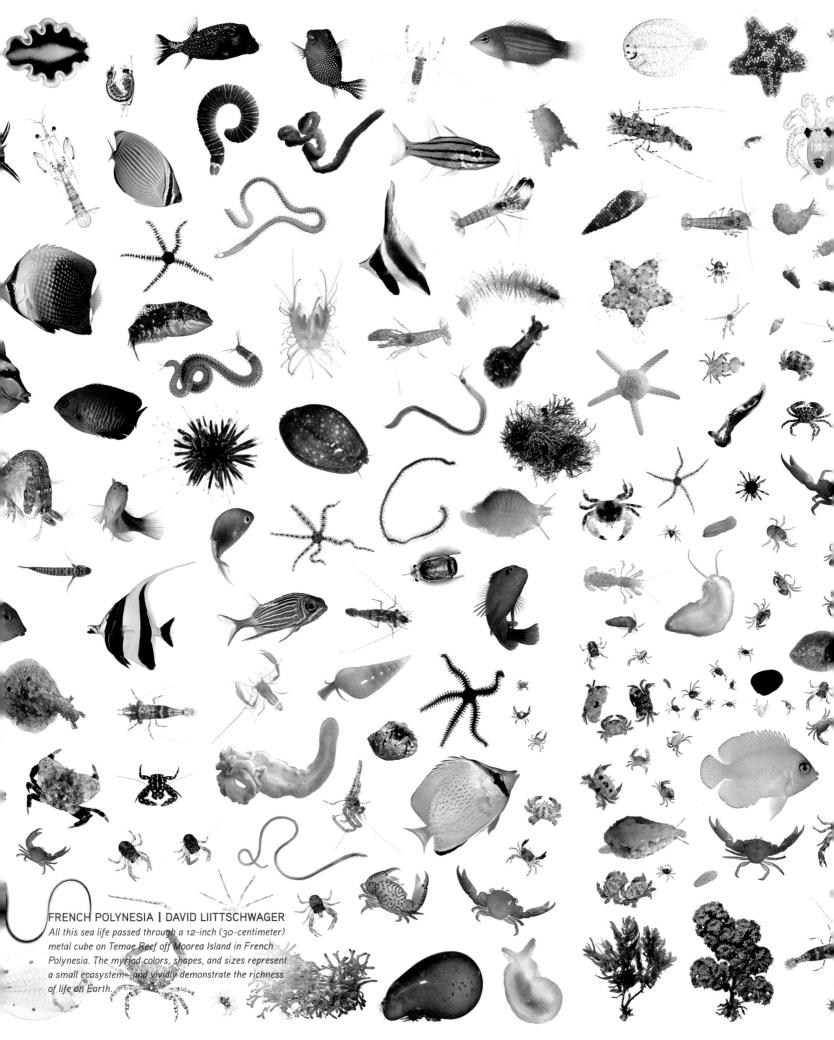

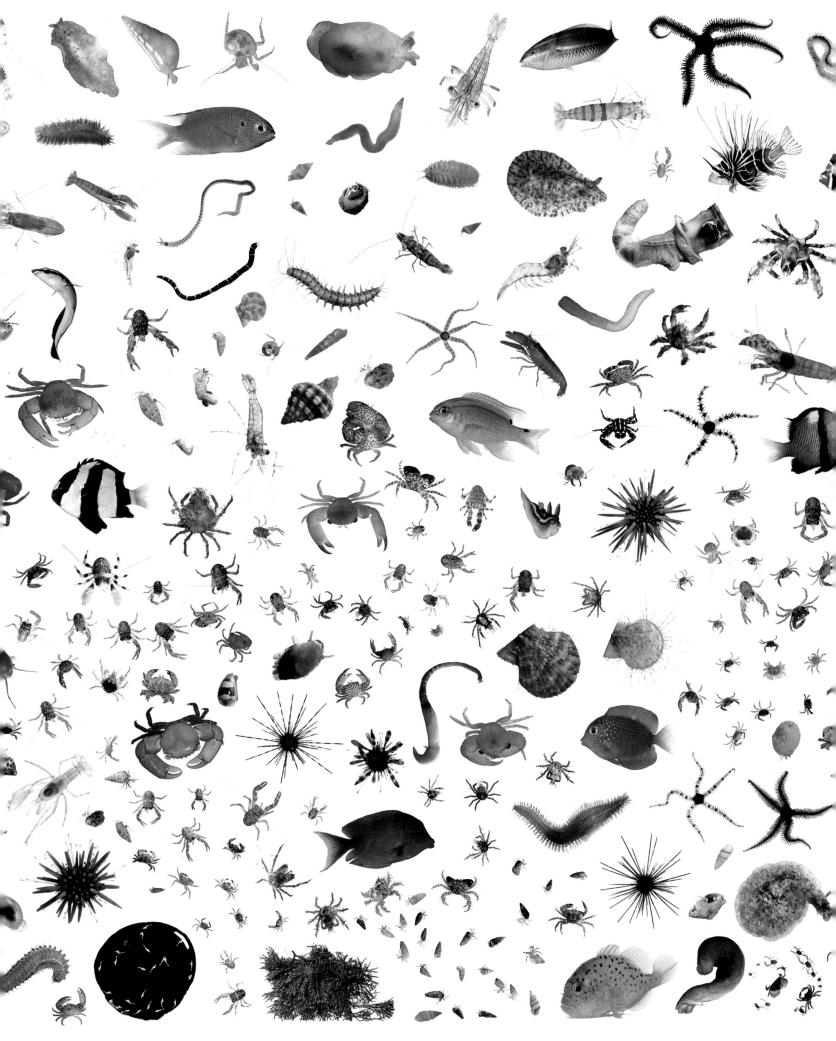

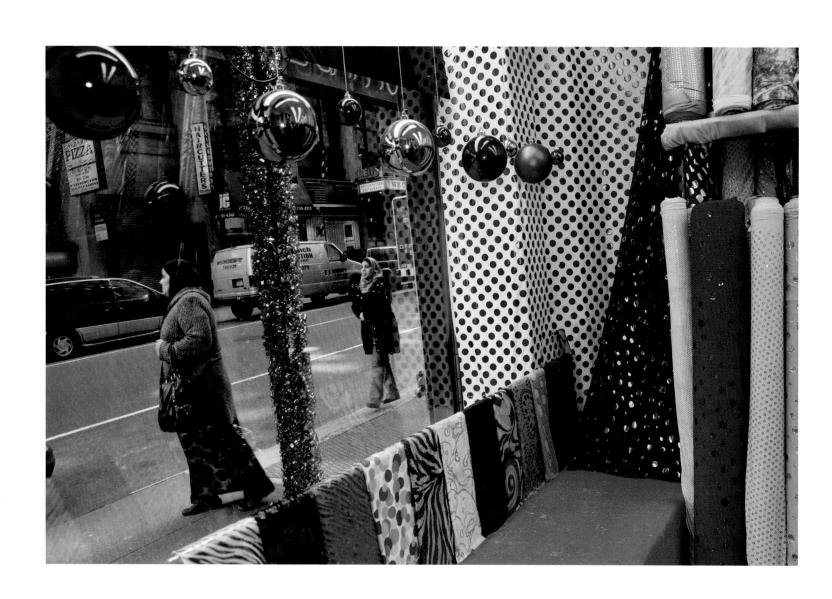

NEW YORK, UNITED STATES | WILLIAM ALBERT ALLARD

Passersby don't seem to notice the bright rows of fabric in a shop window in New York City's Garment District. Fashion designers appreciate the close proximity of materials, but manufacturing doesn't always take place here, as it has shifted to outlying locations and other countries.

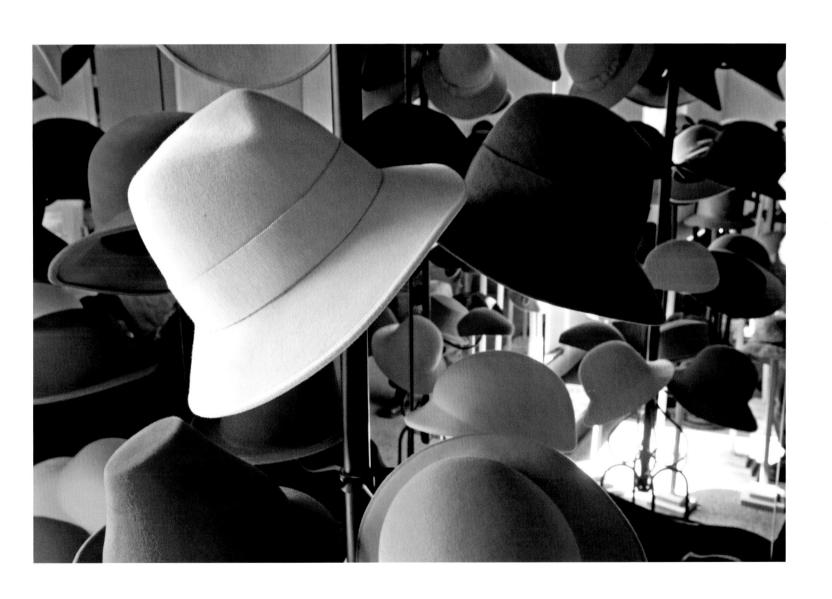

NEW YORK, UNITED STATES | WILLIAM ALBERT ALLARD

Like gumdrops in a candy store, these hats in a milliner's showroom in New York City's Garment District may be destined for a designer's fashion show. One designer showcase requires intense effort but is usually over in less than 20 minutes.

IN CHINA, the color red symbolizes good fortune and joy.
Yellow and gold represent heavenly glory.

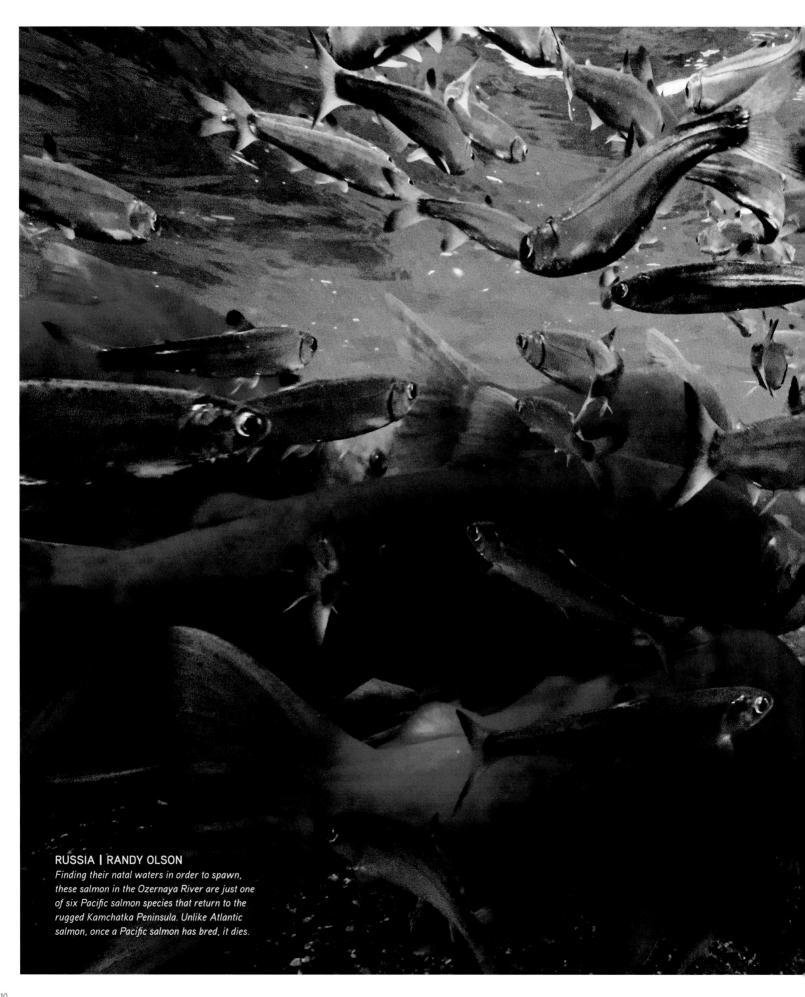

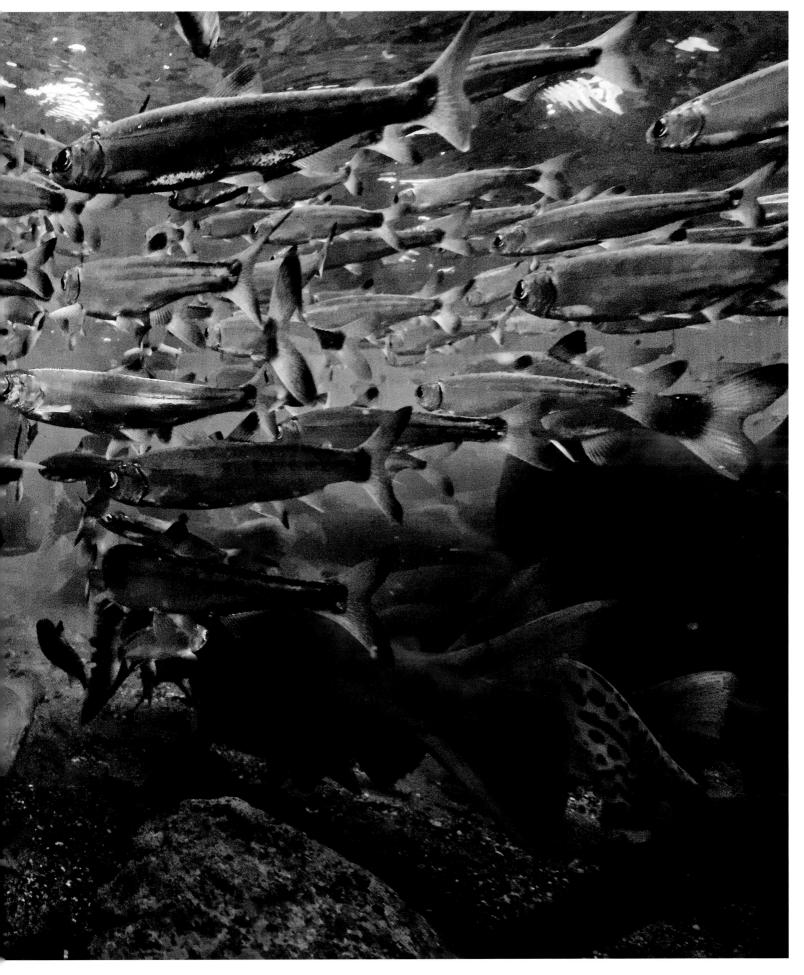

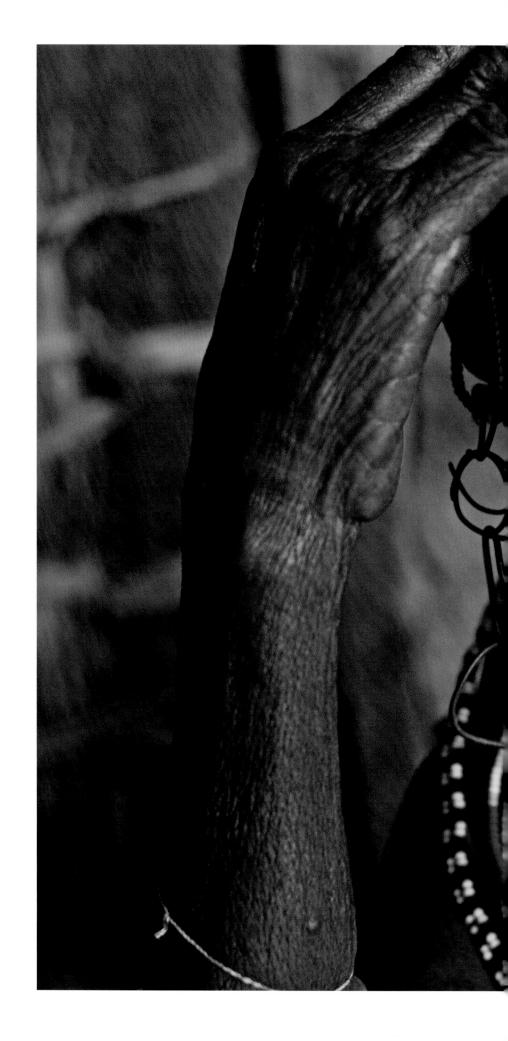

KENYA | LYNN JOHNSON

Colorful beaded necklaces and the striking gaze of an El Molo elder create a timeless image. She lives in a small fishing village on the southeastern shore of Lake Turkana.

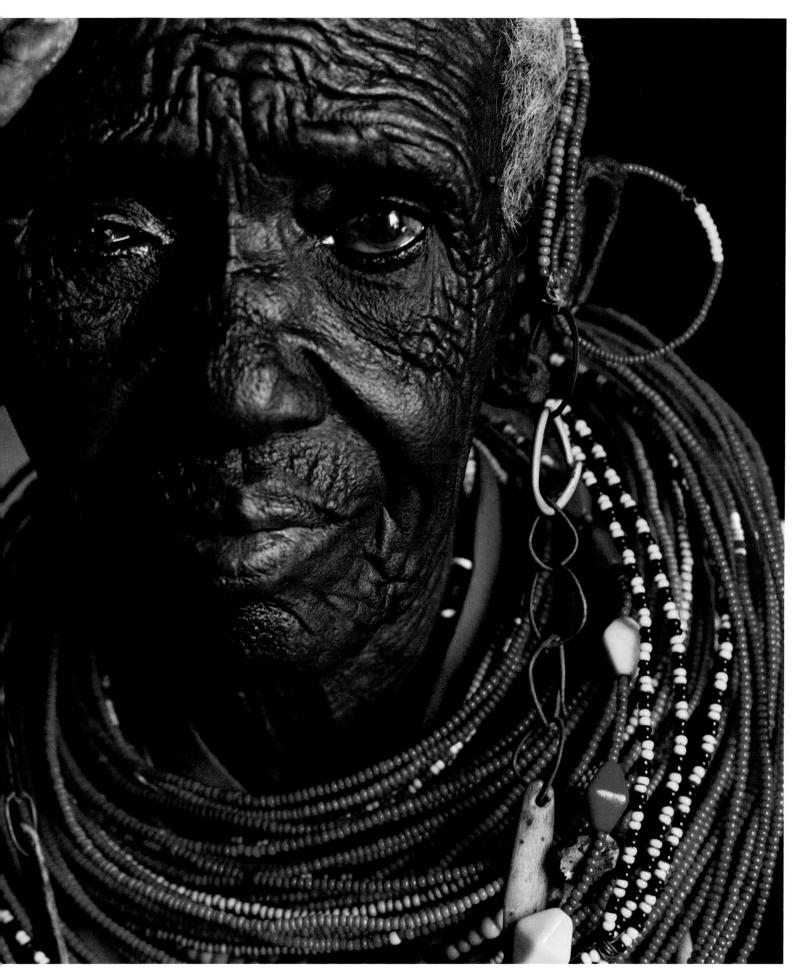

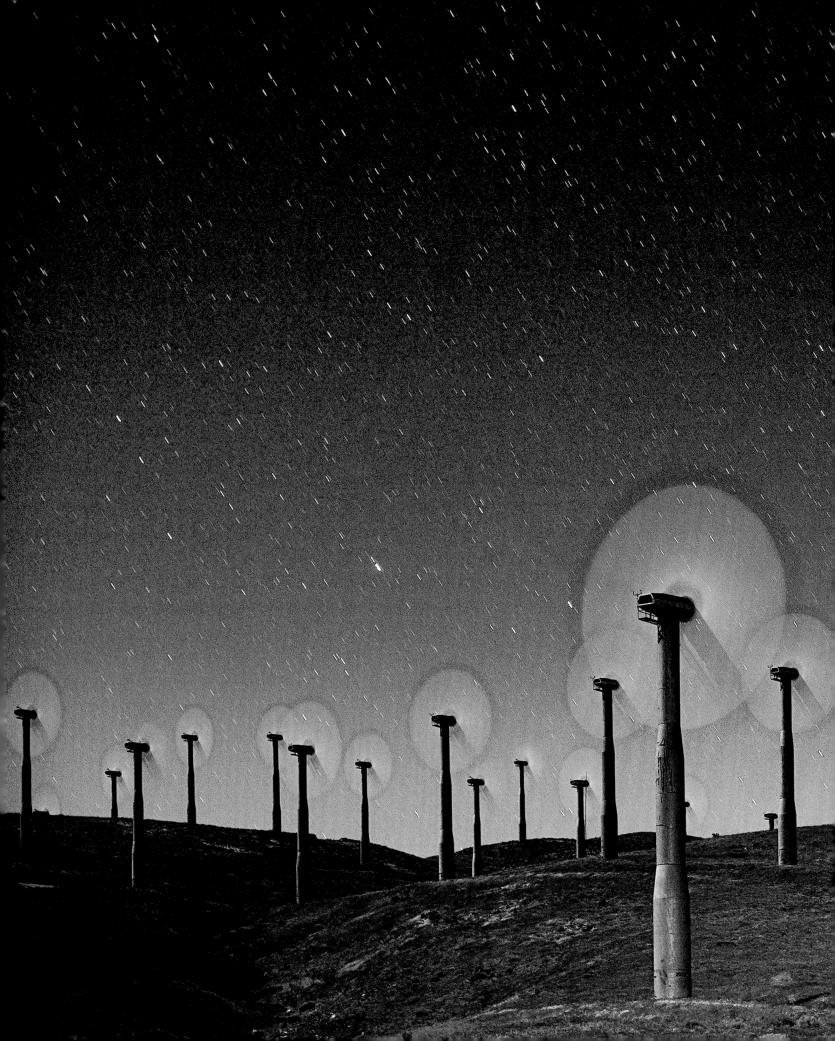

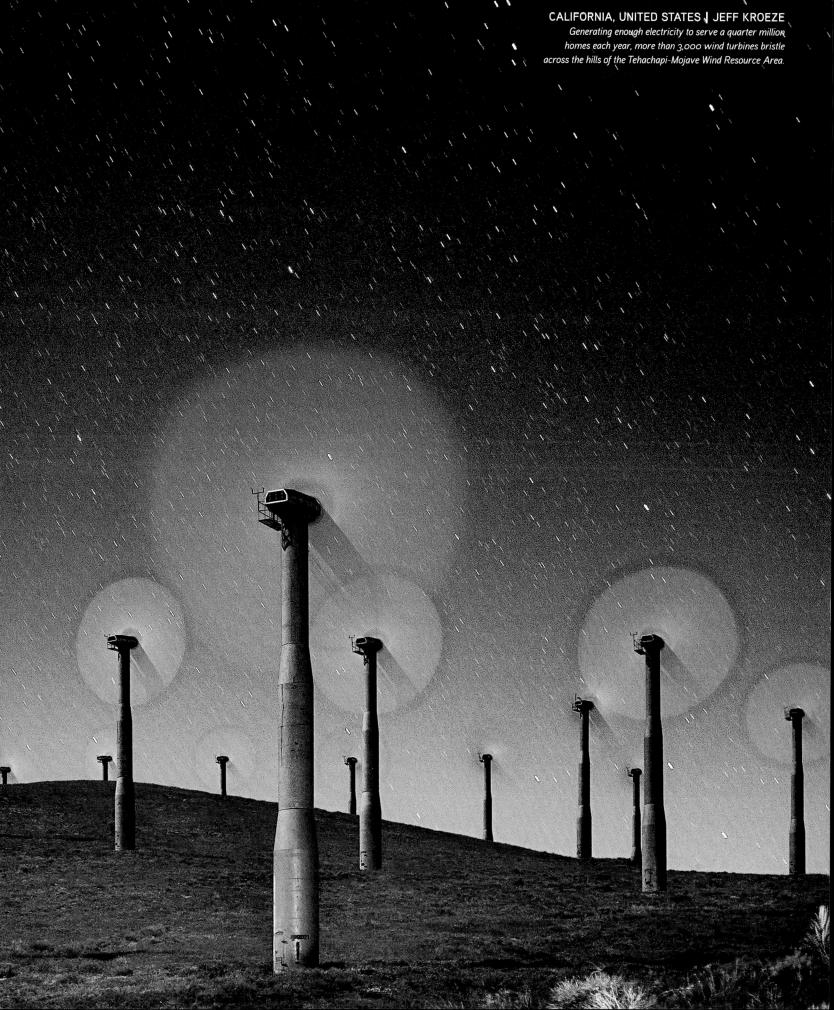

PORTFOLIO SEVEN

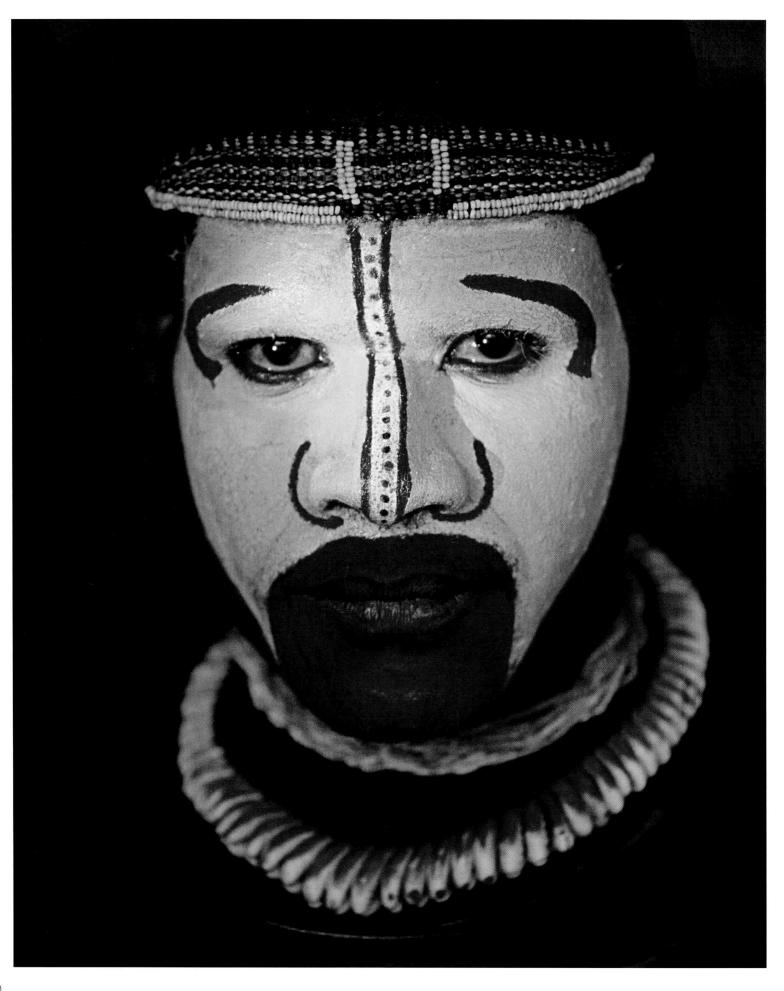

how things differ, and to know how they are the same we line them up in paral

are the same, we line them up in paral-

lel. It's a lesson taught in school early—compare and contrast—and it's a mental exercise invited by visions of the Earth that we inhabit.

Flat rocks poke up out of a stream bed, stepping-stones from one bank to the other. Through parallels, we travel from here to there.

Buttercups bloom along the roadside, one after another, each yellow head bobbing and seeking the sun. They stand straight, almost in a line, almost parallel, each bending a little differently to the same wind. Red-winged blackbirds congregate on the top wire of a farm fence, cheery chevrons distinguishing the males from dusky females, but silhouettes of solidarity, scores of birds perched in parallel. Through parallels, we feel confident that nature can still produce in abundance, and therefore, all feels right with the world.

We humans adopt the concept of parallels and go nature one better: We design our orchards and vineyards in orderly parallels, the better to plant, the better to prune, the better to weed, the better to harvest. Our gardens, too, push parallels to extremes. Carrot seeds poked into the soil in a very straight line sprout into feathery green stalks above and slender spears of orange below. Never would nature scatter seeds in such a pattern, but our backyard gardens prove how humans crave parallels.

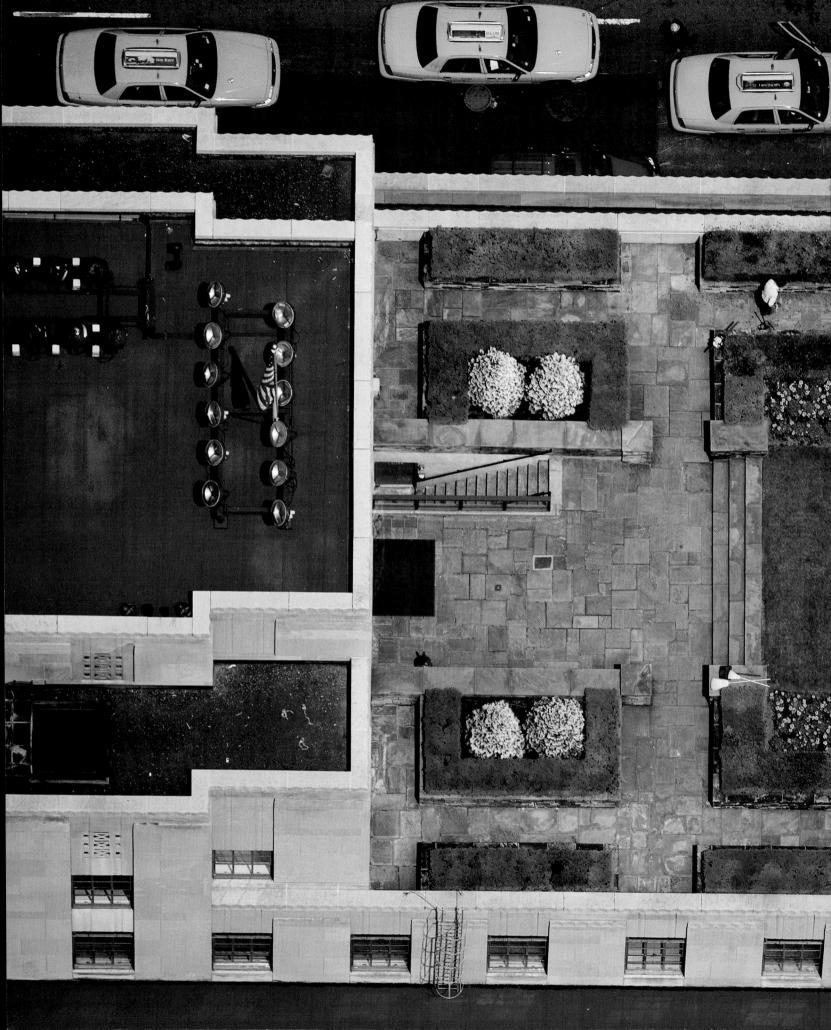

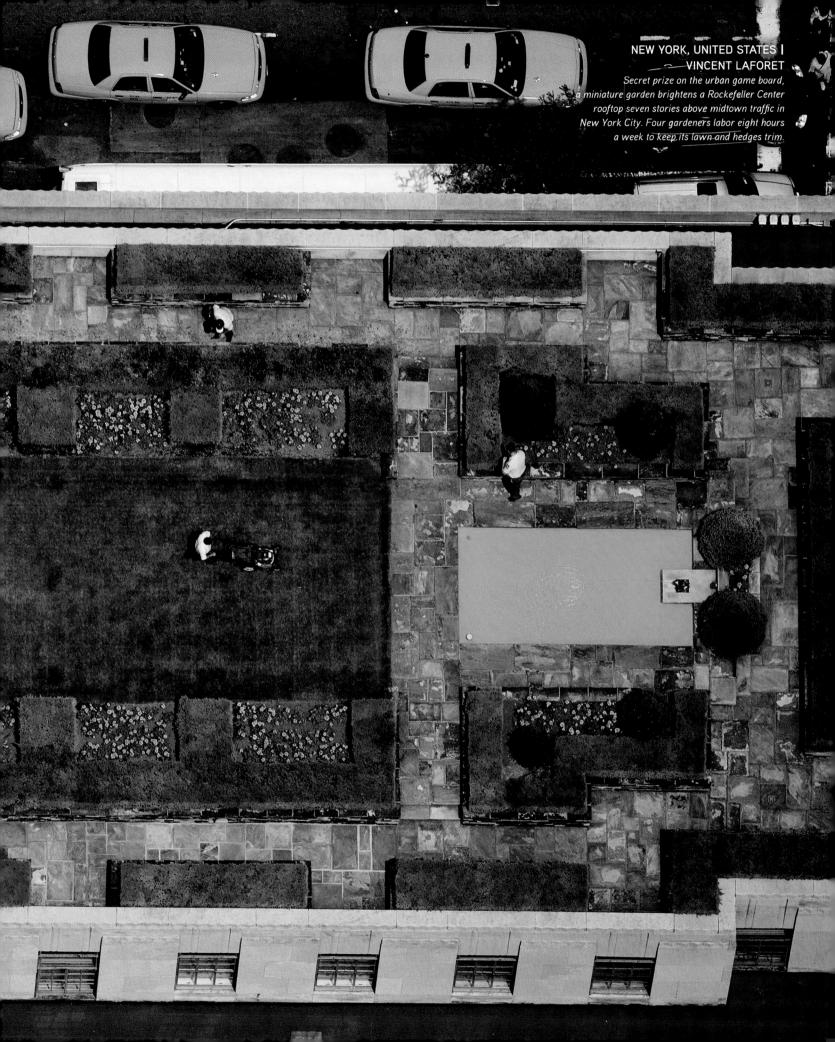

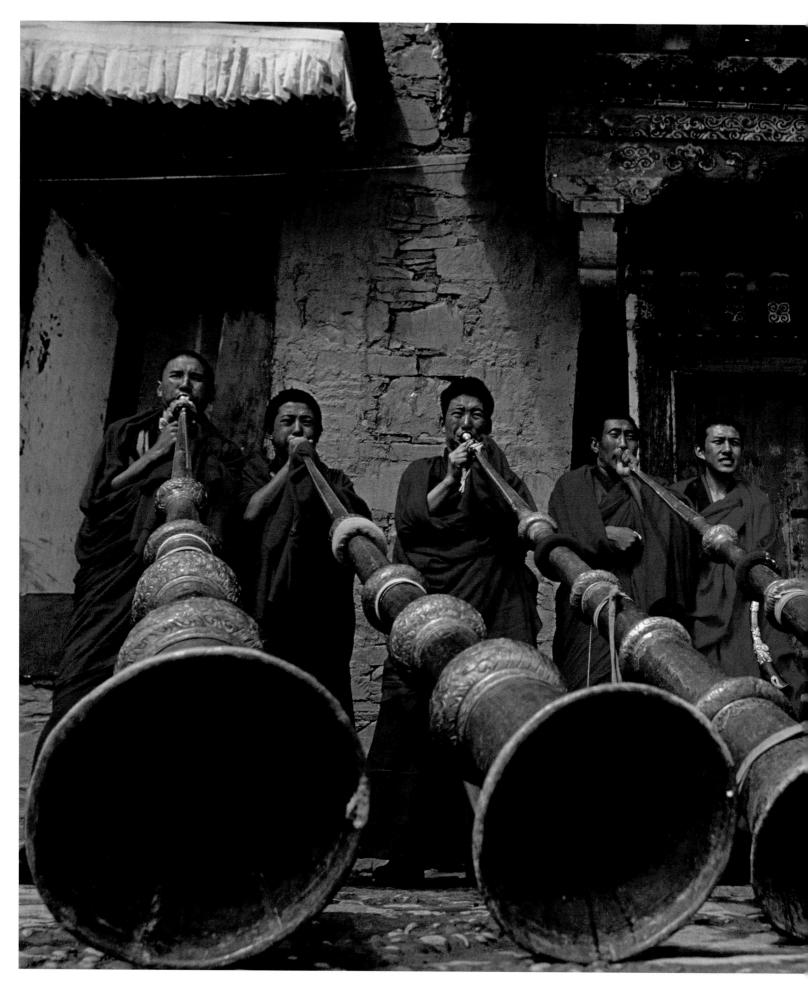

CHINA | MICHAEL S. YAMASHITA

Buddhist monks at Labrang Monastery practice blowing horns, which they use to call their fellow monks to prayer. Neuroscientists hope that by studying brain scans of meditating Buddhist monks they can understand how they achieve a state of oneness with the world.

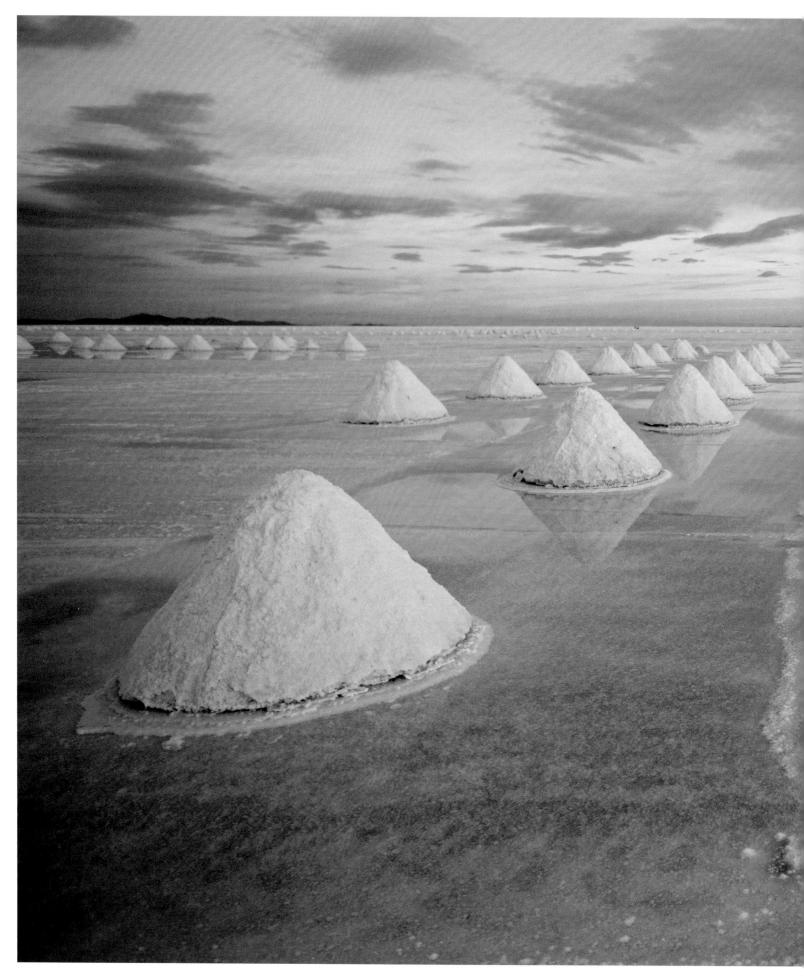

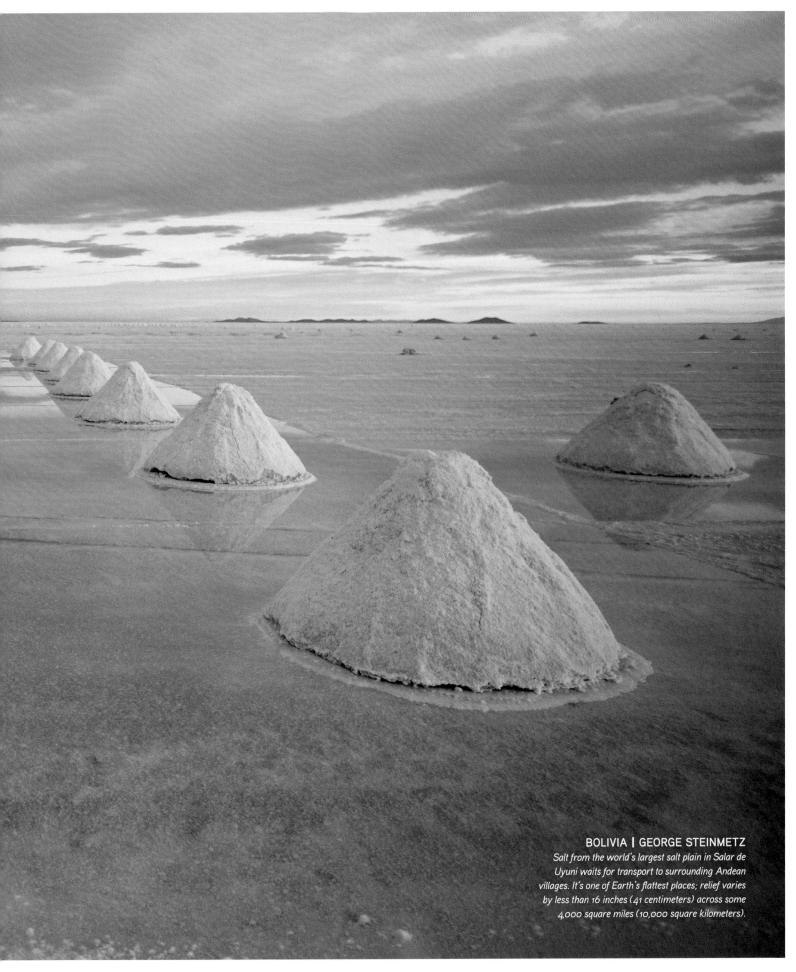

The DEVONIAN PERIOD
of history occurred from 416 million
to 359.2 million years ago.

It is also known as the age of fish
because it was during this period that
the first fish developed legs and
moved onto land.

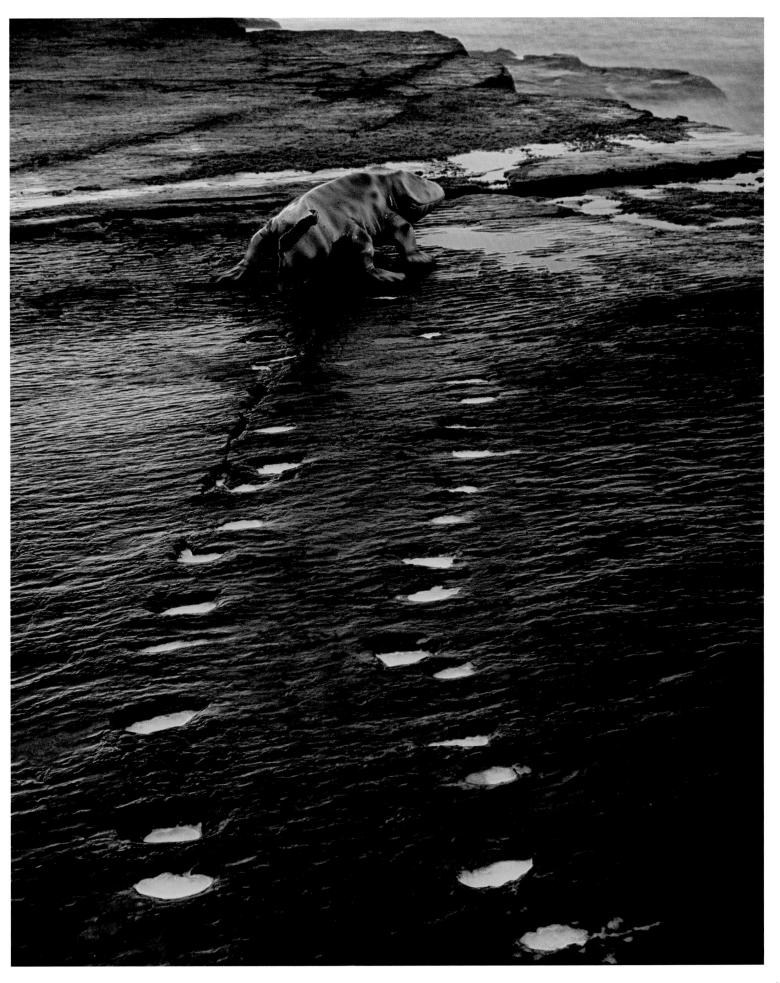

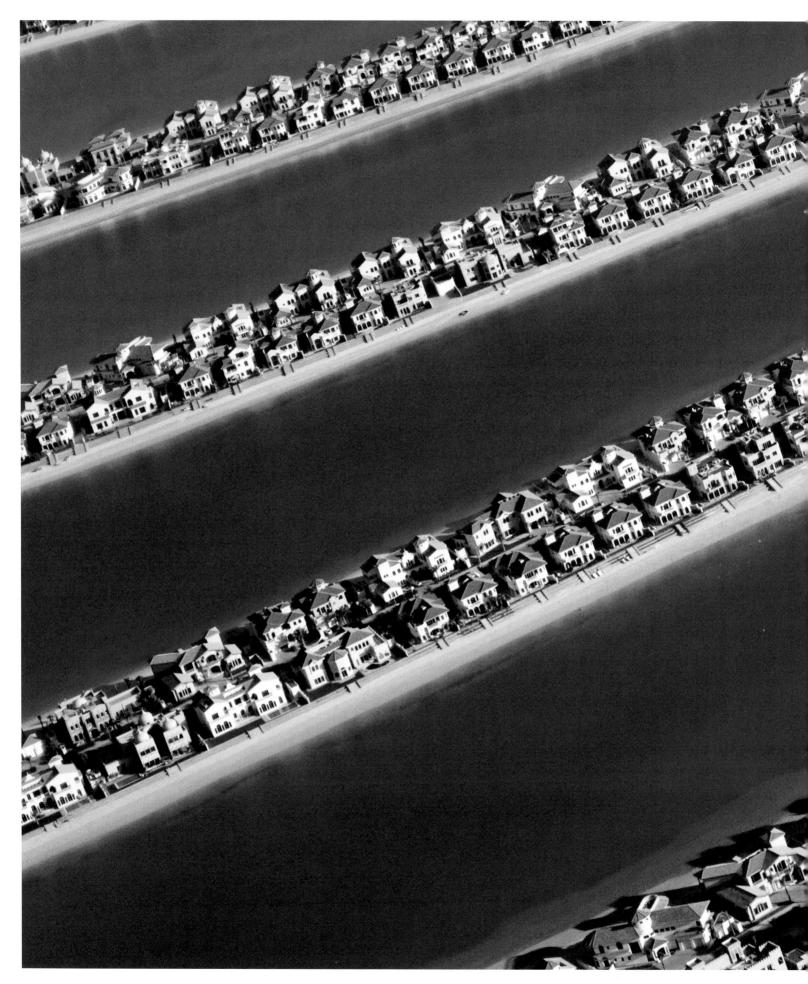

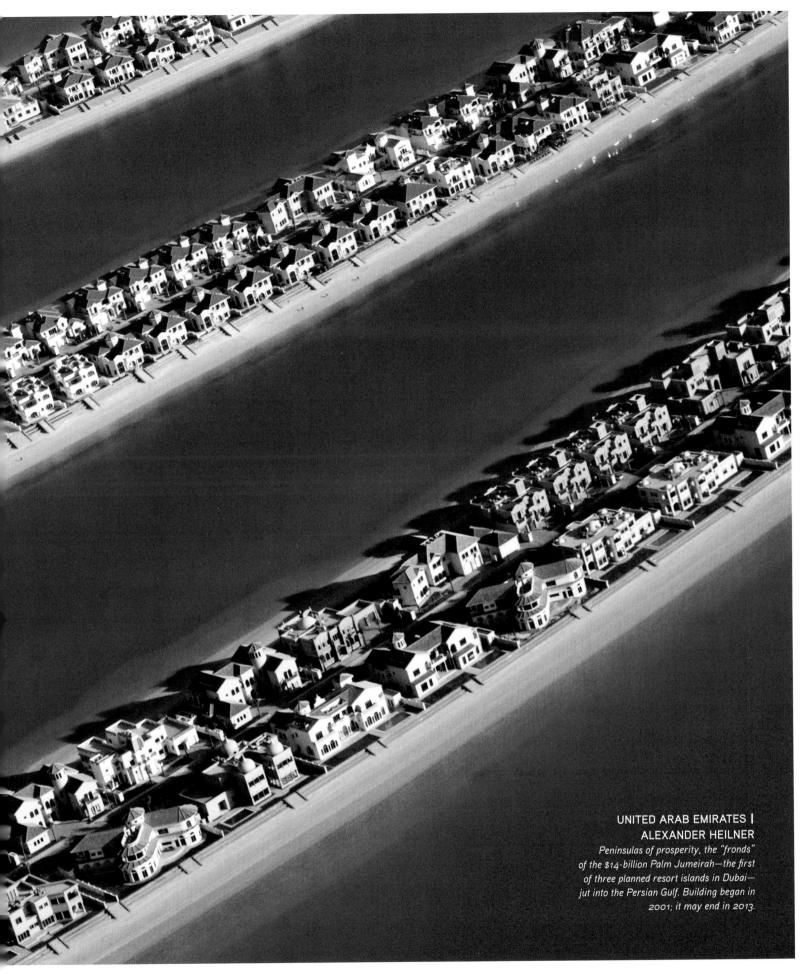

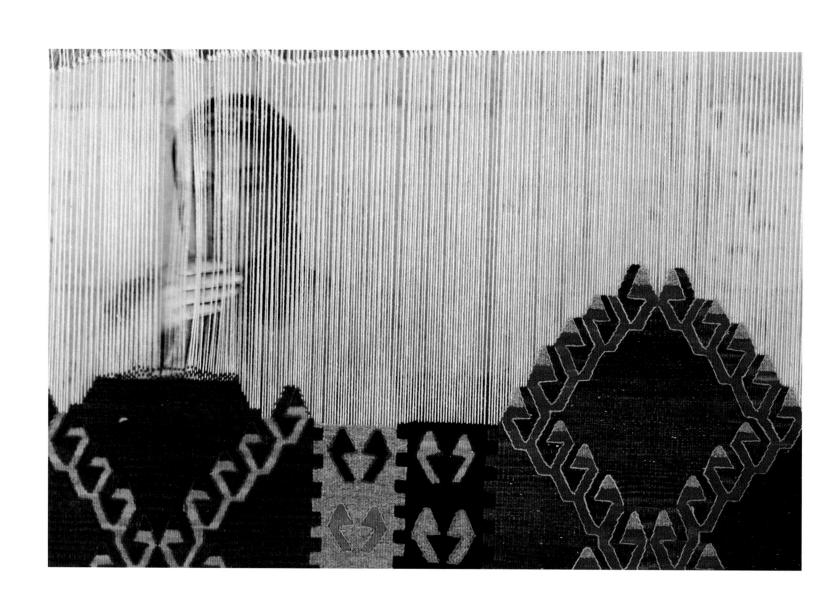

TURKEY | GEORGE STEINMETZ

Appearing veiled behind the patterns of a nascent Turkish carpet, a weaver practices an art that traces its origins to more than 2,000 years ago in Central Asia. The craft was refined and honed during the Ottoman Empire as a way to please rulers.

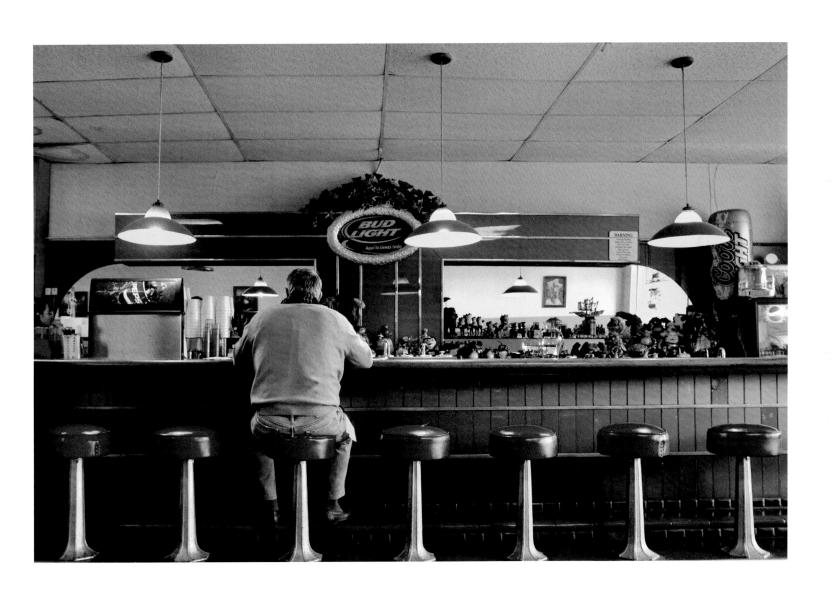

CALIFORNIA, UNITED STATES | SHAUN MCGRATH

Cherry-red bar stools and colorful walls add spirit to this Mexican restaurant in Brawley, California, some 20 miles (32 kilometers) from the border. Part of California's agricultural Imperial Valley, cross-border fertilization enriches the area.

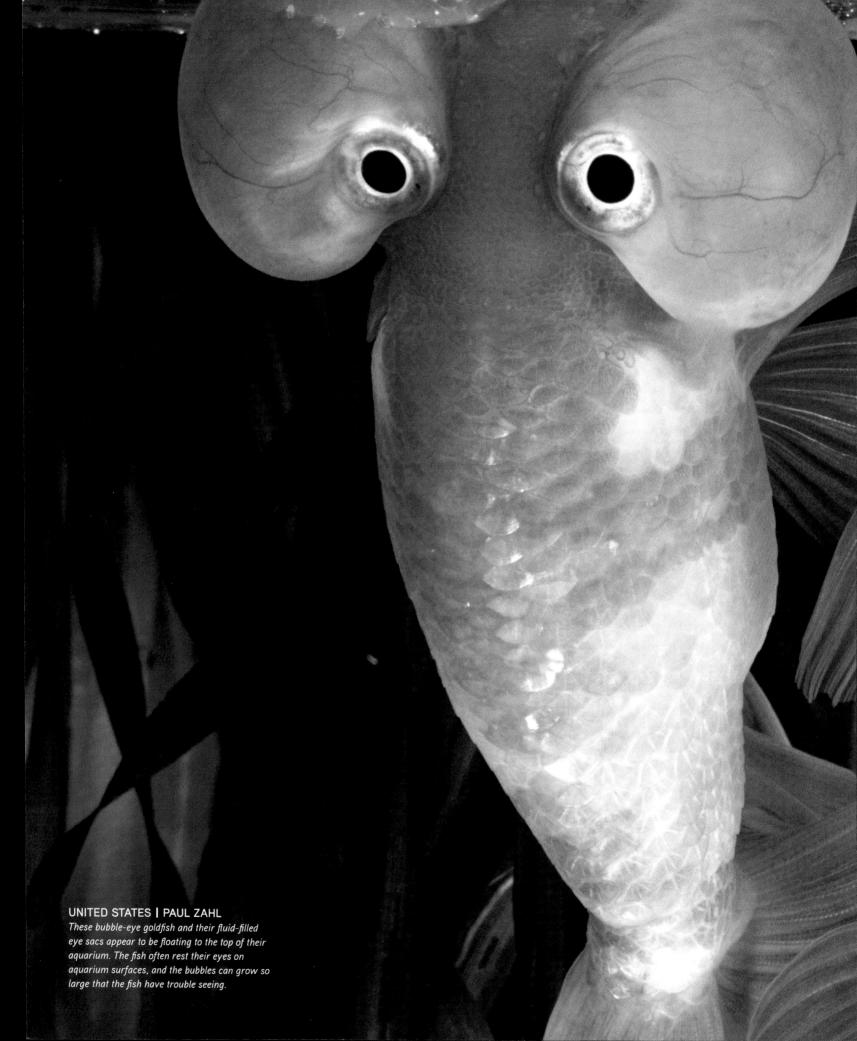

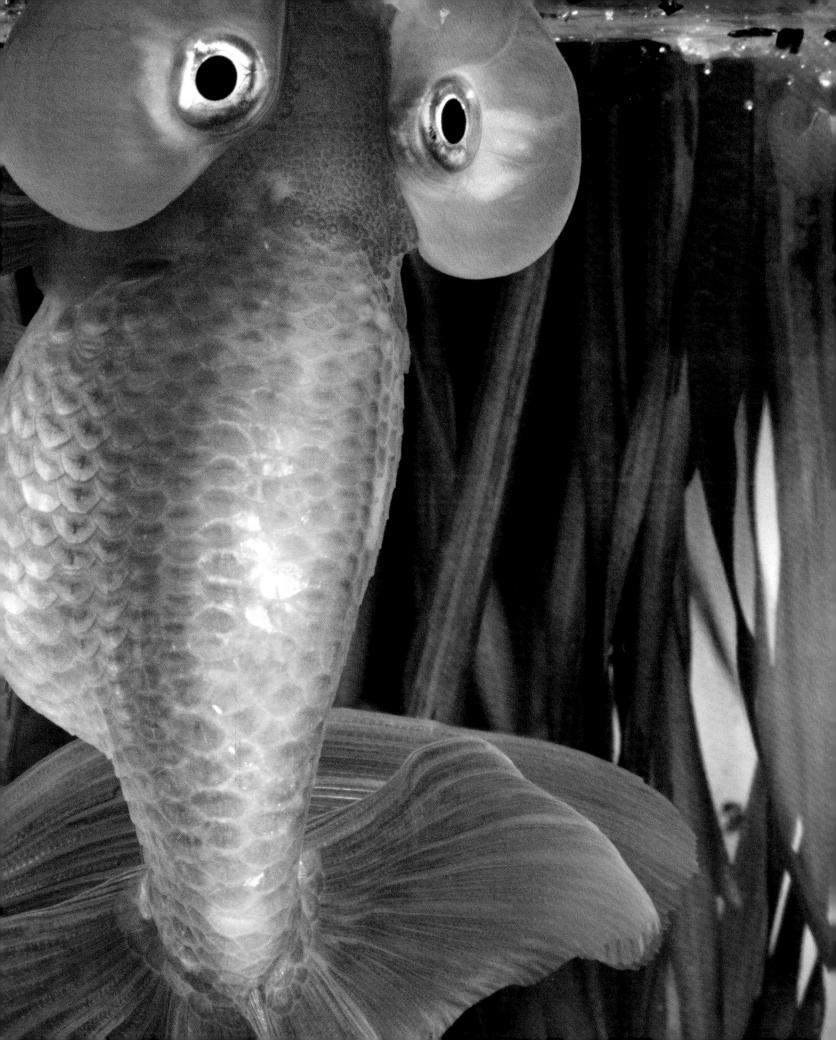

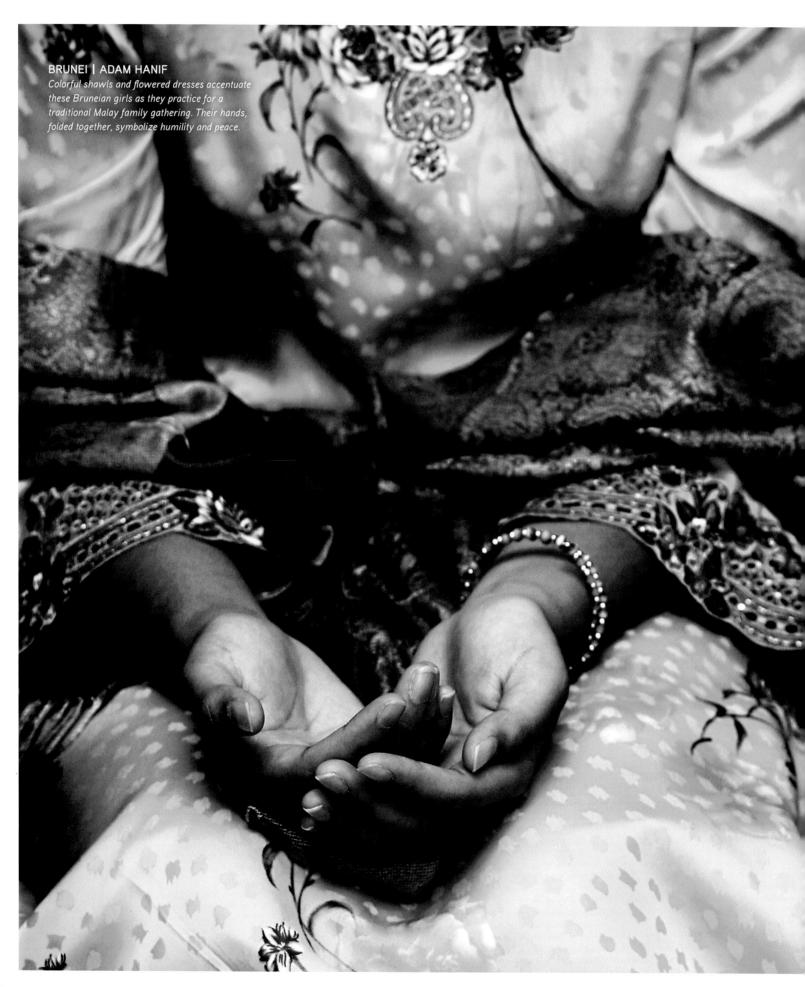

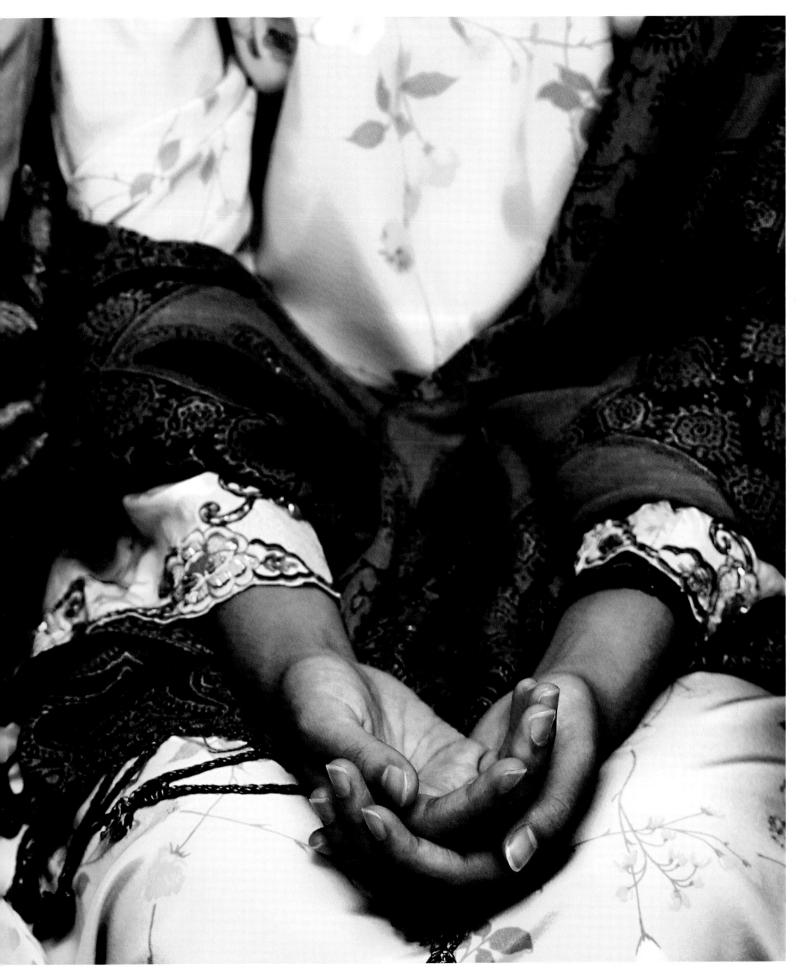

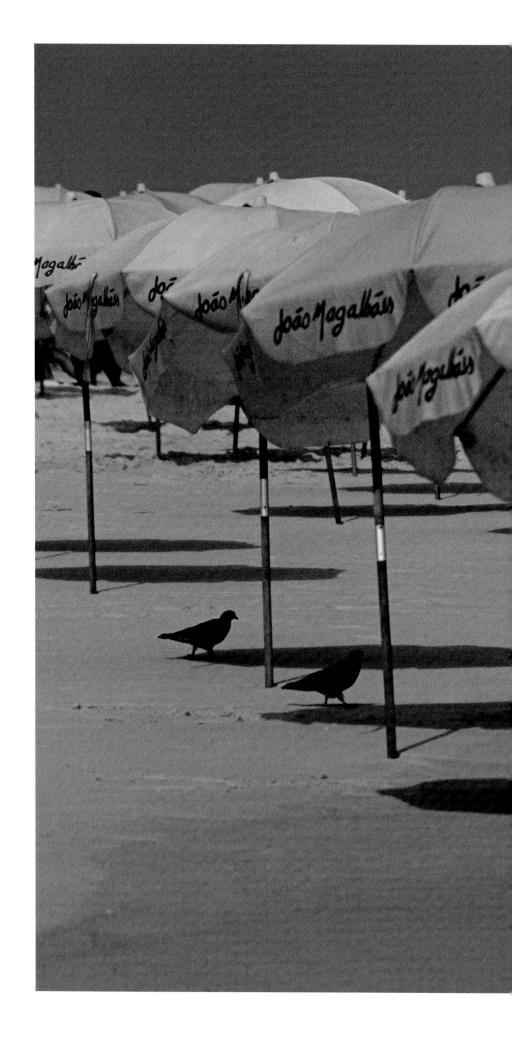

BRAZIL | JODI COBB

Beach umbrellas mimic pink flamingos on Ipanema Beach in Rio de Janeiro. Brazil is getting ready to host the 2014 World Cup and the 2016 Summer Olympics, when Rio's beaches are sure to be popular.

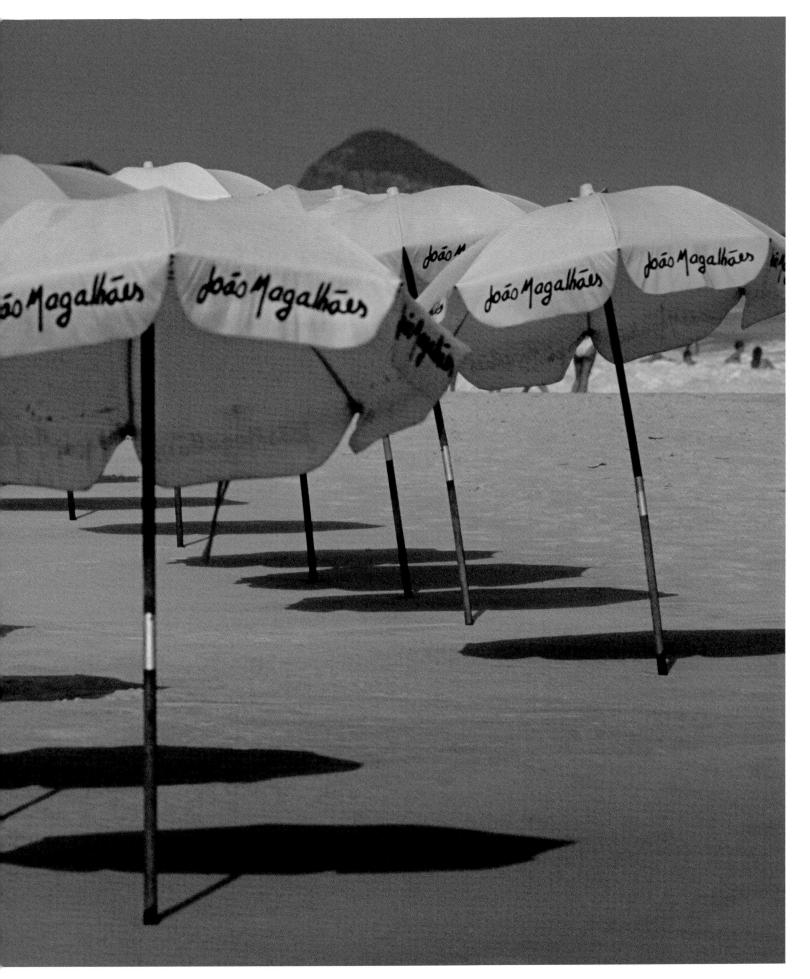

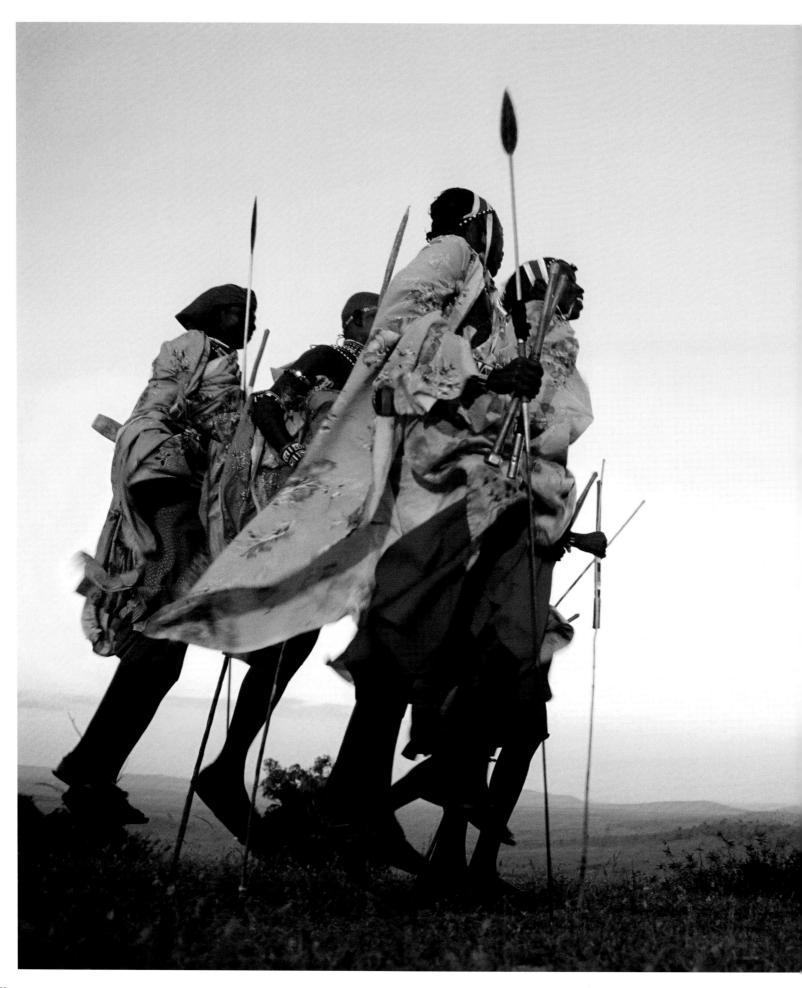

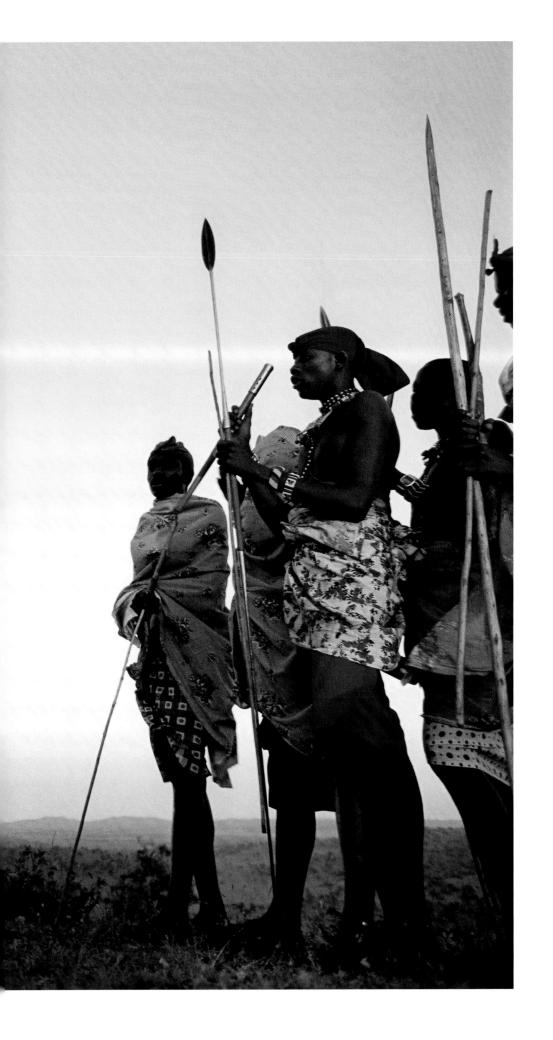

KENYA | DAVID MCLAIN

Maasai men perform a traditional jump dance. The Maasai, nomadic pastoralists of East Africa, divide each year into two: a year of plenty during the rainy season, and a year of hunger.

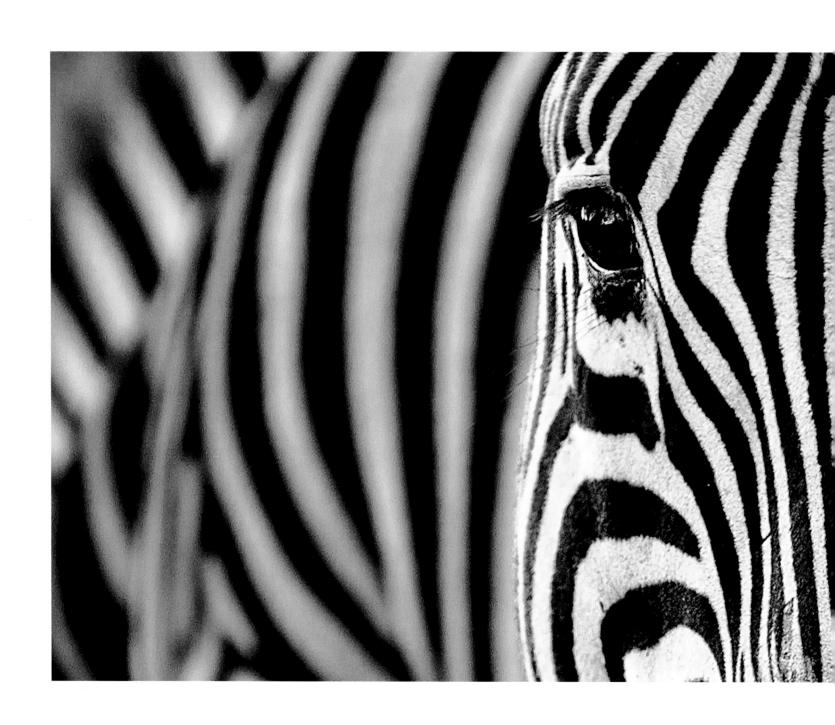

SOUTH AFRICA | CHRIS GRAY

The kind eyes of this zebra look out from behind its stripes. Scientists think the elaborate pattern—no two zebra coats are the same—may confuse predators or repel pesky insects.

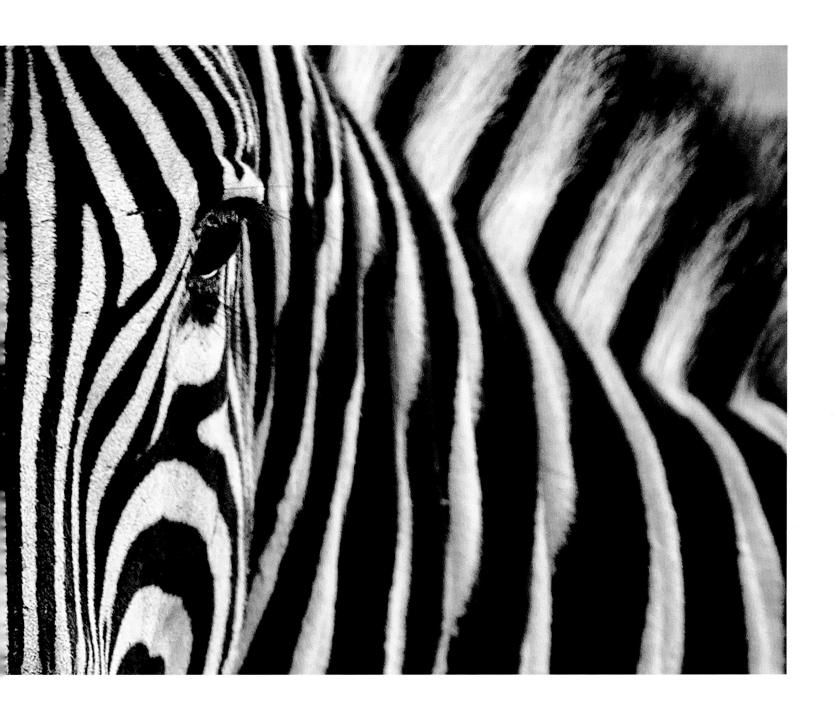

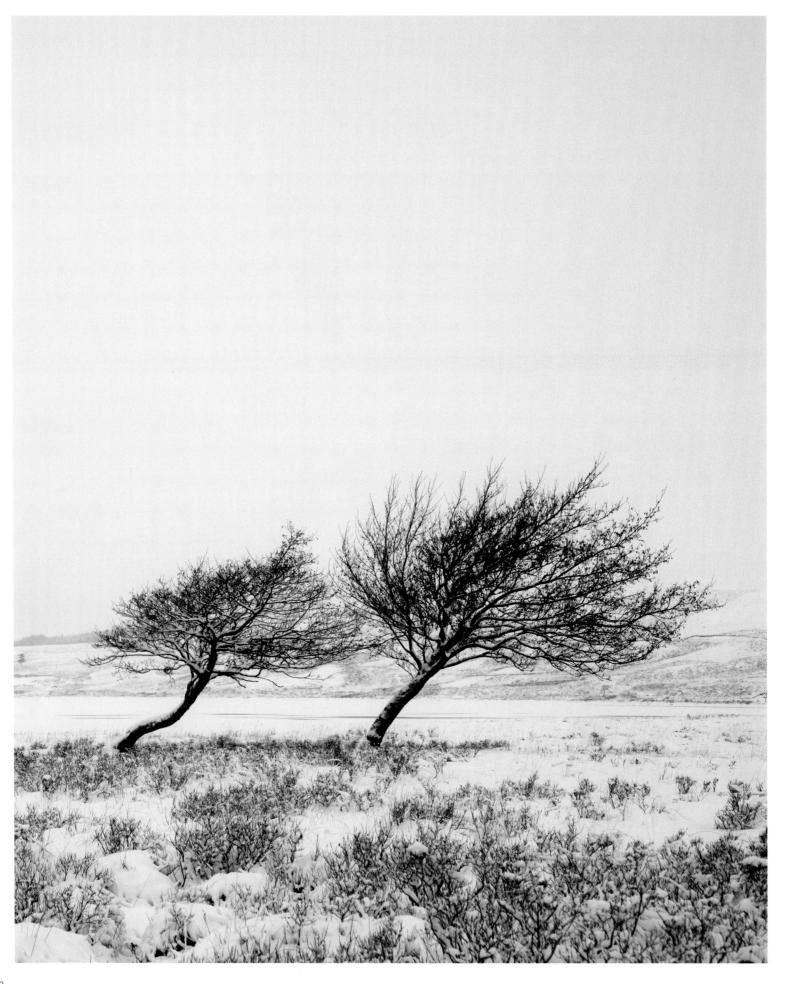

On Earth, wind gusts can blow more than 200 miles an hour (322 kph)—about as fast as a race car's top speed. In contrast, on Neptune the wind blows up to 1,243 miles an hour (2,000 kph)—about the top speed of an F/A-18 Hornet fighter jet.

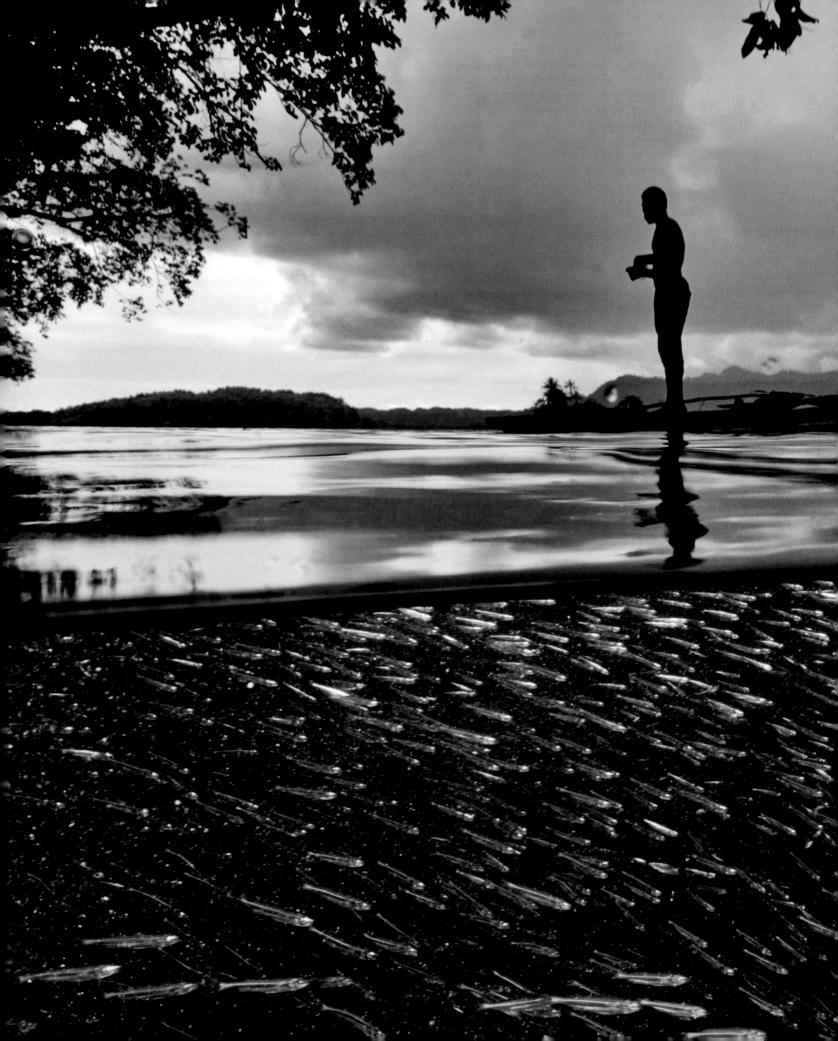

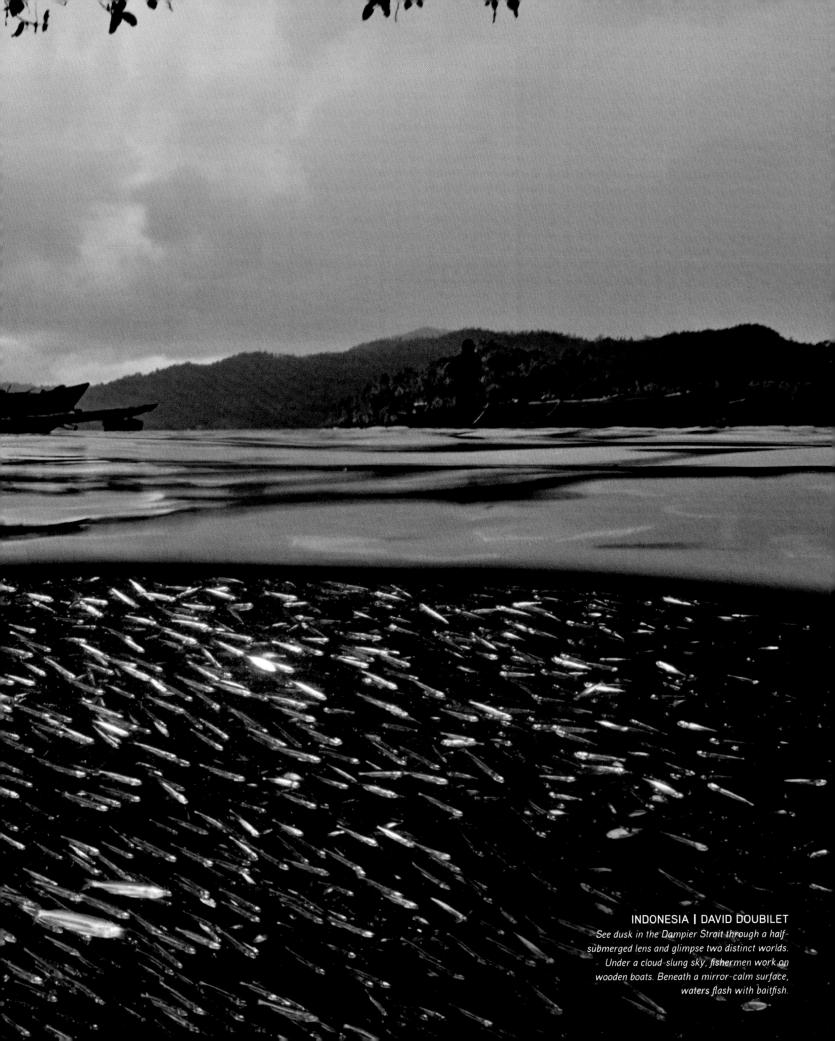

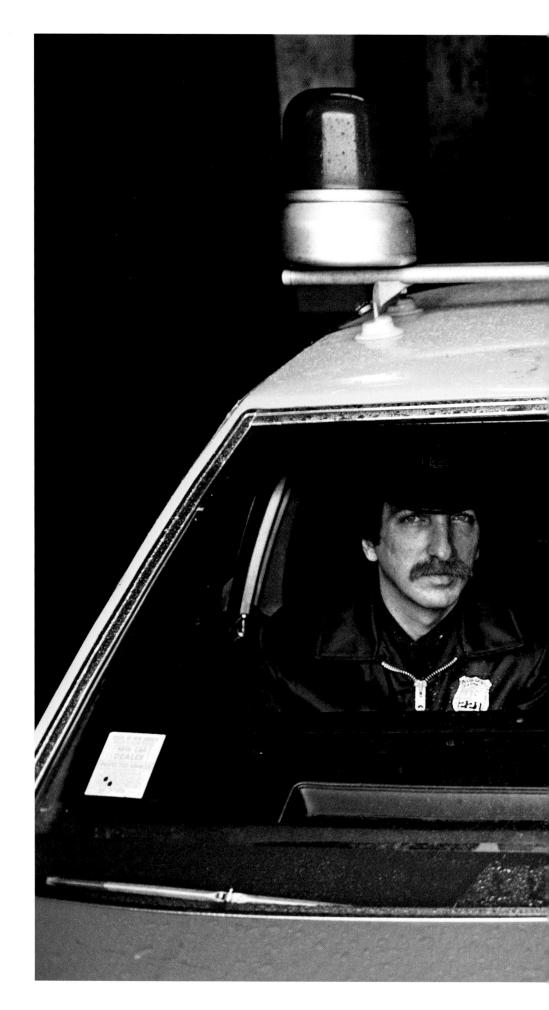

NEW JERSEY, UNITED STATES | MICHAEL S. YAMASHITA

These police officers share more than the same uniform. New Jersey triplets Andrew, Joseph, and Robert Koralja, from left, had a combined 42 years of service in 1981, when this photo was first published.

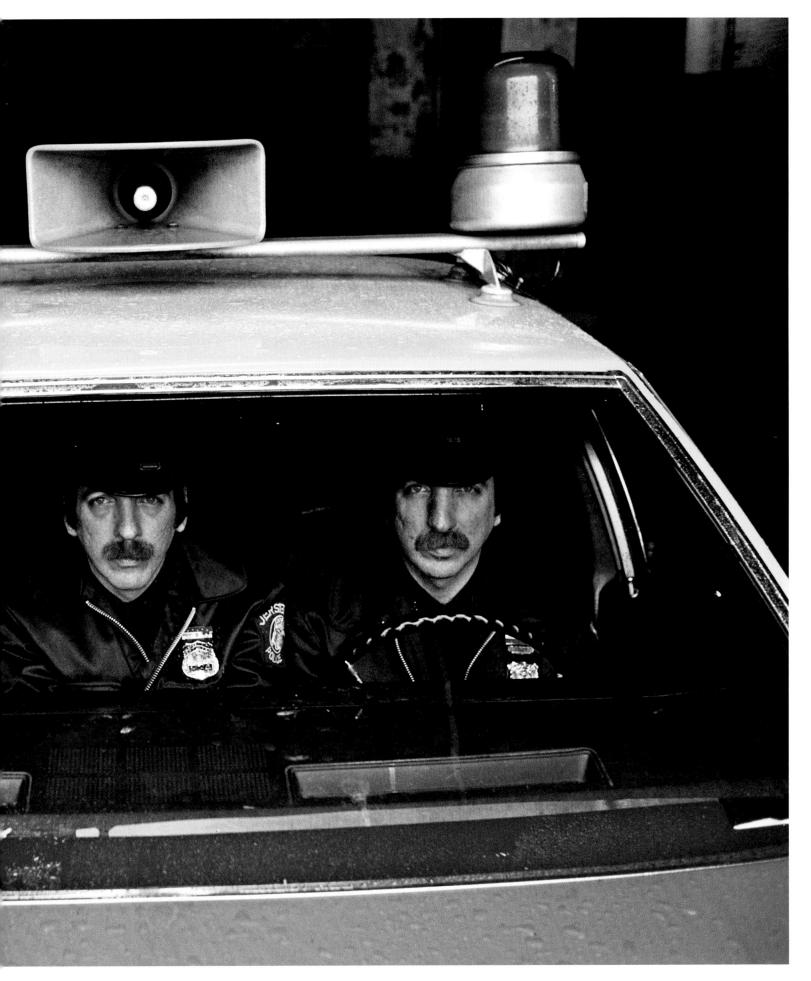

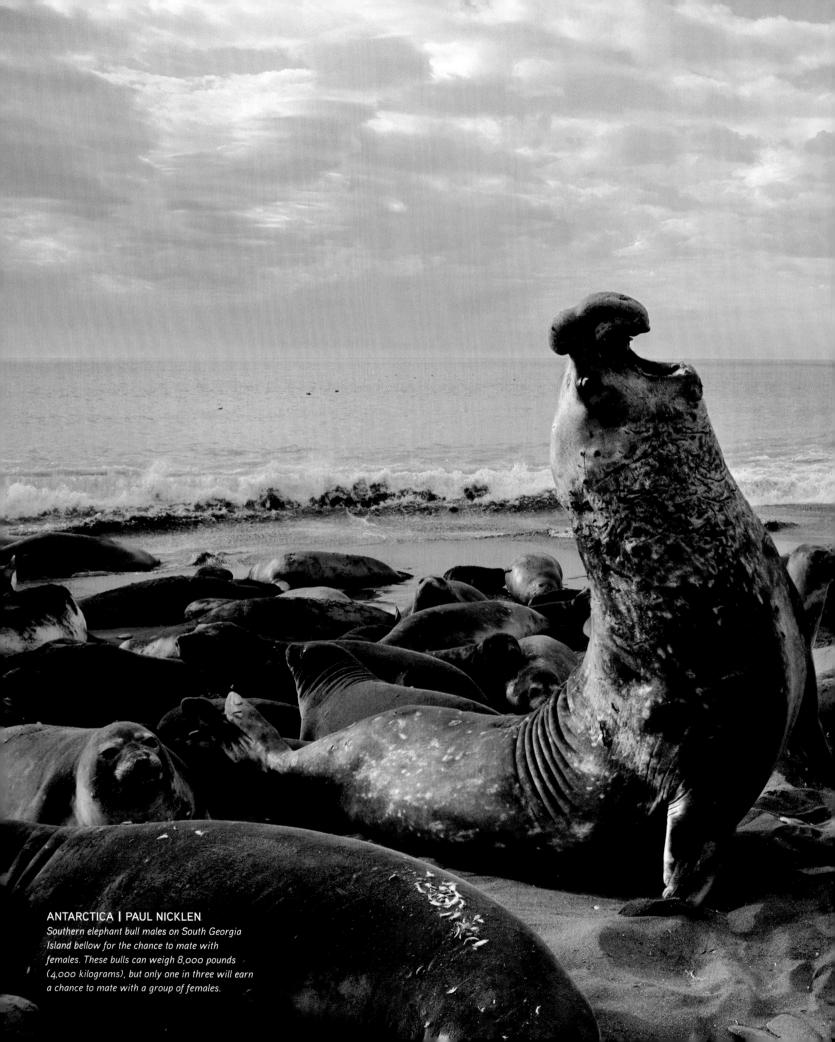

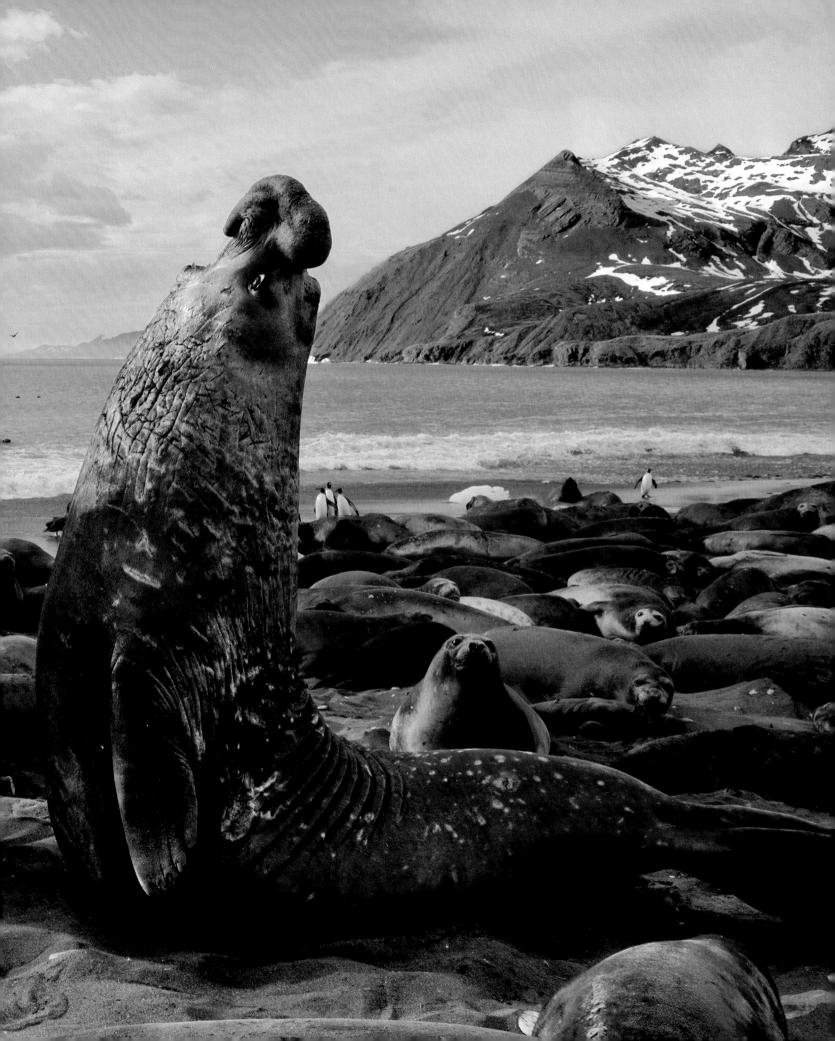

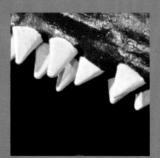

PORTFOLIO EIGHT

mind relaxes in the presence of patterns. Powers of

observation dull, because we think we know what comes next. With a start, an interruption breaks that calm—and yet it sharpens our senses, because we begin to look again, more closely, more carefully, not only to regain the comfort of the regular but also to find some explanation for the appearance of the unexpected.

A golden retriever has a litter of ten, and nine of the puppies are born creamy white, but one has a black stripe right down his snout—an unexpected blaze, a genetic fluke, a mark that makes the puppy distinct, different, all the more lovable.

Photographers roam the world in search of the unexpected, because they know that when a photo breaks the rules, it grabs attention. A photograph of the unexpected makes the viewer look again. It helps the eye to truly see. One black swallowtail butterfly among a flurry of yellow ones. A dandelion holding tall its plump yellow bloom among the prize-winning tulips. One schoolchild breaking the rules and looking the other way. A tiny salamander, audaciously orange among the earthy leaf mold of the brown forest floor.

Sometimes there is no explanation, and what began as a jolt becomes a joke. We toss pattern to the wind, and in our laughter we speak love for this world full of so many possibilities.

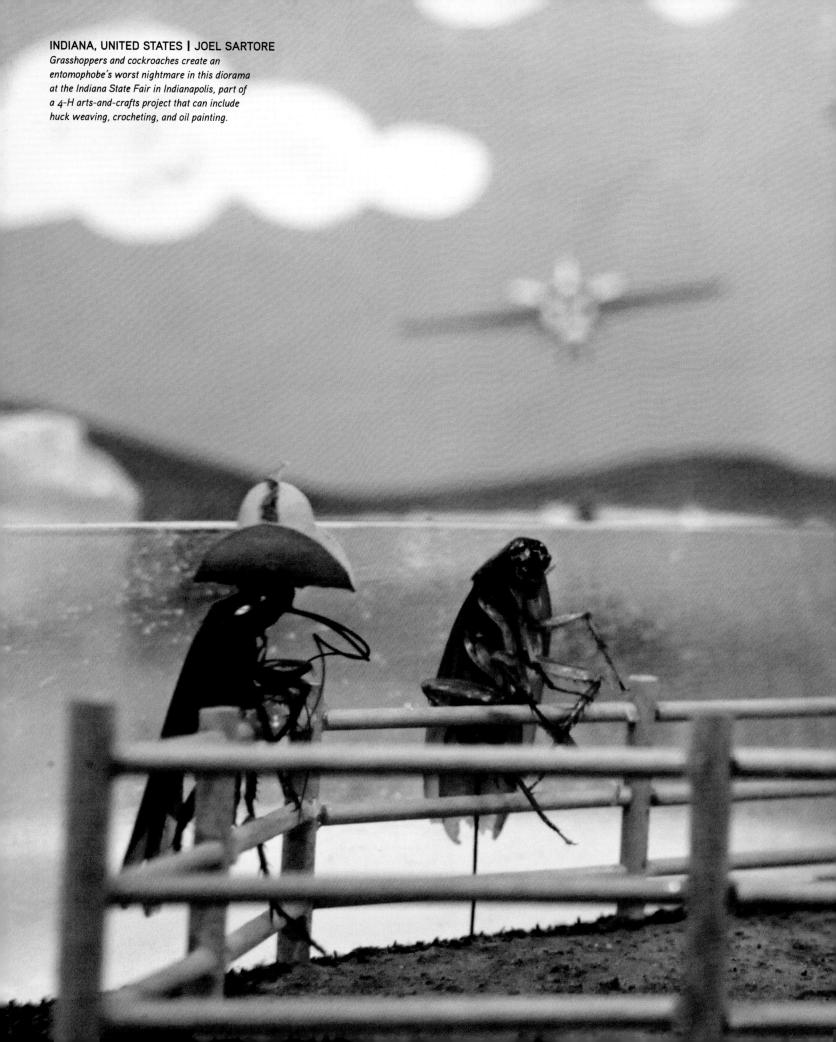

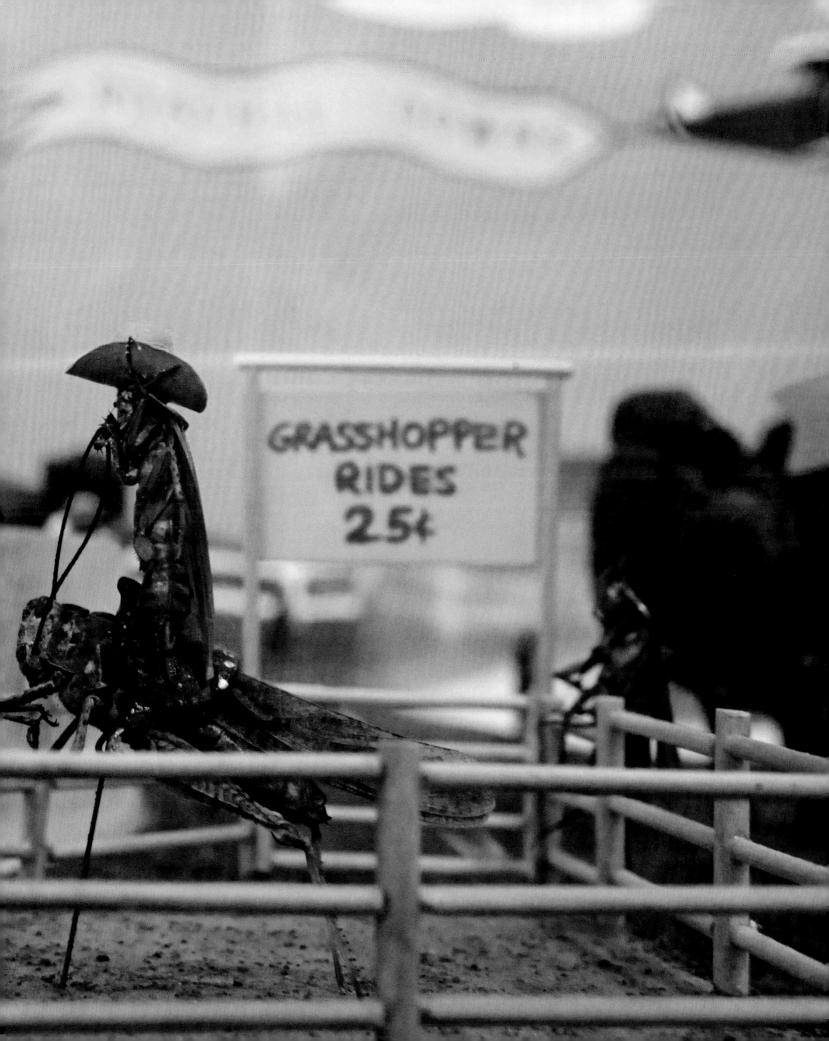

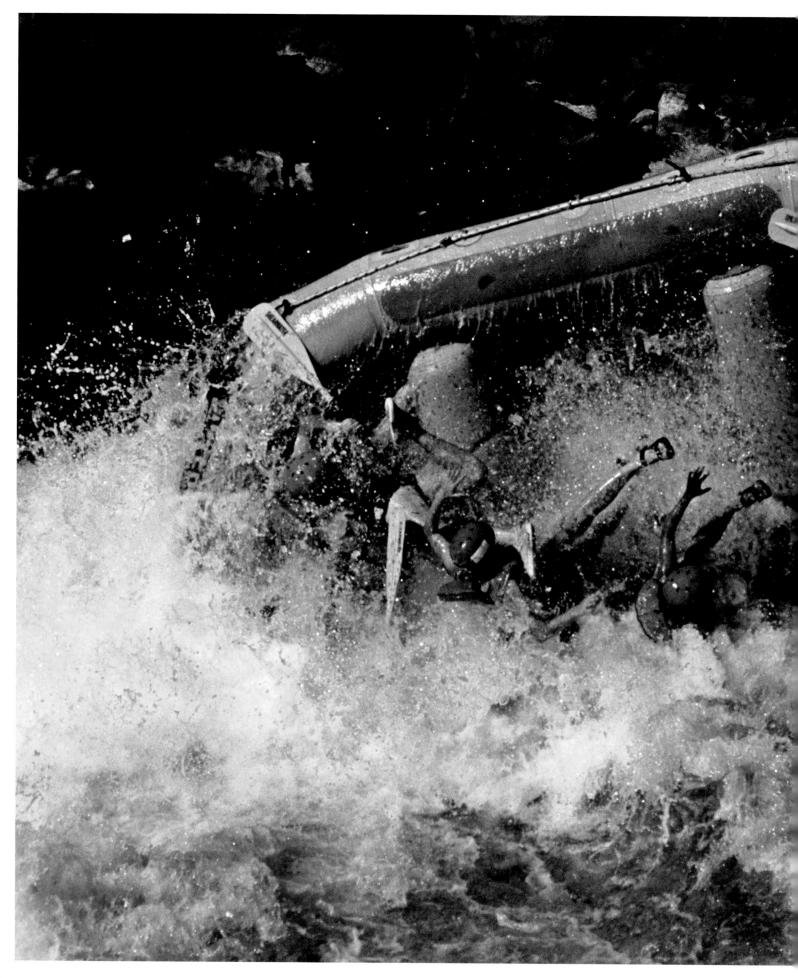

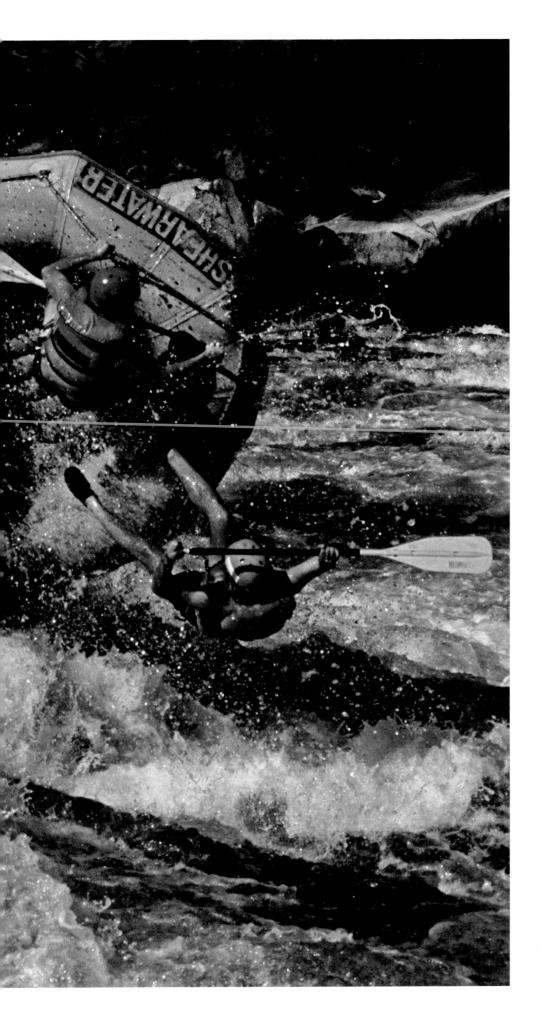

ZIMBABWE | CHRIS JOHNS

Class V rapids on the Zambezi River prove to be a worthy challenge for these white-water enthusiasts. These rapids, located near Africa's famous Victoria Falls, may not have the glory of that 355-foot (108-meter) drop, but this one you can survive.

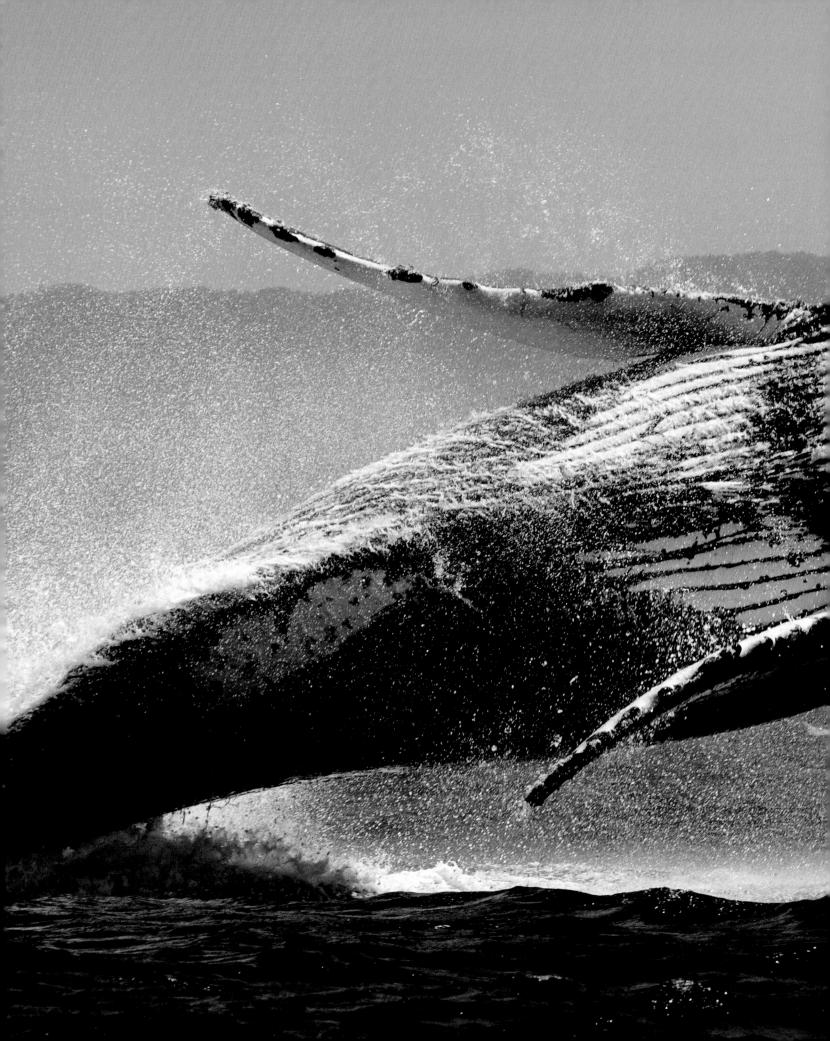

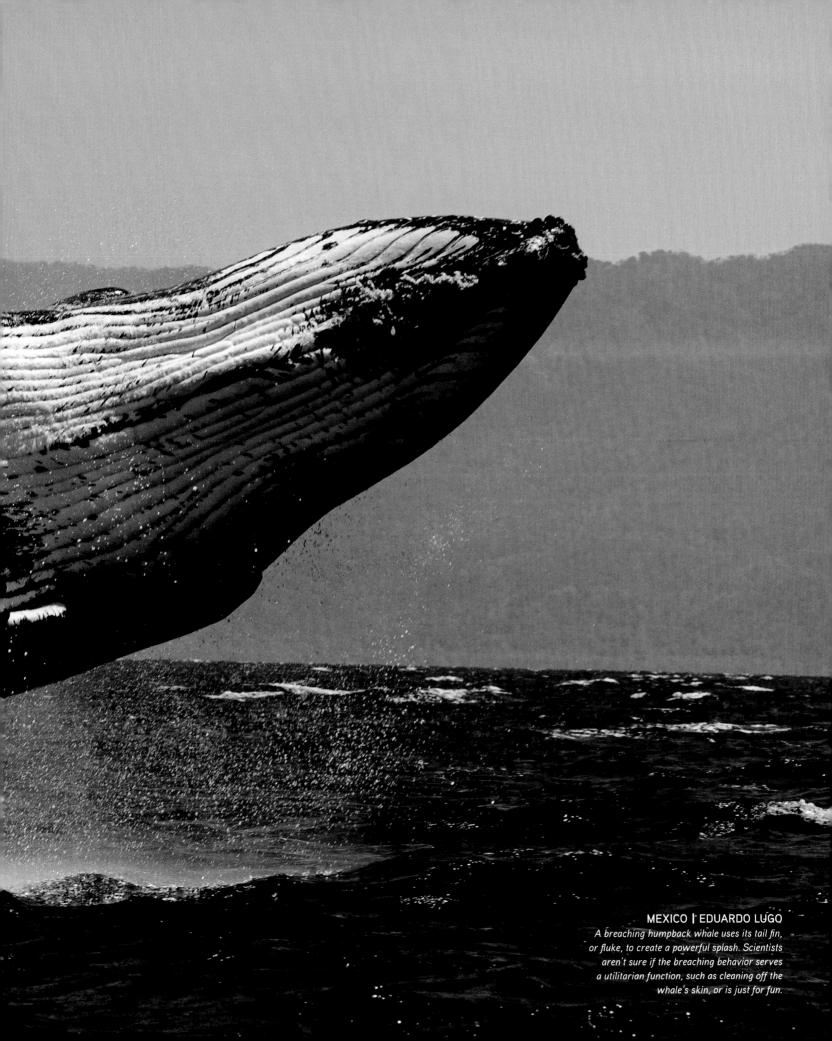

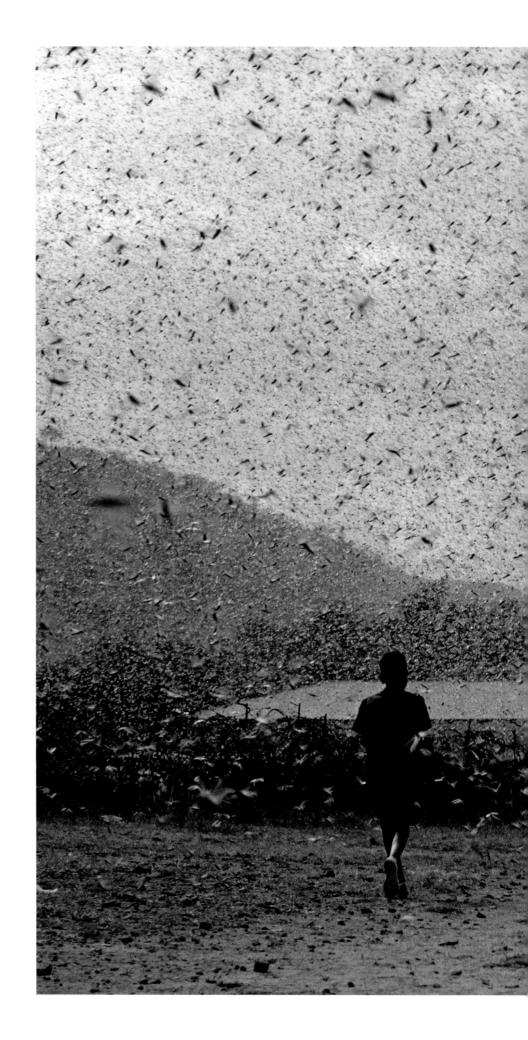

ETHIOPIA | GIANNI TORTOLI

A blizzard of locusts overtakes the town of Keren. Grasshoppers are normally solitary insects, but excessive crowding causes a switch in their behavior to what scientists call a gregarious state and results in a migrating swarm.

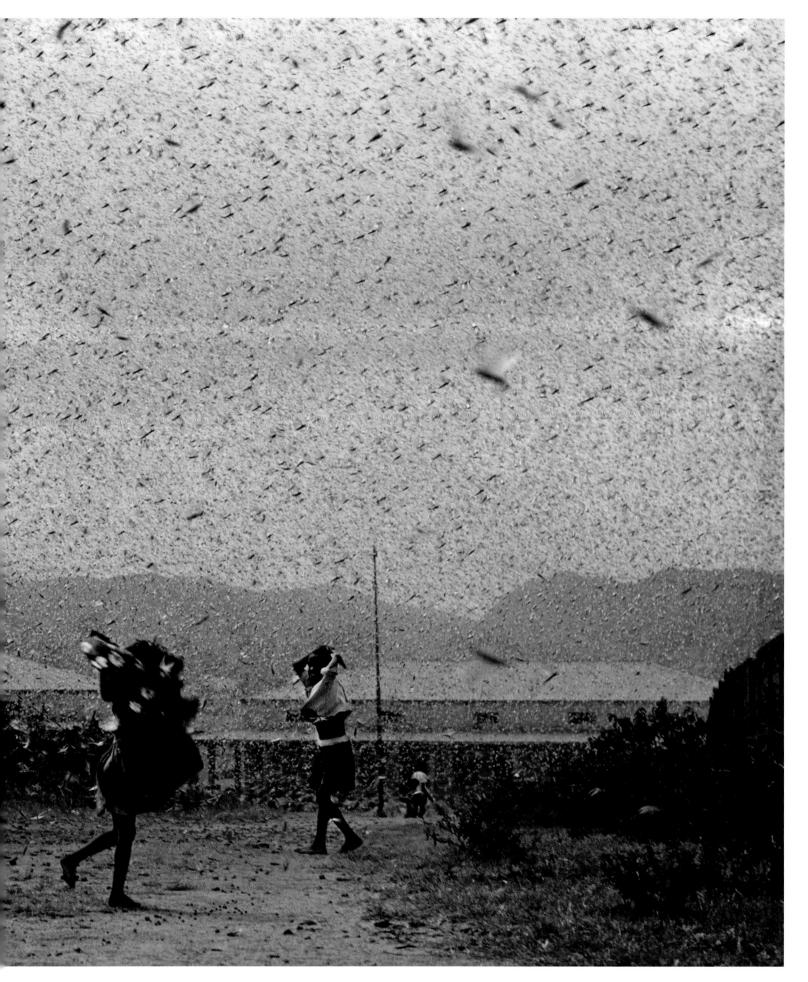

There are more than
a billion birds living
on the planet at any given time.
The most common
is the CHICKEN.

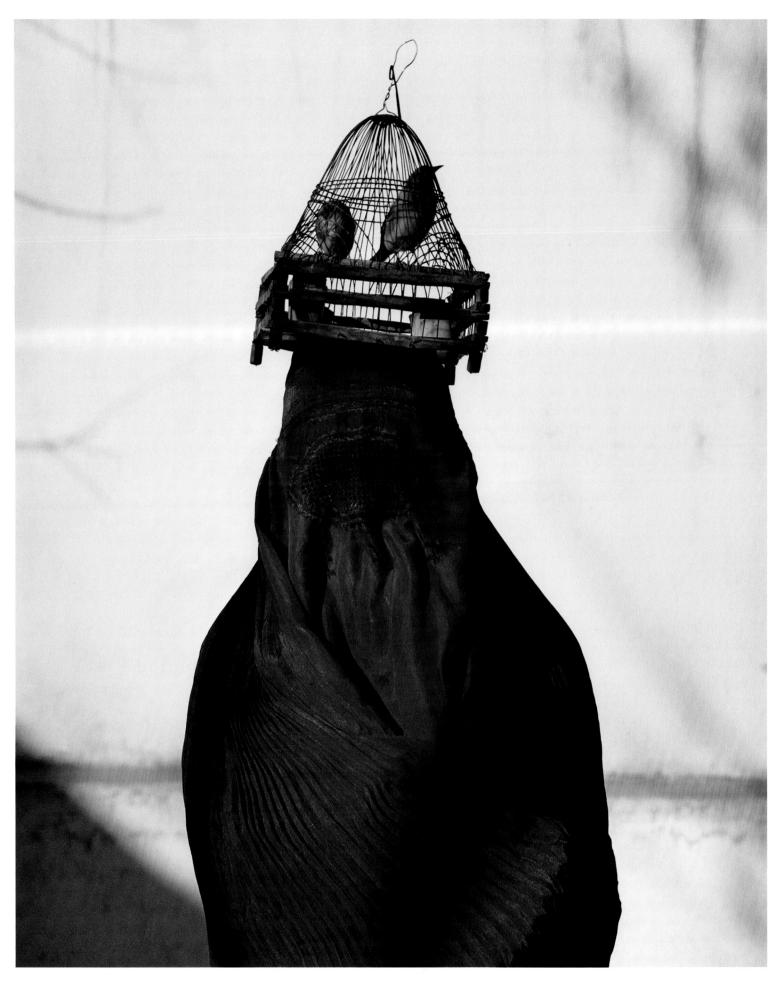

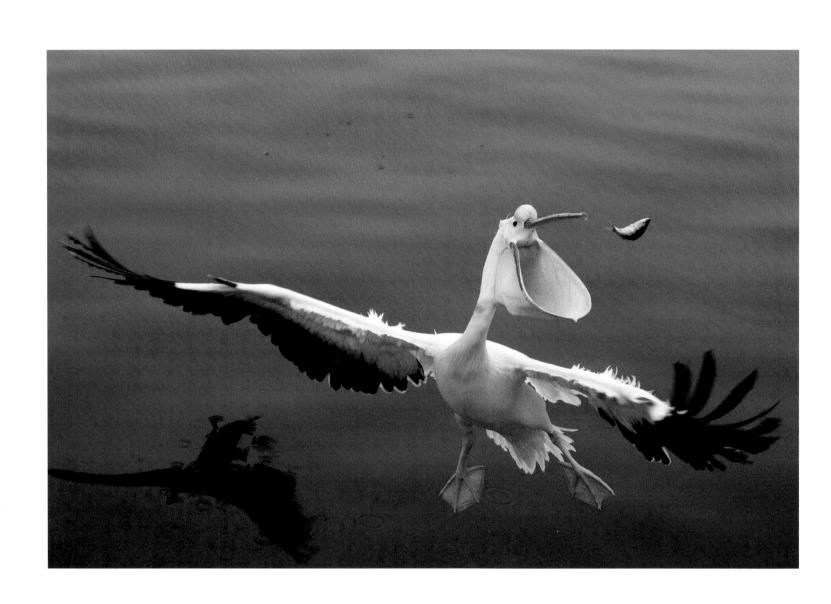

NAMIBIA | LAURENT MERCEY

Its bright pouch agape and two-tone wings spanning perhaps ten feet (three meters), a great white pelican in Walvis Bay sets its sights on a fish breakfast. These migratory birds are found in Africa, Asia, and Europe.

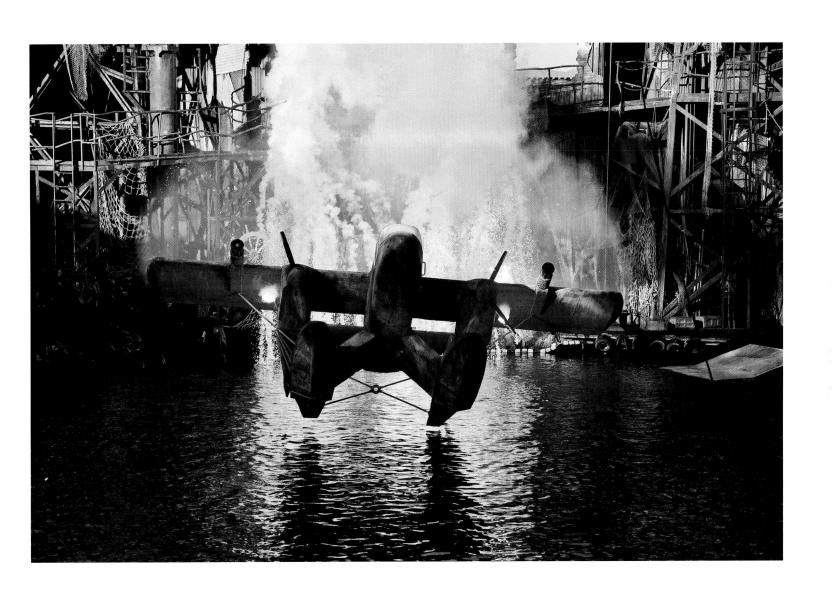

WISCONSIN, UNITED STATES | PRASANNA RAVINDRANATH

Making a fast getaway, a stunt plane departs from a fire on a stage set in West Allis, Wisconsin. The film shoot adds fiery action to this town of some 60,000 residents near Milwaukee.

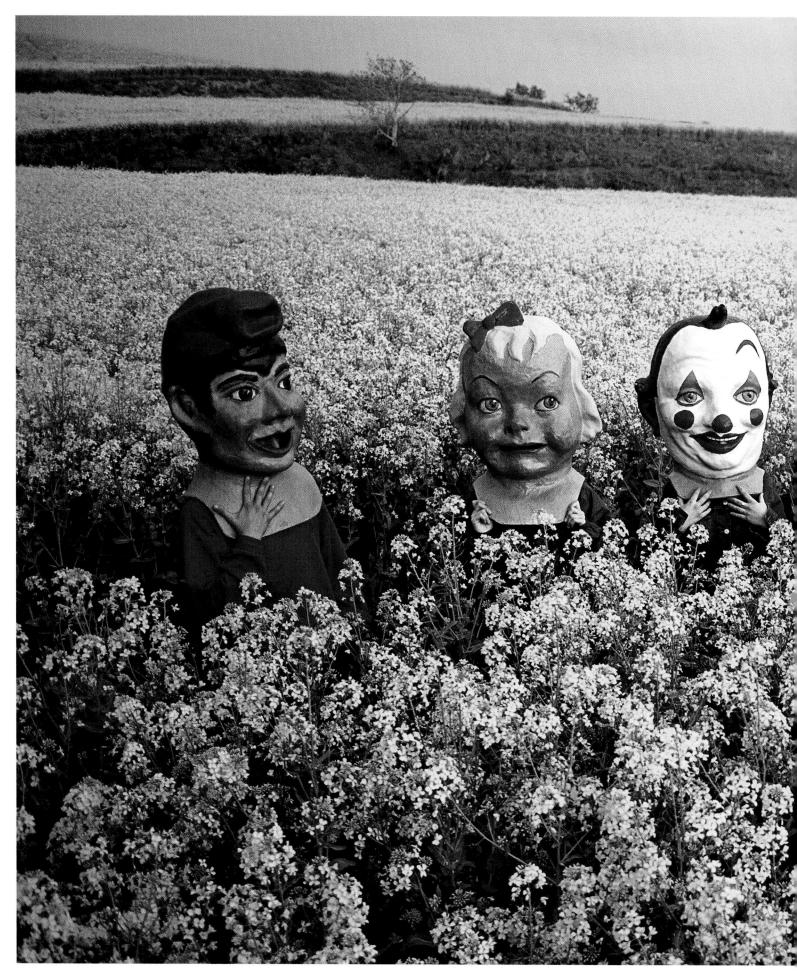

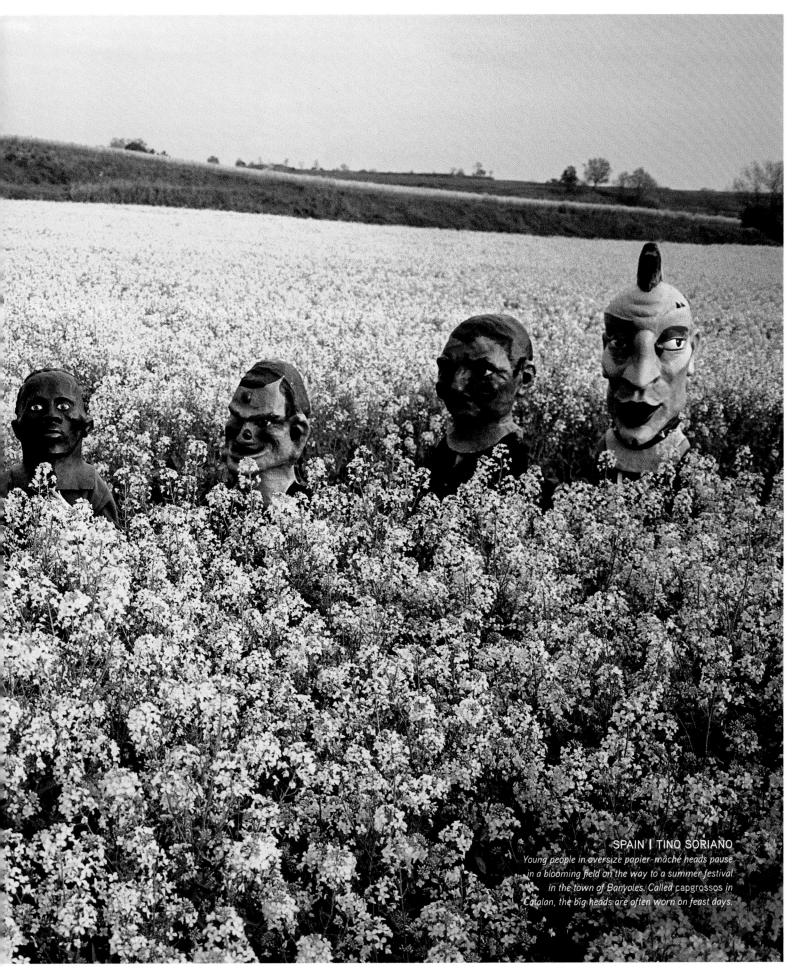

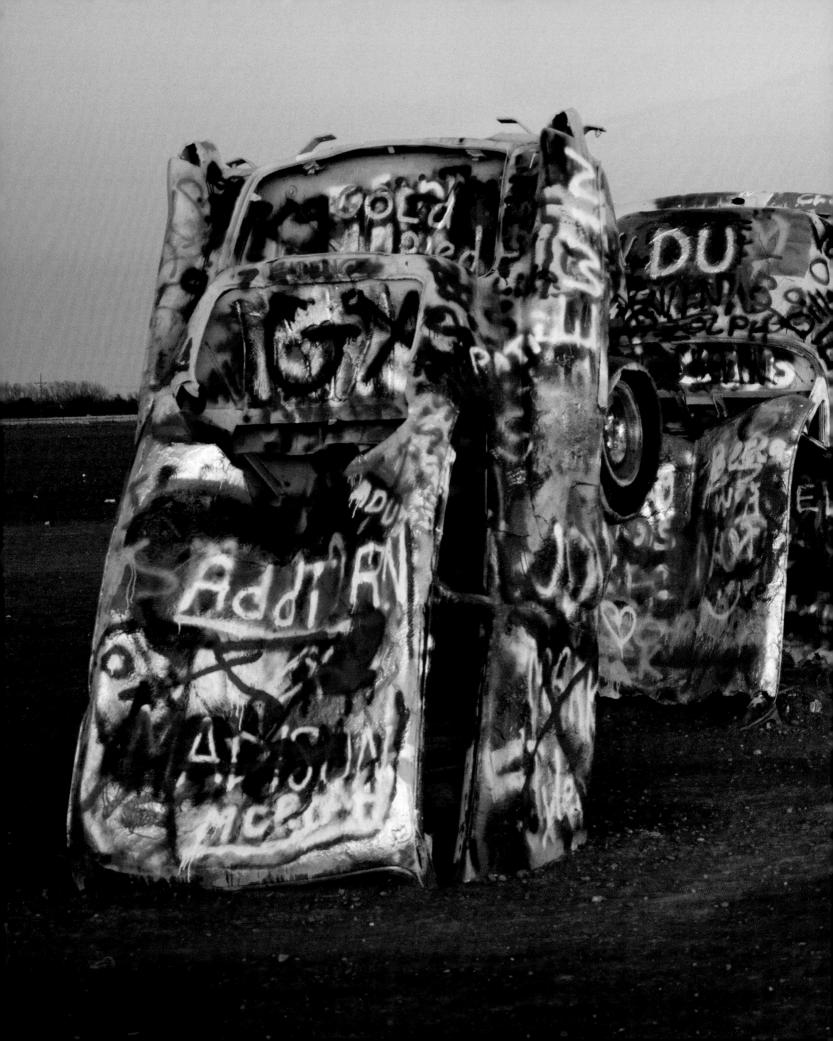

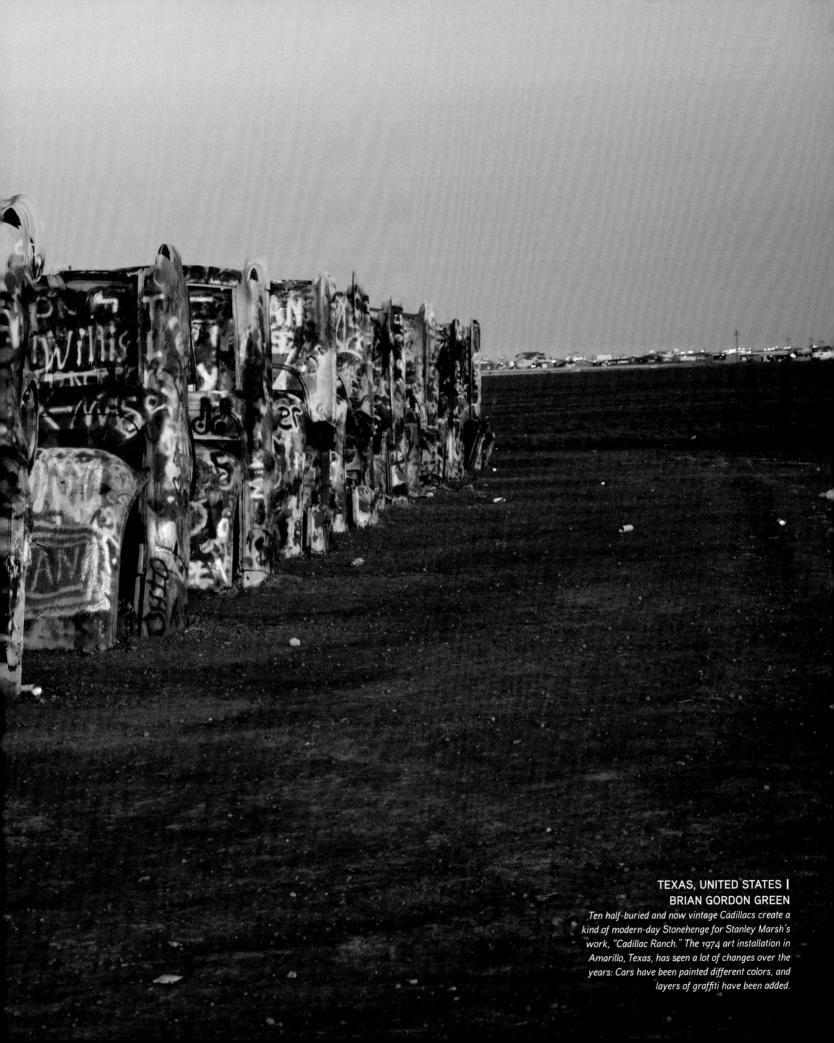

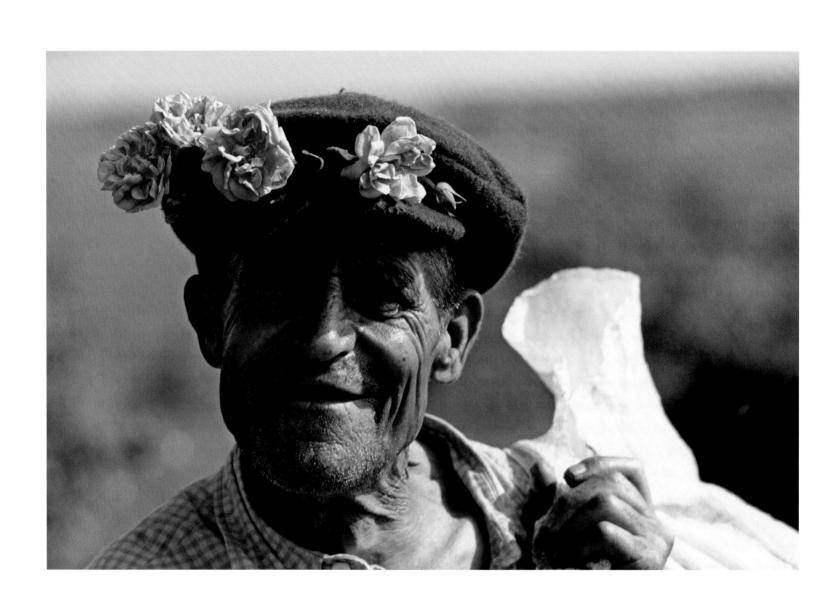

BULGARIA | JAMES L. STANFIELD

A Bulgarian rose picker, up since the crack of dawn, decorated his hat with his trade. The roses are picked early, before the sun can evaporate their oil.

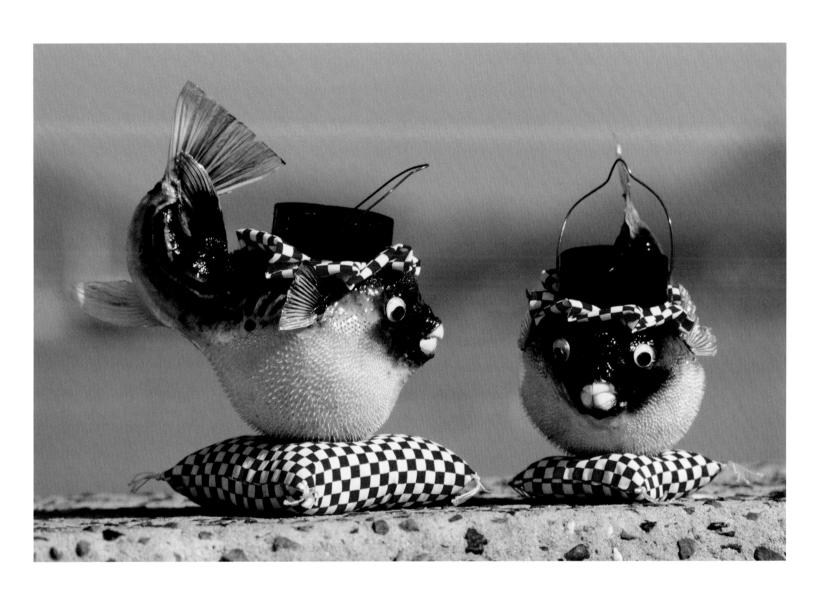

JAPAN | JOSEPH SCHERSCHEL

These lantern souvenirs, available in Shimonoseki, are made from the skin of the small puffer fish. The fish are filled with sawdust to retain their shape, dried, fitted with candles, and sold as good-luck charms.

SOUTH AFRICA | SUSAN MCCONNELL

A cheetah appears to laze away the day on the floor of a safari lodge in Hoedspruit. Wild cheetahs have a much more uncertain future, as their numbers have fallen by 90 percent since the late 1800s.

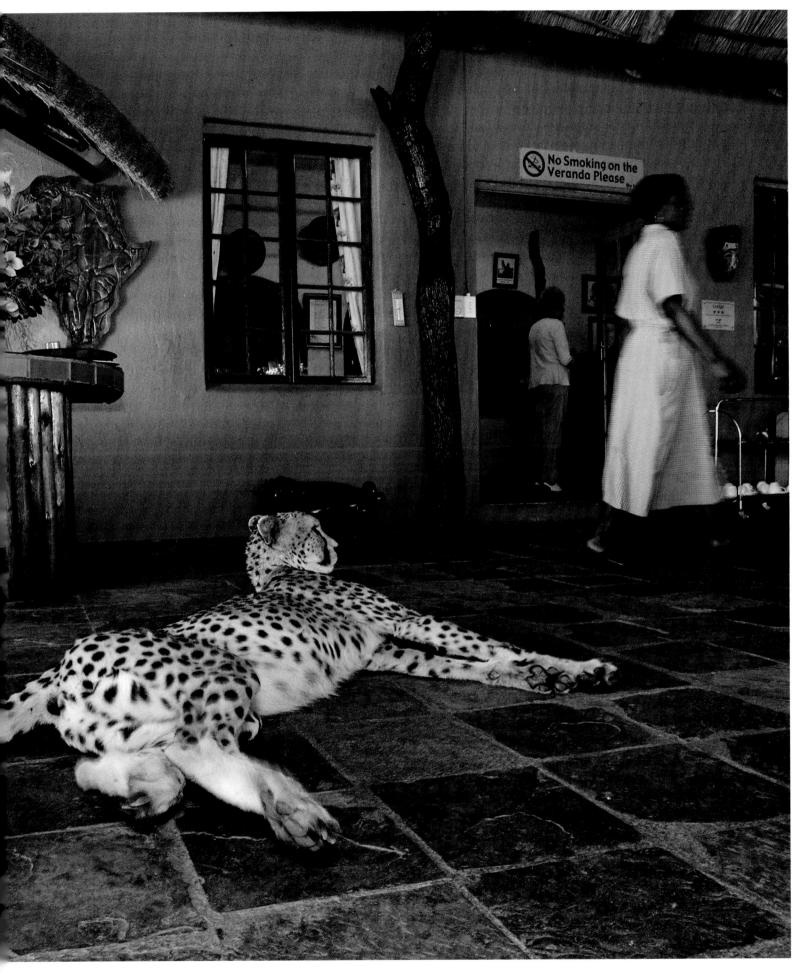

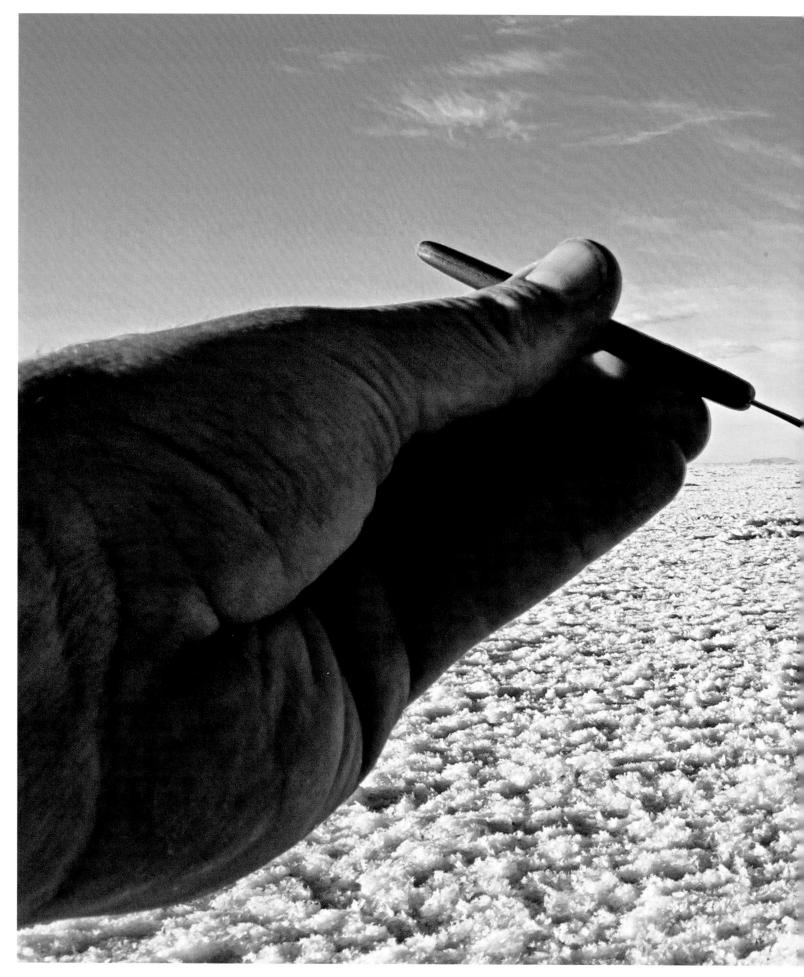

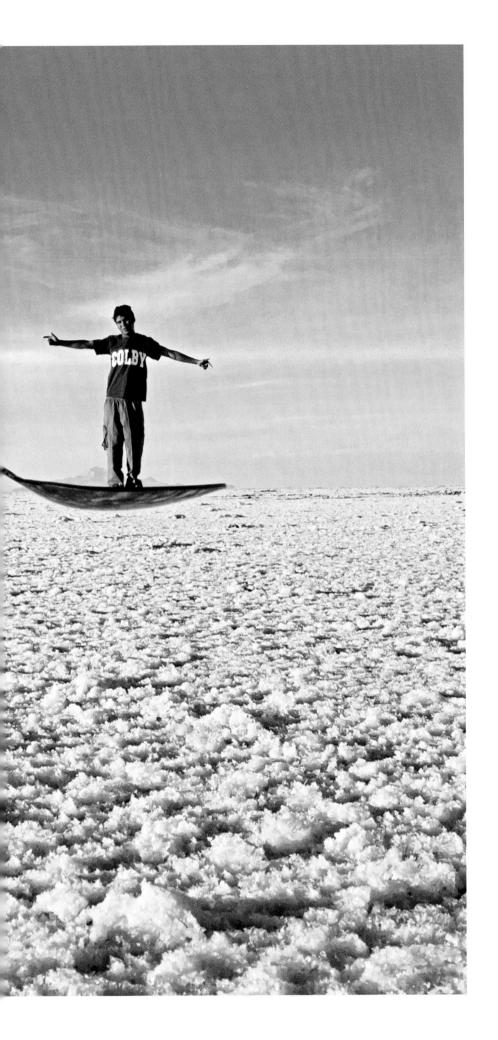

BOLIVIA | MIKE THEISS

Just add a pinch of . . . ? This man appears to stand on a spoon in Salar de Uyuni, the world's largest salt pan. The pan, in Bolivia's Altiplano, can be seen from space.

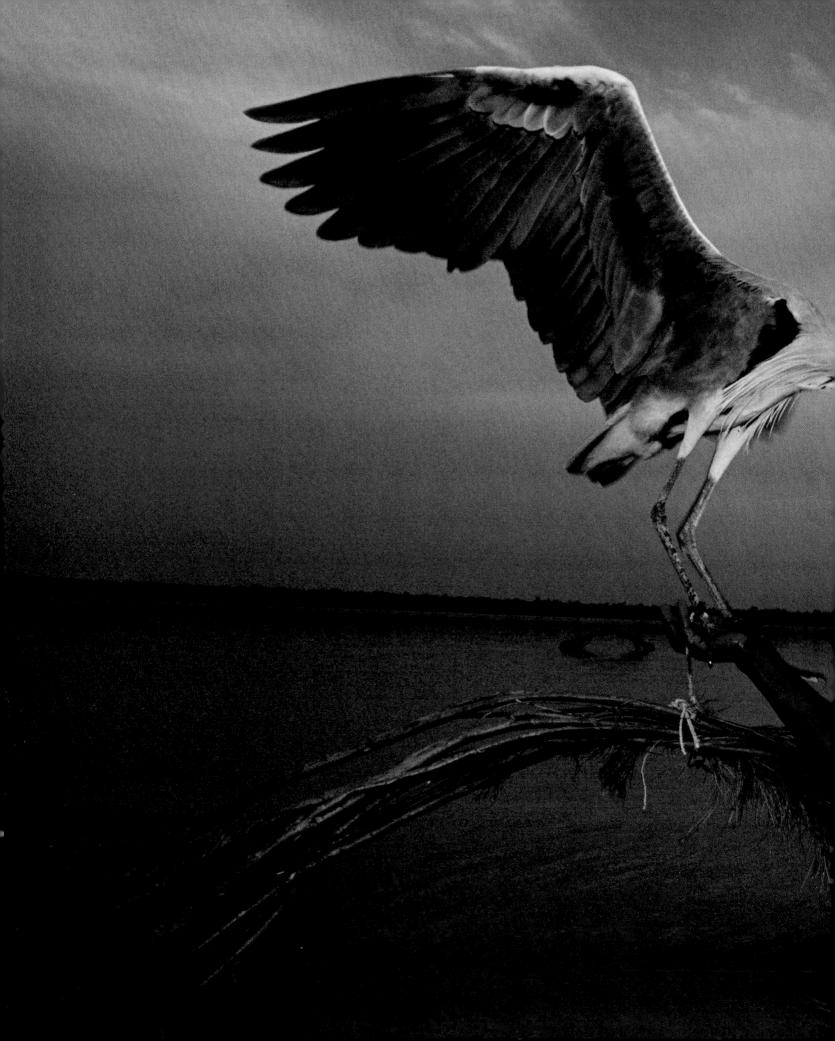

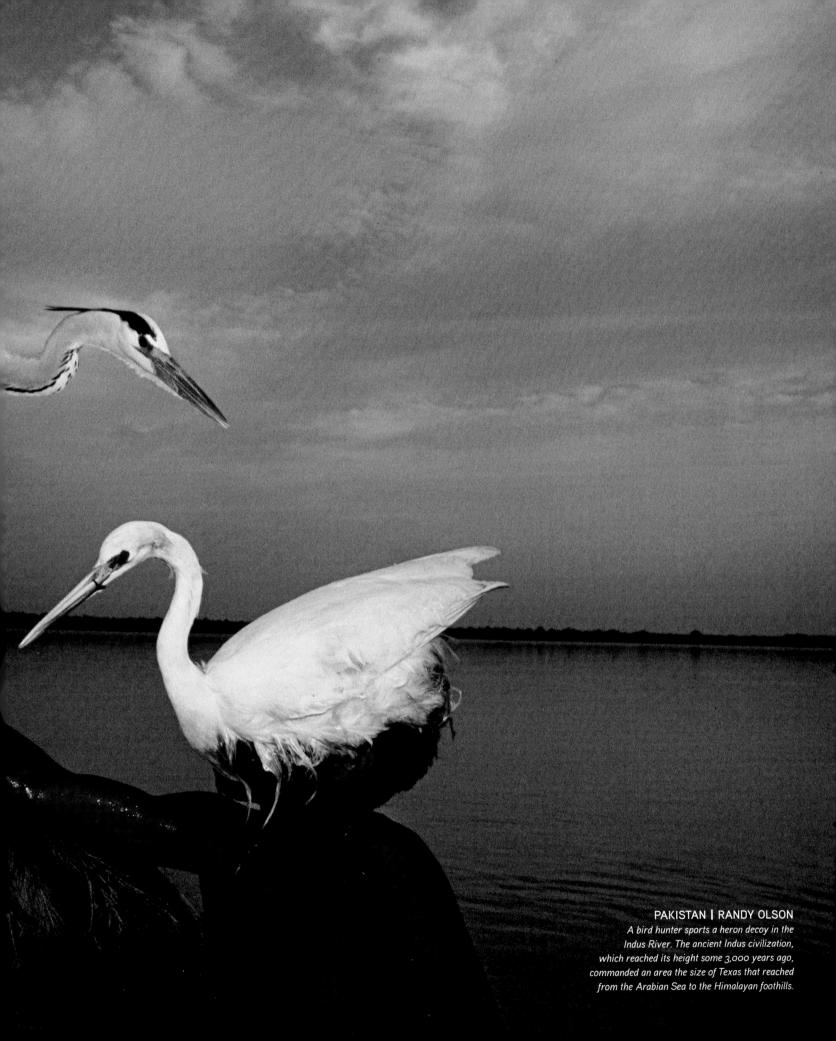

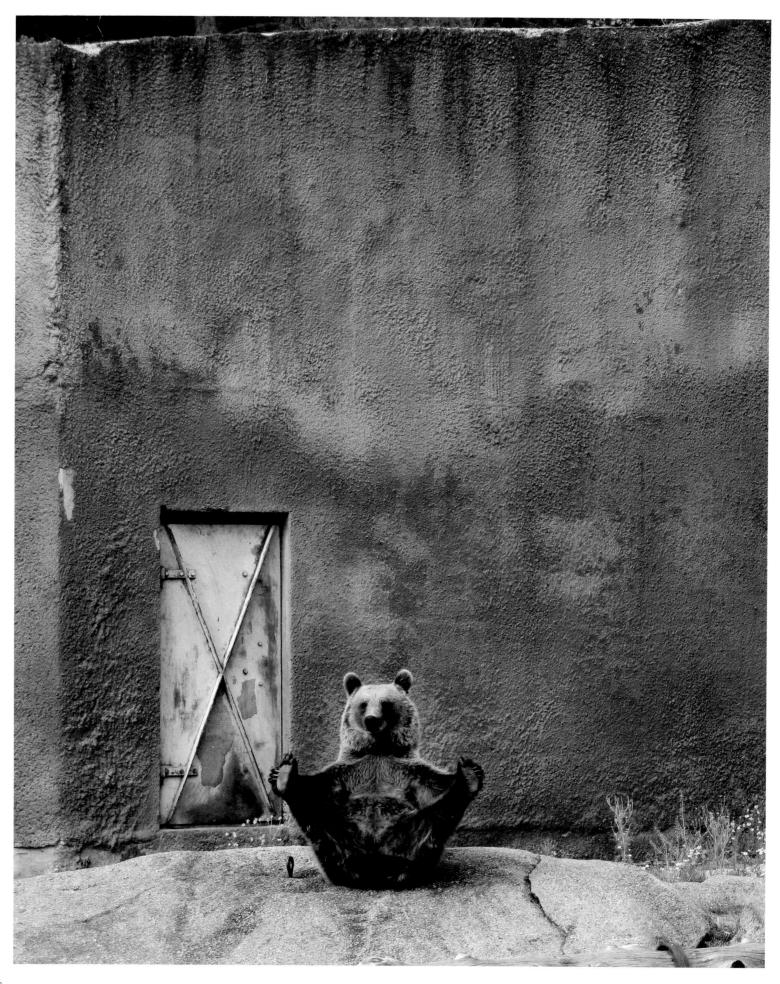

During its winter hibernation,
the BROWN BEAR'S
heart rate and metabolism

Slow down and it does not urinate
or defecate. Most amazing of all,
the female sleeps even during the
birth of her cubs.

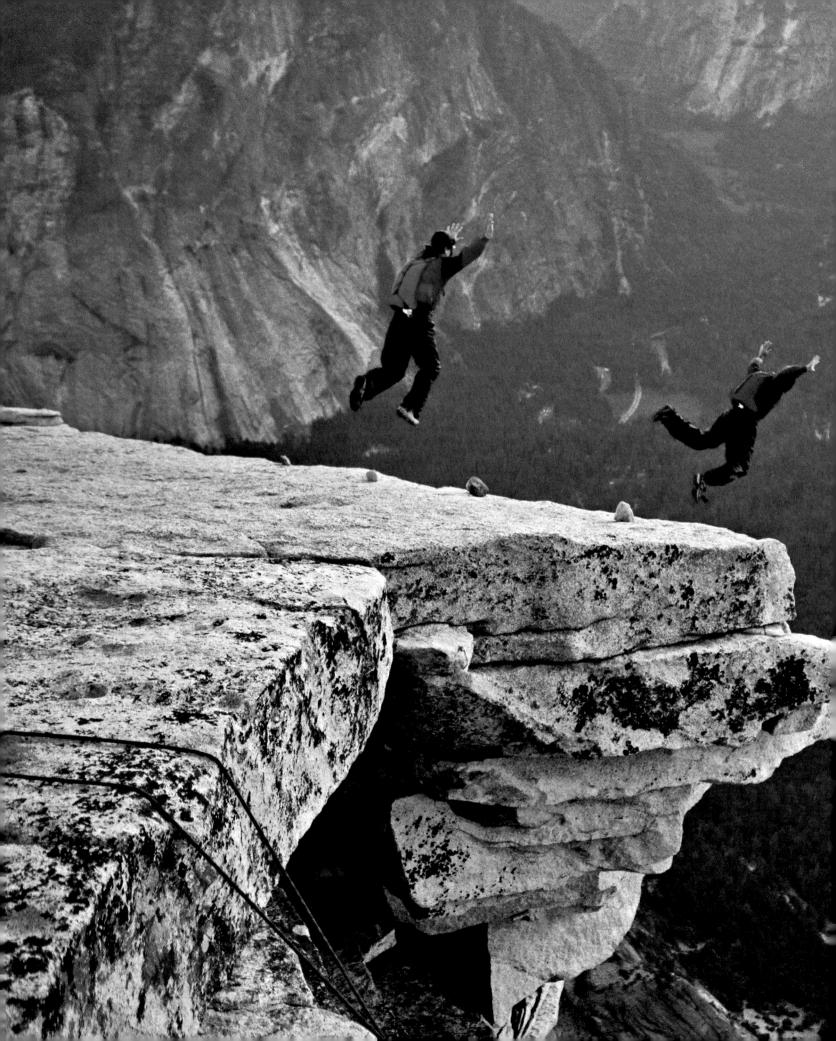

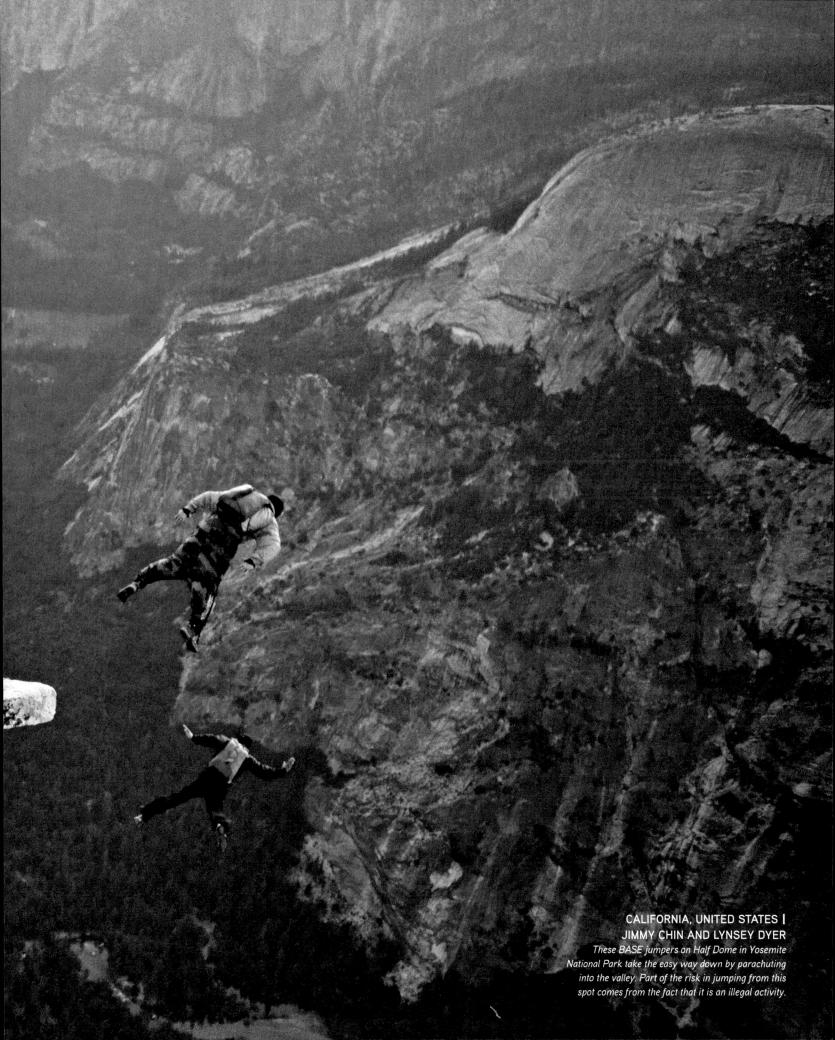

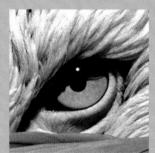

PORTFOLIO NINE

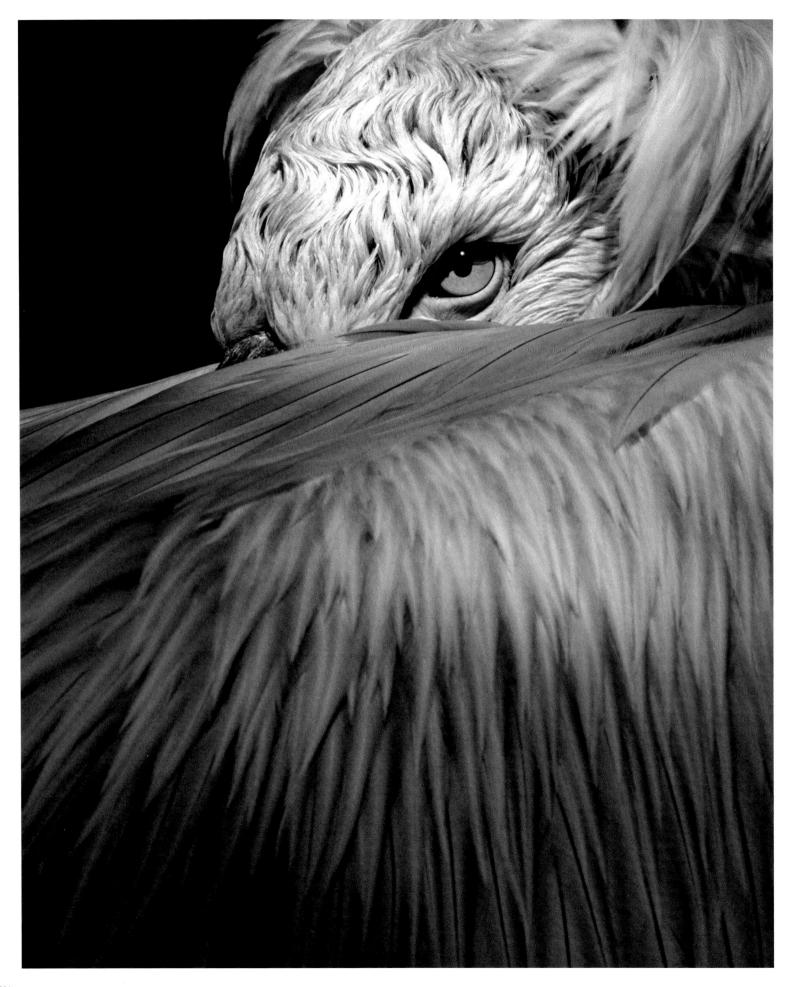

has said that the eyes are the windows of the soul—through them we look into the heart—but the eyes are also the spyglass of perception. We do not have 360-degree vision. Our human eyes partition the world into seen and unseen. Each person establishes his own perspective; each gathers in light and information from her own point of view. A chosen perspective can reveal a new truth.

More than anyone else, photographers know the importance of perspective—the angle of view, the slant of light, the tilt of the camera, the startling combination of subjects fused in an image within a moment's frame. Philosophers may propose some sort of eternal truth unchanging, but photographers know that with just a glance in another direction, the entire picture changes. Instead of getting caught up in the neon and heights of the city's skyscrapers, a photographer can train our eyes to look down at the worn sidewalks, or to look straight up through the bright lights to the stars. All a matter of perspective.

Some photographs help us gain perspective on the ordinary: a blooming flower seen from root end up, when we are so used to looking down upon the garden. Other photographs share a perspective of the rare: the colorful, gleaming beak of a toucan, a perpendicular echo of the bright flowers near the rain forest floor. Never would we see the two in relationship were it not for the perspective caught by the photographer's camera.

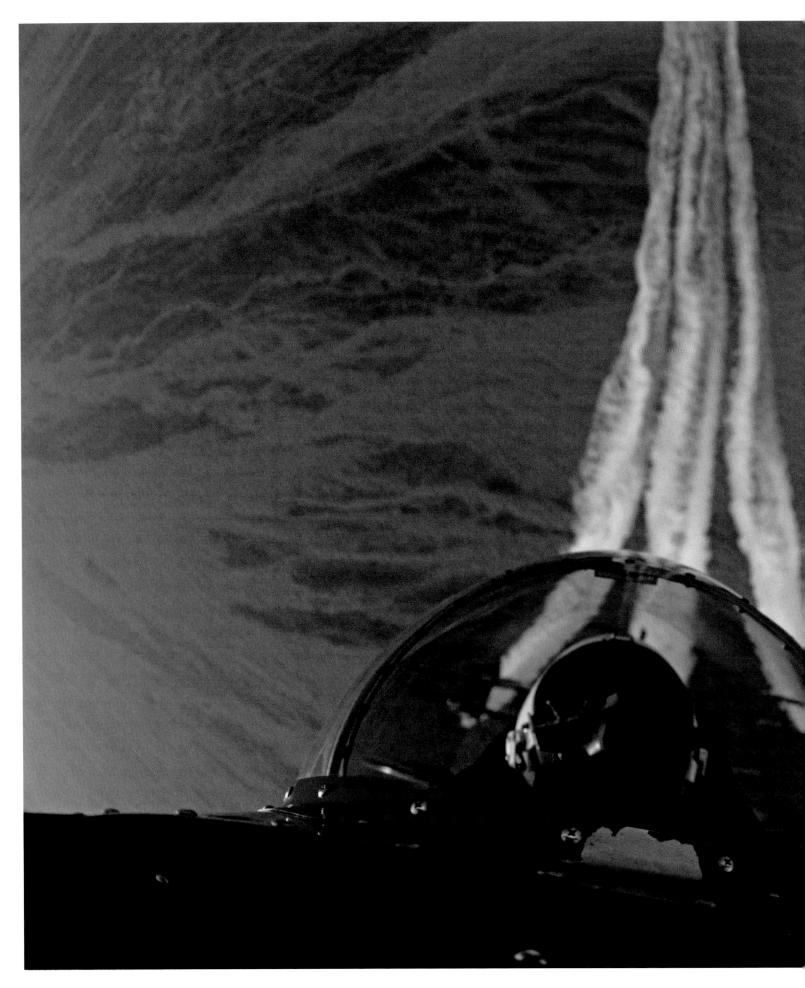

JORDAN | JODI COBB

A fish-eye lens captures a Royal Jordanian Falcons pilot as his plane leaves a contrail behind. The water in the exhaust condenses as ice crystals in the cold, wet air.

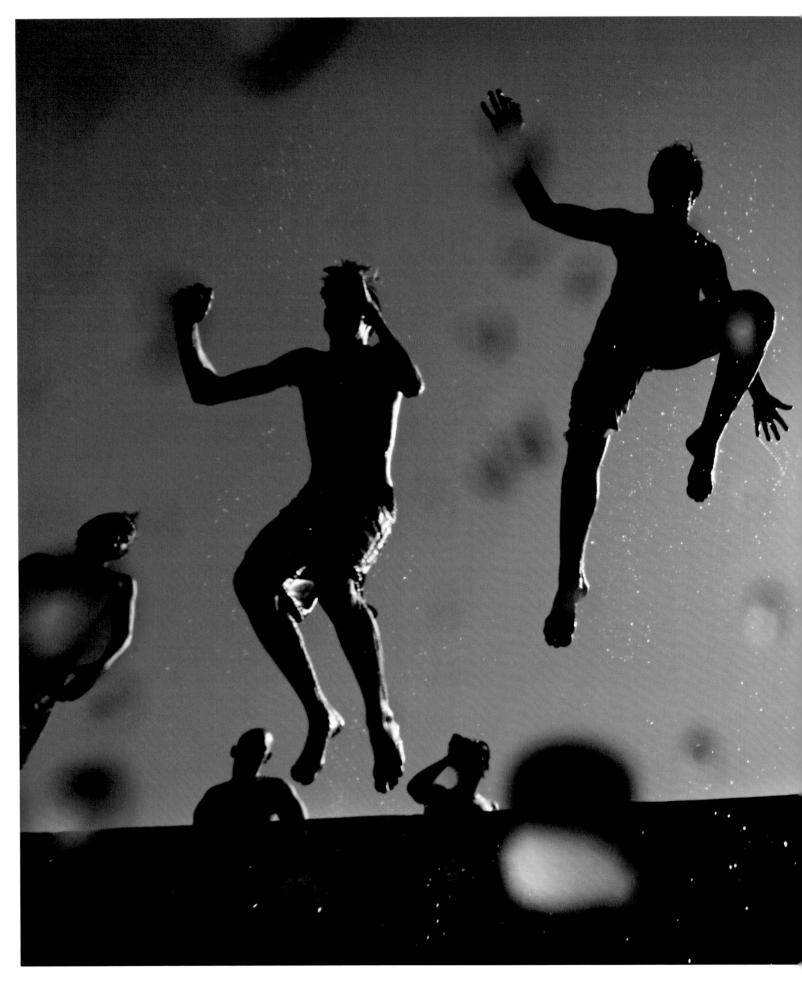

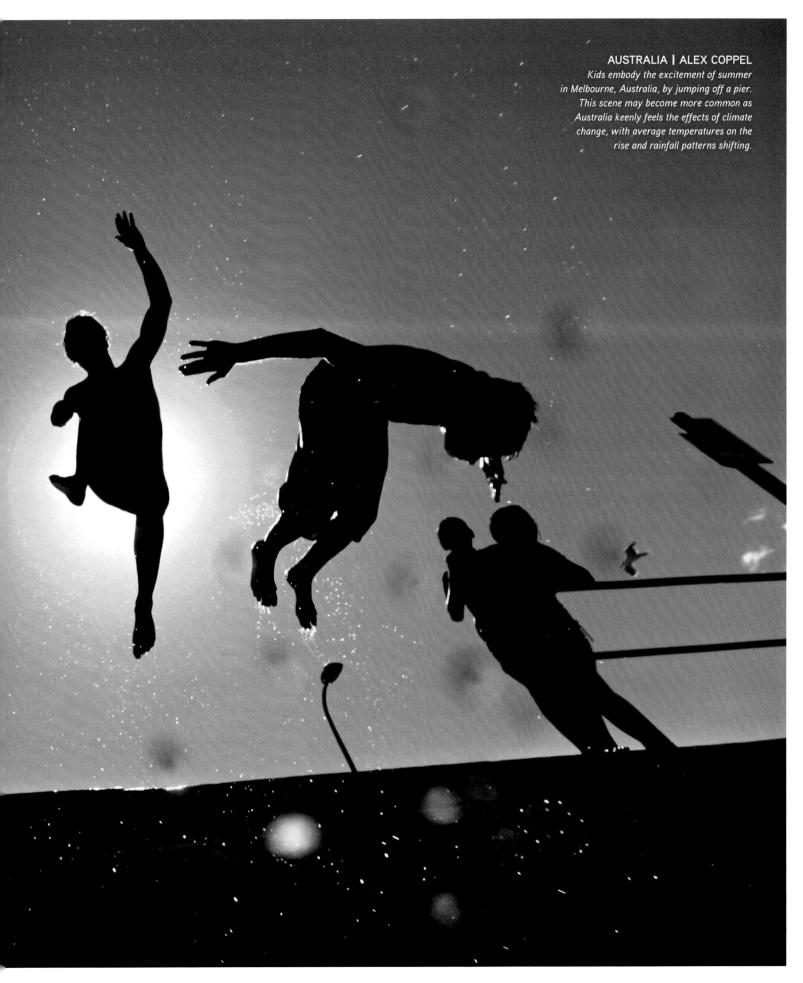

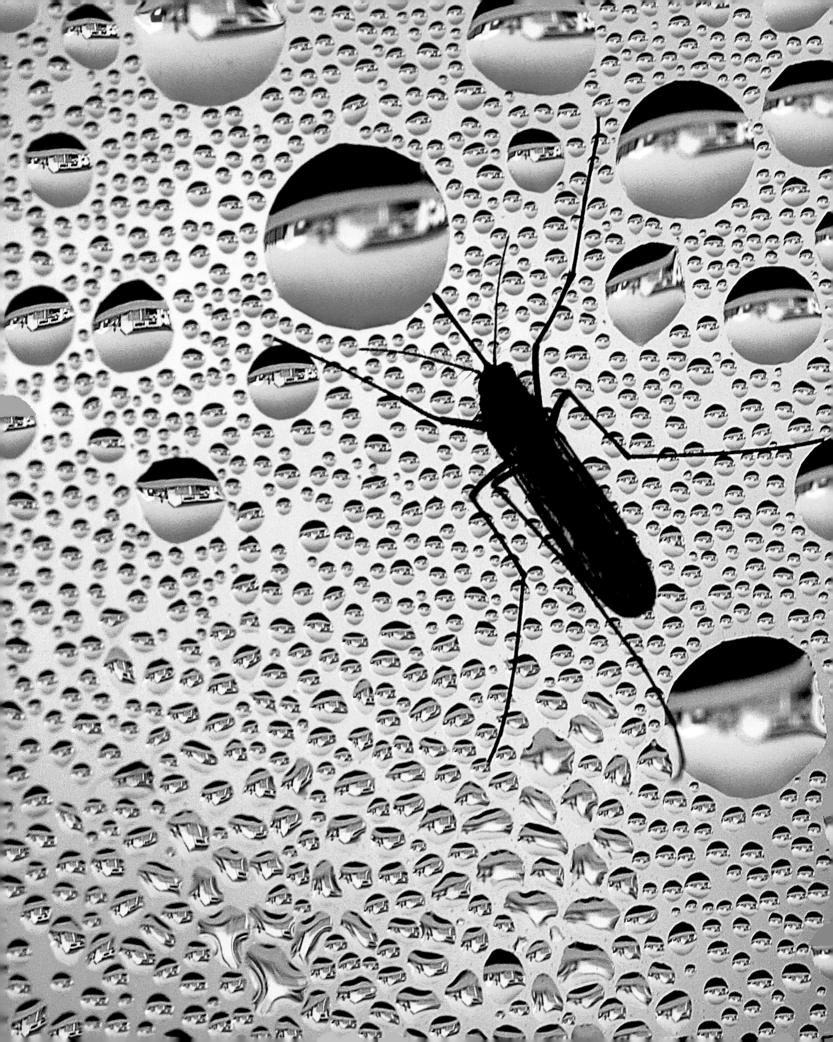

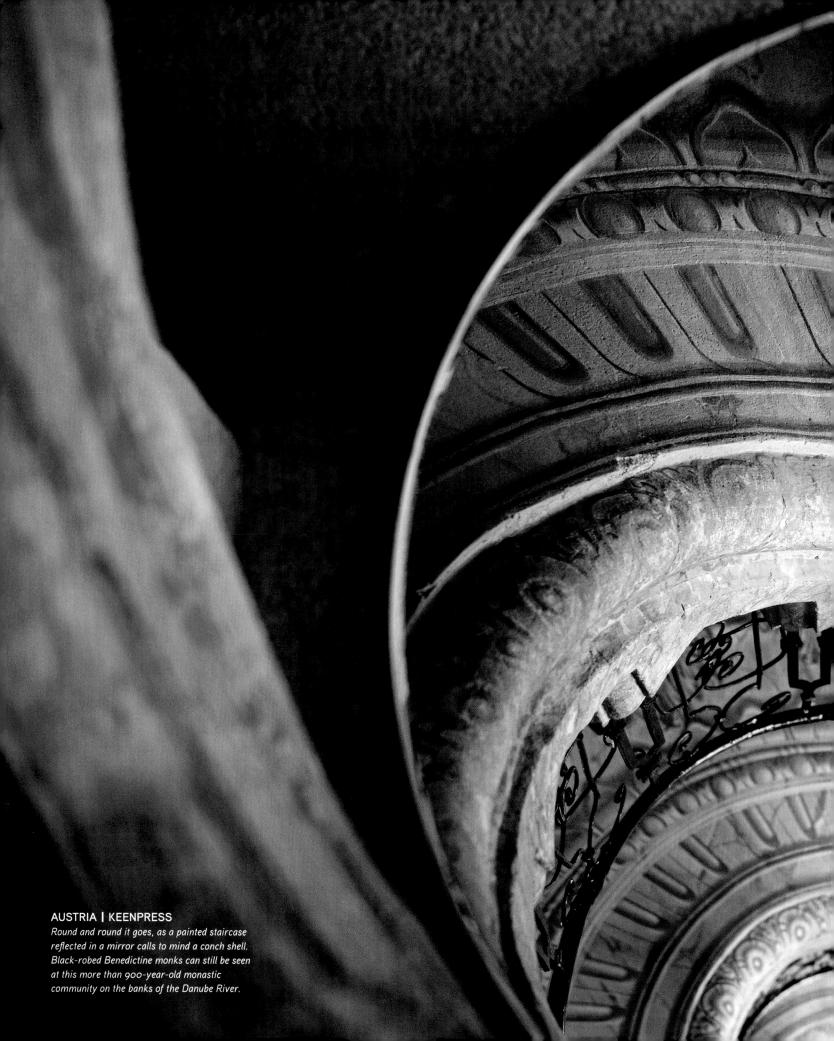

Not only is ANTARCTICA

the coldest place on Earth—the coldest

temperature ever recorded (-129°F/-89°C)

was from there—but it is also the driest,

an area of the continent called the

Dry Valleys not having received any rain

for nearly two million years.

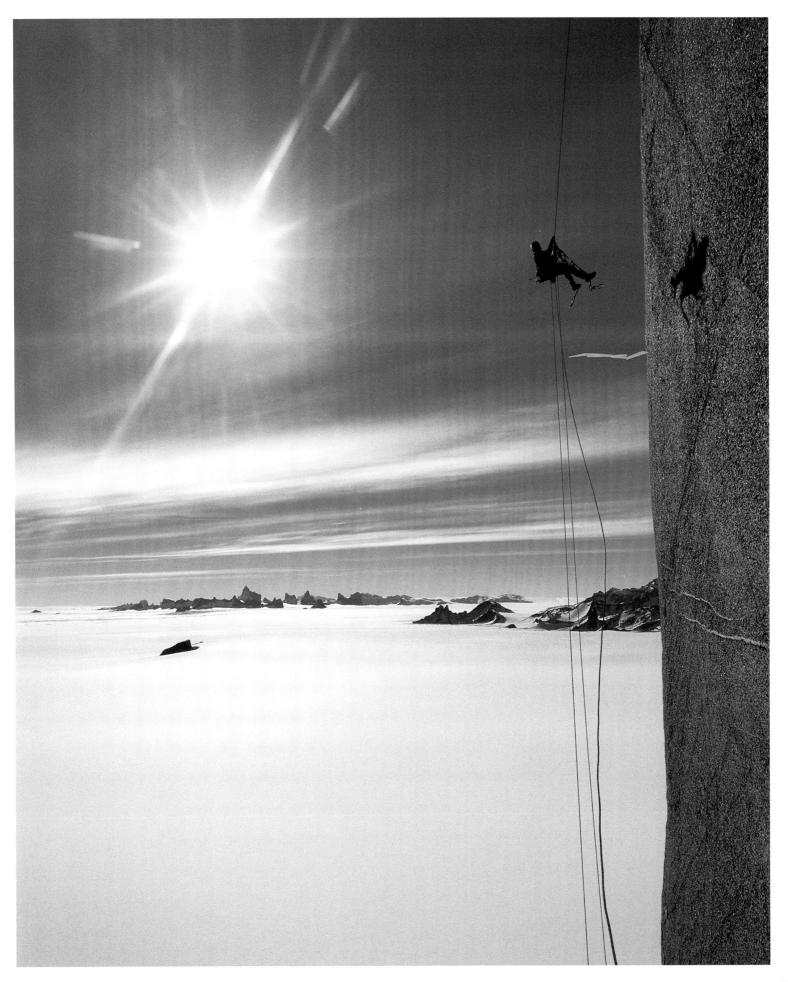

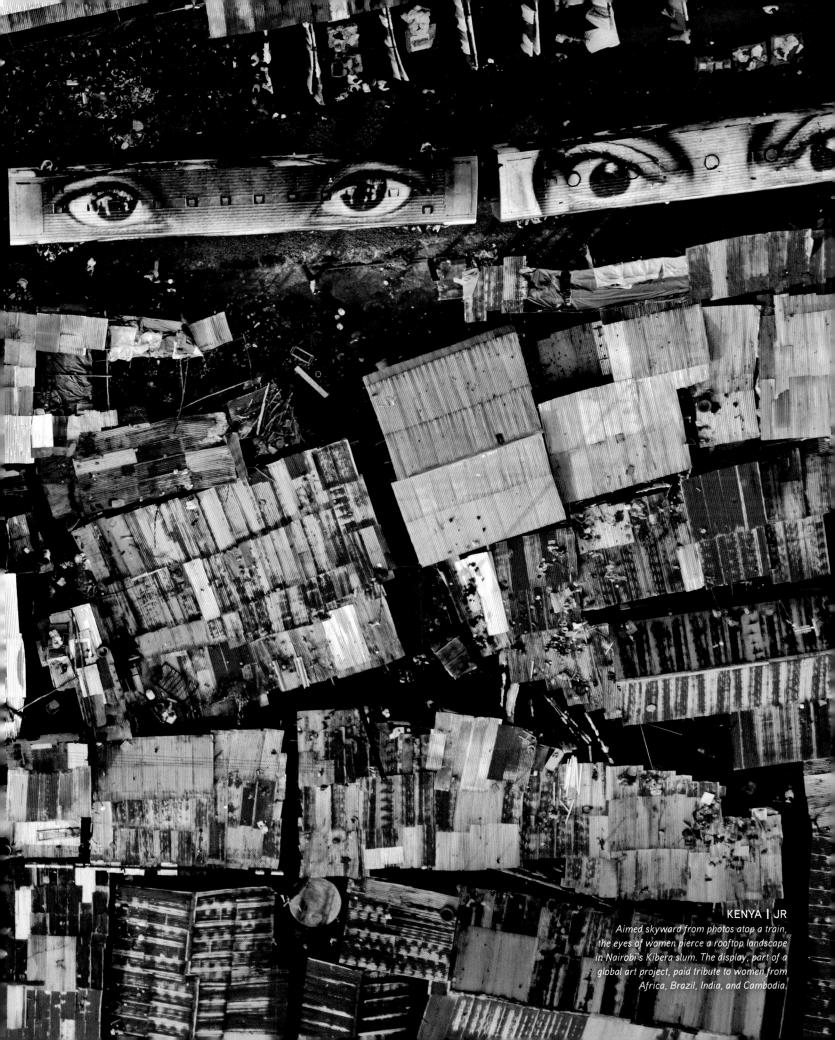

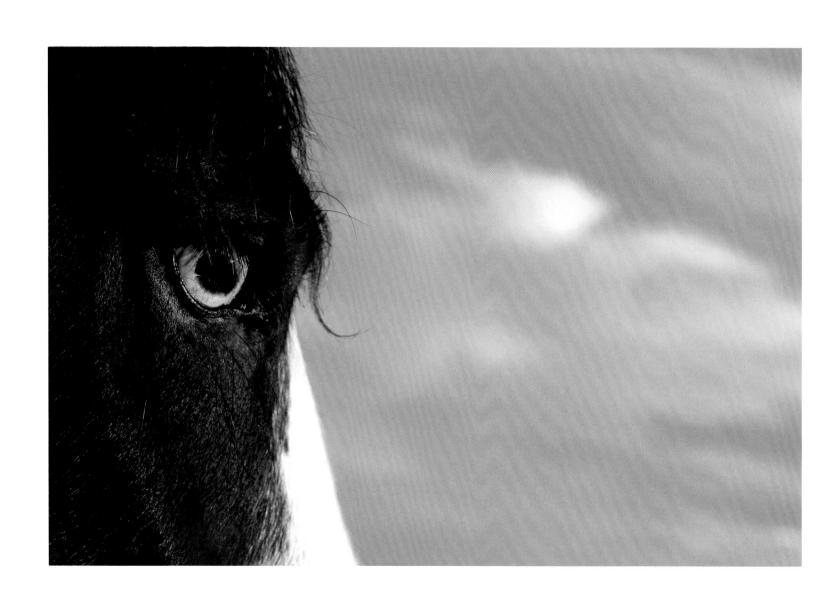

CALIFORNIA, UNITED STATES | ROXI MUELLER

In the blink of this horse's eye, the blue sky becomes a counterpoint to its stare. Early horses arose in North America some five million years ago, only to die out and be introduced, in domesticated form, by Spanish conquistador Hernán Cortés in 1519.

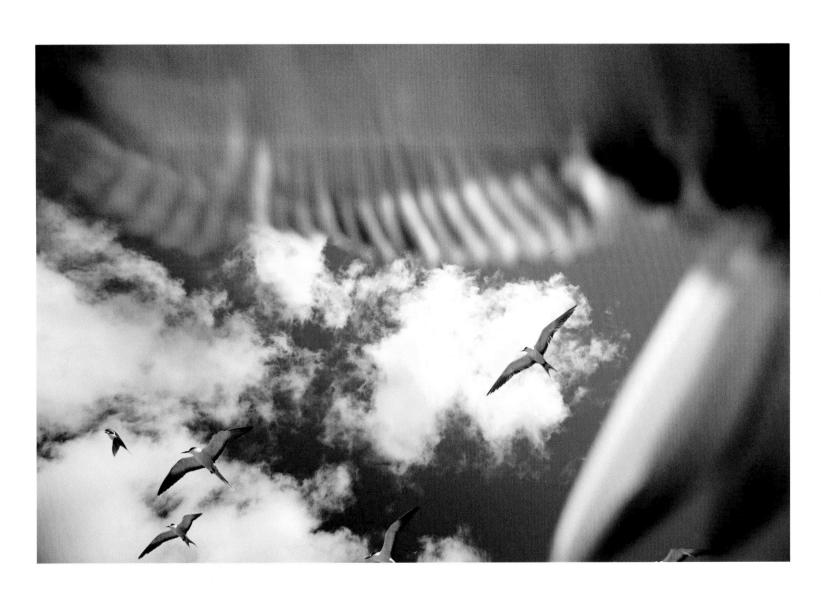

MARQUESAS ISLANDS | TIM LAMAN

Sooty terns, Sterna fuscata, take flight in the Marquesas Islands in French Polynesia. These islands, located thousands of miles from any continental landmass, allowed for plenty of diversification and specialization resulting in a rich biodiversity hot spot.

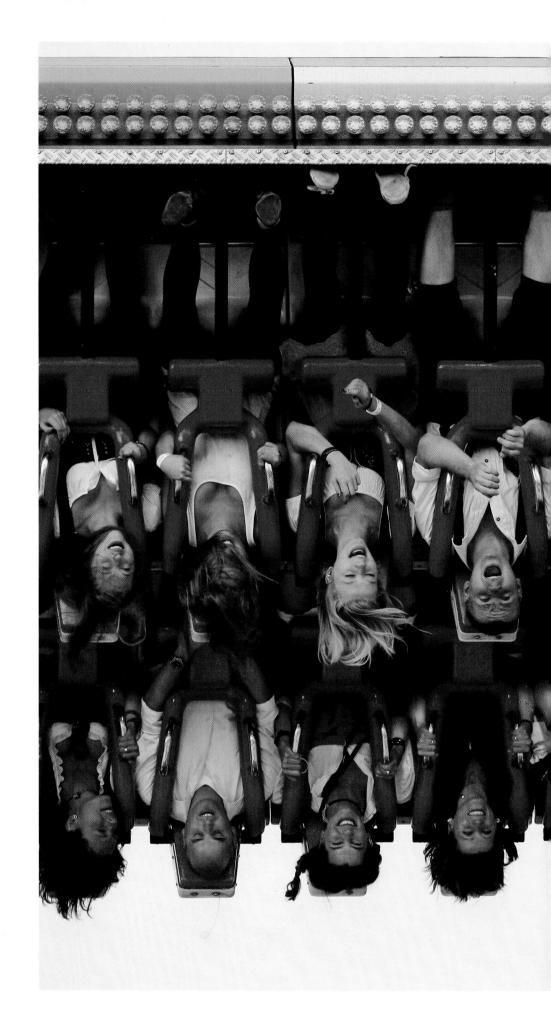

GERMANY | MIGUEL VILLAGRAN

Upside-down thrill seekers ride the Top Spin at Munich's 176th Oktoberfest. Despite terrorist threats, the 16-day beer festival—the largest fair in the world—drew 5.7 million people last year.

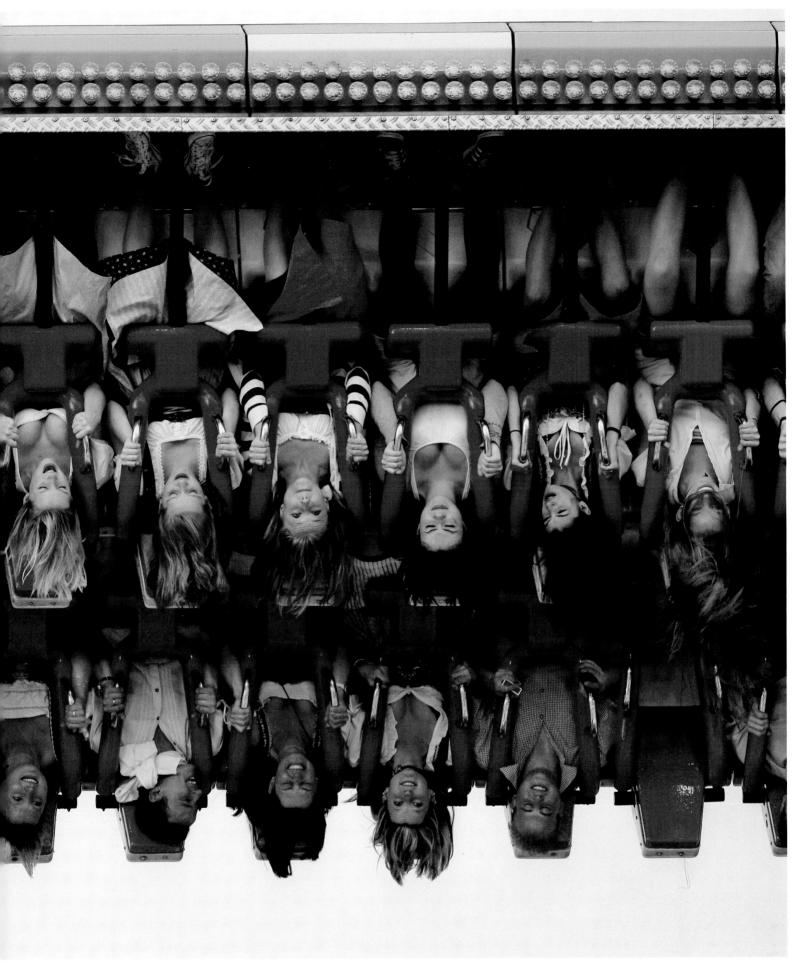

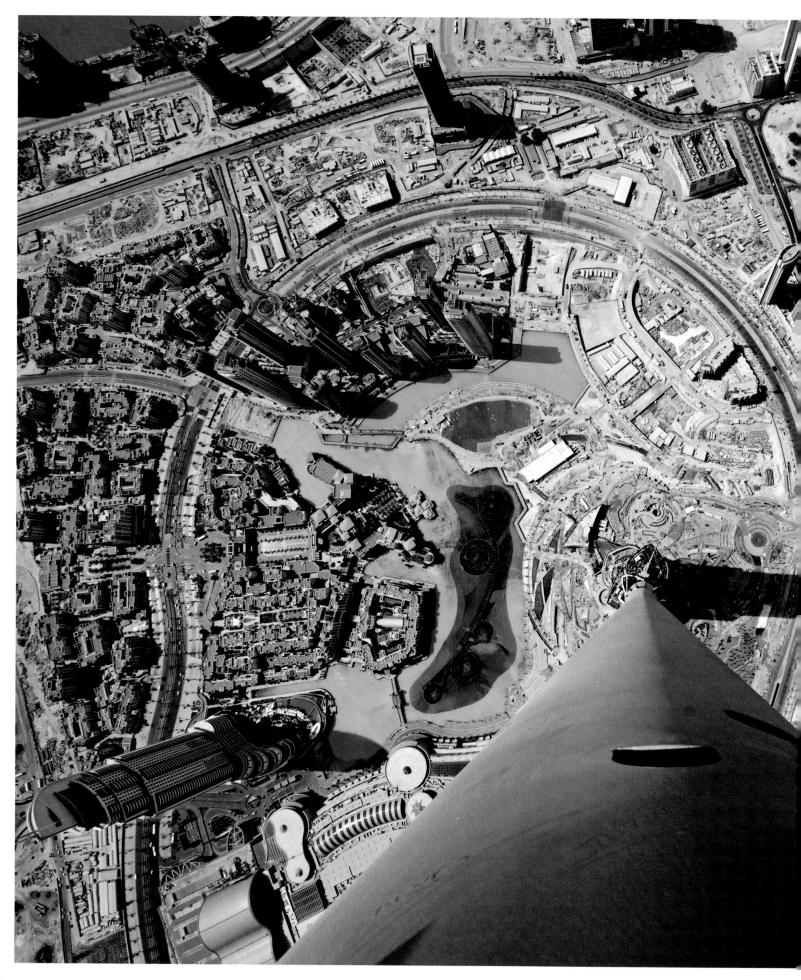

UNITED ARAB EMIRATES | SAMAR JODHA

From the top of the world's tallest building—the 164story, 2,717-foot (828-meter) Burj Khalifa—an economic history of Dubai is visible. Dense development reflects the recent boom; open spaces are remnants of an earlier era.

LOCATION UNKNOWN | BATES LITTLEHALES
A small shorebird creates a puzzling image.
Photographed from below the surface, the water
mirrors this phalarope's belly and lobed feet.

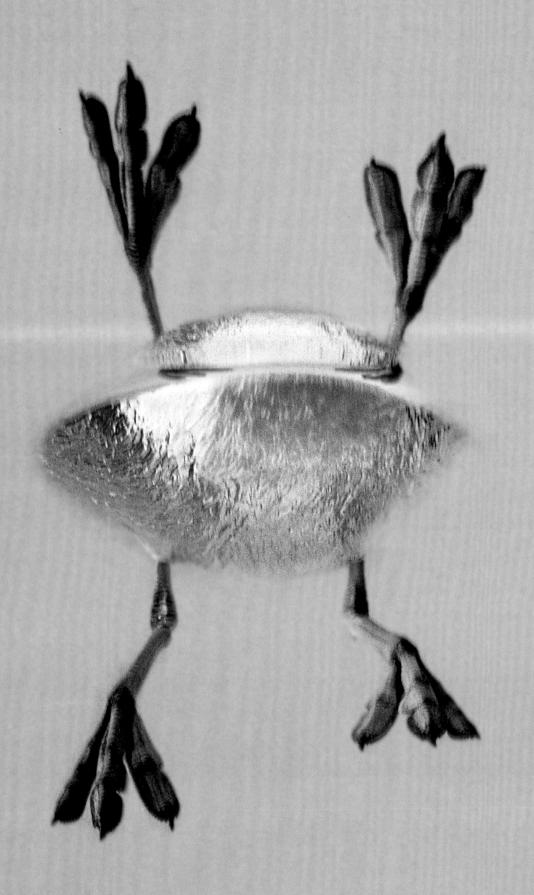

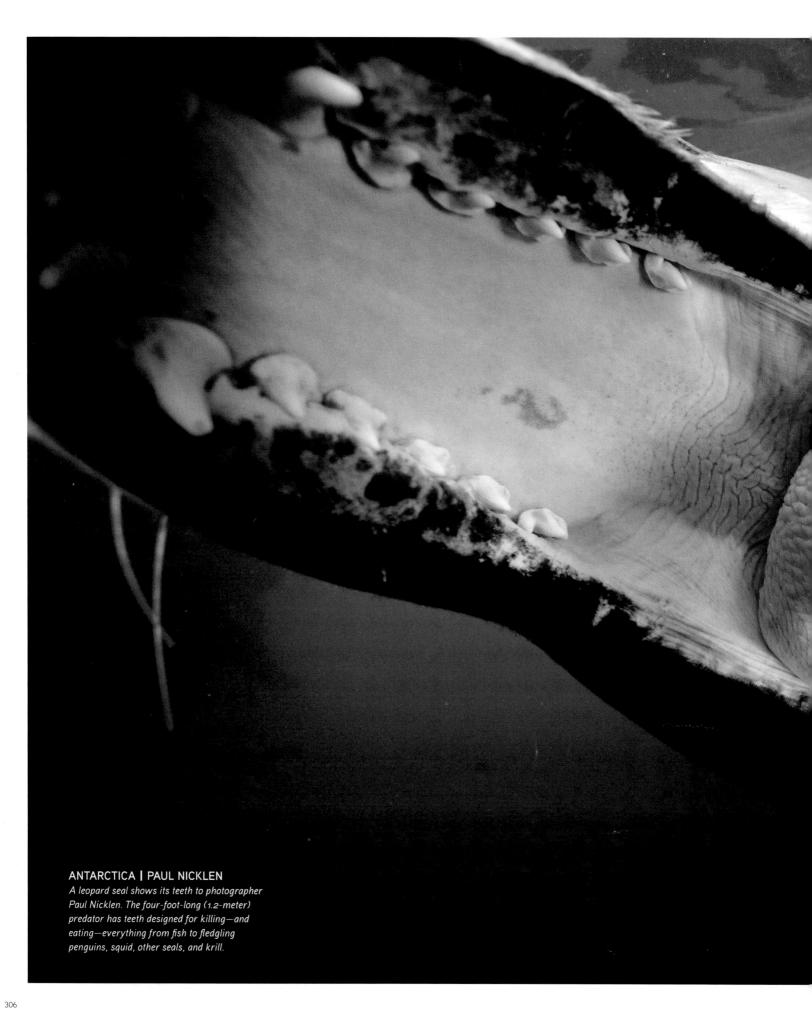

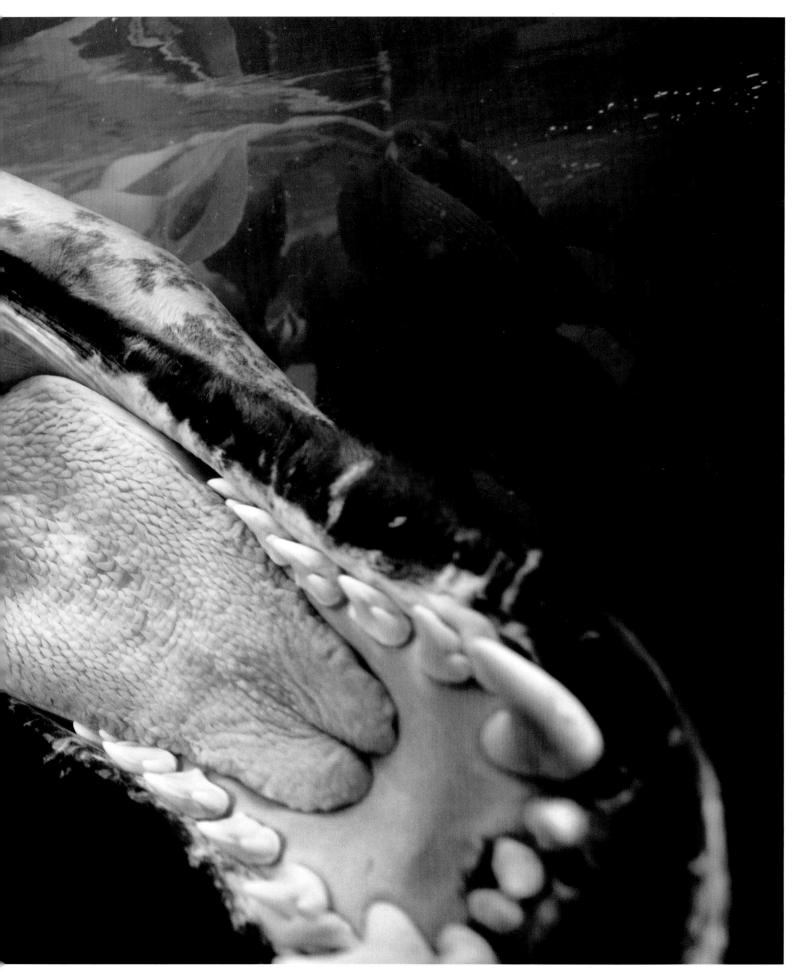

The world's largest known
natural bridge is RAINBOW
BRIDGE, in Rainbow Bridge
National Monument, Utah. This rock bridge
is 290 feet tall (88 m) and
275 feet wide (84 m), and at its top
the arch measures 42 feet thick (13 m) and
33 feet wide (10 m).

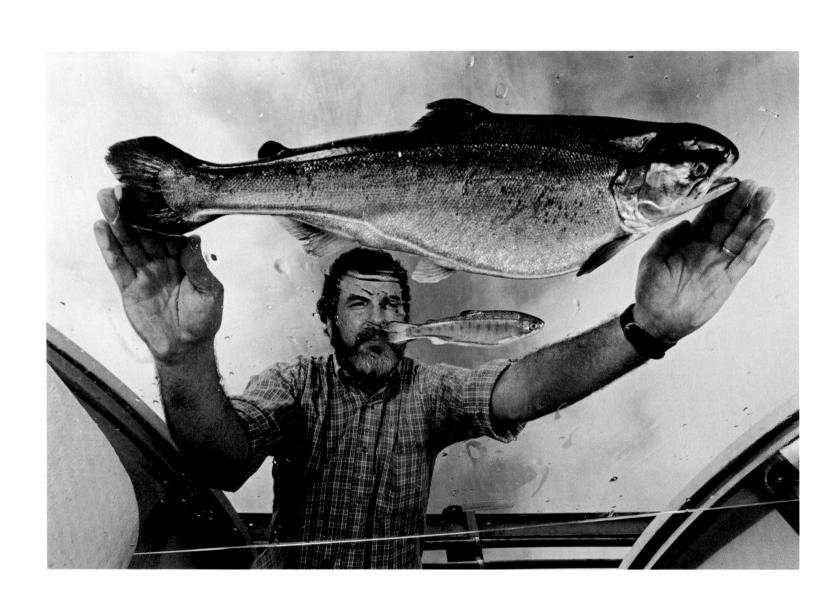

CANADA | JIM RICHARDSON

With his own fish tale, this biologist in British Columbia demonstrates how genetic engineering creates supersize salmon.

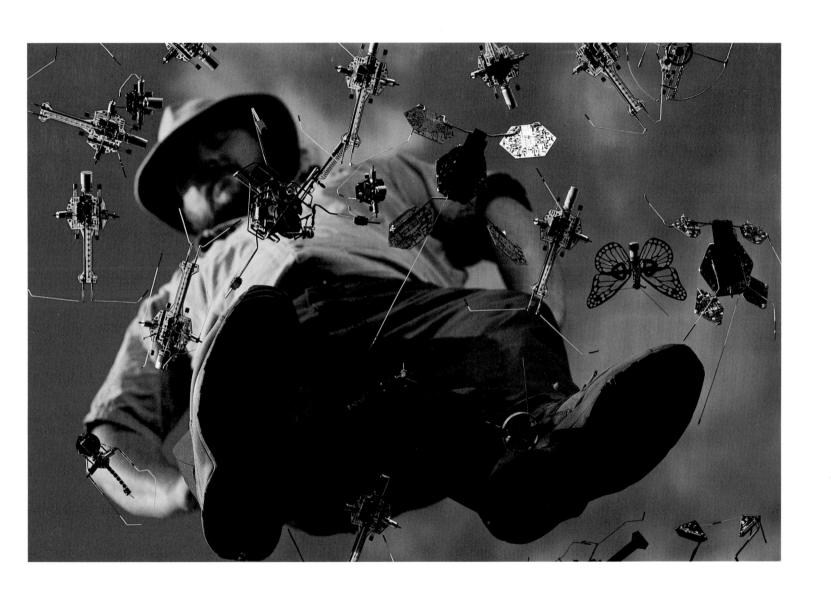

NEW MEXICO, UNITED STATES | GEORGE STEINMETZ

A robot developer looks down on his creations. Used for both military and industrial purposes, today's robots know no bounds.

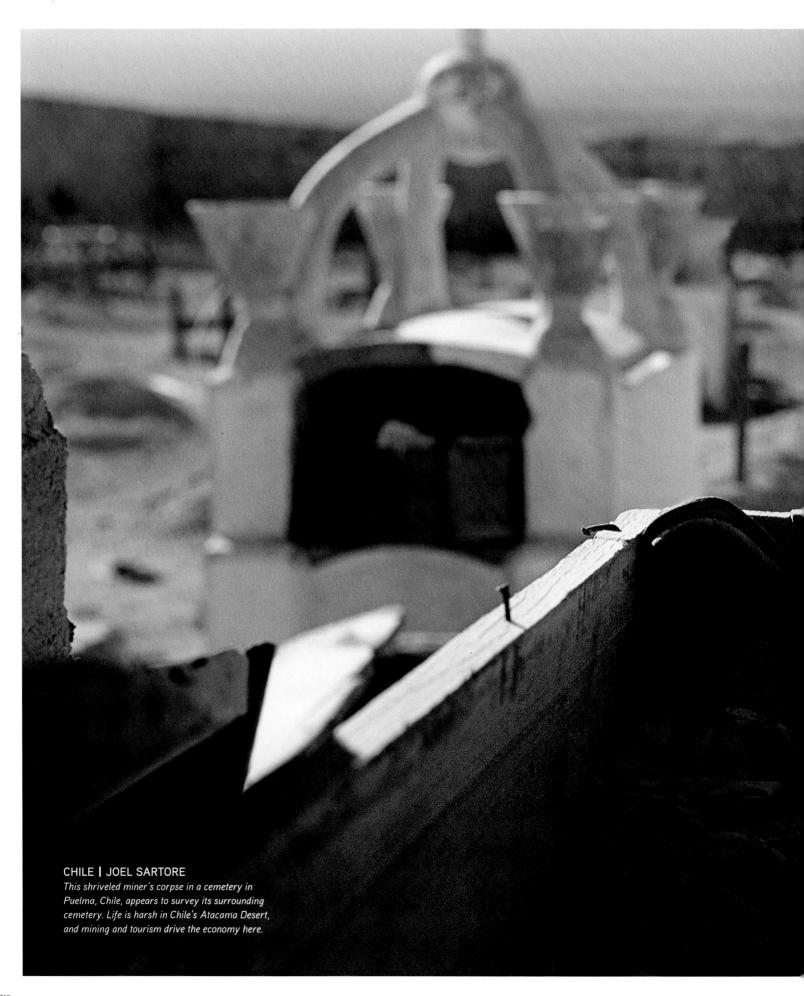

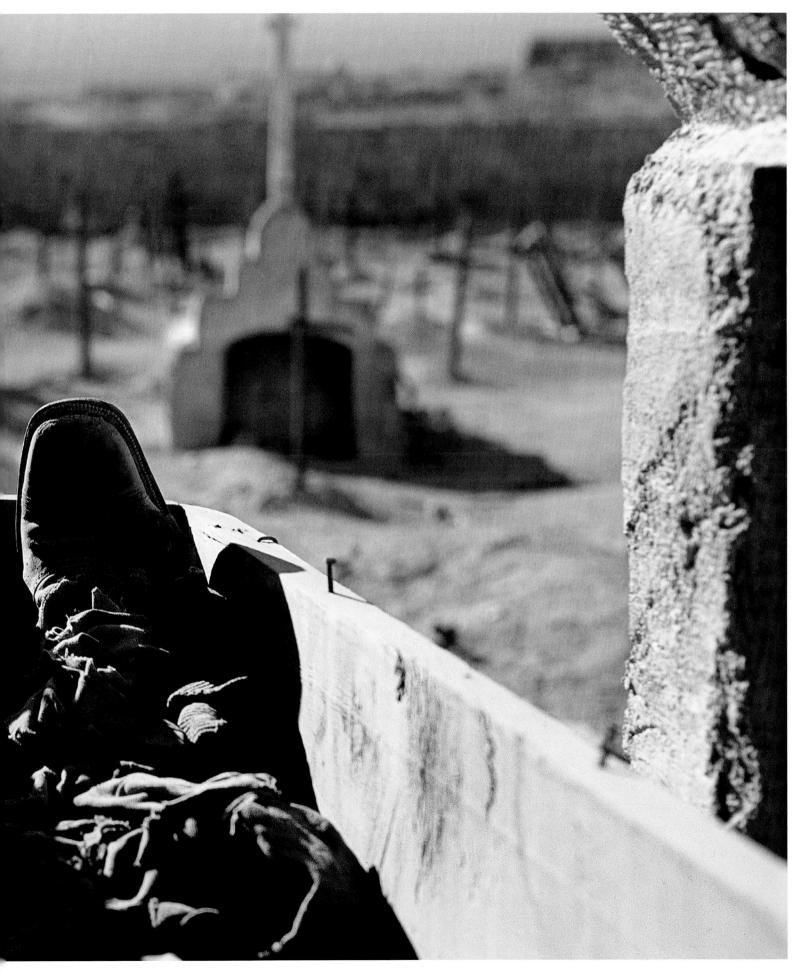

PORTFOLIO TEN

keeps her best secret hidden in white light. Crack it open—hold a crystalline prism just right in the sunlight—and what light comes in white comes out the other side split into many true colors, a wonder to behold. You see the spectrum in other circumstances: in a slick of oil on a driveway puddle, or the spray of a garden hose, or, of course, in the sparkle of tiny raindrops spread between you and the sun at just the right angle and just the right moment. Catch that vision, and you peer into nature's marvelous kaleidoscope, the spectrum of all colors: violet, blue, green, yellow, orange, red.

Every color sings a different note, and the natural world rings with song, sometimes with colorful harmonies and sometimes with a cacophony of colors so brilliant it rattles the brain.

Red, the rich, deep color of roses that pulses through mind and body. Orange, the blaze of dawn, the color of fire, flickering, hot, momentary, fascinating. Yellow, the darting flight of a warbler, brilliantly new, shy, tempting. Green, the calm of tree leaves in summer, growth and health, a resting place for the eyes. Equally serene is the blue of a cloudless sky. Purple comes down to earth again in the lowly violet flower.

These associations may be local—someone else knows a different yellow bird, a different purple flower—but the colors are universal. Rainbows glow all over the planet, but only when there are eyes to see them.

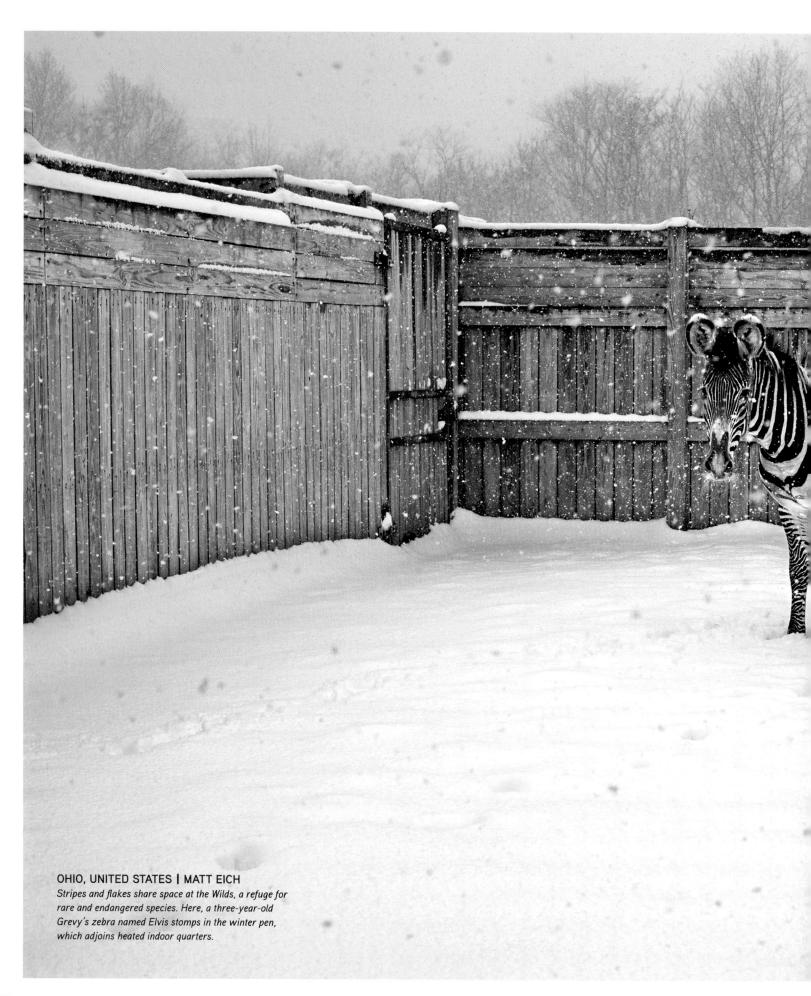

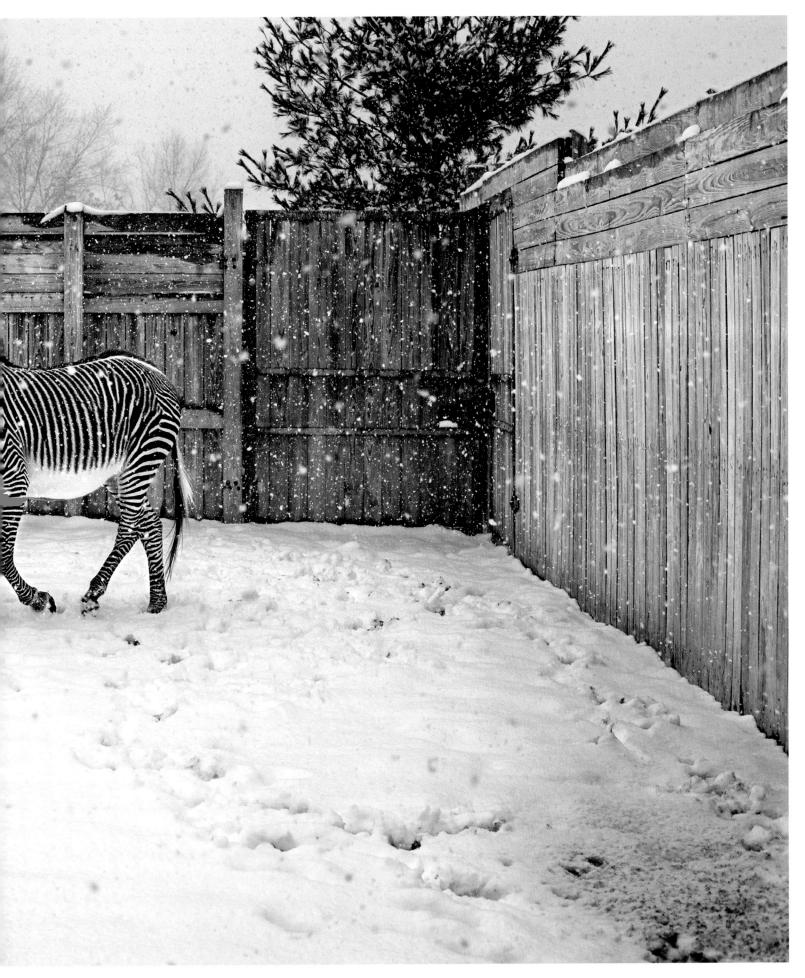

WASHINGTON, D.C., UNITED STATES | PAUL SUTHERLAND

A coiled eyelash pit viper, Bothriechis schlegelii, looks harmless enough, but it's venomous. This Central and South American species earned its name from the modified scales around its eyes that mimic eyelashes.

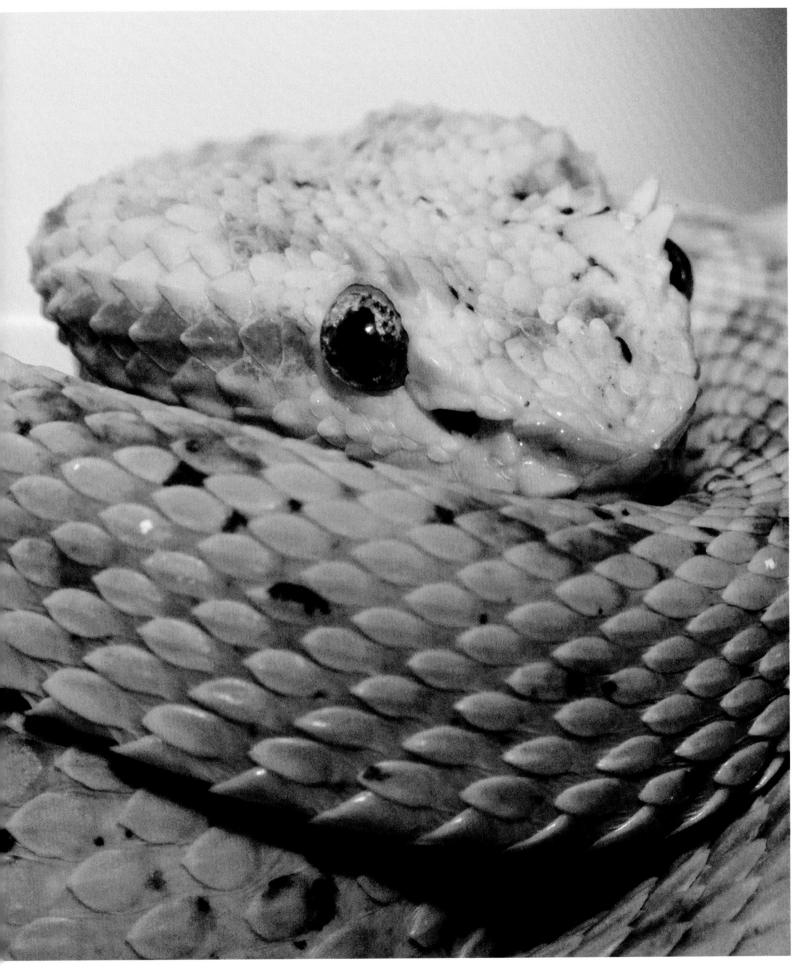

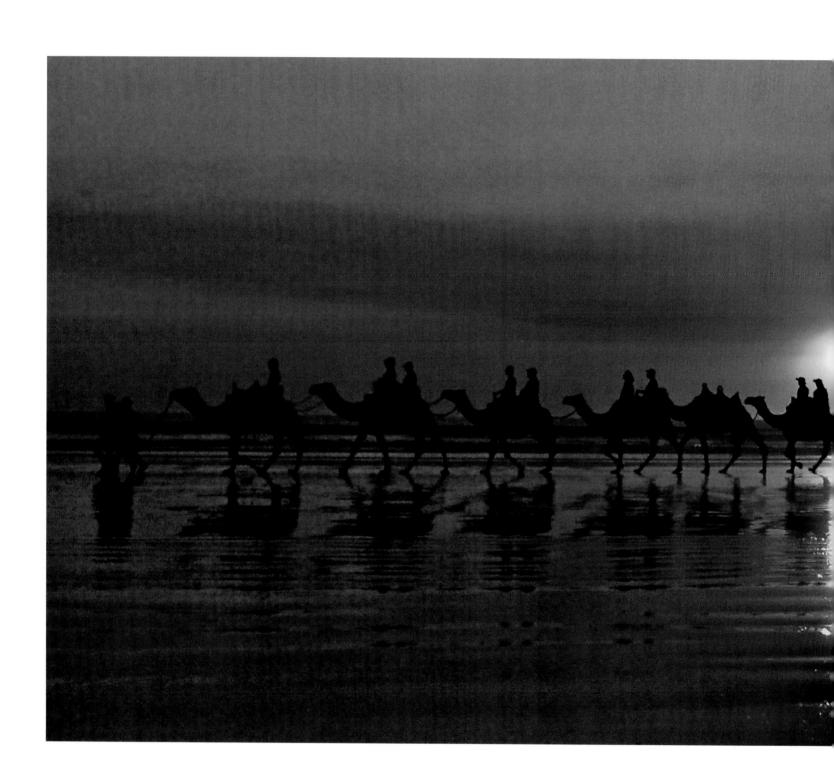

AUSTRALIA | PAUL WILLETS

A line of camels and their riders walks into the sunset on Cable Beach in Broome, Western Australia. Miles of white sands and crystal-clear waters offer a relaxed location that makes this one of Australia's most popular beaches.

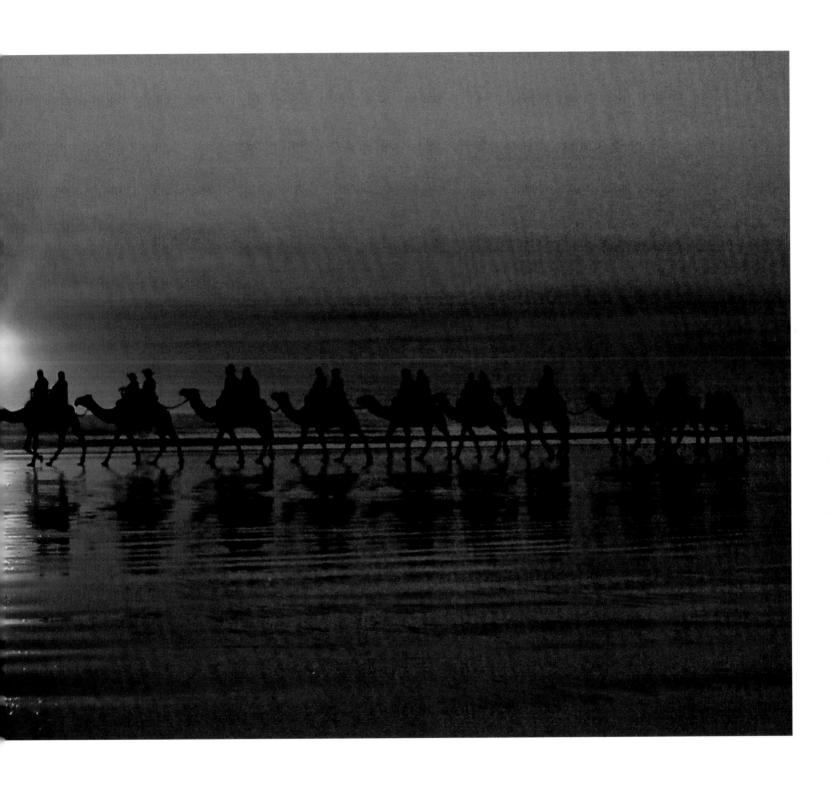

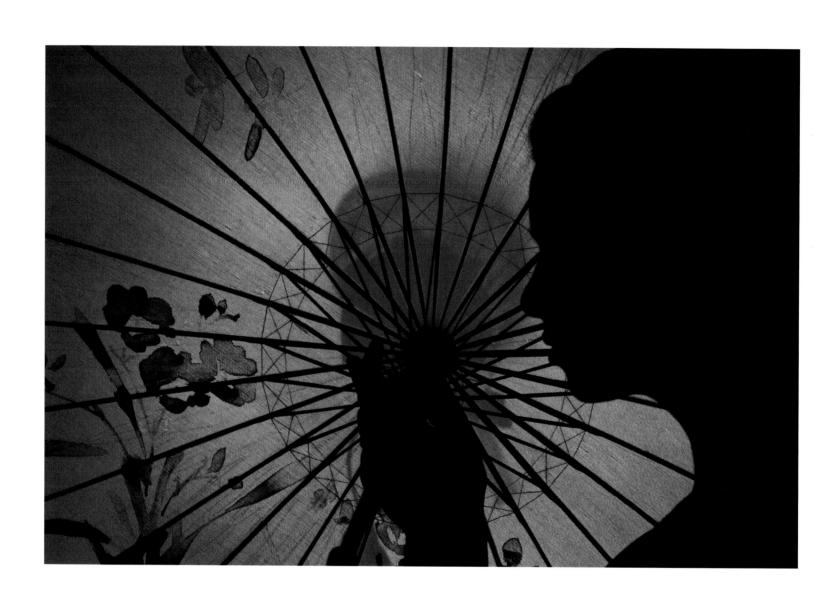

AUSTRALIA | HELEN DITTRICH

An orange paper parasol silhouettes a woman's curves. In ancient Egypt, China, India, and Mesopotamia, umbrellas protected important people from the sun.

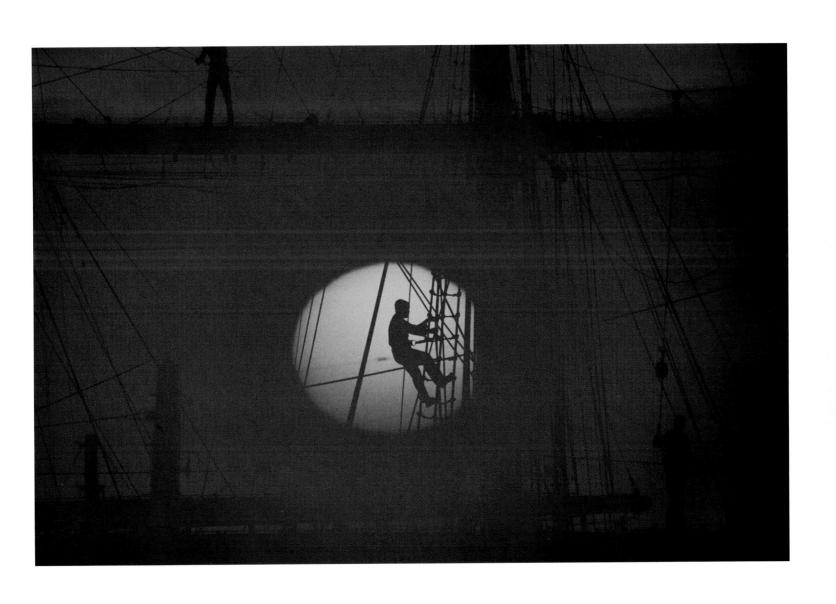

ARGENTINA | BRUCE DALE

The setting sun shows off the agility of a ship hand climbing rigging in Buenos Aires. At this favorite stopover, cruise ships travel up the Río de la Plata and straight into downtown. More men than women are

affected by COLOR BLINDNESS;

about one in ten men has some

form of it. The most common type

of the condition causes people to have trouble distinguishing between

red and green.

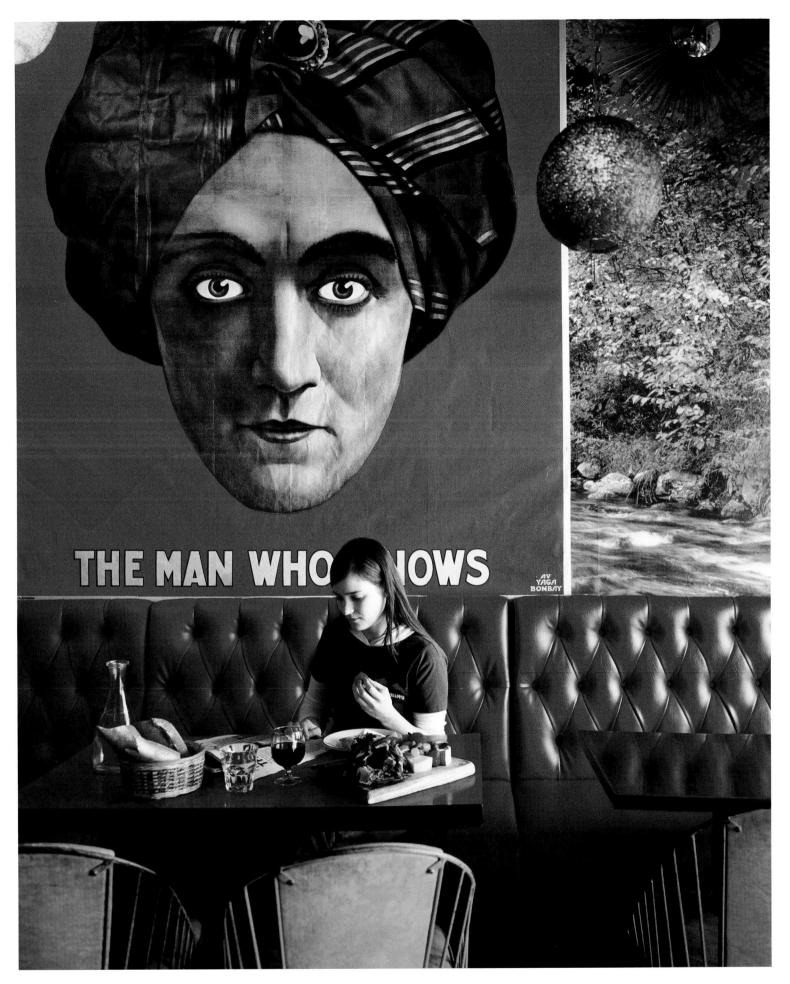

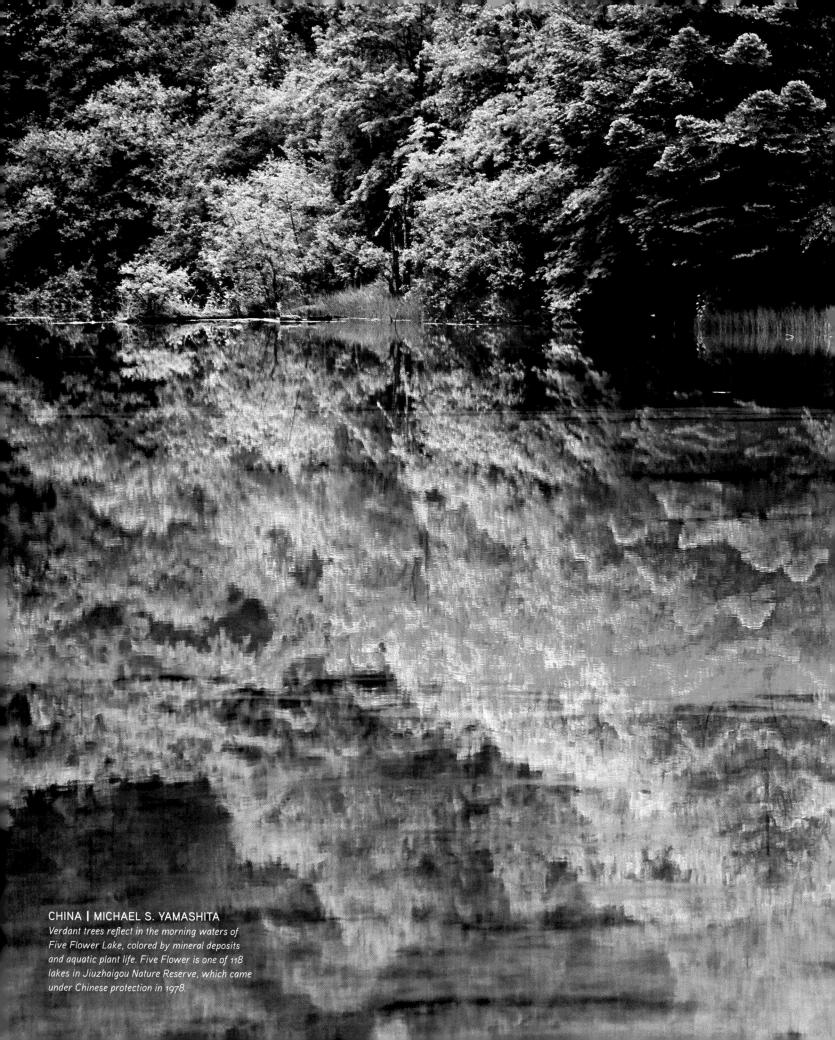

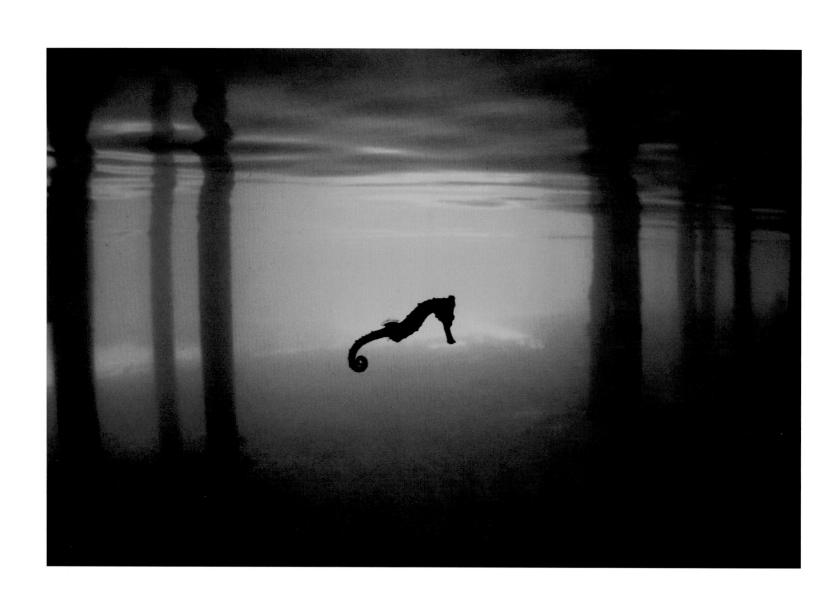

HONDURAS | MARC MISTERSARO

Snorkeling under a nightclub in Roatán, Honduras, the photographer caught this ethereal image of a seahorse. Great snorkeling and scuba diving while surrounded by rich coral reefs attract visitors here to the largest of Honduras's Bay Islands.

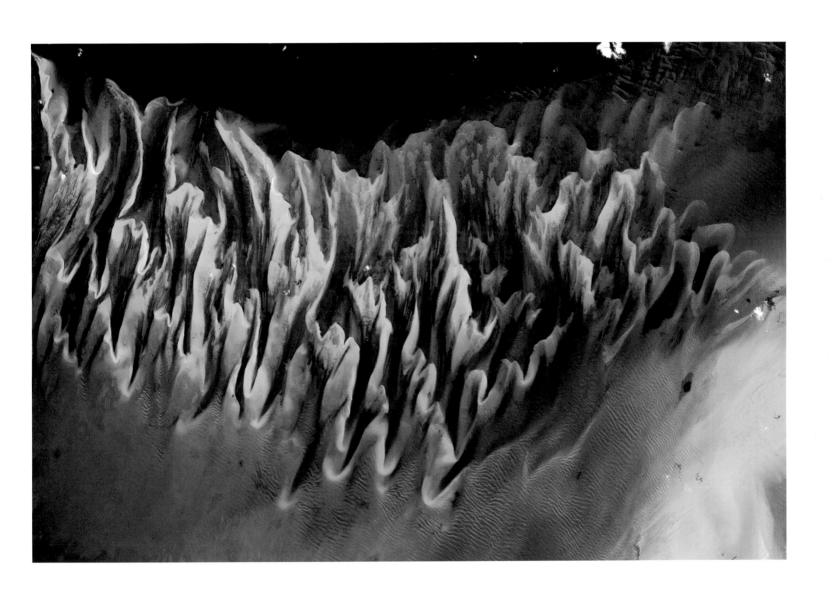

BAHAMAS | SERGE ANDRÉFOUËT AND FRANK MÜLLER-KARGER

West of the Bahamas, the waters are so clear in a trough known as the Tongue of the Ocean that a satellite captured the sand and sea grass some 50 feet (15 meters) below the surface. The image comes from a scan from a sensor on a Landsat 7 satellite.

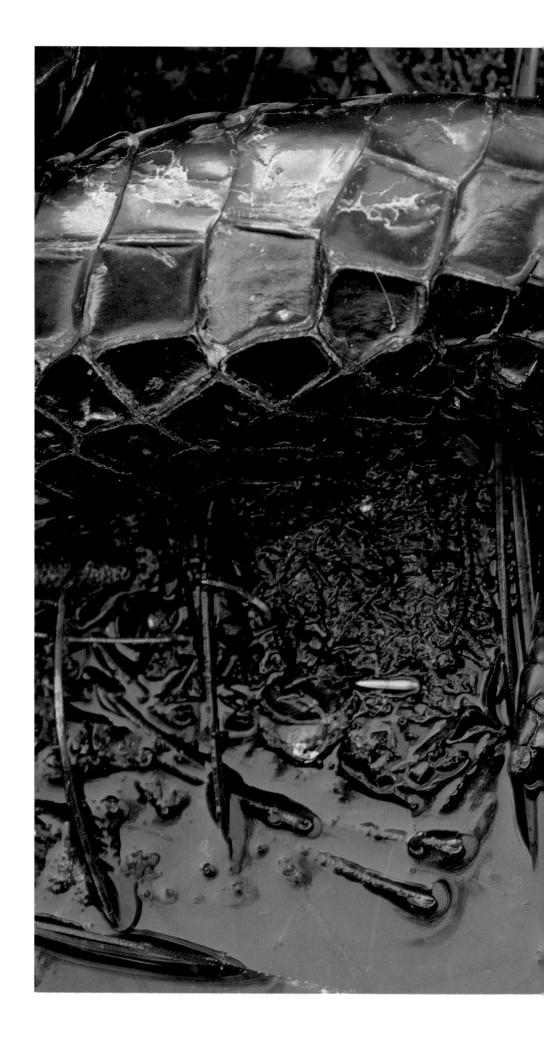

GEORGIA, UNITED STATES | RICHARD T. BRYANT

Though tipped with nightmare claws, the limbs of American alligators—this one photographed at a local park—are more often used to excavate wallowing holes than to slash at prey.

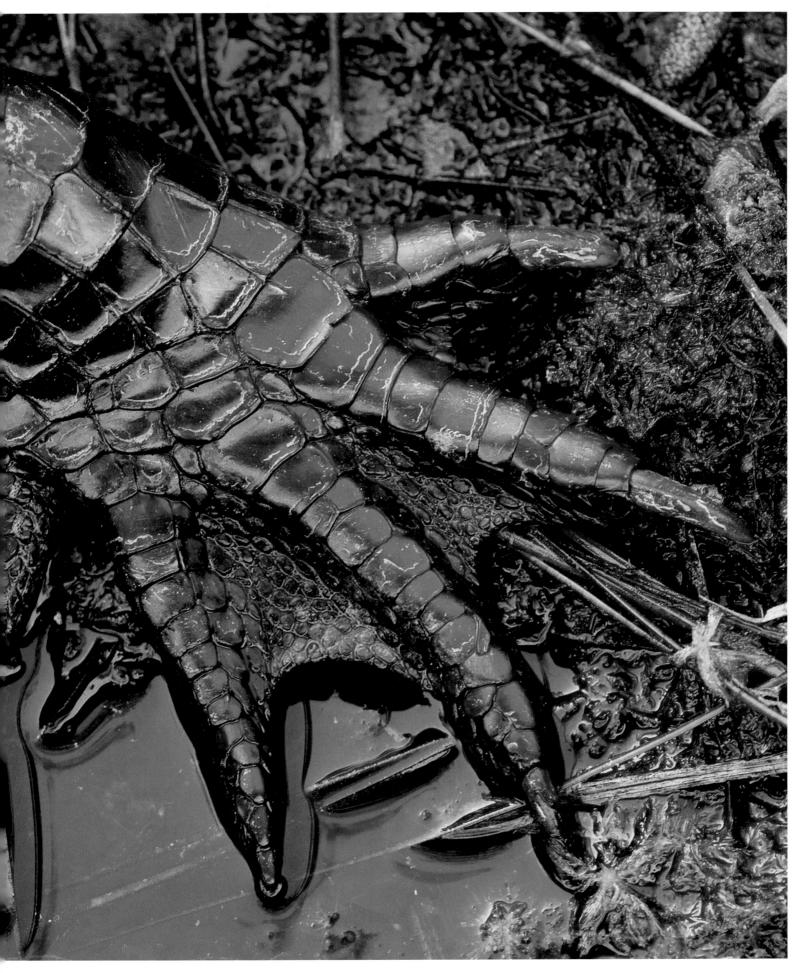

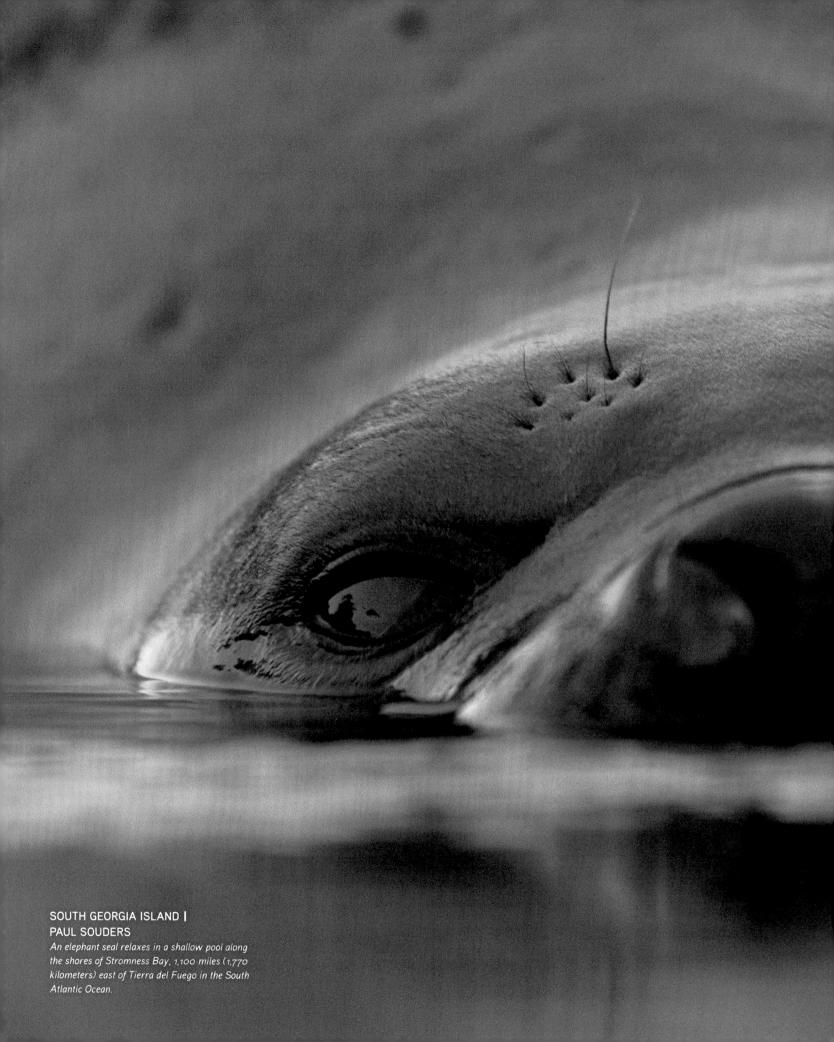

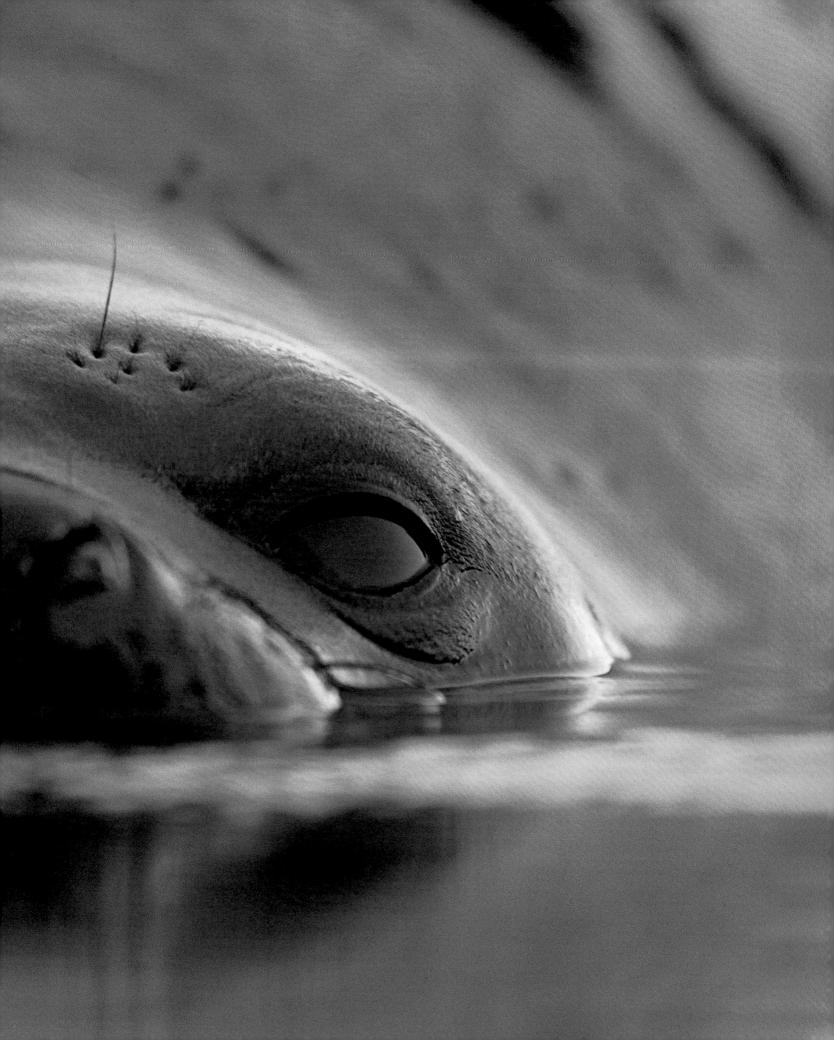

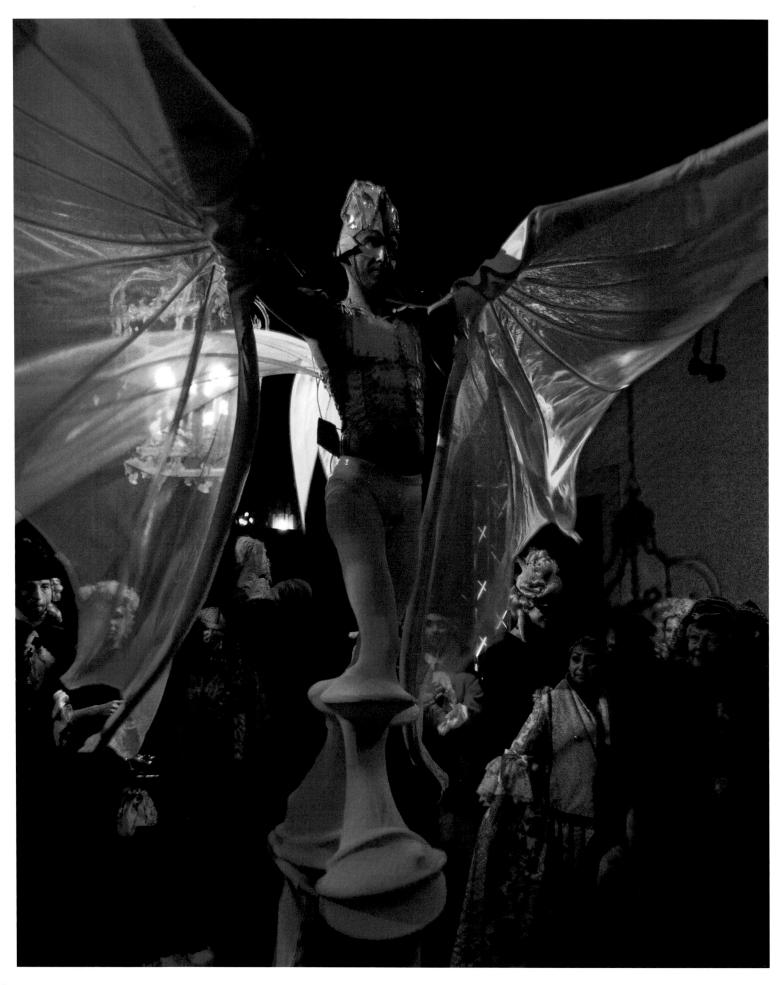

Comprising 117 small bodies

of land crisscrossed by 150 canals

and connected by more than

400 bridges, Venice is the only
city in Europe to have its public transport

entirely on the water.

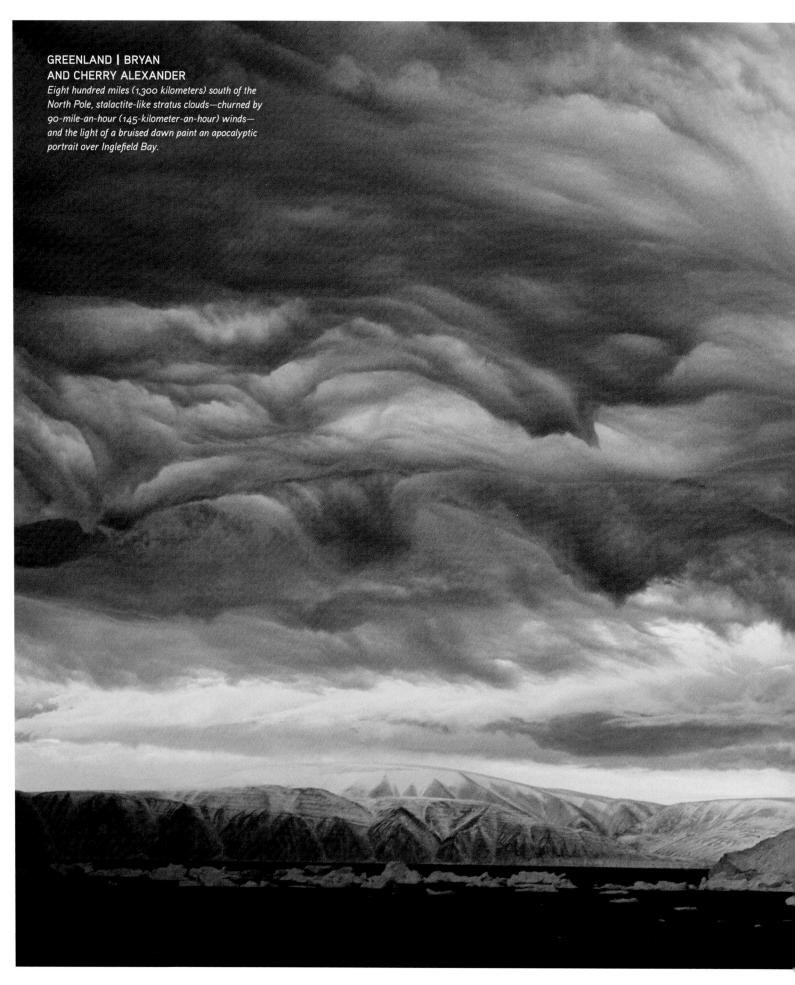

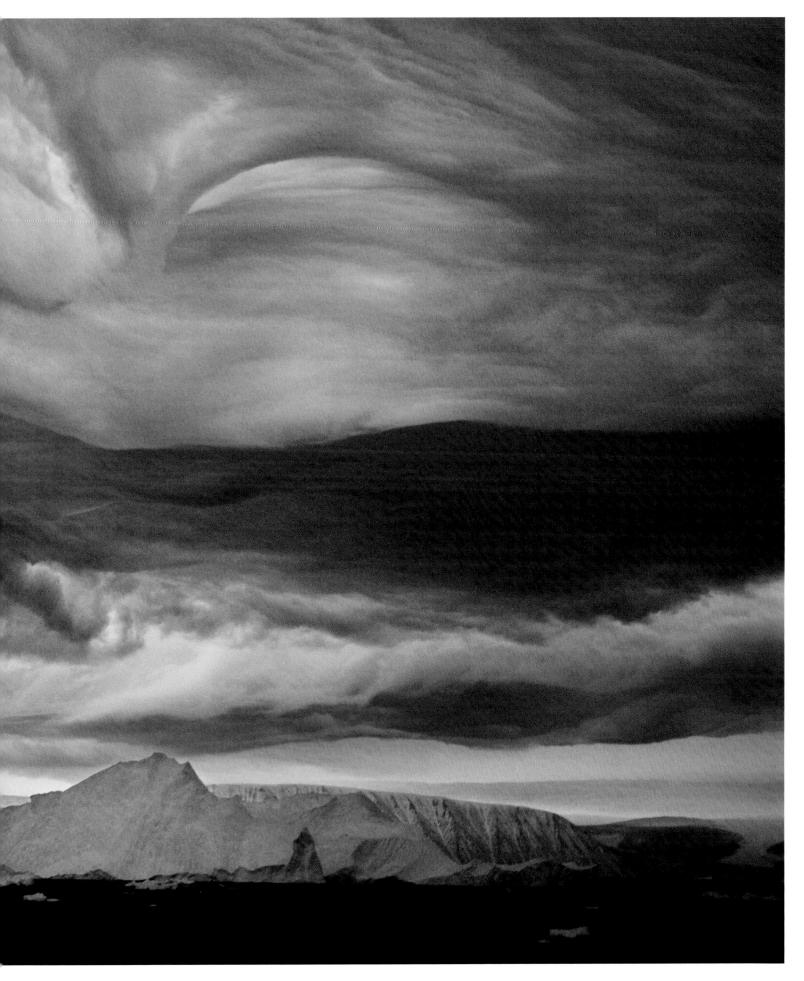

BRAZIL | AGNES KISS

It's only fitting that a hyacinth macaw, the largest parrot in the world at more than 3 feet long (0.9 meter), lives in one of the world's largest wetlands, the 74,000-square-mile (192,000-square-kilometer) Pantanal. The population of macaws, which have been sold actively to the pet trade, is estimated at around 5,000.

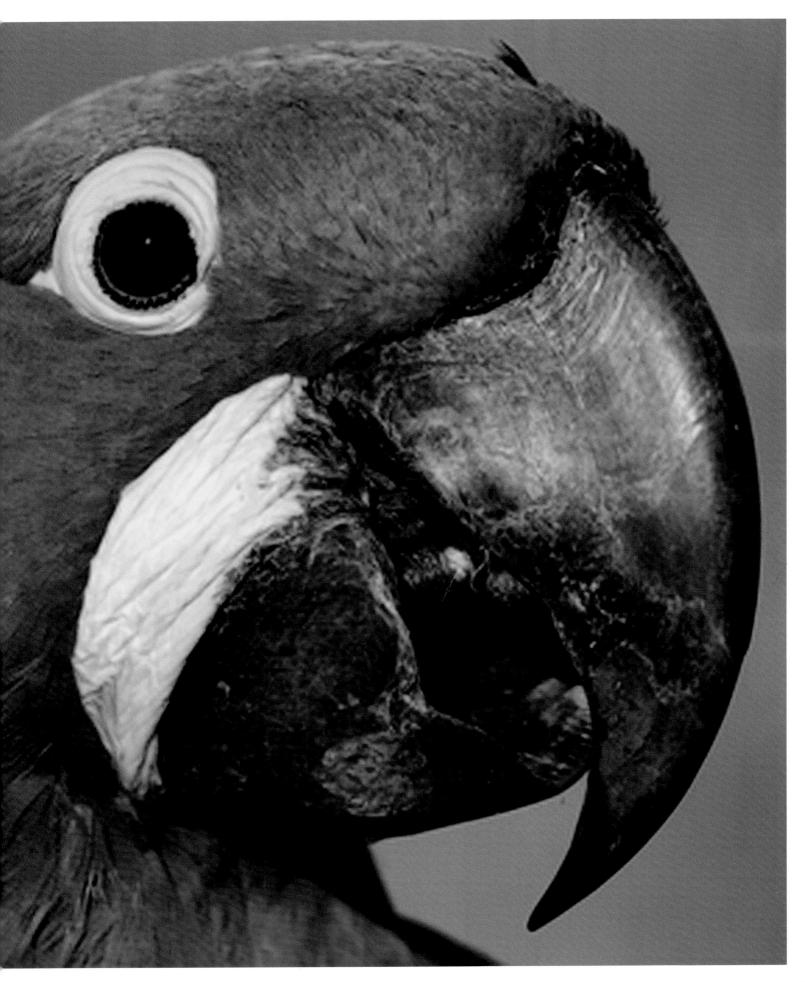

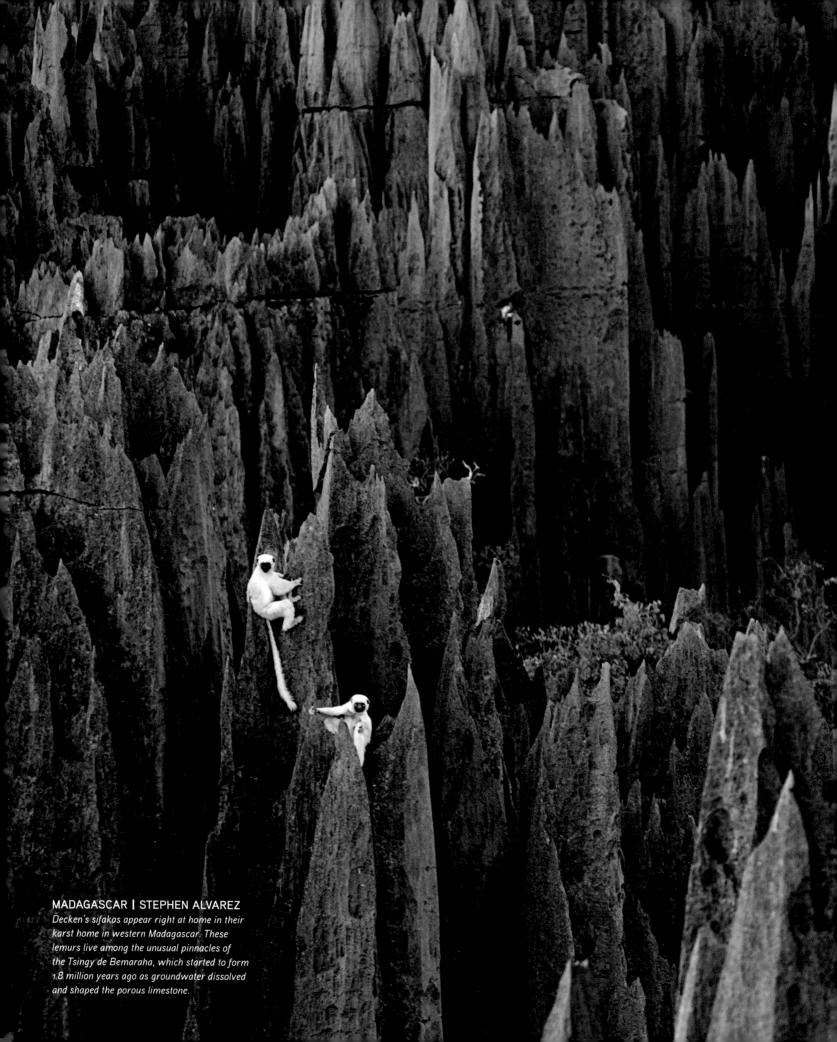

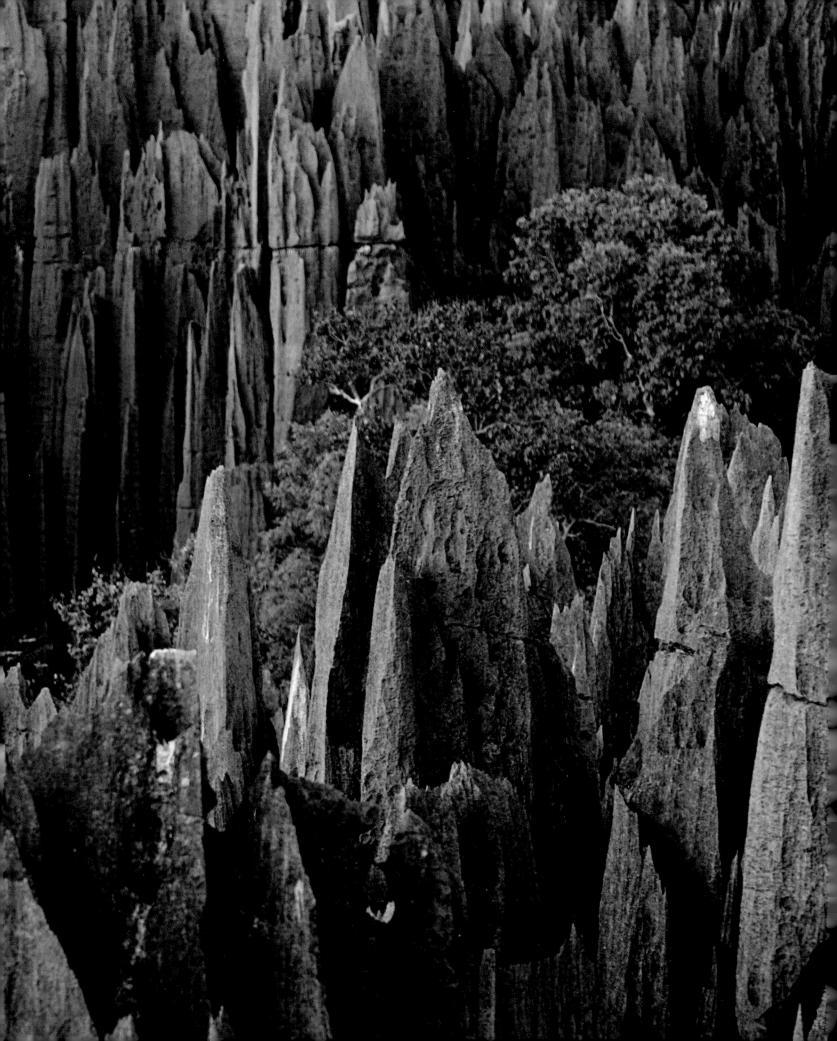

SPAIN | JOSEP LAGO

A late afternoon stroll in Barcelona becomes a study in black and white during a rare snow shower in March 2010. Temperatures in the city, on the Mediterranean coast, usually fall between 50°F (10°C) and 60°F (15°C) this time of year.

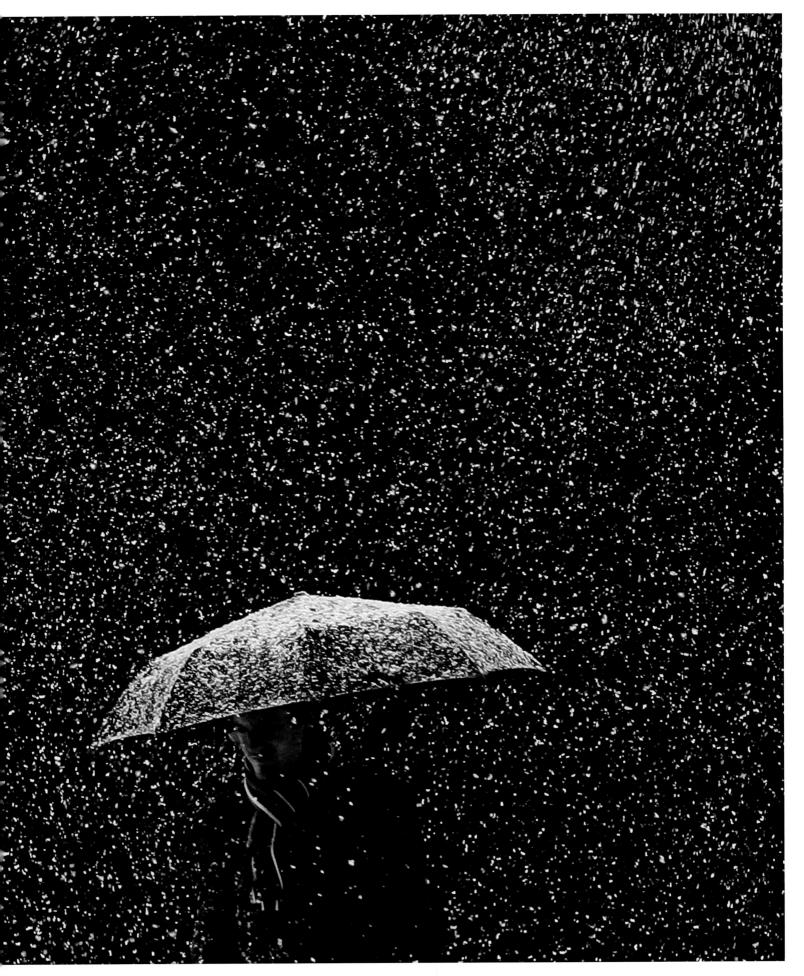

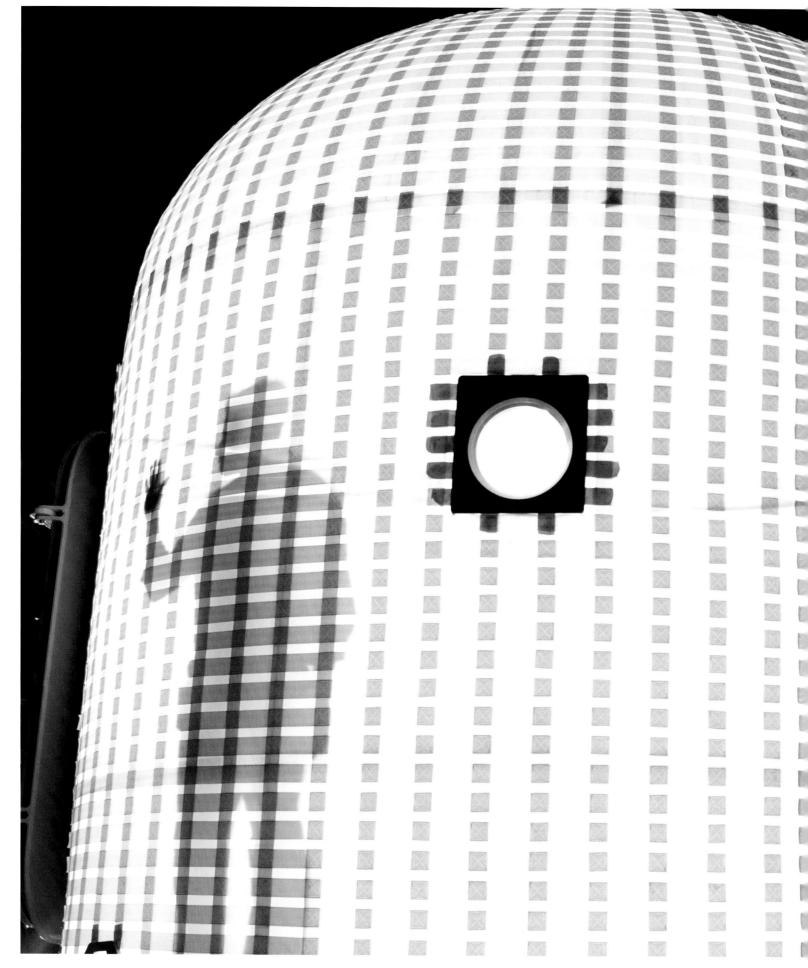

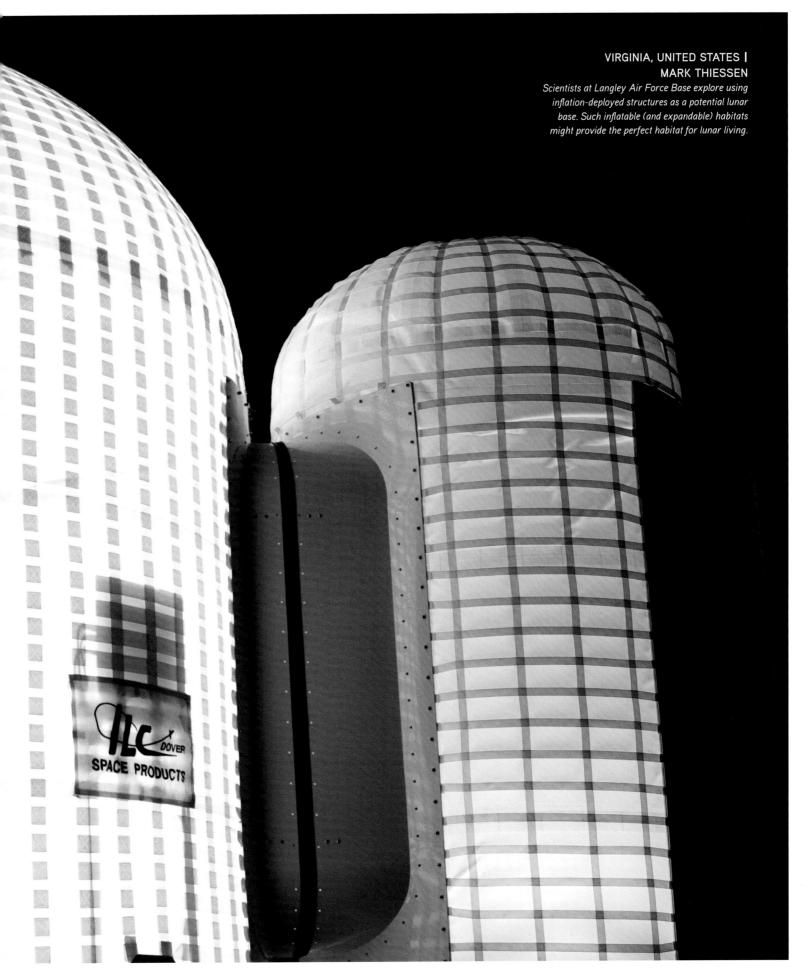

PORTFOLIO ELEVEN

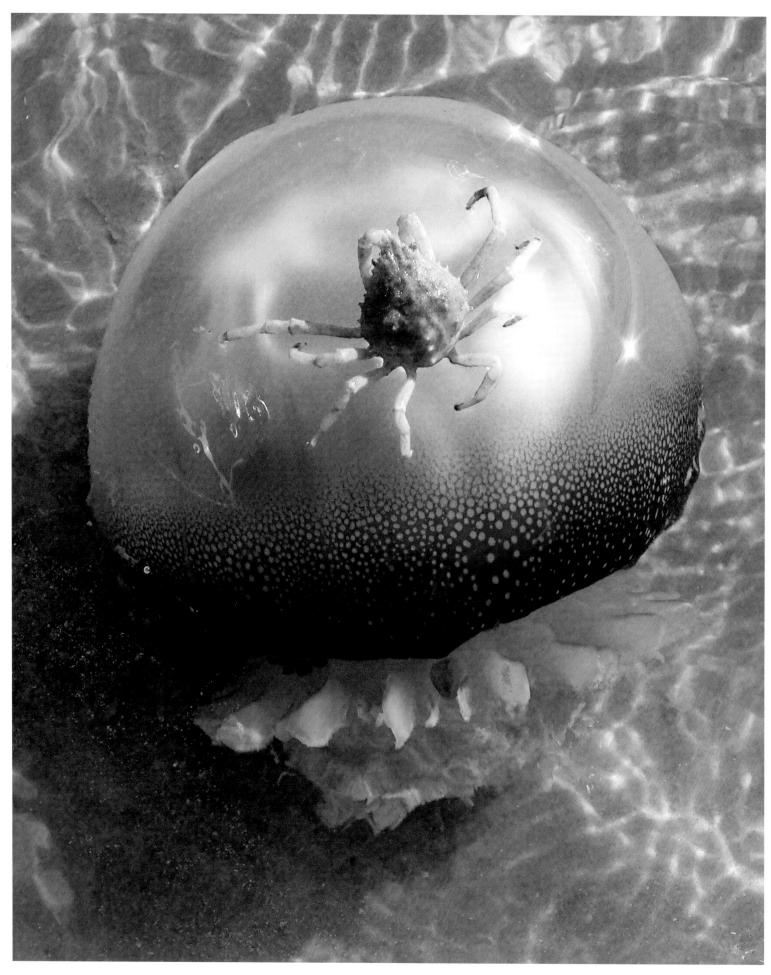

something lovable about an interloper—the odd one out, assured in its separate being yet perfectly comfortable among the many others.

Imagine: It's twilight, and a small herd of white-tailed deer, drawn by the possibility of clover, tiptoes out of the forest darkness to the edge of a field. Somehow you work your way in between a doe and two yearlings without causing concern; somehow you fit in, an interloper, enjoying the pleasure of not belonging.

Or imagine: Deep in the Costa Rican rain forest, you shimmy up a jobo tree and sit, motionless, until the squirrel monkeys start once again to chatter and swing, jump and preen, bounding across the forest floor and into the tree branches close at hand. They accept you; you fit in, an interloper, taking in all the sounds and smells and sights of creatures different from you.

Perhaps it is by imagining the viewpoint of an interloper that we find special pleasure in photographs of interlopers, too—surprises as much to the senses as to our understanding. An orange-and-white clown fish sculls in place among the waving purple-gray fingers of a sea anemone, as if by hovering close enough it might turn its neon colors into the dull earth tones of its surroundings. As much as its colors deny it, this fish belongs.

The stark stripes of one lone zebra call out amid the mud brown of a herd of hundreds of wildebeests, hoofing it through the savanna. Benign interloper, you don't fool me.

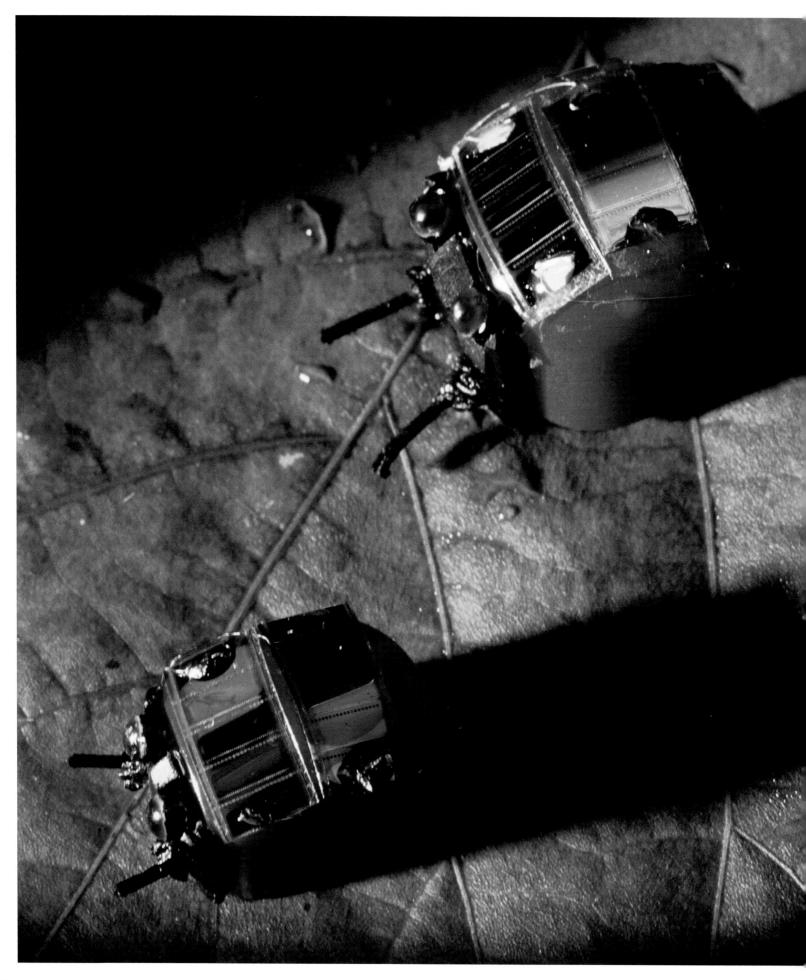

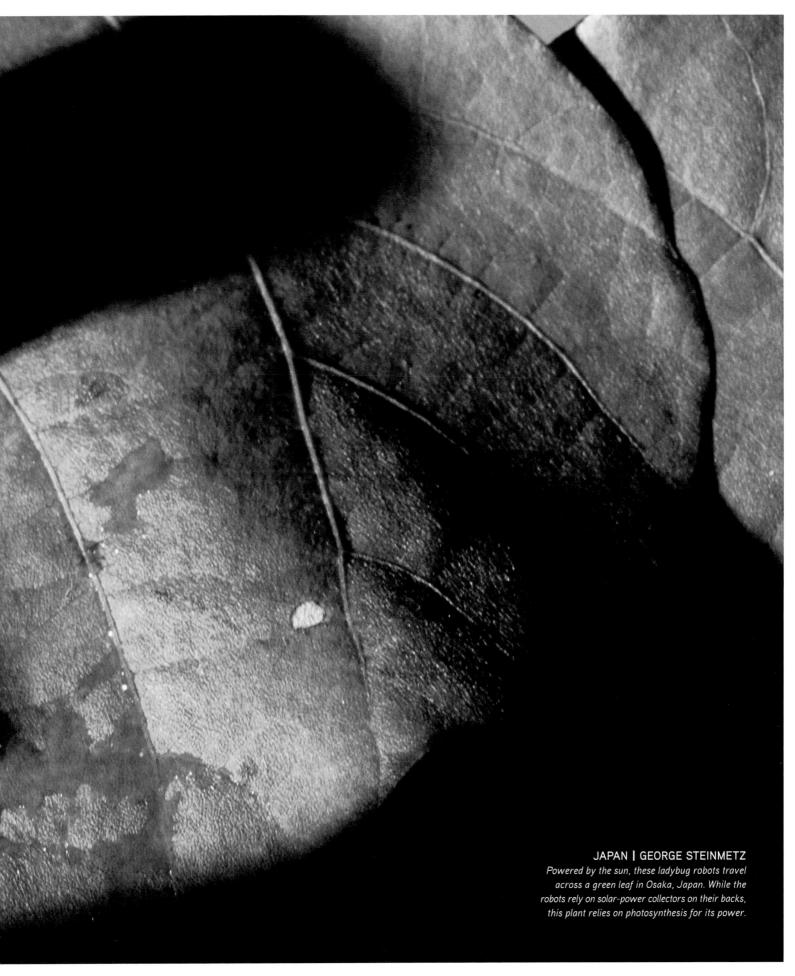

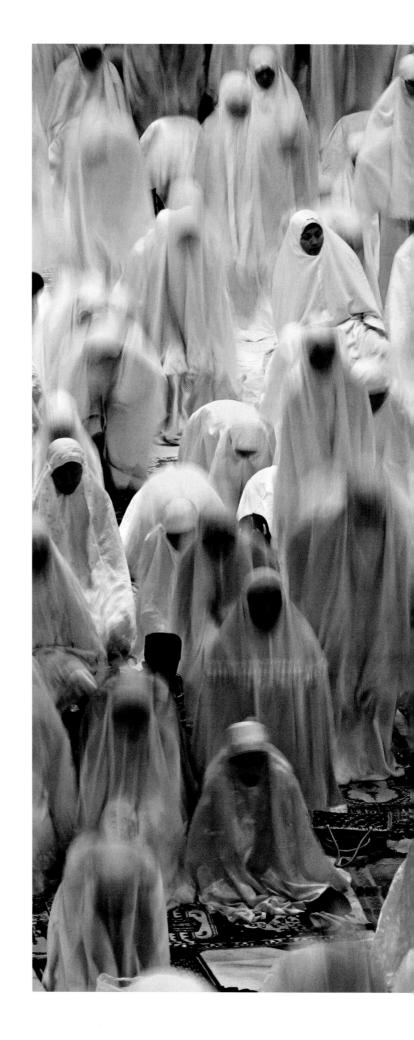

INDONESIA | SIGIT PAMUNGKAS

On the first day of Ramadan, in a mosque filled with white-robed women, one child stands up and stands out. During the month-long holiday, Muslims seeking spiritual purification fast from dawn till dusk.

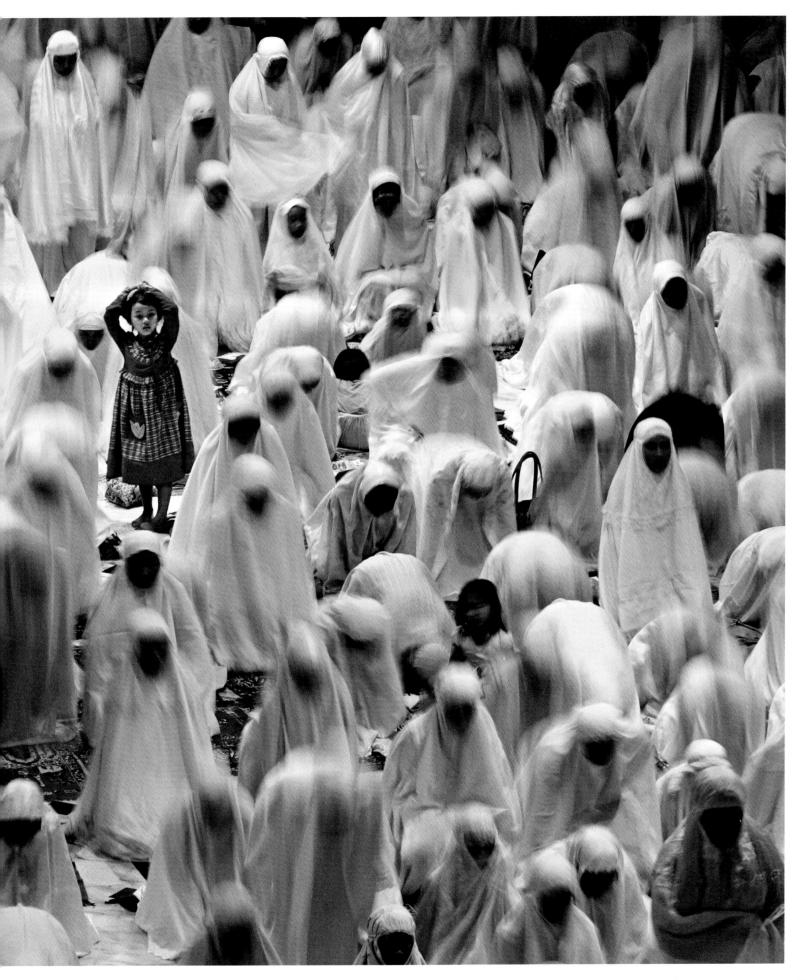

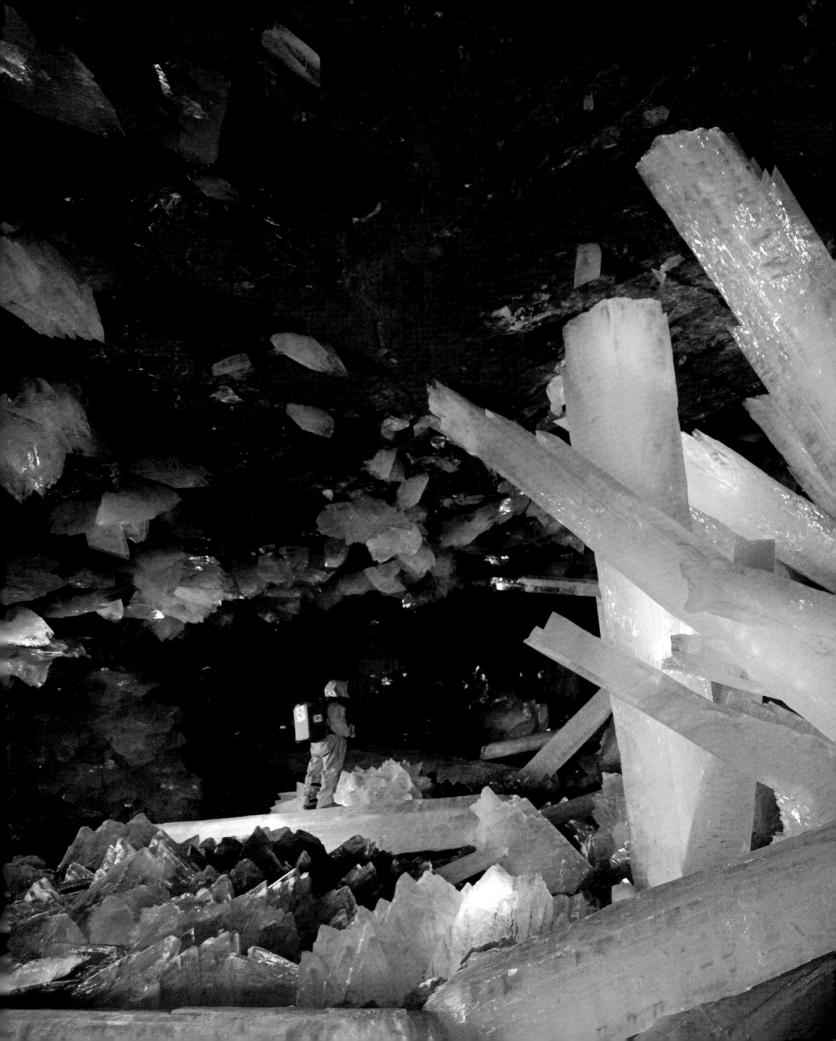

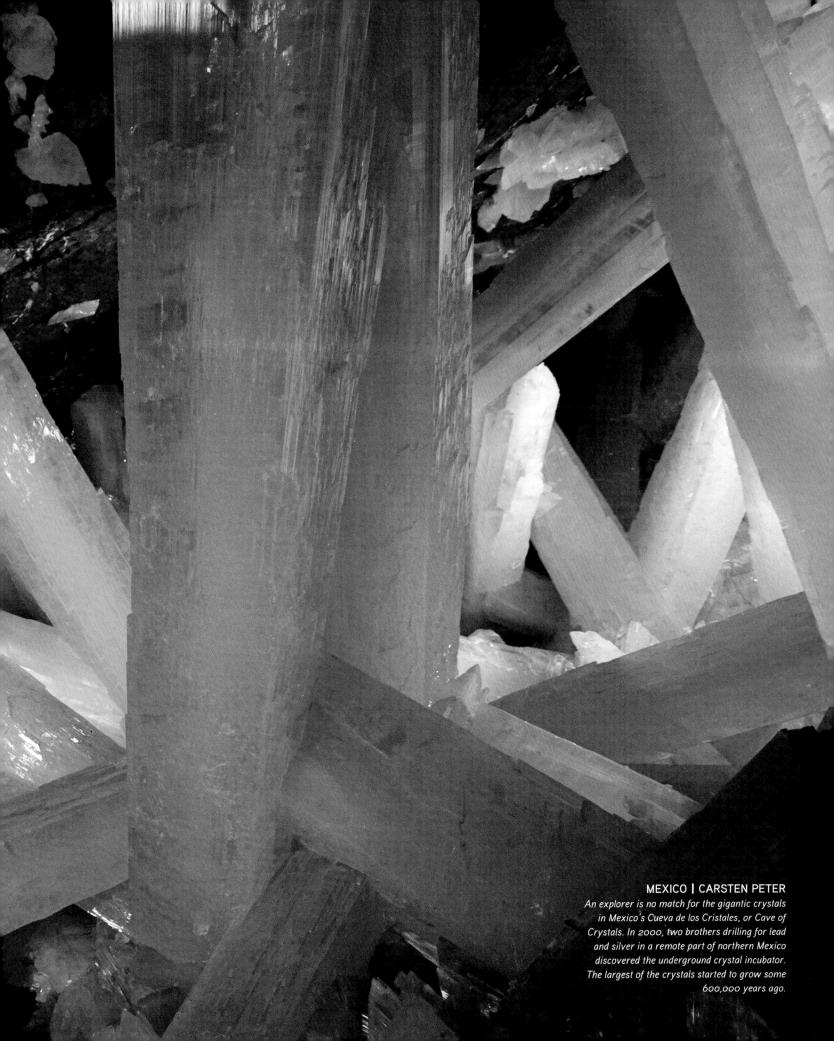

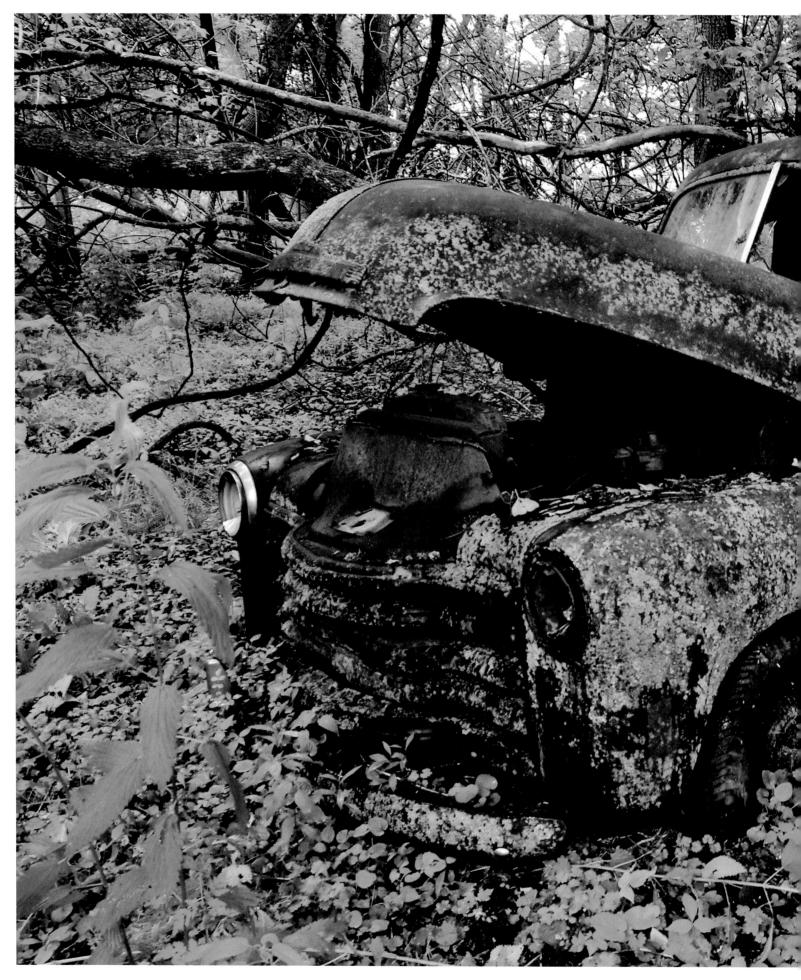

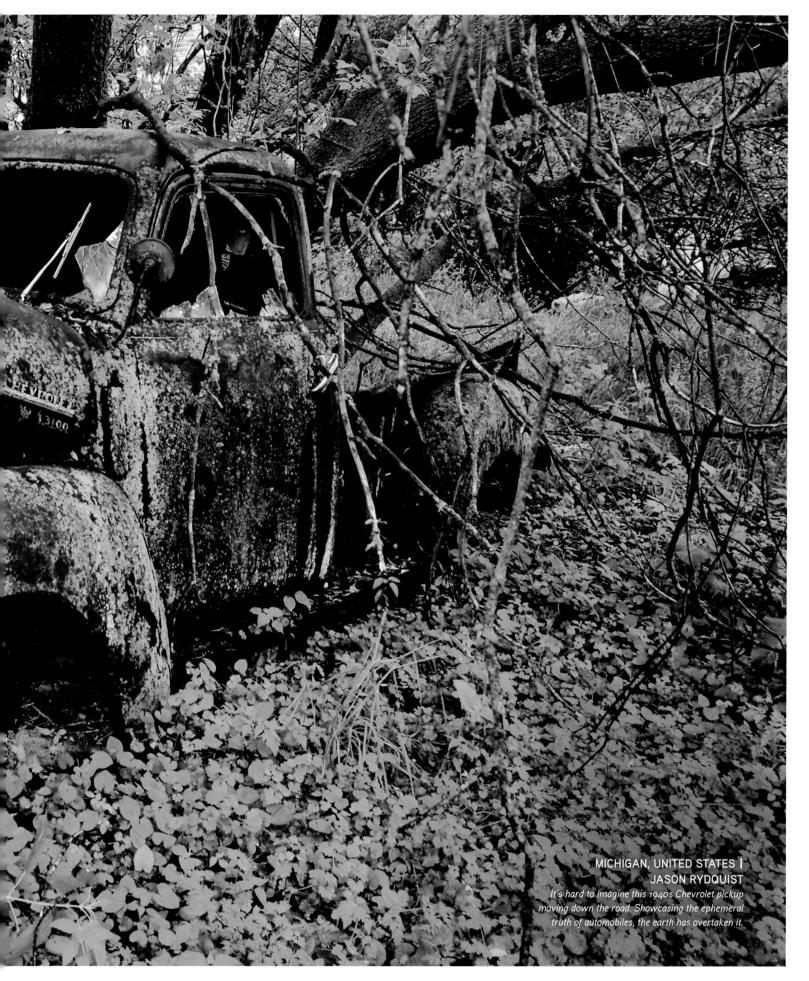

ALABASTER is a form
of gypsum, a soft, translucent stone.
The sand in New Mexico's White Sands
National Monument is almost
pure gypsum, making it
the largest gypsum dune field
in the world.

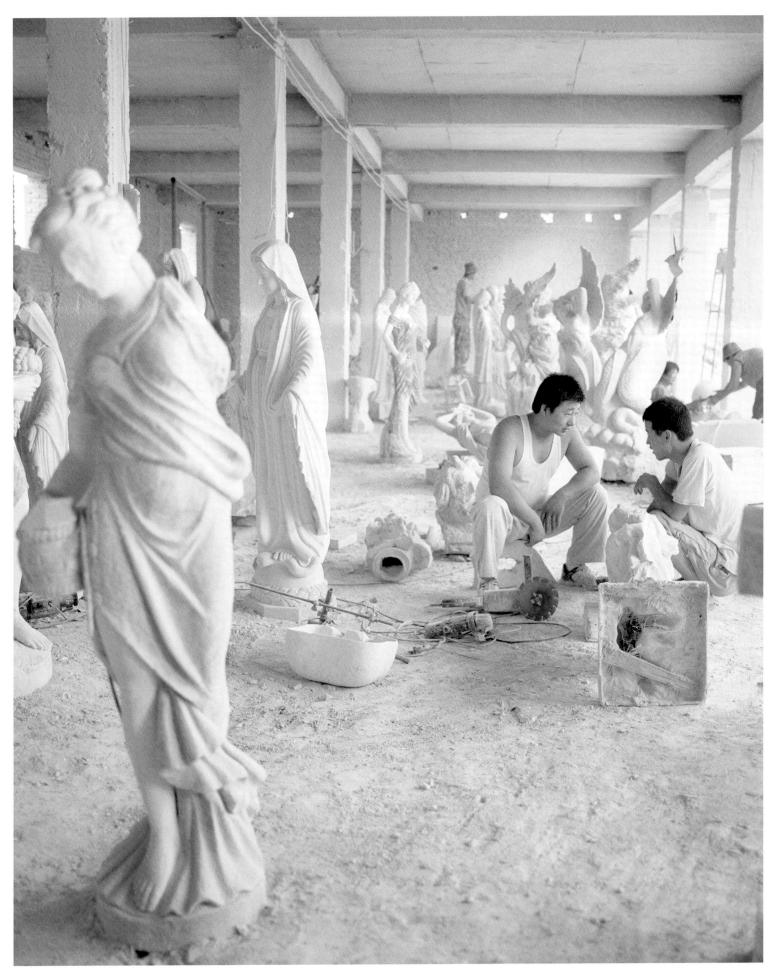

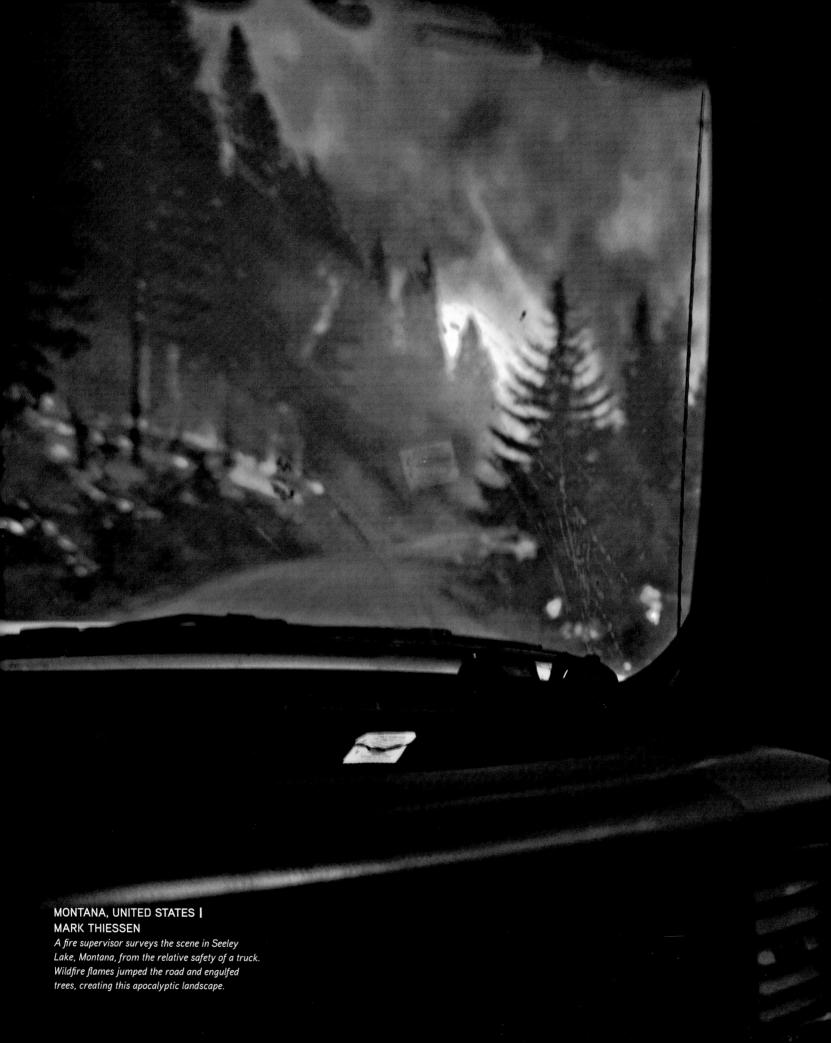

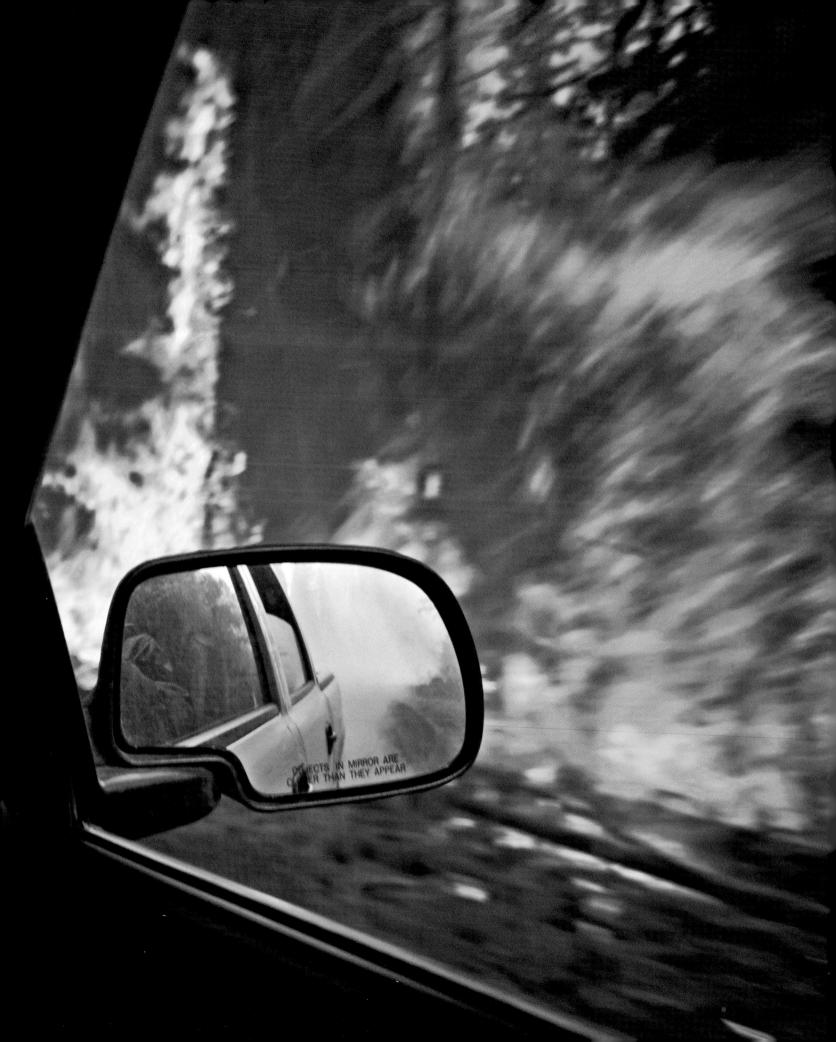

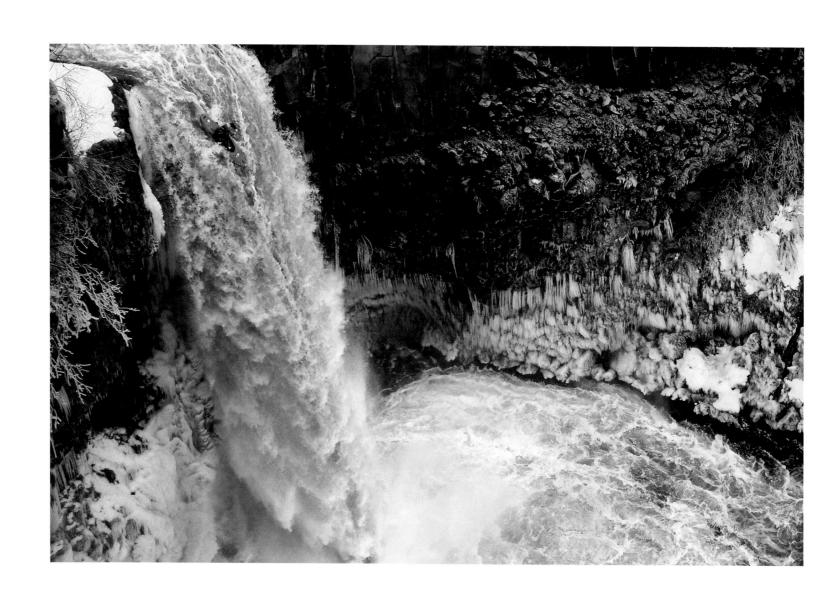

WASHINGTON, UNITED STATES | JED WEINGARTEN

A kayaker plunges 70 feet (21 meters) into winter water at Washington State's Outlet Falls. His January 2009 descent was one of only five tallied on the Klickitat River tributary, here swollen by floods and sallow from runoff.

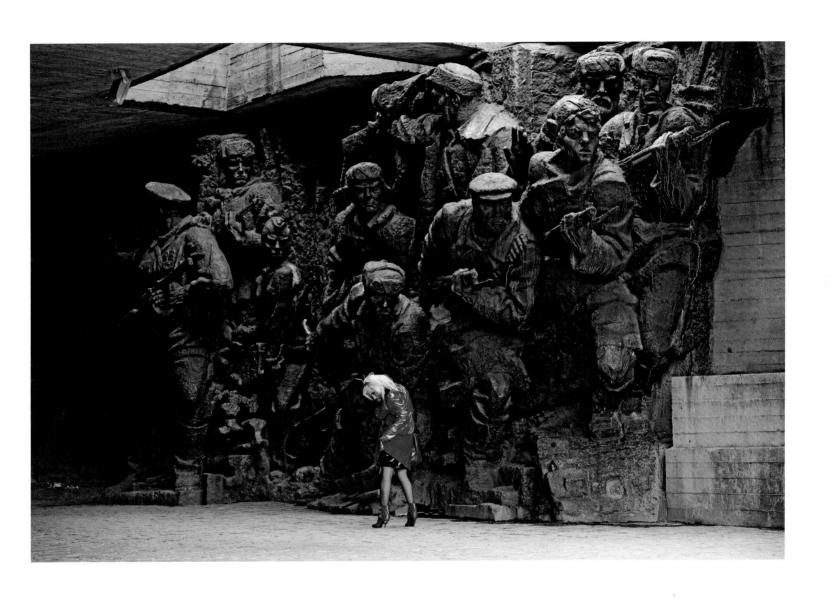

UKRAINE | SERGEI SUPINSKY

Dwarfed by the memory of her nation's past, a woman at Kiev's National Museum of History of the Great Patriotic War of 1941–45 adjusts her outfit in front of a monument to Soviet soldiers.

CANADA | JACKSON AND MELISSA BRANDTS

This ground squirrel couldn't resist the limelight. Melissa and Jackson Brandts were looking for a memento of their trip to Banff National Park, but instead they got an immediate Internet sensation when this squirrel stopped to check out their camera.

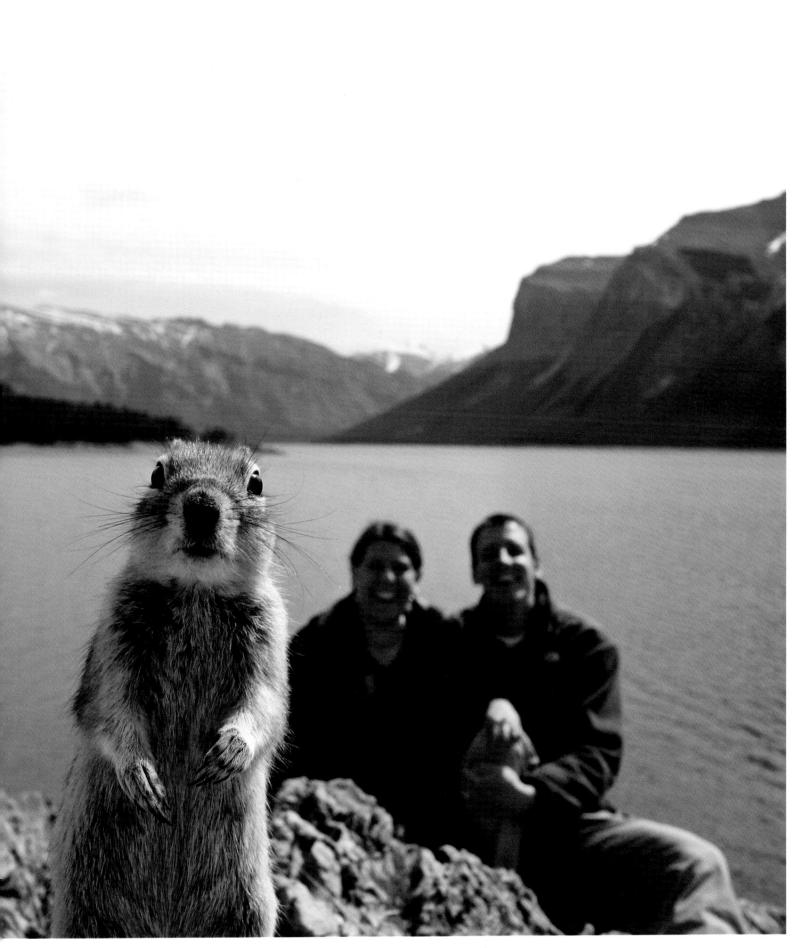

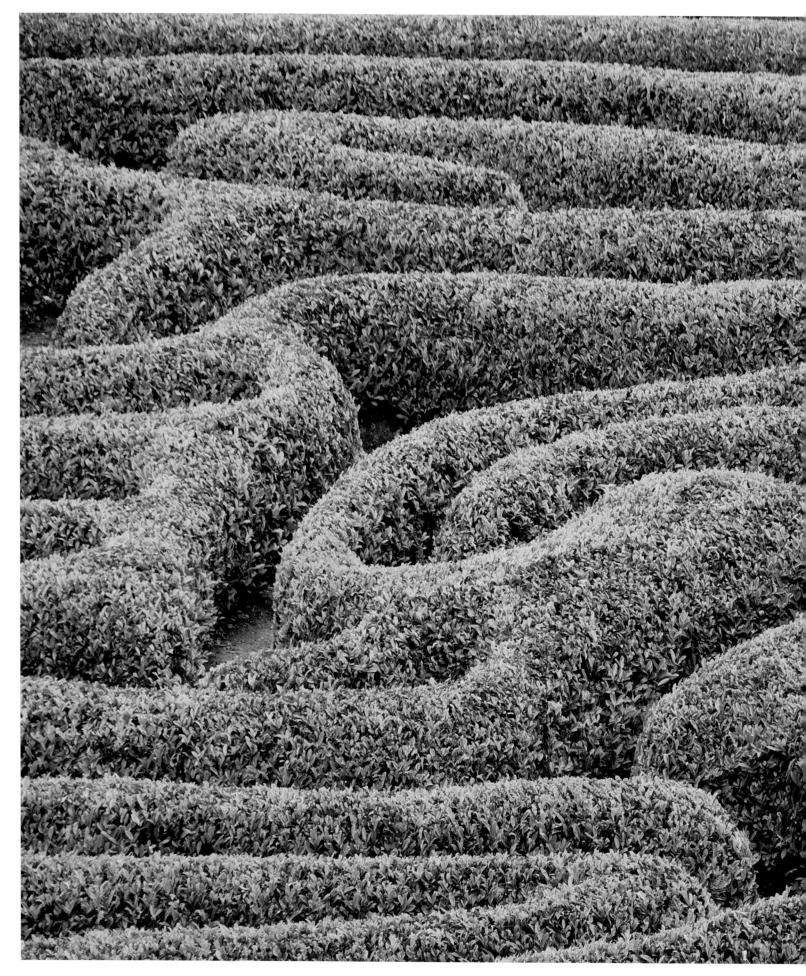

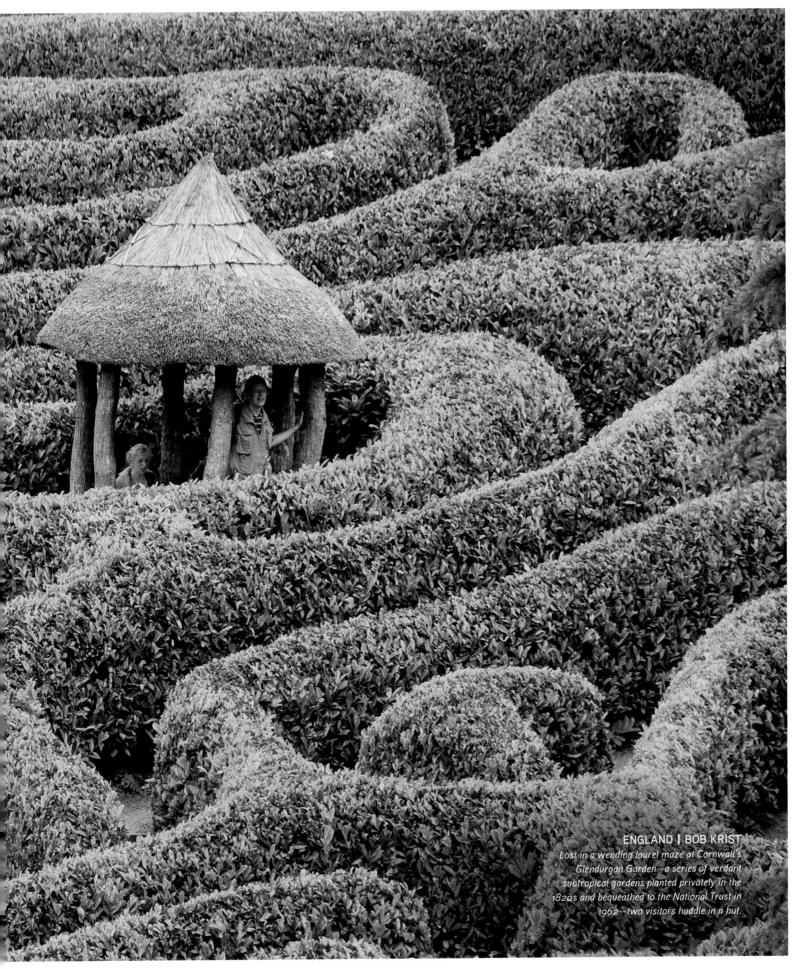

LATVIA | MARTIN ROEMERS

A long exposure blurs sea and sky into a minimalist backdrop for a crumbling Soviet-era military building near Liepāja. More than a decade after Moscow withdrew its forces from Latvia, such ruins litter the Baltic coast.

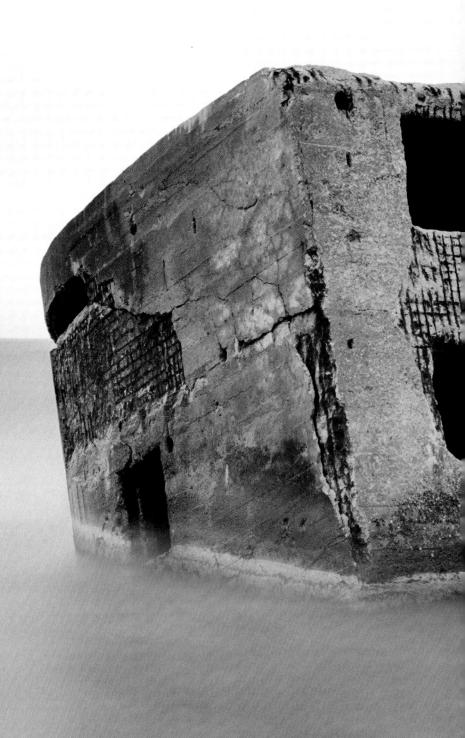

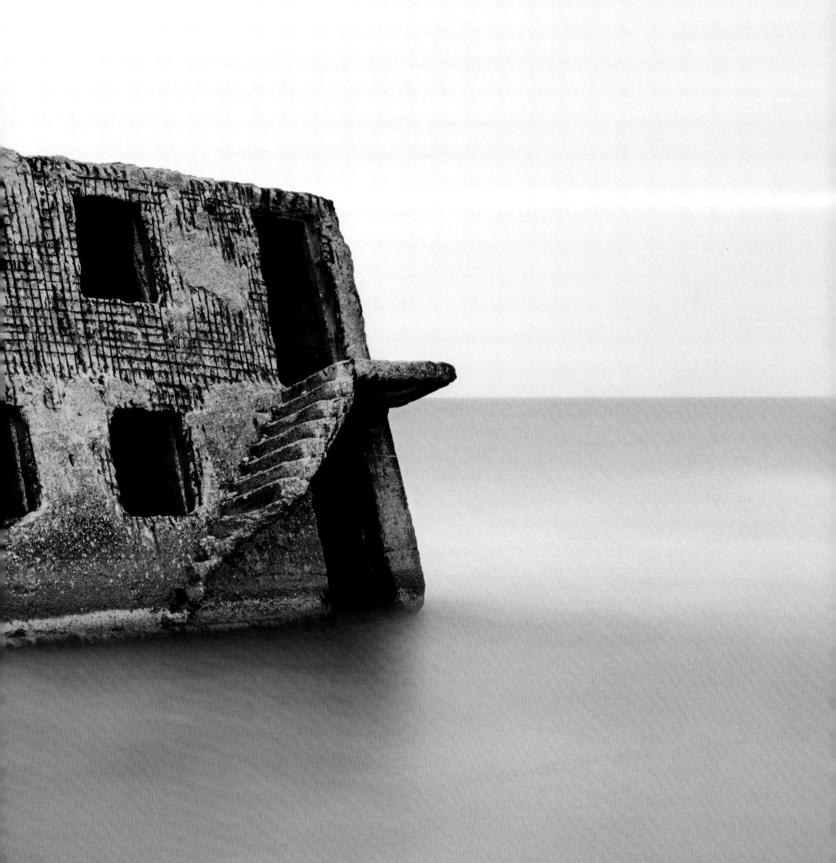

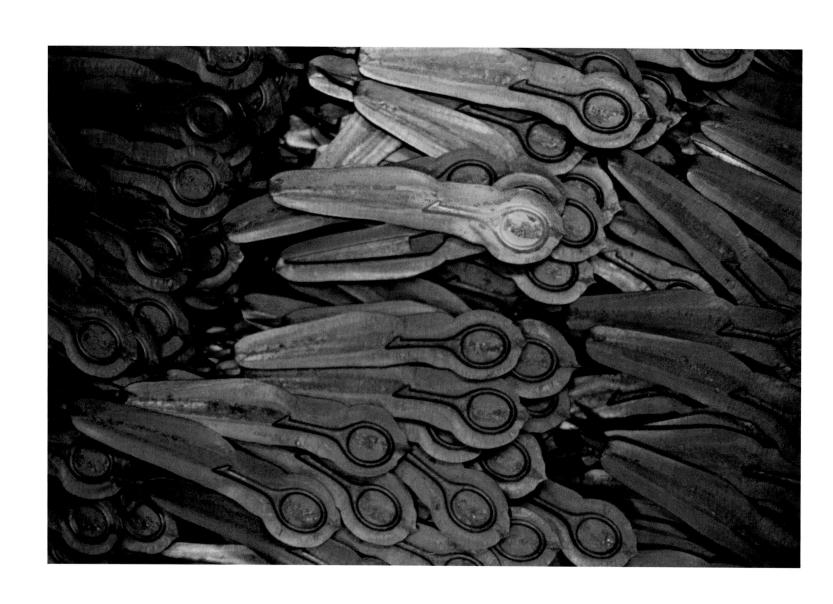

GERMANY | BRUCE DALE

A glowing half of a pair of scissors joins a cooling pile in Solingen, Germany. Situated near a steady supply of water, iron ore, and timber for charcoal, the city has become known for its quality metalwork.

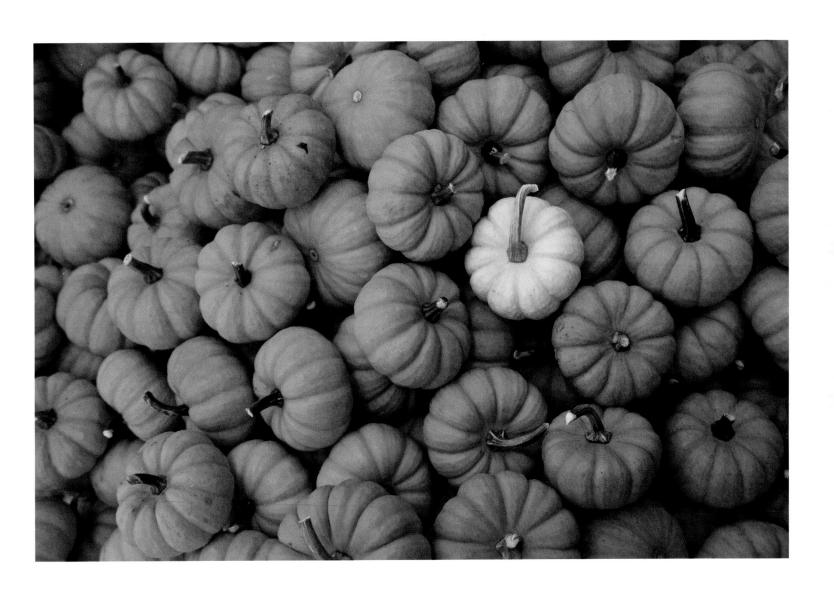

PENNSYLVANIA, UNITED STATES | STEPHEN ST. JOHN

A miniature white pumpkin in Gettysburg, Pennsylvania, provides a worthy counterpoint to its orange cousins. While pumpkins contain vitamins A and C and potassium, they often are used for autumnal decorations instead of for eating.

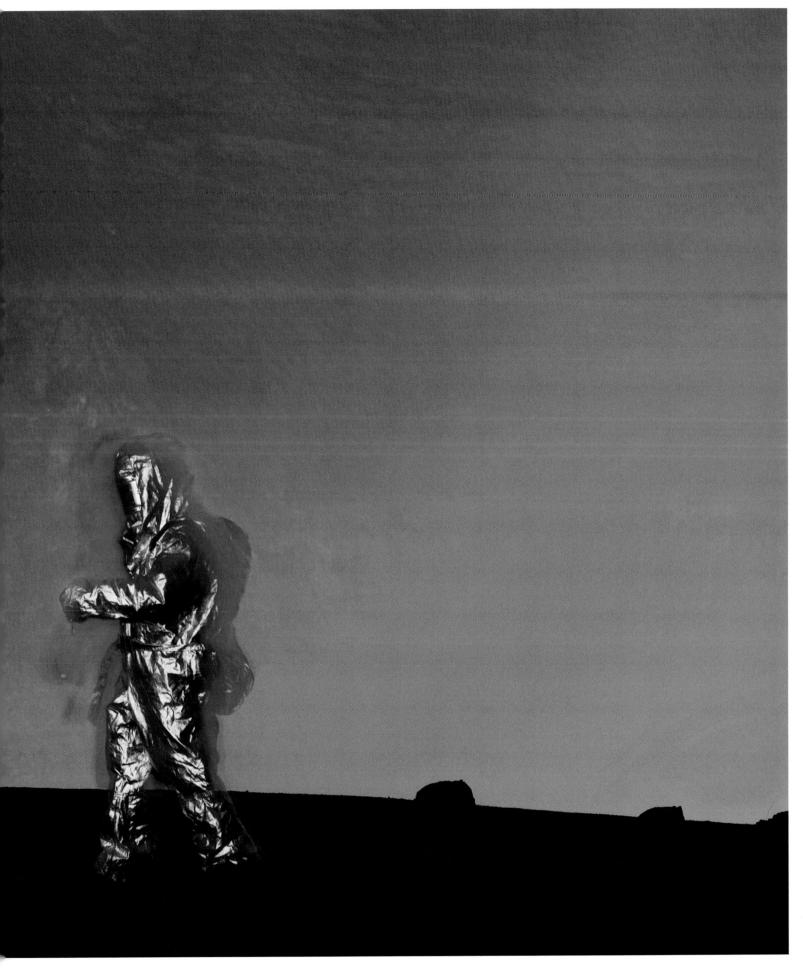

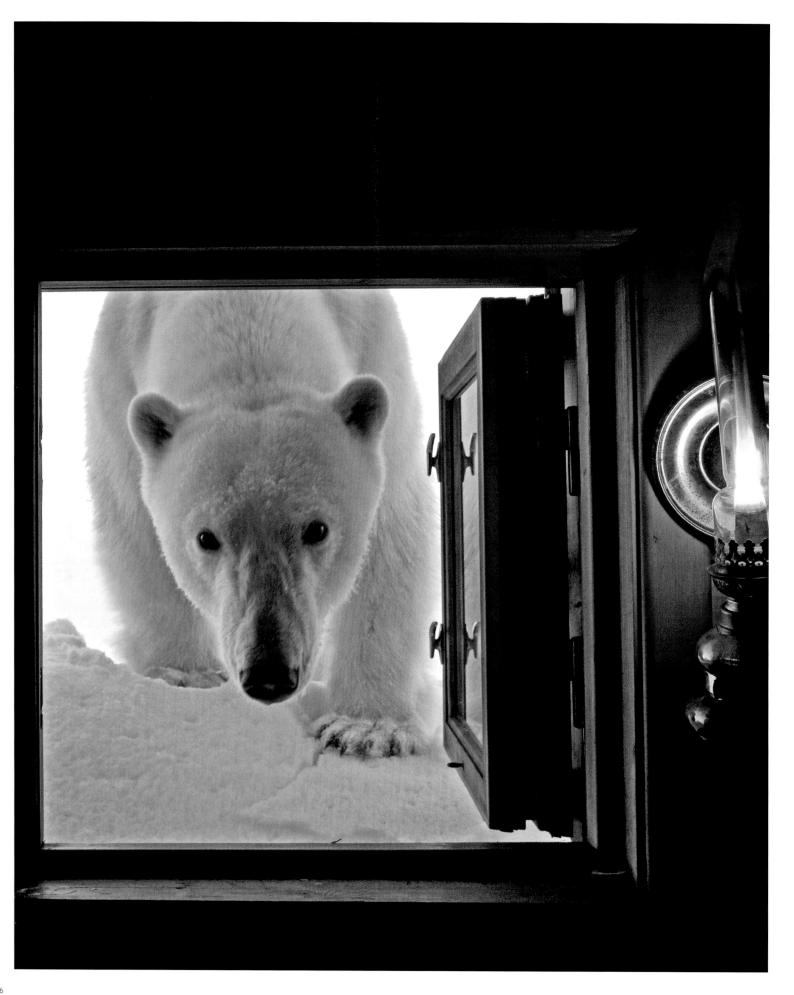

POLAR BEARS sport
a thick coat of insulated fur to help
them survive in one of the planet's
coldest environments. They even
have fur on the bottom of their paws
to protect against cold surfaces and
provide a good grip on ice.

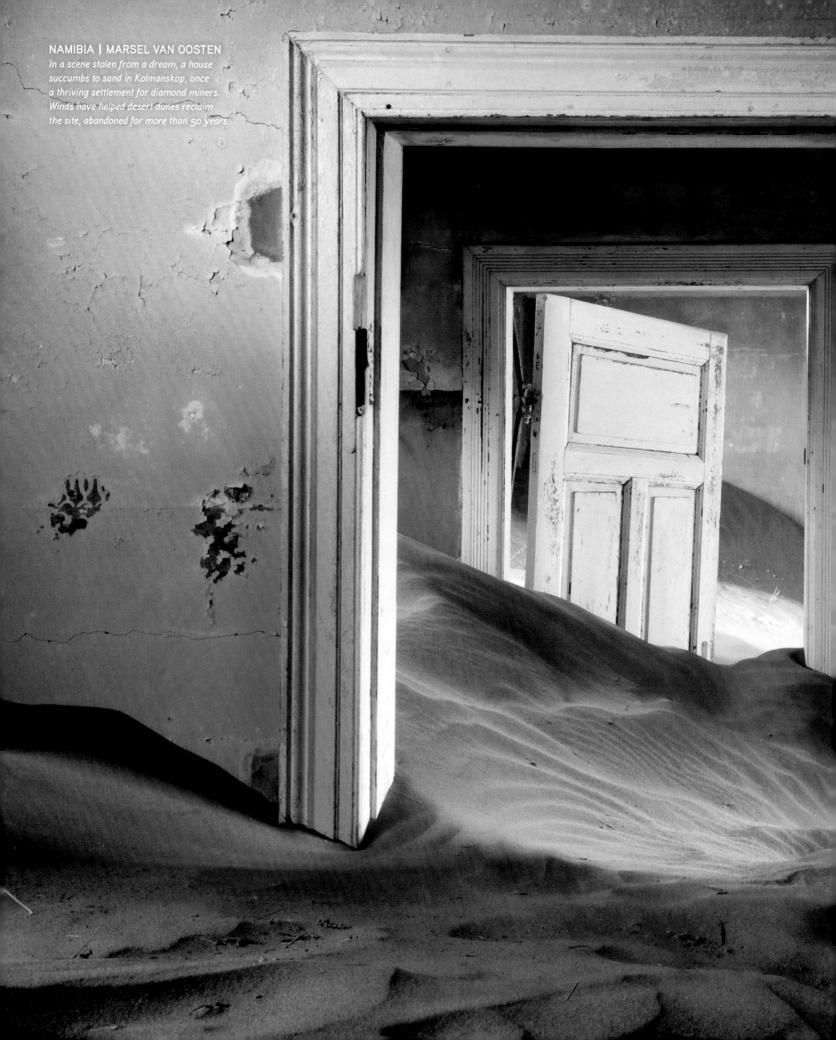

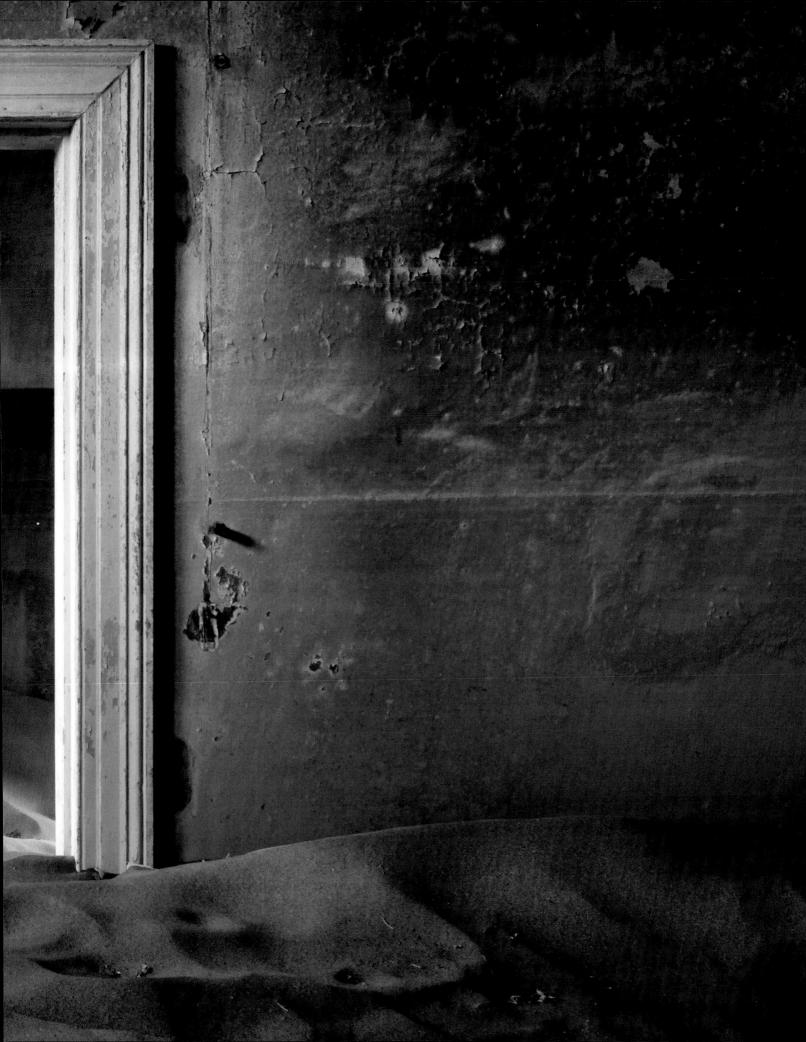

PORTFOLIO TWELVE

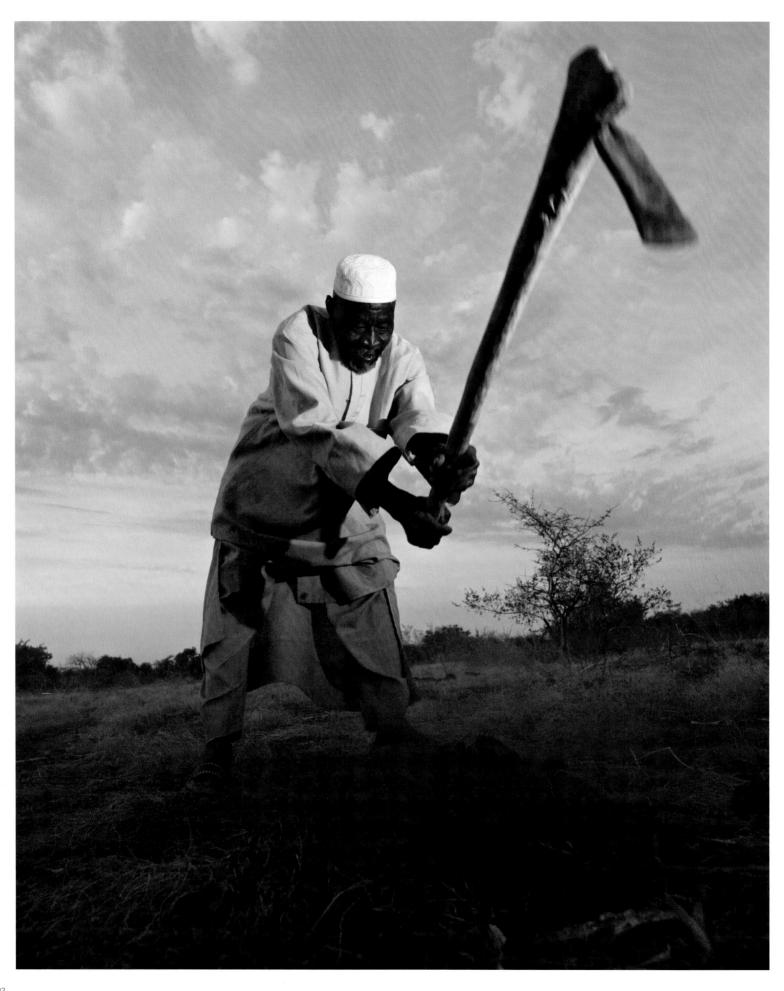

that extols the wholeness of being, breaking represents

a threat. A broken egg will never hatch. A fractured acorn will not sprout. A crushed flower bud will not mature into fruit. Yet breaks will always occur in the shuffle and movement of life on Earth. Photographers see them not as interruptions but as part of Earth's action, fissures into which we gaze to look upon time and space more deeply, stumbles from which we recover and carry on.

Some breaks take an eternity. The Grand Canyon is a massive breaking of Earth's crust. Seen from on high, its carved-out crevices recall the jagged edges of a drought-driven mudflat. A river flows through, still deepening the cracks and smoothing sharp edges, making all things round.

Other breaks happen in an instant. In tropical turquoise waters, the heedless flap of a dolphin's tail or the mighty torrent of hurricane-tossed waves snaps off a broad arm of elkhorn coral. It totters and falls to the ocean floor. Resting fish scatter. Where it broke off, a jagged stub remains.

But from the fallen branch, a new coral world may grow, and this chance is the promised cycle of Earth's breaking. Even in violence, even in death—even when a cheetah mounts a gazelle, sharp teeth sinking into jugular, last shiver of strong limbs, last heartbeat—the lost one feeds the many. Cheetah, hyena, vulture, soil: all enriched by blood, meat, and marrow, one life broken that others may live.

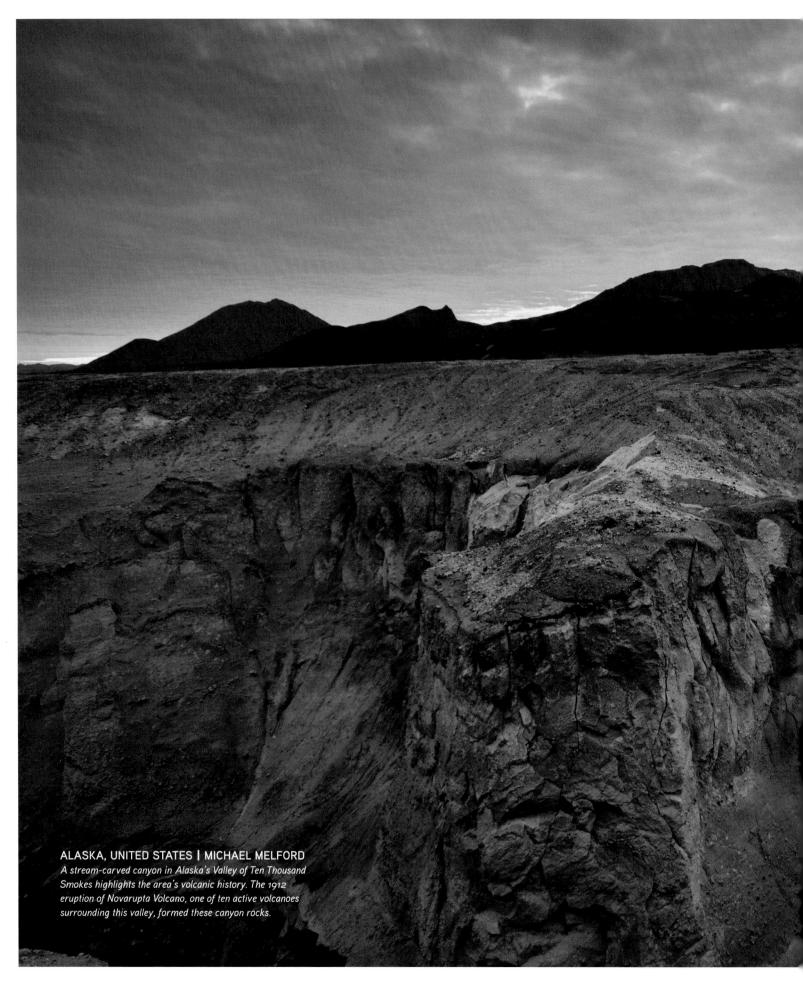

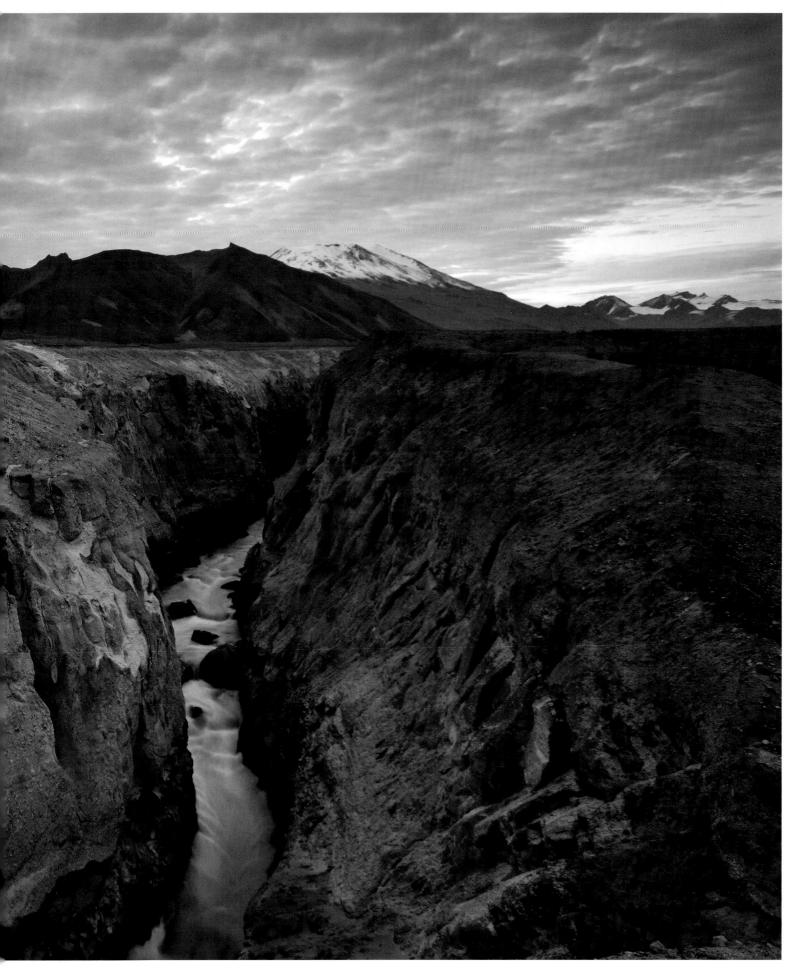

CALIFORNIA, UNITED STATES | STEVE SKINNER

An F-18 fighter jet seems to appear out of a milky curtain as it breaks the sound barrier during a San Diego air show. A vapor cloud surrounds the fighter as it reaches supersonic speeds.

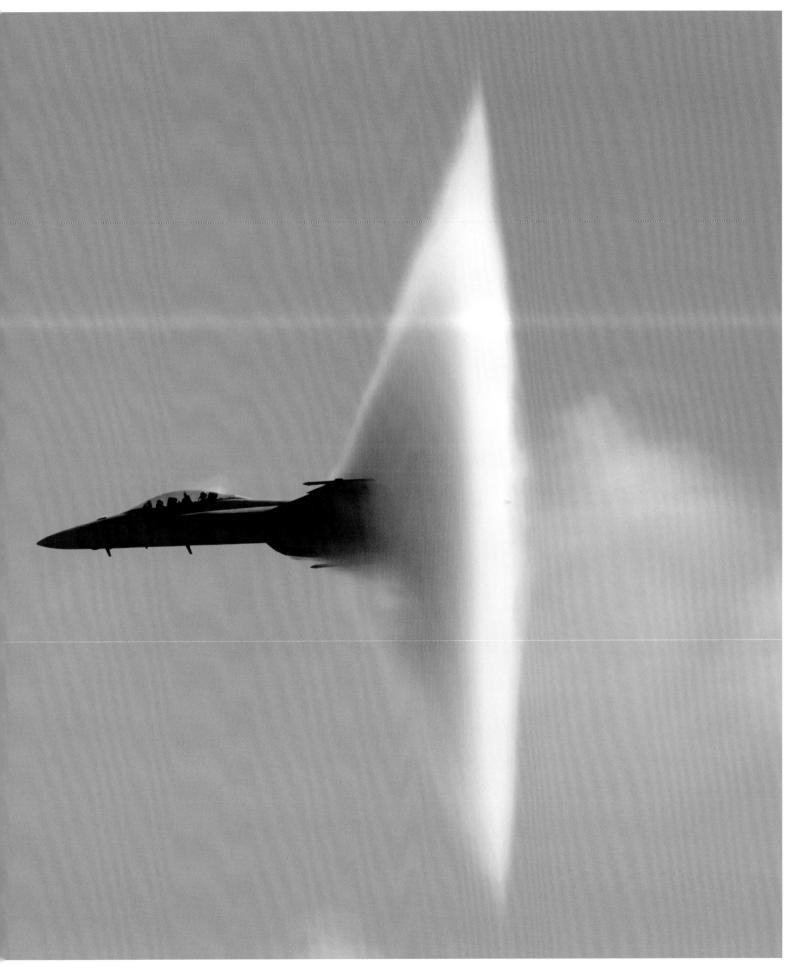

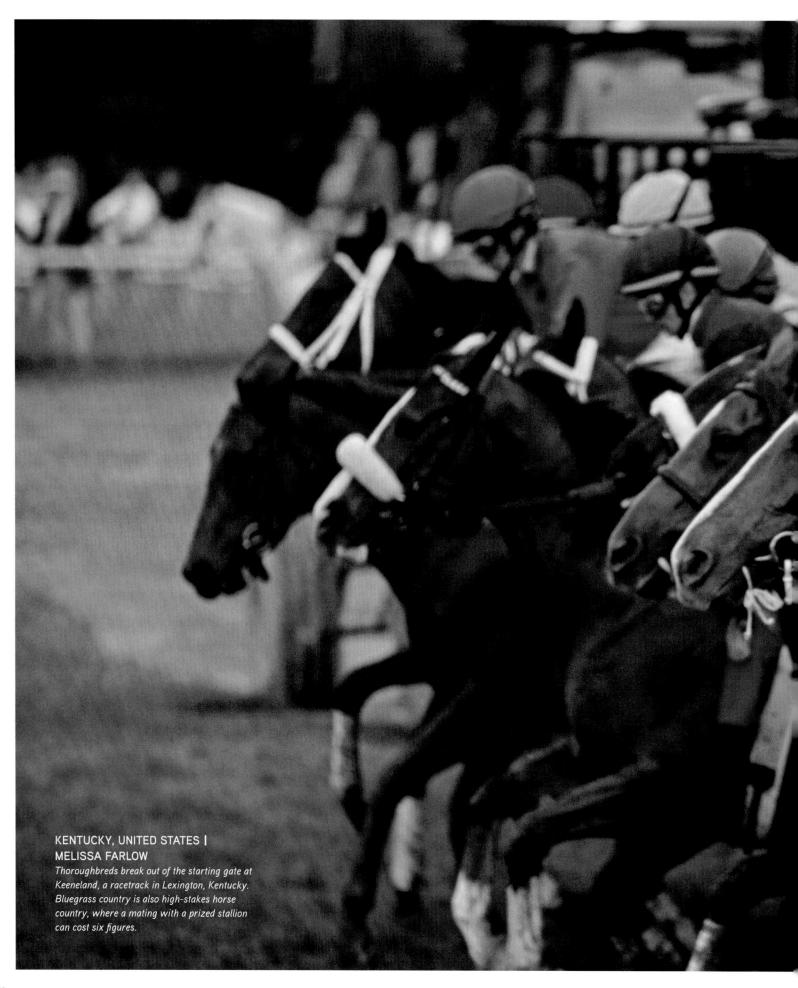

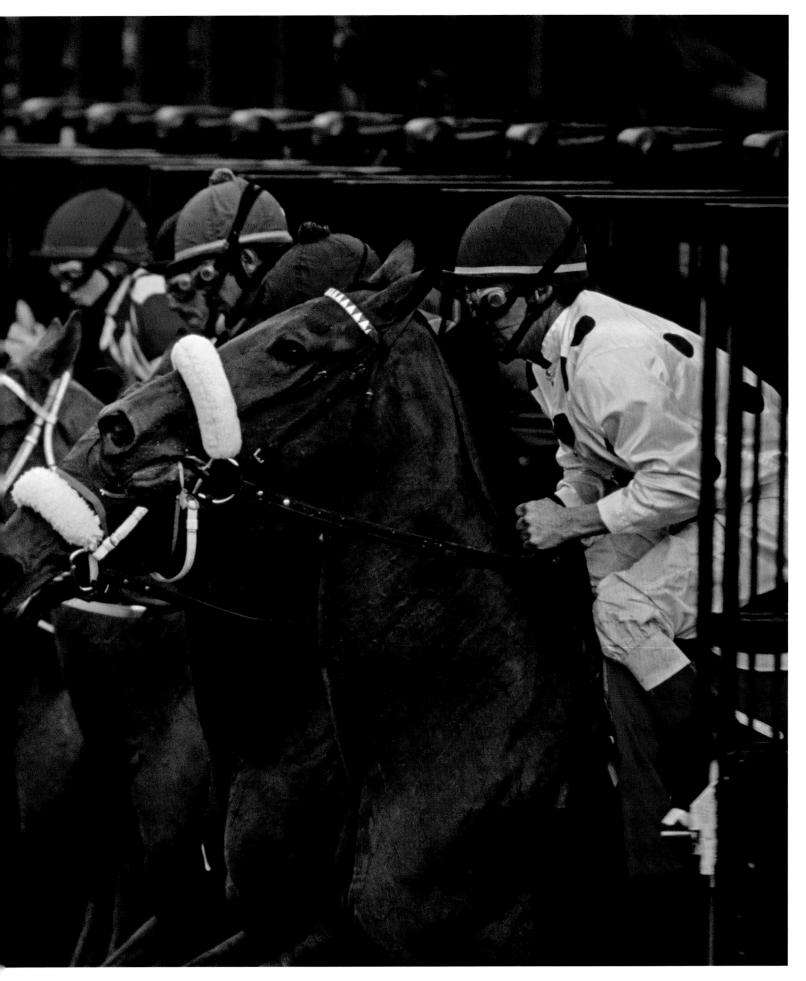

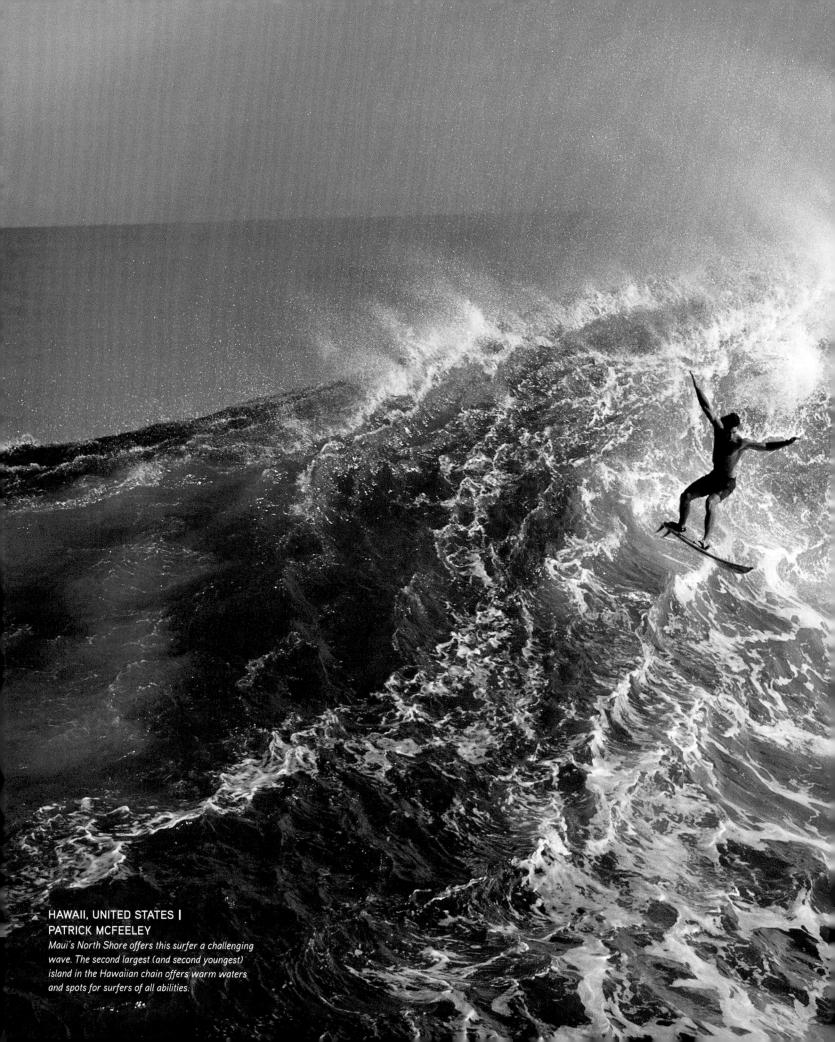

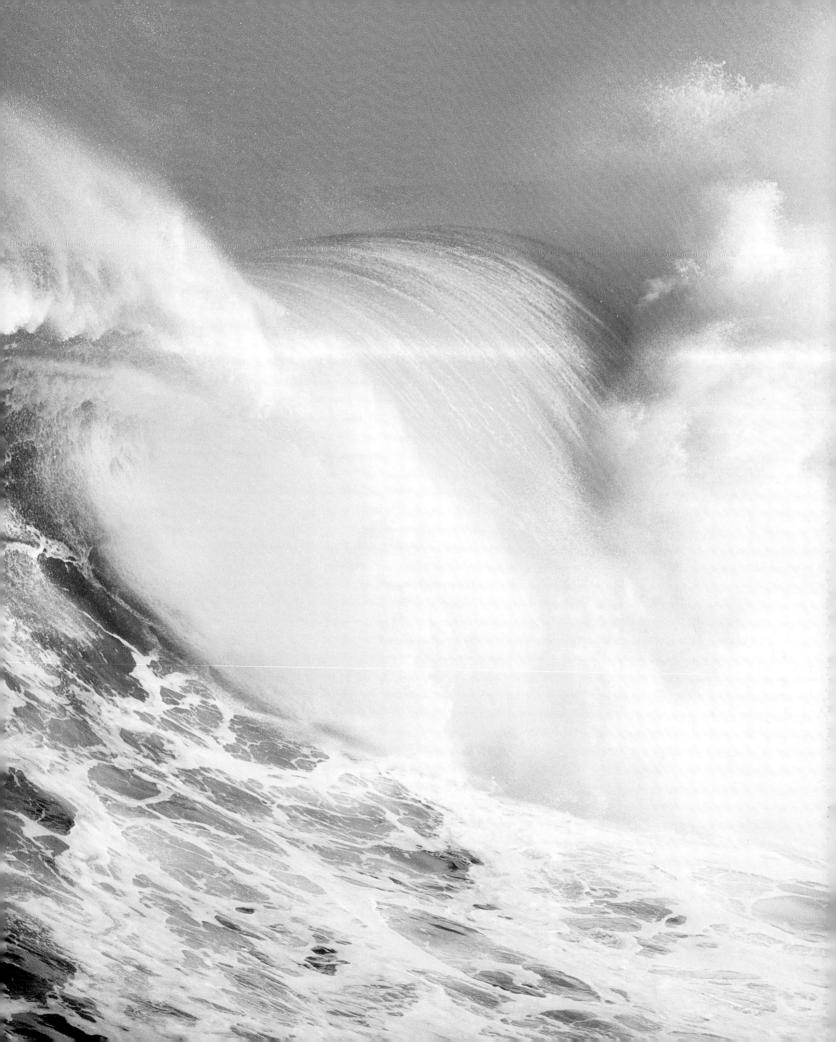

The TIBET PLATEAU

is often called the Roof of the

World because of its high elevation.

Travelers unused to such heights

often experience altitude sickness

when first arriving in Tibet.

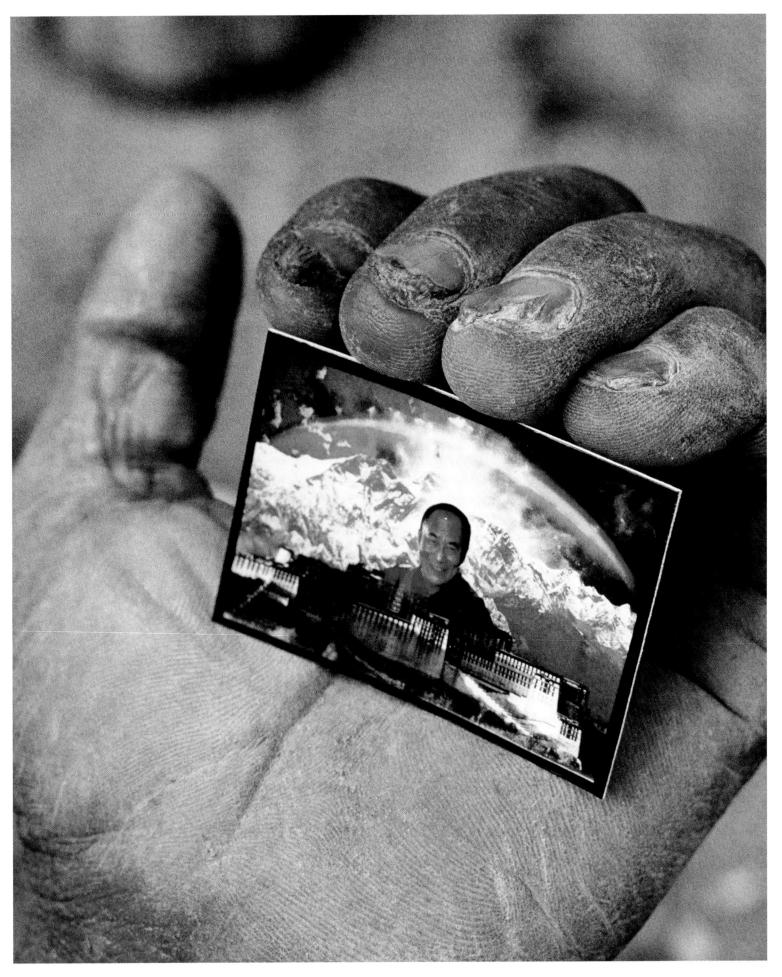

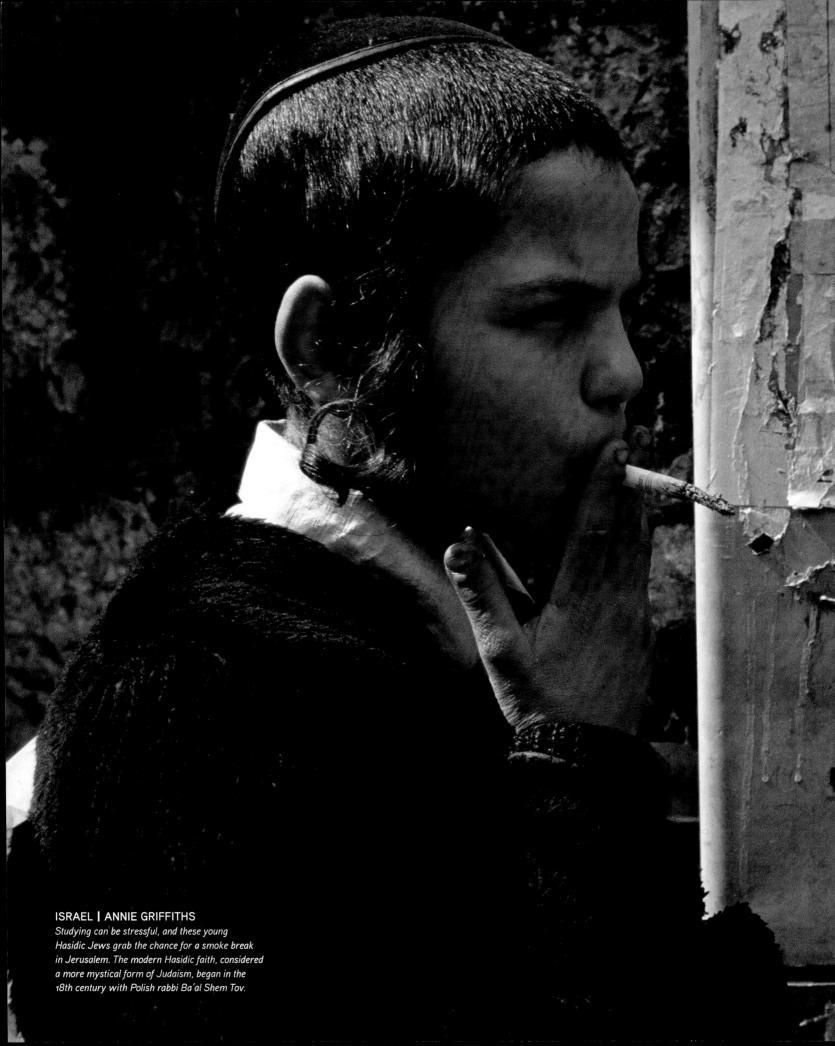

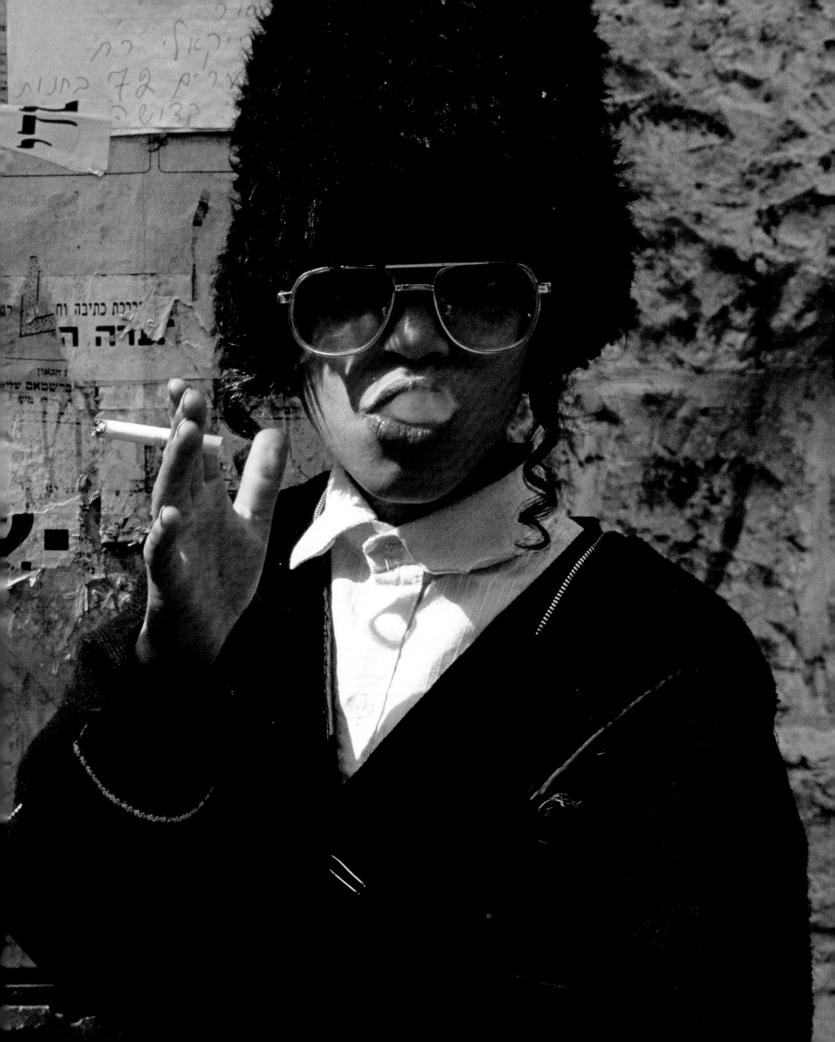

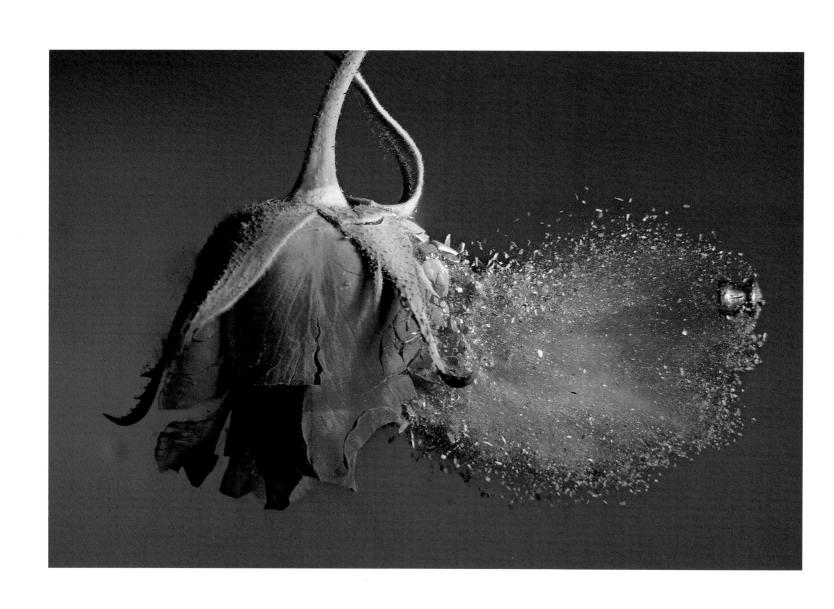

CALIFORNIA, UNITED STATES | ALAN SAILER

Like a high-speed Cupid's arrow, an air-rifle pellet pierces the heart of a rose at some 800 feet per second (244 meters per second). The flower, plucked from a garden and flash frozen in liquid nitrogen, shatters in a spray of petal fragments.

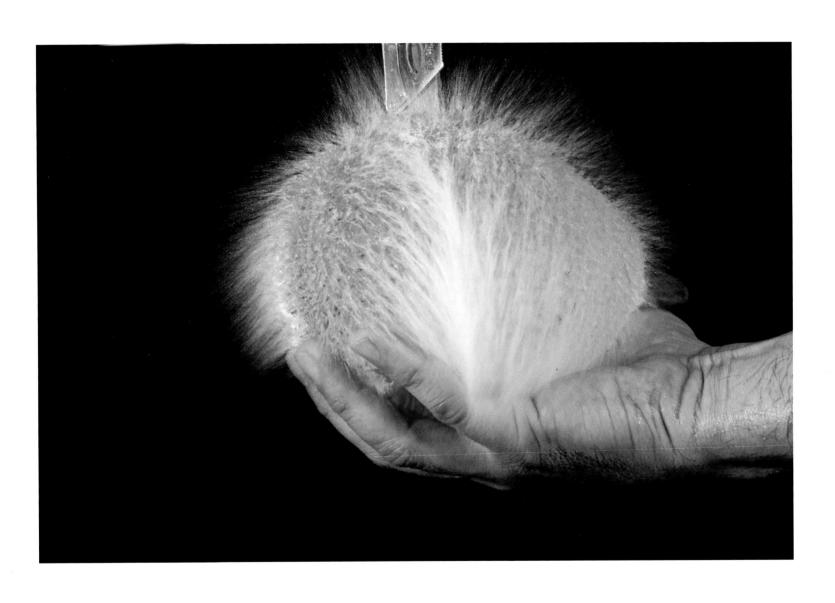

UNITED STATES | TYLER THOMAS

A ruptured water balloon keeps the broad outlines of its shape, at least for a brief time. As it explodes into a misty spray of droplets, surface tension and the gravity of the water help retain the sphere.

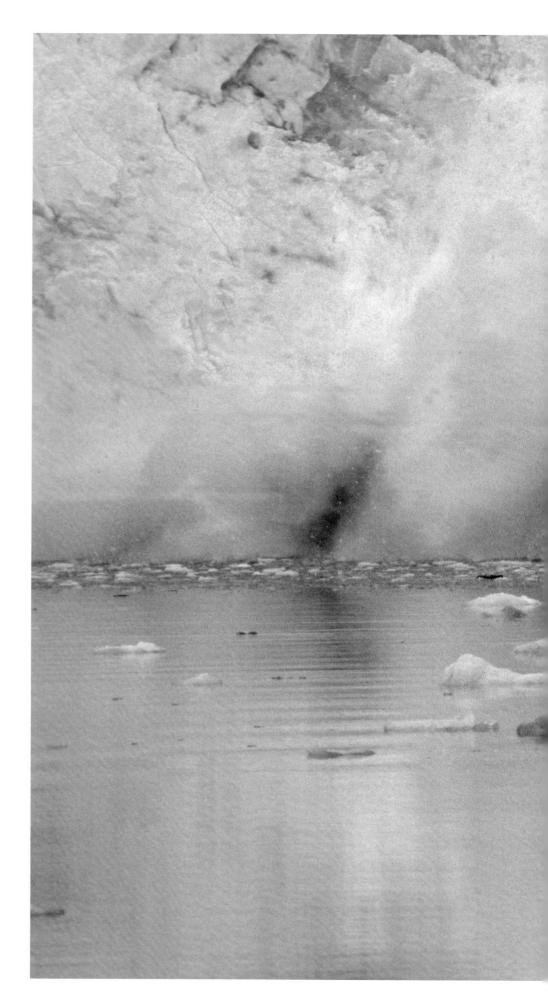

ALASKA, UNITED STATES | ERNEST MANEWAL

The calving Meares Glacier provides quite a summer splash for kayakers in Prince William Sound. As the glacier advances, sections break off into Unakwik Inlet after overtaking an old-growth forest.

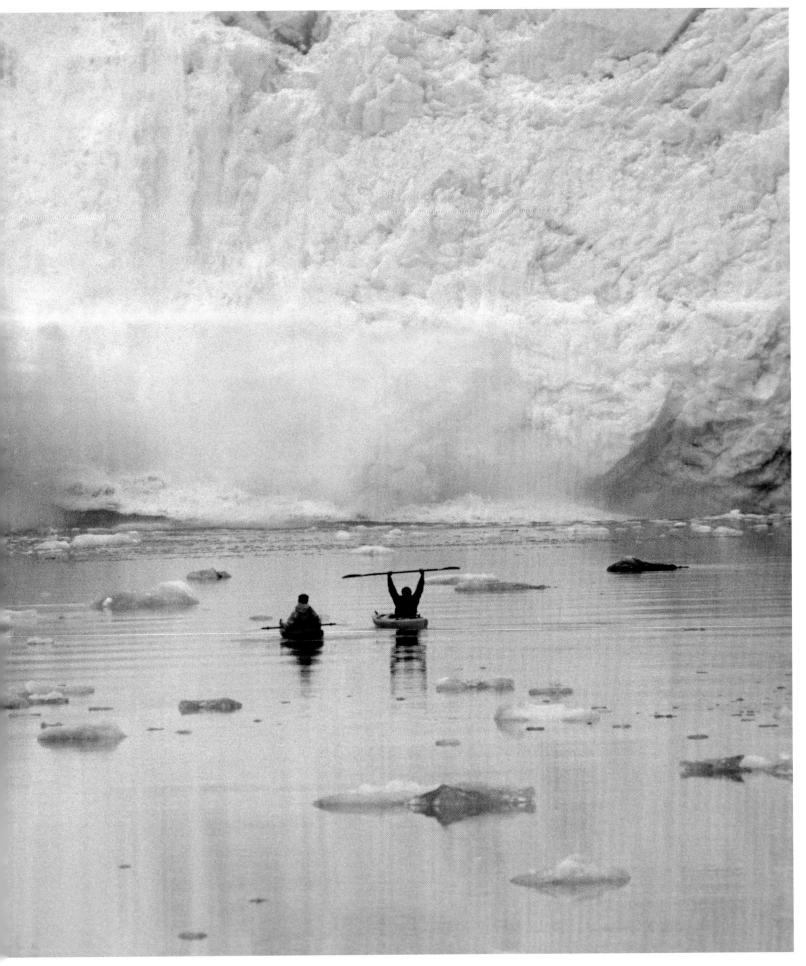

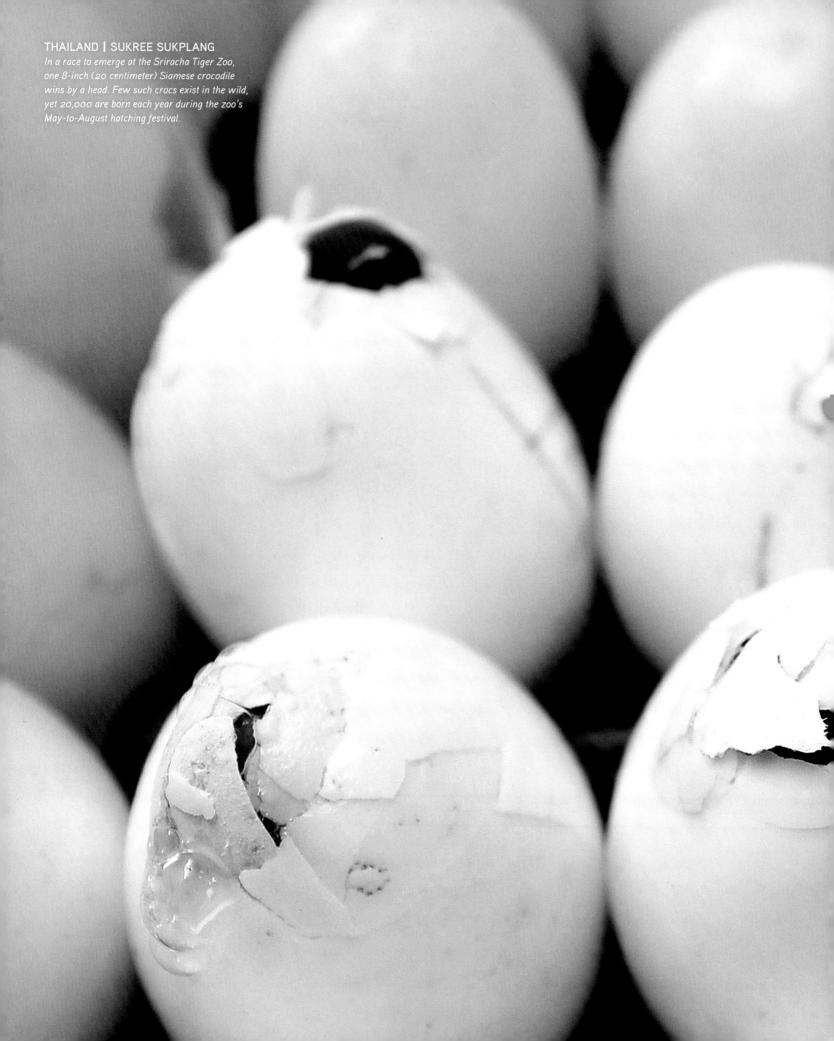

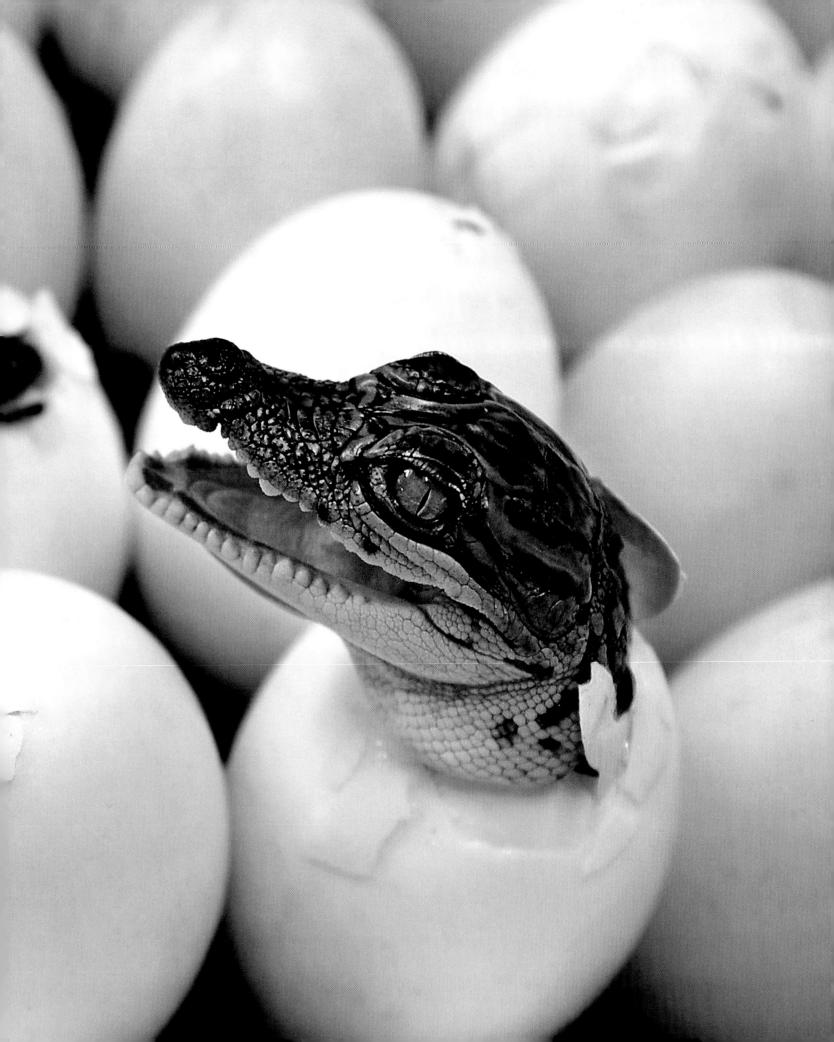

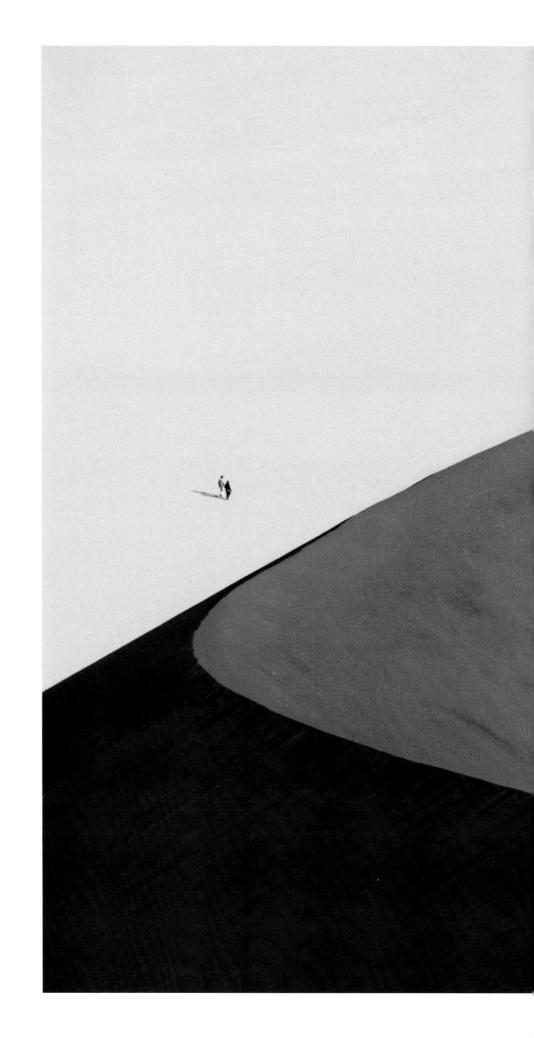

NAMIBIA | FRANS LANTING

Hikers appear as specks climbing on the face of a giant dune in the Sossusvlei region of Namibia's Namib-Naukluft Park. Winds have shaped and reshaped the sands, colored red by iron oxide, for thousands of years.

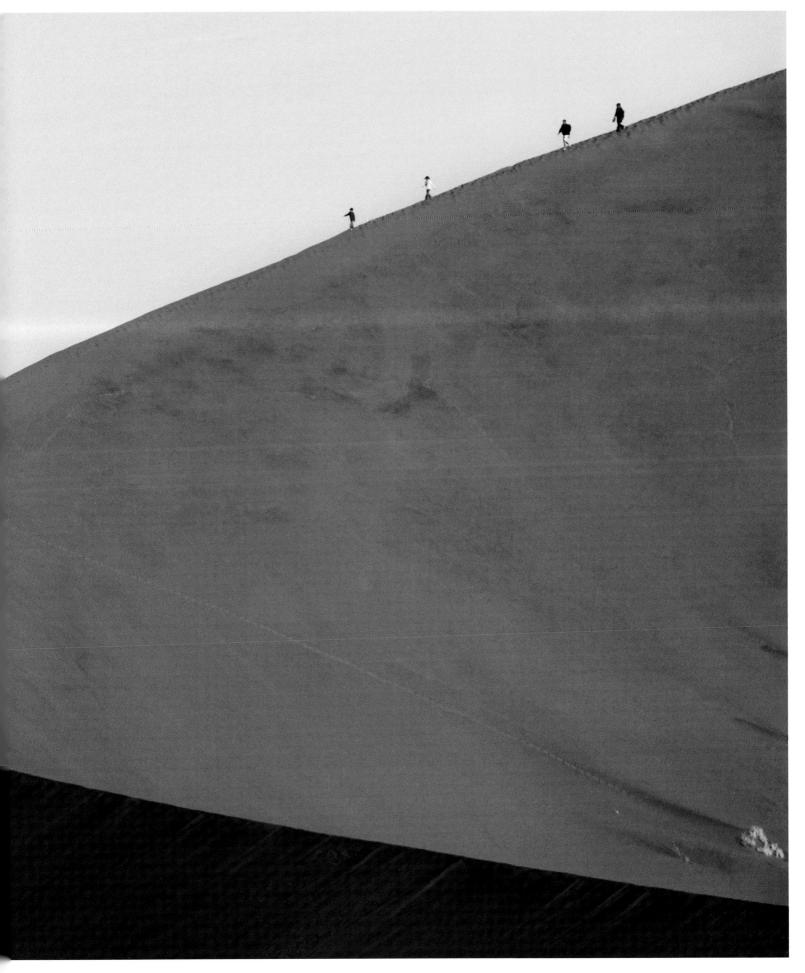

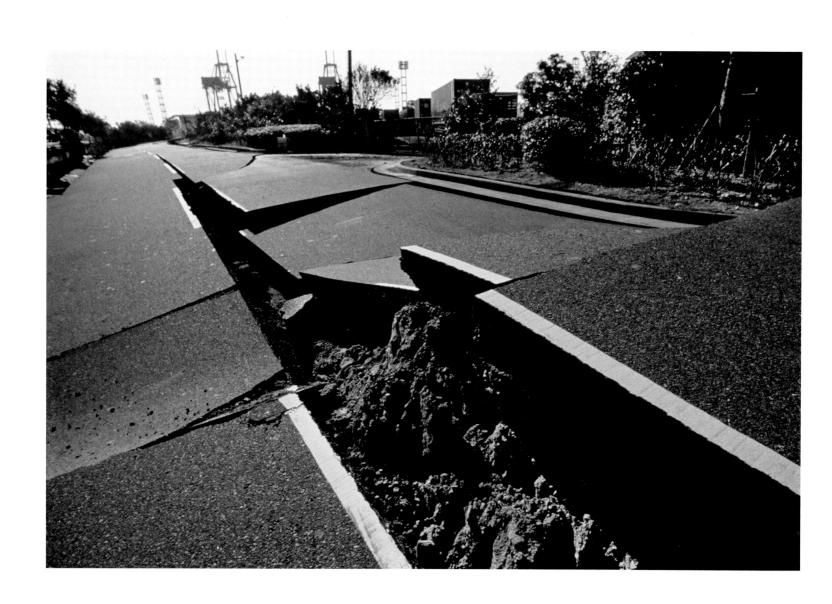

JAPAN | KAREN KASMAUSKI

A visual reminder of plate tectonics, a fissure seemed to follow a road's white line when it cracked open the pavement in Kobe, Japan, in 1995. After that earthquake, Japan set up a nationwide alert system to give its citizens precious time to prepare.

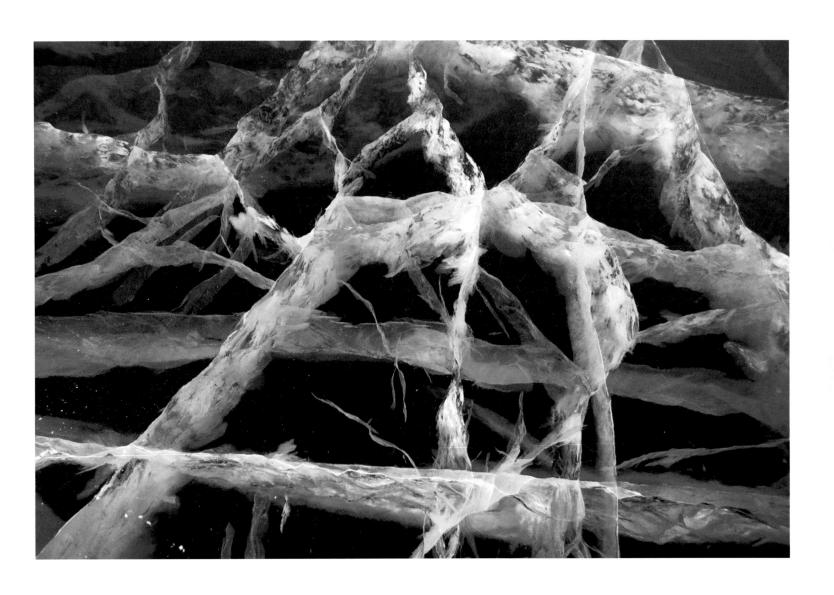

CANADA | PAUL NICKLEN

Pressure cracks in brilliant blue, multiyear Arctic sea ice create a tie-dyed tapestry. This ice contains less brine and more air pockets than first-year ice, and if a hummock a few years old is found, it can provide water fresh enough to drink.

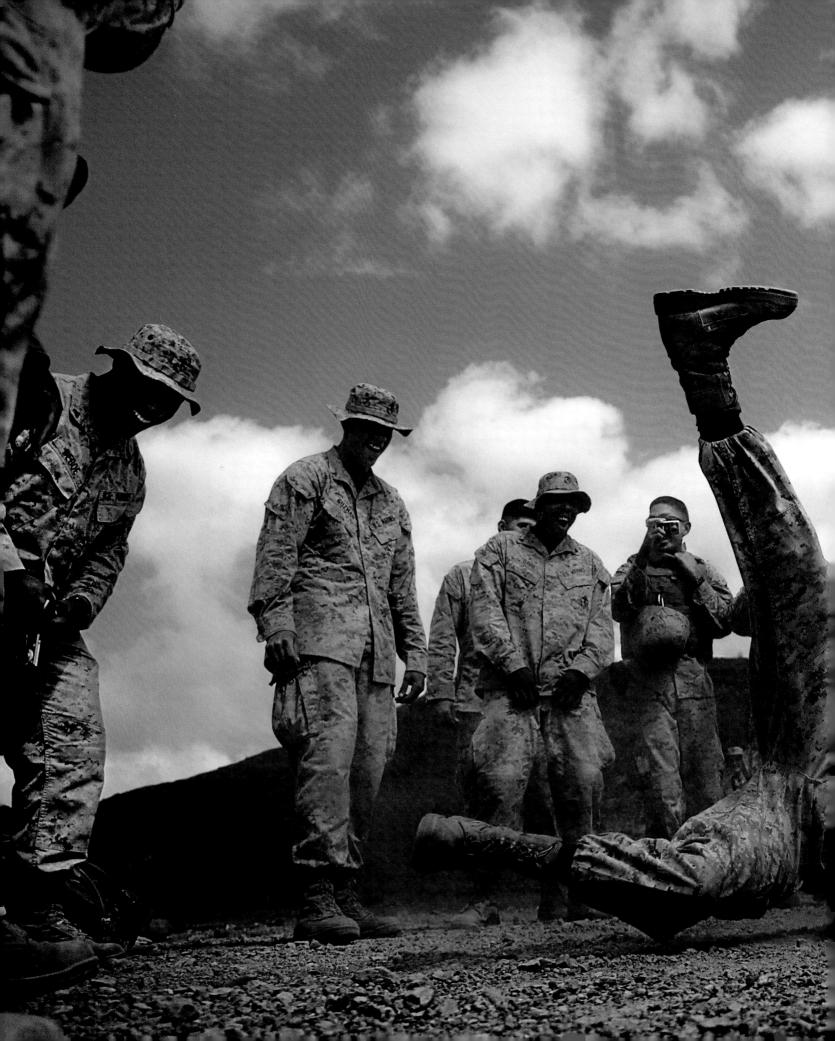

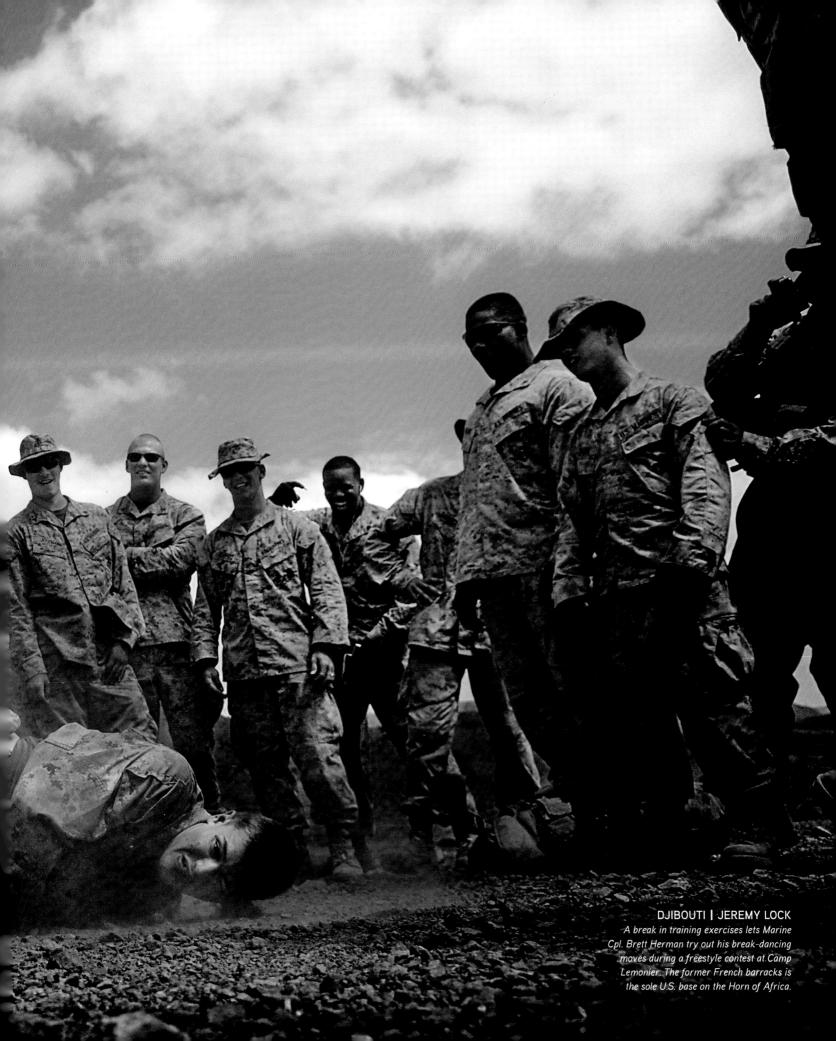

BATS are the only
mammals that can truly fly.
Their wings are made up
of thin layers of skin
that stretch between very long
finger bones.

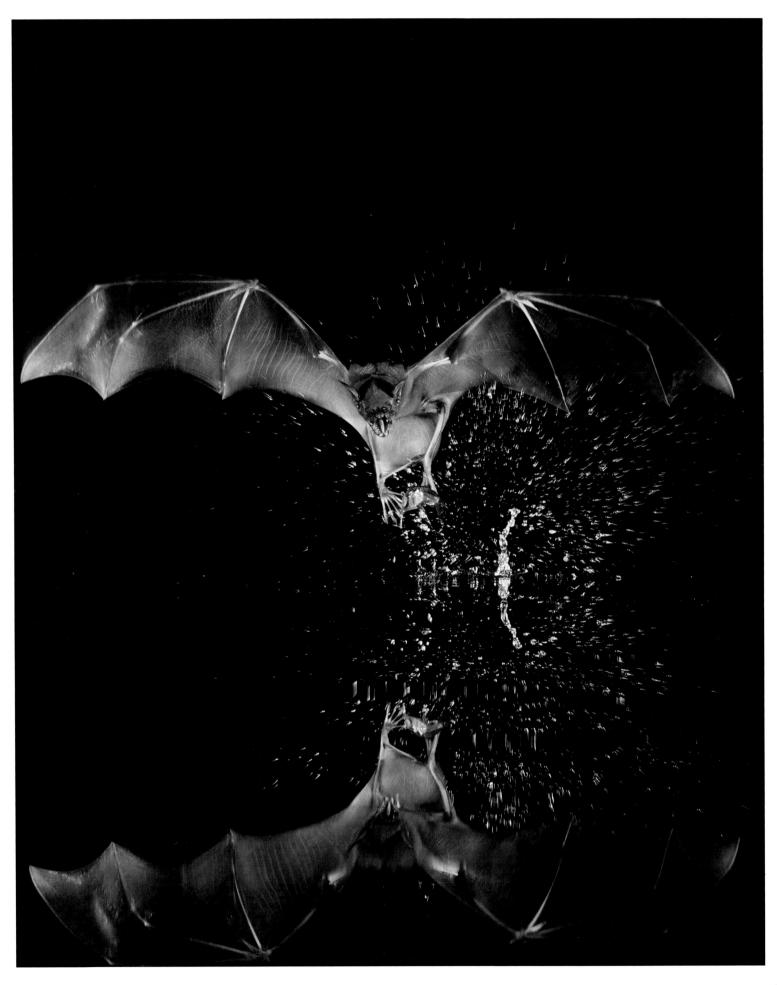

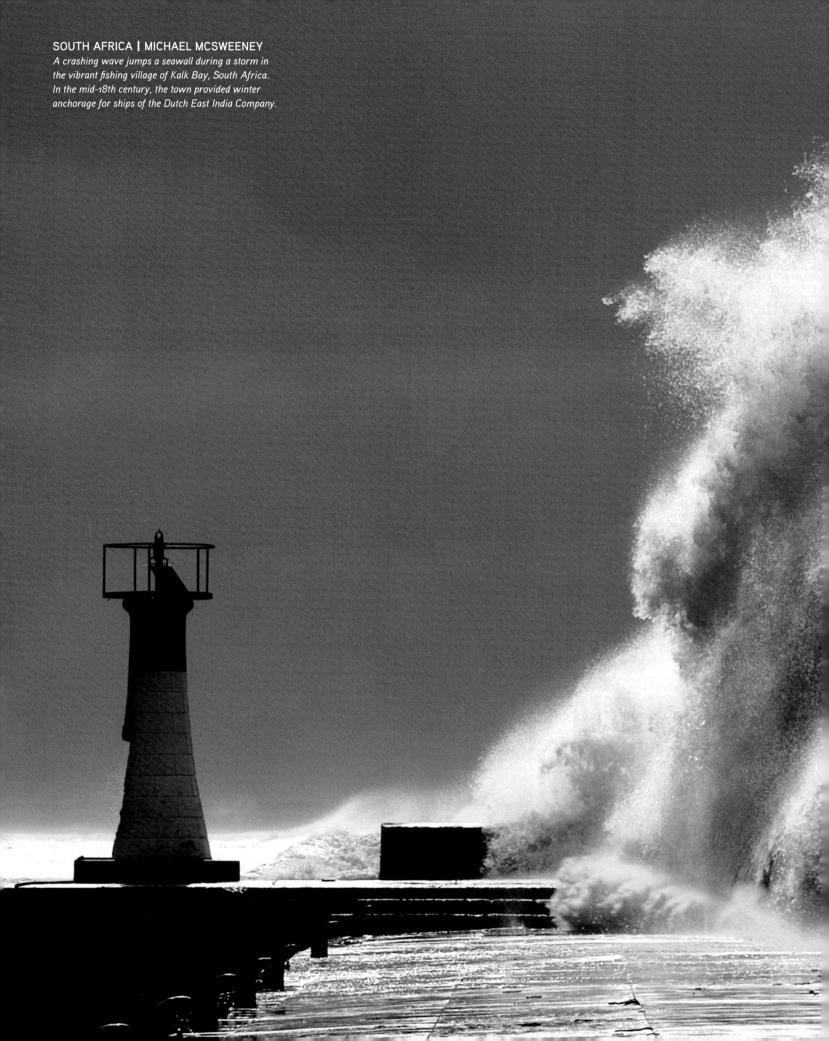

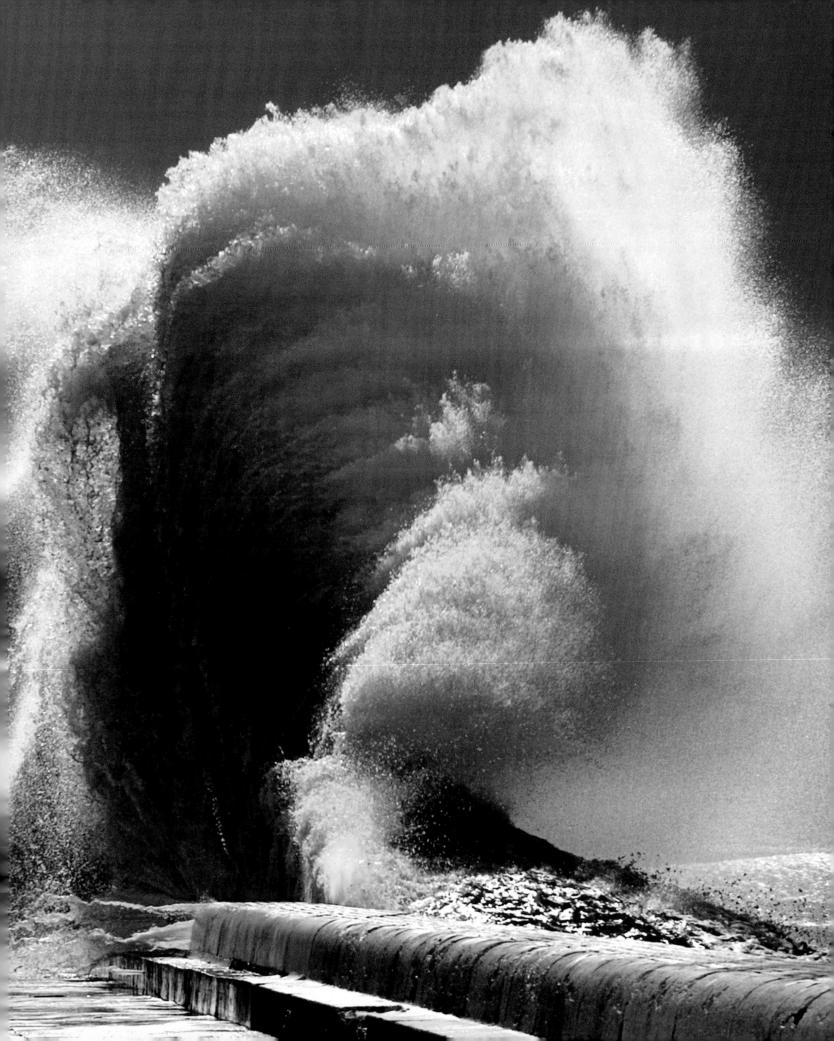

PORTFOLIO THIRTEEN

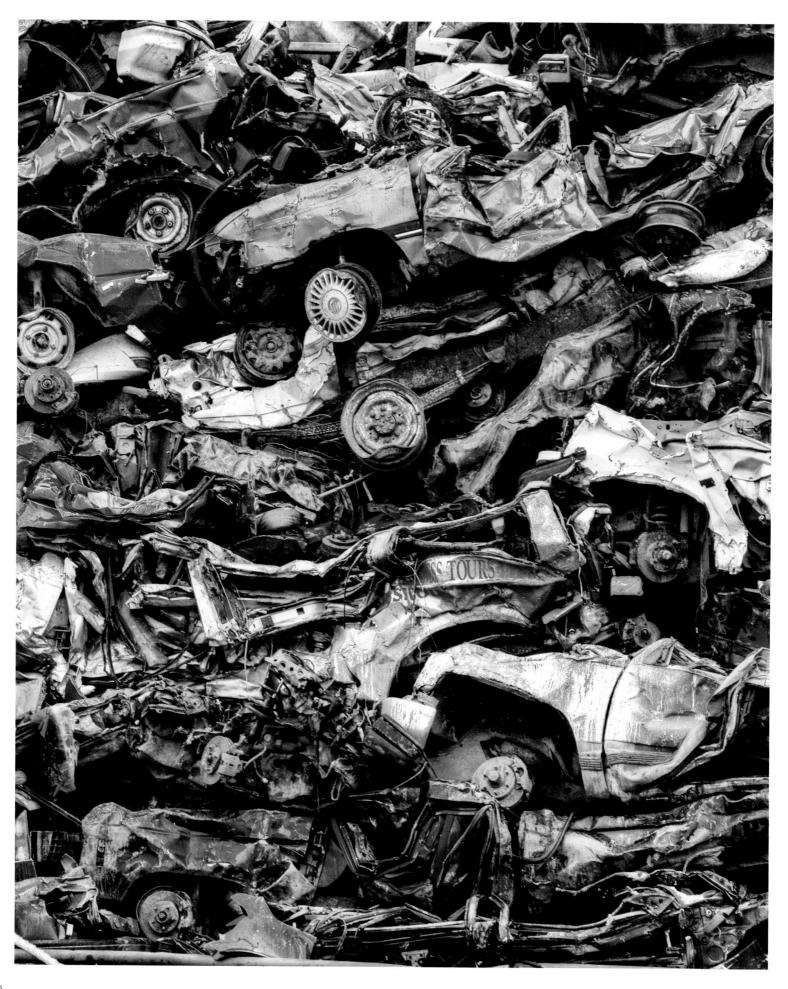

EVERY LIVING thing on Earth enjoys a beginning, and thus

will face an end. The time may come in a matter of days, or years, or centuries. In gazing upon and reckoning with the endings of others, we in a way rehearse our own.

The animals that we know and care for most intimately rarely outlive us. Our dogs and cats, even our cattle and horses, live lives easily framed within the fourscore years of our own. A beloved mutt begins as an adopted puppy, all exuberance and energy and new life. She matures into a dog with personality, faithful and patient, eager to please. Then she mellows into the slow moves of a dog of many years, and we watch as her senses dull, her joints creak, her body sleeps. We participate in the cycle of life with that dog we love, and we cry as the circle closes.

Flowers present a different sort of ending: less tragic, less final, less like our own, and yet tinged with sad reminders of the finitude of beauty.

Rosebuds bulge with hope and promise. They swirl open, petals slowly unfurling. The sweet center of the flower stays hidden, the peak of blooming still ahead. Days pass, and the rose fully opens. Petals lean back and lose their scent and their luster. They fade to brown and fall to the ground. What once was the promise of floral splendor is now spent, invested in the fruit of the fall.

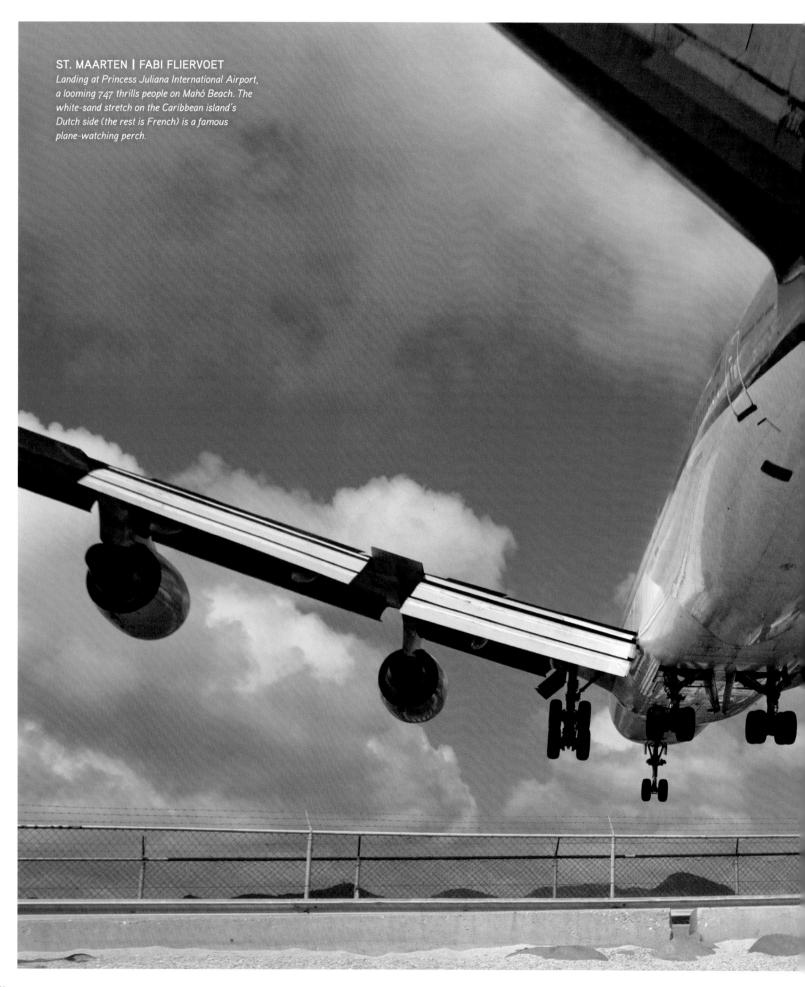

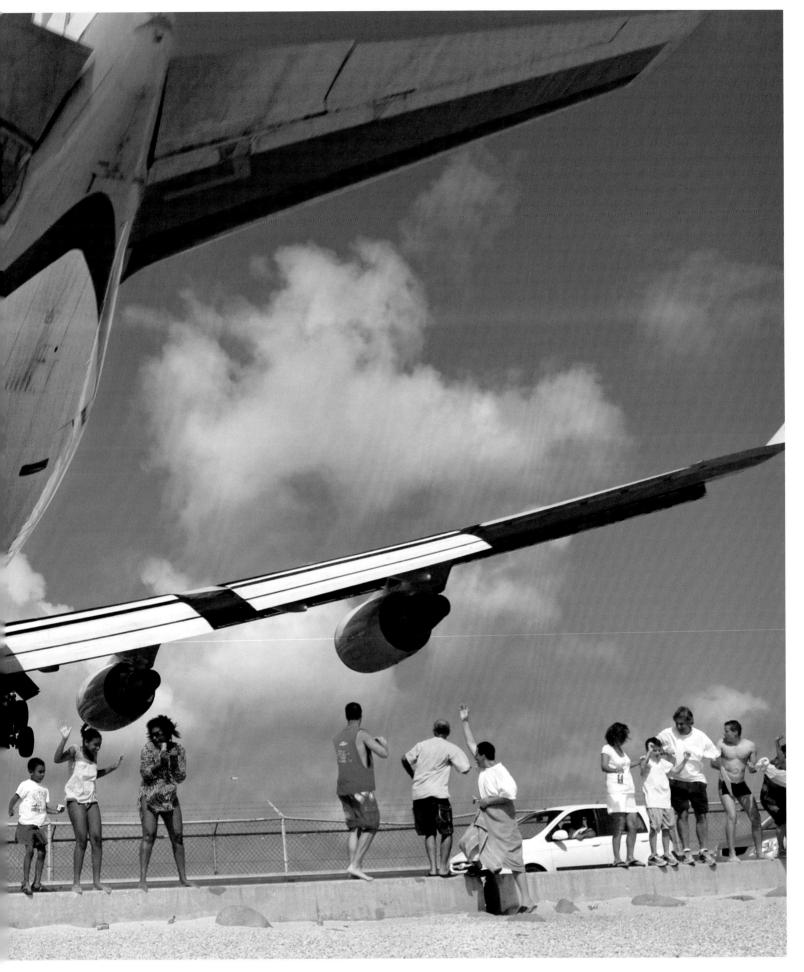

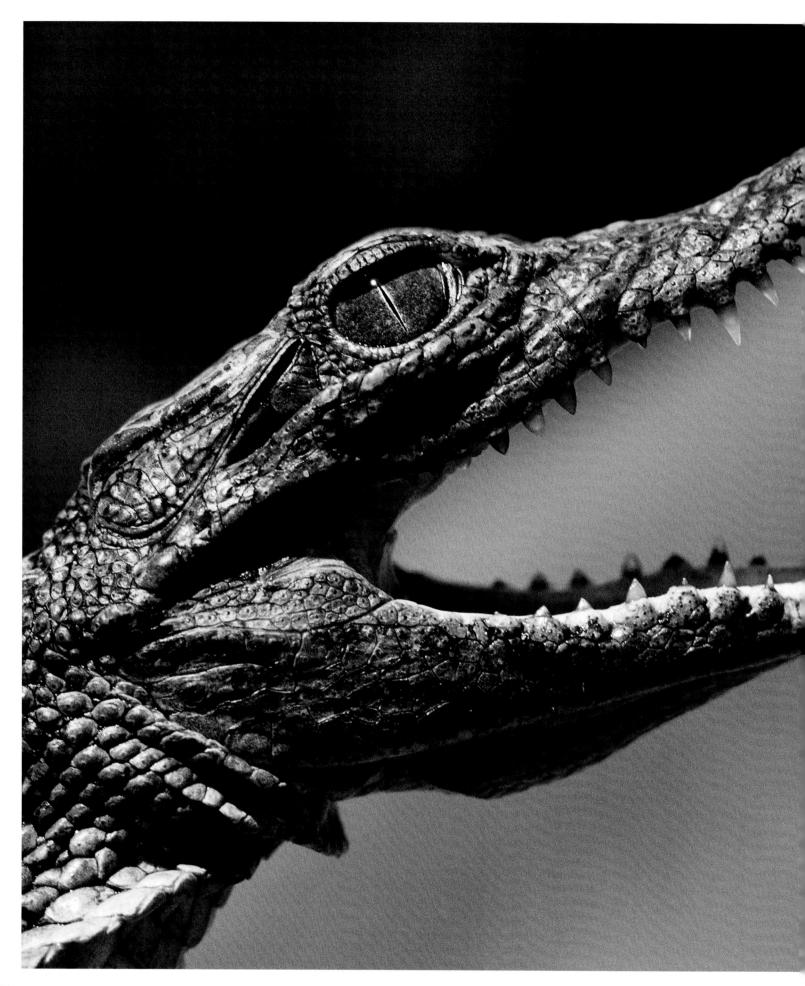

SOUTH AFRICA | JONATHAN BLAIR

A year-old Nile crocodile attempts to snap up a frog in the St. Lucia Estuary. Part of the iSimangaliso Wetland Park, which UNESCO named a World Heritage site in 1999, the protected area is Africa's largest estuarine system.

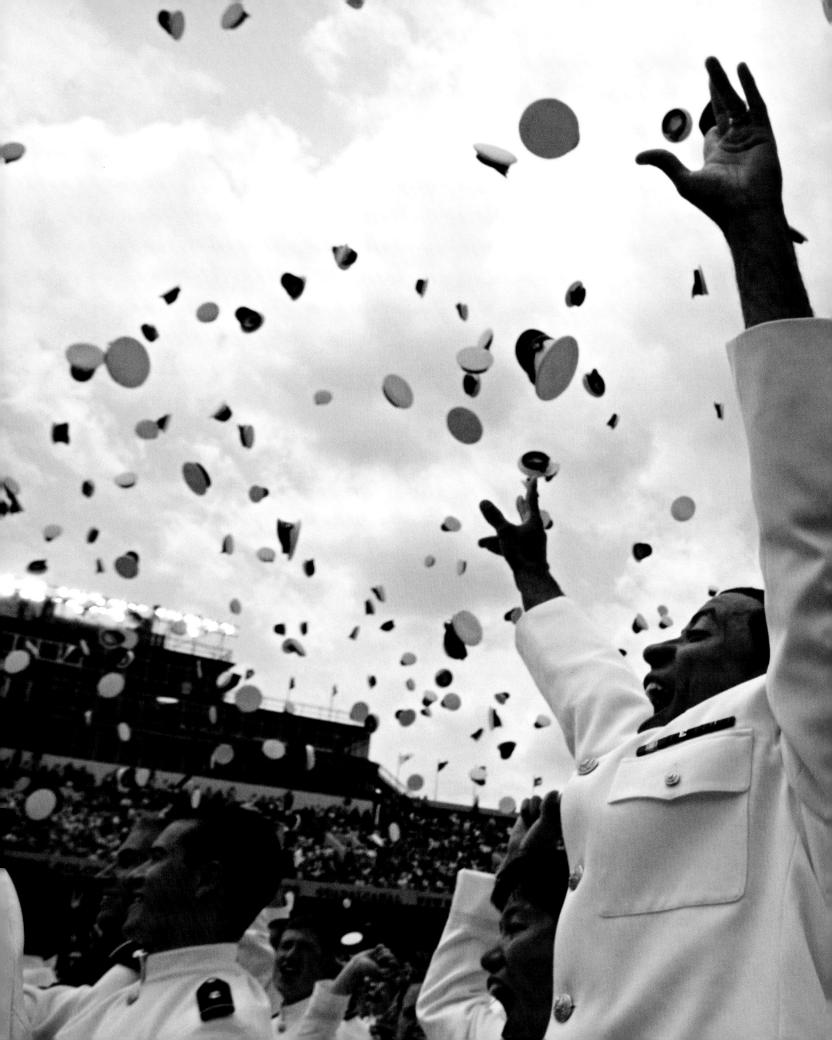

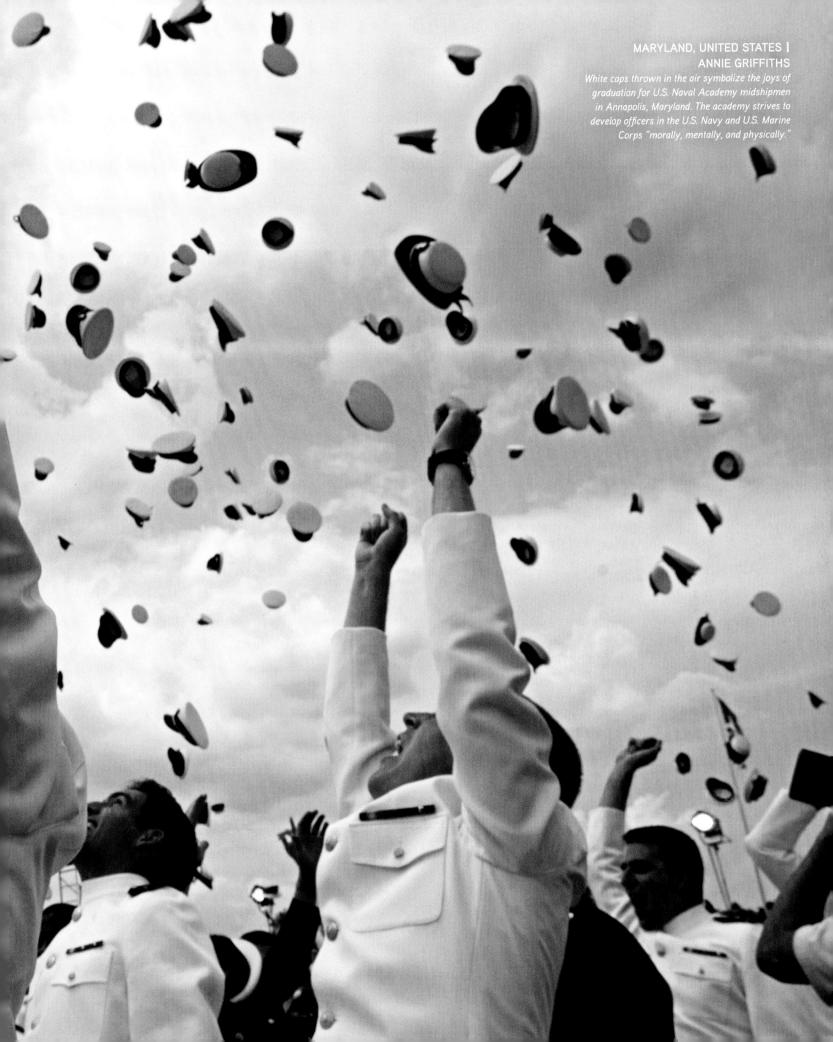

In MEXICO,
legend says that if you lose a tooth,
el ratón (the mouse) will leave
a treasure under your pillow.

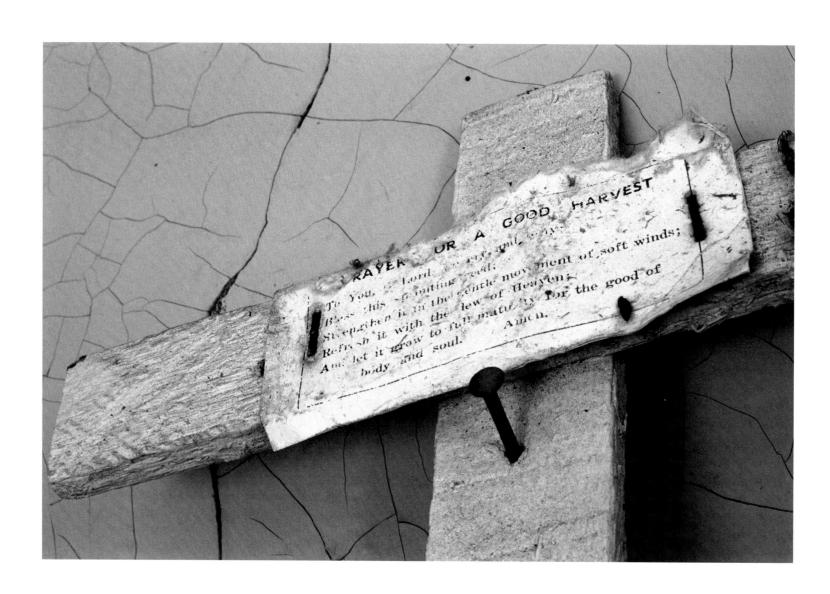

NORTH DAKOTA, UNITED STATES | EUGENE RICHARDS

A worn copy of the Harvester's Prayer, nailed to a weathered cross and placed on a cracked shelf in Belfield, North Dakota, creates an enigmatic scene. It also provides a fitting testament to the grit and faith of North Dakotan farmers.

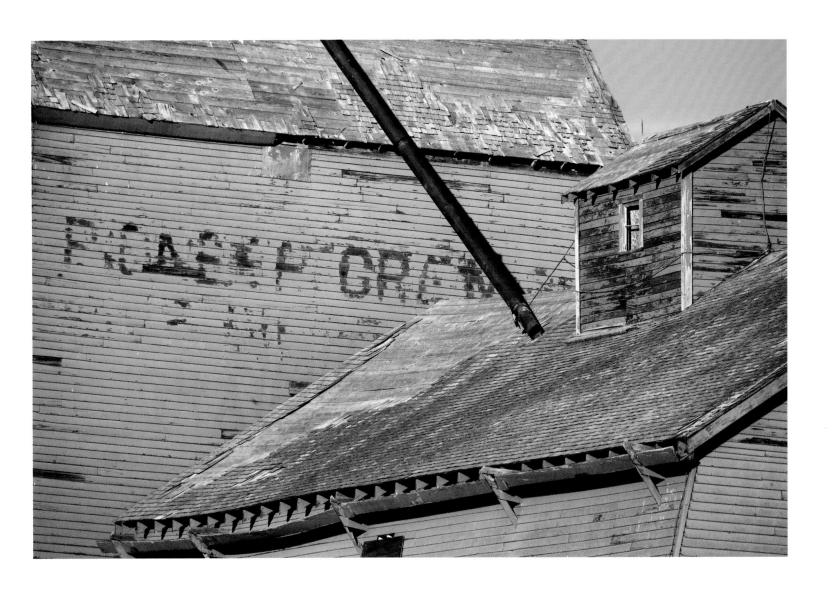

CANADA | PETE RYAN

The weathered red wood of a grain elevator speaks to better times. Many of the small family farms of Saskatchewan Province were shuttered by the early 21st century due to replacement by larger operations.

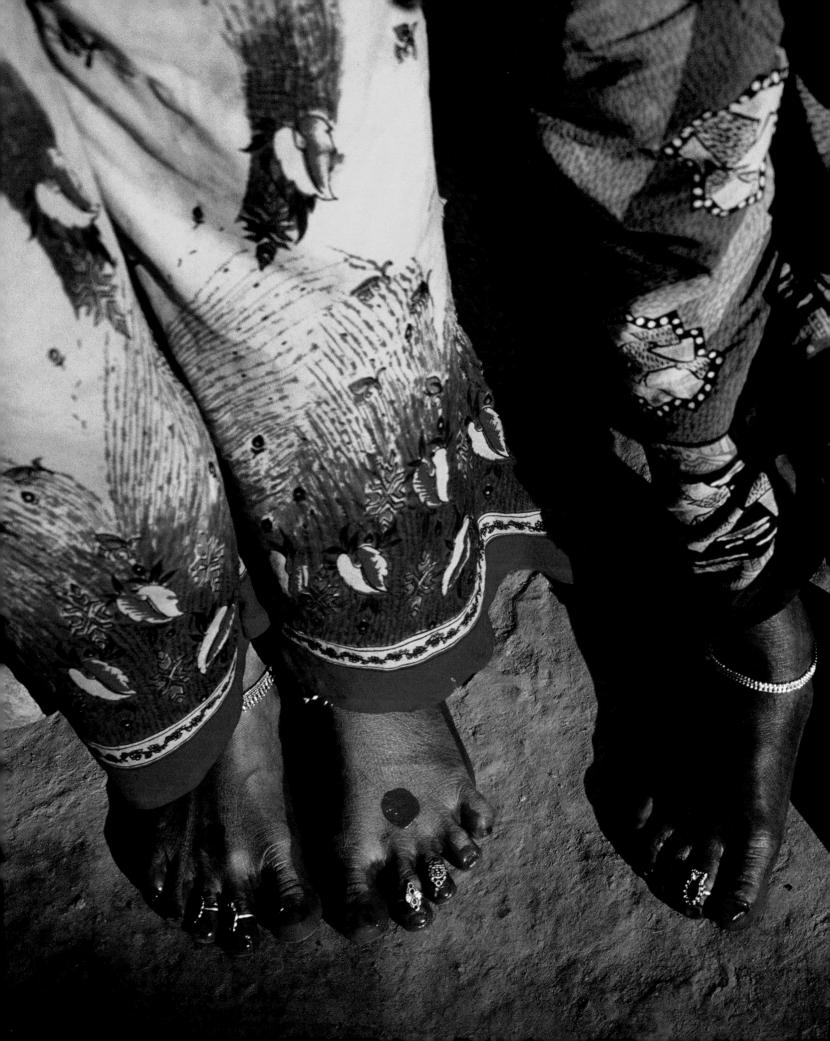

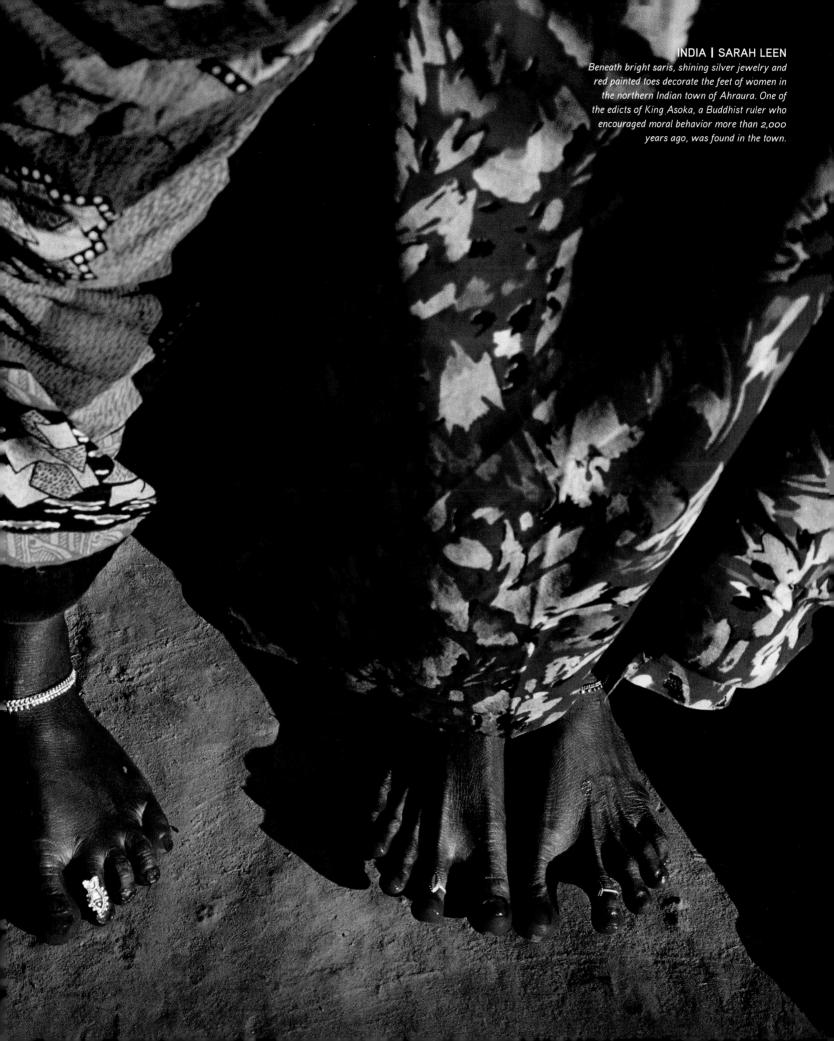

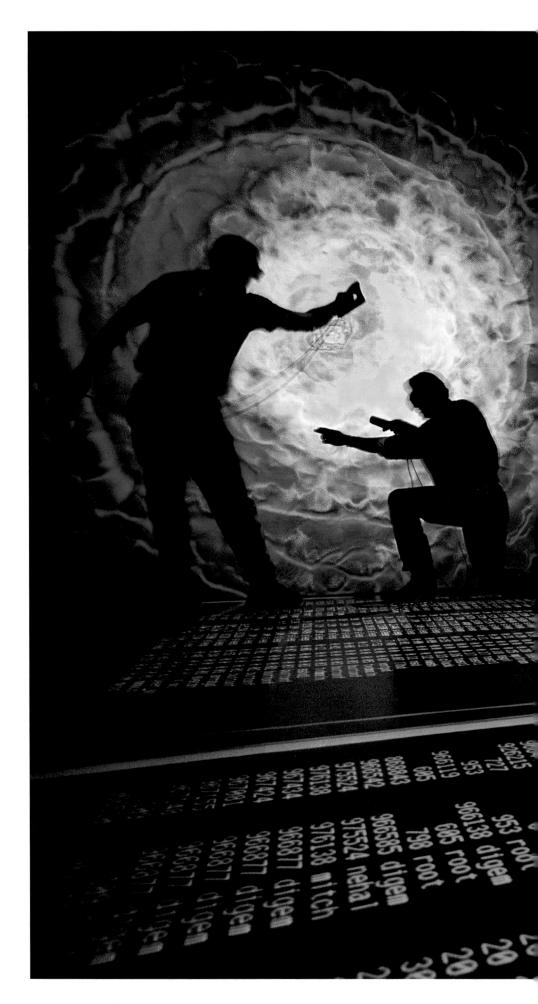

NEW MEXICO, UNITED STATES | LYNN JOHNSON Scientists at Los Alamos National Laboratory study nuclear explosions by using 3-D simulations. They follow a long tradition of nuclear research that led to the creation

of the atomic and hydrogen bombs.

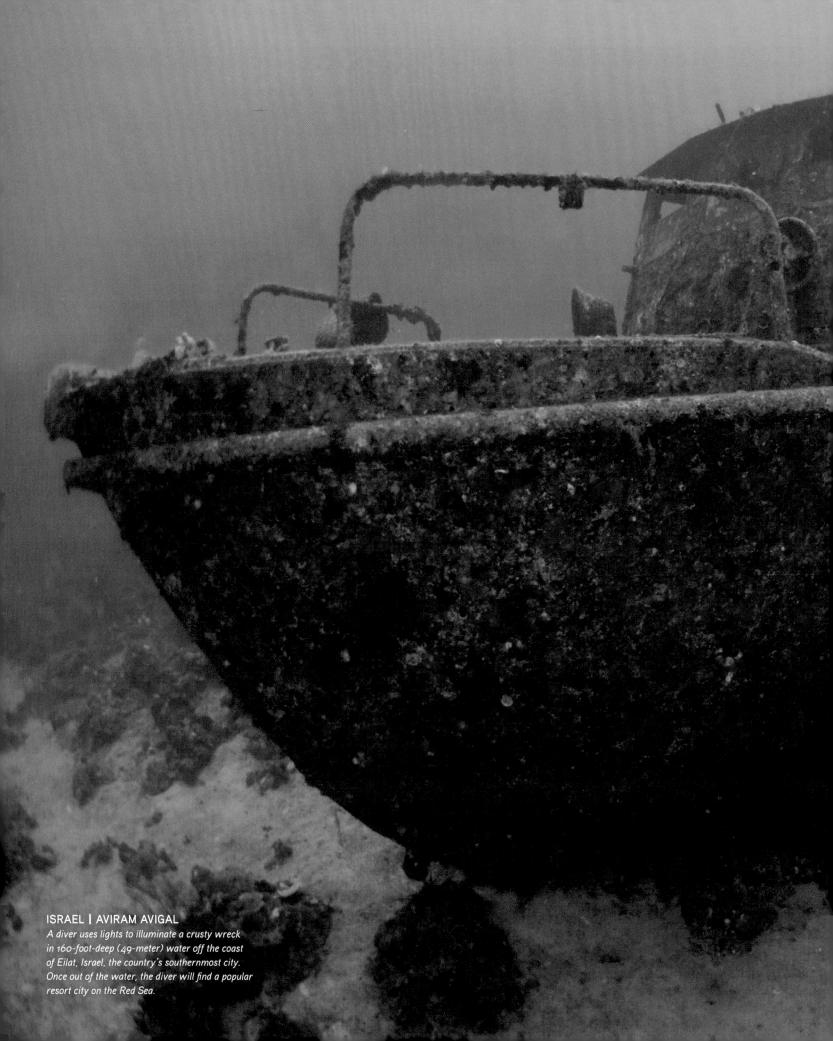

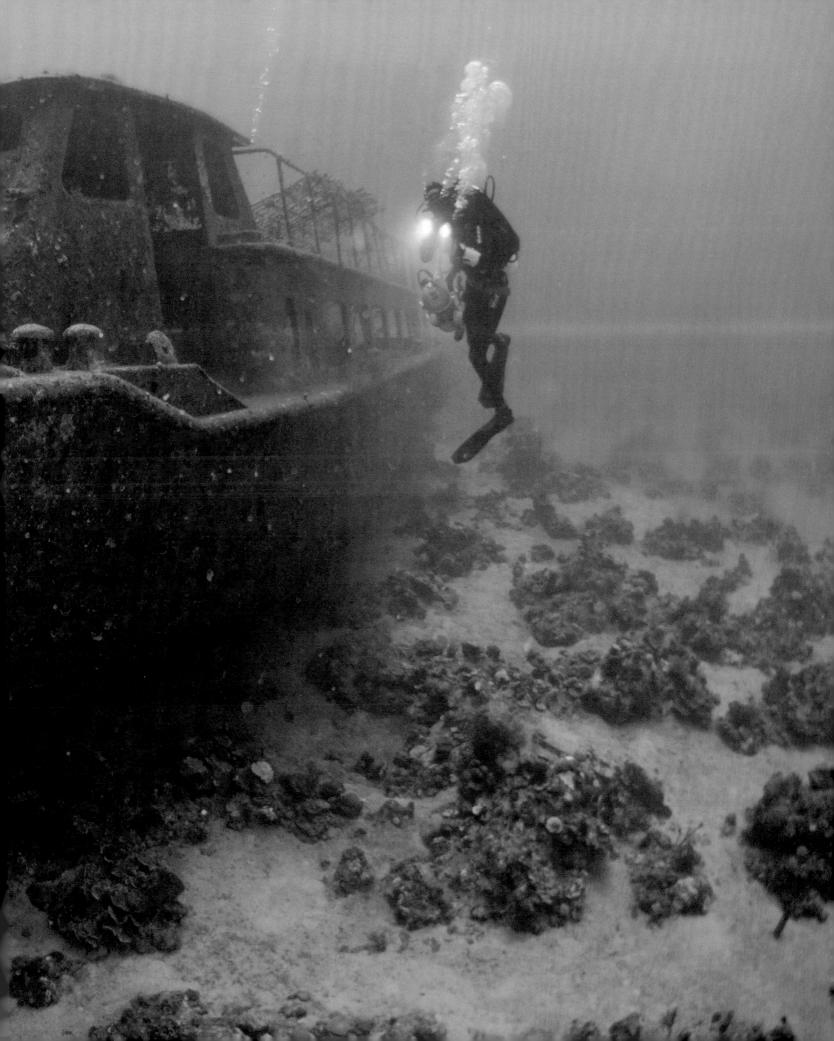

CALIFORNIA, UNITED STATES | RAUL TOUZON

An abandoned gas station, reflected in the glass door of an establishment, offers another fitting place to hang a closed sign. The small community of Death Valley Junction, California, also appears to live up to the message.

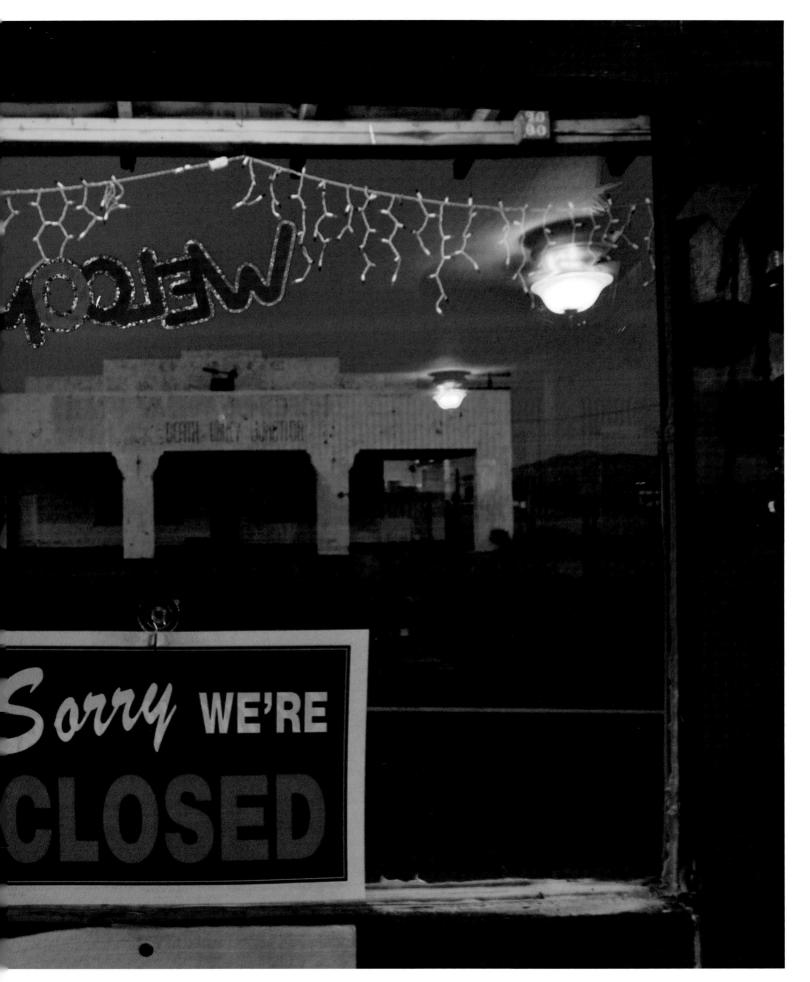

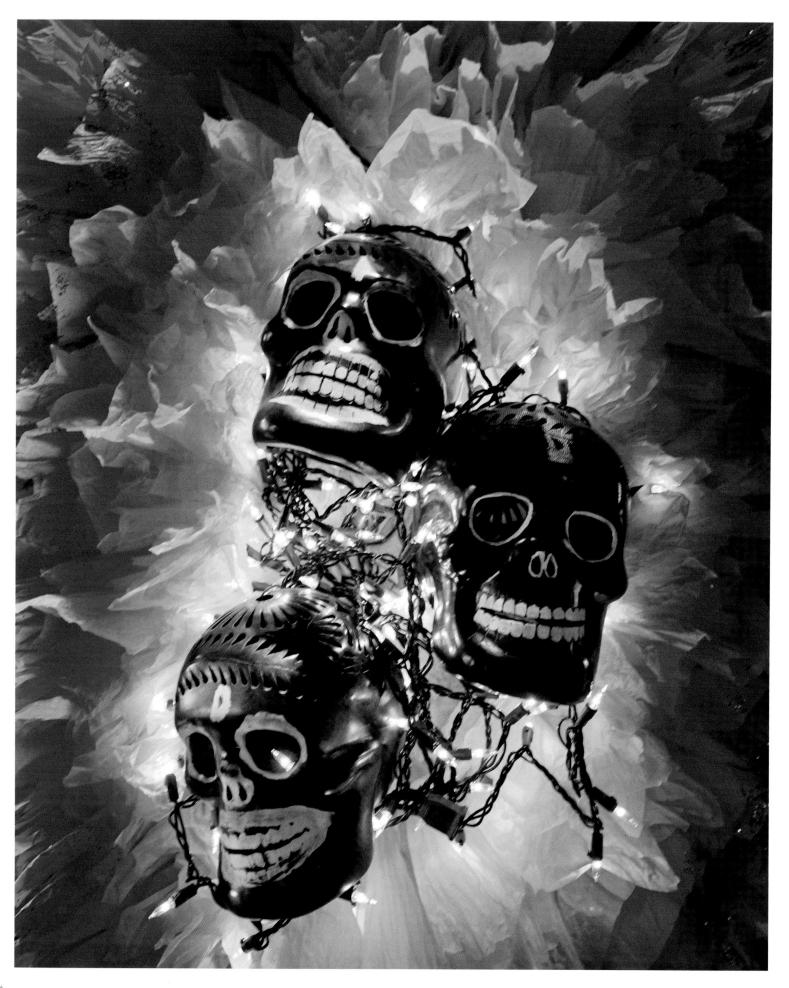

The adult HUMAN BRAIN
weighs approximately three pounds (1.4 kg).
It is more than three times bigger
than the brains of other mammals
that are about the Same size
as humans.

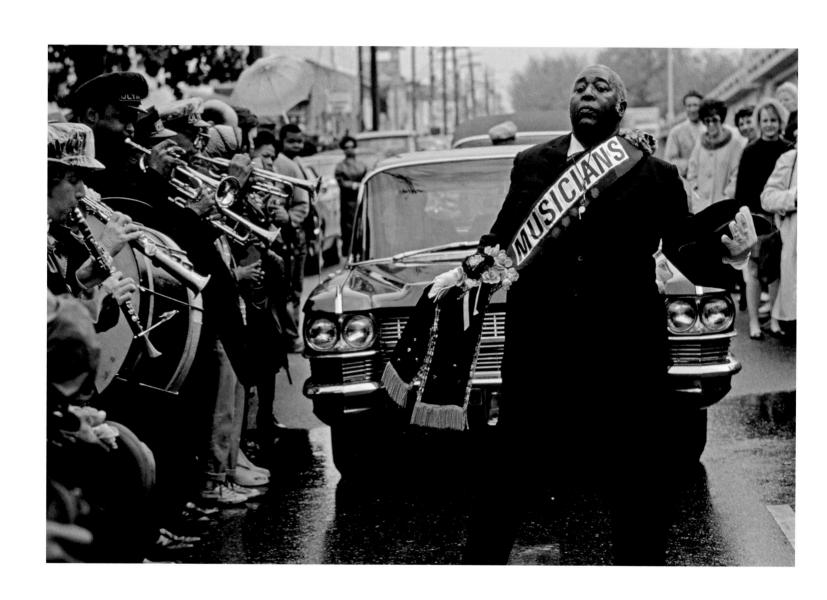

LOUISIANA, UNITED STATES | JAMES L. STANFIELD

Celebrating the life of their friend, clarinetist Emile Barnes, musicians play jazz during Barnes's funeral procession in New Orleans. Barnes, who died in 1970, can be heard on the Smithsonian Folkways label.

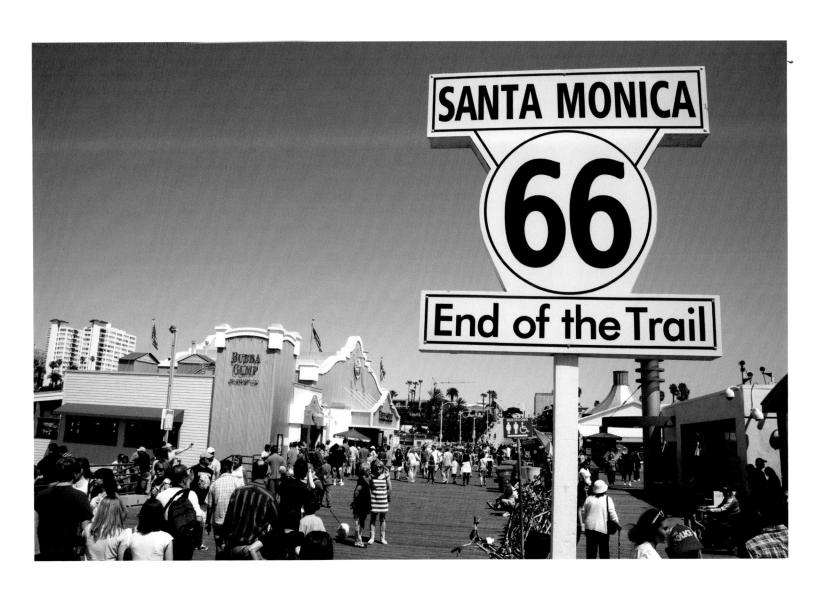

CALIFORNIA, UNITED STATES | STEPHEN ST. JOHN

This sign lets you know when you've reached the end of historic Route 66 in Santa Monica, California. The 2,448 miles (3,940 kilometers), which start in Chicago, Illinois, and make up what novelist John Steinbeck called the Mother Road, have captured dreams since 1926.

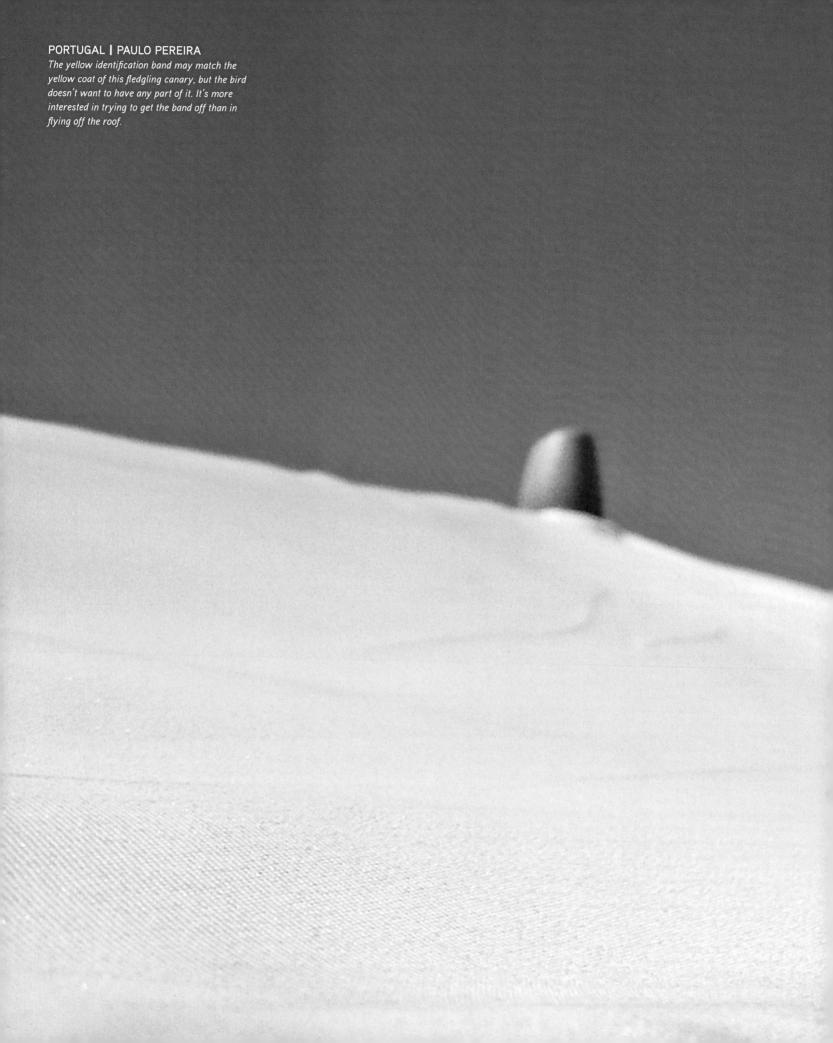

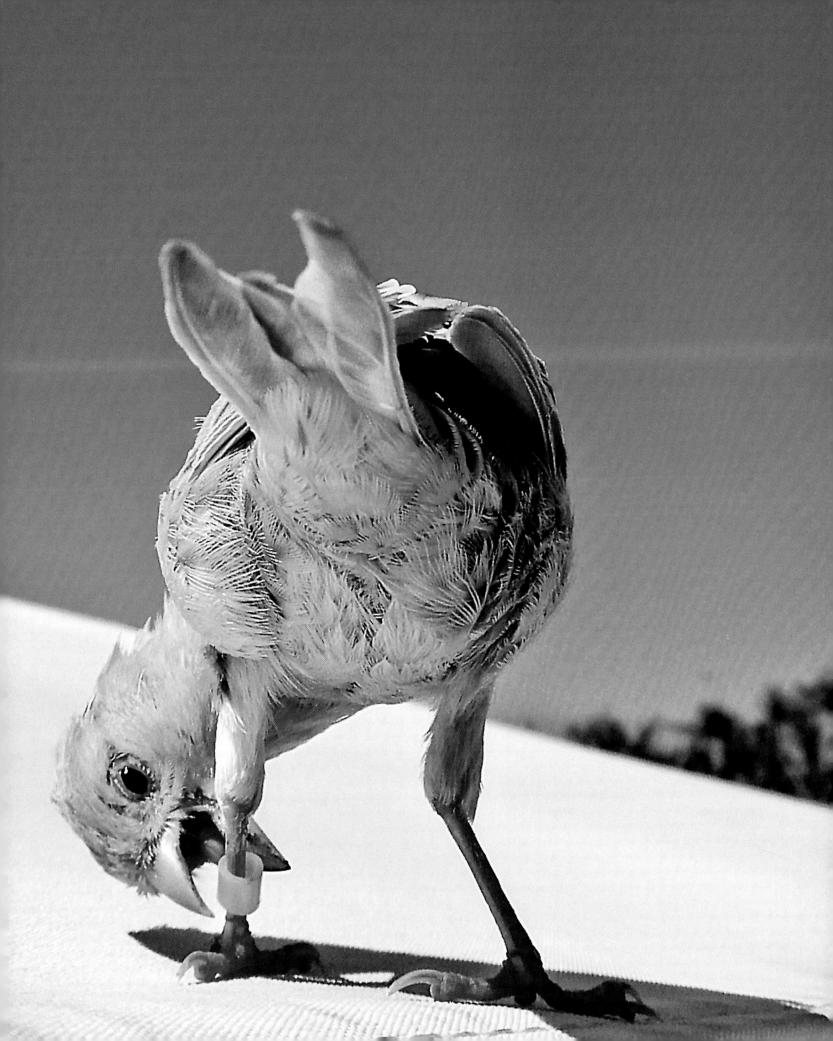

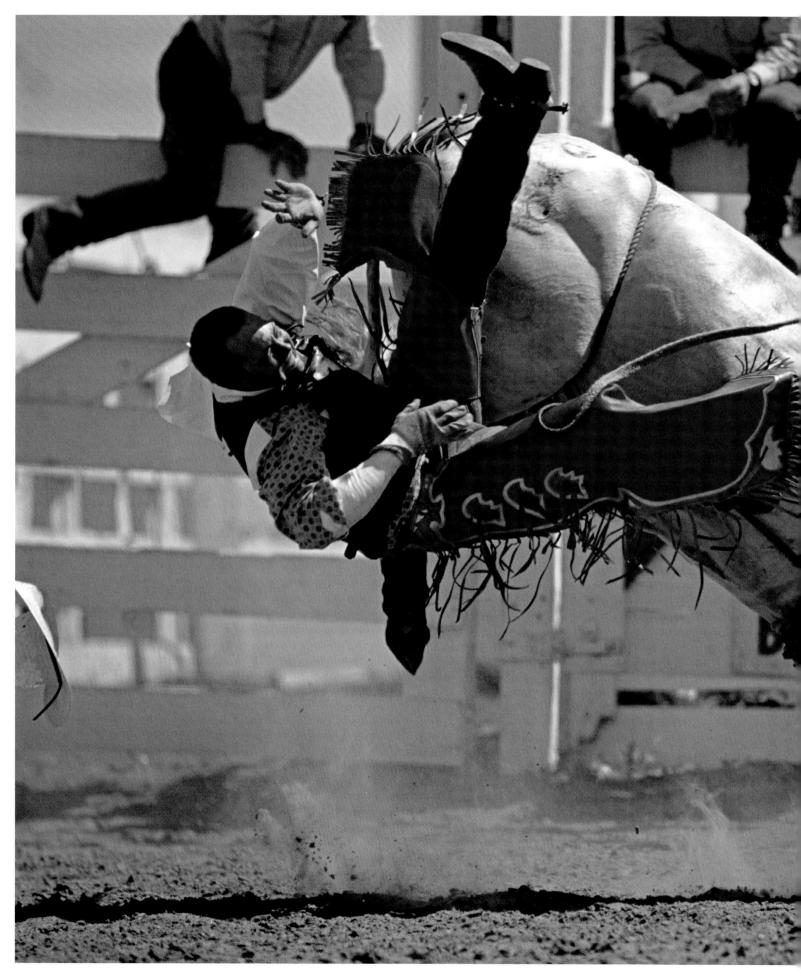

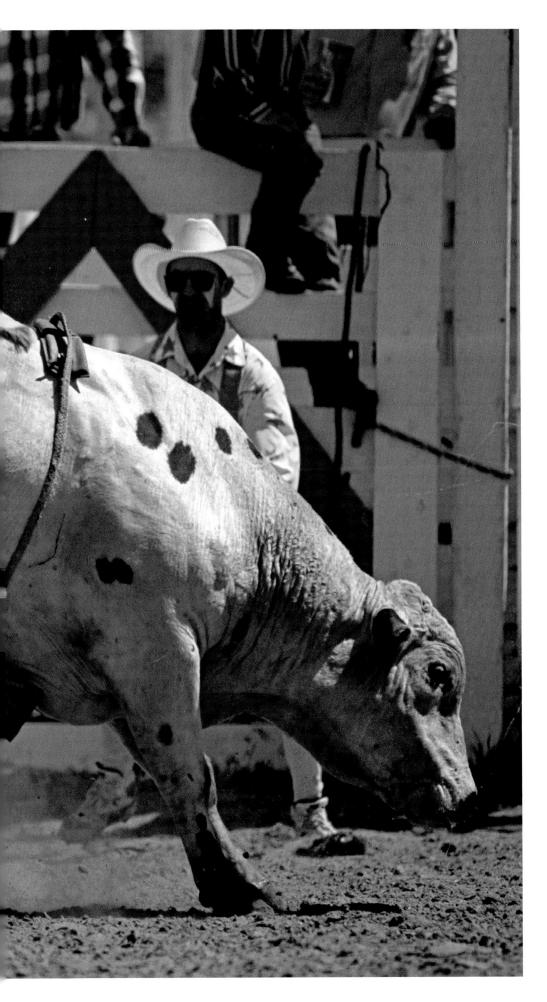

NEBRASKA, UNITED STATES | JOEL SARTORE

Catching the wrong end of a bull, a rodeo rider at the Big Rodeo in Burwell, Nebraska, can no longer hang on. On a bucking horse or bull, a qualifying ride lasts at least eight seconds.

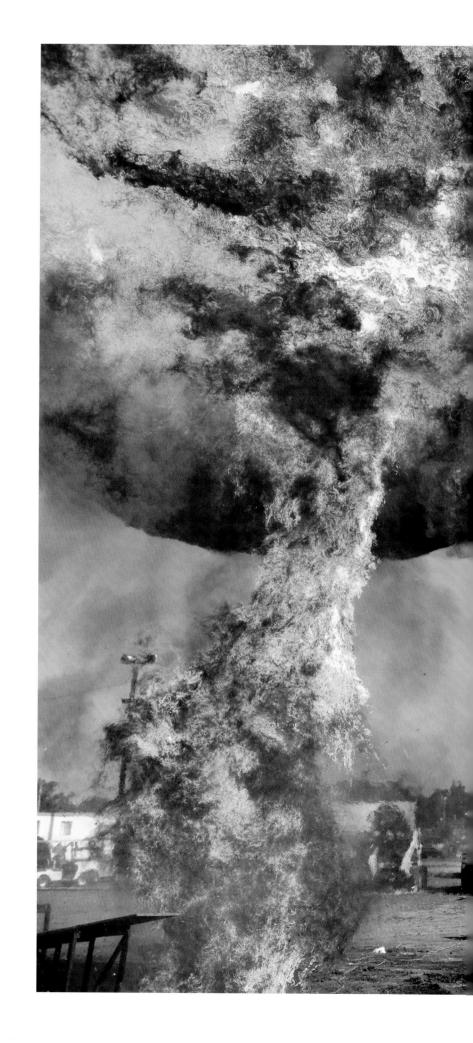

IOWA, UNITED STATES | JOEL SARTORE

Nothing like fiery crashes and twisted metal to make a demolition derby come alive. This stunt driver jumped his car at 60 miles an hour (97 kilometers an hour) from a flaming ramp 50 feet (15 meters) into a stack of junked cars.

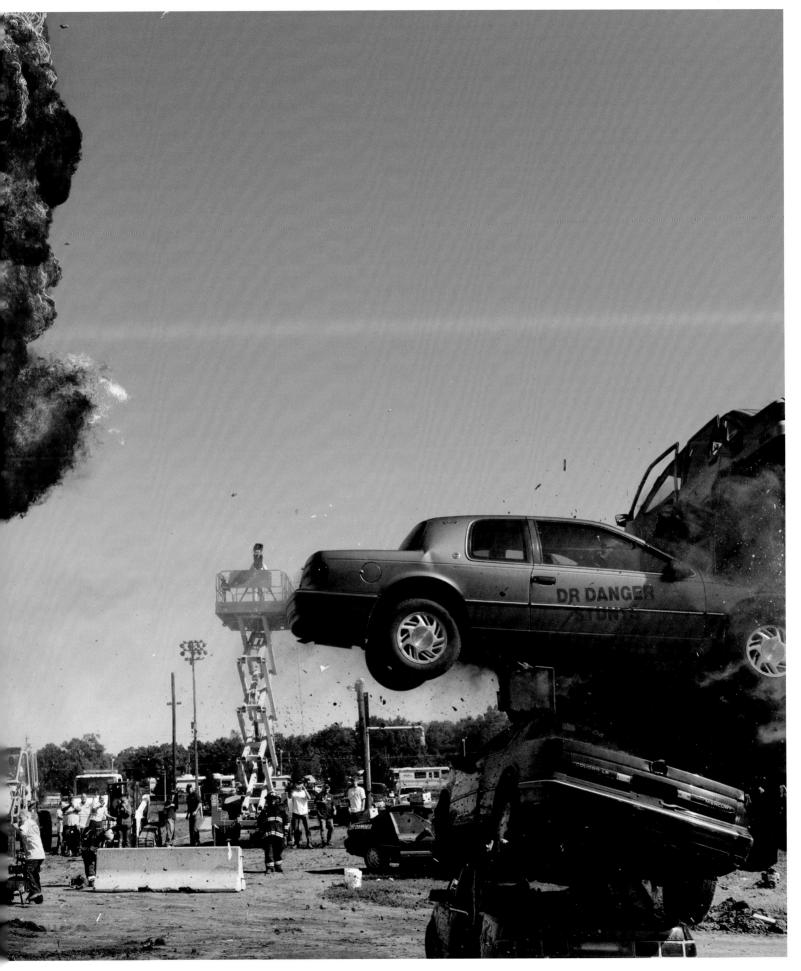

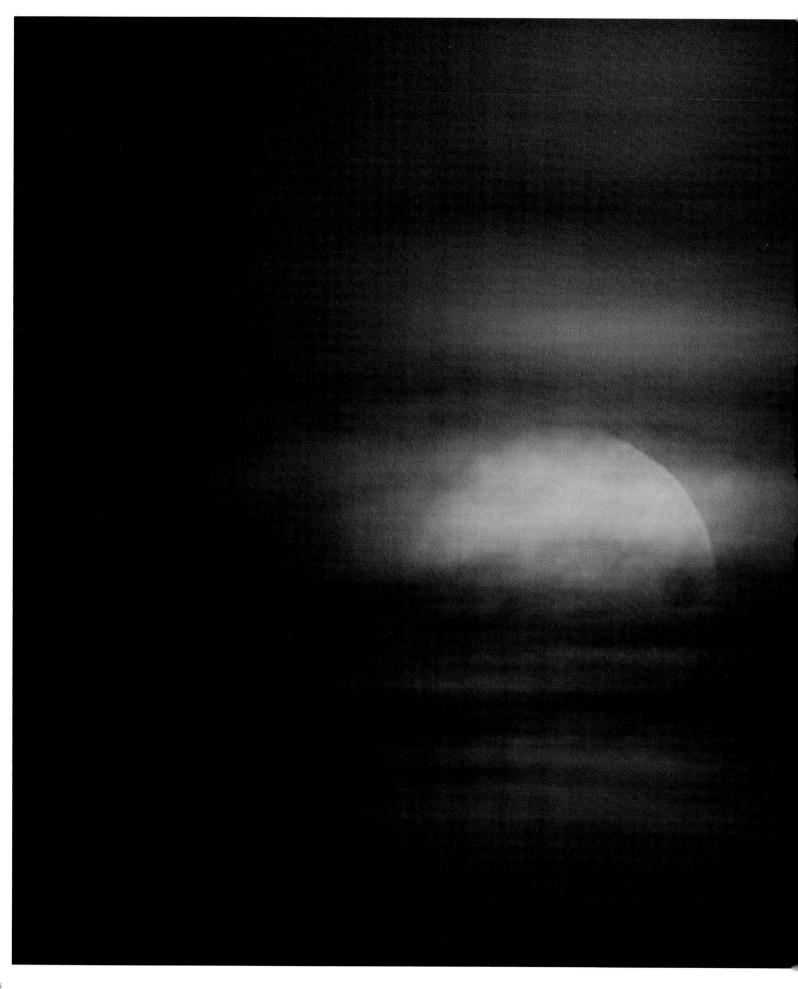

CANADA | PETE RYAN Dusk lends an ethereal tone to the setting sun in Victoria, British Columbia. Whereas our planet has one magnificent moon, there are 165 others in our solar system.

PORTFOLIO FOURTEEN

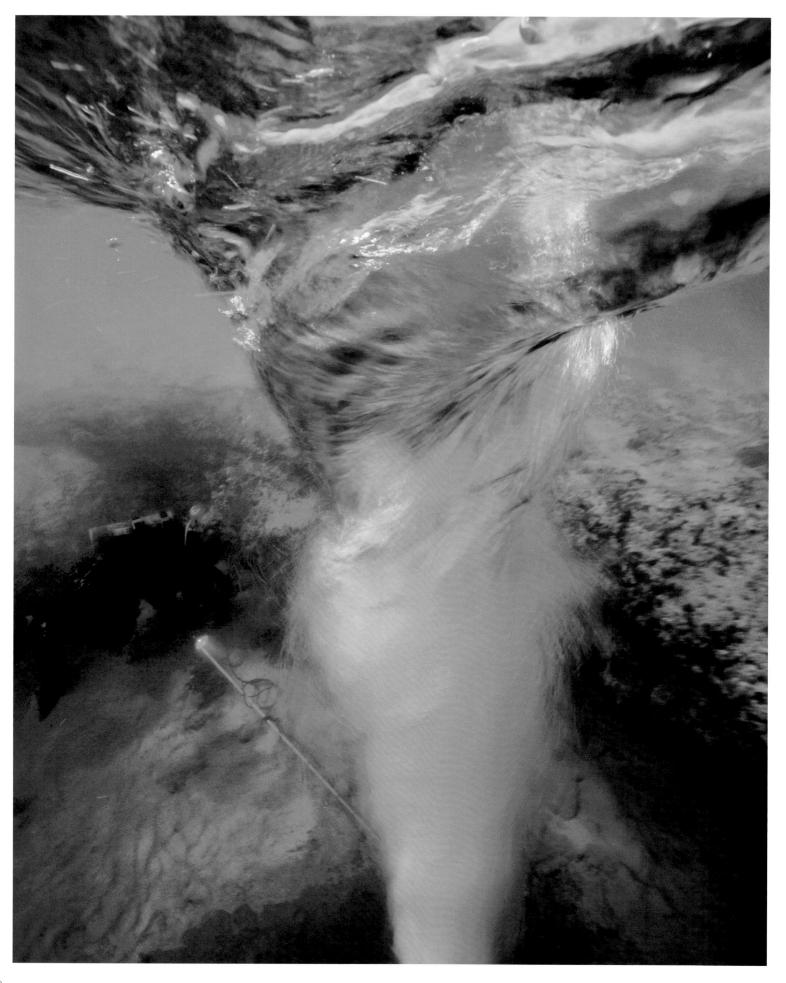

all the breaks and all the endings, despite interruptions and contradictions, despite threats and warnings and worries, the universe of things flows on. Photography captures a moment. Hungry eyes, senses, memories, synthetic imagination—we use all faculties to observe, and we connect those captured moments into a stream of meaning that flows through the mind, now dark, now glittering, every now and then presenting an aha! moment.

That flow begins in tiny trickles, whispers of water seeping up out of soil and shimmering over rock, joining together into streams, streams that course down mountain slopes and carve out valleys, streams that join together into great rivers, strong and life affirming, blood of this world of thought, shape, and feeling. Flow connects the everlasting universe of things with the never-ending quest to see and understand.

Flow beats through every pulse that propels a rarely seen jellyfish through Antarctic waters: rainbow iridescence, numinous tentacles, body made of translucent film that could not even be called flesh. Flow enflames an arctic wolf's eyes, sunset red as she stands above the cold, dry tundra. Flow shapes the curves of a copper-hued corn snake; it is the very impulse that shimmies through an earthworm, the lowly creature that turns death into life.

It is flow that keeps us human beings alive and wondering, and it is flow that helps us believe in such things as eternity.

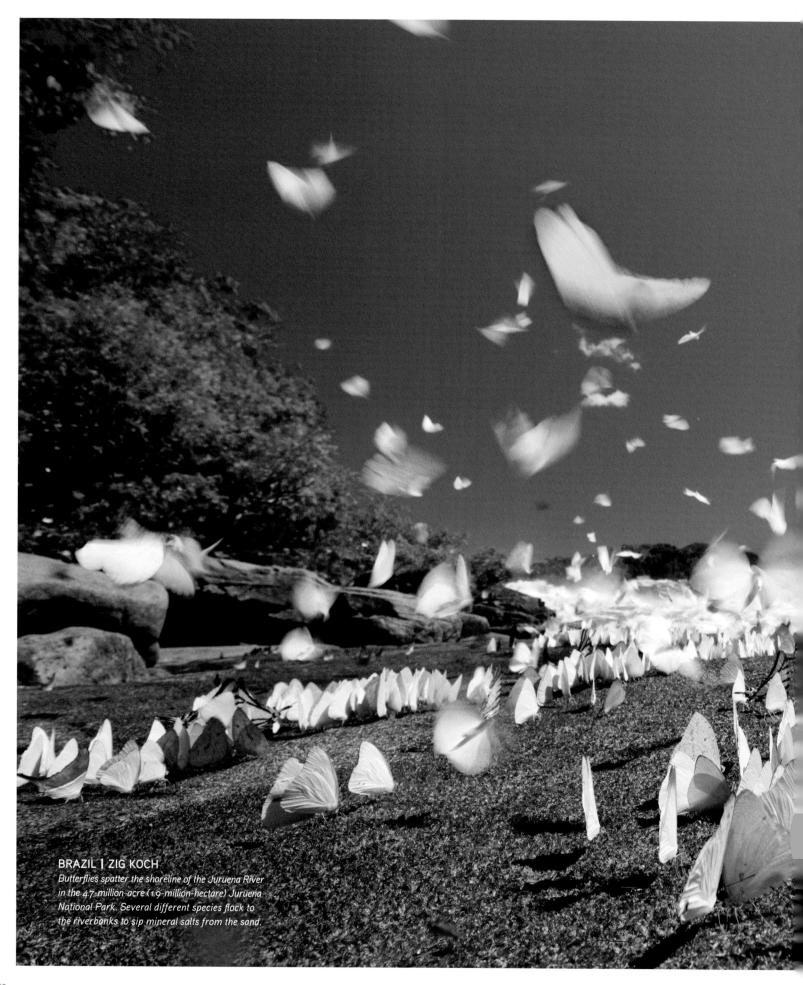

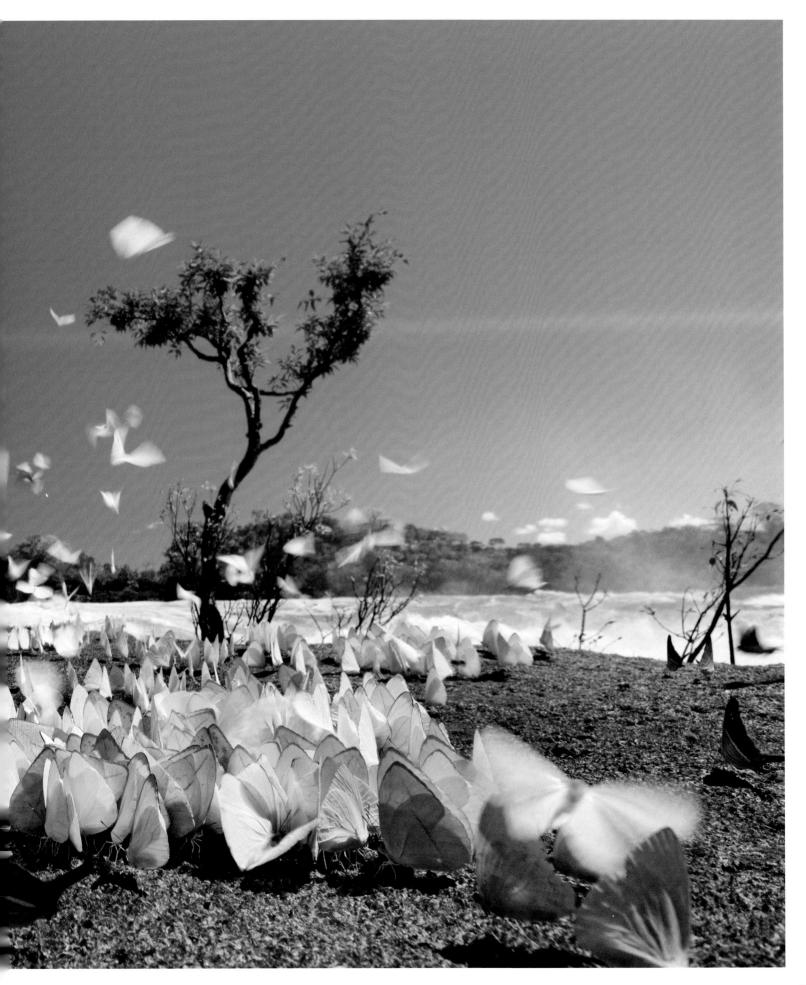

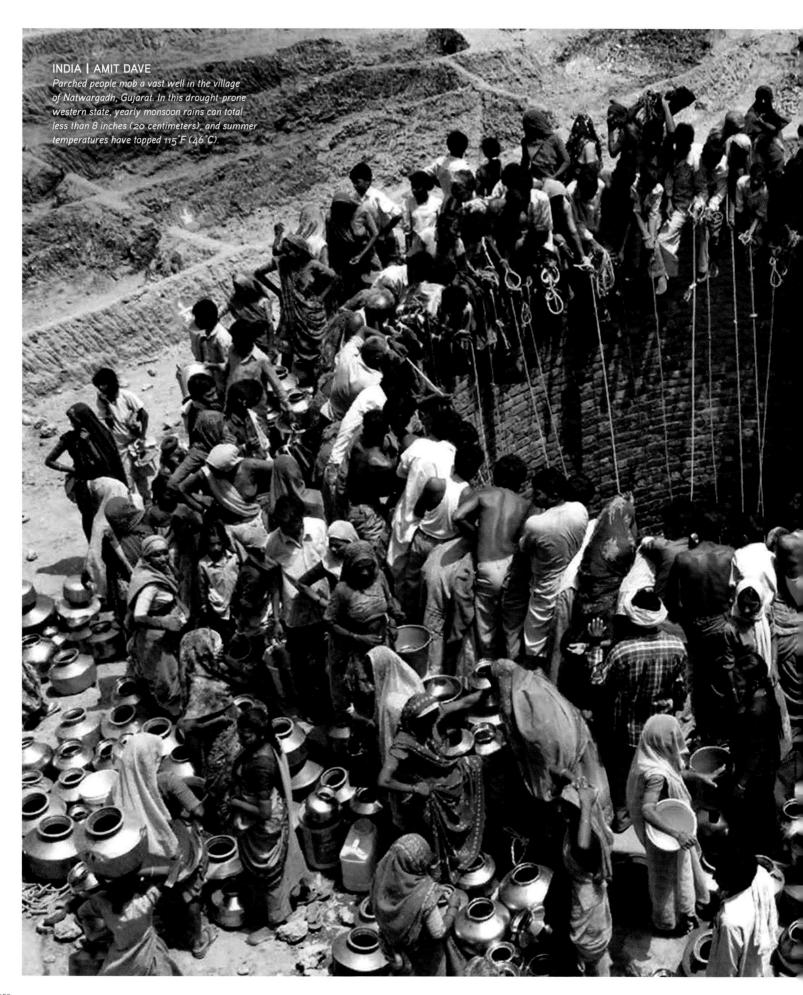

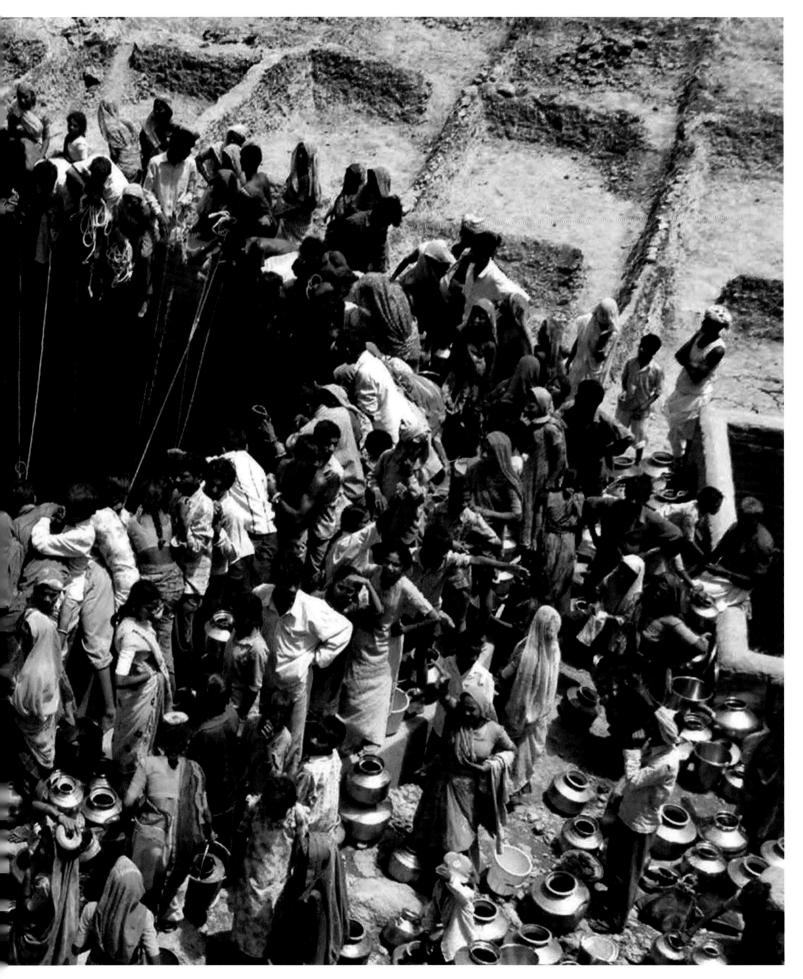

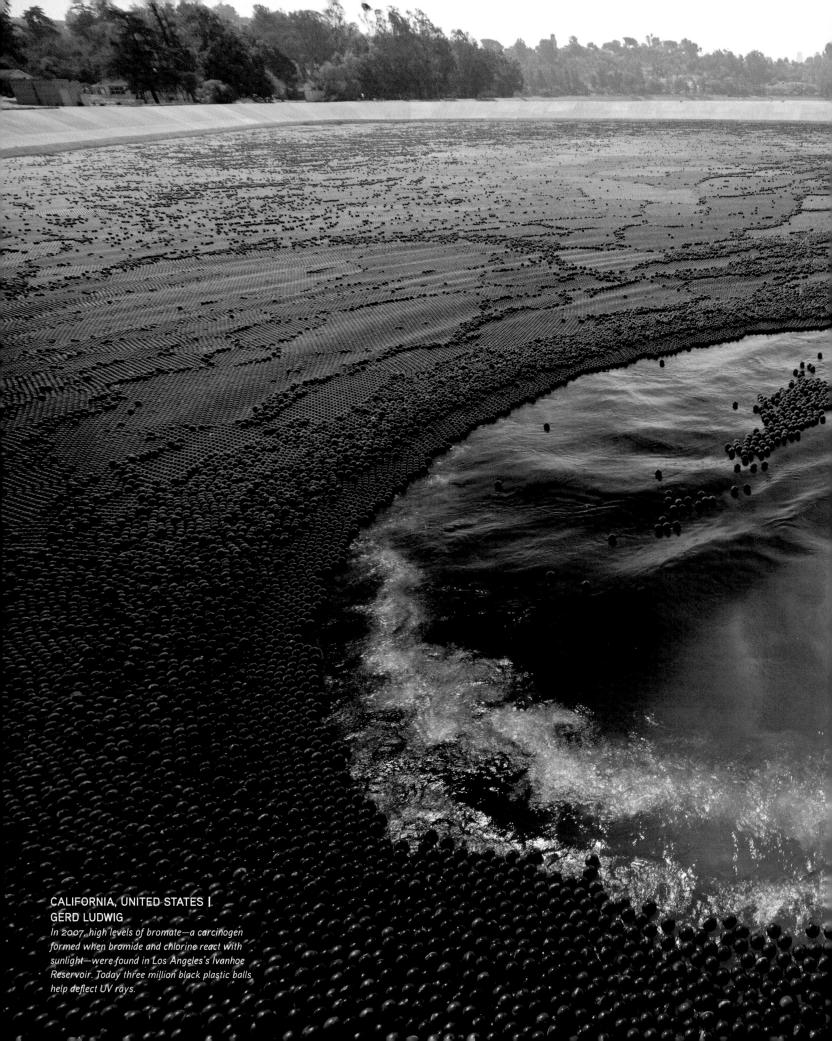

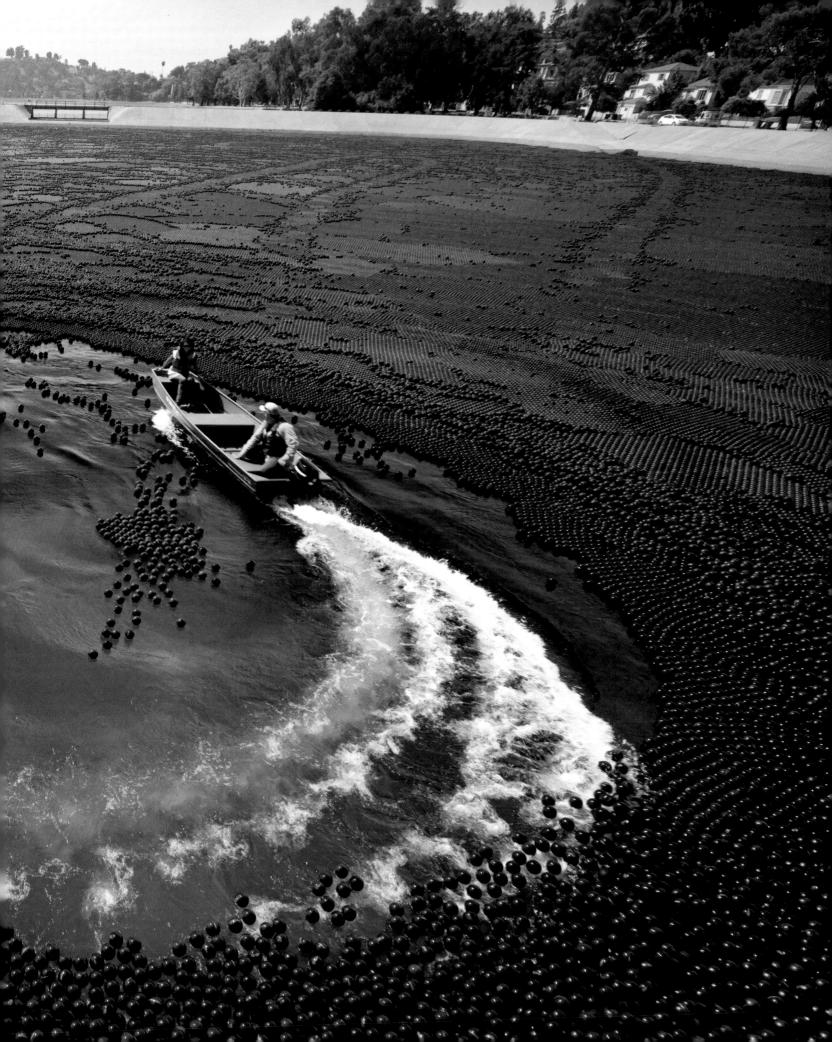

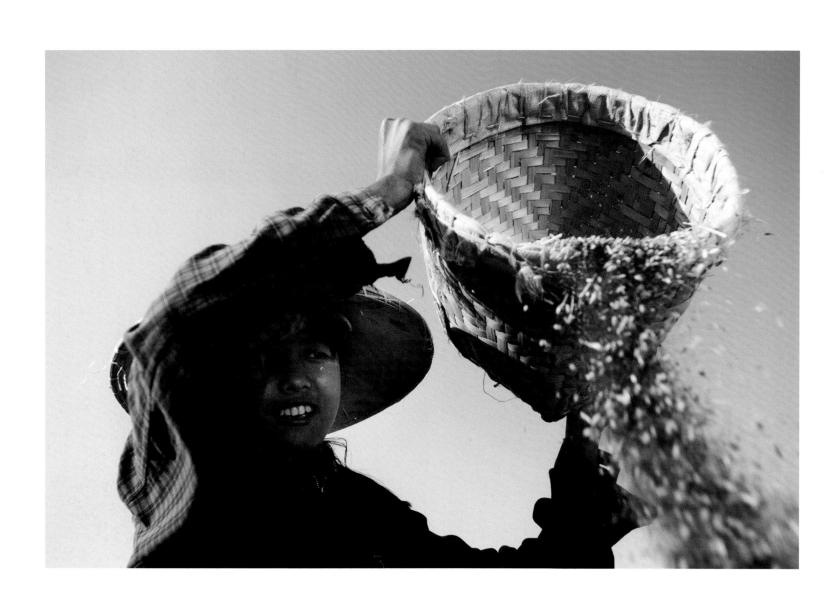

MYANMAR | ALEX TREADWAY

The wind does some of the work for this Burmese girl winnowing wheat. She can separate the hand-harvested wheat from the chaff by letting the wind blow away the lighter chaff.

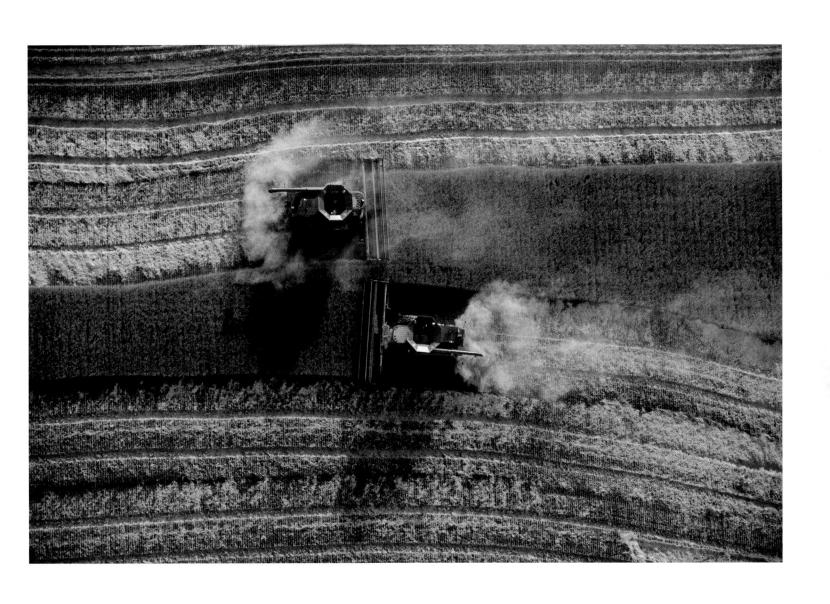

KANSAS, UNITED STATES | JIM RICHARDSON

High-tech combines harvesting a wheat field create a patchwork when viewed from the air. As an example of big business in America's heartland, these machines can reap 200 acres (81 hectares) a day.

The NAMIB DESERT
is the only spot on Earth where
the remarkable Welwitschia
plant grows. Although the average age
of these plants is 500 to 600 years, some
of the larger ones are thought
to be 2,000 years old.

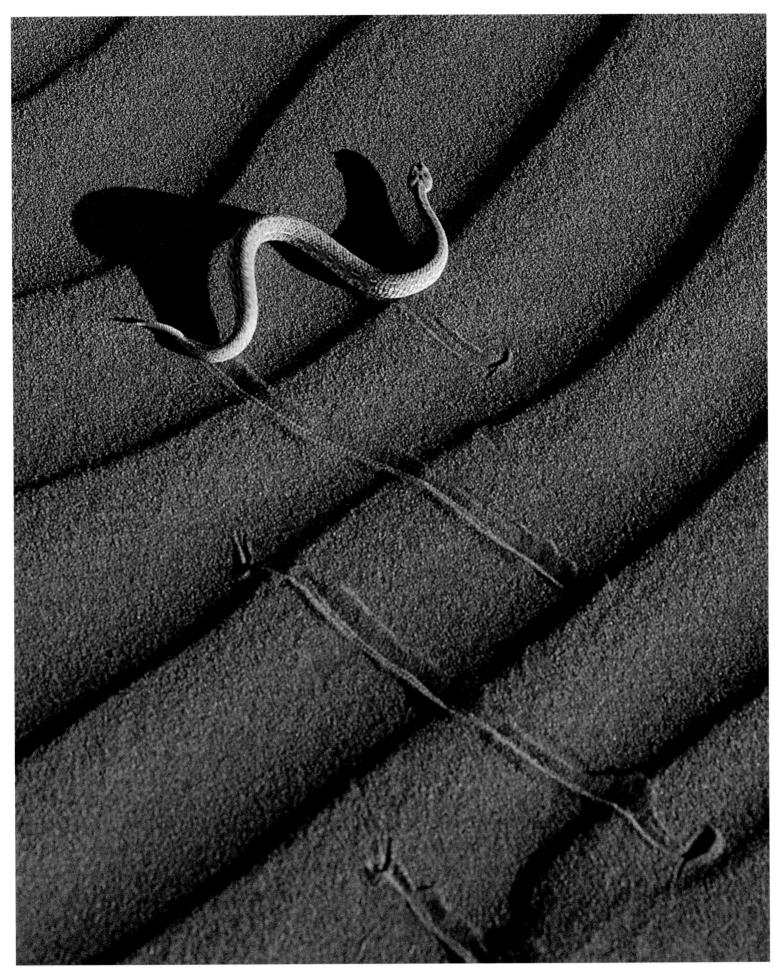

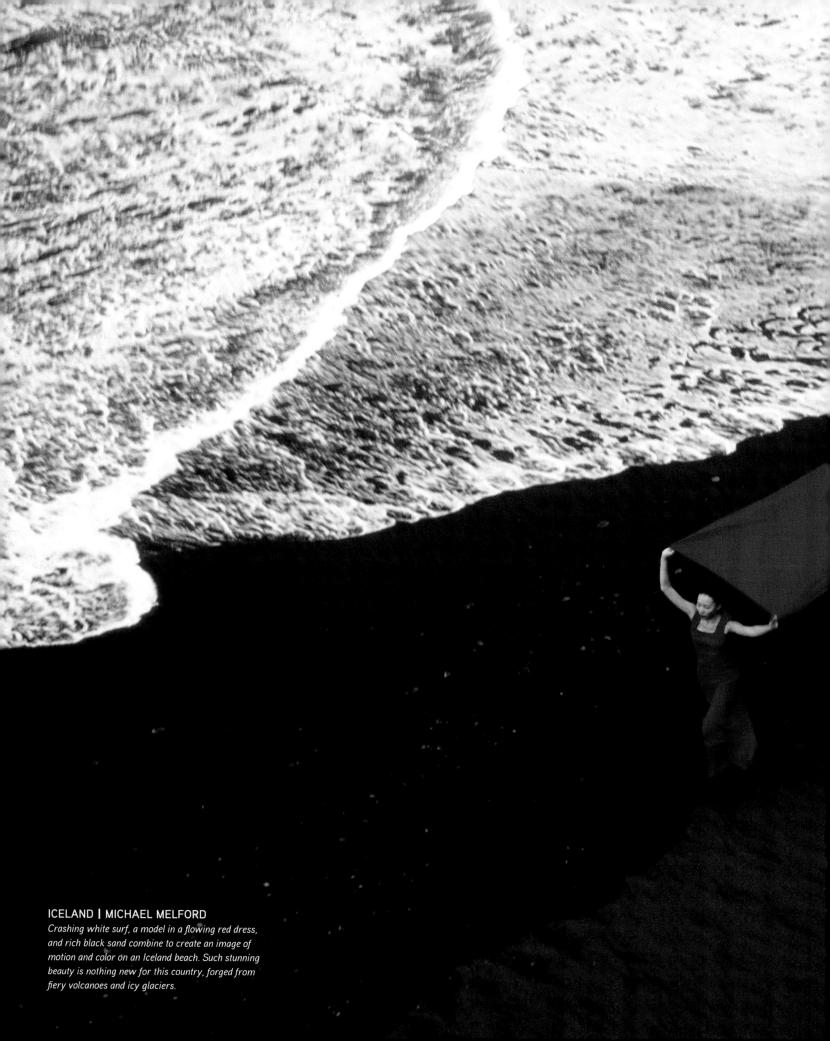

DEMOCRATIC REPUBLIC OF THE CONGO | CARSTEN PETER

An explorer walks on the cooled lava from an eruption of Nyiragongo Volcano, an active peak in striking distance of the city of Goma. The red color comes from the reflected glow of the nearby lava lake.

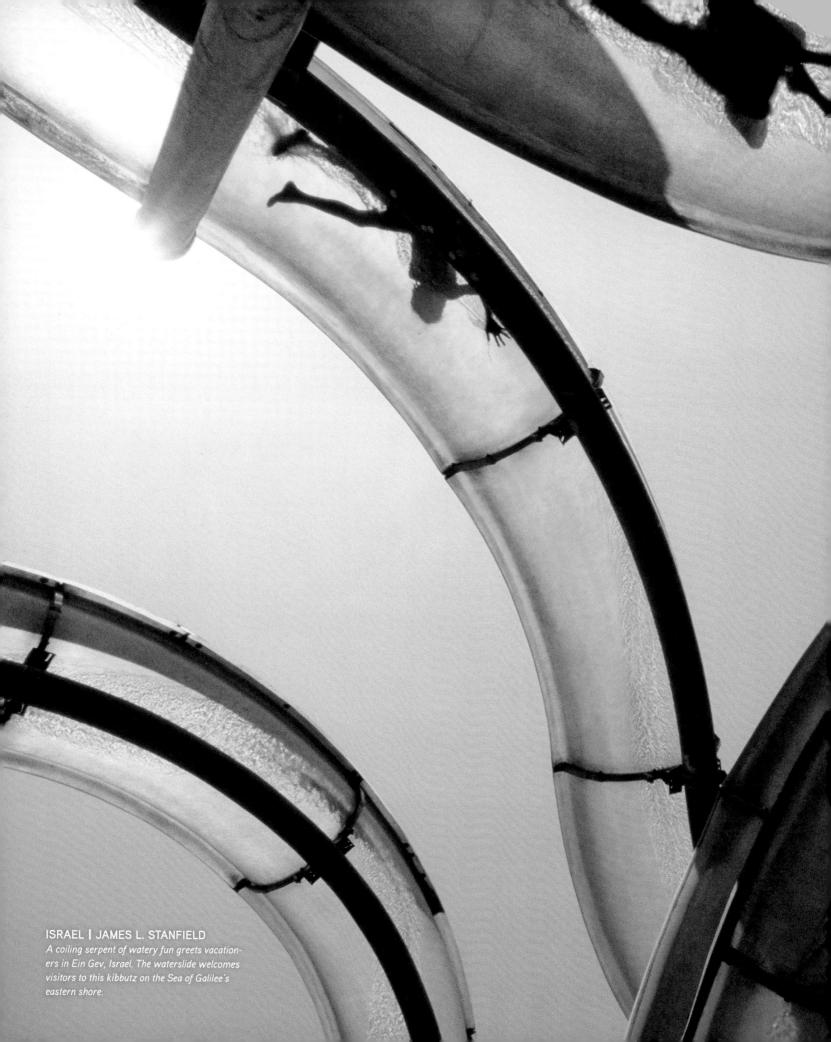

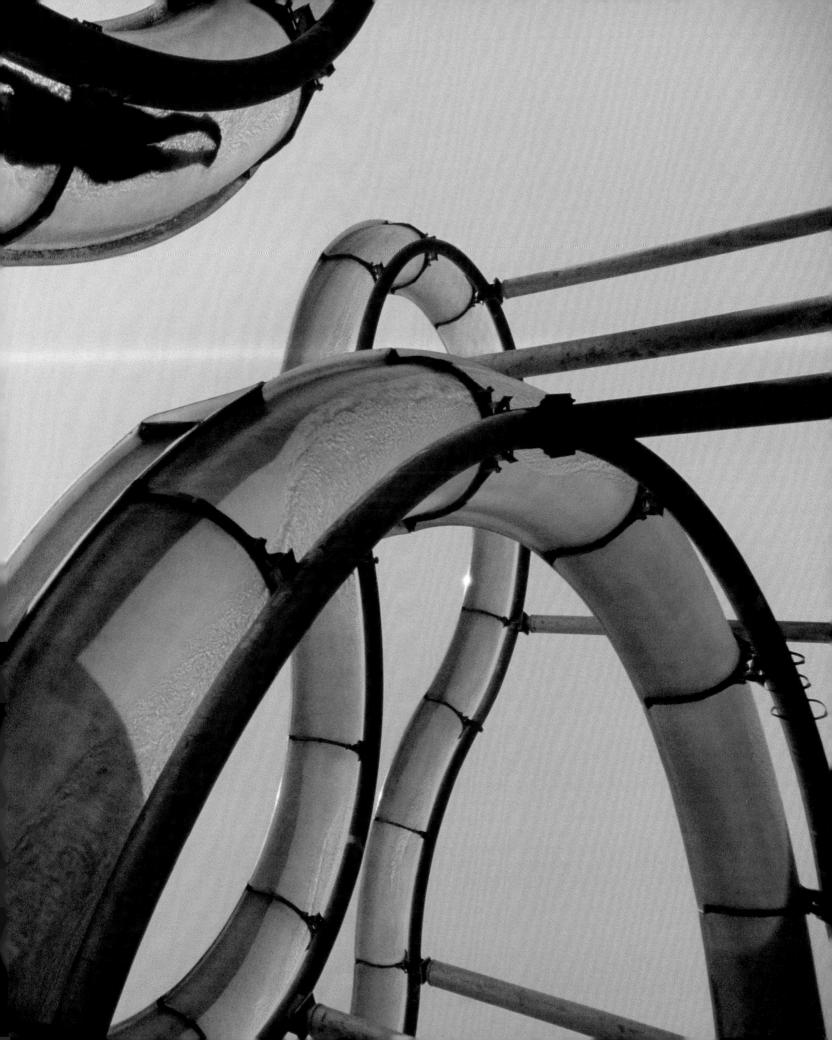

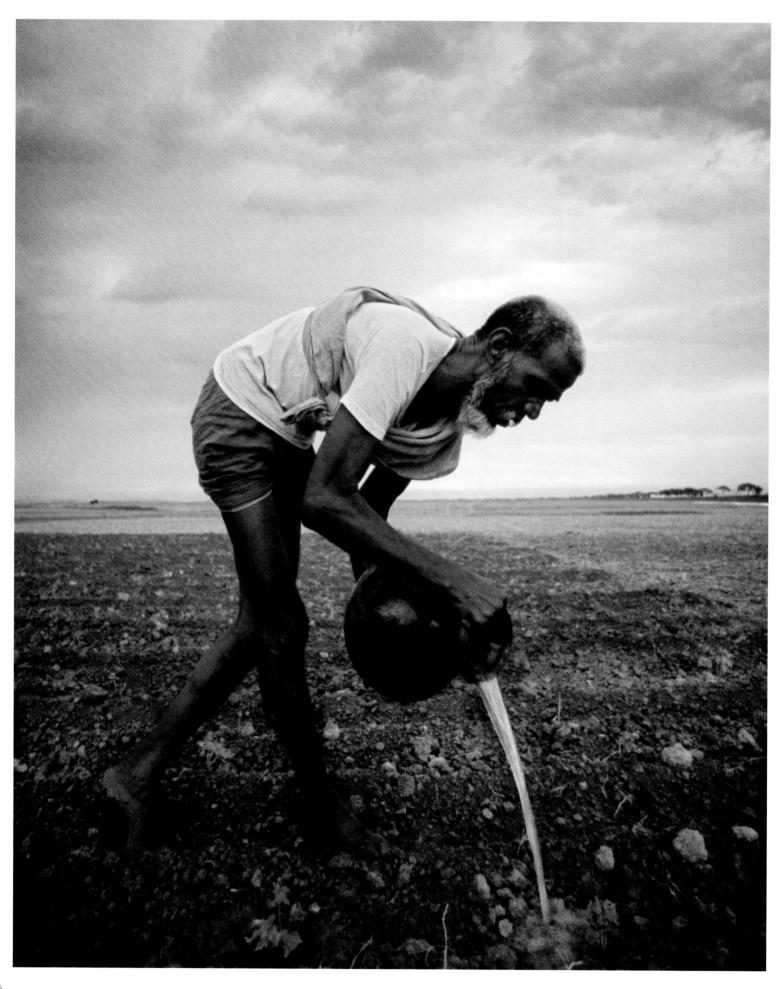

Ninety-seven percent of

EARTH'S WATER

is in the oceans. This means that if all the world's water could fit in a 1-gallon (3.8 L) jug, only about 1 teaspoon (5 mL) of it would be fresh water.

ALASKA, UNITED STATES | ALISON WRIGHT A bartender at the Fairbanks Ice Museum mixes cocktails at a bar made of ice. For those who can't get enough of the cold, this museum offers visitors "Alaska's winter in the summer."

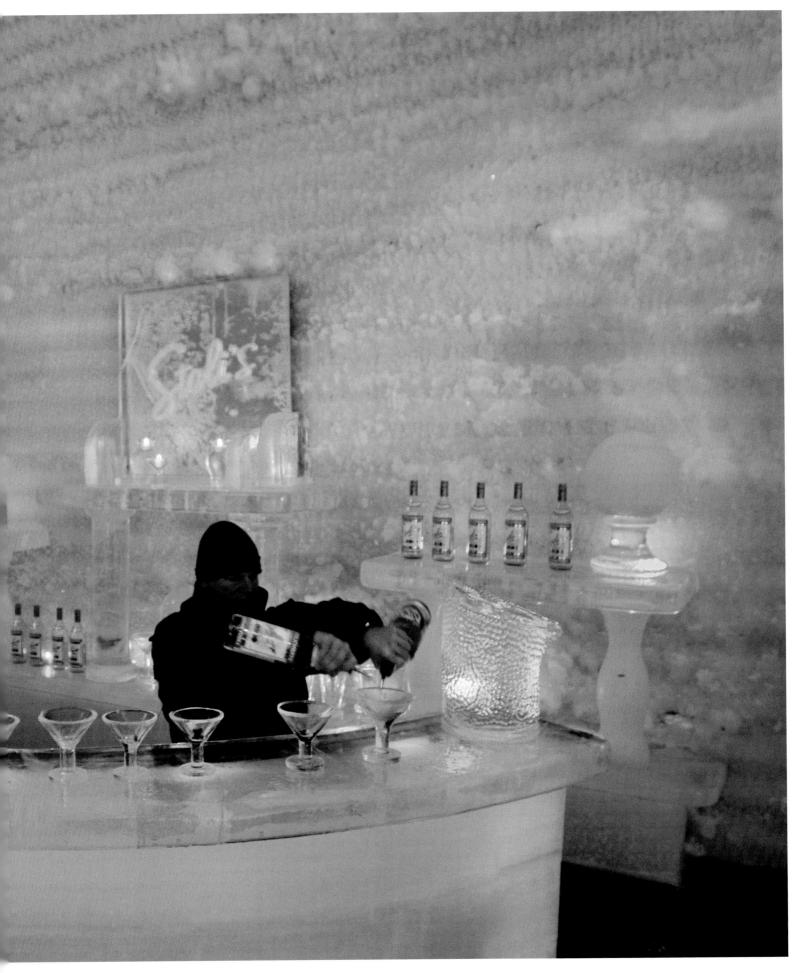

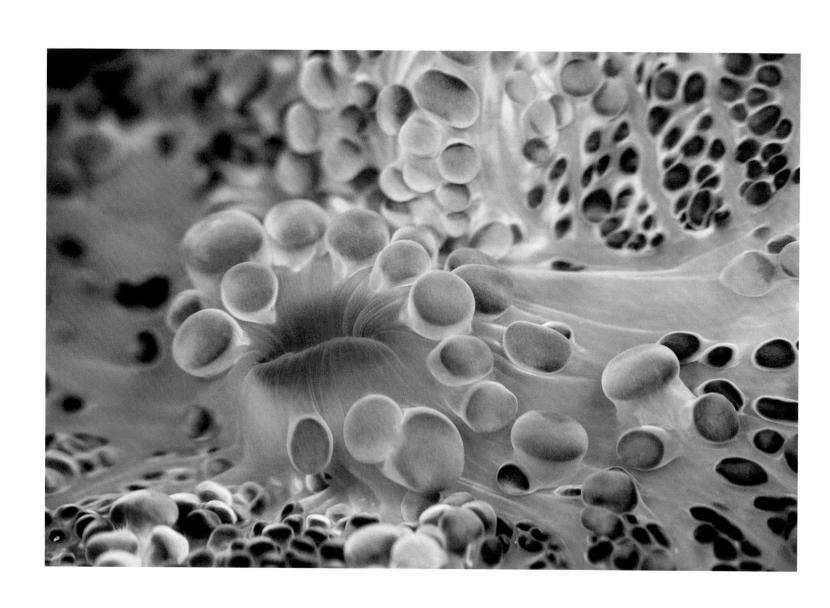

SOLOMON ISLANDS | CHRIS NEWBERT

A close-up of corallimorpharians, also known as mushroom anemones, in the western Pacific looks like alien life when lit by strobe lights. Related to hard corals, this mainly tropical order lacks hard, calcareous skeletons.

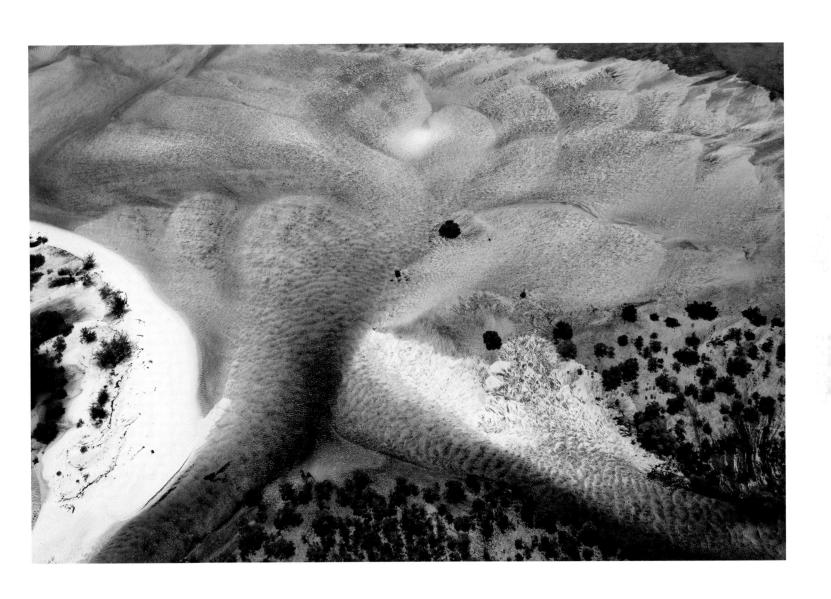

MOZAMBIQUE | MICHAEL POLIZA

A river in Mozambique flows into the Indian Ocean and creates a scalloped pattern. This southeastern African nation has abundant natural resources, including rivers for hydroelectric power.

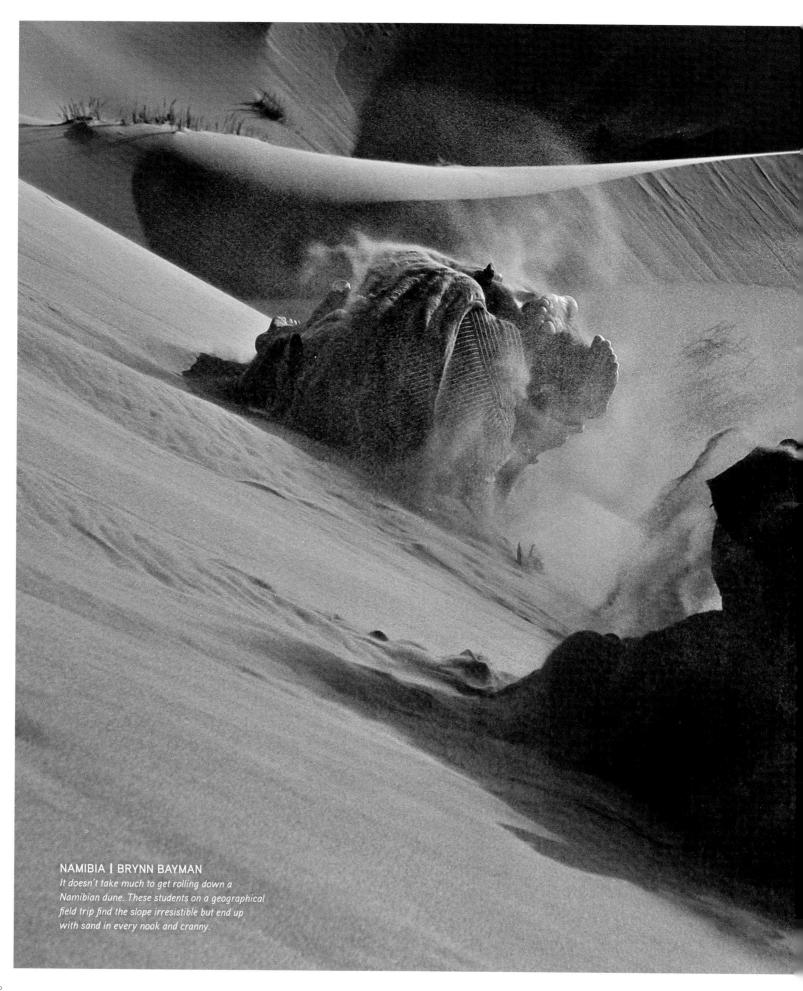

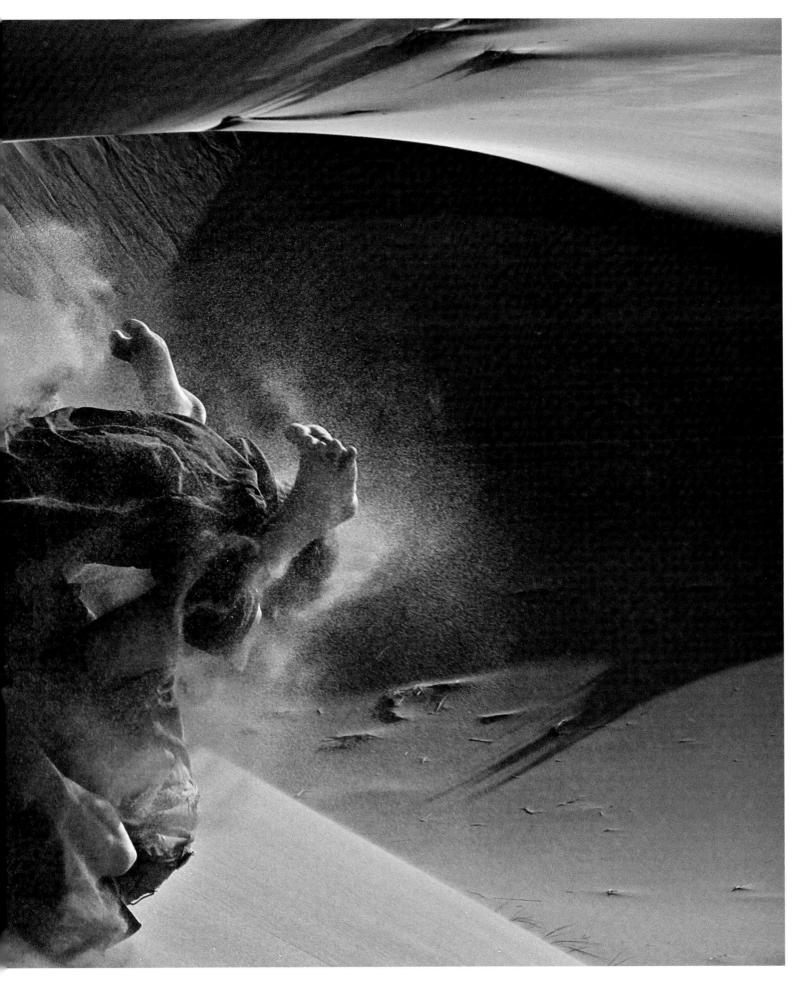

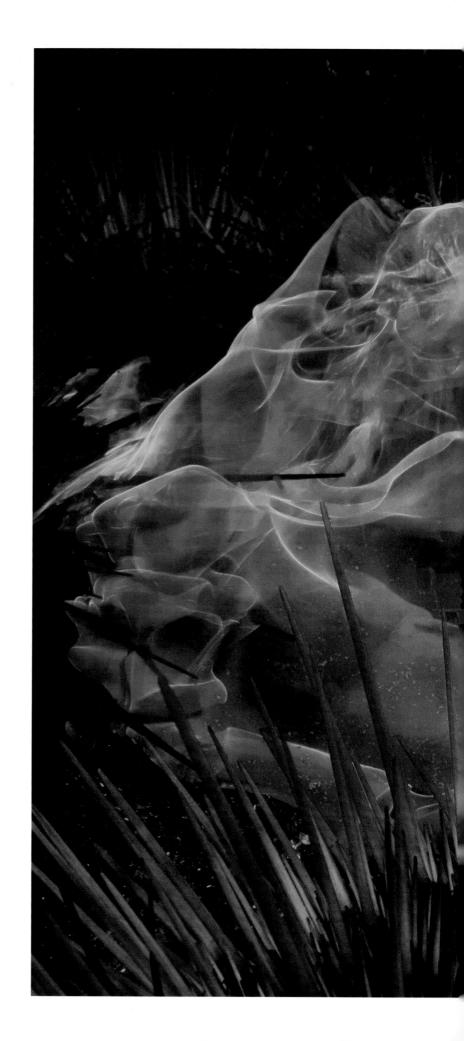

CANADA | PAUL NICKLEN

Colored neon green by a nontoxic dye, the current surrounding this sea urchin colony near British Columbia's Vancouver Island flows through it instead of over it. The fast, nutrient-full waters of the Queen Charlotte Strait nurture an abundance of sea life.

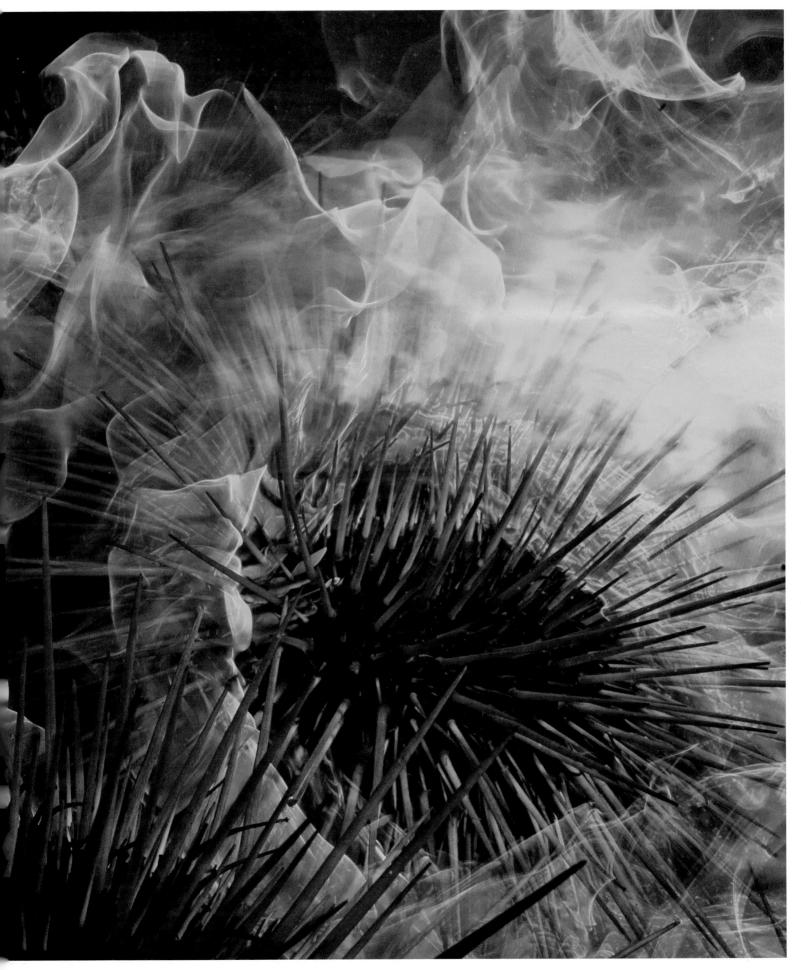

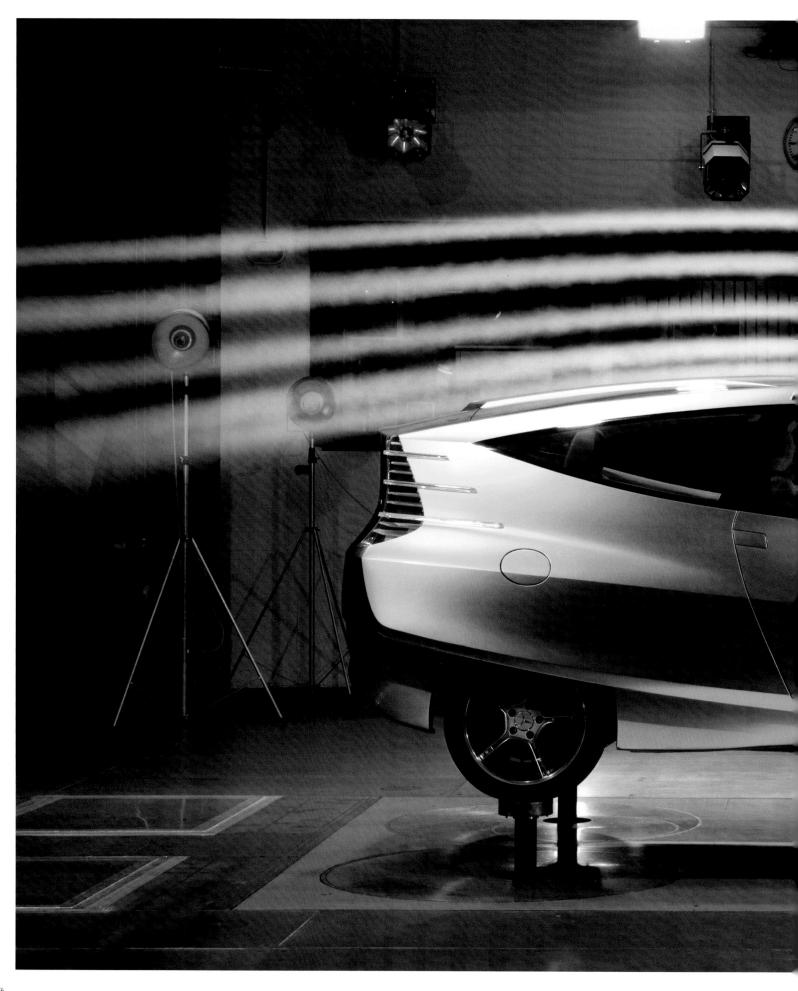

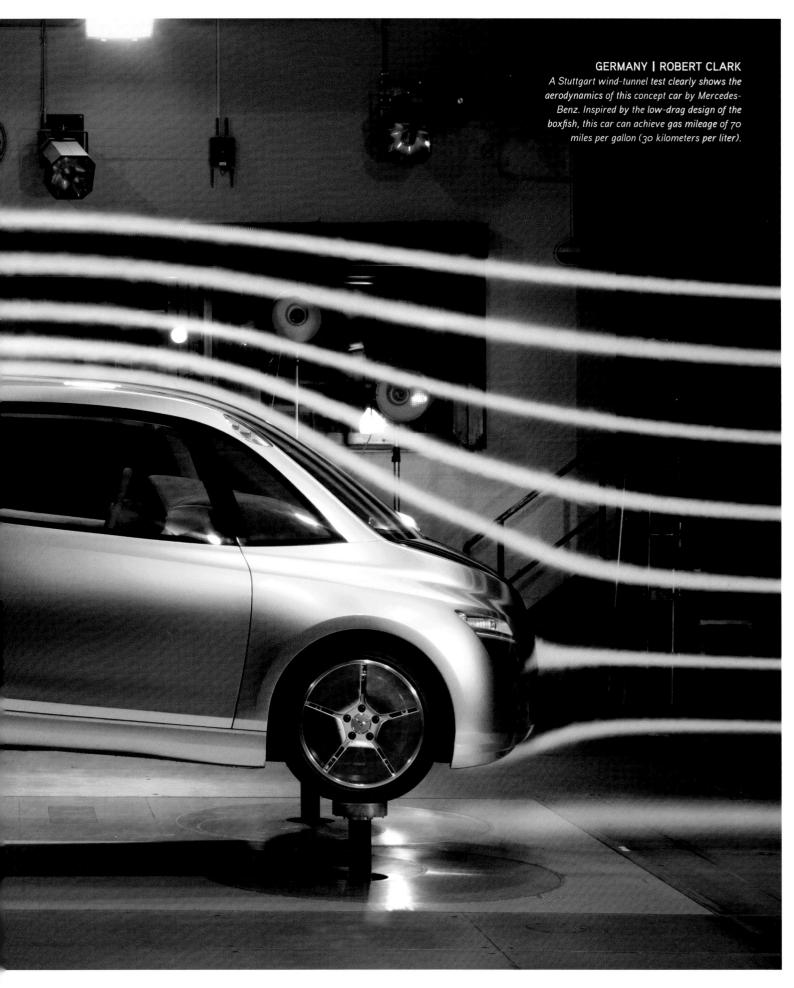

PORTFOLIO FIFTEEN

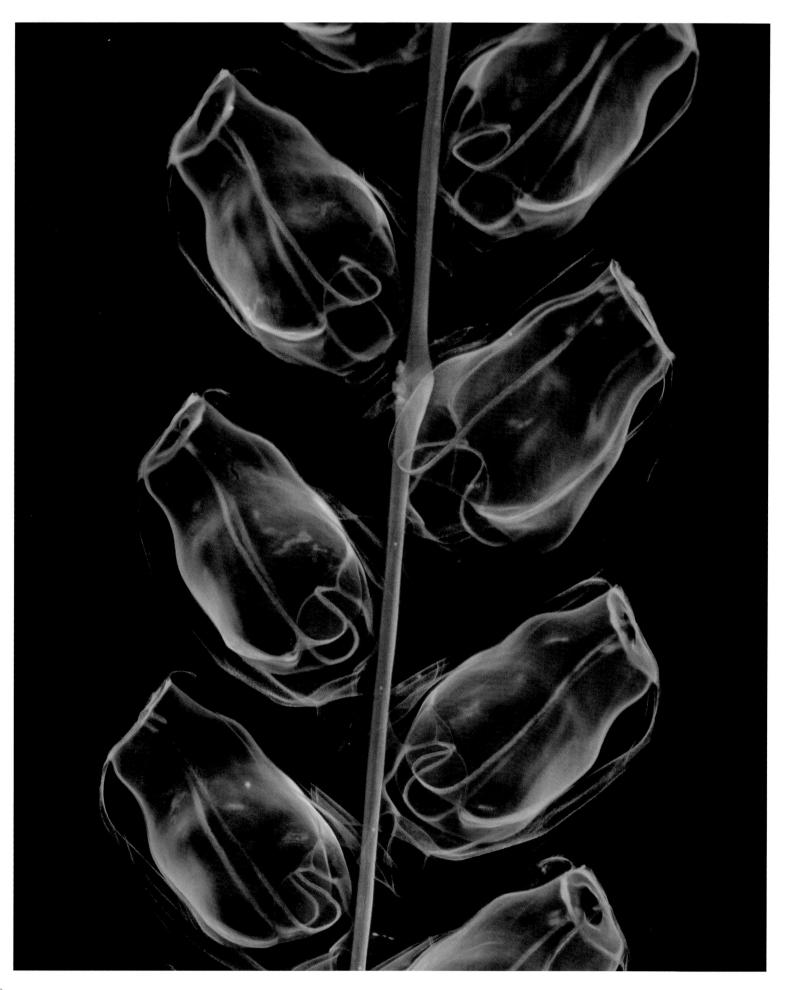

moment of understanding that happens more deeply than words we find radiance deeply than words, we find radiance.

A fragrant white peony, just one of its multiflora petals fringed with red, exudes a scent that lifts the heart. It smells like dawn.

The whir of hummingbird wings sounds on a summer afternoon; the iridescent creature pauses, emerald green balancing on air. It dips its beak, sips nectar from the luxuriant trumpet flower, then rears back delicately and darts up, out, and over to the next flower-rich hedgerow.

A swampside anhinga—awkward of shape, drab in color, ugly in face—glories in the radiance of the day, stretching angled wings out wide to catch the warmth of subtropical sunshine, avian yoga at midday.

Moments of radiance surround us, yet our dulled senses do not always perceive them. We need the help of watchful eyes, trained to precision of expectation.

At just the moment of ripeness, a gleaming yellow apple falls into the grassy field. In evening shadows, a doe takes each step with care, her fawn beside her. She nuzzles the sweet fruit and nudges it toward her young. A moment of love and light in the forest.

The winter sun gleams through bare tree trunks lining the blue ridge of a mountain. Radiance, then darkness. Dawn will come.

And if we are lucky, someone will be there, watching and waiting, on the alert for the new day's first light, making the next great photograph, capturing anew these visions of Earth.

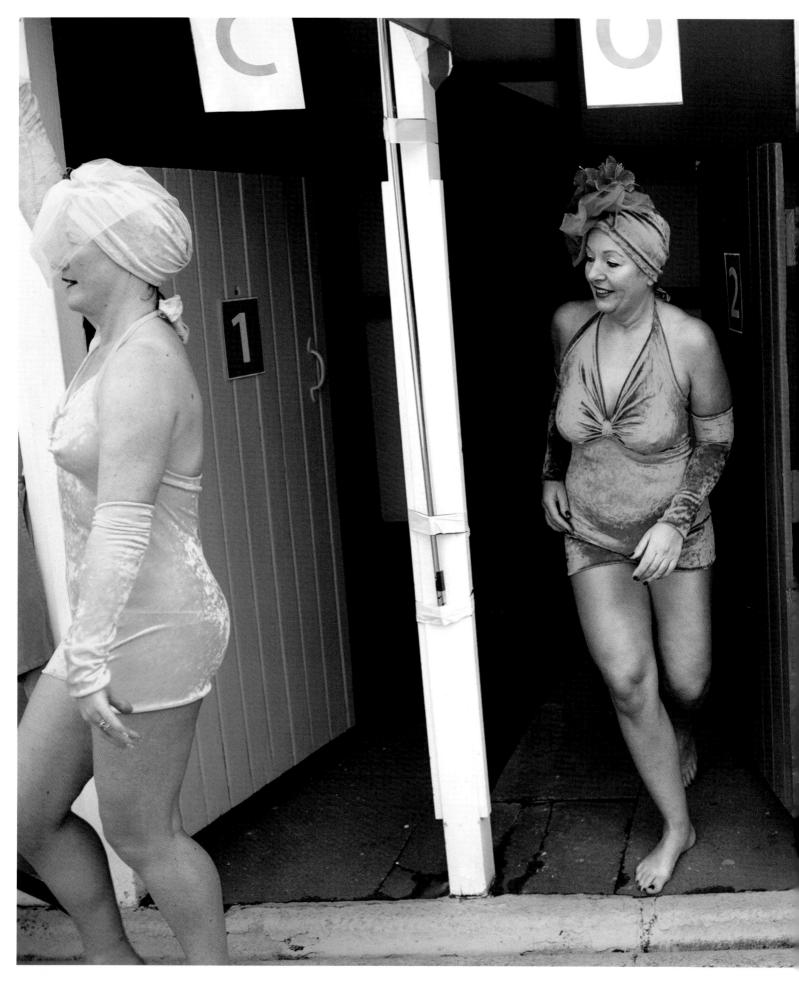

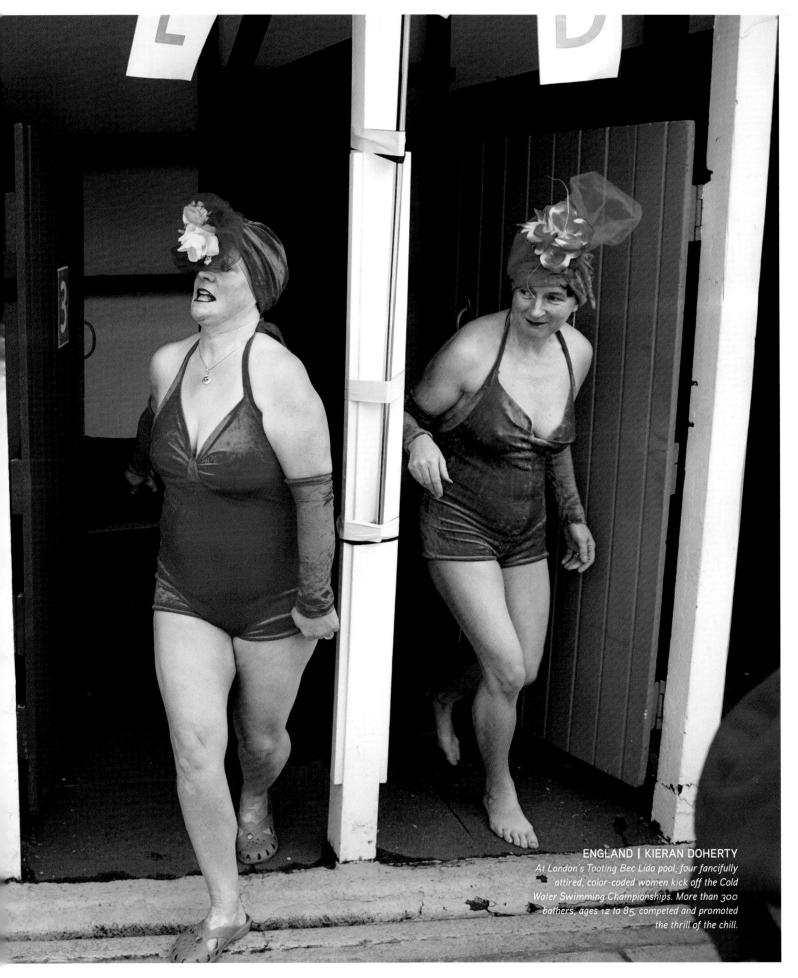

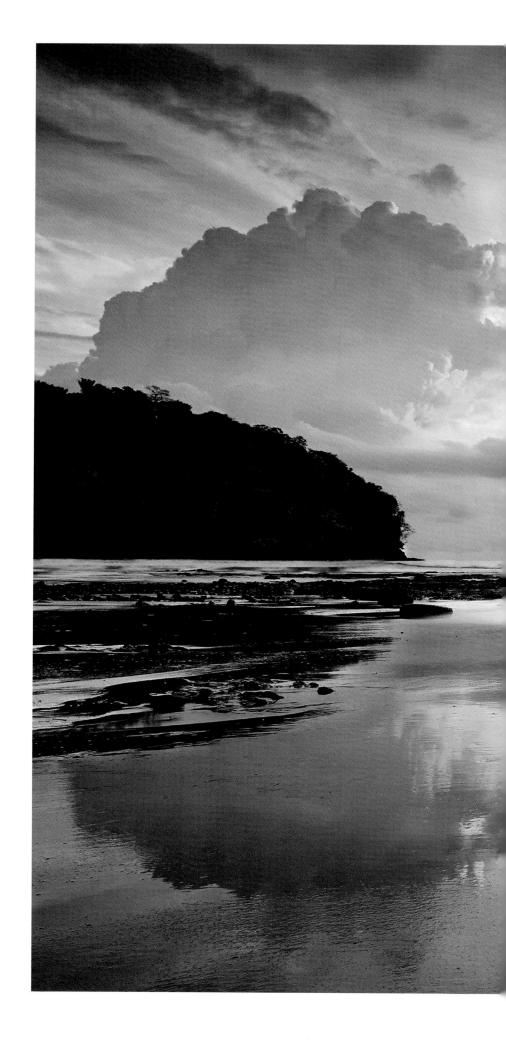

COSTA RICA | PATRICK DI FRUSCIA

Building clouds and a setting sun reflect on a sandy beach on Costa Rica's Nicoya Peninsula. The Pacific offers tranquil beauty and good surfing, just two of many reasons why this stable Central American country has become a favorite destination.

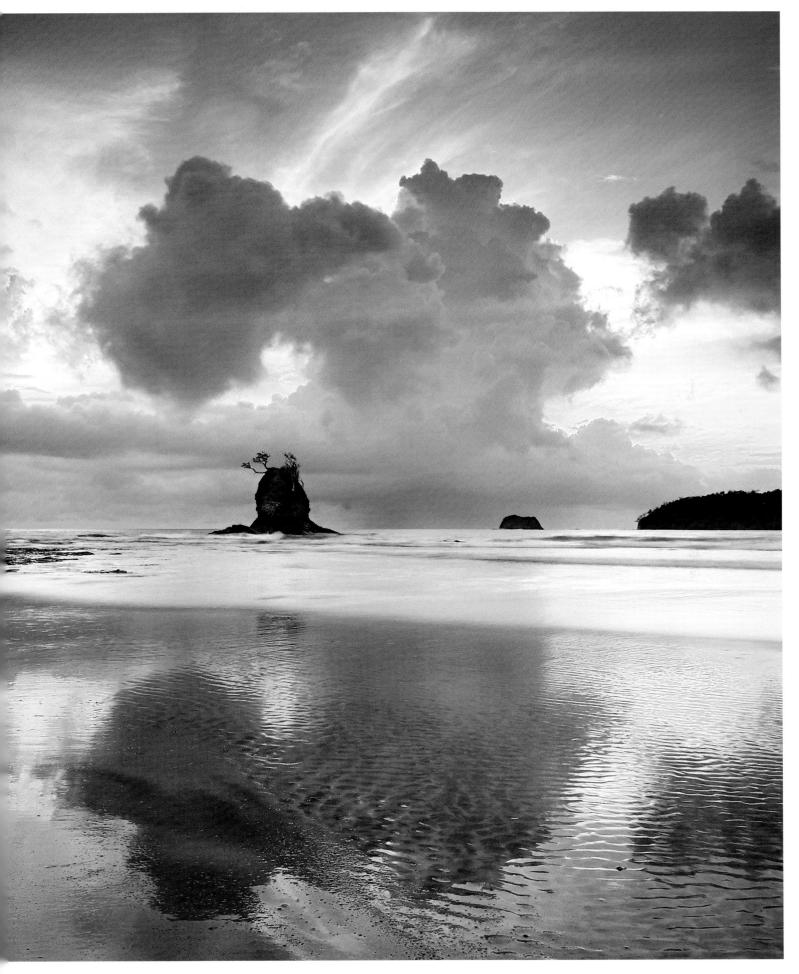

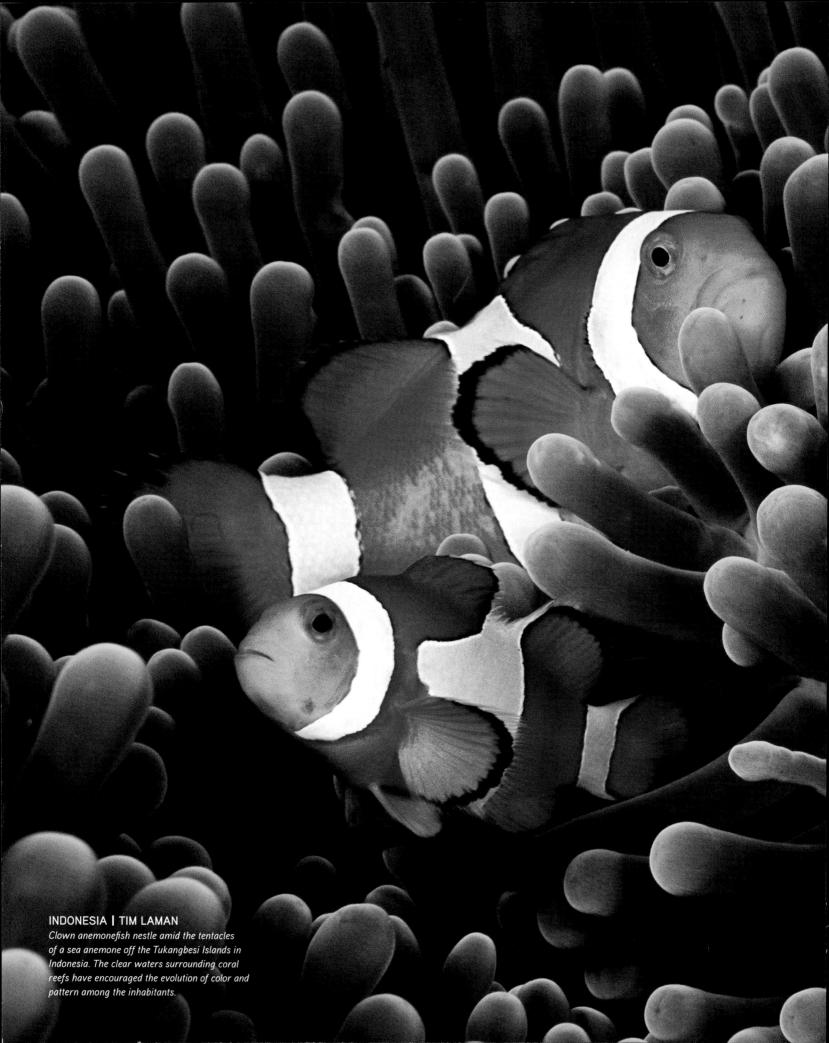

The leg muscles of a LOCUST are about 1,000 times more powerful than an equal weight of human muscle.

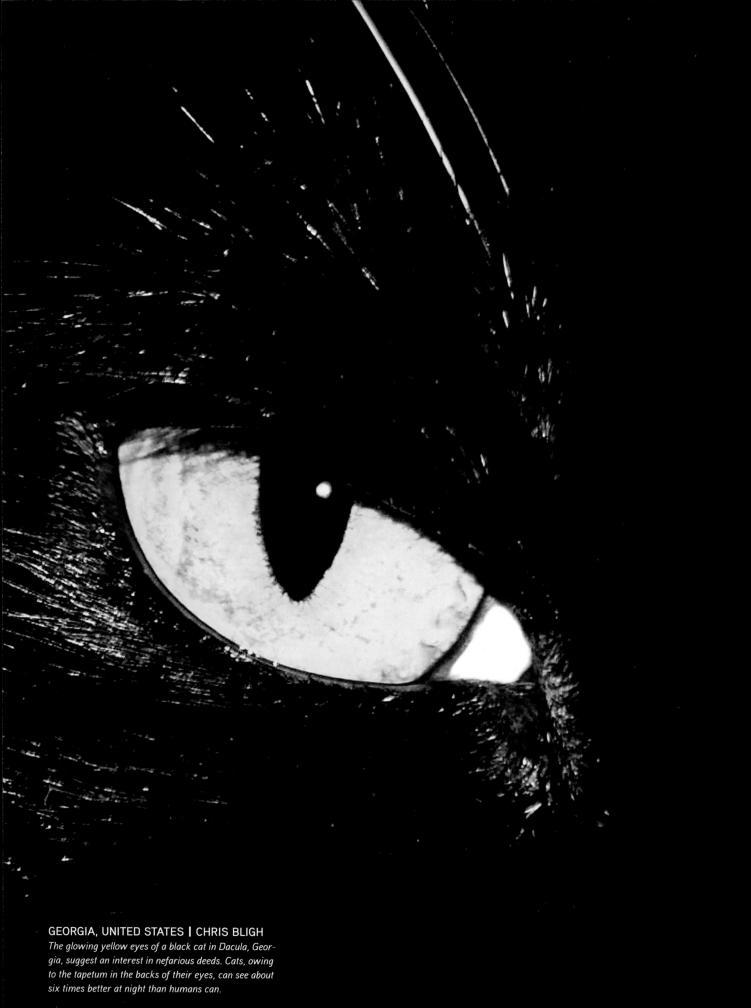

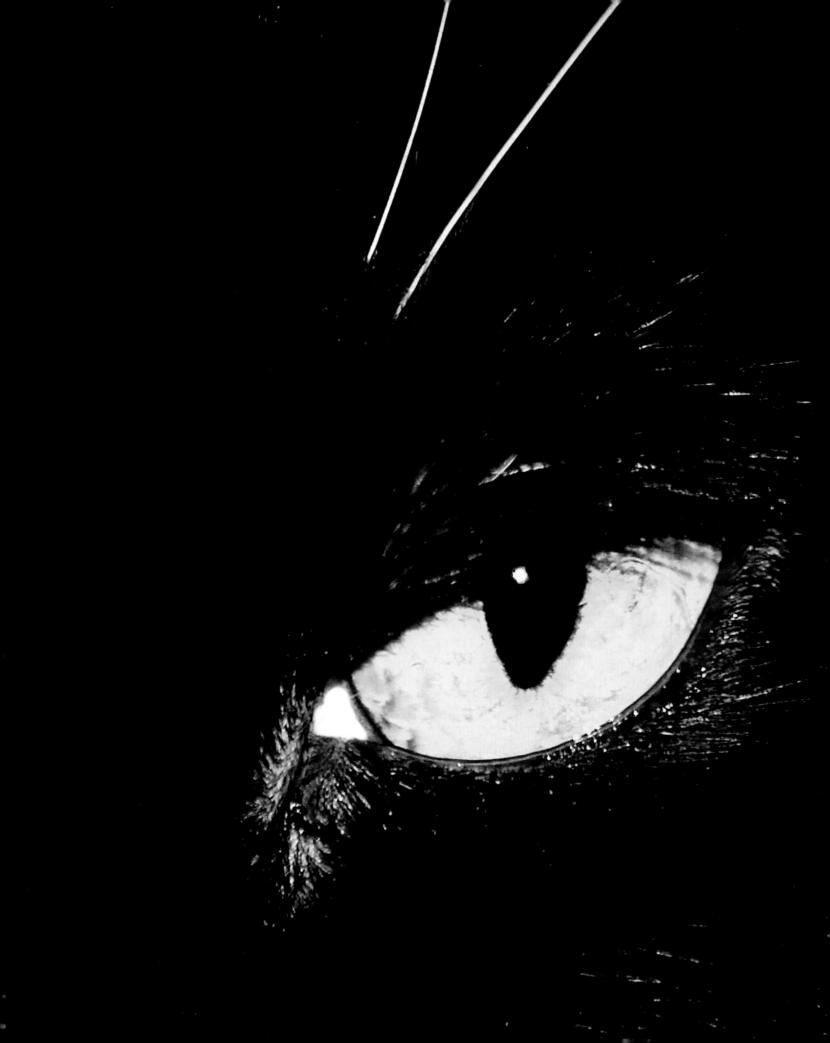

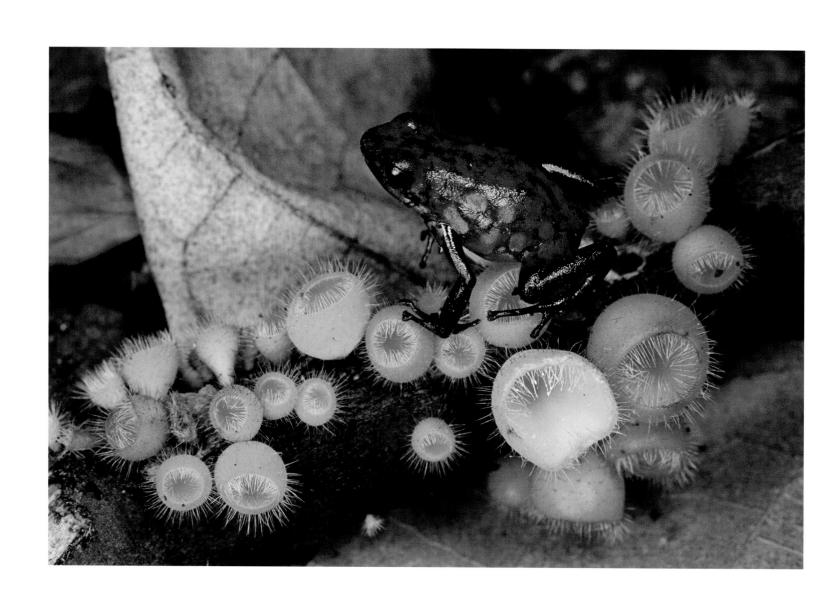

ECUADOR | MARK MOFFETT

A lovely but toxic harlequin poison dart frog, Dendrobates histrionicus, sits on cup fungus in an Ecuadorean rain forest. Its colorful pattern acts as a warning to potential predators to stay away.

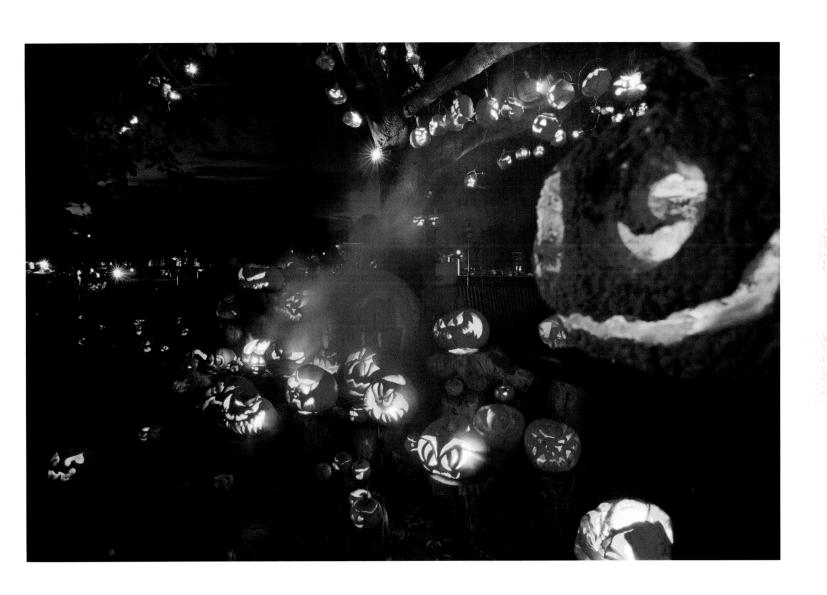

MASSACHUSETTS, UNITED STATES | RICHARD NOWITZ

Grinning jack-o'-lanterns spill across a tree and a porch as a festive welcome to Halloween. The custom of pumpkin carving originated in the British Isles, but people used large turnips or other vegetables instead of pumpkins.

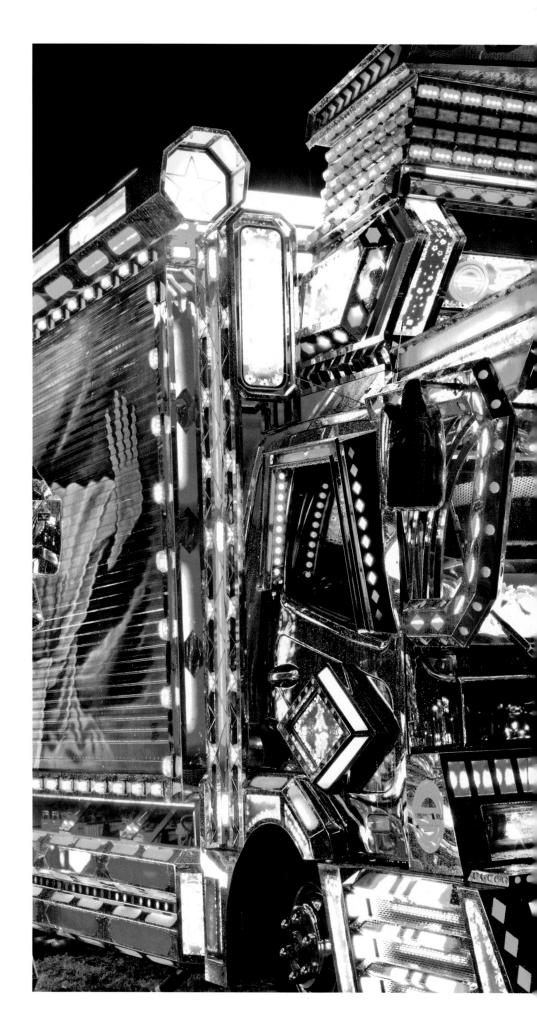

JAPAN | ROGER SNIDER

Covered in chrome and gleaming neon, big rigs from across Japan shine at a truck show in Aichi Prefecture. Known as dekotora, most are working trucks—though on long hauls, they're typically not driven with all their lights on.

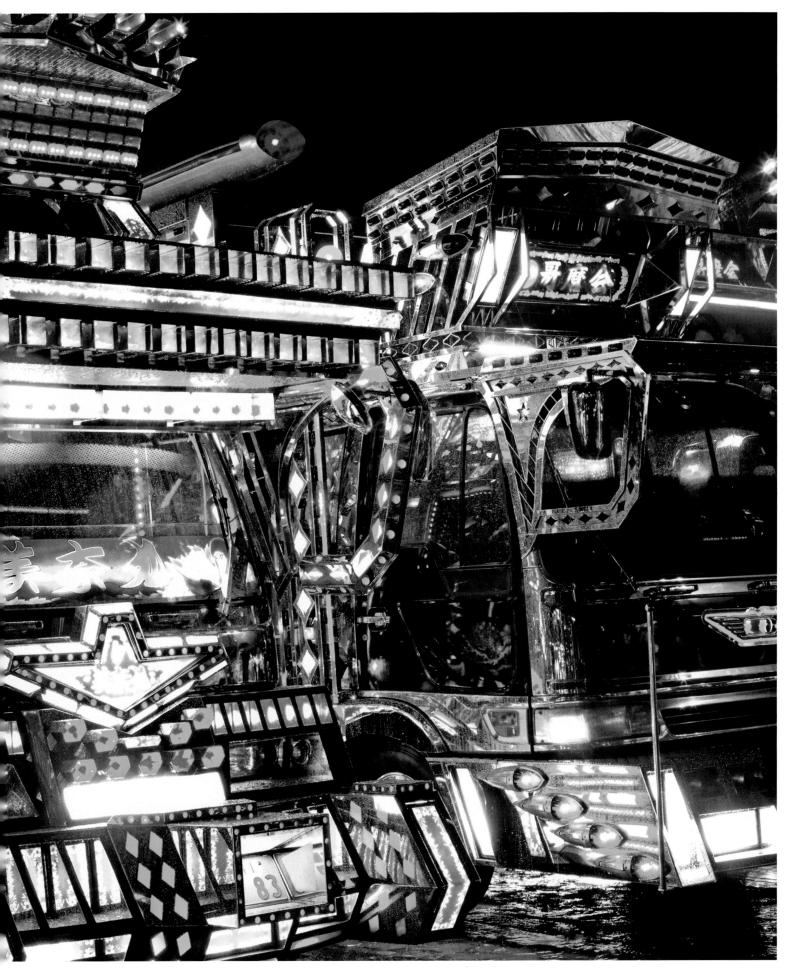

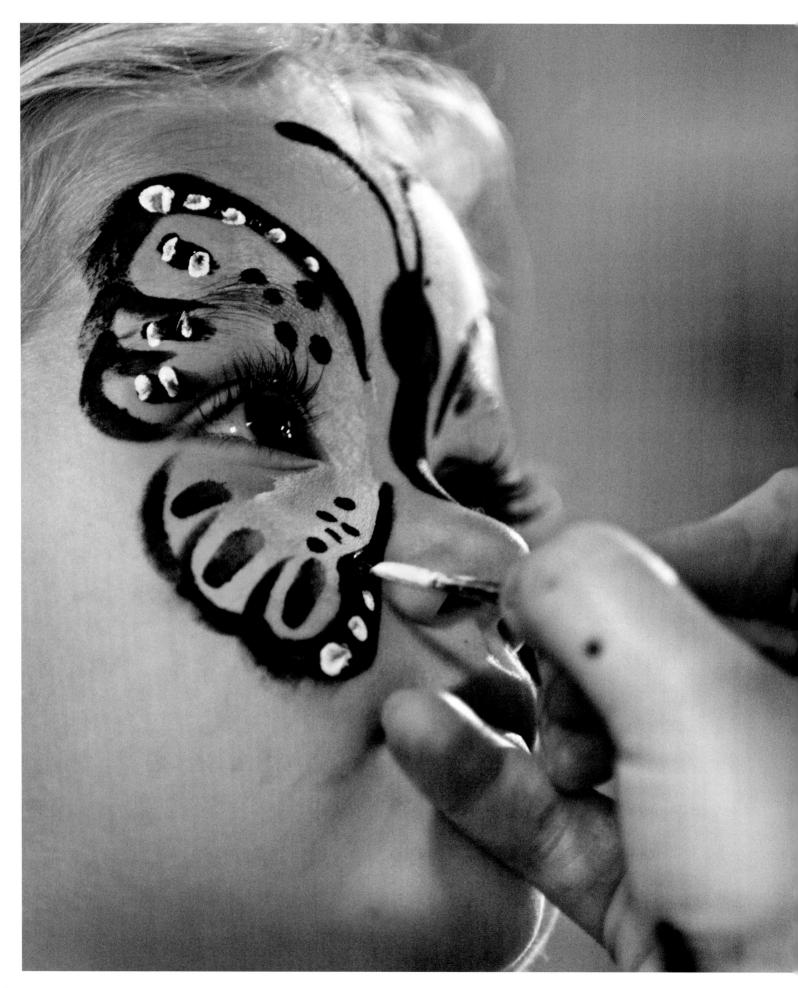

CALIFORNIA, UNITED STATES | RICH REID

A young girl in Pacific Grove, California, transforms into a green butterfly under the brush of a face-painting artist at the Pacific Grove Museum of Natural History, which is dedicated to exploring the wildlife, plants, cultures, and geography of California's central coast.

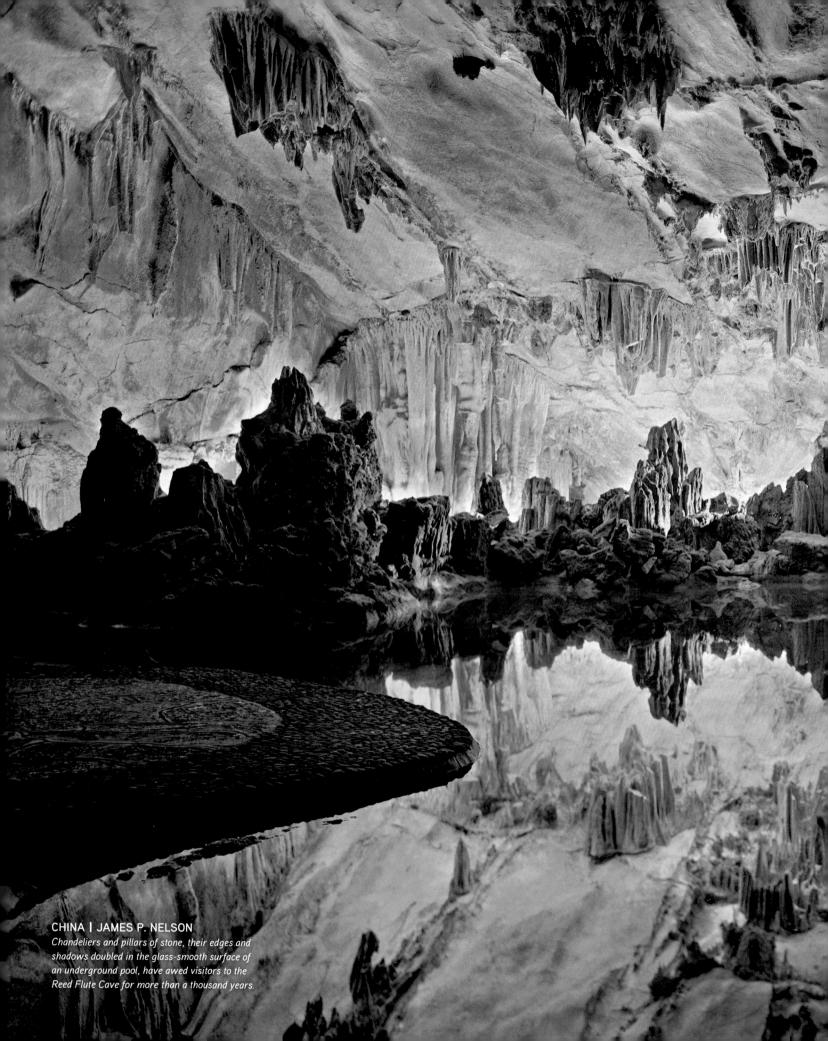

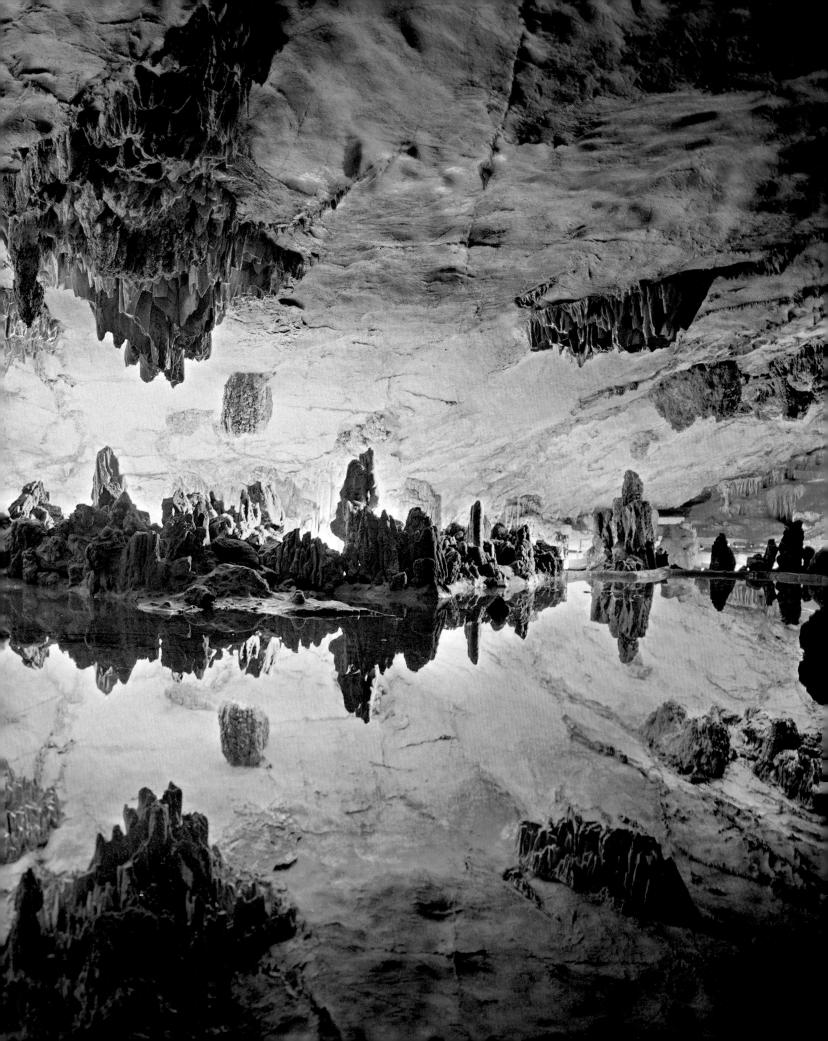

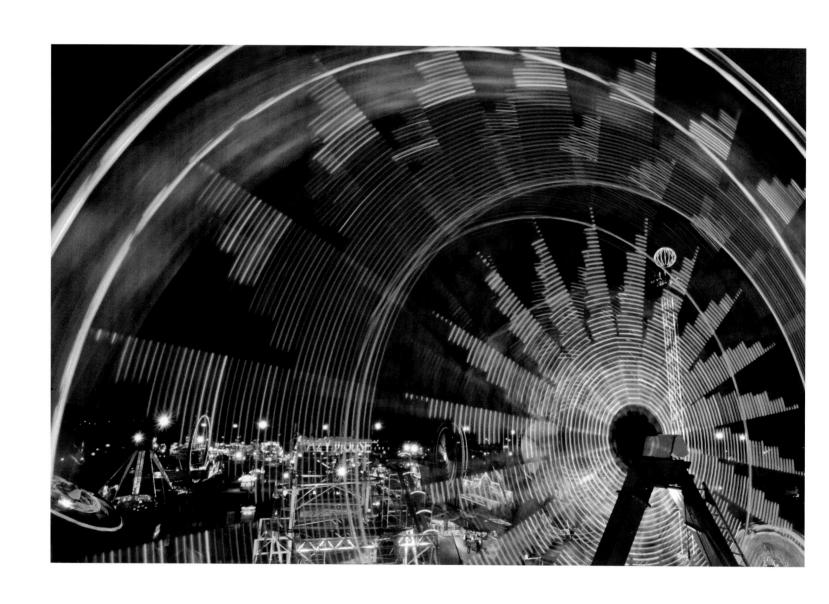

KANSAS, UNITED STATES | JOEL SARTORE

The Ferris wheel at the Kansas State Fair in Hutchinson mimics a giant Lite-Brite toy. Long lines can form at popular midway rides, but in this long exposure all the stress melts away.

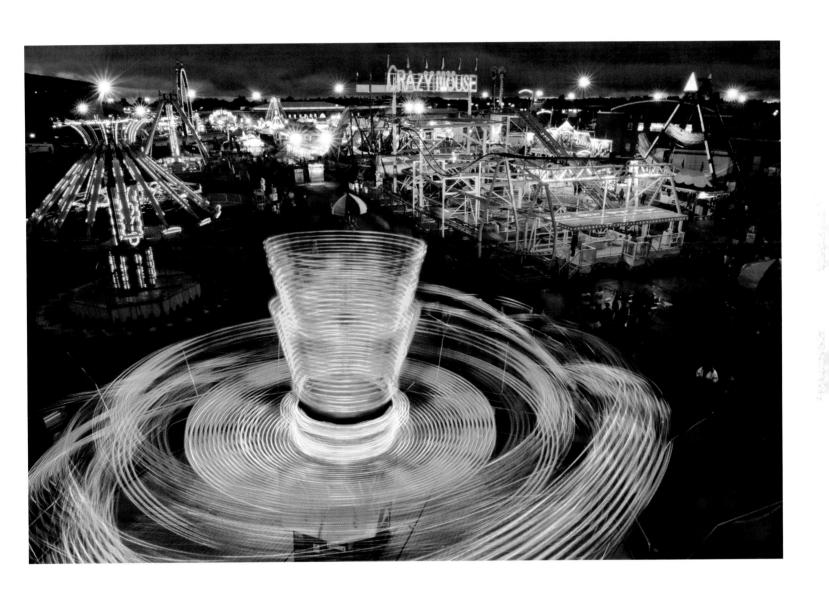

KANSAS, UNITED STATES | JOEL SARTORE

Spinning midway rides light up the night at the Kansas State Fair in Hutchinson. The end-of-summer ritual creates a tapestry of spinning motion, squeals of glee, homespun contests, and the smell of fried foods.

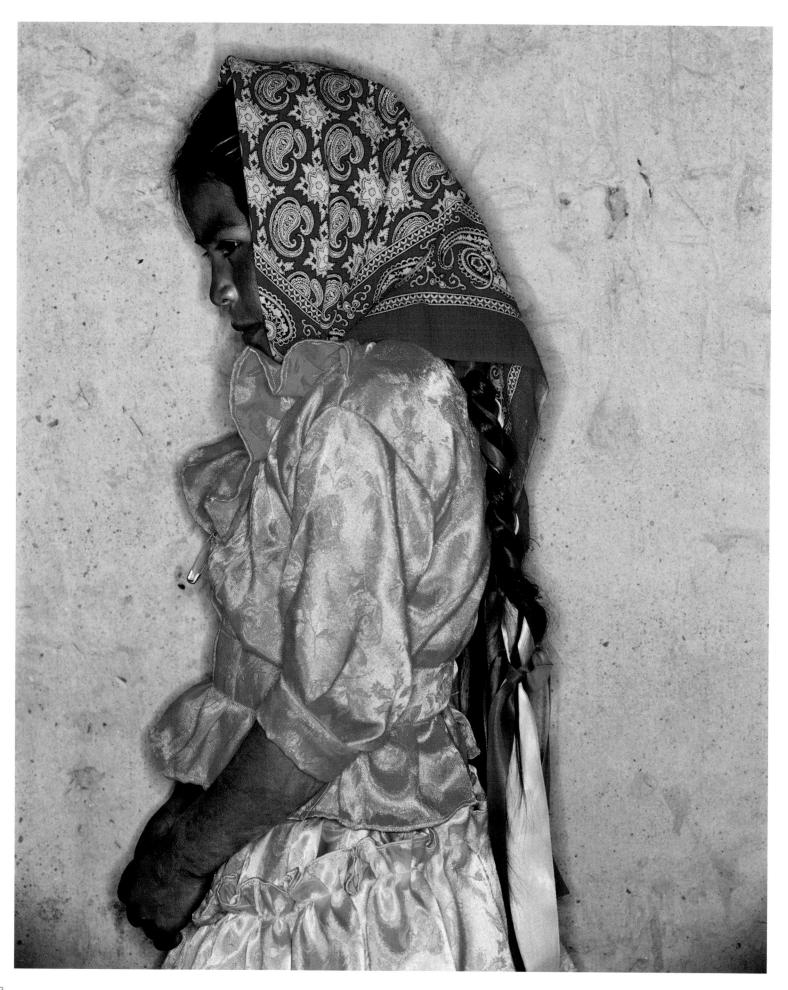

PUEBLA, MEXICO, boasts the world's smallest inactive volcano. Called Cuexcomate, it is only 43 feet tall (13 m).

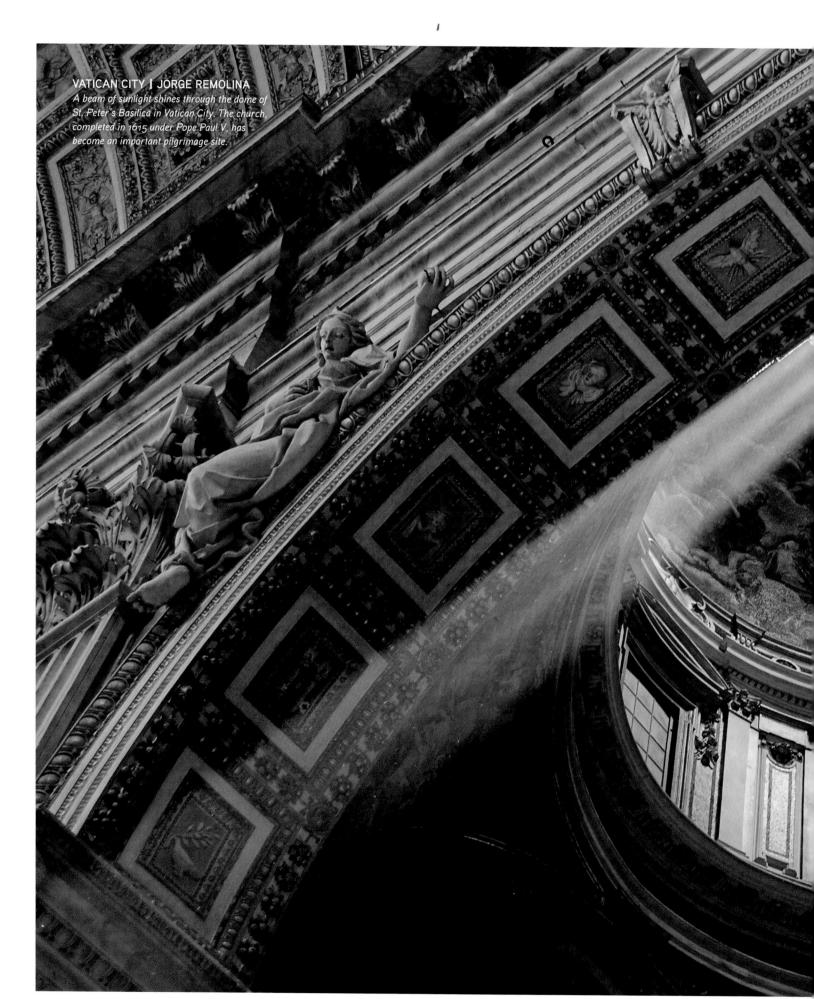

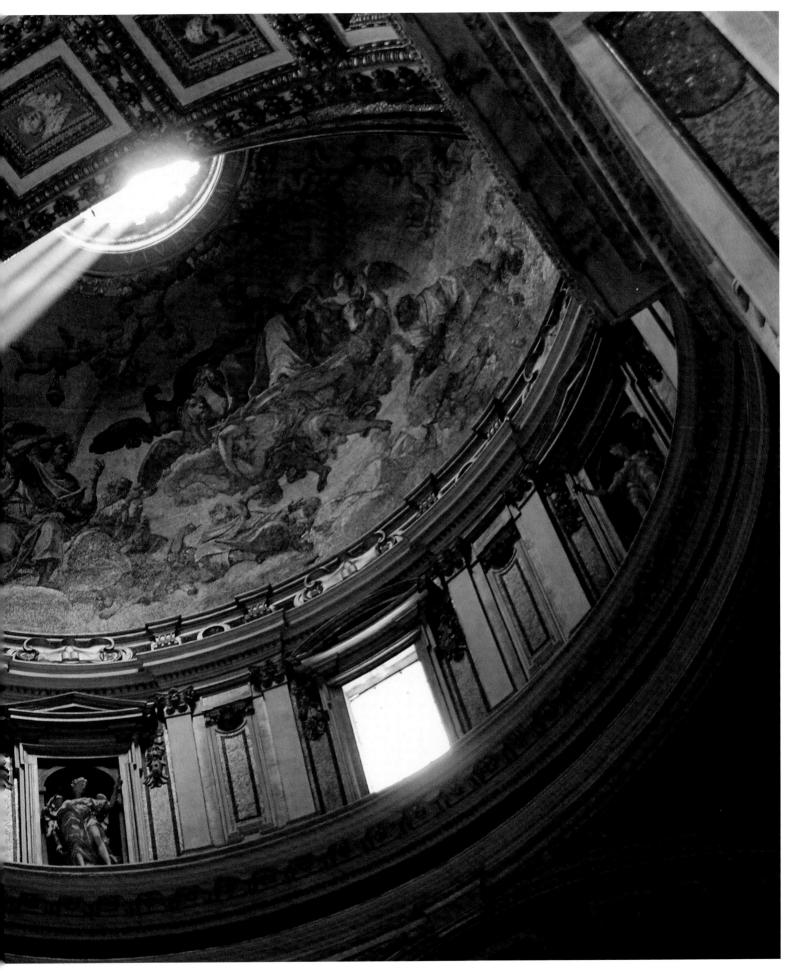

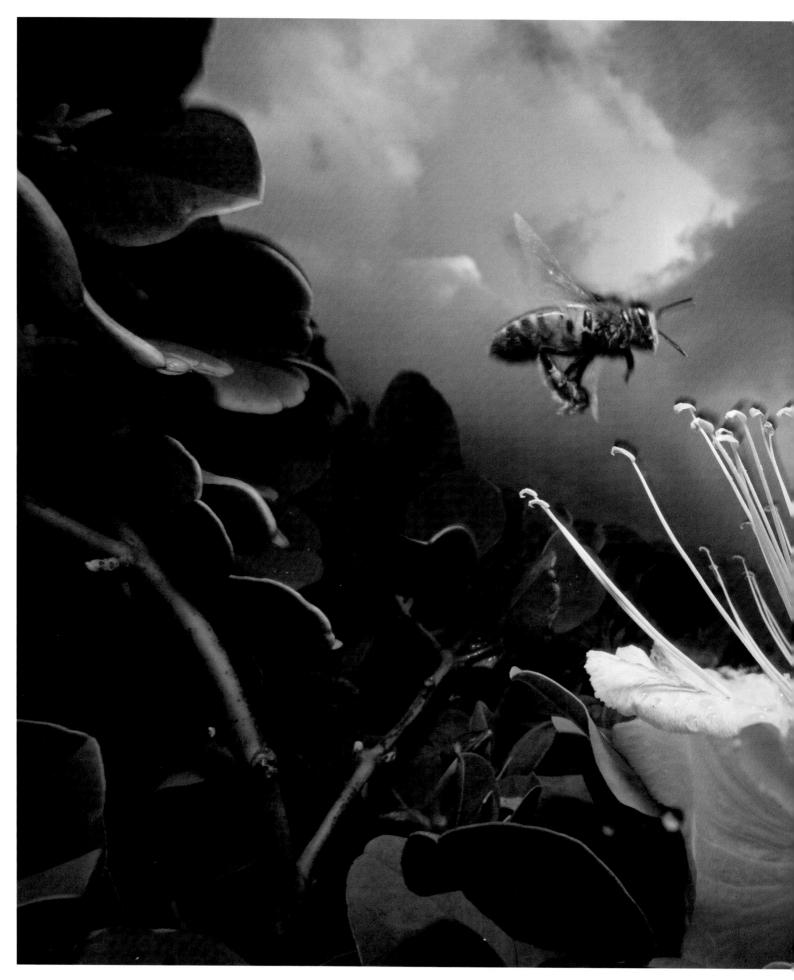

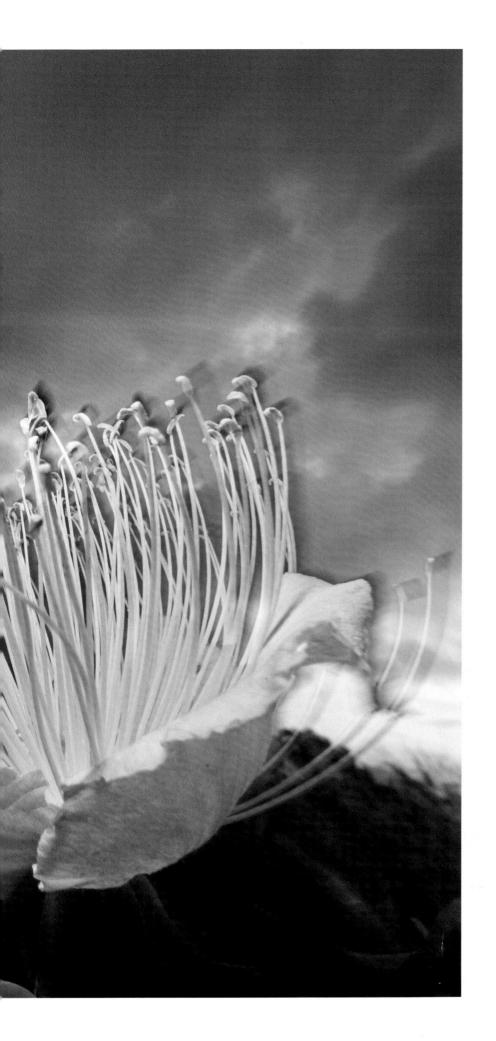

HAWAII, UNITED STATES | MARK MOFFETT

A honeybee comes in for a landing on a caper flower in Kauai, Hawaii. Attracted by the flower's perfume and arriving at dusk, this bee is taking part in worldwide insect pollination that is valued at \$200 billion.

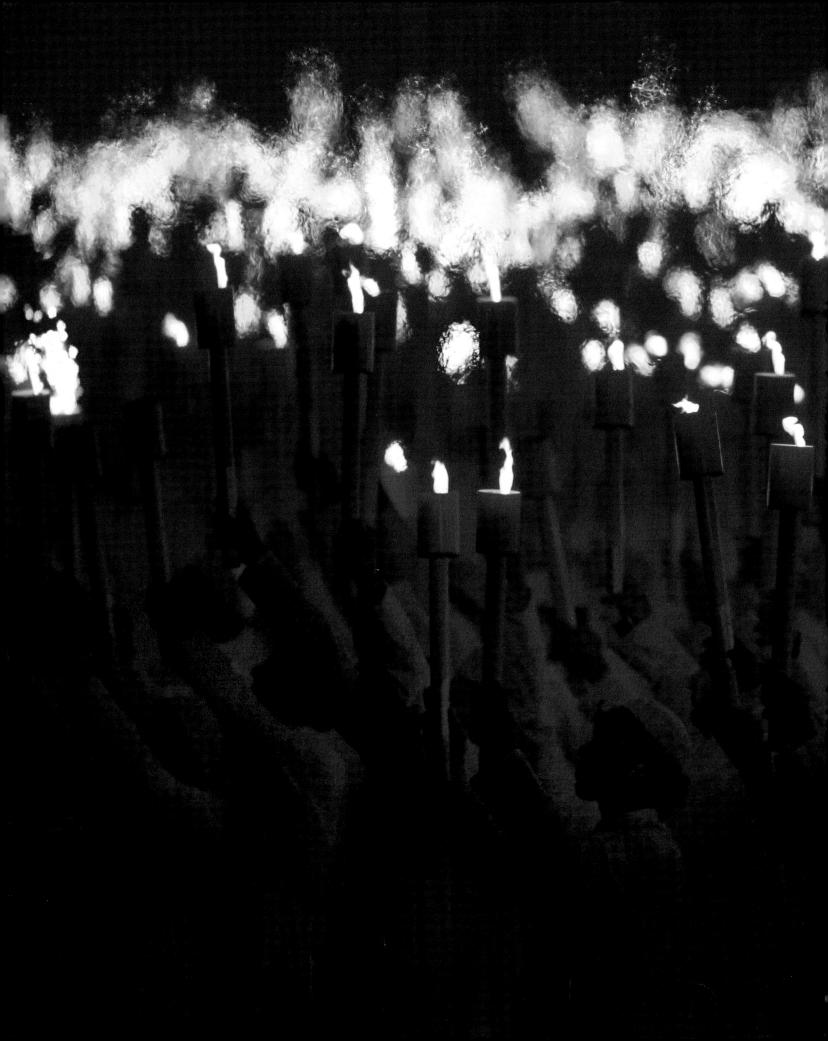

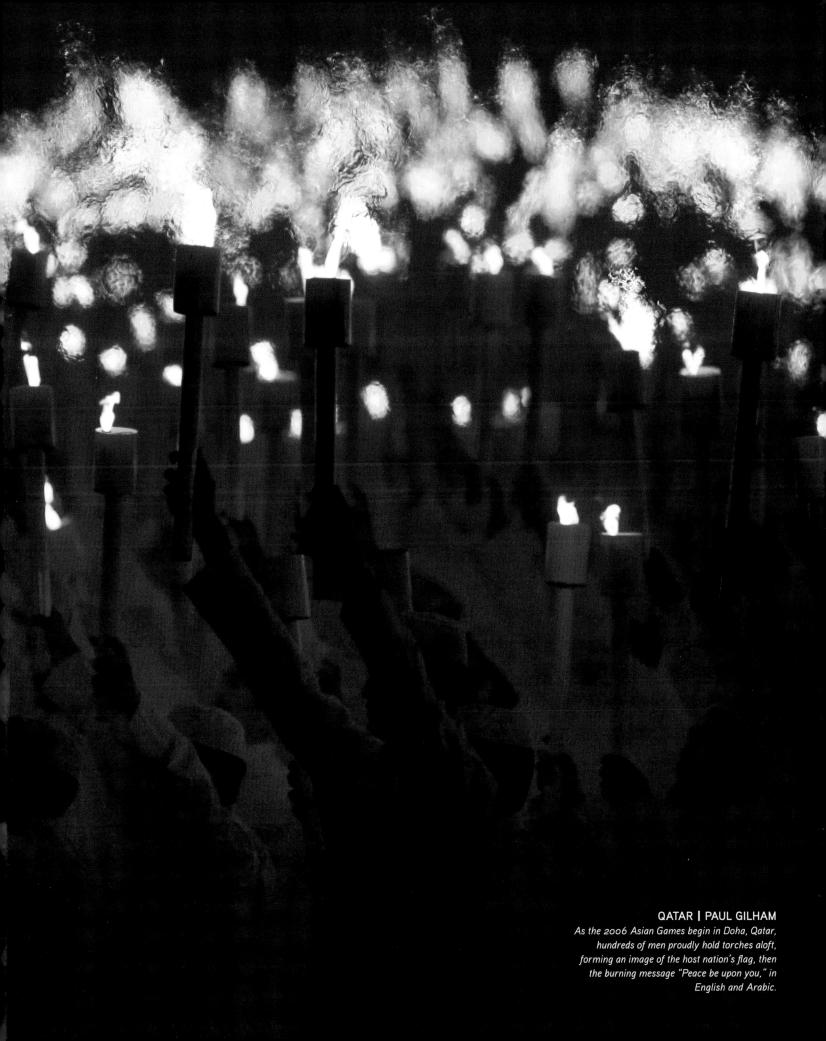

All of the images in this book were drawn from past issues of *National Geographic* magazine or are part of National Geographic's Image Collection. On the page with each photograph in the book we have included the photographer's name.

The list below is additional information on the source of this material, when it is not the National Geographic Image Collection.

If you are interested in licensing a National Geographic image for professional use, please go to National Geographic STOCK.com.

2-3, REUTERS; 4-5, epa/CORBIS; 14-15, National Geographic My Shot; 26, National Geographic My Shot; 32-33, National Geographic My Shot; 40, Minden Pictures/National Geographic Stock; 41, National Geographic My Shot; 44-45, National Geographic Stock; 46-47, National Geographic Stock; 50, NASA, ESA, and F. Paresce (INAF-IASF, Bologna, Italy), R. O'Connell (University of Virginia. Charlottesville), and the Wide Field Camera 3 Science Oversight Committee; 52-53, AFP/Getty Images; 62-63, National Geographic Stock; 69, National Geographic My Shot; 70-71, ZUMA Press; 72, Minden Pictures/National Geographic Stock: 74-75, Redux Pictures: 80-81, AP Photo: 82, National Geographic My Shot; 94-95, National Geographic My Shot; 96-97, National Geographic My Shot; 100, National Geographic My Shot; 101, National Geographic My Shot; 106-107, National Geographic My Shot; 108-109, REUTERS; 112-113, Getty Images; 114, National Geographic My Shot; 116-117, National Geographic My Shot; 122-123, REUTERS; 124-125, Minden Pictures/National Geographic Stock; 126-127, REUTERS; 128-129, National Geographic Stock; 131, National Geographic Stock; 133. National Geographic My Shot; 136-137, National Geographic Stock; 139, National Geographic Stock; 140-141. National Geographic Stock; 152, National Geographic Stock; 154-155, CORBIS; 158-159, Minden Pictures/National Geographic Stock; 164, CORBIS; 165, National Geographic My Shot; 166-167, epa/CORBIS; 168-169, VII/CORBIS; 170-171, Minden Pictures/National Geographic Stock; 176-177, National Geographic My Shot; 178, National Geographic My Shot; 180-181, National Geographic My Shot; 184, National Geographic Stock; 186-187, Wonderful Machine; 188-189, Magnum; 190-191, National Geographic My Shot; 192-193, Aurora Photos; 198, National Geographic Stock; 230,

National Geographic Stock; 231, National Geographic My Shot; 234-235, National Geographic My Shot; 240-241, National Geographic My Shot; 242, Getty Images; 252, National Geographic Stock; 258-259. National Geographic My Shot: 265, National Geographic My Shot: 266-267, National Geographic Stock; 268-269, National Geographic Stock; 272-273, National Geographic My Shot; 274-275, National Geographic Stock; 288-289, National Geographic My Shot; 292-293, National Geographic Stock; 296-297. Agence VU/Aurora Photos: 298. National Geographic My Shot; 300-301, Getty Images: 302-303, National Geographic My Shot; 308, National Geographic Stock; 318-319, LUCEO/www. luceoimages.com; 320-321, National Geographic Stock; 322-323, National Geographic My Shot; 324, National Geographic My Shot: 330, National Geographic My Shot: 331, Landsat 7 image processed by Serge Andréfouët and Frank Müller-Karger, University of South Florida, College of Marine Science/ NASA/USGS; 334-335, Aurora Photos; 338-339, Arctic Photo; 340-341, National Geographic My Shot: 344-345, AFP/Getty Images: 350, National Geographic My Shot: 354-355, REUTERS: 356-357, Speleoresearch & Films/National Geographic Stock; 358-359, National Geographic My Shot; 361, Reportage by Getty Images; 364, National Geographic My Shot; 365, AFP/Getty Images; 366-367, National Geographic My Shot; 368-369, CORBIS; 370-371, Panos Pictures; 373, National Geographic Stock; 378-379, Squiver; 386-387, National Geographic My Shot; 390-391, National Geographic Stock; 393, National Geographic Stock; 396, Whitehotpix/ZUMA Press; 397, National Geographic My Shot; 398-399, National Geographic Stock; 400-401, REUTERS; 405, National Geographic Stock; 406-407, National Geographic My Shot; 410-411, National Geographic My Shot; 414, National Geographic Stock; 416-417, National Geographic My Shot; 420-421, National Geographic Stock; 423, National Geographic Stock: 425, National Geographic Stock: 426-427, National Geographic Stock: 430-431, National Geographic My Shot; 432-433, National Geographic Stock; 434, National Geographic Stock; 437, National Geographic Stock; 438-439, National Geographic My Shot; 444-445, National Geographic Stock; 452-453, REUTERS; 456, National Geographic Stock; 459, Minden Pictures/ National Geographic Stock; 460-461, National Geographic Stock; 468-469, National Geographic Stock; 470, Minden Pictures; 471, National Geographic Stock; 472-473, National Geographic My Shot; 482-483, REUTERS; 489, National Geographic Stock; 490-491, National Geographic My Shot; 492, Minden Pictures/National Geographic Stock; 493, National Geographic Stock; 494-495, Wonderful Machine: 496-497, National Geographic Stock; 498-499, TCS; 504-505, National Geographic My Shot: 508-509, Getty Images for DAGOC.

VISIONS OF EARTH

Susan Tyler Hitchcock

PUBLISHED BY THE NATIONAL GEOGRAPHIC SOCIETY

John M. Fahey, Jr., Chairman of the Board and Chief Executive Officer
Timothy T. Kelly, President
Declan Moore, Executive Vice President; President, Publishing
Melina Gerosa Bellows, Executive Vice President;
Chief Creative Officer, Books, Kids, and Family

PREPARED BY THE BOOK DIVISION

Barbara Brownell Grogan, Vice President and Editor in Chief
Jonathan Halling, Design Director, Books and Children's Publishing
Marianne R. Koszorus, Design Director, Books
Carl Mehler, Director of Maps
R. Gary Colbert, Production Director
Jennifer A. Thornton, Managing Editor

STAFF FOR THIS BOOK

Meredith Wilcox, Project Manager
Susan Blair, Illustrations Editor
Melissa Farris, Art Director
Jane Sunderland, Text Editor
Michelle R. Harris, Picture Legends Writer
Judith Klein, Production Editor
Michael Horenstein, Production Manager
Cameron Zotter, Design Assistant

MANUFACTURING AND QUALITY MANAGEMENT

Christopher A. Liedel, *Chief Financial Officer*Phillip L. Schlosser, *Senior Vice President*Chris Brown, *Technical Director*Nicole Elliott, *Manager*Rachel Faulise, *Manager*Robert L. Barr, *Manager*

The National Geographic Society is one of the world's largest nonprofit scientific and educational organizations. Founded in 1888 to "increase and diffuse geographic knowledge," the Society's mission is to inspire people to care about the planet. It reaches more than 400 million people worldwide each month through its official journal, *National Geographic*, and other magazines; National Geographic Channel; television documentaries; music; radio; films; books; DVDs; maps; exhibitions; live events; school publishing programs; interactive media; and merchandise. National Geographic has funded more than 9,600 scientific research, conservation and exploration projects and supports an education program promoting geographic literacy. For more information, visit www.nationalgeographic.com.

For more information, please call 1-800-NGS LINE (647-5463) or write to the following address:

National Geographic Society 1145 17th Street N.W. Washington, D.C. 20036-4688 U.S.A.

Visit us online at www.nationalgeographic.com/books

For information about special discounts for bulk purchases, please contact National Geographic Books Special Sales: ngspecsales@ngs.org

For rights or permissions inquiries, please contact National Geographic Books Subsidiary Rights: ngbookrights@ngs.org

A large and wonderful variety of stunning images like the ones in this book are available for purchase as high-quality, framable prints. Please visit our site at www.PrintsNGS.com for details.

Copyright © 2011 National Geographic Society

All rights reserved. Reproduction of the whole or any part of the contents without written permission from the publisher is prohibited.

Library of Congress Cataloging-in-Publication Data Visions of Earth: beauty, majesty, wonder / foreword by Chris Johns.

p. cm. ISBN 978-1-4262-0883-6 (hardback) ISBN: 978-1-4262-0935-2 (U.K. edition)

- 1. Nature photography. 2. Landscape photography.
- 3. Human geography. I. Johns, Chris, 1951- II. National Geographic Society (U.S.) TR721.V57 2011 779'.36--dc23

2011024278

Printed in the United States of America 11/CK-CMI /1